Public Monuments and Sculpture
National Record

Public Sculpture of North-East England

PMSA

PUBLIC SCULPTURE OF NORTH-EAST ENGLAND

Paul Usherwood, Jeremy Beach
and Catherine Morris

UNIVERSITY *of*
NORTHUMBRIA
at NEWCASTLE

LIVERPOOL UNIVERSITY PRESS

First published 2000 by LIVERPOOL UNIVERSITY PRESS,
Liverpool, L69 7ZU

The National Recording Project is supported by the
National Lottery through the Heritage Lottery Fund

HERITAGE LOTTERY FUND

Copyright © 2000
Public Monuments and Sculpture Association

The right of Paul Usherwood, Jeremy Beach and
Catherine Morris to be identified as the authors of this work
has been asserted by them in accordance with the Copyright,
Design and Patents Act 1988

British Library Cataloguing-in-Publication Data
A British Library CIP record is available

ISBN 0-85323-625-9 (cased)
ISBN 0-85323-635-6 (paper)

Design and production, Janet Allan

Typeset in 9½/11pt Stempel Garamond
by XL Publishing Services, Lurley, Tiverton, Devon
Originated, printed and bound in Great Britain by
Henry Ling Ltd, Dorchester

Preface

The Public Monuments and Sculpture Association was founded in 1991 to encourage the appreciation and conservation of our national heritage of public monuments and sculpture. Research was immediately recognised as essential to achieve these aims and in 1993 the Association established its most ambitious programme, the National Recording Project, in order to compile an exact and detailed catalogue of public sculpture and monuments throughout Britain by means of a computerised database and of a series of volumes. Ecclesiastical sculpture, which has its own cataloguing procedures, was excluded but in other respects public sculpture was defined as widely as possible to include everything to which the public has easy or restricted access by right or custom. Close co-operation was established with the National Inventory of War Memorials at the Imperial War Museum to ensure that war memorials would be thoroughly catalogued but with no duplication of effort. This is the third of the published volumes after the appearance of those covering Liverpool and Birmingham in 1997 and 1998. It marks however a new departure in two ways.

The first two volumes largely depended on research originally carried out independently of the PMSA but then prepared and updated for publication under its auspices. In late 1996 the PMSA received a grant of £470,000 from the Heritage Lottery Fund to facilitate its research into public sculpture and the compilation of its computerised database recording this research. This permitted the PMSA to sign formal contracts with selected universities, colleges, art galleries and museums throughout most of the country by which these institutions would undertake the research and compilation in their area with the costs shared between them, the PMSA and local and national sponsors. Work was greatly speeded up and twelve more volumes excluding this one are already well advanced. With their publication over the next few years around two thirds of the more important public sculptures throughout Britain will be covered.

Secondly Liverpool and Birmingham are primarily Victorian and Edwardian cities with a notable heritage of later nineteenth- and early twentieth-century sculpture. North-East England is partly urban, partly suburban and partly rural. There are important earlier sculptures but the area has been remarkably successful in the commissioning of new public sculpture over the past twenty years often as part of a conscious policy of regeneration. This volume therefore covers a rather wider range of sculptures and monuments than the earlier volumes and permits some assessment and even judgement of recent developments. More public sculpture is now being commissioned than at any time in the last seventy-five years and a very important sample is in North-East England.

The generous Heritage Lottery Fund grant was directed towards research and the computerised database, not towards publication costs. We are therefore very grateful to the Paul Mellon Centre for Studies in British Art for a substantial publication grant for this volume. The Henry Moore Foundation has also made a contribution together with an offer to support future volumes. In addition a number of North-East organisations have provided help: Northern Arts, Durham County Council, Gateshead Metropolitan Borough Council, Great North Forest and the Joicey Trust. Even with this assistance our publishers, Robin Bloxsidge and the Liverpool University Press, are making a very heavy commitment to our series at a time when even well financed museums are often reluctant to pay the costs of detailed catalogues. We are deeply grateful. Paul Usherwood, Jeremy Beach and Catherine Morris have of course displayed in this volume a depth of research and a mastery of synthesis which will make it a standard work of reference and scholarship for many years but we should also record our thanks to the University of Northumbria at Newcastle and to its Dean of the Faculty of Arts and Design, Professor Kenneth McConkey, for their support and enthusiasm.

EDWARD MORRIS
Chairman of the Editorial Board

Contents

Preface v

Maps viii

Introduction: The Catalogue xiii

Monuments themselves Memorials need xiii *Organisation of the Catalogue* xv *Inclusions and Omissions* xv
PAUL USHERWOOD

Introduction: Themes and Approaches xvii

Iron and Coal xvii *Three Kinds of History* xix
PAUL USHERWOOD

An Embarrassment of Riches: Recent Public Sculpture xx
Site, Place and Meaning xxiv
JEREMY BEACH

Abbreviations xxx

Sources of Illustrations xxxi

Acknowledgements xxxii

PUBLIC SCULPTURE OF NORTH-EAST ENGLAND

Northumberland County 1

Tyne and Wear 52

County Durham 222

Cleveland Area 280

Glossary 311

Biographies 317

Bibliography 341

Index 349

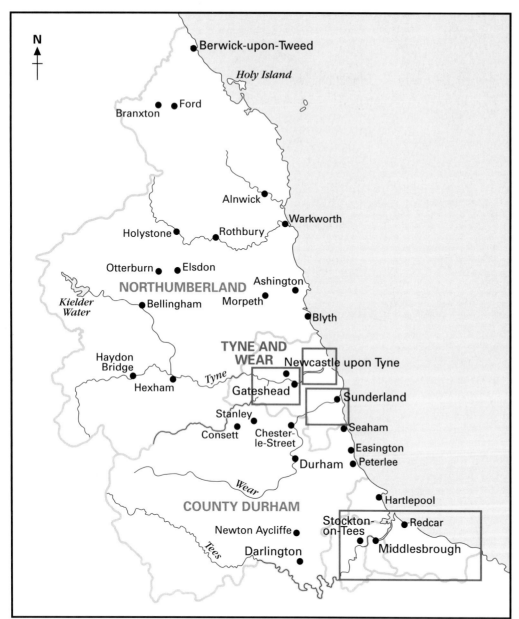

N

Berwick-upon-Tweed

Holy Island

Ford
Branxton

Alnwick

Warkworth

Holystone Rothbury

Otterburn Elsdon

NORTHUMBERLAND

Kielder Ashington
Water Bellingham
Morpeth

Blyth

**TYNE AND
WEAR**

Haydon
Bridge Newcastle upon Tyne

Tyne
Hexham Gateshead Sunderland

Stanley Seaham

Consett Chester- Easington
 le-Street Peterlee

Durham

Wear

COUNTY DURHAM

Hartlepool

Newton Aycliffe Stockton- Redcar
 on-Tees
Tees
Darlington Middlesbrough

North-East England

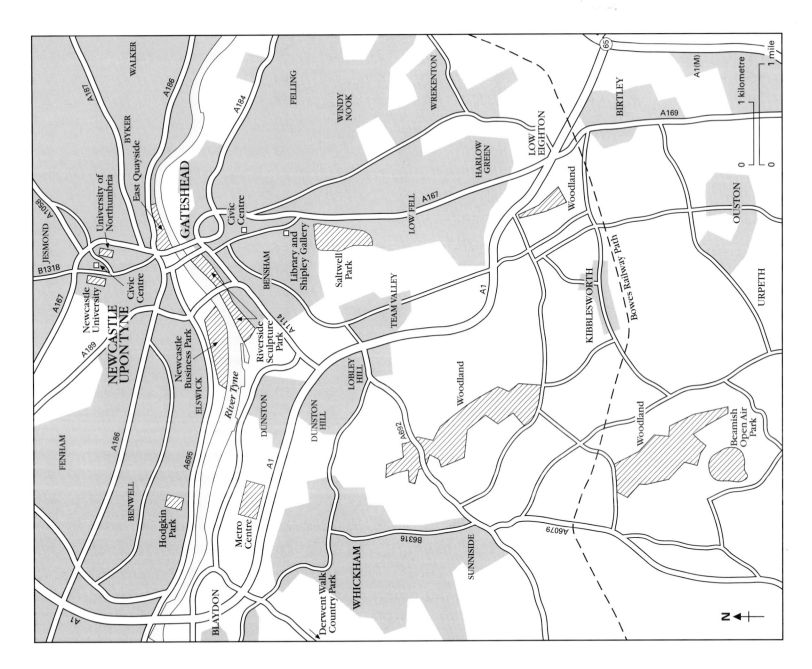

Newcastle and Gateshead

Maps ix

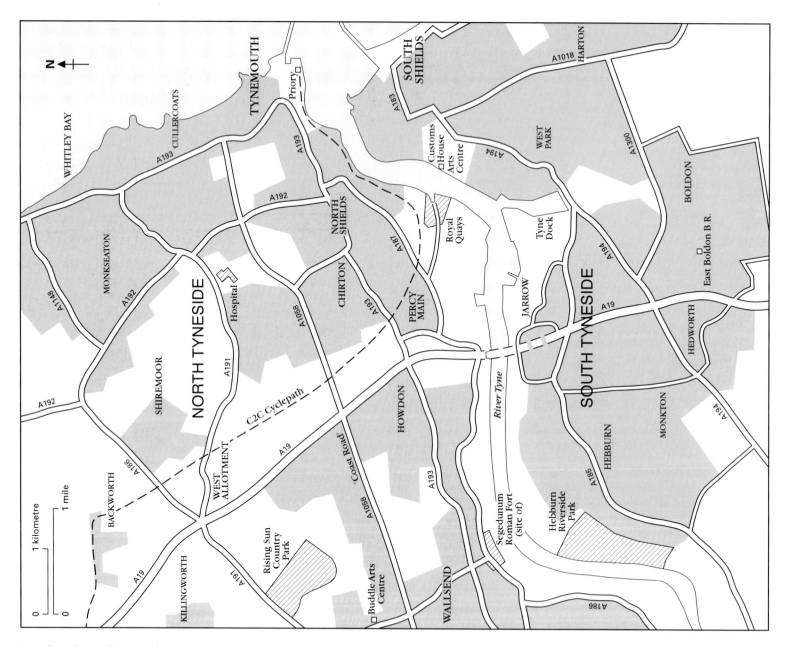

North and South Tyneside

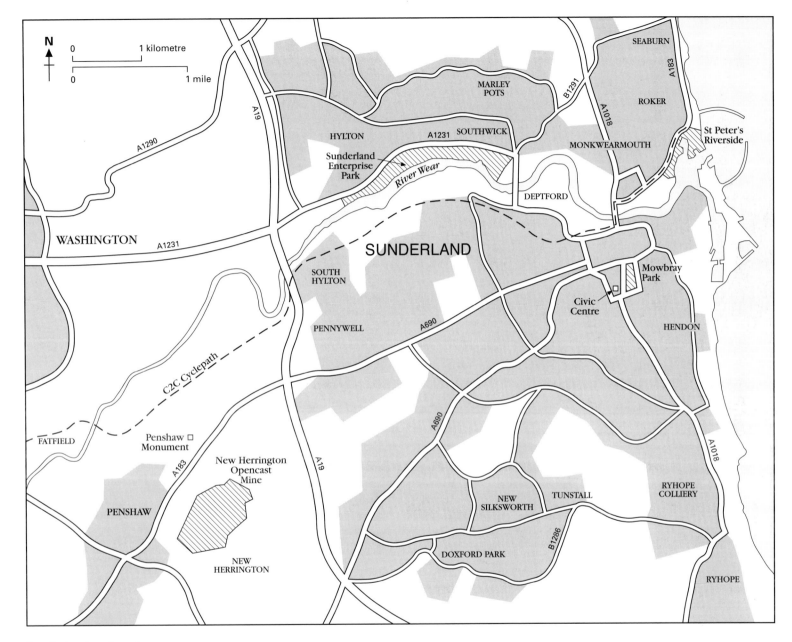

N

0 1 kilometre

0 1 mile

SEABURN

MARLEY
POTS

ROKER

A183

B1291

A19

A1290

HYLTON A1231 SOUTHWICK

A1018

St Peter's
Riverside

Sunderland
Enterprise
Park

MONKWEARMOUTH

River Wear

DEPTFORD

WASHINGTON A1231

SUNDERLAND

Mowbray
Park

SOUTH
HYLTON

Civic
Centre

HENDON

C2C Cyclepath

PENNYWELL

A690

FATFIELD

Penshaw □
Monument

A183

New Herrington
Opencast
Mine

A690

A19

A1018

PENSHAW

NEW
SILKSWORTH

TUNSTALL

RYHOPE
COLLIERY

B1286

DOXFORD PARK

NEW
HERRINGTON

RYHOPE

Sunderland and environs

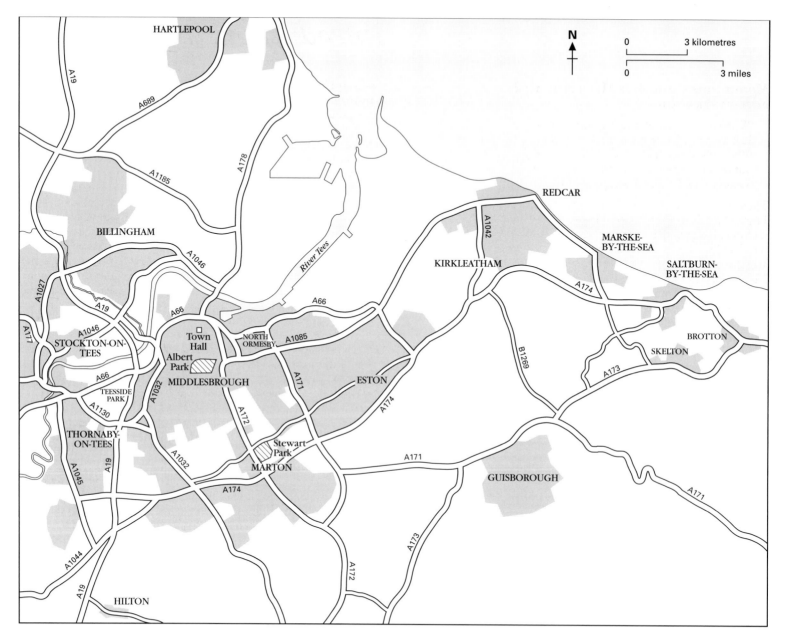

Middlesbrough and environs

Monuments themselves Memorials need

PAUL USHERWOOD

> 'Wonder not, Mortal, at thy quick decay –
> See! Men of Marble piece-meal melt away;
> When whose the Image we no longer read,
> But Monuments themselves Memorials need.
> (George Crabbe *The Borough,* 1810)

There are two reasons why the public sculpture of North-East England needs to be recorded. Firstly, although local interest in public sculpture has greatly increased in recent years, it tends to be focused on a handful of new 'landmark sculptures' by internationally famous artists such as Claes Oldenburg and Coosje van Bruggen's *Bottle of Notes* (1993) in Middlesbrough, David Mach's *Train* (1997) outside Darlington, and Antony Gormley's *Angel of the North* (1998) outside Gateshead. Such works have undoubtedly cemented the North East's reputation as one of the best places in Britain to view new public sculpture (see p.xvii below) but there are many other delightful and remarkable works in the region which deserve attention as well. Secondly, as with any artwork, the form and meanings of particular works change with time and this needs to be brought to people's attention.

Various factors contribute to this mutability. First, nature: a vivid illustration of the damage weather can wreak is to be found in the nave of St Aidan's at Bamburgh, Northumberland, where sits the original stone figure of C. Raymond Smith's *Grace Darling* (1844) looking like a saint on a medieval tomb, save for the oar clutched to her side. Formerly incorporated into the monument in the churchyard, this figure is a sad sight. Grace, the lighthouseman's daughter who famously defied the forces of nature on a September night in 1838 when she helped her father to rescue the passengers of the shipwrecked paddle-steamer *Forfarshire*, has now herself fallen prey to wind and rain, her skin and garments pitted and braided like the surface of the moon.

For the most part sandstone, granite and bronze works survive the ravages of nature and pollution reasonably well. Similarly the lead *Neptune* in the Market Place, Durham, and the various lead figures at Sir William Turner's Hospital at Kirkleatham are in remarkable condition given that they have been out in the open air for more than two hundred and fifty years, albeit that one of them, *Justice*,

nowadays has to brandish a plastic sword from Woolworths. It is the non-traditional materials used in certain very recent works which often prove vulnerable. For instance, the steel abstract shapes of Richard Deacon's *Once upon a Time...* (1992), Gateshead, need repainting every other year and the gravel of David Tremlett's *Gravel Artwork* (1991) on the riverside at Gateshead and the limestone chips and bark of Gary Power's vast mural-like *Badger* (1993) by a roundabout at Prudhoe, Northumberland, need frequent weeding.

Human interference also accounts for many of the changes that occur. Not being sanctioned by those in authority, vandalism is customarily frowned upon as 'gratuitous' and 'mindless': deservedly so it has to be said. It is hard, for instance, to excuse the small boy who snapped off the Percy Lion's tail on the Lion Bridge at Alnwick by sitting on it for a dare in the early nineteenth century (retribution followed swiftly: he fell into the river).[1] And likewise it is hard to find anything to excuse the farmer at West Woodburn, near Otterburn, who broke up a Roman statue at about the same time. Certainly that was Sir Walter Scott's view: 'I wish the fragments were in his bladder with all my heart', he wrote to a friend.[2] Maybe one should be more lenient towards the modern-day teenagers who plight their troth in felt tip and paint on the Coade Stone lions at the base of David Stephenson's *Percy Tenantry Column* (1816) at Alnwick or on the concrete walls of Victor Pasmore's *Apollo Pavilion* (1960s) at Peterlee (see Figure 1); they no doubt are experiencing the traumas of adolescence. However, before showing too much sympathy, it is worth noting that this kind of teenage graffiti is invariably thoroughly élitist in that it is designed to be meaningless to all but a tiny circle.

In addition to vandalism there is the kind of human interference which *is* sanctioned by those in authority. This also gives new meaning, or at the very least, new emphasis, to particular pieces. Consider the two inscriptions on *Grey's Monument* (1838) in Newcastle. Cut sixteen years after the monument itself was erected, the one on the front gives a lengthy account of Earl Grey's various struggles and achievements and must have subtly shifted popular perceptions of the former Prime Minister's long and often controversial career. Meanwhile, on the back are the words, 'After a Century of Civil Peace the People Renew their Gratitude to the Author of the Great Reform Bill'. These were added in 1932 at the behest of a group of influential Northumbrian gentry and were the result of a quite deliberate attempt to co-opt the monument into the

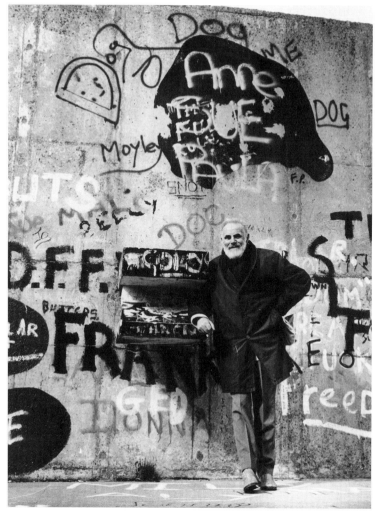

Fig. 1. Victor Pasmore beside *Apollo Pavilion*, 1982.

erecting them elsewhere.[3] This may seem entirely proper. However, it does raise questions about the role of public sculpture within the urban environment if a piece is to be treated like a transportable 'homeless' artwork in a gallery rather than as tied physically and symbolically to a particular place in the traditional manner. Interestingly this was an issue even at the start of the century. Discussing the design of the pedestal for his *Monument to Sir Samuel Sadler* in Middlesbrough, Édouard Lantèri spoke of the need to avoid public statues ending up looking like pawns on a chess-board which can be moved around at will.[4]

The moving around of public monuments and sculpture, however, has a long history. For instance, in 1807, just twenty-four years after it was erected, the *Cale Cross*, the elaborate conduit head put up in the centre of Newcastle by Sir Matthew White Ridley, was taken down and re-erected at the Ridley country seat in Northumberland; and in our own century the statues of the ironmasters Henry Bolckow and John Vaughan in Middlesbrough suffered a similar fate. When first erected in the 1880s they were sited close to one another in Exchange Square, which was entirely fitting in that the two men's careers had depended on their long-standing business partnership. However, subsequently the statues were moved back and forth and have ended up well apart in quite different parts of the town.

To talk, though, of works 'suffering' displacement may be inappropriate because removal may not necessarily be altogether harmful. Take the case of the *Evelyn Column* designed by Sir John Soane in 1787, for example. Certainly, when this was transported stone by stone from Surrey to the grounds of Lemmington Hall in north Northumberland in 1927 it was diminished in various ways. It no longer served any commemorative purpose, it was buffeted by harsh northern winds and the inscription on the entablature 'Soli Deo Gratia' ('To the god of the sun be thanks'), confusingly, came to be turned northwards so that the column's new owner could see it from his home. However, the move undoubtedly brought benefits as well; the column gained a dramatic setting and an engagingly improbable air. And indeed, it is worth noting that there are instances, such as the four stone griffins' heads at Wallington which were transported to Northumberland in the eighteenth century, where a work has been moved specifically in order to make it look incongruous and strange.

Yet whether changes to a work are deemed beneficial or not, it is important to recognise that a work's meanings will change anyway. In the beginning there is no Genesis-like moment when the authentic work as intended by the artist comes into the world which subsequent ages can somehow seek to rediscover. Even where a recent piece, such as Oldenburg and van Bruggen's *Bottle of Notes,* is

defence of the nation against the kind of dangers that seemed to be threatening democracy in Weimar Germany at the time.

In recent years officialdom's motive for altering a piece is sometimes simply to reawaken public interest in it. This apparently was partly the case in Middlesbrough when the Council removed Graham Ibbeson's *The Gardener* (1991) and *Mother and Child* (1991) from the pedestrianised precinct in Linthorpe Road with a view to re-

particularly linked to an artist's name, it comes into existence gradually over time, sometimes over a considerable period, and always as the result of the input of a number of different people: architects, designers, sculptors, carvers, as well as those who commissioned the work, and all those who view the work once it is in place. In their way even the latter ought in fact to be considered as 'makers', for they too help to endow the piece with meaning. Take Brian Wall's large abstract work in Thornaby (1968) with its two overlapping As in steel. This was intended by the sculptor to evoke the design of the motto on Thornaby's old coat of arms. However, long ago local school children decided it looks more like a spider, and now that is what the piece is called. They have in effect therefore helped to 'produce' the work.

In addition, site can radically affect meaning, as the story of Hamish Horsley's *The Way* illustrates. When this arrangement of abstract shapes around a pebble path was first installed in Team Valley for the Gateshead National Garden Festival in 1990 it was called *Aion*, and the artist talked of it as a meditation on 'the beginning, stillness and movement of time'. When, however, it was re-installed four years later on a hill overlooking Durham Cathedral, he said it was concerned with the religious character of the site; in particular, it evoked the life and journey of St Cuthbert. This might seem like a bizarre change of mind, but surely it should be seen more as a candid acknowledgement of the difference that a change of setting inevitably makes.

So how do these various kinds of change point to the need for a catalogue? In two ways. Firstly, the protection of particular works from further, unnecessary, change requires reliable information not just about their present condition and ownership but also about the meanings that they have possessed and the alterations to which they have been subjected in the past. Secondly, public sculpture has much to offer anyone interested in local history. The seemingly reliable, authoritative pronouncements that particular works make may in themselves be of limited value. However, that is not true of the evolving discursive frameworks within which the pronouncements are made. These can offer all kinds of insights into the way taste and attitudes have changed over time. Public sculpture is a valuable resource that is too little used.

Organisation of the Catalogue

The North East region is divided into four main areas using standard county boundaries except in the case of the unitary authorities on the border of the old counties of Durham and Yorkshire. The first section covers Northumberland, the second Tyne and Wear, the third County Durham, and the fourth the area to the south (until recently the county of Cleveland) which we are calling the 'Cleveland area'. Cities, towns and villages within these four areas are listed alphabetically as are streets within cities, towns and villages. However, where, a commonly used unofficial area name exists, this is used instead – as with the 'University of Newcastle' or 'St Peter's Riverside'. Inevitably, the reader will encounter difficulties from time to time, and for this we apologise, but with judicious use of the maps and the index we trust these will not be insuperable.

Inclusions and Omissions

The catalogue's inclusions and omissions need explaining. Unlike the two previous volumes in this series, *Public Sculpture of North-East England* covers not just one city but an entire region of England. Considerations of space have therefore played a particularly important part.

First, inclusions: in addition to the kind of commemorative statues and architectural sculpture one might expect, we have included columns, obelisks and public drinking fountains as long as these seem to us to possess sculptural or associative interest; similarly, pieces of modern street furniture or architectural sculpture. We have therefore, it should be noted, included many works by makers not normally referred to as 'sculptors'.

The word 'public' when attached to the word 'sculpture' clearly raises all kinds of knotty problems. Sufficient to say that here it signifies works which are physically accessible to the general public or visible from the public highway. Thus whilst sculpture in schools or hospitals is seldom included on the grounds that these places are increasingly barred to those without official leave, the *Monument to British Liberty* or the *Griffins' Heads* at Wallington Hall are both in, not because they happen to be on National Trust property but because they can be seen from the highway. As for recent 'public art', a diverse and hard-to-define – albeit in the context of this catalogue very important – category, anything that might be described as 'sculptural' in character is included, but *not* all the other objects which are commonly labelled public art such as murals, temporary installations, stained glass, performance art and utilitarian street furniture.

Thus 'public sculpture' is interpreted very broadly; nonetheless, there is much that is left out, sometimes inadvertently but often quite intentionally. For instance, the catalogue does not include village crosses or market crosses, even, say, the crosses at Bywell and North Charlton which have considerable historical interest or the cross at Stockton which is large and architecturally ambitious. Nor, sadly, are

there any of the delightful chunky stone pants in places like Shilbottle, Corbridge and Hexham erected by benevolent landlords at some point in the nineteenth century. Distinctive to the region though these are, their 'failing' is that they are simply too unpretentious for this particular survey, too distant from what is customarily called sculpture. As for war memorials only a few are included, the reason being that war memorials in the region, as elsewhere in Britain, happen currently to be the subject of the National Inventory of War Memorials Survey. Those which are included are ones which seem to us to be of particular sculptural significance.

Colliery disaster memorials, on the other hand, although not usually any more sculptural than war memorials, are included in most instances. This may seem perverse, but it was felt appropriate to waive the aesthetic criterion in their case because they represent a type of work which is particularly well represented in the region and is previously undocumented.

By contrast, works in churches and cemeteries are omitted. For instance, no place is found for the wonderful fifteenth-century alabaster figures on the *Neville Monument* at Staindrop, Co. Durham or the *Grey Monument* at Chillingham, Northumberland. The only exceptions in respect of this type of work are certain exterior monuments which were raised by public subscription like, say, the *Grace Darling Monument* at St Aidan's, Bamburgh or the *Hartley Disaster Memorial* at St Alban's, Earsdon and therefore were always meant to fulfil a public role.

As regards chronology, we have followed the approach of the PMSA National Recording Project and covered everything from the time of the Eleanor Crosses erected at the end of the thirteenth century to the present day. A seven-century span, this might seem more than enough, but in fact in some ways it is rather restricting. For instance, it leaves no place for the Bronze Age *Yeavering Stone* in north Northumberland, appropriated in the late Middle Ages as a battle-marker and now something that must surely appeal to anyone who has ever responded to, say, the work of Richard Long. As regards the precise cut-off point, this is the summer of 1999 when our manuscript was handed over to the publishers. This means that, sadly, for instance, there is nothing on *Ambit*, Alison Wilding's floating sculpture for the Wear at Sunderland or Eric Bainbridge's *Heaven and Earth Roundabout* at Hartlepool, both of which were installed in September 1999. However, such omissions can be rectified in due course; the digitised database on which this book is based will be up-dated. One of the beauties of the computer age is that there is always scope for revision.[5]

Lastly, two points should be noted. Firstly, the length of an individual entry does not necessarily indicate the importance we attach to the work in question. Sometimes, if it is short, it merely indicates that there happens to be little information available. There are, however, certain works where far more information exists than we had space for. In such instances, it will be clear from the entry where such further information can be found. Secondly, although we have included biographies for most of the sculptors, architects and designers responsible for works in the region, there are a few instances where that is not the case because we have not been able to find any information worth recording about the person in question.

Introduction: Themes and Approaches

Iron and Coal

PAUL USHERWOOD

Despite the demise of manufacturing industry and mining in North-East England in the last few years, the region's identity is still perceived as inextricably bound up with iron and coal.[6] In themselves, for instance, Antony Gormley's *Angel of the North* (1998) and Mark Di Suvero's *Tyne Anew* (1999), two of the largest and most recent pieces of public sculpture in the North East, may not seem to have any special connection with shipyards or coal mines. Significantly, however, Gormley's essay in *Making An Angel,* the book Gateshead published to celebrate the Angel's arrival, is entitled 'Of coal and iron and ships and planes',[7] and Di Suvero has gone on record as saying that *Tyne Anew* 'will be a constant reminder to people of the industrial foundations that the North East is built on'.[8] Clearly a number of factors have helped to create and perpetuate a particular notion of the region's identity, and one of these is public sculpture.

In the first place there are commemorative statues to the men responsible for establishing the mainstay industry of particular towns or districts. Examples are the statues to Joseph Pease of the Quaker millowner and financier family (1875) in Darlington, the shipbuilder Charles Mark Palmer (1904) in Jarrow, the ironmasters Henry Bolckow and John Vaughan (1881, 1884) in Middlesbrough, William Gray and Ralph Ward Jackson (1889, 1897) in West Hartlepool, and the 'Father of Railways', George Stephenson, (1862) and the engineering and armaments magnate, William Armstrong (1906) in Newcastle. When first erected each of these served as the pretext for a particular town or district to marvel at and affirm the story of industrial success which had brought it prosperity and in some instances allowed its population to expand prodigiously.[9] Indeed in the case of *Pease, Bolckow* and *Ward Jackson*, the inauguration of the statue was tied into festivities staged to celebrate the jubilee of the particular town's modern existence.

As one would expect, the festivities, like the statues themselves, were organised by those with most to gain by continuing industrial success, that is to say, members of the town's business and political élite.[10] There is no reason to suppose, however, that the idea of the town owing its success to the vision and zeal of one or two extraordinary individuals was not readily endorsed by all sections of the population. Vast crowds were often present: 100,000 for the unveiling of *Pease* (see Figure 2), 65,000 for that of *Bolckow.*

Furthermore, the number of those who contributed to the public subscription was often huge – 15,000, for instance, in the case of the *Samuel Sadler Monument* in Middlesbrough.

A second type of public sculpture which has served to project an industrial and mining idea of the region is that of the statue of the individual anonymous miner. The first of these to appear was the miner at the base of John Graham Lough's monument to Stephenson in Newcastle. Like his companions – plate-layer, blacksmith and locomotive engineer – who together symbolise the main aspects of the great inventor and industrialist's extraordinary career,[11] this man is clearly idealised in the manner expected of supporter figures on nineteenth-century statues. However, bizarre amalgam of contemporary worker and Greek hero that he is, he manages, perhaps for the first time in High Art, to project a wholly favourable image of the miner. This marked a considerable shift. Look, for instance, at the pithead scenes of the local genre painter, Henry Perlee Parker, produced thirty years earlier, and you find there miners who are picturesque and sometimes slightly comic, but never heroic.[12]

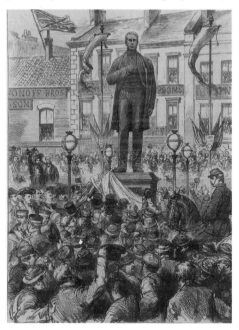

Fig. 2. Inauguration of the *Monument to Joseph Pease* (*Graphic*, 2 October 1869).

The heroisation of the miner was undoubtedly related to the concerted attempt made in the mid nineteenth century to promote Tyneside, Wearside, and Teesside as together forming the country's leading manufacturing area.[13] However, such was the continuing importance of coal to the region's economy, it was not the manufacturing worker who emerged as the ideal representative of the newly industrialised North East but the miner as devised by Lough.[14] Later on, it is true, this figure assumes a more realistic guise in Canavan's 1895 statue of a young miner walking along, pick axe over his shoulder, on the headquarters of the Northumberland Miners' Union in Newcastle, and in John Reid's slightly academic figure of a deputy holding up a lamp on the Ashington Colliery Disaster Memorial (1923). Nevertheless he continues to exhibit the same kind of moral and profoundly masculine authority.[15]

The colliery disaster memorials which first appeared in the latter part of the century added a new ingredient: a sense of the value of service to the community. As with the rather later South African War and First World War memorials which they often closely resemble, the men and boys remembered are presented as martyr figures whose supposed willingness to sacrifice themselves for the good of the community offers a shining example to those who are left (see Figure 3).[16]

Interestingly, heroes of mass spectator sport when they are

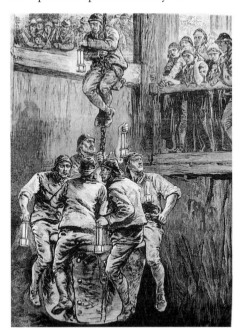

Fig. 3. Colliery Disaster, Seaham (*ILN*, 18 September 1880).

memorialised are made to display a similar blend of pride and dedication. In George Burn's *Renforth Monument* (1871) in Gateshead, for example, the champion oarsman James Renforth is shown not enjoying one of his many triumphs on the water but in his final race on the Kennebecassis in Canada, overcome by exhaustion, slumped in the arms of his crew-mate in a pose which imitates that of Christ in a traditional Pieta.[17] Indeed, vestiges of the same stoic virtues can be discerned in the figure on the three 1990s monuments in the region to Jackie Milburn, ex-miner and celebrated Newcastle United centre forward. The intent gaze and lithe, muscular frame of the figure on each of these and the description of Milburn as 'footballer and gentleman' on the pedestal of Susanna Robinson's *Wor Jackie* in Newcastle suggest that here is someone who is to be admired above all for his moral qualities.

Inevitably in the last thirty years although new public sculpture in the North East has continued to be preoccupied with manufacturing industry and mining, there is no longer any sense that the destiny of the region lies there. Sometimes, for instance, as with two Modernist abstract steel pieces, Eric Wilson's *231* (1990) in Cramlington, Northumberland, and John Hoskin's *Resurgence* (1970) in Darlington, brave hopes for the future are expressed. More commonly though, as with Graham Ibbeson's monument to the early nineteenth-century locomotive designer and manufacturer Timothy Hackworth in Shildon, Co. Durham (1998), the interest in the subject seems to be more antiquarian. Ibbeson's statue makes reference to Hackworth's contribution to railway history (the figure holds a model of the 'Royal George' in his hand) but, typically, conveys no sense that this contribution has any real relevance to the present-day. It is revealing to compare this work with Lough's *Stephenson*. There, despite, or perhaps because, the subject seems to be dressed in a frock coat and cloak which could be mistaken for a classical toga it easy to imagine that railways not only have a glorious past but could still have a glorious future as well.

In other recent works a more elegiac note is struck. For example, Brian Brown's *The Putter* (1995) in Durham was originally intended to commemorate the colliery at Easington which closed in 1993. Likewise, the 1995 colliery disaster memorial at West Stanley with its colliery winding wheel set into a brick base laments the passing of both mining and the communities which mining supported in that part of East Durham.[18]

Occasionally darker emotions are in evidence. Tony Cragg's *Terris Novalis* (1997), with its large-scale versions of a nineteenth-century theodolite and level outside Consett, might seem to pay tribute to the kind of technological expertise which underlay the mighty steel

works, once the largest in Europe. The fact though that these surveyors' instruments are supported by the severed limbs of various animals suggests that a less straightforward view of the industrial era might be intended. This also seems to be true of the rounded abstract forms of Richard Deacon's *Once upon a time...* (1991) on the abutment of the former Redheugh Bridge at Dunston, Gateshead. In themselves these might be read as testament to the region's engineering skills embodied in the six great bridges spanning the Tyne between Newcastle and Gateshead. The title, however, introduces an astringent note which indicates that the work may also be offering a sardonic comment on how the sheds and warehouses which once thronged this part of the river bank were replaced by woods and lawns dotted around with pieces of contemporary sculpture.

These two pieces however are unusual. Many new works erected in the last few years by virtue of being located in areas like Gateshead Riverside Sculpture Park or Sunderland Enterprise Park serve to underpin the symbolism of reclamation. The greening over of industry's depredations, they imply, is all for the best, as are the service sector jobs which have replaced the oppressive working conditions, polluted environments and stunted ambitions of the industrial age.

Yet on the whole, one can say, recent public sculpture suggests a reluctance to think ill of the industrial age. For some this will be because it seems to have been a time of solidarity, relatively high wages and the dignity of labour. They will think of stirring occasions like the inauguration of Lough's *Stephenson* in October 1862 when ten thousand highly paid, highly skilled workers from various local engineering firms marched through the streets of Newcastle bearing banners proudly proclaiming 'Peace promotes Industry', 'By hammer in hand, all arts do stand' and 'May Honest Industry ever be fairly rewarded'.[19] For others, perhaps for most, it will be because of the manifest power and imagination of places like the shipyards on the Tyne and Wear, the ironworks at Middlesbrough and Consett, and the mines of East Durham. That landscape of molten beauty and crackling energy, of Stygian darkness and inhuman scale may have been one which could maim and disfigure, but it was also one which could inspire.

Three Kinds of History

PAUL USHERWOOD

The sheer diversity of work included under the catch-all title 'public sculpture' can be daunting. One possible answer is to consider the kind of comment on the past that individual works make using the typology Friedrich Nietzsche puts forward in his early and uncharacteristic work, *The Use and Abuse of History* (1874). 'History', Nietzsche says, 'is necessary to the living man in three ways: in relation to his action and struggle, his conservatism and reverence, and his suffering and desire for deliverance. These three relations answer to the three kinds of history – so far as they can be distinguished – the *monumental*, the *antiquarian* and the *critical*.'[20]

Taking each of these in turn, *Monument to British Liberty* raised on a country estate at Gibside, Tyne and Wear, in 1757 and the *Monument to the Glorious Revolution* (1788) at Kirkley Hall, Northumberland, are examples of *monumental* history for in their separate ways they both proclaim that, in Nietzsche's phrase, 'a great thing existed and was possible, and so may be possible again'.[21] For the same reason war memorials and colliery disaster memorials may also be regarded as *monumental* history for although these have antiquarian interest, their chief purpose has always been to provide sites of reverence at which viewers are able to pledge themselves to emulate the spirit of self-sacrifice shown by those who have 'given' their lives.[22] This, for instance, was what the Lord Mayor of Newcastle argued about the city's South African War Memorial at its inauguration in 1908. Thomas Eyre Macklin's elaborate and costly edifice, he said, was 'an incentive to all to put their country's claims as one of the first objects of their lives'.[23]

Sybil's Well in a wood in north Northumberland, by contrast, is an example of *antiquarian* history because here the past is presented as valuable in its own right. If one were not aware of when it was installed the emphatic, hortatory style of the work's inscription, 'DRINK WEARY PILGRIM DRINK AND STAY / REST BY THE WELL OF SYBIL GREY' perhaps might give the impression that the pilgrim in question is expected to be stirred to great deeds. However, as soon as one realises that it dates c.1880s, it is clear this person must always have been envisaged as a devotee of Walter Scott, eager to see Flodden Field through the great novelist and poet's eyes, as the kind of person in other words whom Nietzsche describes dismissively as a curious tourist or a laborious beetle-hunter climbing up the great pyramids of antiquity.[24]

Further examples of *antiquarian* history are the *William the Lion Stone* and *Malcolm's Cross* outside Alnwick, installed to lend an air of legitimacy to the claims of the first Duke and Duchess of Northumberland. The *Fothergill Fountain* in Darlington and the *Lanton Obelisk* in north Northumberland, both of which were erected as essentially private memorials, fall into this category as well. Like *Sybil's Well*, these belong to a historiographical tradition which, in the case of the North East, begins with Robert Adam's gothicising of Alnwick Castle in the 1770s, becomes entrenched in the first years

of the nineteenth century with the poetry and antiquarian writings of Walter Scott and then erupts in a whole variety of texts, ranging from T.M. Richardson's etchings of the region's medieval heritage in the 1820s and 1830s to M.A. Richardson's *Local Historian's Table Book, or remarkable occurrences, historical facts, traditions, legendary and descriptive ballads…* (1841, 1844) and Thomas Fordyce's *Local Records; or Historical Register of Remarkable Events* (1862).

Professional historians tend to have little time for this tradition because it focuses on extraordinary people and events (kings, lords, battles, deaths), pays scant attention to periodisation (the past is simply 'olden times', undifferentiated, homogenised) and makes little attempt to view the things of the past in their true perspective. As Nietzsche puts it, 'There is no measure: equal importance is given to everything, and therefore too much to anything'.[25] A further criticism is that it tends to portray the region's past as the direct expression of its landscape. 'Northumberland is a rough county; that is its great attraction' declares Nikolaus Pevsner, for instance, at the start of *Northumberland*. 'Rough are the winds, the moors, the castles, the dolerite cliffs by Hadrian's Wall and on the coast; rough is the stone of the walls which take the place of the hedges; and even the smoother and more precisely worked stone of Newcastle seems rough.'[26] Nonetheless, as even Nietzsche acknowledges, the antiquarian tradition has its use 'in the simple emotions of pleasure and content that it lends to the drab, rough, even painful circumstances of a nation's or individual's life'.[27]

The third kind of history, *critical* history, is most likely to be found in recent public sculpture. Typically, this is a form of public sculpture which does not assume a reverential stance towards the past, while at the same time, by offering the artist's own personal meditation on things within the public domain, suggests ways in which history can help people to live in the present. Approached in a certain way, for instance, Antony Gormley's *Angel of the North* (1998) outside Gateshead, can be seen as offering the possibility of a kind of 'deliverance'. Most commentators, it is true, have not chosen to view it in this manner. They have made much of the work's imposing size, the fact that the skills used in the fabrication process were traditionally those found in the great shipyards on the Tyne and that it is sited on what was once a pithead baths. They have portrayed it, in other words, as a straightforward tribute to the region's mining and manufacturing heritage and the sturdy, manly qualities on which that heritage was built: that is, as a piece of *monumental* history.[28] However, the interpretation offered by the writer Beatrix Campbell shows how the *Angel* can be seen, in Nietzsche's words, as bringing 'the past to the bar of judgement' where it can 'be interrogated

remorselessly and finally condemned': as *critical* history.[29] 'In a region known for its macho iconography', Campbell argues, 'the Angel is a sexual subversive', the reason being that the artist has used his own body as the form from which the work is figured, at once challenging the history of the male artist's invisibility and the objectification of women in Western art. Gormley has also, she claims, found a way of replacing the 'transcendental muscularity' embedded in the classical tradition – see the figures on John Graham Lough's *Stephenson Monument* in Newcastle for instance – with a soft, unassertive sexuality which 'offers to a region notorious for its incontinent, marauding masculinities another challenging model of masculinity: self-contained, serene, in a gesture of embrace rather than attack.'[30]

For a piece of public sculpture to generate this kind of liberating, progressive meaning, to function as *critical* history, the viewer must approach it feeling a pressing need to address some great injustice in the contemporary world. In Nietzsche's words, whereas the man who wishes to perform a great deed looks to *monumental* history and 'the man who can rest content with the traditional and venerable, uses the past as an antiquarian historian', only the man whose 'heart is oppressed by an instant need … turns to *critical* history, the history that judges and condemns'.[31] In the case of the *Angel* this means he or she must feel, maybe not Campbell's distaste for present-day expressions of masculinity on Tyneside, but certainly a desire to bring about reform which is as immediate and strong as Campbell's.

The object of citing Nietzsche's typology, however, is not to say that one type of history is preferable, but simply to underline that different kinds of public sculpture make different kinds of demand of the viewer.[32] It is easy to assume that there is a uniform way that the public sculpture contained here, old and new, should be viewed; indeed the gazetteer-like arrangement of the catalogue encourages such an assumption. Nietzsche's thoughts about the nature of history are a useful reminder that this is not the case.

An Embarrassment of Riches: Recent Public Sculpture

JEREMY BEACH

North-east England has had as many sculptures installed in the second half of the twentieth century as in the previous 600 years. More remarkable still is the leap from 35 sculptures listed in the catalogue as having been installed in the 1980s, to 180 in the 1990s (see Figure 4).[33] Though a similar rise in recent years has been noted for other parts of the country,[34] the extraordinary number of works installed in the 1990s in North-East England has led to the area being characterised as having one of the greatest concentrations of recent public art in Britain.[35]

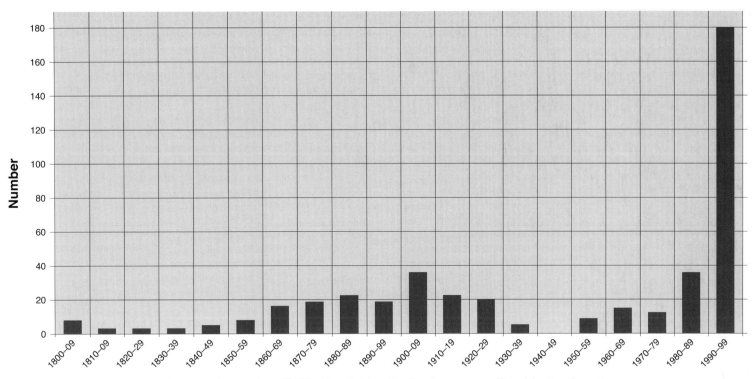

Fig. 4. Sculptures installed in North-East England 1800–1999 (listed in Catalogue).

A number of commissioning bodies have worked to create this rich collection of public sculpture: the Northern Arts regional arts board; local authorities, starting with Gateshead's policies in the 1980s; Tyne and Wear Development Corporation (TWDC) in the 1990s; Great North Forest, New Milestone and Sustrans in rural areas; and public art commissioning agencies. Last but not least, the availability of funds from the National Lottery has been crucial to the success of several very large works. Each of these factors will be discussed in turn below.

Perhaps the most important organisation for all types of arts activities in North-East England is Northern Arts, one of the most energetic of England's ten regional arts boards as regards supporting and publicising works of public art. Northern Arts set up Grizedale Forest in 1977, allowing a number of emerging sculptors to work in a challenging 'non-art' environment. At this time galleries in the region were showing relatively little contemporary art, so particular

emphasis was placed on art in public to develop an audience for this sort of work. More than 60 of the sculptures or schemes listed in this catalogue have been part-funded by Northern Arts since then, 49 of them in the 1990s. The board has also played a key role influencing other organisations to commission works, providing advocacy and expertise as well as money. The influence of Northern Arts was felt particularly keenly in 1996, the Year of Visual Arts UK, a period of intense involvement in all sorts of arts activities across the region which included notable temporary projects such as Bill Viola's video installation *The Messenger* in Durham Cathedral, Antony Gormley's *Field for the British Isles* at Gateshead, and a series of banner events by Angus Watt at Newbiggin and other sea-side towns. Many local councils also found that this was the perfect opportunity to create something more permanent. Fifteen works or schemes are listed in the catalogue as resulting directly from Visual Arts UK. It is also clear that the 'can-do' atmosphere generated by Visual Arts UK has spread

across the many local councils in the region, and subsequently led to even more permanent public art projects.

Much of the credit for the region's public art can be claimed by local authorities' willingness to use public art as a tool of renewal in urban and rural areas. In the 1980s Gateshead MBC and the Tyne and Wear Passenger Transport Executive (TWPTE) were both used as examples of good practice by critics such as Deanna Petherbridge and Phyllida Shaw. A judicious mix of artists with international and local profiles was commissioned by Gateshead to make works exemplifying this promise for its Riverside Sculpture Park – an area that had previously been the site of toxic industries. By the end of 1990 TWPTE had installed 16 permanent works of art around its Metro system (mostly vitreous enamel murals or mosaics), and Gateshead had 10 permanent sculptures, 20 brightly-painted bridges (designed by Jenny Moncur) as well as 70 or so temporary works in the National Garden Festival to its credit. From an early stage, Gateshead's own literature has consistently celebrated its Art in Public Places programme as a 'symbol of confidence in its landscape, its people and its future', highlighting the 'material and social benefits that can result'.[36]

As well as Gateshead, several local authorities have included public art within their landscaping, development and community plans. Sunderland has been particularly active, siting sculptures along the cross-city 'Stephenson Trail', incorporating artist-designed glass, flooring and furniture into the City Library and Arts Centre and holding faith with Alison Wilding's *Ambit* over a three-year development period in the face of considerable technical difficulties.[37] Similarly, Easington wholeheartedly embraced public art for its 'Looking Beyond' project which began in 1996. The council's arts development officer was keen to show how the project was located in the reality of life in the district: 'If art is a mirror of society then Looking Beyond truly mirrored Easington, with its successes and failures, the politics, the people, the artists and the locations, the communications, friction, factions and the friendliness that makes for life here.'[38] Other council projects include Chester-le-Street's development of a riverside walkway with sculptures dotted alongside it; and Redcar's collection of amusing and brightly-coloured works set along its sea front.

The next major factor to consider is Tyne and Wear Development Corporation (TWDC). Established in 1987 with 48km of riverside in its control and hundreds of thousands of pounds to spend, TWDC could not avoid being a major force in the economic and visual transformation of the region. As early as 1989, Artists' Agency proposed long-term artistic intervention on the north shore of the Wear, and soon, as with other Urban Development Corporations such as Cardiff Bay, public art became a vital element in most of TWDC's plans. Up until its dissolution in 1998 TWDC was responsible for many schemes in which artists played a part: 43 sculptures are listed in the catalogue, but there have also been works in glass, street furniture, railings and gateways, interior design and community arts programmes.

TWDC's redevelopment areas were located within four of the five district councils which make up Tyne and Wear (Gateshead was the exception), and the various schemes make an interesting case study of different commissioning processes and types of sculpture installed. Newcastle Business Park installed six one-off commissions which had previously been temporarily sited at Gateshead Garden Festival. In contrast, Artists' Agency's project at St Peter's Riverside in Sunderland concentrated on encouraging local community participation with an on-going artist's residency which has employed three artists and a writer over eight years. To date this project has produced street furniture, gates, a giant mosaic picture, murals, a short story and ten large permanent sculptures. Whereas St. Peter's Riverside has been supervised by Artists' Agency, TWDC readily admitted that it had a steep learning curve when commissioning works for Newcastle's East Quayside.[39] Here there was no 'community' to consult. Instead there was a brief which stipulated 'focal features' within an overall design for a vibrant business- and leisure-orientated riverside. The resulting artworks include a stained glass lamp (seen on the BBC local news every night), a 20-metre-long bird's-eye view map of the river Tyne and a rather young looking *River God* blowing kisses to an enigmatic *Siren*. TWDC never passed up the opportunity to promote the size and scope of its public art initiatives: André Wallace's *Siren*, for example, was reported as 'part of a £1 million commitment to public art by the TWDC' within the £170 million East Quayside development.[40] Thus public art was successfully used to draw attention to a specific redevelopment scheme, and to TWDC's cultural credentials.

Encouraged by the success of these projects, TWDC made a bid for Lottery funding that emphasised the benefits of public art to a variety of constituencies in Tyne and Wear.[41] The Corporation was rewarded with a grant of £3.5 million funding towards 'gateway' sculptures for flagship developments in Tyne and Wear. The official launches of 'gateway' works such as Muñoz's *Conversation Piece* in South Shields continue to serve as reminders of TWDC's lasting influence on public art provision in the region, long after the Corporation's official demise.

It may seem that public art projects have been an exclusively urban

phenomenon in north-east England. This is not actually the case, with Great North Forest, Cleveland Arts and Sustrans all installing works in rural areas. Great North Forest (GNF) was established in 1990 in partnership with five district councils bordering the western stretches of the Tyne and Wear rivers, to create new woodlands, forests and wildlife habitats. The possibility of integrating art into GNF's activities was realised very early on, and 'Arts in the Forest' subsequently commissioned residencies, festivals, education projects and arts access programmes that have introduced a diverse range of way-markers, furniture and sculpture to the countryside. Explaining the rationale behind the scheme, the scientist and broadcaster David Bellamy said that 'the work in the Great North Forest illustrates how important arts programmes in the countryside can be, bridging the cultural and spiritual gap that we have between ourselves and the natural world'.[42] There have also been practical consequences. Artists' residencies have provided a focus for youth groups and older people in particular, developing skills in carpentry, carving and story-telling. For example, the Prime Time woodcarvers (a group of retired people) worked alongside professional sculptors to create a number of seats and stiles around the village of Kibblesworth.

Cleveland Arts also enthusiastically embraced the concept of art for its rural areas in the early 1990s, developing 'New Milestones' projects in conjunction with Common Ground. 'New Milestones' encourages artists to collaborate closely with residents, who have the greatest knowledge and feeling for place: it is 'about what places mean to the people who live in them, about how to express that meaning in an imaginative and accessible way through sculpture'.[43] Richard Farrington's steel sculptures on the cliffs at Saltburn are typical of this approach – the sculptor lived locally and worked in conjunction with a 'support group' to make works which refer to the industrial, social and natural history of the area. Another scheme launched in 1991 in conjunction with Common Ground was 'Marking the Ways', comprising 22 works including carved signs and stiles, seating and artist-designed landscaping along the banks of the Tees west of Middlesbrough's Transporter Bridge (see *Tugboat* by Victoria Brailsford).

A further significant set of works in rural areas has been commissioned by the charity Sustrans for the Consett to Sunderland stretch of its C2C cycle path (11 are listed in the catalogue). After the award of a Gulbenkian plaque for this scheme, Sustrans stated that 'we like to think that for a lot of people who might not otherwise visit galleries it demystifies art and sculpture a little bit'.[44] Most of the works are distinguished by their size and visually stunning locations, such as Tony Cragg's highly polished *Terris Novalis* (1997) set above a

roundabout to the south of Consett. However, *Beamish Shorthorns* (1990) by Sally Matthews 'grazing' under a bridge exemplify a more low-key approach, typical of a willingness to re-use discarded industrial materials.

A number of agencies have also assisted in developing public art strategies within the region. Artists' Agency, which has been placing artists in industrial and social contexts since 1983, is best known for over-seeing the St Peter's Riverside Sculpture Project in Sunderland. A rather different example of their work has been the management of a wetland area at Quaking Houses near Stanley which has become part landscape art, part ecological reclamation scheme. Arts Resource is another facilitation agency which has been central to a number of temporary and permanent schemes in Sunderland and Chester-le-Street, and Northern Freeform, originally an outpost of London's Freeform Arts Trust, is now an independent collaborative group of artists committed to working in a social context.

The size and cost of the region's 'landmark' sculptures has continuously focused national attention on the North East, with many of the agencies and councils involved themselves being keen to emphasise the scale, complexity and huge costs of their projects. Middlesbrough's 10-metre-high *Bottle of Notes* by Claes Oldenburg and Coosje van Bruggen cost £135,000, mostly paid for by Northern Arts. Publicity for David Mach's *Train* in Darlington emphasised the 185,000 bricks, 13,256 man-hours and £650,000 required to make it (see Figure 5).[45] Gormley's *Angel of the North* in Gateshead was subject to perhaps the most extraordinary debate about its size, cost, form and meaning.[46] Other major works installed since late 1998 include Juan Muñoz's *Conversation Piece* at South Shields, Colin Wilbourn et al.'s *Shadows into Light* at Sunderland, Anish Kapoor's temporary installation *Taratantara* at the pre-converted Baltic Flour Mills in Gateshead, Mark Di Suvero's *Tyne Anew* at Royal Quays North Tyneside, and Wilding's long-awaited *Ambit* in Sunderland.

Most of these large sculptures have been made possible through significant funding from the National Lottery, which has contributed £50 million to public art projects in the UK from 1995 to 1999.[47] The Lottery's role in changing the landscape of Britain through architectural and public art schemes cannot be underestimated. Even Richard Wentworth's low-key scheme to mark parish boundaries along the River Tees was facilitated in 1996 by the first Lottery award to be spent solely on a public art project.

Whilst the 1990s has been a notable period, it should be pointed out that the North East had already seen considerable interest generated in public sculpture from the 1950s onwards. Semi-abstract works by J.R.M. McCheyne (1959) and Ken Ford (1962) were sited in

Fig. 5. David Mach, '*I thought they promised a lap-dancer*' (collage)

Newcastle and subsequently removed, whilst Hans Schwarz's *Market Woman* in Wallsend (1966) was the subject of much controversy regarding its blunt depiction of the working-class. The 1972 *City Sculpture Project* installed two works in Newcastle city centre on a trial basis, both of which attracted criticism.[48] William Tucker's *Beulah IV* was supposed to be sited outside the Guildhall, but was deemed a hazard to children and eventually placed beside Swan House. A fibreglass sculpture by Luise Kimme, described by the media as a 'Monster in Red and Black', sprouted from the side of the Laing Art Gallery.[49] A schoolboy tried to raise a 10,000 signature petition for its removal but only collected 600 names, and the work was removed anyway as planned at the end of its six-month tenure. One-off works of sculpture continued to be installed through the 1970s either on a temporary or permanent basis, and an emphasis on local relevance can be detected in their forms and their titles. John Hoskin's *Resurgence* in Darlington (1970) was intended to symbolise the town's industrial good fortune, and Charles Sansbury's huge *Locomotive* attached to the side of a shopping complex in Killingworth (1971, lost) proudly depicted Stephenson's first steam engine which underwent trials in the locality a century earlier. This trend continued through the 1980s with works such as the overtly historical *Jarrow March* (Vincent Rea, 1984) and *Lambton Earthwork* (Andy Goldsworthy, 1988), which hints at local mythology.

The installation of these works coincided with increasing amounts of attention given to the role of art in public by artists, agencies and critics. Advocacy for the benefits of public art[50] has often been based on the argument that, as Eric Moody wrote in 1990, 'communities of artists, craftspeople and designers demonstrate that they have a part to play in economic regeneration'.[51] As has been discussed above, local authorities, urban development corporations and other statutory bodies in North-East England have all included public art in their regeneration policies as a matter of course, to the extent that by 1990 public art had become 'an orthodoxy' in the UK.[52]

A decade later, a national newspaper's tongue-in-cheek leader column called attention to the ubiquity of sculptures in the North East, the superlatives needed to describe them and the amazing effort required to get them in place: all this could lead to 'sculpture fatigue – the effect of disgorging too much grandeur from a surfeit of lottery money'.[53] However, we now have the opportunity to review a substantial body of work, and detailed analysis of the entire range of recent public sculpture in North-East England has only just begun. Such is the 'embarrassment of riches' that only a few of the region's works have received the attention they deserve and the catalogue is one way of redressing this situation. Further landmark sculptures yet to be installed will ensure that attention will continue to be focused on public art in North-East England for some time to come.

Site, Place and Meaning

JEREMY BEACH

Nowadays, as Halina Taborska has pointed out, 'a work of art in the public domain is seldom perceived and debated as a "thing in itself", a self-contained entity … The modernist stance has been abandoned, with critical discourse focusing on the setting and on the real, or assumed, responses of the public.'[54] Any work of modern public

sculpture exists at the centre of a web of interconnections. Location, commissioning processes, artists' concepts, funding packages, press attention, community involvement, written criticism, sign-posting and weathering (to name a few) must all be considered when analysing the cultural form that is modern public art.

As a result, critical attention is no longer necessarily focused on the sculpture, but on its position in physical and social networks and its meaning for 'shifting and multiple' publics.[55] Yet a catalogue such as this does not reflect the new style of critical discourse. Its unashamedly 'old'-style art historical approach concentrates on the provenance of works and their dimensions, subjects and forms. The catalogue's eclectic mix of old and new, avant-garde and conservative, high-profile and forgotten pieces seemingly militates against any sustained analysis of modern public sculpture according to the latest tenets. However, there is one concept which can act as a key to understanding the role of modern public sculpture from both 'old' and 'new' angles: that of *site*. Site provides both a focus for historical and iconographical analysis and a point of departure for wider contextual discussion. Accordingly, the location of each work in the catalogue is carefully noted according to its town, road and nearest building.

The two words 'site' and 'place' have become infused with mystical significance in critical arguments about public art. In an influential talk in 1989, Jeff Kelley argued that in the late 1970s art practice had 'moved beyond sites and into places' so that there is now a 'consciousness of the thresholds at which the sites of art become the arts of place'. His distinction between the words 'site' and 'place' was summarised as, 'Sites are like frameworks. Places are what fill them out and make them work… A place is useful and a site is used.'[56] Kelley then went on to argue that if an artist approaches a site like a clean slate 'ready to receive, interpret and represent what is already there' then 'a place will be both the content and the context of an art of place'. The facilitator of this change from site to place is, according to Lucy Lippard, the artist as an 'envisionary' guide through responses to landscapes, history and cultures.[57]

In their introduction to *New Works for Different Places*, Foster, Harvey and Lingwood make a case for approaching a work, and the site it occupies, with an open mind: 'Each work seeks to make its own place, … it does not passively occupy space any more than it actively seeks to satisfy a pre-ordained set of expectations.'[58] In other words, good artworks exist as autonomous objects that may not be made with a relationship to site in mind. Equally, the site's meaning may or may not be altered by the presence of the artwork, whatever the physical changes. Yet the claim that sympathetic artists will be able to make a 'place' out of what was previously only a 'site' has gained much credence. It seems a natural assumption that can be broadly applied to any element of landscape design: build interesting and good-looking buildings, organise the traffic flow creatively, encourage the right types of shopping and what was previously an unremarkable site becomes an interesting place. Yet as Kelley has said with regards to art in public, not only is the latent meaning of a place revealed, but new and potentially more powerful meanings are invested in it.

The difference between 'latent' and 'invested' meaning has been articulated by Seamus Heaney when he wrote of two ways of knowing and cherishing place: '[They are] two ways which may be complementary but which are just as likely to be antipathetic. One is lived, illiterate and unconscious, the other learned, literate and conscious.'[59]

Just as a piece of poetry can provide commentary on the political and physical state of Irish landscape, so a piece of public art exposes the unconscious (latent) meaning of a particular place and adds a layer of allusions. However, a work of public art is unlike a poem because its presence brings about an immediate physical change to its location – what was 'lived' as a matter of course now has to be 'read', and its readability will depend on the 'language' that the artwork uses. In time this literate way of approaching a place through its public sculpture will be replaced again by the illiterate, because the altered landscape eventually becomes known and unremarkable again.

Modern public sculpture offers further complications. As Heaney points out, our conscious and unconscious ways of understanding a landscape can coexist. Whilst a place may be 'known', the work of art itself continues to carry meaning which can only be decoded through literate analysis.[60] As long as a sculpture is extant and in situ its subject-matter, materials, size and shape will be fairly immutable, and the duty of a catalogue such as this is to record them. It is the sculpture's relationship to the site-which-has-become-place which alters over time.

So, how does this assist in the analysis of recent public sculpture in north-east England? In the first instance, as has already been made clear, the region is itself a well-defined 'site' for modern public sculpture: works are installed on an almost weekly basis with attendant publicity, then quickly disappear from the limelight to become part of the knowable landscape. At the level of individual sculptures, an explicit concern of many commissioners and artists has been to make a distinctive *place* by putting sculptures in previously unremarkable sites – to give a reason for going there and developing a *genius loci* for the area. In this respect the sculptures found across North-East England are no different than in any other part of the

country; it is sheer volume that perhaps is the point of significance.

That *public* sculpture in particular has played such a key role in the region's public art is fairly remarkable, given that at the end of the twentieth century there are many other forms of media available to artists working in the public realm, such as video projections, posters, murals and mosaics, sound installations and 'happenings'. Sculpture's occupation and definition of three-dimensional space gives it a great sense of physicality: as William Tucker averred, 'sculpture, of its nature, *is* object in the world, in a way in which painting, music, poetry are not'.[61] Certainly the number of sculptures installed each year is testament to commissioners' continued liking for this art form, and 60 per cent of all public art projects are sculptures.[62] Furthermore, despite the initial flashes of hysterical reaction to large new commissions and talk of 'fatigue' and 'controversy', most sculptures are installed in the North East with little antagonistic comment or critical attention.

With regards to the media frenzy that sometimes accompanies high-profile public art projects, Walter Grasskamp has noted that, 'the art-in-public-places dispute so eagerly fuelled by the media and the local press in particular is not nearly as representative as the participants would like it to be. The image of art in public places as presented in the much-attended scandals is a false one, and these scandals should not blind us to the wholly different circumstances which are the rule.'[63] This is borne out in north-east England where approaches to public sculpture range from the apathetic and uninformed (even on the part of commissioning agencies) to acceptance, interest and involvement. The spread of sculptures creates a layer of objects across the region which are meaningful not so much in terms of scandal but perhaps because they are generally unremarkable in form, subject and acceptability to the general public.

In fact a quick scan of the pages of this catalogue will reveal that most artists have worked hard to make their sculptures comprehensible and accessible to the people who will have to live with them day to day. There continues to be a tradition of figurative sculpture made for public places, both commemorative (such as Robert Olley's *Stan Laurel*, North Shields) and generalised (a man and a woman are depicted seated on either side of Michael Disley's *Meeting Point* in Spennymoor town centre). The best-known 'figurative' work in the region (Antony Gormley's *Angel of the North*) is close to a state of metamorphosis between human and machine (its ribbed wings have been likened to those of a Spitfire fighter). Non-figurative works often contain elements that can be instantly related to their surroundings, such as a cormorant taking off (*Flight* by Craig Knowles at Sunderland St Peter's Riverside), or have

domestic themes that merit close attention, as with the multiplicity of everyday objects found upon the *Blacksmiths' Needle*, Newcastle Quayside. There are few purely abstract works, and these are often accorded meanings which relate to their locale or industrial heritage (see p.xvii). Business parks are often fruitful hunting grounds for this sort of sculpture – *Quintisection* by Robert Erskine at New Silksworth (1993), and *231* by Eric Wilson in Cramlington (1990) have both made use of traditional steel-working skills to create forms that are futuristic and dynamic.

The position of recent public sculpture in 'knowable' landscapes is also demonstrated by the multiplicity of roles works may have to perform. Firstly they are often functional, providing directions or places to sit. Secondly they act as markers for specific plots of land or trails, helping to put fairly isolated places 'on the map'. Thirdly their formal qualities usually relate directly to the landscape or local community. Such roles can be challenging; for instance, Matthew Jarratt said that his design for a seat needed to be 'robust, comfortable and also relate to the natural "feel" of the site – quite a task!'[64] Explanatory maps or brochures have often been published for projects soon after installation, especially for rural projects (Gateshead's *Marking the Ways* leaflet even includes a story linking many of the works). This encourages people to explore the countryside and also gives each project a distinctive identity. For example, by commissioning Felicity Watts to carve a number of large stone sculptures for Russell Wood near Newbottle, Great North Forest (GNF) immediately brought attention to an initially nondescript area. In consultation with locals, Watts has carved a range of abstract and figurative pieces, creating a sense of expectation for the future of the plantation: she has 'enabled' meaning. In time the sculptures will be engulfed by fast-growing woodland, but the sense of place will still exist in a way that has altered over time.

One of the major concerns for public art commissioners is how artists can contribute to the regeneration of urban landscapes and communities through place-making. In the 1990s emphasis is given to projects which build links, become role models or help out people in quite low-key ways whilst also providing aesthetic improvement. For example, Colin Wilbourn's approach at Sunderland is typical: 'the artist, as the children of St. Peter's have found out, is as ordinary as they are, but has particular skills which some of them might have too and might want to develop'.[65] The success of the Common Ground and GNF rural schemes is likewise based on co-operative approach – artists have become part and parcel of community development. Their artworks do not necessarily 'intervene' in their surroundings in an overt way, they are not catalysts for explosive change: 'as the works

weather and blend into the landscape, … they will become an increasingly familiar part of that landscape and are more likely to be claimed by the community as theirs'.[66] In other words, to return to the distinction between latent and invested meaning, it is as if the sculptors want their works to be *immediately* comprehensible on an unconscious level.

The practice of integrating text into the process of creation and/or final work of art, a feature of recent public sculptural output which has not had much attention paid to it, highlights the 'antipathetic' polarity of conscious and unconscious knowledge of place.[67] On the one hand including written text may actually improve the 'readability' of particular works, because the words may be explanatory, informative or encouraging. On the other hand, any textual content (in particular poetry or creative writing) adds meaning and therefore requires a 'learned' approach to the place (see Figure 6). Avant-garde artists have long used text in publicly sited works, often as a polemical or subversive element. Since the 1970s text in more 'mainstream' situations has also become increasingly common.[68]

Looking at works in North-East England, a range of approaches can be seen. Sometimes words are written by the artist and published separately, like Graciela Ainsworth's reaction to the site of her *Circling Partridges*, Kibblesworth (she also includes a quote from First World War poet Julian Grenfell on the structure of the sculpture). On other occasions the written word is central to the sculpture's form: Linda France has been particularly active around Tyneside working with residents to make texts that are then incorporated into finished works by painters or stonemasons (for example, she worked with Birtley Aris in Sunderland on a text project for bus-shelter posters).[69] At St Peter's Riverside in Sunderland, locally based crime writer Chaz Brenchley has been an instrumental part of the long-term artists' residency, incorporating texts by himself and local amateurs into the growing number of stone and bronze sculptures at the mouth of the river Wear. In addition, using braille has allowed an often overlooked potential group of art-lovers access to sculpture; on the collaborative work *Watching and Waiting*, for instance, one line of braille reads 'sometimes we see further with our eyes closed'. The idea that a sculpture can act as a springboard for the imagination is an appealing one, and the inclusion of poetry within works may reveal more of the artist's intentions than any explanatory panel could ever do. For example, contemplation of the words etched

Fig. 6. Sign by Lucy Freeman, Newcastle upon Tyne. Installed 1995, removed 1999.

onto the multitude of stone spheres that make up Isabella Locket's *Milky Way* in Chester-le-Street certainly transports the mind beyond the little park to more celestial realms.

Sculptures like these do not necessarily exist only at physical sites: they also exist at so-called social or mental sites which are meaningful in different ways to the artist, the commissioner, the person who lives nearby and the casual visitor. These are the 'multiple publics' making 'real or assumed responses' that the contextual study of modern public art is concerned with. The effort put into individual works and the concentration of sculptures in this particular region make it possible to regard North-East England as, to use the words of Patricia Phillips, a 'metaphysical site where personal needs and expression meet with collective aspirations and activity'.[70] As discussed above (p.xvii), public sculpture helps to reveal latent meaning in the North East, dealing as it does with football teams, coal mining and ship building. Yet the region is also invested with a new level of meaning as a distinctive and progressively cultural *place*, known for a more modern achievement – the successful integration of public sculpture into its landscape.

Notes

1 Story told by Oliver Wendell Holmes in his *Autocrat at the Breakfast Table*. See *Monthly Chronicle*, 1889, pp.41–2.

2 Whitehead, F. and Yarrow, O., 'Scott and Northumberland', *Archaeologia Aeliana*, (1986), 5th series, vol.XIV, p.172.

3 Information provided by Tony Duggan, Middlesbrough Council, 1998. Because these works are currently in storage they are not included in the catalogue.

4 *North-Eastern Daily Gazette*, 21 June 1913.

5 The PMSA's web-site holds details of the continuing National Recording Project: http://gofast.to/PMSA.

6 'Iron and Coal' is the name now usually given to a much reproduced painting of 1861 at Wallington Hall, the last in a series of scenes from Northumbrian history by a member of the Pre-Raphaelite circle, William Bell Scott. The painting's full title is 'In the NINETEENTH CENTURY, the Northumbrians show the World what can be done with Iron and Coal.' See Usherwood, P., 'William Bell Scott's *Iron and Coal: northern readings*' in Laing Art Gallery, *Pre-Raphaelites. Painters and Patrons in the North East*, Newcastle upon Tyne 1997, pp.39–56.

7 Gormley, A., *Making an angel*, Gateshead, 1998, pp.14–15. Interestingly, when the sculpture was first projected several years before, the artist made no mention of industry. Instead he spoke of it in quasi-philosophical terms as a meditation on the human condition.

8 North Tyneside Arts press release, July 1999.

9 Some of the most dramatic population growths were: Jarrow 3,500 in 1851, 18,000 in 1871; West Hartlepool 4,700 in 1851, 21,000 in 1871; Middlesbrough 154 in 1831, 7,893 in 1851. It might be argued that the monuments to the 3rd Marquis of Londonderry at Durham (1861) and the Penshaw Monument (1844) commemorate landowners who played an important part in the development of the Great Northern coalfield and therefore ought to be included here. Indeed, Londonderry's feat in creating Seaham Harbour is quite as remarkable as, for instance, Palmer's in creating Jarrow. However, it should be noted that in their iconography and design these works do not highlight the coal-mining aspect of the commemorated person's careers. They have not therefore played a significant role in projecting a manufacturing and mining idea of the local district or of the region as a whole.

10 For example, in the case of the elaborate proceedings at the inauguration of the Stephenson Monument it is recorded that a Mr Currie of Robert Stephenson's locomotive works was responsible for arrangements. See *Newcastle Daily Chronicle*, 3 October 1862.

11 There was in fact some uncertainty at the time of the monument's inauguration as to exactly what these four figures represent. See p.149.

12 See Usherwood, P., *Art for Newcastle. Thomas Miles Richardson and the Newcastle Exhibitions 1822–1843*, Newcastle upon Tyne, 1984, p.51.

13 The promotion of the area as an industrial centre came to a climax in October 1862 with the unprecedented honour of a three-day visit to Tyneside, Wearside and Teesside by a renowned figure on the national stage, the Chancellor of the Exchequer, W.E. Gladstone. He was given a tumultuous reception wherever he went and each of his speeches eulogising the region was fully reported in the local press. See, for instance, the report of his visit to Teesside in *Newcastle Daily Chronicle*, 10 October 1862.

14 An important part of the region's economy since the Middle Ages (see the figure of the miner in medieval garb on the Mining Institute in Newcastle) coal mining was crucial in the mid nineteenth century. The Great Northern Coalfield supplied a quarter of the country's coal and employed a fifth of the country's miners, and all the region's new industrial developments were associated either directly or indirectly with coal production. See Fordyce, W., *A History of the Coal, Coke and Coal Fields, and the Manufacture of Iron in the North Of England*, London, 1860, p.32.

15 The dominant manufacturing and mining image of the North East does not acknowledge women's work.

16 There is seldom much carving on colliery disaster memorials; the charming reliefs of widows and rescuers on the memorials at Tudhoe and Trimdon are unusual.

17 The monument to *Robert Chambers* (1869) is similar. Interestingly, however, that to *Harry Clasper* at Whickam (1871), presents its subject as an industrialist, probably because of Clasper's work developing the technology and training regimes of modern boat-racing.

18 Ostensibly this honours 168 men and boys who died in a pit disaster of 1909, but the disaster had in fact already been commemorated in a memorial of 1913 which still exists. It should be noted that real or replica colliery winding wheels are quite frequently used as town signs in Co. Durham.

19 *Newcastle Daily Chronicle*, 3 October 1862.

20 Nietzsche, F., 'The Use and Abuse of History' in *Thoughts Out of Season, Part II*, (trans, Collins, A.), London, 1909–24, p.16.

21 *Ibid.*, p.19.

22 For the notion of war memorials as sites of ritual see King, A., *Memorials of the Great War in Britain. The Symbolism and Politics of Remembrance*, Oxford, 1998.

23 Newcastle City Council, *Proceedings*, 1907–8, p.1039.

24 *Ibid.*, p.24.

25 *Ibid.*, p.26. See also Raphael Samuel's stout-hearted defence of popular history in *Theatres of Memory*,. vol.1 'Past and present in context', London, 1994.

26 Pevsner, N., *Northumberland*, London, 1957, p.11.

27 Nietzsche, *op.cit.*, p.25.

28 The press photographs which appeared when the *Angel* was first erected are relevant here. They invariably accentuate the materials and processes used in the making of the sculpture and the way it seems to loom above the housing nearby.

29 Nietzsche, *op.cit.*, p.28.

30 Campbell, B., 'Gateshead and the Angel' in Gormley, A., *Making An Angel*, Gateshead, 1998, pp.52–5. It should be noted that Nietzsche, an

avowed misogynist, would doubtless have been appalled at a piece of feminist writing being used to illustrate his idea of 'critical history'.

31 Nietzsche, *op.cit.*, p.23.

32 *Ibid.*

33 Separate research covering just Tyne and Wear shows that five times the number of all works of art in public (not only sculpture) have been installed in the 1990s than in the 1980s: Beach, J., 'Public Art in Tyne and Wear 1960 to 1998: History, Context and Meaning', unpub. ongoing PhD research.

34 Cf. for example, Noszlopy, G.T. with Beach, J. (ed.), *Public Sculpture of Birmingham*, Liverpool, 1997, p.xii.

35 Sykes, A., 'The Past is Orange – From a Present Perspective', *Northern Review*, September 1999, p.3.

36 Gateshead Libraries and Arts, *Introducing Art for Public Places, Gateshead*, Gateshead, n.d., p.1.

37 These and other art projects are outlined in: City of Sunderland, *Review: Visual Arts UK in the City of Sunderland*, Sunderland, 1996; and City of Sunderland, *publicart.sunderland.com*, Sunderland, 1999.

38 Sutherland, A., 'Introduction', in France, L., *Looking Beyond: Easington District Council's Progamme for Visual Arts Year 1996*, 1997.

39 Unpublished interview with Lin Simmonds, TWDC, 1997.

40 *Northern Echo*, 15 July 1996.

41 Tyne and Wear Development Corporation, unpublished Application for Lottery Funding, 1996, p.6.

42 Great North Forest, *Arts in the Forest*, Dunston, 1998.

43 Clifford, S. and King, A. in Morland, J., *New Milestones: Sculpture, Community and Land*, London, 1988.

44 *Independent*, 29 September 1992.

45 *Darlington and Stockton Times*, 27 June 1997; Morrisons' press release, 23 June 1997.

46 Gormley, A., *Making An Angel*, London, 1998.

47 Statistic provided by Arts Council of England, September 1999.

48 See Arts Council of Great Britain, *City Sculpture*, London, 1972.

49 *Evening Chronicle*, 10 February 1972.

50 For a brief overview of the literature surrounding public art in the 1980s, see Miles, M., *Art, Space and the City*, London, 1997, pp.91–103.

51 Moody, E., 'Introduction' in Shaw, P., *The Public Art Report: Local Authority Commissions of Art for Public Places*, London, 1990, p.2.

52 Vasseur, I., with Prince, G., 'Art and the Garden Festival' in Prince, G. and Cumings, S. (eds), *Festival Landmarks '90*, Gateshead, 1990, p.11.

53 *Independent*, 19 June 1999. It should be noted that *Bottle of Notes* did not receive any funding from the National Lottery. Interestingly, Tynesiders spend 25 per cent above the national average on National Lottery tickets: *Independent*, 16 April 1996.

54 Taborska, H., *Current Issues in Public Art: Roehampton Lectures*, London, 1998, p.20.

55 Barrett-Lennard, J., 'Thinking Through the Public', *Artists Newsletter*, March, 1994, p.35.

56 Kelley, J., 'Art in place', *Headlands Journal*, San Francisco, 1991, pp.34–8.

57 Lippard, L., 'Looking Around: Where We Are, Where We Could Be', in Lacy, S. (ed.), *Mapping the Terrain. New Genre Public Art*, Seattle, 1995, pp.114–30.

58 Introduction to Lingwood, J. (ed.), *New Works for Different Places*, Bristol, 1990, p.8.

59 Heaney, S., *Preoccupations. Selected Prose 1968–78*, London, 1980, p.131.

60 'Monuments, as Bataille would say, are the object of "daily inattention". Musil wrote wonderfully about this paradox. He has a beautiful image: the monument, as everything that makes up "the walls of our life", escapes our awareness.': Hollier, D., 'While the City Sleeps: Mene, Mene, Tekel, Upharsin', *October*, vol.64, Spring, 1993, p.14.

61 Tucker, W., *The Language of Sculpture*, London, 1974, p.107.

62 1960–98, figures for Tyne and Wear only: Beach, *op.cit*. Figures given in Shaw, *op.cit.*, p.34 for the period 1984–8 show that sculptures made up 47 per cent of works commissioned by local authorities.

63 Grasskamp, W., 'Art and the City' in Bußmann, K., König, K. and Matzner, F. (eds), *Contemporary Sculpture. Projects in Münster 1997*, Ostfildern-Ruit, 1997, p.17.

64 Gateshead Libraries and Arts, *Marking the Ways in Gateshead*, Gateshead, 1996.

65 Shaw, P. and Thompson, I., *St. Peter's Riverside Sculpture Project*, Sunderland, p.14.

66 *Ibid.*, p.14.

67 A conference at the British Library in September 1999 considered poetry and public art.

68 An early example of this sort of work is David Harding's 1970s installation of a pavement in Glenrothes that carried the poetry of Alan Bold.

69 *publicart.sunderland.com*, *op. cit.*, p.31.

70 Phillips, P.C., 'Out of Order: The Public Art Machine', *Artforum*, December, 1988, pp.92–7.

Abbreviations

The following abbreviations have been used in the catalogue:

1. References

Abromson: Abromson, M.C., *Dictionary of Twentieth Century Art*, London, 1973

Airey & Airey: Airey, A. and Airey, A., *The Bainbridges of Newcastle: A Family History 1679–1976*, Newcastle upon Tyne, 1979

AXIS, Artists Register: AXIS Visual Artists Register, Leeds Metropolitan University, Calverley Street, Leeds

Ayris et al.: Ayris, I., Jubb, P., Palmer, S. and Usherwood, P., *Tyne and Wear Guide to Public Sculpture and Monuments*, Newcastle upon Tyne, 1995

Beattie: Beattie, S., *The New Sculpture*, London, 1983

Bénézit: Bénézit, E., *Dictionnaire Critique et Documentaire des Peintres, Sculpteurs et Graveurs*, Paris, 1976

Brockie: Brockie, W., *Sunderland Notables: Natives, Residents and Visitors*, Sunderland, 1894

Buckman: Buckman, D., *Dictionary of Artists in Britain since 1945*, Bristol, 1990

Colvin: Colvin, H., *A Biographical Dictionary of British Architects, 1600–1840*, New Haven and London, 1995

Concise DNB 1901–30: Concise Dictionary of National Biography, 1901–1930, Oxford, 1930

Darke: Darke, J., *The Monument Guide to England and Wales: A National Portrait in Bronze and Stone*, London, 1991

DBArch: Felstead, A., Franklin, J. and Pinfield, L., *Directory of British Architects 1834–1900*, London, 1993

DNB: *Dictionary of National Biography* (editions noted in text)

Festival Landmarks: Prince, G. and Cumings, S. (eds), *Festival Landmarks '90*, Gateshead, 1990

Fordyce: Fordyce, T., *Local Records or Historical Register of Remarkable Events which have Occurred in Northumberland and Durham, Newcastle upon Tyne and Berwick upon Tweed*, Newcastle, 1867

Foster, *Newcastle*: Foster, J., *Newcastle upon Tyne, A Pictorial History*, Newcastle upon Tyne, 1995

Gateshead, *Four Seasons*: Gateshead Libraries and Arts, *Four Seasons: A Gateshead Sculpture Project*, Gateshead, 1997

Gateshead Art Map: Gateshead Libraries and Arts, *Gateshead Art Map*, Gateshead, 1997

GNF, *Arts in the Forest*: Great North Forest, *Arts in the Forest*, Dunston, 1998

Graves, *London Exhibitions*: Graves, A., *Dictionary of Artists who have Exhibited Works in the Principal London Exhibitions from 1760 to 1893*, London, 1901

Graves, *Royal Academy Exhibitors*: Graves, A., *Royal Academy of Arts. A Complete Dictionary of Contributors and their Work from its Foundations in 1769 to 1904*, London, 1906

Gunnis: Gunnis, R., *Dictionary of British Sculptors 1660–1851*, London, 1961

Latimer: Latimer, J., *Local Records or Historical Register of Remarkable Events which have Occurred in Northumberland, Durham, Newcastle upon Tyne and Berwick upon Tweed*, Newcastle upon Tyne, 1857

Looking Beyond: France, L., *Looking Beyond: Easington District Council's Progamme for Visual Arts Year 1996*, 1997

Lovie: Lovie, D., *The Buildings of Granger Town*, Newcastle upon Tyne, 1997

Mackenzie, *N'land*: Mackenzie, E., *An Historical, Topographical and Descriptive View of the County of Northumberland*, Newcastle upon Tyne, 1825

Marking the Ways in Gateshead: Gateshead Libraries and Arts, *Marking the Ways in Gateshead*, Gateshead, 1997

Nairne and Serota: Nairne, S. and Serota, N., *British Sculpture in the Twentieth Century*, Whitechapel Art Gallery (exhib. cat.), London, 1981

N'land War Mems Survey: Association of Northumberland Local History Societies, War Memorials Survey 1988/93, Newcastle upon Tyne

Pevsner, *Co. Durham*: Pevsner, N., *The Buildings of England: County Durham*, Harmondsworth, 2nd ed., 1985

Pevsner, *Northumberland*: Pevsner, N. and Richmond, I., *The Buildings of England: Northumberland*, 2nd ed. revised by Grundy et al., London, 1992

PsoB: Noszlopy, G. with Beach, J. (ed.), *Public Sculpture of Birmingham*, Liverpool, 1998

PsoL: Cavanagh, T., *Public Sculpture of Liverpool*, Liverpool, 1997

Read: Read, B., *Victorian Sculpture*, New Haven and London, 1982

Richardson: Richardson, M.A., *Local Historian's Tablebook*, Newcastle, 1841–4

Spalding: Spalding, F. (ed.), *20th Century Painters and Sculptors*, Woodbridge, 1990

Spielmann: Spielmann, M., *British Sculpture and Sculptors of To-day*, London, 1901

Stephenson: Stephenson, G. (ed.), *Directory of Professional Artists in Northumberland*, Ashington, 1994

Strachan: Strachan, W.J., *Open Air Sculpture in Britain: A Comprehensive Guide*, London, 1984

Sykes: Sykes, J., *Local Records or Historical Records of Northumberland and Durham*, Newcastle upon Tyne and Berwick upon Tweed, London, 1866

Turner (ed.): Turner, J. (ed.), *Dictionary of Art*, London, 1996

Welford: Welford, R., *Men of Mark twixt Tyne and Tweed*, London, 1895

Yarrington, *Commemoration*: Yarrington, A., *Commemoration of the Hero 1800–1864: Monuments to the British Victors of the Napoleonic Wars*, New York and London, 1988

2. Newspapers and Periodicals

Evening Chronicle: *Evening Chronicle*, Newcastle

ILN: *Illustrated London News*

Journal, Berwick: *The Journal*, Berwick-upon-Tweed

Journal, Newcastle: *The Journal*, Newcastle upon Tyne

Monthly Chronicle: *Monthly Chronicle of North Country Lore and Legend*

Sources of Illustrations

The photographs for this catalogue were all taken by the authors between 1997 and 1999, apart from the following for which grateful acknowledgement to their sources is made: *Fothergill Fountain* (p.236), courtesy of Darlington Borough Council; *Skedaddle* (p.38), by Keith Paisley courtesy of Kielder Partnership; Victor Pasmore at the *Apollo Pavilion* (p.266), courtesy of North of England Newspapers; *Maze* (p.263), courtesy of Sustrans; *Neptune* 1860, 1890 and 1914 (pp.245, 246), courtesy of Durham County Council; *Windy Nook* (p.74), by Northlight Photography, courtesy of Gateshead MBC; *Rolling Moon* (p.69), by Mark Pinder, courtesy of Gateshead MBC; detail of *British Liberty* (p.214), by Raymond Rourke, courtesy of The National Trust; *Seahorse Heads* (p.95), *Grey's Monument* (pp.96, 97), *Miner* (p.144), and *Admiral Lord Collingwood Monument* (p.139), all courtesy of Newcastle upon Tyne City Libraries and Arts; *John's Rock* (p.168), by Dave Williams, courtesy of City of Sunderland Libraries and Arts; *Horns of Minos* (p.221), the Philipson Studio, courtesy of *The Architectural Review*; *Train* photomontage (p.xxiv), by David Mach, courtesy of the artist.

Acknowledgements

The research on which this catalogue is based was undertaken between 1997 and 1999 as part of the Public Monuments and Sculpture Association's National Recording Project. The North-East England Regional Archive Centre (NERAC) was based at the University of Northumbria at Newcastle upon Tyne (UNN) and was generously funded by the Heritage Lottery Fund and the University of Northumbria which enabled Catherine Morris and Jeremy Beach to be employed as researchers. Additional sponsorship was provided by Northern Arts, Durham County Council, Gateshead Metropolitan Borough Council, Great North Forest, the Joicey Trust, the Henry Moore Foundation and the Paul Mellon Centre for Studies in British Art. We are extremely grateful to all these organisations for their help.

We would also like to thank the NERAC Steering Committee for their practical assistance and support particularly in the early days of the project: Grace McCombie; Les Milne, City of Sunderland; David Lovie, City of Newcastle upon Tyne; Ian Thompson, University of Newcastle upon Tyne; Anna Pepperall and Steve Palmer, Gateshead Metropolitan District Council; John Millard, Tyne and Wear Museums Service; James Bustard, Northern Arts; Gilbert Ward, sculptor; Colin Rose, sculptor; and Nicholas Whitmore, sculptor.

In addition, we are indebted to PMSA's Editorial Board, Edward Morris, Ian Leith, Jo Darke and Benedict Read, for their help in checking the manuscript; as well as to Robin Bloxsidge of Liverpool University Press and our production editor Janet Allan, for their hard work and patience during the publishing process.

Special thanks must go to our team of volunteer helpers: Harriet Curnow, Sarah Wachman, Colin Ibbotson, Virginia Pattisson, Alexandra Ryley, Janet Davis, and Derek Timlett. Their assistance as drivers and skilful, painstaking researchers was crucial. In particular, we wish to thank Philip Smith and Lesley Richardson both of whom devoted a very considerable amount of time and effort to the project.

At various points in the preparation of this catalogue a large number of people helped us in one capacity or another, and we would like to express our gratitude to them all: Simon Smith and Judith Winter, Cleveland Arts; Janet Brown, Association of Northumberland Local History Societies War Memorial Survey; Matthew Jarratt, Commissions North; Andrew Greg, Laing Art Gallery; Mike Campbell, North Tyneside Arts; Les Hooper, Peddling Arts; Gail-Nina Anderson; Dilys Harding, Newcastle Central Library; Iain Watson, Durham Studies Manager; Susan Priestley, Arts Resource; Lucy Milton, Artists' Agency; Ian Stubbs, Dorman Museum, Middlesbrough; Jean Gartland, Durham City Library; Katharine Gibson; Elizabeth Roscoe; Tony Duggan, Middlesbrough Council; Chris Growcott, Great Northern Forest; Lorraine Turnbull and Julia Baine, Sustrans; Peter Bowes, local historian Weardale; Mason Williams PR Consultancy; Sarah Laws, City of Sunderland Libraries and Arts; John Meagher, Nexus; Sally Thomas, Art on the Riverside; Hilary Norton, Kielder Partnership; Pauline Murphy, University College, Dublin; Pamela Wallhead, The National Trust; Lord Hastings; Sir Charles Aitchison; Mark Pinder, photographer; Barbara Usherwood; University of Teesside; Philip Ward-Jackson, Conway Library; Mike White, Gateshead MBC; John Pendlebury, University of Newcastle upon Tyne; Elizabeth Doley and F. Manzeh-Longbone, local historians, Berwick; Collin Dallison and Tom Corfe, Hexham Local History Society; B.S. Stanton, Glendale Local History Society; Tom Read, PMSA; Colin Venters, Kenneth McConkey, Christopher Bailey, Sean Figgis, Helen Whitman, Malcolm Gee, Tony Harding, Thomas Faulkner, Bill Lancaster, Patricia Maher and the administrative staff of the department of Humanities, University of Northumbria, Newcastle upon Tyne; and Ray Mackenzie, Glasgow School of Art.

Last but not least, three different groups must be thanked: librarians in academic and local authority libraries in London and the North East; officers in local authority planning departments in the region; and living artists who provided us with information about themselves and their work.

Northumberland County

ALNWICK

Alnmouth Road TOWN CENTRE
Junction with Denwick Lane

Alnwick War Memorial

Sculptor: Roger Hedley

Unveiled 11 November 1922
Figures: bronze 2m high
Column: sandstone 4m high
Pedestal: sandstone 2.4m high
Lantern: bronze and glass 1.8m high
Bronze plaque with raised lettering on the
north face of pedestal: [189 names]
Incised Roman lettering on south face: THIS
COLUMN OF REMEMBRANCE / IS DEDICATED TO
THE MEN OF / ALNWICK WHO GAVE THEIR LIVES /
IN THE WARS OF 1914–18 AND / 1939–45 / We
will remember them / R. HEDLEY / SCULPTOR /
1921
Status: II
Condition: fair
Condition details: spalling and crumbling on
south-east of pedestal; algae on north face of
pedestal
Commissioned by: Alnwick War Memorial
Committee
Custodian: Alnwick District Council

Description: war memorial with statues.
Three bronze figures with reversed rifles: sailor
(south-west), airman with cap (south-east),
soldier with tin helmet and backpack (north)
stand at the corners of a triangular pedestal with
chamfered corners. From the latter a Doric
column rises with an elaborate bronze and glass

Hedley, *War Memorial* (detail)

lantern on top.

History: the overall cost of the memorial was
more than £2,000 with the figures costing £120
to be moulded and £200 to be cast. The bronze
tablet cost £250 and the lamp £200.[1] John
Green, Senior was the builder.

[1] *Alnwick and County Gazette,* 19 November 1919.

Bondgate, in park

Percy Tenantry Column

Architect: David Stephenson

Foundation stone laid 1 July 1816
Column: sandstone 22.8m high
Pedestal: sandstone 4.28m high × 5.8m square
Supporting lions: Coade stone each 62cm high
× 76cm wide × 2.72m long
Incised in Roman letters on each face of the
pedestal: ESPERANCE EN DIEU
Formerly incised on east face dado of the
pedestal: TO / HUGH, DUKE OF NORTHUMBER-
LAND, K.G. / IS ERECTED, DEDICATED, AND
INSCRIBED, / BY / A GRATEFUL AND UNITED
TENANTRY / ANNO DOMINI / MDCCCXVI.
Status: I
Condition: fair
Condition details: lion (south-east) has lost left
front paw and tongue and spalling on back; lion
(north-east) has lost left front paw; lion (south-
west) has lost both front paws; inscription on
east face of dado has been sandblasted away;
white paint on recumbent lions chipped; moss
on west face of pedestal and on entablature;
scratches and spray paint on west and south
faces of pedestal and on two of the recumbent
lions
Commissioned by: the 2nd Duke of
Northumberland's tenants
Owned by: Northumberland Estates

Description: an imposing Greek Doric
column. Sitting on a square pedestal with
chamfered corners on top of a circular flight of
three steps, the column supports a viewing stage
with a light iron fence surround surmounted by

Stephenson, *Percy Tenantry Column*

a drum on which stands a lion passant, symbol of the Percy family. At each corner of the main pedestal there are four smaller pedestals, each one supporting a recumbent Coade stone lion, painted white, its head turned to look back over the shoulder. It has been suggested that this feature may have inspired Landseer's lions at the foot of Nelson's Column in Trafalgar Square (1858–67). The column was formerly protected by an iron fence of which the sandstone base is now all that remains.

History: when agricultural prices fell after the Napoleonic Wars, Hugh, second Duke of Northumberland, sought to alleviate the hardship of his tenants by reducing their rents by 25 per cent. The tenants first met to discuss ways of registering their gratitude on 25 January 1816. It was not, according to one report, 'a question of the patron deciding what should be done, but a matter of protracted debate'.[1] By April they had decided on a column; in the words of Sir David W. Smith, the duke's agent, 'The tenants … have resolved to erect a column to perpetuate their sense of his grace's benifice in reducing their rents'.[2] By June 1816 over £3,000 had been subscribed, collected in amounts ranging from 6d., given by 14 of the tenants, to £500 given by lessees of a colliery.

Plans and estimates were sought from the architects Robert Smirke and John Soane in London and David Stephenson in Newcastle, but initially without success. Smirke claimed that he was too busy and Soane that he was still recovering from the death of his wife. The Committee therefore turned to another London architect, Thomas Hardwicke who had worked at Syon House and Northumberland House, the duke's London residences. Hardwicke did his best to secure the commission by announcing that he was willing to waive his fee. His action did not, however, have the hoped-for effect; instead it spurred the other candidate for the job, David Stephenson, the duke's architect in Northumberland, to make a similar offer, claiming that 'the honor of being employed in such a work, a most ample recompence'. In the event it was Stephenson whose offer was accepted; in a a letter of 1 June 1816 he formally agreed to build a column at a cost of £2,600 making use of tenant labour.

The foundation stone was laid on 1 July 1816 after much discussion as to who should lay the stone and where each person should walk in the procession (it was eventually decided that length of tenancy should be the criterion in each case). The procession, it is reported, started out from the White Swan Inn, Alnwick. When it arrived at the column the regimental roll of the late Percy tenantry volunteers written on vellum, hermetically sealed in a glass tube, together with several medals was deposited in a cavity. Then 'when the clergyman had concluded a prayer, corn, wine, and oil, were poured upon the stone, and the company united in shouts of applause; after which the procession returned.'[3] At the ceremony itself medals depicting the duke (obverse) and the column (reverse) were presented: copper, bronze or silver versions to subscribers and gold versions to the duke, Stephenson and Mrs Pringle, the tenant in whose field the column stood. A little later, after the death of the second duke in July 1817, the chairman of the committee presented the duke's successor with a key to the column in a red morocco case as an 'offering to the Hereditary Virtue of your noble family'. This gesture, however, did not prevent the new duke from increasing rents when conditions improved, a move which prompted tenants to dub the column the 'Farmers' Folly'.

Describing the column in 1822, a local writer, William Davison claimed that it 'cannot fail to convey the idea of an approach to a place flourishing under the protection and auspices of

Stephenson, *Percy Tenantry Column* (detail)

a family whose wealth and power are only exceeded by their virtue and benevolence.' He also, interestingly, commented that 'The far-famed columns raised by imperial Rome to her heroes invariably rise from pedestals, as does our London Monument and Buonaparte's brasen pillar in the Place Vendome at Paris. But a pedestal ill accords with the dignified simplicity of the Grecian Doric, and the Percy Column rises without the incumbrance of a pedestal', presumably referring to the simplicity of the square plinth at the base of the column.[4]

In 1990 Alnwick District Council decided that it would pay £10,000 towards repairing the column which had been vandalised, Northumberland Estates having agreed to spend £15,000 on replacing the metal railings.[5]

[1] Davison, W., *Descriptive and Historical View of Alnwick*, Alnwick, 1822, p.297. [2] Hudson, M., 'Landowner's Landmark. The Tenantry Column at Alnwick, Northumberland', *Country Life*, April 1981, pp.1212–13. [3] Richardson, *(Historical Division)*, 1844, vol.3, pp.166–7. [4] Davison, *op. cit.*, passim. [5] *Journal*, Newcastle, 27 September 1990.

B6341

Lion Bridge, centre of the east parapet

Percy Lion

Sculptor: John Knowles

Erected 1773
Base: sandstone 14cm high × 38cm wide × 1.43m deep
Lion: lead 1.2m high × 50cm wide × 2m long
Status: I
Condition: good
Condition details: paws replaced
Commissioned by: the 1st Duke of Northumberland
Owned by: Northumberland Estates

Description: a cast lead Percy lion with pointing tail.
History: the Lion Bridge replaces an earlier

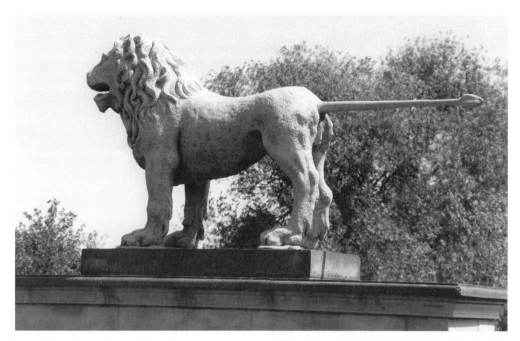

Knowles, *Percy Lion*

bridge which was partially destroyed in a flood in 1770.[1] The foundation stone was laid on 21 August 1773.[2] Its design in the eighteenth-century Gothic 'castle style' is said to be by Robert Adam's older brother John, although this attribution has been questioned on the grounds that it is certain the drawing was produced in Robert Adams's office which at the time was extensively employed by the Duke of Northumberland.[3]

The statue of the lion has suffered various vicissitudes down the years. The early nineteenth-century American writer Oliver Wendell Holmes in *Autocrat of the Breakfast Table* tells a story of a small boy breaking the lion's tail off when he sat on it for a dare.[4] More recently the paws were removed on one occasion and in the late 1980s the whole statue was knocked into the river by a fairground wagon crossing the bridge.[5]

[1] Tate, G., *The History of the Borough, Castle and Barony of Alnwick*, vol.1, Alnwick, p.462. [2] Richardson, *(Historical Division)*, 1844, p.222. [3] Adam, D., *The Complete Works of Robert and James Adam*, London, 1991, p.320. [4] *Monthly Chronicle*, 1889, pp.41–2. [5] Information provided by Ron Lytton, Northumberland County Council, 1999.

In wood, 600m north of Lion Bridge

Malcolm's Cross

Stonemason: not known

Erected 1774
Cross and steps: sandstone 3.45m high × 2.32m wide × 2.32m deep
Fragment of medieval cross: sandstone 25cm high × 27cm wide × 27cm deep
Incised in Roman letters on the west dado of pedestal: MALCOLM III / KING OF SCOTLAND / BESIEGING ALNWICK CASTLE / WAS SLAIN HERE /

Malcolm's Cross

NOV. XIII […]
Incised in Roman letters on the east dado of pedestal: MALCOLMS CROSS / DECAYED BY TIME / WAS RESTORED BY HIS DESCENDANT / THE DUCHESS OF / NORTHUMBERLAND / MDCCLXXIV
Incised in Roman letters on the west face of the base of medieval cross: THIS ANCIENT PEDESTAL / OF MALCOLMS CROSS / KING OF SCOTLAND
Status: II
Condition: poor
Condition details: cross clumsily repaired; corners of pedestal broken; inscription on face very worn; algae and lichen on steps, pedestal and shaft; grass growing in cracks on steps; steps cracked; graffiti incised on shaft
Commissioned by: the Duchess of Northumberland
Owned by: Northumberland Estates

Description: an eighteenth-century sandstone Gothic cross. Three steps lead to a pedestal surmounted by a square shaft, chamfered and dogtoothed at the corners with a cross fleury on top. The pedestal is decorated with relief carvings of the arms of Scotland on the south face and of a Scottish crown and thistle on the north face. The shaft is decorated with grotesque mask heads. On the ground nearby there is the base, and a fragment of the head of the medieval cross which formerly stood on the spot.

Subject: the cross marks the spot where Malcolm III (?–1093), 'the first king of Scotland who is more than a name', was killed during the siege of Alnwick in 1093.[1] Malcolm succeeded his father Duncan I after he had defeated Macbeth in 1054. During a turbulent reign he invaded Northumberland on no fewer than five occasions.[2]

History: Elizabeth, Duchess of Northumberland (1716–76) who commissioned the cross was the daughter of the Duke of Somerset. In 1740 she married an obscure but ambitious Yorkshire baronet, Hugh Smithson (1715–86) who by looks, luck and guile twenty years later contrived to become heir to the Percy estates and the 1st Duke of Northumberland.[3] One way the Duchess contributed to her husband's remarkable rise to fame and fortune was by erecting or 'restoring' monuments like Malcolm's Cross which served to associate him with the medieval earls of Northumberland. A resourceful and energetic woman, she was described by a contemporary as 'coarse', 'ostentatious' and junketaceous'.

A romantic engraving of the cross dated 1856 in its sylvan surroundings shows it looking very much as it does today.[4]

[1] Mackenzie, *N'land*, 1825, vol.I, p.453. [2] *DNB*, vol.XXXV, pp.400–1. [3] Brennan, G., *A History of the House of Percy*, (2 vols), London, 1902, p.443. [4] Howitt, W., *Visits to Remarkable Places*, London, 1856, p.441.

Bondgate Without TOWN CENTRE
Alnwick Playhouse, above ground floor bow window

Seven Ages of Man
Sculptor: David Edwick

Installed January 1997
Panels: sandstone 60cm high × 80cm wide
Status: not listed
Condition: good
Commissioned by: Alnwick Playhouse
Owned by: Alnwick Playhouse

Description: an illustration of the lines from *As You Like It*. The panels depict, left to right: the head and shoulders of a mother and child; the head and shoulders of a boy looking at a snail; the heads of a man and a woman under a cherry tree; a helmeted figure kneeling with a starving child; the head of a man with an eighteenth-century wig and a plate of turkey; the head of a shepherd with a crook and dog;

Edwick, *Seven Ages of Man* (detail)

and a girl feeding an old man in bed.

History: Edwick was commissioned in 1997 to produce reliefs for Alnwick Playhouse, a former 1920s cinema restored in 1990. Given the stage-like curve of the renovated theatre's exterior the artist considered 'All the world's a stage' an appropriate theme. He later commented that the soldier presented the trickiest problem, that of 'how to depict a truly honourable military act without glamourising war'.[1]

[1] Information provided by Alnwick Playhouse, 1998.

Clayport Street TOWN CENTRE
Opposite Market Place

St Michael's Pant

**Sculptor: James Johnson
Builder: Matthew Mills
Restorer: Frederick Richard Wilson**

Erected 1755
Figure and dragon: sandstone 1.6m high
Trough with iron bars: sandstone 74cm high × 2.77m wide × 3.05m deep
Pedestal: sandstone 3.2m high × 1.37m wide × 1.35m deep
Status: II*
Condition: poor
Condition details: St Michael's lance is missing; tracery on pedestal much worn; two south-west finials missing; spalling and crumbling on each face of pedestal; algal growth on each face of pedestal; carved head of animal (lion) with spout much worn
Commissioned by: Alnwick Borough Council
Owned by: Alnwick District Council

Description: an eighteenth-century Gothic-style fountain with statue. A square pedestal with traceried panels and crocketed finials at each corner surmounted by an octagonal plinth on which stands a statue of St Michael lancing a

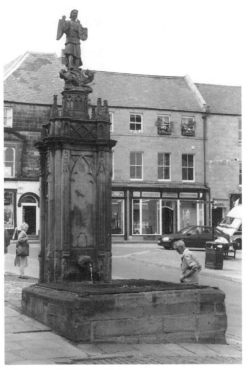

Johnson, *St Michael's Pant*

winged dragon, his bare right foot on the dragon's back. From a spout on the east face water still flows into a large square, ashlar-faced trough.

History: Alnwick Borough resolved to erect a new pant in 1752 and this was carried out three years later. Matthew Mills was paid £60 for the waterworks, 'Mr Bell, the architect' £4 16s. for the construction of the fountain, and James Johnson £5 7s. 6d. for the figure carving.[1] The fountain was later restored by the Alnwick architect, F.R. Wilson at the end of the nineteenth century.[2]

[1] Tate, G., *The History of the Borough, Castle and Barony of Alnwick*, vol.1, Alnwick, 1866, p.471.
[2] *Alnwick and County Gazette*, 'In Memoriam Frederick Richard Wilson', Alnwick, 1894, p.7.

Hope House Lane
SWANSFIELD PARK
Camphill, Alnwick Golf Club

Peace Column
Stonemason: John Hall

Erected *c.*1814
Column: sandstone 5m high approx
Pedestal: sandstone 2.1m high × 2.17m square
Incised in Roman letters on dado, south face (now largely erased): ENGLAND HAS SAVED HERSELF BY HER FIRMNESS / AND EUROPE BY HER EXAMPLE / PITT / THIS PILLAR WAS ERECTED BY / HENRY COLLINGWOOD SELBY, / A MAGISTRATE OF THIS COUNTY, / TO COMMEMORATE / THE PERSEVERING AND VICTORIOUS EFFORTS / OF THE BRITISH EMPIRE / BY SEA AND LAND / DURING AN ARDUOUS STRUGGLE OF XX YEARS, / AND / THE SIGNAL SUCCESSES OF / THE POWER UNITED WITH THIS COUNTRY / AT THE CLOSE OF THAT EVENTFUL PERIOD; / THE EXPULSION OF THE FRENCH FROM RUSSIA / AFTER THE BURNING OF MOSCOW IN MDCCCXII / THE DEFEATS OF THEIR ARMIES IN GERMANY / IN THE MEMORABLE CAMPAIGN OF MDCCCXIII, / THE INVASION OF FRANCE, / THE SURRENDER OF PARIS, / THE DOWNFALL OF NAPOLEON BUONAPARTE, / THE RE-ESTABLISHMENT OF THE BOURBON MONARCHS, / AND THE RESTORATION OF PEACE TO EUROPE / IN MDCCCXIV.
Incised in Roman letters on dado, west face: VICE-ADMIRAL / HORATIO VISCOUNT NELSON / OF THE NILE / DEFEATED THE FRENCH AND DANISH FLEETS / AT ABOUKIR AND COPENHAGEN, / AND FELL / IN THE DECISIVE VICTORY / OF TRAFALGAR / ACHIEVED OVER THE COMBINED NAVIES / OF FRANCE AND SPAIN / IN MDCCCV.
Incised in Roman letters on dado, north face: FIELD MARSHAL / THE DUKE OF WELLINGTON/ HAVING VANQUISHED THE ARMIES OF FRANCE / IN PORTUGAL / AND IN SPAIN, / AT THE BATTLES OF / VALMEIRA AND TALAVERA, / SALAMANCA

AND VITTORIA, / DROVE THEM BEYOND THE PYRENEES, / AND ADVANCING TO THE BANKS OF THE GARONNE / AGAIN OVERTHREW THEM / UNDER THE WALLS OF TOULOUSE / IN MDCCCXIV
Incised in Roman letters on dado, east face: THE RIGHT HONOURABLE / WILLIAM PITT / DIRECTED / THE COUNCILS AND ENERGIES OF HIS COUNTRY / DURING THE FIRST YEARS / OF A JUST AND NECESSARY WAR , / AND DIED IN MDCCCVI, / HAVING ESTABLISHED / THAT WISE AND

Hall, *Peace Column*

VIGOROUS SYSTEM OF POLICY, / WHICH SUCCEEDING STATESMEN, / EMULOUS OF HIS EXAMPLE, / STEADILY PURSUED / TILL THEY SECURED INDEPENDENCE / FOR THE NATIONS OF THE CONTINENT / AND A PEACE OF UNPARALLELED GLORY / FOR THIS EMPIRE.
On the north-west face, incised on plinth: JOHN HALL / MASON
Status: II*
Condition: poor
Condition details: inscription worn away on south face; lichen and algae on all surfaces; bottom step almost covered in grass
Commissioned by: Henry Collingwood Selby
Owned by: Northumberland Estates

Description: small Tuscan column surmounted by a platform with a small pedestal and ball finial on top. It stands in a copse on the damaged remains of an oval univallate hillfort in the middle of what is now a golf course.

Subject: the column commemorates England's success in defeating the French in 1814, in particular the part played by William Pitt, the Duke of Wellington and Lord Nelson.

History: the column was erected in the grounds of Swansfield House (1823 by John Dobson, demolished *c.*1975), the seat of Henry Collingwood Selby (1749–1839).[1] Records suggest that Selby, a landowner of great wealth, steward of the Duke of Northumberland and an alderman of Alnwick, was a keen defender of the status quo against those locally who were sympathetic to the principles of the French Revolution. 'On one occasion a company of the Percy tenantry was drawn up before Gawain Scott's house, and, commanded by their captain, H.C. Selby, advanced towards it with fixed bayonets to terrify its inmates. Such wretched bullying created disgust…'[2] He also commissioned 'a beautiful statue, commemorative of the battle of Waterloo and its victorious results' (no longer extant) for the front of his house.[3]

This devotion to the existing order appears to have gone hand in hand with loyalty to the Duke of Northumberland. It is said that a tablet on a flag tower (now destroyed) in the grounds of Swansfield House displayed the profiles of the 2nd Duke and Duchess of Northumberland with the inscription: 'To the memory of his early patrons / the most noble HUGH and ELIZABETH / DUKE and DUCHESS of NORTHUMBERLAND, / not less eminent for their virtues / than distinguished by their rank, / this tribute of grateful affection / is dedicated by / MDCCCXV HENRY COLLINGWOOD SELBY.'[4]

[1] Faulkner, T. and Lowery, P., *Lost Houses of Newcastle and Northumberland*, York, 1996, p.69.
[2] Tate, G., *The History of the Borough, Castle and Barony of Alnwick*, Alnwick, 1866, *passim*.
[3] Parson, W. and White, W., *Directory and Gazetteer of the Counties of Durham and Northumberland*, Newcastle, 1827, p.387.
[4] Davison, W., *Descriptive and Historical View of Alnwick*, Alnwick, 1822, p.301.

Market Street TOWN CENTRE
Opposite Town Hall

Adam Robertson Fountain
Designer: not known

Unveiled 8 June 1891
Work: sandstone, polished pink granite, bronze and glass 4.38m high × 2.36m square
Incised in pink granite on the north face of the pedestal in black Roman lettering: PRESENTED / BY / ADAM ROBERTSON / TO / HIS NATIVE TOWN / 1890
And below: OPENED BY EARL PERCY JUNE 8th 1891
Attached to the south face inscribed on a painted plaque in lettering: ROBERTSON'S PANT / THIS FOUNTAIN / OR PANT WAS ERECTED / IN 1890 BY ADAM ROBERTSON / LOCAL FREEMAN AND / BENEFACTOR AS A / GIFT TO HIS NATIVE TOWN / RESTORED 1986

Adam Robertson Fountain

On the left side of the north face of the pedestal: sv40
Status: II
Condition: fair
Condition details: algae, especially on the west and east faces of the pedestal; lichen on the north face of the pedestal; a small amount of graffiti on the south face of the pedestal
Commissioned by: Adam Robertson
Custodian: Alnwick District Council

Description: a working drinking fountain in the style of 'a phase of the Italian Renaissance'.[1] A square sandstone pedestal with chamfered corners supports an octagonal cornice from which rise eight polished pink granite columns. These bear an arcade with spandrels and keystones above which is a decorated frieze which includes Robertson's monogram and a masonic emblem. This is capped by a sandstone panelled dome with a bronze and glass lantern on top. There is a polished pink granite trough on the north side.

History: the fountain was the gift of Alderman Adam Robertson, the founder of a successful local firm of decorators and a leading figure in Alnwick politics. Robertson offered to erect the fountain on 18 June 1890. His wife Nancy laid the foundation stone on 3 February 1891 and Earl Percy declared the fountain open at a ceremony on 8 June 1891 attended by the band of the Northumberland Fusiliers and a large group of freemasons.[2]

[1] *Alnwick Guardian*, 13 June 1891. [2] *Ibid.*

The Peth TOWN CENTRE
Alnwick Castle, Barbican

Battlement Figures
Stonemason: James Johnson

Erected 1750–86
Each figure: sandstone 1m high
Status: I
Condition: poor
Condition details: figure on merlons of south-west corner of the barbican has lost hand; all figures dirty and worn
Commissioned by: the 1st Duke of Northumberland
Owned by: Northumberland Estates

Description: seven apotropaic figures, some with histrionic combative poses. They stand at

Johnson, *Battlement Figures*

various points on the merlons of the battlements of the barbican and gatehouse (*c.*1310–20): on the south-west projecting tower of the barbican; above the portal of the barbican; on the north-west projecting tower of the barbican; on the south-west gatehouse; and on the north-west gatehouse. All wear fanciful, eighteenth-century versions of medieval armour or classical attire. There are similar figures on the battlements elsewhere but they are less easy to see from outside the Castle.

History: the figures were installed by the 1st duke of Northumberland as part of his wholesale refurbishment of the Castle (1750–86) in the Gothic style under the direction of James Paine and Robert Adam. The work of James Johnson, they reportedly took 'upwards of twenty years' to complete.[1] They replace earlier figures which had become decayed.[2] Nineteenth-century engravings and written descriptions suggest that they have long been a key element of the tourist image of the town.[3]

There are similar apotropaic figures in the region, on the battlements of the castles at Bothal, Raby, Hylton and Bambrugh.[4]

[1] Sykes, vol.1, p.197. [2] Knowles, W.H., 'The

Gatehouse and Barbican at Alnwick Castle, with an account of the recent discoveries', *Archaeologia Aeliana*, series 3, vol.5, 1909, p.296. [3] Smiles, S, *Lives of the Engineers*, London, 1862, vol.III, p.415. [4] Scott W., *Border Antiquities of England and Scotland*, London, 1814, *passim*.

Alnwick Castle, over Barbican portal

Lion Rampant

Carver: not known

Erected 1400s
Panel: sandstone 1.4m high × 1.1m wide
Incised on the upper cornice between two crescents and a locket in low relief: ESPERANCE MA COMFORTE
Incised on the lower cornice: ESPERANCE H.P.EN.DIEU
Status: I

Lion Rampant

Condition: fair
Commissioned by: the 4th Earl of Northumberland
Owned by: Northumberland Estates

Description: the Percy armorial lion. A low relief carving of a lion rampant on a recessed panel over the portal of the barbican, with hollow moulding work on the ashlar which encloses it. On the underside there are three badges between supporters comprising a locket between a crowned lion and a leopard or panther; a bird displayed within a cable moulding, between an uncrowned lion and a collared unicorn; and a lion with crown.[1]
History: the lion was installed by the 4th Earl of Northumberland (1461–89). The barbican into which it is set (described by Pevsner as the finest example of a barbican in the country) dates from the second decade of the previous century.

[1] Knowles, W.H., 'The Gatehouse and Barbican at Alnwick Castle, with an account of the recent discoveries'; *Archaeologia Aeliana*, series 3, vol.5, 1909, p.296.

Pottergate TOWN CENTRE

Narrowgate junction

Will Dickson Fountain

Architect: not known

Erected 1873
Fountain: polished pink granite and iron and glass 2.16m high × 93cm wide × 93cm deep
Plaques: bronze 22cm diameter each
Incised in Roman letters on the east face of the entablature: ERECTED / 1873 / AT THE COST OF / WILL DICKSON / OF ALNWICK / IN PLACE OF / THE/ OLD PANT
Status: II
Condition: poor
Condition details: fountain not working; cracks on east face of pedestal and trough; lichen on

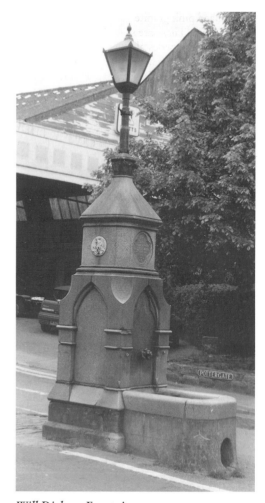

Will Dickson Fountain

the base of the pedestal
Commissioned by: William Dickson
Custodian: Alnwick District Council

Description: an elaborate fountain in the Gothic style. A polished pink granite pedestal rises from a sandstone base with blank arches on each face and an inscription on the east face of the entablature. On this sits a pyramid cap in

unpolished pink granite supporting an iron and glass lantern. There are small bronze plaques attached to the pedestal showing St Michael and Dragon in low relief.

Subject: William Dickson (1799–1875) was born in Berwick and trained as a solicitor. For forty years from 1831 he filled various public offices in the county, particularly in the Berwick and Alnwick areas, and was the founder of the Alnwick and County Bank. He was also a notable local historian with a number of publications to his name.[1]

[1] *Monthly Chronicle*, 1890, p.205.

Rotten Row TOWN CENTRE

Forest Lodge, behind railings

William the Lion Stone

Carver: not known

Installed 1800s
Stone: sandstone and polished grey granite 1.1m high × 2.2m wide
Incised in Roman letters: WILLIAM THE LION, / King of SCOTLAND, / besieging / ALNWICK Castle, / was here / taken Prisoner / MCLXXIV
Status: II
Condition: fair
Condition details: lichen and algae on face
Commissioned by: the 1st Duke of Northumberland
Owned by: Northumberland Estates

Description: polished grey tablet inset in sandstone slab at the top of steps.

Subject: the stone commemorates the capture of William the Lion (1143–1214) during the siege of Alnwick Castle in 1174. He was taken prisoner by English soldiers whilst out riding with a small party of followers. As the price of his release he agreed to the Treaty of Falaise by which he swore to do homage and fealty to Henry II, the English king.[1]

William the Lion Stone

History: the tablet was probably originally installed several miles away from where it is now, at the delightful eighteenth-century Gothic summer-house and eye-catcher at Ratcheugh Crag which Robert Adam designed for the first duke.[2] Engravings show that at that time it was mounted in an eighteenth-century Gothic frame decorated with finials and a relief carving of the Scottish thistle. A reference to the *Lion Stone* by a travel writer in 1856 suggests that it was moved to the entrance to Hulne Park in the early nineteenth century.[3]

[1] *DNB*, vol.LXI. [2] Davison, W., *Descriptive and Historical View of Alnwick*, Alnwick, 1813, p.291. [3] Howitt, W., *Visits to Remarkable Places*, London, 1856, vol.2, p.443.

ASHINGTON

A197

Woodhorn Colliery Museum, car park

Ashington Colliery Disaster Memorial

Sculptor: John Reid
Architect: William Henry Knowles

Erected 1923; re-erected 1991

Statue: bronze 1.9m high approx
Pedestal: granite 7m high approx × 1.38m square
Raised Roman letters on bronze plaque on south face of the base of pedestal: ERECTED BY / THE MINERS AND / DEPUTIES TRADE- / UNION BRANCHES IN THE ASHINGTON GROUP / OF COLLIERIES (ASSISTED / BY DONATIONS FROM THE / ASHINGTON AND CO. LTD., THE NORTHUMBERLAND / MINERS ASSOCIATION, THE NORTHUMBERLAND / DEPUTIES ASSOCIATION AND FRIENDS) / IN MEMORY OF THEIR FELLOW WORKMEN / WHO LOST THEIR LIVES IN THE WOODHORN / COLLIERY EXPLOSION ON SUNDAY, AUGUST 13TH 1916 / [names underneath]
Status: II
Condition: good
Custodian: Woodhorn Colliery Museum

Description: a bronze statue of a colliery deputy in breeches, short-sleeved shirt and flat cap with his hand raised to hold up a lamp (the lamp no longer exists). The tall tapering, light-coloured granite pedestal on which it stands has drinking basins to the west and east and a carved wreath in relief high up on the south face. On the north face there is a bronze plaque with a low relief scene of a colliery complete with figures of miners and a colliery railway.

Subject: the memorial commemorates Woodhorn Colliery's worst disaster. On the morning of Sunday, 13 August 1916, at about 7a.m., an explosion ripped through the pit killing eleven men instantly and two others who died later in hospital. The losses would have been far greater had it not been a Sunday when there were only thirty men down the pit. The disaster was particularly hard for the community to bear because it occurred at a time when many men from the colliery were away in France. One of the victims, Walter Hughes, aged 38 and father of four, had only the week before returned from spending a period in hospital after being gassed in the trenches.[1]

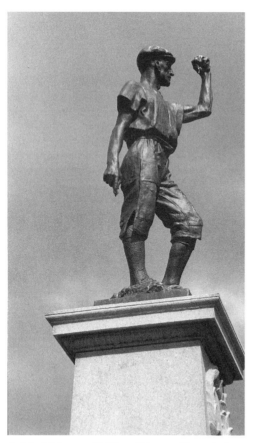

Reid, *Ashington Colliery Disaster Memorial*

History: the memorial was initally erected in Hirst Park, Ashington, in 1923. It was moved to Woodhorn Colliery Museum in 1991 at the request of Bob Howard, the son of one of the victims. The sculptor broke with tradition by not depicting the figure with a pick over his shoulder and lamp by his side (see p.144). Since the majority of men killed were deputies, it was thought appropriate that the statue should show a deputy whose 'practised eye can, by the action of the flame, recognise the presence of gas and so warn the workers of possible danger'. Such a pose, it was thought, would also

serve as a 'reminder that Safety First should be the watchword'.

[1] Kirkup, M., *Biggest Mining Village in the World*, Warkworth, 1993, pp.169–72.

Station Road TOWN CENTRE

Park gardens, outside public library

Ashington War Memorial

Sculptor: Colin Rose
Designer: Gene Healey

Unveiled 13 November 1983
Figures: steel 1.98m high × 95cm wide
Four pedestal corners: pebble-dash in concrete 1.85m high × 1.08m wide
Incised in Roman letters, painted white, on plaque on the north face of pedestal: THIS FOUNDATION STONE / WAS LAID JOINTLY BY / COUNCILLOR J.SCOTT / CHAIRMAN, WANSBECK / DISTRICT COUNCIL / AND MR. R. SEWELL, B.SC. / C.ENG M.I.MECH.E FA.M.E. M.E. / PRESIDENT ASHINGTON BRANCH / OF THE ROYAL BRITISH LEGION / ON 28TH OCTOBER 1983
Incised in Roman letters, painted white, on plaque on the north face of pedestal: TO THE GLORY OF GOD IN GLORIOUS / MEMORY OF THOSE INHABITANTS OF / ASHINGTON AND DISTRICT / WHO GAVE THEIR LIVES FOR THEIR COUNTRY / IN THE GREAT WAR 1914–1918 / [names]
Incised in Roman letters, painted white, on plaque on the west face of pedestal: AND TO THE GLORIOUS MEMORY / OF THOSE MEN WHO GAVE THEIR / LIVES IN THE WAR 1939–45 [names]
Status: not listed
Condition: poor
Condition details: plaques coming adrift from the pedestal; nails rusting or missing; plaques in need of cleaning; leaching from the bronze plaques has stained the concrete pedestal
Commissioned by: public subscription
Custodian: Wansbeck District Council

Rose, *Ashington War Memorial*

Description: war memorial with modernist figures of soldiers. Three soldiers in trench coats resting on their rifles are represented as flattened abstracted silhouettes. They stand on a white concrete cube pedestal to which are attached plaques from a war memorial erected earlier in the century.

History: the plaques were originally installed outside the Memorial Ward of Ashington Hospital. After the Second World War, when the ward was demolished they were moved to Ashington Cricket Clubhouse. In 1945 there was a proposal to designate the new Library as the town's war memorial but this came to nothing.[1] Eventually, in 1983, after a long campaign by ex-servicemen in the town to give

the dead of two world wars a fitting memorial, Wansbeck Council organised a competition to find the best design for a new memorial and invited entries from pupils at Hirst High School. The competition was won by Gene Healey of Woodlands Road, North Seaton.[2] His design was then translated into working drawings and models by the locally-based sculptor, Colin Rose and installed by a team from Wansbeck Community Programme Agency.[3]

From the first the new memorial came in for criticism. It was said that it looked like 'a group of coat-hangers', that Colin Rose had not adhered closely enough to Healey's design and that the site would cause difficulties on Remembrance Day if it rained.[4]

[1] *Morpeth Herald,* 16 February 1945. [2] *Evening Chronicle,* 12 November 1983. [3] N'land War Mems Survey, WMSA17.1. [4] Newcastle City Libraries, *Monuments and Memorials 1968–1993,* n.d., p.15.

Jackie Milburn
Sculptor: John Mills

Unveiled 5 October 1995
Sculpture: bronze 2.44m high
Pedestal: brick 88cm high × 2.57m wide × 2.59m deep
Base: bronze 9cm high × 1.79m square
In raised Roman letters on plaque on pedestal on the east face: IN MEMORY OF ASHINGTON-BORN / JACKIE MILBURN / ONE OF NEWCASTLE UNITED AND ENGLAND'S GREATEST CENTRE-FORWARDS / STATUE UNVEILED 5 OCTOBER 1995 / BY MRS LAURA MILBURN / MONEY FOR THE STATUE WAS RAISED THROUGH / A PUBLIC APPEAL LAUNCHED BY / COUNCILLOR GEORGE FERRIGON / CIVIC HEAD OF WANSBECK 1992/3 / SCULPTOR: JOHN MILLS
Incised on the east face of the statue base: Jackie Milburn / 1924–1988
Incised on the west face of the statue base:

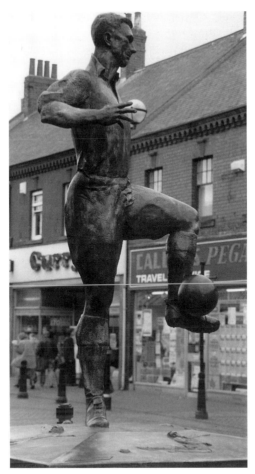

Mills, *Jackie Milburn*

Sculptor / John W.Mills
Signed on base: '95 / John Mills
Status: not listed
Condition: good
Commissioned by: public subscription
Custodian: Wansbeck District Council

Description: slightly over-life size bronze statue of Milburn. He wears Newcastle United stripes and is represented trapping the ball with his left foot. On each side of him on top of the

low brick pedestal there are four small bronze low-relief images (each 53cm high) of Milburn in action in his playing days. These are clearly based on press photographs.

Subject: John Edward Thompson Milburn (1924–88), also known as 'Wor Jackie', was born in Ashington and began life as a miner. He joined Newcastle United in 1943 and, unlike his cousins Bobby and Jack Charlton, stayed in the region throughout his playing career, scoring 283 goals in 492 appearances. Unusually for a footballer his fame did not fade when he stopped playing. Various reasons have been given for this.[2] Firstly, he had a particularly distinctive, dashing style of play which people did not easily forget. Secondly, his career was crowned in 1951 by a legendary goal, 'the hardest shot in any Wembley final', a match which subsequently became known as the 'Milburn Final'. Thirdly, his playing days coincided with the moment in the 1930s and 1940s when the bond between Newcastle and neighbouring mining communities like Ashington was complete; indeed, being a former miner himself he played his part in cementing that bond. Fourthly, he started playing in the post-war era of massive attendances and continued to play long enough to see the beginning of coverage of football on TV. And last but not least, after he stopped

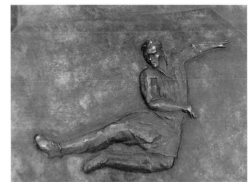

Mills, *Jackie Milburn* (detail)

playing, he spent 23 years as the North-East football reporter for the *News of the World*. Milburn died on 9 October 1988 and to this day his name is synonymous with that of Newcastle United.[1]

History: an appeal was started in November 1991. Four years later, Milburn's wife, Laura unveiled the statue with Jackie Charlton, various members of Jackie's team mates and representatives of the current Newcastle United team in attendance.[2]

[1] Holt, R., 'Football and Regional identity in the North East of England: the legend of Jackie Milburn' (unpub. thesis), n.d. [2] *Journal*, Newcastle, 6 October 1995.

BAMBURGH

B1342

St Aidan's churchyard, north-west corner

Grace Darling Monument

Sculptor: C. Raymond Smith
Architect: Hicks and Charleswood
Restored by: Frederick Richard Wilson

Erected 1844; restored 1885; restored again 1895
Recumbent figure: Portland stone 1.8m long
Monument: sandstone 3m high × 3m long × 1.25m wide
Railings: cast iron 1.4m high × 5.2m long × 3.25m wide
Incised Roman letters on base of east face: W[…]Sc[…]1838.
On base of west face: C.R.SMITH.
Incised Gothic letters on north face: Died- 20th Oct 1842– Aged 26 years
On south face: G[…] D[…] Born-24th Novr 1815.

Raised Roman letters on bronze plaque on base of south face: GRACE HORSLEY DARLING / BORN-NOV. 24TH 1815 / DIED-OCT. 1842 / AGED 26 YEARS
Status: II
Condition: fair
Condition details: inscription on the east and the south of the base very worn; railings corroded on the north face; lichen and algae on the north face of the base; south of figure worn on arm and oar
Commissioned by: public subscription
Owned by: St Aidan's Church

Description: a canopied tomb in the Decorated Gothic style with a carved recumbent figure of the saintly-looking heroine holding a stone oar by her side. Carved relief seaweed forms the decoration under the mattress on which the figure lies. The tomb has three arches supported by metal colonettes and is topped by metal finials.

Subject: Grace Darling (1815–42) was the daughter of the keeper of the new lighthouse on Longstone in the Farne Islands. She shot to national fame after her courageous exploits in the early hours of 7 September 1838 when she and her father rowed half a mile through stormy seas to rescue nine survivors of the wreck of the paddle steamer, Forfarshire.[1] There are several monuments to her in Bamburgh, including a stained glass window in St Aidan's Church, plaques on the wall of cottages in the village where she was born and died of consumption in 1842, and the Grace Darling Museum, erected in 1938, where amongst other relics is displayed the 21–foot coble used in the rescue.

History: it was first proposed that Grace Darling should be commemorated by the restoration of the chapel of St Cuthbert on Great Farne Island. The Queen and others duly sent money and by 1848 the restoration of the chapel with a stone monument was complete.[2]

Smith, *Grace Darling Monument*

But neither this nor the suggestion of the *Gateshead Observer* that a lighthouse should be erected met with the approval of the Darling family and their Bamburgh friends who preferred that a more conventional monument be erected in Bamburgh churchyard. Accordingly it was decided to build a plain tombstone and alongside it a thirteenth-century style monument in St Aidan's chuchyard in a position where it would be seen by sailors out at sea. This was finished in 1844. The figure for it was carved by C. Raymond Smith of London.

However, by 1885 it was found that the stonework, especially the soft and porous Portland stone used for the base, had deteriorated badly and the outer stonework had to be repaired. A new figure of the dead heroine was carved. Luckily this was possible because, even after forty years, Smith still possessed his original model. (His original figure of Grace Darling now sits in the nave of St Aidan's.) As for the monument as a whole, this was slightly changed as well as repaired and the ground between the basement and the outer rails laid

with cement of variegated colours and an inscription added. A line illustration shows that at this stage it differed from how it is now by having a pitched roof and no metalwork decoration.[3] However, in the autumn of 1893, soon after this work was completed, the monument was almost demolished in a gale and, two years later, had once again to be restored, this time by the Alnwick architect, F.R. Wilson.

[1] Smedley, C., *Grace Darling and Her Times*, London, 1932, pp.253–4. [2] *Illustrated London News*, 22 January p.43. [3] *Monthly Chronicle*, 1888, p.265.

BEDLINGTON

Front Street West
Junction with Hartford Road West

Trotter Memorial Fountain

Sculptor: not known

Erected 9 July 1899; re-erected 1972
Whole work: red sandstone 4m high × 1.25m square
Incised on lower part of pillar on the east face:
ERECTED BY / PUBLIC SUBSCRIPTION / TO THE
MEMORY OF / DR JAMES TROTTER / WHO DIED AT
BEDLINGTON / JULY 9TH 1899 / CALM REST BE
THINE BEYOND LIFE'S SHADOWS MORE / THY
NOBLE ACTS WE'LL CHERISH EVERMORE / FAIR
FREEDOM MOURNS HER RICHLY GIFTED SON /
WHO LIVES IN GOOD DEEDS BRAVELY DONE
Status: II
Condition: poor
Condition details: fountain spout missing; tops of stone pinnacles missing; finial rusting; severe deterioration of sandstone surfaces
Commissioned by: public subscription
Custodian: Wansbeck District Council

Description: fountain in the Eleanor Cross manner with a relief portrait of Trotter. Two

chamfered steps lead to a square pillar surmounted by crocketed arches and a crocketed pinnacle. The pillar is in two parts. The upper part has a limestone panel inserted into it on the east face with a low relief medallion portrait of Dr Trotter looking left.

Subject: the fountain commemorates Dr James Trotter (1843–99) who came to Bedlington from Scotland in 1864 and practised as a doctor with his brother at nearby Choppington. Trotter particularly championed the cause of local miners and helped to secure the election to Parliament of the miners' leader, Thomas Burt. He is buried in Kells, Galloway. One of Bedlington's pits, Doctor's Pit, was named after him.[2]

History: a photograph of the fountain in 1902 on a triangular traffic island at the Hartford Road West / Front Street West junction makes clear that even then it was suffering from graffiti.[1] The fountain was later moved in 1972 by Bedlington U.D.C. so that a

Trotter Fountain

traffic roundabout could be built. Currently English Heritage and Northumberland County Council, as part of the Conservation Area Partnership Scheme, have plans to move it to the middle of the roundabout where it will be more visible than at present.[2]

[1] Martin, E., *Bedlingtonshire*, Chalford, 1997, pp.2 and 11. [2] Information provided by Frank McPhail, Wansbeck District Council, 1998.

BELLINGHAM

Manchester Square
Rose and Crown Public House, outside

Bellingham South African War Memorial

Sculptor: J. Milburn

Erected *c.*1903; re-erected 1950s
Pedestal: grey stone 1.9m high × 1.2m square
Canopy: grey stone and marble 1.5m high
Statue: stone and iron 90cm high
Incised in black lettering on panel on front face of pedestal: ERECTED / IN HONOUR OF THE
FOLLOWING LOCAL MEMBERS OF / YEOMANRY
AND VOLUNTEERS WHO FOUGHT IN THE / BOER
WAR 1900–2 [names under]
Also inscribed with names on a small plaque attached to left face of pedestal
Signed on base of statue: J.MILBURN SC
Status: II
Condition: fair
Condition details: stonework broken at bottom of columns; drinking spouts missing; statue details weathered and broken; pedestal covered in lichen; main stonework spalled; dirty
Commissioned by: public subscription
Custodian: Bellingham Parish Council

Description: drinking fountain with statue. A square pedestal with drinking troughs on each

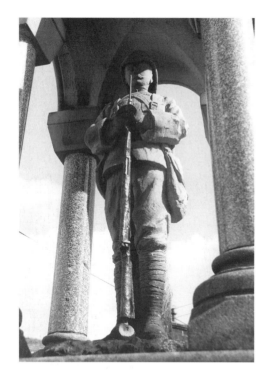

Milburn, *War Memorial*

side supports a canopy on polished granite columns. Beneath the canopy is a stone statue of a soldier in pith hemet holding a Lee Enfield rifle. White marble panels on the front and left faces carry inscriptions.

History: formerly at the cross-roads in the middle of the village, the memorial was moved to its present location in the 1950s. It used to have a lamp on top. Those whom it commemorates are thought to have all returned home safely from the war.[1]

[1] N'land War Mems Survey, WMSB18.5.

Bankhill　　　　TOWN CENTRE

Marygate

Monument to Lady Jerningham

Sculptor: O.P. Pennacchini
Designers: Hubert Jerningham and Walter Ingram

Erected 1908
Statue: white marble 92cm long × 1.68m high
Base: grey granite 1.68m wide × 1.68m long × 1.13m high
In black lead letters on front face: ANNIE / LADY JERNINGHAM / OF LONGRIDE TOWERS, BERWICK UPON TWEED / OBIT 9 OCT. 1902 / PRESENTED TO THE TOWN OF BERWICK UPON TWEED BY / SIR HUBERT JERNINGHAM, K.C.M.G. / LATE AND LAST MEMBER FOR THE BOROUGH.
Raised lettering on metal panel on north face: THIS MEMORIAL WAS OFFERED TO AND ACCEPTED BY / THE TOWN COUNCIL / OF BERWICK UPON TWEED. / 1903 / G.F. STEVEN, ESQ, MAYOR / G. WEATHERSTON ESQ. SHERIFF / AND ERECTED / 1908, FRANK EDMINSON ESQ MAYOR / JAMES LESLIE ESQ SHERIFF.
On metal panel on south face: YET IN THESE EARS TILL HEARING DIES / ONE SLOW BELL WILL SEEM TO TOLL / THE PASSING OF THE SWEETEST SOUL / THAT EVER LOOKED WITH HUMAN EYES / TENNYSON: IN MEMORIAM.
On rear of the base of the statue: DESIGNED BY HUBERT JERNINGHAM 1903 / SKETCHED BY WALTER INGRAM 1904 / EXECUTED BY O. P. PENACHINI 1906
Status: II
Condition: poor
Condition details: right ear of figure missing; right ear of one of the dogs missing; algal growth on pedestal; staining from inscription

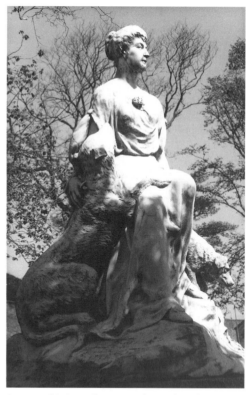

Pennacchini, *Lady Jerningham* (detail)

Commissioned by: Sir Hubert Jerningham
Custodian: Berwick-upon-Tweed District Council

Description: a naturalistic statue of a young woman resting on a rock. She wears simplified Edwardian dress and has a single rose pinned to her bosom. There are two dogs at her side, the larger one looking up at her, its paw resting on her knee.The statue sits on a tapering rusticated base.

Subject: the monument commemorates Annie, Lady Jerningham (1850–1902), daughter of Edward Liddell of Benton Park, Newcastle. She was first married to Charles Mather of

Longridge Towers, Berwick (who at his death left her a modest fortune and Longridge Towers) and then to the diplomat Jerningham. When Sir Hubert was posted to Trinidad and Tobago she accompanied him and it was there that her health began to suffer. She returned to Britain but never fully recovered and died on 9 October 1902. Her death was marked locally by the closing of shops and the lowering of blinds.[1] At the unveiling of the statue the mayor of Berwick spoke of Lady Jerningham's philanthropy: 'Generous and kindly she ever was.'[2]

History: Sir Hubert Jerningham who designed the monument and presented it to Berwick was born and educated in France before becoming a British diplomat. After being MP for Berwick (1881–5) he became Governor of first Mauritius (1892–7) and then Trinidad and Tobago (1897–1900). He was knighted for services in a great cyclone in Trinidad and Tobago.[3]

The statue was carved by Pennacchini (the spelling on the inscription appears to be incorrect) in Ealing, West London and was erected in Berwick in 1908 on a spot where at certain times of year it could just about be seen from the Jerningham's home, Longridge Tower, four kilometres to the south-west. Until the 1970s it was covered in straw during the winter in case of frost damage. It has recently been treated with chemicals in the hope that it can remain on view all year round (the injection process was featured on the BBC TV childrens' programme 'Blue Peter'). In the winter of 1998–9, however, it was once again wrapped.[4]

[1] Information provided by Elizabeth Doley, 1998. [2] *Journal*, Berwick, 5 November 1908. [3] *Who's Who 1897–1916*, London, 1920, p.378. [4] Information provided by F. Manzeh-Longbone, 1999.

Castlegate Scotsgate

Jubilee Fountain
Architect: not known

Inaugurated 20 June 1897
Fountain and steps: polished granite 5m high × 1.5m wide
On a panel on the front north side face in raised lettering: TO COMMEMORATE / THE SIXTIETH ANNIVERSARY / OF QUEEN VICTORIA'S / ACCESSION TO THE THRONE / THIS FOUNTAIN / WAS PRESENTED TO THE / BOROUGH OF / BERWICK-UPON-TWEED / ON JUNE 20, 1897 / BY FRANCIS MARTIN NORMAN / COMMANDER RN, JP / SUCCESSIVELY SHERIFF, / MAYOR, AND ALDERMAN
On a bronze plaque in raised lettering, also on the north face: VRI / 1837 1897
On the east and west face in Gothic raised lettering: Sigilla . majorata . Villa . Berwuc . super . Tweedam
Status: not listed
Condition: fair
Condition details: fountain not working; guano on some surfaces; algal growth on some surfaces
Commissioned by: Commander Francis Norman RN
Owned by: Berwick-upon-Tweed District Council

Description: a square pink granite column on a pink granite base with fluted pilasters at each corner and an arched-topped panel on each face. On top of the column is a stepped base on which sit two carved cushions in red sandstone surmounted by a bronze crown. There are bronze crests of the town and lion-head spouts on each face.
History: Commander Francis Martin Norman RN (1833–1918) had had a busy naval career before retiring to North Berwick in 1863

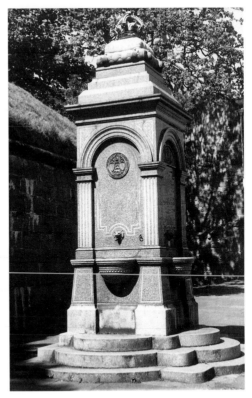

Jubilee Fountain, Berwick

(not his native village; he came originally from Bromley, Kent). In 1877 he became a leading light of the Berwickshire Naturalists' Club and the Historic Monuments Committee, the bodies responsible for the restoration of the town's Elizabethan fortifications and for the Flodden Memorial (see pp.21–2).[1]

Initially his offer to Berwick of a Jubilee fountain met with some resistance because it involved the council spending £200 refurbishing the nearby public lavatory and it was felt that the Maclagan Memorial erected five years earlier (see pp.18–19) 'had not really and truly been a boon to the public'. Nonetheless, in due course a fountain was erected and Sir Edward

Grey, MP for North Northumberland, the future Foreign Secretary, performed the unveiling.[2]

[1] Information provided by Elizabeth Doley, 1998.
[2] Anon., *History of the Berwickshire Naturalists' Club*, vol.XXIV, part 1, 1923, pp.81–5.

Northumberland County Council social services, opposite

War Memorial

Sculptor: Alexander Carrick

Erected *c.*1920
Statue: bronze 2.2m high × 1.75m square
Pedestal: stone 4m high × 1.75cm square
Steps: stone 38cm high × 4m square
Raised lettering on plaque on front (south) face:
[480 names] / THE GREAT WAR 1914–1918 / IN HONOUR OF ALL WHO SERVED / IN SYMPATHY WITH ALL WHO SUFFERED / AND / IN REMEMBRANCE OF ALL THESE FALLEN SONS / OF THIS BOROUGH / WHOSE NAMES ARE HERE INSCRIBED
On a separate plaque below: TO THE MEMORY OF / THE MEN AND WOMEN OF THIS BOROUGH / WHO FELL IN THE 1939–45 WAR
On a separate plaque below: TO THE MEMORY OF / THE MEN AND WOMEN OF THE BOROUGH / WHO HAVE FALLEN SINCE 1945
On the east, west and south faces are lists of names in raised lettering on plaques. On the west plaque also: THEY TROD THE PATH OF HIM UPON THE ROAD / PERFECT IN ONE GREAT ACT OF SACRIFICE
Status: II
Condition: good
Commissioned by: public subscription
Custodian: Berwick Borough Council

Description: war memorial with statue of winged *Victory* on pedestal. Two graduated steps lead to square plinth with rusticated sides and bronze plaques indented into each of its

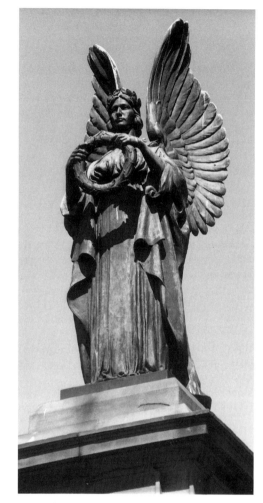

Carrick, *War Memorial*

faces. The figure of *Victory* holds a wreath in front of her; her wings are raised behind her back.

History: the memorial is now in a small round memorial garden. A postcard in Morpeth County Library shows that at one time it was set inside a walled enclosure.

Duke of Wellington

Sculptor: not known

Installed 1800s
Bust: stone 60cm high
Status: II
Condition: fair
Condition details: painted in gloss house paint which is now peeling
Privately owned

Description: bust of the Duke of Wellington in full uniform with a cloak draped over his shoulders.

Duke of Wellington

History: possibly the work of William Wilson, a local stonemason and sculptor responsible for other, similar busts in Berwick and Spittal (see pp.47–8). The present owner of 9 Palace Green believes that it was sited elsewhere *c.*1914. It was painted in gloss paint in the 1990s.

The Parade TOWN CENTRE
Ravensdowne Barracks, above gateway

Coat of Arms

Carver: not known

Installed *c.*1721
Whole work: painted stone 1.5m high
Status: I
Condition: fair

Coat of Arms, **Berwick**

Condition details: painted and paint now slightly peeling
Owned by: English Heritage

Description: the coat of arms of George I in relief above the main gateway. It has a scallop shell at the top and an elaborate surround.
History: the carver of the coat of arms is not known but the design of Ravensdowne Barracks is now usually attributed to the celebrated Baroque architect, Nicholas Hawksmoor (1661–1736).[1]

[1] English Heritage, *The Fortifications of Berwick-upon-Tweed*, 1995, pp.29–30.

Railway Street
11 Railway Street

Three Busts

Stonemason: William Wilson

Installed *c.*1850
Each work: red sandstone 80cm high approx.
In raised lettering on the pedestal of the central bust: AD / 1850
Status: II
Condition: poor
Condition details: two of the busts, possibly of Shakespeare and Scott, are worn down around the face, Scott's nose missing
Privately owned

Description: three busts on the parapet of a two-storey house. They seem to depict Byron (left), Shakespeare (centre) and Scott (right). The house was built in 1844 and may originally have been a coaching inn.[1]
History: it seems likely that the busts are the work of William Wilson, a local stonemason and sculptor who was probably responsible for other, similar works in Berwick and Spittal (see pp.47–8)

[1] Interview with local resident, 1998.

Tweed Street TOWN CENTRE
48 Tweed Street, above gable end windows

Eagle and Heads

Stonemason: William Wilson

Installed *c.*1854
Each keystone head: red sandstone 35cm high
Standing eagle: red sandstone 60cm high
Status: not listed
Condition: fair
Condition details: one of the heads is missing; algal growth and dirt on all surfaces; some heads very weathered
Privately owned

Wilson, *Eagle and Heads* **(detail)**

Description: seven keystone heads, all different but not identifiable, above the windows and on the parapet of an early nineteenth-century three-storey terrace house. In addition, there is a free-standing carving of an eagle on the parapet.
History: the keystone heads and eagle were added to 48 Tweed Street probably at the time that the house was extended in 1854. Together

with the eccentric rustication of the front elevation they are almost certainly the work of the Berwick stonemason and sculptor, William Wilson.[1]

[1] Pevsner, *Northumberland*, p.185.

The Walls off Ravensdowne

Lions House, gatepiers

Venetian Lions

Sculptor: not known

Installed 1800s
Each lion: stone 80cm high × 1.04m wide
Status: II*
Condition: fair
Condition details: some loss of detail through weathering; fragments of nineteenth-century paint
Privately owned

Description: two identical recumbent stone lions with tails curled around their bodies and snarling expression on their faces. They are flat at the back which suggests that they were originally attached to the walls of a building. They now sit outside Lions House, a three-storey house dated 1809 which faces east towards the sea.

Venetian Lions

History: the lions have been identified by the Victoria and Albert Museum as likely to be seventeenth-century Venetian.[1] Before Lions House was restored in the 1970s, the gatepiers on which they now sit were somewhat taller and further apart.

[1] Interview with current owner, 1998.

Wellclose

Berwick Infirmary, exterior

Monument to Philip Maclagan

Sculptor: David W.S. Stevenson

Erected *c.*1892
Hygeia: stone 2.5m high
Panel with relief head: bronze 53cm high × 56cm wide
Plinth: Doddington stone 1.33m high
Three steps: stone 45cm high × 1.85m square
Incised on the front piece of the plinth: PHILIP WHITESIDE MACLAGAN / M. D. / BORN 9th OCTOBER 1818 / DIED 25th MAY 1892 / IN AFFECTIONATE & GRATEFUL REMEMBRANCE / OF A NOBLE LIFE SPENT UNGRUDGINGLY / IN PROMOTING THE HIGHEST INTERESTS / OF HUMANITY / "THE BELOVED PHYSICIAN"
On the left side of the base of the statue: D.W.S.STEVENSON RSA / SC
Status: not listed
Condition: fair
Condition details: algal growth and dirt on most surfaces; crumbling on figure; metallic staining underneath dado relief
Commissioned by: public subscription
Custodian: Berwick-upon-Tweed District Council

Description: commemorative monument with statue of *Hygeia* (goddess of health). Two graduated steps supporting a square plinth with a square bronze tablet above the inscription on the front (south) face. The bronze tablet has a

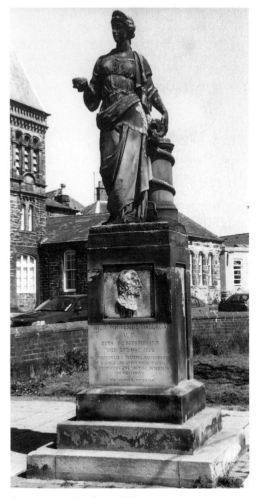

Stevenson, *Maclagan Monument*

relief portrait of Maclagan in profile facing right. The figure of *Hygeia* is characteristically posed holding a saucer in her right hand with water for a serpent which is wound around a column at her side.

Subject: Dr Philip Whiteside Maclagan (1818–92) was born in Edinburgh, the second son of an army surgeon. He trained at

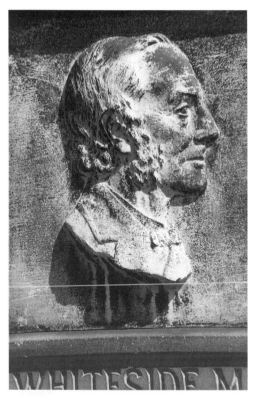

Stevenson, *Maclagan Monument* (detail)

Edinburgh University and became an army surgeon himself with the Royal Canadian Regiment. After marrying the daughter of Dr George Johnston of Berwick in 1847 he joined Johnston's practice in 1853, eventually inheriting it on Johnston's death. Over the next decades whilst he and his son Charles steadily built up the practice he busied himself as an elder and lay preacher at the Wallace Green Presbyterian Church and a trustee of the British School.[1]

History: in August 1892, three months after Maclagan's death, it was decided to erect a memorial, something simple costing no more than £150. In the event, however, £758 was raised and designs for a fountain were invited. The Edinburgh sculptor D.W.S. Stevenson was commissioned and it was resolved that he should incorporate into his design a statue of *Hygeia* which he happened to have on the stocks. The memorial once finished was not universally liked. When several years later Commander Norman RN proposed erecting a Jubilee Fountain several councillors claimed that the Maclagan Monument 'had not really and truly been a boon to the public' (see p.15).

The monument stood at Marygate until 1922 when, in order to ease traffic congestion, it was moved to a site outside the Infirmary.[2] In 1993 it was moved again, once more for traffic reasons, but this time by only a few metres.

[1] Information provided by Elizabeth Doley.
[2] Berwick Infirmary, *Maclagan Memorial Report, 1922*, Berwick upon Tweed, 1922.

BLAGDON

A1

Blagdon Hall, 40 metres north of North Lodge

Cale Cross

Architect: David Stephenson

Erected 1783: re-erected 1807
Building: sandstone 3m high approx × 2m long approx × 3.1m wide approx
Recumbent lion: moulded concrete 80cm high × 1.5m long × 30cm wide
Each urn: moulded concrete 90cm high
Status: II

Stephenson, *Cale Cross*

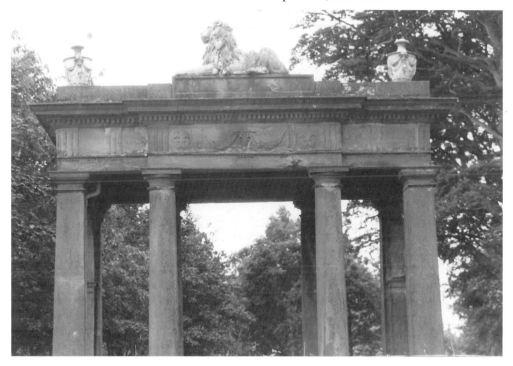

Condition: fair
Commissioned by: Sir Matthew White Ridley
Owned by: Viscount Ridley

Description: an open three-bay Roman Doric former conduit head. It stands facing north-east within sight of the A1 behind a low wall. The metope is decorated with an ox skull in low relief flanked by two shields each carrying the emblem of the Newcastle Corporation. A lion couchant and two urns on top.

History: designed by the Newcastle architect David Stephenson, the Cale Cross was originally erected at the foot of the Side, Newcastle in 1783 at the expense of Sir Matthew White Ridley.[1] There it replaced a medieval shelter with a cross on top, a drawing of which is to be found at Alnwick Castle (the name 'Cale' refers to the produce sold in a nearby market).[2] In 1807 in order to ease traffic congestion on the Side it was moved to its present site in the grounds of Blagdon Hall, the Ridleys' country seat where it is a purely decorative feature.[3]

[1] Richardson, *(Historical Division)*, 1844, vol.I, p.280. [2] *Ibid.*, vol.V, p.364. [3] Anon, *Guide to Blagdon, Northumberland*, 1984, p.8

Seaton Burn to Blagdon road
Blagdon Hall, on gatepiers of South Lodge

Ridley Bulls
Sculptor: not known

Installed 1800s
Each work: painted stone 60cm high × 1.6m long × 50cm wide
Status: II*
Condition: good
Commissioned by: Sir Matthew White Ridley
Owned by: Viscount Ridley

Description: a pair of carved seated bulls

Ridley Bulls

(emblem of the Ridley family) on the gatepiers of the South Lodge of Blagdon Hall. They are painted white.

History: the gatepiers on which the bulls sit were designed by James Wyatt in 1786, but Wyatt's drawings for the gatepiers show lions rather than bulls. It seems possible that the bulls are the work of John Graham Lough who from 1836 was often employed by the Ridleys although Lough's biographers make no such attribution.[1]

[1] Lough, J. and Merson, E., *John Graham Lough 1798–1876. A Northumbrian Sculptor*, Woodbridge, 1987.

BLYTH

Bridge Street
Police Station

Mastiffs
Carver: not known

Installed 1896
Each work: sandstone 70cm high

Status: II
Condition: fair
Condition details: partially obscured by standard neon-lit police sign; stonework weathered
Custodian: Blyth Police Station

Description: two seated mastiffs with snarling expressions, studded collars and chain leads. They support the lintel over the main entrance.

History: the mastiffs are in keeping with, and therefore probably contemporary with, the rest of Blyth police station, an elaborate Italianate Gothic building designed by John Cresswell which was opened in 1896.[1]

[1] Pevsner, *Northumberland*, p.194.

Mastiffs

Ridley Park
South entrance

Matthew White Ridley
Sculptor: George Skee

Erected 1909
Pedestal: sandstone 1.4m high × 74cm square
Bust: bronze 60cm high
Incised in Roman letters on pedestal: MATTHEW
WHITE / 1ST VISCOUNT RIDLEY / PRESENTED TO
THE / RIDLEY PARK BY HIS SON / 1909
Incised in Roman letters in bottom left corner:
GEO.SKEE / Blyth
Status: not listed
Condition: fair
Condition details: frost damage to pedestal;
chips from cornice of pedestal
Commissioned by: the 2nd Viscount Ridley
Custodian: Blyth Borough Council

Description: a bronze bust. It stands on a
sandstone pedestal at the entrance to Ridley
Park.

Skee, *Viscount Ridley*

Subject: the 5th Baronet and 1st Viscount
Ridley (1842–1904) was a distinguished
politician on the national stage and Home
Secretary 1895–1900.[1] (The Ridleys had long
been parliamentarians; the family represented
Newcastle in Parliament in a line of unbroken
succession between 1747 and 1836.[2]) The bust,
however, honours him chiefly for his generosity
in giving the land which became Ridley Park,
Blyth, in 1894.[3] The Ridleys had been connected
with Blyth and its development since 1715
when land confiscated by the Crown after the
Jacobite Rebellion was sold to two Newcastle
merchants, Matthew White and his son-in-law,
Richard Ridley. Viscount Ridley's particular
contribution in Blyth was to help expand the
port.

[1] *Concise DNB 1901–30*, p.139. [2] Brett, P., 'The
Newcastle Election of 1830', *Northern History*, vol.
24, *1988*, p.105. [3] *Journal*, Newcastle, 27 July 1904.

BRANXTON

A697

*Piper's Hill, Branxton Moor, 500m west
of Branxton*

Flodden Memorial
Designer: not known

Unveiled 27 September 1910
Base: grey Aberdeen Granite 2.04m high ×
2.77m wide × 2m deep
Cross: grey Aberdeen Granite 3.3m high ×
80cm wide × 33cm deep
In raised sans serif letters on plaque on north
face: FLODDEN / 1513 / TO THE BRAVE OF BOTH
NATIONS / ERECTED 1910
Status: II
Condition: good
Condition detail: lichen on the base of north
face

Flodden Memorial

Commissioned by: Berwickshire Naturalists'
Club
Owned by: Northumberland County Council

Description: a Celtic cross on a tapering
rusticated, cyclopean base of granite. This is
surrounded by a fence with granite boulder
posts and galvanised tubular supports.
Subject: the cross commemorates the battle
of Flodden fought on 9 September 1513, the last
pitched battle between Scotland and England
and the last battle on English soil in which
knights in armour fought under personal
banners. It occurred because James IV of
Scotland, although married to the daughter of
Henry VII of England, had renewed 'The Auld

Alliance' in 1512 which placed him under an obligation to make war on England if Henry VIII invaded France, which he did in 1513. The story of the battle was that although the Scots army was far larger than the English, James rashly relinquished his strong position and thereby allowed the key weapon of the English, the long pike, to come into play. At the end of the day the Scots were routed and James killed, along with perhaps 9,000 of his men. An information board erected by Northumberland County County Council beside the protective fence illustrates the positions of the armies during the battle.

History: a public subscription for a memorial was first proposed at the Berwickshire Naturalists' Club in 1907 by Commander Norman RN (see p.15) who argued that it was high time that Flodden was commemorated and that to show that old enmities no longer mattered whatever was put up should be the work of both the English and the Scots.[1]

The response to the request for funds was gratifying 'though somewhat slow'; £350 was eventually raised. The Duke of Norfolk headed the list of subscribers, presumably because his ancestor, the Earl of Surrey, had been the victor at the battle.

The memorial was unveiled on 27 September 1910 by Sir George Douglas of Kelso, poet and essayist, with a thousand people present.[2] It has since been the scene of an annual cavalcade and wreath-laying ceremony.

[1] *Proceedings of the Berwickshire Naturalists' Club,* 1909–10, pp.165–7. [2] *Journal,* Berwick, 29 September 1910.

Junction of Wooler and Crookham roads

Robertson Memorial Fountain
Designer: George Reavell

Installed July 1910

Reavell, *Robertson Fountain*

Fountain: pink sandstone 2.5m high × 1.78m wide
Flanking walls: pink sandstone 1.45m × 1.22m wide
Incised in Roman letters above drinking basin: TO THE MEMORY / OF / WATSON ASKEW ROBERTSON / OF / PALLINSBURN / JULY 1910
Status: II
Condition: good
Condition details: bucket bar missing; dirt on all surfaces
Owned by: Berwick-upon-Tweed District Council

Description: drinking fountain with elaborate cornice and festoons flanked on either side by a curving wall with seats.
Subject: Watson Askew Robertson of Pallinsburn House.
History: there is a record dated 19 December

1910 of various payments in connection with the fountain: G. Patterson (mason) £75 6s.1d., J.P.Whittle (carver) £4 10s., Fairington (joiner) £3 3s., and Mrs A. Ford (plumber) £12 9s. 6d.[1] The fountain stands next to the Cement Menagerie, an eccentric private sculpture garden, assembled earlier in the century.

[1] Northumberland Public Records Office, NRO 4232/A Microfiche of Office Ledgers 1896–1923, Ledger 2 (Fiche 16).

CHILLINGHAM

Lilburn to Chillingham road
Chillingham Castle park, 25m east of road

Field Marshall Viscount Gough
Sculptors: John Henry Foley and Thomas Brock
Restored: J.S. Lunn and Sons

Unveiled 22 February 1880; re-erected 1990
Statue: bronze 3m high
Pedestal: bronze 2m high × 5.4m wide × 2m deep
Raised Roman letters on east face of pedestal: [...] OUGH
Raised Roman letters, painted gold, on west face of pedestal: IN HONOUR OF / FIELD MARSHALL HUGH VISCOUNT GOUGH, K.P., G.C.B., G.C.S.I. / AN ILLUSTRIOUS IRISHMAN, / WHOSE ACHIEVEMENTS IN THE PENINSULAR WAR, IN CHINA, AND IN INDIA, HAVE ADDED LUSTRE / TO THE MILITARY GLORY OF HIS COUNTRY, WHICH HE FAITHFULLY SERVED FOR SEVENTY FIVE YEARS. / THIS STATUE [CAST FROM CANNON TAKEN BY TROOPS UNDER HIS COMMAND / AND GRANTED BY PARLIAMENT FOR THE PURPOSE] / IS ERECTED BY FRIENDS AND COMRADES.
Status: not listed
Condition: fair

Condition details: missing raised lettering on the east face; the base of the pedestal is missing; red paint splashed on east face; scratched graffiti on the south and east face
Commissioned by: friends of subject
Privately owned

Description: bronze statue of Viscount Gough on horseback. Gough is depicted in the uniform of Colonel of the Guards reviewing his regiment, field-marshal's baton in his right hand. The gun metal from which the statue is cast weighs fifteen tonnes.[1] It now stands on private land but within sight of the road.

Subject: Field Marshall Viscount Gough (1779–1869) is said to have commanded in more general actions than any other British officer of his time apart from Wellington. In the Peninsular War he distinguished himself by his bravery and dash, and was knighted in 1815. For services in China in 1814 he was created a baronet and made commander-in-chief in India. After a pyrrhic victory over the Sikhs at Chillanwallah in 1849 his star temporarily went into decline, until victory at Goojerat later that year restored his reputation and he was rewarded with a viscountcy.

History: the statue has had a troubled history. At the time of his death in 1869, Gough's friends felt that since he was born in Co. Limerick and, when not on military service, had always lived in his native land, a statue on a prominent site in Dublin was appropriate, at either Carlisle Bridge, Foster Place or Westmorland Road. However, the Dublin Corporation was reluctant to commemorate a servant of the empire who had gained the nickname the 'Hammer of the Sikhs', and vetoed each of these suggestions.

A commission for a commemorative statue was subsequently given to the Irish-born J.H. Foley who was keen to take it on, declaring 'I need scarcely repeat how gratifying the task would be to me, and how willing I am to forgo

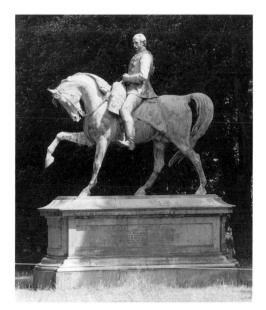

Foley, *Viscount Gough*

all consideration of profit in my desire to engage myself upon it. I feel that the time has arrived for our native country to add to the memorials of her illustrious dead an Equestrian Statue, and that Lord Gough at once presents a worthy subject for such a memorial.'[2] Unfortunately, however, Foley died in 1874 before the work had been completed and it was finished by his leading pupil, Thomas Brock, as an inscription on the base apparently once noted. The latter ensured that he received due credit for his work by exhibiting a study for the head at the Royal Academy in 1878.[3] In addition, a shortage of funds meant that the horse had to be made from a cast which Foley had used for another work, his renowned statue of Viscount Hardinge in Calcutta (1858; private collection, Kent). Hardinge's horse, it should be noted, had been especially admired when first exhibited in 1859: so much so indeed that as the *Art Journal* commented at the time, 'Arab

horse-dealers, with whom the love of the horse is a passion, and knowledge of their points of excellence a universal acquirement, are daily to be seen gazing at it.'[4]

Once finished the statue's problems continued. A site was found for it in Phoenix Park, Dublin, but at the time of the inauguration there was a strong feeling that it would have been more suitably erected in London. This was reinforced by the inauguration ceremony at which so many soldiers were present that the Duke of Marlborough, Lord Lieutenant of Ireland, was prompted to remark that the Park looked like the 'Champs de Mars of Dublin'.[5]

Once in place, because it was subsequently seen as a celebration of empire, the statue was physically attacked on a number of occasions. On Christmas Eve 1944 the rider was beheaded and his sword removed. In November 1956 the right hind leg of the horse was blown off and then finally, at 12.45a.m. on Monday 3 July 1957, the whole statue was hurled from its base by a huge explosion, the work of experts in plastic bombing brought in from France by the IRA.[6]

Following this, for the next 29 years, the base remained in place in Phoenix Park while the statue itself was kept in storage by the Office of Public Works at the Royal Hospital, Kilmainham. (Photographs exist of Gough's severed head sitting in a cupboard.)

Eventually, in August 1986, the statue was sold to Robert Guinness of Straffan, Co. Kildare for a sum believed to be £1,000 or less, on the condition, according to the *Irish Times*, that it left Ireland. In 1988, it came into the possession of its present owner, a distant relative of Gough, who had it painstakingly restored by the Newcastle blacksmiths, J.S. Lunn and Sons and re-erected at his newly acquired home, Chillingham Castle, in 1990.[7] The statue is now once again complete except for the 18cm high base of the pedestal.

[1] *Irish Times*, 23 February 1880. [2] Murphy, P., 'The Politics of the Street Monument' *Irish Arts Review*, vol.10, pp.202–8. [3] Sankey, J., 'Thomas Brock and the Albert Memorial', *Sculpture Journal* 1999, vol.III, p.92. [4] *Art Journal*, 1859, p.259. [5] *Irish Times, op. cit.* [6] Read, p.40. [7] *Journal*, Newcastle, 3 July 1990.

CRAMLINGTON

Crowhall Road
NELSON INDUSTRIAL ESTATE

Enterprise Court, garden at centre of carpark

231

Sculptor: Eric Wilson

Installed 10 May 1990
Whole work: steel 4m high approx × 3.5m diameter
Status: not listed
Condition: fair
Condition details: naturally oxidised
Commissioned by: Blyth Valley Council
Custodian: Enterprise Court

Description: sculpture made from bands of steel oxidised dark brown. The main shape spirals up to a sphere at the top; a further half-sphere is set at the bottom of the structure. The sculpture stands on an area of gravel-chip-covered concrete.

History: in its way reminiscent of Tatlin's *Monument to the Third International*, *231* was intended as a 'monument to new employment' and a symbol of the development of Cramlington's trading estates. Its interlocking forms were said by the artist to represent pit wheels or other turning gear and the overall shape to suggest 'power-energy, dynamics, movement, expansion, space and time'.[1]

Costing £15,000 *231* was funded by Northern Arts, ABSA and British Coal

Wilson, *231*

Enterprise.[2] Fabrication was undertaken by AMARC and Peter Johnston Ltd, a firm that usually manufactures North Sea pipelines: 'It is all the same to us, pipes or art' the company's financial director commented, 'just as long as it is a commercial proposition we will take it on.'[3]

[1] AXIS, Artists Register, 1999. [2] *Journal*, Newcastle, 4 May 1990. [3] *Evening Chronicle*, 10 March 1990.

ELSDON

Elsdon to Cambo Road

Harewood Forest Enterprise car park, opposite

Gibbet

Designer: not known

Original 1792; replica installed late twentieth century
Gibbet: wood and iron 5m high approx
Base of cross: stone 45cm high × 82cm square
Status: II
Condition: fair
Condition details: cracks on head; rust on gibbet
Commissioned and owned by: National Trust

Description: a modern replica of a gibbet with a carved wooden head. Beside the gibbet lies the base of a medieval boundary marker, the Steng Cross.

Subject: the structure commemorates the gibbetting, one of the last in Britain, of William Winter in August 1792.

History: in August 1792 William Winter was hung in chains after being executed in Newcastle for his part in the murder of an old woman, Margaret Crozier, at Raw Farm, Hepple on the night of 29 August 1791. His two accomplices, Jane and Eleanor Clerk, vendors of crockery, were also hanged but their bodies were dissected rather than gibbetted.[1]

It is recorded that Winter's face, limbs and chest were bound with bands of iron and then the body was hoisted up onto the gibbet using a set of shear legs from Carrick Colliery. Once in place the rotting body was visited by thousands, despite the stench which apparently was so ghastly that 'horses which travelled the road could scarcely be urged to pass the place'. Part of the attraction it seems was that it was still widely believed at the time that the way to relieve toothache was to rub one's teeth with chips from a gibbet.[2]

Eventually Winter's clothes rotted away so that it was found necessary instead to hang up the bones in a tarred sack. When with time the sack burst and the bones fell out, a wooden figure 'bearing some resemblance to the human form' was erected in its place. This also,

Gibbet

however, eventually rotted away and a 'still ruder construction' comprising 'only the head, with the upright pole to support it' was installed. (There are photographs of the gibbet in this form *c.*1900 in Newcastle Central Library.)

In recent times the gibbet has constantly been vandalised and repaired. After an attack *c.*1970 Robin Dower, a local sculptor, was called upon to carve a new head but this was stolen in May 1985 and he had to carve another.[3] When in January 1988, this too was stolen,[4] a concrete cast was installed made from a new carving by another local sculptor, Alan Urwin. This remained for a while but was stolen when the

gibbet was attacked at Easter 1998. After this the gibbet with a new cast of Urwin's carving was re-erected in August 1998.

[1] Richardson, *(Legendary Division)*, vol.1, 1841, pp. 375–84. [2] Tomlinson, W., *Comprehensive Guide to Northumberland*, Newton Abbot, 1968, p.309. [3] Information provided by Pamela Wallhead, National Trust. [4] *Journal*, Newcastle, 7 January 1988.

Village Green (B6341)
Bacchus Inn, above door

Bacchus

Bacchus

Carver: not known

1700s
Seated figure: sandstone 1m high
Status: II
Condition: good
Condition details: loss of detail due to weathering
Privately owned

Description: a crudely carved figure on a corbel over the door of what was previously an inn, depicting the naked Bacchus sitting on a beer barrel, swigging from a bottle. On the underside of the corbel there is a carving of a cherub.
History: the statue is probably of the same date as the inn itself which Pevsner says is eighteenth-century.[1]

[1] Pevsner, *Northumberland*, p.268.

FORD

A697
Flodden Hill Plantation

Sybil's Well
Designer: not known

Installed 1880s
Whole work: sandstone 2.5m high × 1.6m wide
Incised in Gothic letters on back wall above basin: DRINK WEARY PILGRIM DRINK AND STAY / REST BY THE WELL OF SYBIL GREY
Status: not listed
Condition: fair
Condition details: rim of basin cracked; algae and lichen on all surfaces
Commissioned by: Lady Waterford
Owned by: Ford and Etal Estates

Description: a Gothic niche set into the rockface with water from a natural spring

falling into a stone basin. There is a stone trough below.

Subject: the well sits on the north-east side of Flodden Hill which at the battle of Flodden in 1513 was occupied by James IV and the Scots army; there is a tradition that its true name is 'the soldier's well'.[1] The name 'Sybil's Well' was given to it because it supposedly marks the spot made famous by Walter Scott's poem *Marmion*: 'Behold her mark, / A little fountain cell, Where water, clear as diamond-spark, / In a stone basin fell. /Above, some half-worn letters say, Drink, weary pilgrim, drink and pray, / For the kind soul of Sybil Grey, / Who built this cross and well.' In the poem Lord Marmion died at the well with Lady Clare 'laving' his brow. 'They dig his grave e'en where he lay, / But every mark is gone; / Time's wasting hand has done away / The simple cross of Sybil Grey, and broke her font of stone. / But yet from out the little hill / Oozes the slender springlet still.'[2]

History: Louisa, Marchioness of Waterford (1818–91) commissioned Sybil's Well as it now is. The daughter of Lord Stuart de Rothesay, Lady Waterford met her future husband (see p.27) in wonderfully romantic circumstances at the Eglington Tournament in 1839. After his death in a hunting accident in 1859, she lived mostly at nearby Ford Castle, devoting herself to good works and painting. She achieved considerable renown as an amateur artist, her most notable work being the Raphaelesque schoolhouse murals at Ford (1862–83).[3]

The precise date and circumstances of the well's commission have not been discovered. However, as a friend of Lady Waterford noted, the wording of the inscription is somewhat different from what appears in Scott's *Marmion* which suggests that the well is in fact entirely Lady Waterford's creation.[4] According to one mid-nineteenth century visitor the medieval well which Scott was referring to in *Marmion* had long since been incorporated into a modern farmyard.[5]

[1] Neville, H., *Under a Border Tree: sketches and memories of Ford Castle, Northumberland*, Newcastle, 1896, p.258. [2] Scott, W., *Marmion: A Tale of Flodden Field*, 1808, passim. [3] *Monthly Chronicle*, 1891, p.331. [4] Neville, H., *op. cit.* p.259. [5] Howitt, W., *Visits to Remarkable Places*, London, 1856, vol.1, p.192.

B6353
Village Green

Waterford Memorial Fountain
Sculptor: Birnie Philip
Designer: George Gilbert Scott

Installed 1864; restored *c.*1868
Column and statue: pink and grey granite 10.3m high
Incised on the south face of the base of the column: 'WITH JOY SHALL YE DRAW WATER OUT OF THE WELLS OF SALVATION.'/ ISAIAH CHAP.3, VERSE 3 / DRINK YE, DRINK ABUNDANTLY, O BELOVED' / SONG OF SOLOMON CHAP. V VERS 1
Incised on grey granite panel on west face of the base the column: 'THIS FOUNTAIN IS PLACED BY / LOUISA MARCHIONESS OF WATERFORD, / IN GRATEFUL AND AFFECTIONATE REMEMBRANCE OF HER HUSBAND, HENRY, / 3RD MARQUIS OF WATERFORD K.P.; BORN APRIL 26TH, 1811; DIED MARCH 29TH, 1859'
Status: II
Condition: poor
Condition details: lichen and algae on all surfaces making inscriptions on north face of the base of the column illegible; all surfaces weathered
Commissioned by: Louisa, Marchioness of Waterford
Custodian: Ford and Etal Estates

Description: an ornamental fountain standing at the western end of the model village which Lady Waterford began *c.*1860. From a locally-quarried stone basin with cable moulding on the rim rises a Gothic column, the shaft of

Philip and Scott, *Waterford Fountain*

which is in polished red Aberdeen granite, the base in light grey Peterhead granite. There is a small bronze panel on the east face of the base with a relief of the Waterford arms and two supporters. The lower part of the shaft is octagonal and bears small shields; the upper

part is cylindrical. A foliated capital in Caen stone supports the figure of an angel with down-turned sword and shield. This angel, almost certainly Archangel Michael to whom Ford Church is dedicated, faces west towards Ford Castle. There are four stone spouts at the base of the shaft and four semi-circular troughs attached to the outside of the basin with bronze lion's head spouts. Both the troughs and the basin are now filled with earth.

Subject: the fountain commemorates Henry de la Poer, 3rd Marquess of Waterford (1811–59) who died in a hunting accident. 'A noble-looking man, light of limb, square-shouldered, and with light hair', he met his future wife, the beautiful Louisa Stuart de Rothesay (see p.26) at the famous pseudo-medieval Eglington Tournament in 1839.[1] They married three years later and went to live on his estate at Carraghmore, Ireland, where he spent his time hunting and she devoted herself to good works. That he should die as he did was particularly poignant for Lady Waterford who, knowing how fearless a rider he was, had only a short time before made him swear to give up hunting at the end of the season.[2]

History: erected by Louisa, Lady Waterford in the autumn of 1864. Her friend Hastings Neville commented on the inscription from 2 Samuel 18, 18 on the north face of the base of the column (now illegible due to lichen and algae): 'Now Absalom in his life time had taken and reared up for himself a pillar, which is in the king's dale: for he said, I have no son to keep my name in remembrance: and he called the pillar after his own name: and it is called unto this day, Absalom's place.' 'There seems to have been in her mind' he said, 'the idea of Absalom's pillar, for that was the subject of her Scripture reading with Lord Waterford on the morning of the day he met with so sudden a death.' After the column was blown down and shattered in a gale on 5 February 1868, it was promptly restored and a new angel installed.

[1] *Illustrated London News*, 22 May 1869.
[2] Neville, H., *Under a Border Tree: sketches and memories of Ford Castle, Northumberland*, Newcastle, 1896, pp.6–10.

HARBOTTLE

Rothbury to Shilmoor road
Almshouses, at the top of steps

Clennell Memorial Fountain
Designer: D. McMillan

Erected 1880
Whole work: sandstone and polished granite
5m high × 1.66m square
Incised in Roman letters on the polished pink granite plaque on the west face of the architrave: MRS CLENNELL OF HARBOTTLE CASTLE, DIED NOV 17TH 1879, / SHE DEVOTED THE POWERS OF AN ACTIVE MIND, THE IMPULSES OF A GENEROUS HEART, AND THE INDUSTRY OF A BUSY LIFE TO THE / WELFARE AND HAPPINESS OF THE INHABITANTS OF HARBOTTLE / AND THE NEIGHBOURHOOD. / TO PERPETUATE HER NAME AND VIRTUES / THEY ERECTED THIS FOUNTAIN AUGUST 1880
Incised in Roman letters on west face of the architrave: D.McMillan FECIT / ALNWICK
Status: II
Condition: good
Condition details: lichen on base
Commissioned by: inhabitants of Harbottle
Custodian: Alnwick District Council

Description: an elaborate drinking fountain in the Gothic style. A sandstone roof canopy and finial is supported by polished pink granite columns.

Subject: the fountain commemorates Harriet Pennell Clennell who lived at nearby Harbottle Castle, the seat of the Fenwick-Clennell family.[1]

History: the fountain was erected by the inhabitants of Harbottle at a cost of £120.

McMillan, *Clennell Fountain*

[1] *Kelly's Directory of Durham, Northumberland, Cumberland and Westmorland*, Newcastle, 1894, p.140.

A686 LANGLEY

500m north of Langley Castle

Earls of Derwentwater Memorial

Designer: not known

Erected 1883
Base: sandstone 1.01m high × 84cm wide ×
64cm deep
Cross: sandstone 2.1m high
Incised Roman letters on on the west face of
pedestal: IN MEMORY OF / JAMES AND CHARLES /
VISCOUNTS LANGLEY / EARLS OF DERWENTWATER
/ BEHEADED ON TOWER HILL / 24 FEB 1716 AND
8 DEC 1746 / FOR LOYALTY TO / THEIR LAWFUL
SOVEREIGN
Status: not listed
Condition: fair
Condition details: moss and lichen on every
face
Commissioned by: Cadwallader J. Bates
Owned by: Tynedale District Council

Description: Celtic cross. A square stone
base surmounted by a cross with celtic-style
decoration on the west face of the shaft. It
stands on its own in a wooded valley.

Subject: James, 3rd Earl of Derwentwater
was born in 1689, the eldest son of one of
Charles II's illegitimate daughters and was
brought up in France. In 1705 he succeeded his
father and in 1710 came to Dilston in
Northumberland. As a Northern Catholic
nobleman he was ordered to be taken into
custody at the Hanoverian Succession in 1714,
but avoided capture by going into hiding. In
October 1715 he joined the Northern Jacobite
insurrection. When this eventually failed he was
imprisoned in the Tower in December 1715,
tried for high treason and beheaded on Tower
Hill on 24 February 1716.

Derwentwater Memorial

His brother, Charles (born 1791; succeeded
to the earldom in 1731) suffered a similar fate.
He sailed from France to Scotland in 1745 to
join Bonnie Prince Charlie and was arrested on
landing in Scotland. He was beheaded on Tower
Hill on 8 December 1746.[1]

History: Cadwallader J. Bates (1853–1902), a
leading authority on Northumbrian history and
frequent contributor to *Archaeologia Aeliana*
erected the memorial in 1883, the year after he
bought the barony of Langley and Langley
Castle. Whether the memorial's erection owed
anything to his religious sympathies is not clear.
He did convert to Catholicism, but not until
1893, ten years after the erection of the

memorial.[2] The choice of a celtic design,
however, was almost certainly prompted by his
enthusiasm for all things celtic, which, it seems,
was such that at one stage he even took Irish
lessons from a priest on Tyneside.

[1] Welford, vol.1. pp.65–76. [2] Culley, M. (ed.),
Letters of Cadwallader J.Bates, Kendal, 1906, *passim.*

Church Street

Churchyard wall

Haydon Bridge War Memorial

Sculptor: Percy George Bentham

Unveiled September 1921; re-erected 1970
Statue: bronze 1.9m high
Pedestal: sandstone 1.81m high × 1.27m wide ×
1.1m deep
Incised in Roman letters painted black on the
west face of the pedestal: IN PROUD AND LOVING
MEMORY / OF THE MEN OF THE / PARISH OF
HAYDON / WHO GAVE THEIR LIVES / FOR KING
AND COUNTRY / IN THE GREAT WAR 1914–1919
On the south face of the base: P.G.BENTHAM
R.B.S.
Status: II
Condition: good
Condition details: bayonet rusted
Commissioned by: public subscription
Owned by: Haydon Bridge Parish Council

Description: bronze statue on a tapering
pedestal. The figure of a standing soldier looks
out resolutely towards the south-west. He has a
bayoneted rifle, knapsacks on both front and
back and a helmet on his head. The names of
the fallen are on plaques flanking the statue. A
post and chain protects the memorial from the
road.

History: various proposals for a Haydon
Bridge memorial were considered, including a
recreation ground, a hospital and land set aside
for widowers and dependants. It was eventually

Bentham, *War Memorial*

decided to erect a statue in Ratcliffe Road at one end of the old bridge over the Tyne.[1] The statue, which was unveiled in September 1921 by General Sir Loftus Bates, cost £475 for the figure and £425 for the surround and plaques.[2]

The memorial was moved to its present site in 1970 when the new road bridge over the Tyne was built. One advantage of the new site was the space it allowed for Remembrance Day parades.

[1] *Hexham Courant*, 12 April 1921. [2] N'land War Mems Survey, WMSH21.1.

A697

50m east of road, on edge of farmyard

Percy's Cross

Designer: not known

Erected *c.*1500
Base: sandstone 44cm high × 80cm wide × 80cm deep
Shaft: sandstone 2.57m high × 36cm wide × 36cm deep
Status: II*
Condition: poor
Condition details: cross head missing; lichen and algae on every surface; scratch marks on east face of shaft
Commissioned by: probably the 4th Earl of Northumberland
Owned by: Northumberland Estates

Description: the base and shaft of a medieval cross protected by Victorian spiked railings. The square chamfered shaft is in two sections and is carved with a variety of Percy emblems: crescents, lucies, and fusils on the four principal sides, and lockets on the truncated corners. The head of the cross is missing.

Subject: the cross marks the spot where Sir Ralph Percy, the younger son of the 2nd Earl of Northumberland, died at the Battle of Hedgeley Moor in 1464 during the Wars of the Roses. Sir Ralph was one of the commanders of the Lancastrian army which attempted to surprise Lord Montagu, brother of the Earl of Warwick, who was bringing the ambassadors of James III of Scotland to York to negotiate with Edward IV. It is said that he was killed after being deserted by his companions, Lord Roos and Lord Hungerford. There is, however, some debate about this and also about the import of his supposed dying words: 'I have saved the bird in my bosom'.[1]

History: the cross appears to have been erected soon after the death of Sir Ralph. It is said that it became the spot where the inhabitants of the neighbouring villages met each year to play at 'football, cudgels, and other rustic games'.[2] An interesting early nineteenth-century engraving of the cross after Luke Clennell shows it standing isolated in an empty, treeless landscape without any sign of the farmyard clutter with which it is surrounded today.[3]

[1] Dodd, M. (ed.), *A History of Northumberland*, London, 1935, vol.XIV, pp.452–3. [2] Tomlinson, W., *Comprehensive Guide to Northumberland*, Newcastle, 1880, p.489. [3] Scott, W., *Border Antiquities of England and Scotland*, London, 1814, vol.2, p.17.

Percy's Cross

HEXHAM

Beaumont Street TOWN CENTRE
Junction with Battle Hill

Monument to Colonel G.E. Benson

Sculptor: John Tweed
Assistance to Sculptor: Auguste Rodin

Unveiled 9 March 1904
Standing figure: bronze 2.5m high approx
Pedestal: stone 3m × 1.88m wide × 2.13m deep
Raised Roman letters on bronze plaques on the
south face: (on emblem of Royal Artillery)
UBIQUE / QUO FAS ET GLORIA DUCUNT / TO THE
MEMORY OF A GALLANT SOLDIER / GEORGE
ELLIOTT BENSON / LIEUT.COLONEL / IN THE
ROYAL REGIMENT OF ARTILLERY / WHO WAS
BORN AT ALLERWASH MAY 24TH 1861 / ENTERED
THE ARMY MAY 9TH 1880 / AND AFTER SERVING
WITH DISTINCTION / IN THE SOUDAN CAMPAIGN
OF 1885, 1896, 1898 / IN THE ASHANTI
EXPEDITION 1895 / AND IN THE SOUTH AFRICA
WAR 1899–1901, / FELL WHEN COMMANDING HIS
COLUMN / AT THE BATTLE OF BRAKENLAAGHE
OCT. 30TH 1901. / HE IS BURIED WITH THOSE
WHO FOUGHT / AND DIED WITH HIM / " THE
UNRETURNING BRAVE" / ERECTED BY PUBLIC
SUBSCRIPTION
Status: II
Condition: fair
Condition details: graffiti on the stone face of
the base, especially the north face; bronze
blackened or stained
Commissioned by: public subscription
Custodian: Hexham Borough Council

Description: a dramatically posed
commemorative statue. The uniformed figure of
Benson is depicted striding forward wearing
riding breeches and spurs, right hand holding
binoculars, left hand on waist, his
'attitude…one of eager watchfulness'.[1] The
stone pedestal has a gently curved dado and
simple entablature.

Subject: Colonel Benson (1861–1901) was
the youngest son of William Benson of a local
landed gentry family. As the inscription states,
he saw action in various imperial campaigns
before distinguishing himself as a clever and
bold commander in South Africa. In the action
at Bakenlaagte (this is the usual spelling) in the
Eastern Transvaal where he met his death, his
column was out-manœuvred by a numerically
superior Boer force. More than a quarter of his
men were killed and over a third wounded.

It has been claimed that Benson himself fell
victim to a sniper's bullet when the sun glinted
on his binoculars, which, if true, would lend a
certain irony to the way the figure in Tweed's
statue is presented holding a pair of binoculars.[2]
The official history of the South African War,
however, is emphatic that the column fought a
heroic rear-guard action and Benson himself
was especially brave, 'crawling from point to
point in the firing line encouraging all around
him with a splendid example of coolness and
courage', although badly wounded in the knee.
'When the whole tendency of British military
policy was to sacrifice enterprise to
organisation, he showed an example of fearless
initiative. He sought risks with an ardour and
obstinacy which were at once his best safeguard
and his final justification.'[3]

History: almost as soon as news of Benson's
death arrived in Hexham, a memorial
committee and public subscription were
established.[4] The site was selected in March
1902 and the distinguished London sculptor,
John Tweed was chosen in August 1902.[5]
Originally it was planned that the monument
should face north towards Market Place, but in
March 1903 Tweed persuaded the committee
that it would be more satisfactory facing south
towards the sun.[6] On 11 March 1904 the
monument was unveiled by Benson's old
commander, General Lord Methuen, with a

Tweed, *Benson Monument*

large crowd watching. According to the
sculptor's biographer, the committee considered
themselves very lucky to have got the work,
which was greatly admired, for £840 instead of
the £2,000 quoted, and passed a resolution
conveying to the sculptor their gratitude, noting
that not only had he entered into the work
'heart and soul' but also, interestingly, that he
had been advised and assisted by his old
mentor, the great French sculptor, Rodin.[7]

By 1973, the disadvantages of the
monument's hemmed-in, traffic-bound site and,
in particular, the south orientation had become
all too evident and plans were drawn up to re-
erect it in nearby Abbey Gardens. These
though came to nothing.[8]

[1] *Journal*, Newcastle, 10 March 1904. [2] Charlton, M., *Hexham: A Pictorial Record*, Hexham, 1987, pp.19, 34. [3] Amery, L. (ed.), *The Times History of the War in South Africa 1899–1902*, vol.V, London, 1907, p.375. [4] *Hexham Courant*, 7 December 1901. [5] *Courant*, 22 March 1902. [6] *Ibid.*, 3 March 1903. [7] Tweed, L., *John Tweed: Sculptor. A Memoir*, London, 1936, p.146. [8] *Courant*, 22 May 1998.

Fore Street TOWN CENTRE

Midland Bank, north elevation

Decorative Frieze

Architect: George Dale Oliver

Building 1897
Whole work: red sandstone 67cm high × 7.5m wide
Status: II
Condition: fair
Commissioned by: London and Midland Bank
Owned by: HSBC

Description: a red sandstone low-relief frieze inset above the ground-floor windows on the curving north elevation of HSBC, a building in free sixteenth-century Renaissance style. Sixteen putti hold swags in front of shields and various denominations of coin (sovereign, shilling, penny).

History: the artist responsible for the frieze has not been discovered. However, the architect of the bank, who may well have had a large hand in its design, was George Dale Oliver, county architect for Cumberland, assisted by J. Henry Sellers. Construction of the present building began in 1896 when the Carlisle City and District Banking Company which had had a Hexham branch since 1892 was amalgamated with the London and Midland Bank. The frieze originally bore the inscription 'The London and Midland Bank'.[1]

[1] Information provided by Alan Birkinshaw, HSBC, Hexham, and Colin Dallison, Hexham Local History Society, 1998.

Oliver, *Decorative Frieze*

Market Place TOWN CENTRE

Temperley Memorial Fountain

Architect: William Henry Knowles
Sculptor: G.W. Milburn
Builder: J. Herman & Sons

Inaugurated 30 August 1901
Pedestal: red sandstone 1.25m high × 1.65m square
Plaques on dado: copper 66cm high × 1.02m wide
Column: red sandstone 3m high approx.
Raised letters on the south face: O! YOU WHO DRINK MY COOLING WATERS CLEAR / FORGET NOT THE FAR HILLS FROM WHENCE THEY FLOW / WHERE OVER FELL AND MOOR AND YEAR BY YEAR / SPRING SUMMER AUTUMN WINTER COME AND GO / WITH SHOWERING SUN AND RAIN AND STORM AND SNOW, / WHERE OVER THE GREEN BENTS FOREVER BLOW / THE FOUR FREE WINDS OF HEAVEN; WHERE TIME FALLS / IN SOLITARY PLACES CALM AND SLOW, / WHERE PIPES THE CURLEW AND THE PLOVER CALLS, / BENEATH AN OPEN SKY WELLING FAIR AND SWEET, / A DRAUGHT OF COOLNESS FOR YOUR THROAT TO BRING, / A SOUND OF COOLNESS IN THE BUSY STREET. WILFRED WILSON GIBSON HEXHAM FEB–1901
In raised letters on the north face: FOR THE COMMON GOOD / PLACED HERE / NEAR THE SITE OF THE OLD MARKET PANT / IN THE 64TH YEAR OF THE REIGN OF / QUEEN VICTORIA / AND THE FIRST OF KING EDWARD THE VII / A.D.1901
Status: II
Condition: poor
Condition details: plaques on north and west face are bent; plaque missing rivet on east face; weathering on the shaft, capital of column and consoled drum; spout missing on north face
Commissioned by: the family of William Temperley
Custodian: Tynedale District Council

Knowles, *Temperley Fountain*

Description: large ornamental red sandstone drinking fountain. A square platform pedestal with copper plaques on each face decorated with the arms of Hexham and Northumberland and floral motifs is surmounted by an octagonal quatrocento-style column with Ionic pilasters on four sides and carved low-relief decorations on the others (on the south-east the English rose and crown, on the north-east the lion and thistle of Scotland, on the south-west the harp and shamrock of Ireland, and on the north-west the harp and leek of Wales). Above the column are tented pediments surmounted by a consoled drum decorated with shields of the four countries of Great Britain (lions rampant, harp, and St Andrew's Cross) on top of which is a small cupola decorated with the arms of the Sees of York, Durham, Newcastle and Carlisle. This in turn is topped by a small dentil dome surmounted by a stone cross painted in gilt. The present stone cross replaces an electric light which was installed in the 1950s and which itself replaced a cross.[1]

Subject: the fountain commemorates William A. Temperley (1819–98) a leading member of Hexham Congregational Church and, up to his retirement c.1870, a corn merchant in Hexham and Newcastle.[2]

History: the fountain was erected by Temperley's family which had been in business in Hexham since 1801. Sir Richard Allgood's pant which had stood on the site since the 1700s had for some time been deemed inadequate and there had been a number of proposals to replace it;: in 1866 at the opening of Hexham Town Hall, in 1895[3] and in 1899.[4]

The last of these was accepted but in April 1900, before it could be carried out, the Temperley family came forward with a design by the Newcastle architect, W.H. Knowles, which the Council decided to accept in preference. This design, however, was itself shortly afterwards replaced by a new one which better reflected Knowles's new-found

enthusiasm for Italian Renaissance architecture. A letter to the *Hexham Courant* from a member of the Temperley family explained why this should be adopted. 'When the design, which was approved by the Council, came to be worked out in detail we were not satisfied with the result as it seemed so severe in character. Since then Mr Knowles has been engaged in developing other sketches which he had previously made for us and we have now arrived at what we think will be a very satisfactory and pleasing one. Mr Knowles has just returned from a visit of about a month in Northern Italy...'[5]

The fountain in the new Italian Renaissance style was formally handed over to the Council by Mrs Schofield on behalf of the Temperleys on 30 August 1901. The occasion it seems was slightly marred by the absence of Wilfrid W. Gibson (1878–1962) the locally-born poet whose lines are prominently quoted in the inscription (he was away in Chartres at the time). However, Gibson's father, the well-known local historian and archaeologist John Pattison Gibson, was there in his stead.

[1] Information provided by Collin Dallison, Hexham Local History Society. [2] *Hexham Courant*, 10 September 1898. [3] *Ibid.*, 1 December 1895. [4] *Ibid.*, 30 September 1899. [5] *Ibid.*, Letter from T.I. Temperley, 27 October 1901.

HOLY ISLAND

St Mary's churchyard

St Aidan

Sculptor: Kathleen Parbury

Erected 1958
Statue: red concrete 3.4m high
Base: undressed stone with concrete top 46cm high × 2.1m square
Status: not listed

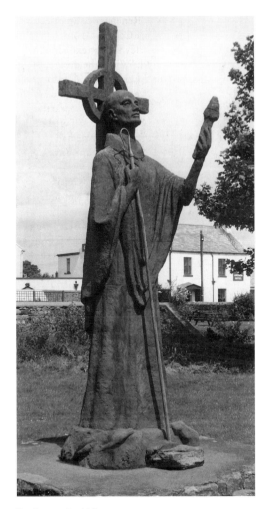

Parbury, *St Aidan*

Condition: good
Condition details: algae on cross behind head

Description: roughly modelled figure of the bald-headed saint in monk's garb with a torch in his raised left hand and a bronze crook in right. The shaft of a Celtic cross supports the figure's back. It stands on a simple base.

Subject: an Iona-trained monk and bishop, St

Aidan (died AD 651) was invited by King Oswald of Northumbria to convert his subjects to Christianity, and founded the monastic community at Lindisfarne in AD 635. He was closely associated with the royal court at Bamburgh and was credited with saving the (then) city from fire and siege with his prayers. He was also a friend of the needy. Bede says that he never travelled by horse and used the gifts he received from the rich and powerful to ransom the enslaved and aid the poor. During his sixteen-year episcopate he built several chapels.[1]

[1] Bede, *Ecclesiastical History of the English People*, 731, Book III, Sections 3, 5, 16, 17.

HOLYSTONE

Rothbury to Yardhope road
400m west of village in small copse

Cross, Lady's Well
Stonemason: not known

Erected 1800s
Cross: sandstone 2.1m high
Tank: stone kerb 6.34m wide × 12.68m deep
Incised in Roman letters on the south face of the base: THIS PLACE / [...] / BAPTIZED / THREE THOUSAND NORTHUMBRIANS / EASTER [...]
Status: I
Condition: fair
Condition details: covered in lichen and algae
Custodian: National Trust

Description: a plain celtic cross standing on a base in a shallow rectangular water tank.

History: the cross marks the spot where the Celtic saint Ninian is said to have baptised 3,000 converts c. AD 400.[1] A National Trust information board at the site states that before this the well had been a watering place on the Roman road from the coast to Redesdale which

Lady's Well

was walled around in either Roman or medieval times. The name 'Lady's Well' came into use some time after the first half of the twelfth century when Holystone became the site of a priory of Augustinian canonesses dedicated to the Virgin Mary.

The water tank in which the cross stands was installed in 1788. The cross itself almost certainly dates from the early nineteenth century.[2]

[1] Alnwick DC, *The District of Alnwick Visitors' Guide*, 1986, p.36. [2] Northumberland National Park, *Archaeological Sites and Buildings*, 1976, p.viii.

St Paulinus

Sculptor: attributed to James Johnson

Installed *c*.1789
Figure: sandstone 1.65m high
Base: sandstone 1.3m wide × 1.65m deep
Incised on the south face of base: 1789
Status: I
Condition: fair

Johnson, *St Paulinus*

Condition details: left hand missing; lichen and algae on base
Custodian: National Trust

Description: statue of bearded monk facing the cross of Lady's Well (see p.33).

Subject: the statue depicts St Paulinus who, according to eighteenth-century historians, thought conducted mass conversions at Lady's Well in AD 672.[1]

History: similar in character to the armed figures on the battlements at Alnwick Castle (see p.7) and at Hulne Priory, the statue is probably by James Johnson and was brought from Alnwick in 1789.

[1] Northumberland National Park, *Archaeological Sites and Buildings*, 1976, p.viii.

HOLYWELL

A192

Seaton, top of bank

Holywell War Memorial Fountain
Designer: not known

Erected 1901
Fountain: pink and grey granite 2.8m high × 81cm square
Incised in Gothic letters on the east face: TO THE MEMORY / OF / [Roman lettering] SMITH BERWICK / WHO DIED FROM WOUNDS / RECEIVED AT SHOREMANS DRIFT, / SOUTH AFRICA / DEC. 20TH, 1901, IN HIS 48TH YEAR
Incised in Gothic letters on the south face: TO THE MEMORY / OF / [Roman letters] WILLIAM COXON / WHO FELL AT THE / BATTLE OF RHEINOSTERFONTEIN, / SOUTH AFRICA / SEPT. 5TH, 1901 IN HIS 22ND YEAR / ERECTED BY / PUBLIC SUBSCRIPTION 1901
Status: II
Condition: good

War Memorial Fountain, Holywell

Condition details: fountain not working
Commissioned by: public subscription
Owned by: Blyth Valley District Council

Description: a drinking fountain and horse trough beside the gable end of Holywell Manor. A round pink granite pedestal on a grey granite base supports a pink granite canopy with ball finial on top resting on grey granite pillars. There is a polished pink urn under the canopy.

'Georgian-style' railings now enclose the fountain.

Subject: the well commemorates two local residents who died in the South African War.

History: the fountain is in good condition but no longer functions as a memorial in the way that it did. After suffering vandalism in 1984, it was restored in April 1993 and placed behind protective railings. This entailed moving the horse trough from the north to the south side and turning the fountain 45 degrees. The inscription on the east side closest to the gable end of Holywell Manor is now very difficult to read.[1]

[1] *Planning News*, 25 June 1993, no.1024, *passim.*

KIELDER

First planted in 1926, Kielder Forest is the Forestry Commission's largest forest. At its centre stands Kielder Water, Europe's largest man-made reservoir, nearly ten kilometres long, built by the Northumbrian Water Authority 1975–81. *Waterstones*, erected in 1982 to mark the completion of the Kielder Dam at one end of the reservoir, was the area's first piece of public sculpture. However, the main public sculpture programme in the area dates from the mid-1990s when Kielder Partnership, an organisation set up to develop Kielder as a tourist attraction, began commissioning works. Kielder Partnership is supported by Tynedale Council, Northumbrian Water, Forest Enterprise, Northumberland County Council, Northumberland National Park and Northumbria Tourist Board. The vastness of Kielder means that the works are sometimes miles apart and accessible only to determined walkers.

The Belling, at water's edge
Wave Chamber
Sculptor: Chris Drury

Erected May 1996
Whole work: dry stone walling 4m high × 3m diameter
Status: not listed
Condition: good
Commissioned by: Northumbrian Water
Owned by: Kielder Partnership

Description: a conical hut beside Kielder Water with a periscope mirror set into the roof which projects an image of the lake down onto the circular concrete floor of the hut as in a *camera obscura.* 80 tonnes of rock from Bull Crag and Ladycross Quarry were used in its construction.[1] On the outside the hut is unremarkable. On the inside, with the door closed, it offers an ethereal pattern of constantly shifting light projected onto the floor. Combined with sound of lapping water this can be at once soothing and magical.

[1] Kielder Partnership, *Elements in Harmony*, 1997, *passim.*

Drury, *Wave Chamber*

Bull Crag Trail, Bull Crag Peninsula
Keepsake
Sculptor: Nicola Moss

Installed 1998
Each plaque: bronze 8cm high × 11cm wide
Status: not listed
Condition: good
Commissioned and owned by: Kielder Partnership

Description: twelve bronze plaques with low-relief images on various surfaces, some of them newly-cut stone, some old-cut stone, scattered along a 4-kilometre footpath. Each plaque's image relates to the history, legends or scenery of the spot where it is located. On coming across the plaques passers-by are invited to take rubbings and put these in a specially prepared book available from the Kielder visitor centres. They then can present the completed book at a visitor centre and be rewarded with a bronze medal depicting Kielder designed by the artist.[1]

[1] Information provided by the artist, 1998.

Moss, *Keepsake* (detail)

Duchess Trail, Kielder Castle

The Flock

Sculptor: Andrea Wilkinson

Installed 1997
Each bird: painted resin and fibreglass 12cm
approx
Status: not listed
Condition: good
Commissioned and owned by: Kielder Forest
Park

Description: two flocks of life-size brightly
coloured, entirely natural-looking budgerigars.
There are over seventy in all and they sit on
branches approximately three metres from the
ground beside a footpath.

History: the artist has explained, 'Our own
sense of freedom could in part be reflected in
the idea of the liberated birds, though swiftly
followed by concern and protectiveness
towards these little escapees vulnerable to the
extremes of the Northumberland weather. Are
these birds less unnatural than their
surroundings? Kielder Forest is made up of
Canadian Sitka and Norwegian Spruce, is it
really then an incongruous pairing?'[1] The birds
are so real it is said a walker once phoned the
RSPB to report what he thought was a
particularly rare and exciting sighting. A
visiting London art critic was less impressed,
condemning them as nothing but 'silly decoys'.[2]

[1] *Kielder a Place for Public Art,* 1998, *passim.*
[2] *Observer,* London, 6 September 1998.

Wilkinson, *The Flock*

Halfpenny Rigg near Hawkhirst and Needs Hill, looking across Howlet Bog

Viewpoint

Sculptor: Tania Kovats

Installed 1998
Whole work: Portland Cement 1.1m × 1.84m
long × 86cm wide
Status: not listed
Condition: good
Commissioned and owned by: Kielder
Parnership

Kovats, *Viewpoint*

Description: two groups of wedge-shaped
blocks 200 metres apart on either side of an
inlet of Kielder Water. Each group is arranged
in a semi-circle at the water's edge. They can be
seen as three-dimensional versions of the
Ordnance Survey map symbol for 'viewpoint'.

History: the artist has explained: 'Viewpoints
can be heroic, static or quiet, they are
destinations. There is always pleasure in being
able to stop, and view an area, see where you
have come from, locate a future destination,
allow your vision to open. *Viewpoint* offers a
frame for the landscape and mediates the
experience of looking. They become
destinations, walked or driven to, where
panoramas shift your perception of scale,
dwarfing the individual. The object of this work

is to offer a scale shift, from the map to the
territory.'[1] The hard-edged quality and pristine
whiteness of each of the blocks can also be seen
as making some kind of comment on the
newness of the Kielder landscape and the
engineering involved in the construction of the
nearby Kielder Dam in the 1970s.[2]

[1] Kielder Partnership Press Release, September,
1998. [2] Usherwood, P., 'Park Life', *Art Monthly,*
September, 1998, p.46.

Hawkhope Visitor Centre

Waterstones

Stonemasons: not known

Installed May 1982
Each boulder: stone 2m high × 50cm wide
Incised on a metal plaque attached to wall
below: TO COMMEMORATE THE OPENING OF /
KIELDER WATER / BY / HER MAJESTY THE QUEEN
/ 26 MAY 1982 / NORTHUMBRIAN WATER
AUTHORITY
Status: not listed
Condition: good
Condition details: considerable lichen growth
on south-facing surfaces

Waterstones

Commissioned by: Northumbrian Water
Owned by: Kielder Partnership

Description: three slabs of locally-hewn rock up-ended to form menhirs and stood in a group. Although ostensibly naturally formed, each has grooves cut into it, or has been polished to a smooth surface. The work is set above a wall and steps, overlooking the valley below Kielder Dam.

History: unveiled by the Queen when she opened Kielder Water, the boulders 'represent the strong foundations on which the dam and whole Kielder Water scheme was built'. They were quarried at Elsdon, Northumberland.[1]

[1] Kielder Partnership, *Elements in Harmony*, 1997, *passim.*

Leaplish Waterside Park, lakeside walk

Hedgehog Seat
Sculptor: not known

Installed *c.*1996
Whole work: sandstone 70cm high × 1.9m long × 1.3m wide
Inscribed on slab in ground: In memory of David Simpson

Hedgehog Seat

Status: not listed
Condition: good
Condition details: some surface dirt
Commissioned by: Northumbrian Water
Owned by: Kielder Partnership

Description: a rough-hewn hedgehog crouching on a plinth, with a bench set into one side.

Leaplish Waterside Park, lakeside walk

Shadow
Sculptor: Julia Barton

Installed May 1995
Whole work: whinstone, sandstone and earth 20m long × 5m wide
Status: not listed
Condition: good
Commissioned by: Northumbrian Water
Owned by: Kielder Partnership

Description: locally quarried stone set into a grassed slope to form a pattern of curving ridges.

History: inspired by the nearby Beeches

Barton, *Shadow*

Walk, an ancient remnant of land enclosure, the curving stone walls mark out a form which suggests something organic or archaeological. The title is derived from the fact that, as the artist has explained, the lines of stones create a 'shadow' down the hill where none usually falls.[1]

[1] Kielder Partnership, *Elements in Harmony*, 1997, *passim.*

Leaplish Waterside Park, lakeside walk

Whirling Beans
Sculptor: Colin Rose

Installed 1996
Three balls: fibreglass core, rope exterior 76cm, 71cm and 60cm in diameter
One ball: moss and netting 70cm diameter
Status: not listed
Condition: good
Condition details: the ball made of moss has split
Commissioned by: Northumbrian Water
Owned by: Kielder Partnership

Rose, *Whirling Beans*

Description: three balls made from rope coiled around fibreglass cores, and another made from moss held together with wire netting are attached to branches approximately six metres from the ground.

A variant of Rose's practice of giving objects 'homes' in trees, the whirling beans comprise a series of rope and moss balls that, in his words, 'draw on both the element of play and the energy stored within seeds'.[1]

[1] Kielder Partnership, *Elements in Harmony*, 1997, *passim.*

Lewisburn Trail

Skedaddle

Sculptor: Alan Franklin

Installed 1997
Whole work: larch and pine blocks 6.4m high × 3m diameter
Status: not listed
Condition: good
Condition details: dirt found on base; red stain on houses worn off in certain places
Commissioned and owned by: Kielder Partnership

Description: a giant skittle-like object standing in a pine wood with little red 'houses' attached to its sides. It is constructed from triangular blocks of pine and larch and rests on an invisible base of railway sleepers.

The artist has explained: 'Its form appears to be somewhere between a giant skittle and a chess pawn. Clinging to its surface area is a colony of small wooden houses which like ants seem to have taken possession of their host. I wanted the scale of this piece to take on the grandeur of the forest site I had chosen and like a child with its building blocks I wanted to see how high I could build. Relative to the heroic scale of the sculpture's mass the individual houses are small and insignificant. In this way

Franklin, *Skedaddle*

the houses are a metaphor for the human individual seen against the collective power and scope of all humanity. I wanted to make a piece that was impressive, beautiful, life affirming, mysterious and thought provoking, but above all something that has never before existed.'[1]

[1] Kielder Partnership Press Release, July, 1988.

KIRKLEY

Ponteland to Ogle road
Kirkley Hall, 100m west of road

Monument to the Glorious Revolution

Architect: not known

Erected 1788
Base: ashlar sandstone 2.5m high × 2.32m square
Shaft with base: ashlar sandstone 15m high approx
Plaque: ashlar sandstone 64cm high × 1.39m wide
Incised in Roman letters on plaque on the south-west face: VINDICATAE LIBERTATIS PUBLICAE / ANNO CENTESIMO / […] MDCCLXXVIII / NEWTON OGLE
Status: II
Condition: fair
Condition details: algal growth on plaque
Commissioned by: the Revd Newton Ogle
Owned by: Kirkley Hall College

Description: plain obelisk with an insert plaque on the south-west face, above which is a

Monument to the Glorious Revolution

shield with a low-relief carving of a Phrygian cap. On the north-east face there is a similar shield emblazoned with three crescents.

Subject: the obelisk commemorates the centenary of the 1688 Revolution when at the invitation of Anglicans and Dissenters, the Dutch stadtholder, William of Orange, seized the English throne from the absolutist and Catholic-favouring James II. Some present-day historians see this as little more than a palace coup instigated to protect the privileges of a selfish and conservative oligarchy. However, politicians of all kinds in the eighteenth and nineteenth centuries, even Tories such as Edmund Burke and Lord Liverpool, saw it as the foundation stone on which the nation's freedoms and prosperity were based: as the 'Glorious Revolution'.[1] There therefore is no reason to believe the Kirkley obelisk was necessarily intended or viewed as a radical statement, even though it incorporates the symbol of the Phrygian cap which subsequently (during the French Revolution) assumed such tumultuous connotations.

History: Newton Ogle (1726–1804) who commissioned the obelisk was born at Kirkley and educated at Oxford before going into the Church. He became Archdeacon of Surrey in 1766 and Dean of Winchester in 1769. He married the only daughter of the Bishop of Winchester and appears to have lived mainly in Hampshire in the latter part of his life.[2]

[1] Derry, J., *Politics in the Age of Fox, Pitt and Liverpool. Continuity and Transformation*, London, 1990, *passim*. [2] Foster, J., *Alumni Oxoniensi*, Oxford, 1888, *passim*.

Obelisk, **Lanton**

LANTON

Coupland to Lanton Mill road
Hilltop 300m to the north of road

Obelisk

Designer: not known

Erected 1827
Base: sandstone / igneous stone 3.8m high × 2.82m square
Obelisk: sandstone / igneous stone 8m high
Incised in Roman letters on string course of obelisk on south face: ALEXANDER DAVISON
Incised in Roman letters on entablature of base on south face: JOHN DAVISON 1827
Incised in Roman letters on plaque inserted into south face: This tablet [...] / [...] by Sir Will[...]ison of Lanton / Knight of the Royal & Most [...]hic Order of Hanover / To the Memory / of his most be[...] and [...] /

Alexander D[...] / of Swarland Pa[...] / whose Priv[...]Virtues [...] / and whose [...]Public S[...] / [...] / [...] died [...] / [...] Brighto [...] / December 10 [...] / 1829 / Aged 80 years
Status: II
Condition: fair
Condition details: border of plaque missing in parts; lichen on each face
Commissioned by: Alexander Davison
Privately owned

Description: an obelisk faced in rough igneous rock with ashlar quoins. It stands in an isolated and exposed position on a hill 208 metres in height with fine views on all sides, especially to the south-east and east.

Subject: the obelisk was erected by Alexander Davison (see p.49) in remembrance of his older brother John, a local landowner.

History: the obelisk commemorates John Davison who died in 1827. He was succeeded by Sir William Davison who added the tablet commemorating Alexander following the latter's death in 1829.

LEMMINGTON

B6341
Lemmington Hall Road

Evelyn Column

Designer: John Soane

Erected 1785; re-erected 1927
Step and drum: Turner's Hill Stone 1.8m high × 2.9m wide × 2.96m deep
Column: Turner's Hill Stone 16m high approx
Incised on entablature in Roman letters on north face: So[...] / DEO / Gloria
Incised in italics lower down on column on south face: VII / Through hidden dangers, Toils and Deaths, / It gently cleared my way / And

through the Pleasing Snares of vice / More to be fear'd than they. / When worn with Sickness oft hast thou / with Health renew'd my face / And when in Sins and Sorrows Sunk, / Revived my Soul with Grace JACOBUS EVELYN FILIUS EDWARD EVELYN / ET JULIAE, UXORIS TUUS, / (O! BENINGNISSIMI [*sic*] PARENTUS) / HANC COLUMNAM, / HAC TERRA (NATALE SOLUM) / PANENDAM / PENTISSIME GRATISSIMEQUE / JOHANNES SOANE / Architectus / Manners Makeyth Man

Incised in italics lower down on column on south-east face: Thy bounteous Hand with wordly Bliss / Has made my Cup run over, / And in a kind and faithful Friend / Has doubled all my Store. / × [...] Ten thousand thousand precious Gifts / My Daily thanks employ, / Nor is the least a cheerful Heart, / That tastes those Gifts with Joy.

Incised in italics lower down on column on south-west face: Unnumbered Co [...] Is my Soul / Thy tender...bestowed / Before my Inf[...] Heart conceiv'd / From whom th [...]Comforts Found / [...] the Slippery Paths of Trouth / With heedless Steps I am/ Thine Arm unseen convey'd me Safe / And led me up to Mon [...]

Incised in italics lower down on column on north-west face: When all thy Mercy God / My rising Soul Surveys / Transported with the View, I'm left, / In wonder, love and Praise / II / O how shall Words with [...] / Thy Gratitude declare / That glows within my Ra[...] / But thou can't read it there. / III / Thy Providence.../ And all my W [...] / When in the Silent [...] / And hung upon [...] / IV / To all my weak Complaints and [...] / Thy Mercy lent an Ear. / Ere yet my Feeble Thoughts had learnt / To from themselves in Pray [...]

Incised in italics lower down on column on north-east face: XI / Through every Period of my Life / Thy Goodness I'll pursue. / And after Death in distant Worlds / Thy glorious theme renew. / XII / O Blessed Jesu Intercede / My

Soane, *Evelyn Column*

pardon to obtain / Without thy aid poor Fallen Man. / Is doom'd to Endless Pain. / XIII / When Nature fails, and Day and Night / Divide thy Works no more. / My Ever grateful Heart O God / Thy Mercy shall adore. / XIV / Though all Eternity's too short / To utter all thy Praise. / Vide Spectator 1712

Status: II*
Condition: fair
Condition details: cracked south-east corner of base; large crack in column on the north-west face 3m up; tail of serpent chipped; spalling and crumbling on all faces
Commissioned by: James Evelyn
Owned by: the Lemmington Trust

Description: a column with verses from Addison's *Hymn of Gratitude* incised on the shaft. One of the themes of Addison's lines, eternity, is echoed in the snake swallowing its tail carved on the circular drum at the base of the column, an Egyptian symbol of eternity used by the architect in several of his later funerary designs. The shaft, which is plain and slightly tapering, ends in a narrow scrolled neck and an entablature block. The latter is plain except for the words ' Soli Deo Gloria' now very worn and, inappropriately, facing northwards towards Lemmington Hall. Above the cornice is an altar with spiral flutings bearing the eternal flame. The column stands on a grassy platform, 100 metres square, rimmed with stone and protected by a ha-ha. There are magnificent views of the Cheviot Hills to the north-west. Nearby, 50 metres to the west, are three stone slabs (86cm high) inscribed respectively: 'N / [bee motif] / S.G.de L.A. / 1923', 'N / [bee motif] /L.G.F.A. / 1925','N / [bee motif] / S.D.A. / 1927'. These were erected by Sir Walter Aitchison to commemorate the births of his children.[1] (Sir Walter was the son of Sir Stephen Aitcheson who was responsible for re-erecting the column at Lemmington – see below.)

Subject: the column was originally erected at Felbridge Place, Surrey, by James Evelyn (no relation of the diarist) in memory of his 'benignissimi' parents, the Surrey landowners, Edward and Julie Evelyn. James Evelyn is otherwise known as the founder of the Felbridge School, the Beef and Faggot Charities and for endowing a church in Surrey.[2]

History: Soane's first proposal was for an Ionic column and an obelisk on a circular pedestal. The British Museum possesses drawings and two letters giving workmanlike details. The earlier of these, dated 12 August 1785, gives an estimate for the work in Ashdown stone, which is more than double the £19 eventually paid, and ends: 'My own

Soane, *Evelyn Column* (detail)

commission & Journies you fixed at £25. You now have every expense attending the column & I could wish to have the foundation dug out directly the Stone is brought, that no time may be lost in advancing the building as much as possible this year.' In the other letter, dated 27 August 1785, there is the final estimate for the column which came to £280, with £20 to be deducted if planking of the foundations proved unnecessary.

There are also two drawings of the column in the Soane Museum, London. The first shows the snake devouring its tail and the wording 'Soli Deo Gloria' on the entablature block. The second was clearly produced to give the client an idea of what the column would look like and may be by George Basevi.

Interestingly also, the column figures prominently in J.M. Gandy's well-known capriccio of Soane's œuvre (Soane Museum, London) which it has been claimed is an indication that the architect was particularly pleased with it. The architectural historian, David Watkin, however, says that there is good evidence that in fact Soane regretted that he had designed it before he had begun to pay proper attention to 'first principle': a reference no doubt to the fact that the column lacks a standard architrave, frieze or cornice.[3]

When the Felbridge estate was sold in 1927 the column was bought by a Northumbrian

landowner, Sir Stephen Aitchison (1863–1942) for his estate at Lemmington Hall (now a convent) which he had purchased in 1913.[4] Dismantling the column and bringing it north from Surrey proved costly and difficult; a light electric railway had to be built to bring the stones the last part of the journey. After seventeen years the lettering on the shaft became so worn away it had to be recut.[5]

[1] Information provided by Sir Charles Aitchison Bt., 1998. [2] Waterfield, G., *Soane and Death*, 1996, p.85. [3] Hudson, M., *Country Life*, August, 1978, pp.592–3. [4] *Who's Who 1897–1916*, London, 1920, *passim*. [5] Waterfield, *op. cit.*, p.16.

LONGFRAMLINGTON

A697
Centre of village, 5m from road

Memorial fountain
Designer: not known

Inaugurated 22 June 1911
Column: sandstone 2.07m high × 87cm square
Lion: sandstone 70cm high × 80cm long
Incised in Roman letters on the east face:
GEORGE V / AND / QUEEN MARY / JUNE 22ND 1911
Status: II
Condition: poor
Condition details: fittings missing on the east and west faces; chipping on the lion's rear; planting in trough; algae on lion; weathering on the east face of the column

Description: drinking fountain in the form of column with chamfered base and carved recumbent lion on top. It has a lion's head spout and a carved low-relief crown above the inscription.

The fountain commemorates the coronation of George V.

***Fountain*, Longframlington**

MORPETH

A197
County Hall, forecourt

Viking Warrior
Sculptor: Margaret Wrightson

Erected 1925; re-sited 1981
Statue: bronze 2.2m high approx
Pedestal: sandstone 1.8m high × 1m square

Raised Roman letters on bronze plaque on west face of pedestal: THE VIKING LANDING ON THE NORTHUMBERLAND COAST / SCULPTED BY MARGARET WRIGHTSON F.R.B.S. IN 1925 / TRANSFERRED FROM DOXFORD HALL AND UNVEILED BY / LT. COL. R.A. BARRETT M.C.,T.D., D.L., CHAIRMAN OF THE NORTHUMBERLAND COUNTY COUNCIL / ON APRIL 3RD, 1981
Status: not listed
Condition: good
Commissioned by: Walter Runciman
Owned by: Northumberland County Council

Description: a fluidly modelled bronze statue of a Viking warrior about to land from a longboat. The warrior stands with his sword raised above his head and his back against the prow as if in the act of summoning companions. The longboat has a horsehead prow (facing east) and is cut away at the front. The statue surmounts a tapering ashlar stone pedestal which stands on a slightly raised brick platform in the forecourt of the 1979 red-brick County Hall.

History: before it was re-erected at Morpeth, the statue stood at Doxford Hall, the north Northumberland home of the Liberal politician, Walter Runciman (1870–1949). The son of a Tyneside shipowner, Runciman held a number of ministerial posts during a long parliamentary career, including President of the Board of Education 1908–11, of Agriculture 1911–14 and Trade 1914–16. In 1937 he was made a viscount and the following year he was appointed British mediator between the Sudeten Germans and the Czech government.[1]

[1] Waitt, E., 'John Morley, Joseph Cowen and Robert Spence Watson: Liberal Divisions in Newcastle Politics, 1873–1895', unpub. thesis, University of Manchester, 1972, p.470.

Market Place TOWN CENTRE
Outside Morpeth Town Hall

Hollon Fountain

Designer: A. Hutchinson

Unveiled Easter 1886
Whole work: grey granite 2.7m high × 1.42m square
Incised in Roman letters on south face: ERECTED BY PUBLIC SUBSCRIPTION / A.D.1885
Incised in Roman letters on east face: IN RECOGNITION OF THE MUNIFICENCE OF RICHARD WELCH HOLLON ESQUIRE / OF THE CITY OF YORK

Incised in Roman letters on north face: "BLESSED IS HE THAT CONSIDERETH THE POOR" / A.HUTCHINSON SC / MORPETH / A. Hutchinson Sc / Morpeth
Status: II
Condition: poor
Condition details: lamp falling off; fountain missing parts; masonry dislodged on base;

Wrightson, *Viking Warrior*

Hutchinson, *Hollon Fountain*

inscription on north face chipped; basins filled with soil
Commissioned by: public subscription
Custodian : Morpeth Town Council

Description: a memorial drinking fountain. A rusticated base supports a granite fountain with stepped ogival roof surmounted by a lamp. There are round-headed arches and protruding drinking basins on each side. The cornice is decorated with incised rosettes and acroteria.

History: the fountain commemorates the generosity of R.W. Hollon of York who founded an annuity in memory of his wife, a niece of Dr William Trotter, four times mayor of Morpeth. Under the terms of Hollon's annuity £10 was given to thirteen elderly men and twelve women of 'good character' and coal provided for the poor.

The fountain stands on the site of the Market Cross which was built in 1699 and removed in 1871.[1] The £169 2s. 6d. that it cost was raised by public subscription. Since 1885 its lamp has been replaced at least five times, most recently for the centenary of the fountain's erection in 1985.[2]

[1] Anon, *Westmorland, Cumberland, Durham Illustrated*, vol.1, London, 1832, p.50. [2] Thompson W., *The Hollon Drinking Fountain, Market Place, Morpeth, Centenary 1885–1985*, Morpeth, 1995, *passim*.

Morpeth Town Hall, *front elevation*

Joicey Memorial Plaque
Sculptor: not known

Installed 1919
Plaque: bronze 1.56m high × 1.06m wide
In raised Roman letters: INTER SYLVANUS. T. FLUMINA. HABITANS / IN RECOGNITION / OF THE MUNIFICENT GIFT OF THIS / BUILDING AND ADJOINING PROPERTY / TO THE TOWN OF MORPETH BY / THE RIGHT HONOURABLE / JAMES BARON JOICEY / A.D.1919

Joicey Memorial Plaque

Status: II
Condition: good
Commissioned by: public subscription
Custodian: Morpeth Town Council

Description: bronze plaque. An arched top frames the Morpeth town arms and motto rendered in coloured enamel. Beneath this there is a low-relief profile of Lord Joicey looking left.

Subject: the plaque commemorates Lord Joicey's generosity to Morpeth. When the 10th Earl of Carlisle offered to sell the Town Hall to Morpeth Town Council in 1915 Joicey lent them the £3,000 they needed to purchase it. Two years later, when the Council presented a cheque to Joicey for repayment, he refused to accept it, 'calmly tearing it up'.[1]

James Baron Joicey (born in Tanfield, Co. Durham, 1846) had had a successful business career in Co. Durham and for a time been MP for Chester-le-Street.[2]

[1] Tweddle, A.M., *Town Trail for Morpethians*, Morpeth, 1983, *passim*. [2] Pike, W. (ed.), *Contemporary Biographies – Durham*, Edinburgh, 1985, p.99.

Clock tower, *east corners*

Watchmen of the Clock Tower
Sculptor: not known

Installed *c.*1700
Each: stone 80cm high
Status: II*
Condition: good
Custodian: Morpeth Town Council

Description: two stone figures, each of them armed with a pike-staff, standing guard on the south-east and north-east corners of the Clock Tower. Since the Tower is 21 metres high they are hard to see clearly from the ground.

History: the Clock Tower was built in 1604 using stone from an earlier medieval structure. The top storey was added in 1705 to house 'six bells, which according to the inscription upon them, were the gift of Major-General Edmond Main to the corporation of Morpeth'.[1] General Main was MP for the town at the time. The style of the figures' uniforms suggests that they may well have been installed at the same time as the bells.[2]

[1] Hodgson, J., *A History of Morpeth*, Newcastle, 1832, p.90. [2] *Journal*, Newcastle, 17 February 1939.

OTTERBURN

A696

1km west of Otterburn, 80m north of road

Percy Cross
Stonemason: not known

Erected before 1400; restored and re-erected 1777
Stepped base: sandstone 1m high × 2m diameter
Square stepped base: sandstone 46cm high × 1.09m wide × 1.12m deep

Shaft on base: sandstone 2.4m high overall
Status: II
Condition: fair
Condition details: lichen and algae on every face; shaft chipped
Commissioned by: Henry Ellison
Owned by: Northumberland National Park

Description: the 'cross' stands in a small wood beside the A696. A circular stepped base leads to a square stone base on which sits another, smaller square stone base of medieval date. From this rises an upright tapering stone with two iron pegs attached to the south face.

Percy Cross

Subject: the Percy Cross commemorates the Battle of Otterburn between the Scots and the English in 1388. Although indecisive and of no great importance historically this has long been the subject of ballads and poems, most notably *The Battle of Otterbourne* of the early 1400s, *Chevy Chase* of the fifteenth century and a poem in Sir Walter Scott's *Minstrelsy of the Scottish and English Borders* (1803).

The story of the battle is that the Scots army under the Earl of Douglas camped at Otterburn on their return from a raid on Northumberland. The English army under Henry Hotspur (see pp.126–7) and Ralph Percy pursued them and attacked before night fell even though they had by then already marched 50 kilometres that day. In the ensuing slaughter Douglas was killed and so were 100 of his men, but his army remained in possession of the field. Meanwhile, Hotspur and Percy were both captured and 1,800 of their men were killed.[1]

The exact site of the battle has long been debated, by amongst others Sir Walter Scott.[2] It has recently been suggested that the lower part of the medieval base which is incorporated in the present structure originally marked the spot where, after the battle, the body of Douglas was mounted on a bier to be carried to Melrose Abbey. The fact that there still exist socket-stones, known as the Golden Pots, marking the spots where the bier was set down each day supports this theory.

History: the cross was probably erected in its present form in 1777 by Henry Ellison, the owner of the land on which it stood. Ellison, it is said, moved the medieval cross by some 150 metres so that it could be seen from the turnpike road to Scotland which was being built at the time. He also, it seems, made it more imposing by altering and adding to the design which until then was 'nothing more than a roughly carved boulder that stood – or rather lay in an oblique direction – in a socket considerably too large for it'.[3]

In the early nineteenth century there was some argument about the origins of the upright stone that forms the upper part of the present structure. The historian, John Hodgson claimed that it came from Davyshiel Crags. His contemporary, Robert White, on the other hand, said that it was from the kitchen fireplace of Otterburn Hall. A delightful early nineteenth-century engraving after T. Allom shows the cross in its present form being inspected by two kilted Highlanders by moonlight, but without the trees of the little copse which was planted quite recently by the Northumberland National Park.[4]

The work's name has always been a source of confusion. A writer in 1832 noted, 'The best topographical authorities concur in noticing the incorrectness of the name "Percy Cross" as applied to this pillar; the error had probably arisen from confounding the present memorial with another at Hedgeley Moor' (see p.29). In his view 'Battle Stone' was 'a more significant and intelligible appellation'.[5]

[1] Northumberland County Council National Park, *Battle of Otterburn*, Hexham, 1985, pp.10–12. [2] *Monthly Chronicle*, 1891, p.550. [3] *Ibid.*, 1888, pp.290–1. [4] Anon, *Westmorland, Cumberland, Durham Illustrated*, London, 1832, *passim*. [5] *Ibid.*

PRUDHOE

Prudhoe to Ovingham road
Beside roundabout at Prudhoe

Badger

Sculptor: Gary Power

Installed 1993
Whole work: limestone and wood bark 10.66m long × 3.48m wide
Status: not listed
Condition: fair

Condition details: bark chips have become scattered; weeds now partially obscure picture of the badger
Commissioned by: Highway Percent for Art Programme
Owned by: Northumberland County Council

Description: earthwork depicting a badger facing east.

History: the work was commissioned in 1993 as part of the Highway Percent for Art Programme and cost £15,000. The artist has explained: 'the badger was designed to integrate with the rural environment, create awareness about local ecology, and provide a landmark for the village and the nearby country centre and its activities'.[1]

[1] AXIS, Artists Register, 1999.

ROTHBURY

Town Foot
Queen's Head Pub, façade

Queen's Head
Sculptor: not known

Building erected *c.* 1900
Bust: painted stone 80cm approx
Status: not listed
Condition: fair
Owned by: Vaux Breweries

Description: high-relief bust of the young Queen Victoria in round niche with wreath border.

Queen's Head

B6341
Village Green

Rothbury Cross
Designer: Charles Clement Hodges

Erected 1902
Steps: stone 80cm high × 3.6m wide × 3.5m deep
Base: stone 56cm high × 1.14m wide × 1.1m deep
Shaft and cross: stone 4.2m high approx
Incised in Roman letters on the west face: THIS MONUMENT WAS ERECTED IN THE YEAR 1902 / ON THE SITE OF THE ANCIENT MARKET CROSS BY / THE INHABITANTS OF ROTHBURY AND OTHER FRIENDS / IN ADMIRATION AND GRATEFUL REMEMBRANCE / OF THE LONG AND USEFUL LIVES OF WILLIAM GEORGE BARON ARMSTRONG OF CRAGSIDE C.B. / (1810–1900) AND OF

Hodges, *Rothbury Cross*

MARGARET HIS WIFE (1807–1893)
Status: II
Condition: good
Condition details: slight chipping on shaft of east face and on the carving of the east and west faces; protective railings replaced; lichen on steps of west face; algae on base and bottom of shaft
Commissioned by: the inhabitants of Rothbury and friends of Lord Armstrong
Owned by: Rothbury Parish Council

Description: an Arts-and-Crafts Celtic cross.

Hodges, *Rothbury Cross* (detail)

SEATON DELAVAL

A190

1km south west of Seaton Delaval Hall

Obelisk

Designer: John Vanbrugh

Erected *c.*1737
Obelisk: ashlar sandstone 18.2m × 4.2m square
Status: II
Condition: poor
Condition details: missing grouting on all faces of the pedestal; stone missing from the north-east face of the base; entabulation of pedestal, patched with cement on the west face; spalling on west face of obelisk, crumbling on the west face; grass growing out of the base of the north and east faces; base has scratched and daubed-in paint on the west face.
Commissioned by: Captain Francis Blake Delaval RN
Owned by: Lord Hastings

Description: an obelisk of squared stone standing on a stepped base with a moulded plinth and base. It sits on a grassy mound 2.5 metres high.

History: it is said that three obelisks were included in Sir John Vanbrugh's original scheme for the grounds of Seaton Delaval, the dramatic, brooding house which he designed for Admiral George Delaval (1660–1723): this to the south-west of the house, another on the seaward side and another beside the avenue to the west of the house which marked the spot where supposedly Admiral Delaval suffered a fatal riding accident in June 1723.[1] Since the house was completed

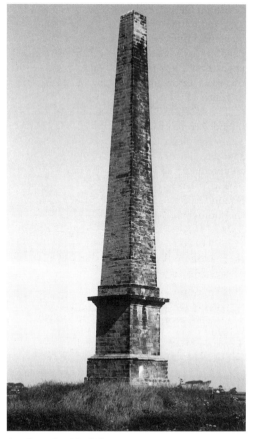

Vanbrugh, *Obelisk*

by 1729 it seems likely that all three – if indeed there were three – were commissioned by Admiral Delaval's nephew and heir, Captain Francis Blake Delaval RN (1692–1752) who on inheriting the Seaton property particularly devoted himself to the completion of the house and grounds.[2] Of the three obelisks only the one to the south now remains; there is no record of where the one on the seaward side stood and the one by the avenue was demolished in the 1940s with only the base still standing.[3]

The shaft has foliated, interlocking decoration in low-relief on the west and east faces. This decoration incorporates various kinds of wildlife naturalistically rendered: squirrels, a deer, an owl and birds on the west face, and rabbits and birds on the east face. The north and south faces of the shaft are decorated with geometric Celtic designs. The cross stands on a stone platform and is protected by railings.

Subject: the cross commemorates Lord Armstrong (see p.92) whose dramatic Norman Shaw-designed house, Cragside (1872–85) stands slightly to the east of Rothbury.

Seaton Delaval cashbooks for 28 September 1737 and 9 June 1738 mention a blacksmith being paid thirteen shillings, a payment of three pence 'for poynts Sharp at the Obelisk' and a payment of five shillings 'to raise stones for the obelisk'.[4] Unfortunately, however, it is not clear to which obelisk they refer.

The existing obelisk was certainly always intended to be ornamental. As was his wont, Vanbrugh planned a perimeter ditch on the southern side of Seaton Delaval which allowed an uninterrupted view from the garden into the park where it stood.[5] A writer describing Seaton Delaval's grounds in 1776 says that 'to the south there is a fine view over a verdant lawn to another bay of the sea where frequently 150 sail of colliers may be seen... enriched with the fine ruin of Tynemouth Priory, a grand obelisk and several villages and hamlets interspersed...'[6]

[1] Information provided by Lord Hastings, September, 1998. [2] Welford, vol.2, pp.48–9. [3] Information provided by Lord Hastings, September, 1998. [4] Northumberland Record Office (NRO650E2). [5] Lasdun, S., *The English Park. Royal, Private and Public*, London, 1991, p.88. [6] Graham, F., *Northumberland's Lordly Strand. The Northumbrian Coast from Berwick to Tynemouth*, Newcastle, 1974, pp.233–4.

SNOD'S EDGE

A691
Doctor's Cottage, Black Hedley, 40m south of road

Soldier, Fox and Dog

Sculptor: not known

Installed mid-1700s
Soldier: sandstone 1.5m high approx
Fox: sandstone 1m long approx
Dog: sandstone 1m long approx

Soldier, Fox and Dog (detail)

Status: II
Condition: poor
Condition details: arm missing from the figure of soldier; algae on all surfaces
Privately owned

Description: carvings of a soldier, a fox and a dog. The soldier in eighteenth-century uniform stands on a farm wall beside the eighteenth-century Doctor's Cottage. The fox and dog on the parapet are at either end of the nearby lectern dovecote.

History: it has been suggested that the carvings are juvenile works by John Graham Lough who was born at Greenhead, 400 metres to the west of Black Hedley.[1] Lough's recent biographers, however, give no support for this theory.[2] They say, rather, that there were several figures of eighteenth-century soldiers on the gatehouse at Black Hedley which were installed by a retired naval officer, a member of the Hopper family living at Black Hedley mansion, and these must have made a stong impression on Lough whose family lived at the gatehouse when the sculptor was a boy. As for the other two carvings, the dog and the fox, they make no reference to these.

[1] Pevsner, *Northumberland*, p.574. [2] Lough, J. and Merson E., *John Graham Lough 1798–1876*, Woodbridge, 1987, p.4.

SPITTAL Berwick-upon-Tweed

Main Street
178 and 180 Main Street

Keystone Heads, Busts, Decorations and Dog

Stonemason: William Wilson

Installed c.1880
Each bust: sandstone 60cm high
Each keystone head: sandstone 35cm high
Status: not listed
Condition: fair
Condition details: one keystone head missing; weathering on all surfaces; algal growth and dirt on all surfaces
Privately owned

Description: a bizarrely decorated terrace house. The decorations include: rusticated walls, windows surrounded by scrolled and patterned architraves, a stringcourse with relief foliate design, a row of acanthus leaves on the cornice and keystone heads above the second-storey windows. The latter depict Prince

Wilson, *170 and 180 Main Street* **(detail)**

Albert, Queen Victoria and two other unidentified personages. Over the substantial porch there are three busts, Sir Walter Scott, Lord Byron and a classical Greek figure, and on the gatepier of No.178 a carving of a dog curled up asleep.

History: Nos 178 and 180 Main Street are very similar in the way they have been decorated to the Wilson Terrace, Nos 204 and 206 Main Street (see below), and appear to be the work of the same stonemason, William Wilson.

Wilson Terrace, 204 and 206 Main Street

Figures, Animals and Keystone Heads

Stonemason: William Wilson

Installed *c.*1878
Keystone heads: sandstone 35cm high
Statues: sandstone 80cm high approx
Roundel relief: sandstone 25cm diameter
Panel relief: sandstone 60cm square approx
In raised figures, with decorations round each, below relief panel on west elevation: 1878
Status: not listed
Condition: poor
Condition details: six keystone heads missing; algae staining on statues and spalling
Privately owned

Description: like the nearby Nos 178 and 180 Main Street (see above) the north and west elevations of this three-storey terrace house are richly and bizarrely decorated. However, here there is also all manner of architectural sculpture: eight keystone heads (all different) over the windows on the ground and first floors; eight standing figures (four of Hercules with club and one each of Napoleon, a knight in armour, a medieval king and an unidentified man) above the round-headed half dormers; two eagles positioned at each gable end; and a

Wilson, *204 and 206 Main Street* **(detail)**

recumbent dog on the lintel of No. 204. In addition, above the round-headed half dormers of the south elevation there are statues of a pelican and a heron, and on the west elevation two reliefs, one of them a roundel of Shakespeare's head, the other a panel with a scene of herons fishing amongst bulrushes.

SWARLAND

A1 (T)

50m north of the A1(T) turn-off

Nelson Monument

Designer: not known

Installed 1807
Pedestal: dressed sandstone 3.3m high × 2.75m wide
Obelisk: dressed sandstone 1.1m high
Incised in Roman letters on east face of base: VICTORY, 21st OCTOBER, 1805
Incised in Roman letters on inset panel on east face on shaft: "ENGLAND EXPECTS EVERY MAN TO DO HIS DUTY"
Incised in Roman letters on inset panel on dado: NOT TO COMMEMORATE THE PUBLIC VIRTUES / AND HEROIC ACHIEVEMENTS OF / NELSON, / WHICH IS THE DUTY OF ENGLAND; / BUT TO THE MEMORY OF A PRIVATE FRIENDSHIP, / THIS ERECTION IS DEDICATED BY / ALEXANDER DAVISON / SWARLAND HALL
Status: II
Condition: fair
Condition details: scratches on the south-west corner of the plinth
Commissioned by: Alexander Davison
Privately owned

Description: an obelisk with inscriptions. Partially obscured by bushes and trees, it stands on a slightly raised platform at the eastern edge of what were formerly the grounds of

Nelson Monument

Alexander Davison's house at Swarland Park (demolished in 1947) and is protected on the western side by a ditch and the remains of a curved, squared-stone wall with railings on top.[1]

Subject: although supposedly a commemoration of a private friendship, the monument quotes Nelson's famous signal to the fleet at Trafalgar and thus in part honours Nelson the public man. (It is worth noting that another way in which Alexander Davison paid homage to his friend was to have trees at Swarland planted out in the formation of the ships at the Battle of the Nile.[2])

Horatio, Viscount Nelson (1758–1805) was born at Burnham Thorpe, Norfolk, the son of a clergyman. He entered the Navy at the age of 12. During the French wars he was in almost continuous service, distinguishing himself at the battles of Cape St Vincent (1797), the Nile (1798), Copenhagen (1801) and Trafalgar (1805). His death in the hour of victory at Trafalgar confirmed the position he already had as a national hero.

History: Davison came from a Northumberland family. He first met Nelson in Quebec in 1782 during the American War of Independence when he was a merchant ship owner in the Canada trade and Nelson the captain of a frigate. At the start of the French revolutionary wars he was connected with the commissariat of the Duke of York's army in Flanders, and by 1795 he had made sufficient money to be able to buy Swarland Park.

When, after the Battle of the Nile, he was appointed Nelson's agent for the sale of prizes he had medals struck in gratitude which were presented to every officer and man present in the engagement, a singular act of generosity which cost him over £20,000. However, by 1798 he could afford such largesse. General de Lancey, the barrack-master-general, had appointed him his official agent for purchasing supplies, and he had factories at Millbank in London and elsewhere.

In 1807, perhaps significantly the very year that the Nelson Monument was erected, Davison's nemesis arrived when a parliamentary committee inquiring into the barrack department accounts found that since 1798 he had been in the habit of charging buyer's commission on goods supplied by himself. He was duly prosecuted, fined £8,883 and sent to Newgate for 21 months. He died in Brighton in 1829 and is commemorated by a plaque on the obelisk he erected to his older brother John at Lanton (see p.39).[3]

In 1995 Felton and Newton-on-the-Moor and Swarland Parish Councils prepared a detailed report on how best to restore the obelisk and its site which although not particularly damaged had become obscured by trees and undergrowth. The report recommended clearing round the monument, repairing the cast-iron railings and small stone wall to the west, and re-profiling the ditch to the east. An application for funding was made to English Heritage, but as yet work has not begun.[4]

[1] Richardson, *(Historical Division)*, 1844, vol.3, p.52. [2] Pevsner, *Northumberland*, p.581. [3] *DNB*. [4] Felton and Newton-on-the-Moor and Swarland Parish Councils, *Davison's Obelisk*, 1995, *passim*.

WALLINGTON

B6342
Wallington Hall, on lawn

Griffins' Heads
Sculptor: not known

Installed *c.*1700; re-installed 1755; re-installed 1928
Each head: stone 78cm high × 1.2m long
Status: II*
Condition: fair
Condition details: one head missing left side of face and part of right ear; ears missing or damaged on three
Owned by: National Trust

Description: four griffins' heads with protruding eyes, large ears, snarling mouths and hair sprouting from their jowls.

History: the heads originally belonged to griffins on the medieval gate at Bishopsgate, London, which was demolished in 1761.[1] An engraving at Wallington Hall shows how they looked in the early eighteenth century.[2]

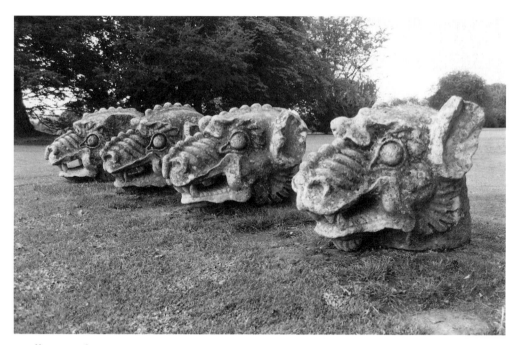

Griffins' Heads

A1068

Castle Keep, north face

Lion Rampant

Carver: not known

Installed *c.*1390
Panel: sandstone 1.5m high approx × 1m wide
approx
Status: I
Condition: fair
Commissioned by: the 1st Earl of
Northumberland

Description: relief carving of a lion rampant
(emblem of the Percys). It is nine metres up on
the north-east face of the castle keep which
itself stands on a ten-metre high Norman
motte. Running round the keep at the same
level there is a row of shields held by figures of
angels.

History: unlike the spectacular but now
much disfigured lion on the Lion Gate within
the castle walls (slightly later in date), this
particular Percy lion is clearly visible from
Warkworth village below and is therefore
appropriately included here. Pevsner especially
commends the keep of Warkworth Castle for its
remarkable balance of military strength and
harmonious design.[1]

[1] Pevsner, *Northumberland*, pp.616–17.

The story goes that they arrived in
Northumberland as ballast in one of the coal
boats belonging to the Blacketts, the great coal-
and lead-mining family that owned Wallington
Hall.[3] It is not known when exactly this was,
but certainly by 1789 the heads were part of the
motley array of objects decorating Rothley
Castle, the eighteenth-century Gothic eye-
catcher and viewing-point which David Garrett
designed for Sir Walter Calverley *c.*1755 to
stand in his newly laid-out deer-park at
Rothley Park, eight kilometres to the north of
Wallington. 'The southern front opens on a
small plain, naturally of a circular form,
scattered over with huge heads of griffins,
broken cornices, and ensigns of Calverley (the
lamb and flag of Grace) sculpted on white free-
stone; in the midst of which stand two
preposterous effigies, representative of no
known dress, personage, or people. And to
give the coup de grace to this composition,
enormous ribs, jaw-bones, and members of a
whale, are fastened to the walls for decorations.
We entered the tower, in which, by way of
tables, are three large rude unhewed stones, one
in the centre, and one in each recess at the sides,
benched with similar stones: pretty enough for
the reception of Thomas of Hick-a-thrift or
Jack the Giant-killer.'[4]

In 1928 the heads were moved from Rothley
Castle (which now stands empty) to their
present position at Wallington.[5]

[1] Bradley, S. and Pevsner, N., *London I: The City of
London*, London, 1997, p.425. [2] Information
provided by Pamela Wallhead of the National Trust,
1999. [3] Pevsner, *Northumberland*, p.604.
[4] Hutchinson, J., *Memoirs of the Public Life of Sir
Walter Blackett of Wallington*, Newcastle, 1789,
p.xxxiii. [5] Anon, *Wallington*, Northumberland,
1971, p.22.

WHITTINGHAM

Glanton to Callerly Road
South end of village

Ravensworth Fountain

Sculptor: Brownlee
Designer: George Reavell

Erected 1905
Statue: sandstone 1.3m high
Whole work: sandstone 3m high × 53cm square
Incised in Roman letters on base of statue on
west face: BROWNLEE 1905
On east face: THE LORD IS MY SHEPHERD / I
SHALL NOT WANT PS.XXIII.I.
Incised in Roman letters on base of pillar on
west face: HE SHALL FEED ME / IN A / GREEN
PASTURE AND LEAD / ME FORTH BESIDE THE /
WATERS OF COMFORT / PS.XXIII.II.
On north-west face: TO THE DEAR MEMORY / OF
/ ATHOLE / THIRD EARL OF / RAVENSWORTH.
On south face: ERECTED / BY HIS WIFE /
CAROLINE / COUNTESS OF RAVENSWORTH
Status: II
Condition: fair
Condition details: algae on base of column;
lichen on base; flowers in trough
Commissioned by: the Countess of
Ravensworth
Owned by: Eslington Estates

Description: a drinking fountain with statue.
An octagonal sandstone base and pillar rising
from an octagonal sandstone trough (now filled
with plants). On this stands a small statue of
Lord Ravensworth informally dressed for a
country walk with a seated collie by his side.

History: Athole, the 3rd Earl of
Ravensworth, lived a mile away at Eslington
Hall. He held his title for one year only, 1903–4.
The fountain was disconnected c.1950.

Brownlee, *Ravensworth Fountain*

Tyne and Wear

Birtley Lane
Crossroads with Fell Bank, on green

Monument to Colonel Edward Moseley Perkins

Sculptor: George Burn

Unveiled 22 June 1874
Statue: Sicilian marble 1.8m high
Pedestal: Prodham stone and pink granite insets
2.8m high × 1m square
Steps: Prodham stone 1m high × 3m square at
bottom
Incised on west (front) tablet: ERECTED / TO
THE / MEMORY OF / EDWARD / MOSELY / PERKINS
/ OF BIRTLEY HALL / LIEUT COL / 1ST AD BATT
DRV / 1874
Status: II
Condition: fair
Condition details: cracks on rear of statue;
statue weathered with details smoothed;
blackened by rain at rear; pedestal badly
corroded, the cornice is especially chipped and
eroded
Commissioned by: public subscription
Custodian: Gateshead Metropolitan Borough
Council

Description: soft white marble statue of
Perkins with hands on the hilt of his sword. Set
upon a yellow stone pedestal including a two-
tier base and rising from three steps. Each face
of the pedestal is inset with a pink granite
tablet.

Subject: Edward Mosely Perkins (1821–71)
was born in London and came to Birtley as a
partner in its Iron Company and two local pits
in 1858. He took over Birtley Hall and was

Burn, *Perkins Monument*

famous for his fine conservatory of ferns,
described as being just like a hot jungle. Apart
from his business interests, Perkins was very
active in public office, being a Councillor,
Magistrate and Lord Mayor of Newcastle. He
became a Captain in the Durham Rifle Corps,
rising to the rank of Lieutenant Colonel. He
died in London.[1]

History: the memorial was paid for by public
subscription and unveiled by Isaac Lowthian
Bell in front of a large crowd of locals and a
detachment from the Durham Rifle Volunteers.[2]
Burn's obituary lists this statue amongst his
works.[3] Its naïve style led Pevsner to describe it
as the 'funniest monument of County
Durham'.[4]

[1] Letch, H., *Gleanings from the History of Birtley*,
Gateshead, n.d., pp.35–7. [2] Gateshead MBC, *War
and Other Memorials: Report of a Survey*, Gateshead,
1977. [3] Information provided by John Pendlebury,
Newcastle University. [4] Pevsner, *Co. Durham*, 1953,
p.51.

A694
Open ground beneath Thornley
Woodlands Centre, west of Derwent
Walk

Stones Garden

Sculptor: Alberto Carneiro

Installed 1997
Whole work: white stone on grey stone bed
1.75m high × 2.2m wide × 1.1m deep

Status: not listed
Condition: good
Commissioned and owned by: Gateshead Metropolitan Borough Council

Description: a raised brick bed filled with grey granite chips, within which are placed five rough-hewn boulders of white stone.

History: commissioned for 'Autumn' as part of 'Four Seasons', a project organised by Gateshead MBC for the 1996 Year of Visual Arts UK. Its aim was to bring international sculptors to the rural areas of Gateshead, where local artists had already been working since 1993 within the 'Marking the Ways' scheme.[1] Each artist was asked to respond to a different season and work with local groups to develop their creative ideas as community resources.

The site of *Stones Garden* is the former Derwenthaugh Coke Works, now demolished and landscaped to become an open green park. The Derwent Walk footpath and cycle way passes across a nearby viaduct, and Thornley Woodlands Centre (notable for its red squirrel population) is on the hill above. Carneiro was assisted in fabricating *Stones Garden* by Tom Scicluna, a recent graduate from the University of Northumbria. The work is intended to reflect zen gardens of the Far East as much as the stoneworking skills of rural Portugal, where the artist comes from. The five large white stones which stand upright in the 'garden' are given the following names: *The Mother Stone*; *The Waterfall Stone*; *The Cave Stone*; *The Moon Stone*; and *The Boat Stone*.

Various poems were written about 'Autumn' at local community workshops, of which the following most explicitly refers to *Stones Garden*: 'Stone shaped in cones / is our season's memorial: / we stand it against millenia / more eloquent than song, / our giant mimicry / of the methods of the forest / as though we could grow again / our voices unchanged by their graves.'[2]

The Four Seasons project was supported by Great North Forest, Northern Arts, the European Community Kaleidoscope Fund, European Regional Development Fund, Air UK and a number of other business sponsors. The other works in the scheme are *West Wind* and *Bridge* by Laurent Reynes (see pp.80–1 and 205), *Circling Partridges* by Graciela Ainsworth (see pp.205–6), and *Viewing Platform* by Maurice O'Connell (see p.59).

[1] *Marking the Ways in Gateshead, passim.*
[2] Gateshead, *Four Seasons*, pp.16–19, 24.

Shibdon Road
Blaydon Library, displayed inside

Head of Garibaldi
Sculptor: George Burn

Statue originally erected 1868
Remains (head): stone 35cm high
Status: not listed
Condition: poor
Condition details: facial features much worn and brim of hat chipped; rest of statue missing
Commissioned by: Joseph Cowen, Junior
Custodian: Gateshead Metropolitan Borough Council

Description: the much eroded head of 'the Liberator of Italy' from George Burn's statue, now mounted on a wooden block and displayed in a case in the entrance lobby of Blaydon Library.

Subject: Giuseppe Garibaldi (1807–82) was born in Nice and joined Mazzini's Young Italy Society in 1834. Condemned to death for treason he escaped to South America and became a mercenary. He returned to Italy in 1848 as the commander of the army of the Roman republic in its defence of the city against the French. A period of exile followed during which in March 1854 he made a brief visit to Tyneside at Joseph Cowen's invitation. In the war of 1859 Garibaldi fought against the French and in 1860 led the conquest of Sicily and Naples for the new kingdom of Italy. He later led two unsuccessful expeditions to liberate Rome from papal rule in 1862 and 1867. In 1864 he made a second visit to England, but this

Carneiro, *Stones Garden*

Burn, *Statue of Garibaldi* (original state)

appears to have been abruptly terminated by a nervous British Government before he could travel to Tyneside.

History: Burn's statue was slightly over life-size and represented Garibaldi characteristically attired in round-topped hat and loose shirt, holding the sword and telescope with which he was presented at a ceremony at Shields on 11 April 1854. The industrialist and Radical politician, Joseph Cowen, Junior (see p.152)

who made the presentation on this occasion, concluded his speech with the declaration that 'the heirs of Milton and Cromwell will not be the last to say, even from their deepest heart, "God speed your work!"'[1]

Cowen had long been associated with the cause of Italian freedom. When still in his teens he was a friend of, and secret supplier of arms to, Mazzini, and in 1851 he established the Subscription for European Freedom. His controversial support for Garibaldi came into the open when on 13 August 1860 his newspaper, *The Newcastle Daily Chronicle*, actively promoted the formation of a British Legion with the headline, 'Who will fight for Garibaldi?'.

The statue by George Burn was commissioned in 1868 for Stella Hall, Cowen's home at Blaydon, where there were portraits of several European revolutionaries.[2] At the turn of the century it was toppled from its pedestal (some say by cattle, others by Fenians) and rolled down the hill. It is not known where the torso and legs are today.[3] The head was discovered in a builder's yard in 1941 and for the next 17 years served as a garden ornament in the home of Jack Thomas, a retired Blaydon builder.[4] Since 1977 it has been kept in a glass case in Blaydon Library.

[1] Dillon, W., *Life of Joseph Cowen*, New York, 1904, p.13. [2] Todd, N., *The Militant Democracy and Victorian Radicalism*, Whitley Bay, 1991, p.9. [3] Information provided by Nigel Todd and Bill Lancaster, 1999. [4] *Evening Chronicle*, 23 September 1977.

Tilesheds Lane
Tilesheds Nature Reserve, car park

This part of Boldon used to be the site of brick- and tile-making factories, hence the name of Tilesheds. Since 1991 a large plot of land has been restored to farmland, woodland and open wildlife areas as part of the Great North Forest. Paths lead through the grassland and past a pond and nature reserve which attracts a range of birds and animals.

Dream Boat
Sculptor: David Gross

Installed *c.*1996
Whole work: wood 1.6m high × 2.2m long × 1.3m deep
Status: not listed
Condition: fair
Condition details: weathered and bleached; hole burnt through
Commissioned by: Great North Forest
Custodian: North Tyneside Council

Description: a rowing skiff on its side, constructed from roughly hewn pieces of pale wood. The bottom of the hull is carved with a

Gross, *Dream Boat*

number of images including a space ship, a boat, a tree, a football cup, a shark and a spider. The sculpture is located by a hedge which fronts on to the main road, next to a small car park.

History: resulting from a residency at King George's School where Gross developed ideas with pupils, the symbols carved on the hull of this upturned boat reflect the children's dreams, as described to the artist. 'As the boat was for sitting in, rather than sailing, I thought that on the bottom, instead of barnacles, scratches and scars recording the history of long sea voyages, we should carve images which related more to being still and wandering with your mind.'[1]

Children made a further carving of a *Whale and Snail*, sited a little way down the path leading north from the car park. There is also a sculptural seat by Gross at another car park to the east: carvings of seed pods rise on stems about four metres above the red-stained benches.[2]

[1] GNF, *Arts in the Forest*, p.19. [2] *Ibid.*, Map, no.32.

CULLERCOATS
North Tyneside Council

Beverley Terrace

Sea front pavement, near Marine Laboratory

Adamson Memorial Drinking Fountain

Designer: not known

Installed 1888
Base and trough: stone, marble panels 93cm high × 1.4m diameter
Spire: marble 1.95m high × 78cm diameter
Raised black lettering on white marble panel on side of base: ERECTED BY A FEW / FRIENDS IN

Adamson Fountain

MEMORY OF / BRYAN JOHN HUTHWAITE / ADAMSON LIEUT. R.N. / COMMANDING H.M.S. WASP / WHICH SAILED FROM SINGA / PORE SEP.10–1887 AND WAS / NEVER HEARD OF AFTER / THE SITE WAS GIVEN FOR / THIS MEMORIAL BY HIS / GRACE THE DUKE OF / NORTHUMBERLAND 1888
Status: II
Condition: poor
Condition details: large chips off marble; two water spouts missing; badly eroded lion-head spouts; loss of detail on spire; green algal growth on base
Commissioned by: public subscription
Custodian: North Tyneside Council

Description: an octagonal memorial fountain consisting of a soft white marble spire rising from an octagonal trough. Iron lion-head spouts are located on two sides, whilst two others are missing. The spire is carved with raised lettering BJHA and a faded Latin inscription, and is also decorated with dolphins, shell and foliate reliefs, all much worn.

History: the memorial's installation is mentioned in the *Monthly Chronicle*, with no further information as to its circumstances beyond the details on the inscription.[1]

[1] *Monthly Chronicle*, 1889, p.186.

EARSDON
North Tyneside Council

Earsdon to Backworth road

St Alban's churchyard

Hartley Disaster Memorial

Designer: not known

Erected 1862
Pedestal and obelisk: sandstone 4.5m high × 3m wide
Incised Roman letters painted black on the frieze of the east face of the pedestal: ERECTED / TO THE MEMORY OF THE 204 MINERS, WHO LOST THEIR / LIVES IN THE HARTLEY PIT, BY THE FATAL CATASTROPHE / OF THE ENGINE BREAKING, 16TH JANUARY 1862
Incised Roman letters painted black on the frieze of the south face of the pedestal: BE NOT DECEIVED: GOD IS NOT MOCKED: FOR WHAT- / SOEVER A MAN SOWETH. THAT HE SHALL ALSO REAP / (GALAT VI CHAP VII VERS)
Incised Roman letters painted black on the frieze of the north face of the pedestal: THEREFORE BE YE ALSO READY: FOR SUCH AN HOUR / AS YE THINK NOT THE SON OF MAN

Hartley Disaster Memorial

COMETH. / MATTHEW XXII CHAP XLIV VERS/ BLESSED THE DEAD WHICH DIE IN THE LORD / REVN XIV CHAP XIII VERS / "IN THE MIDST OF LIFE WE ARE IN DEATH".
Status: II
Condition: good
Commissioned by: public subscription
Custodian: St Alban's Church

Description: a sandstone memorial decorated at the entablature with egg and dart and rope moulding and surmounted by an obelisk. The names of 204 men who died in the disaster are inscribed on raised round-topped panels on each face of the pedestal. It is protected by iron railings and stands in St Alban's churchyard in a wooded spot 50 metres north-east of the church.

Subject: 204 men and boys lost their lives in the North East's worst pit disaster at Hartley Colliery on 16 January 1862. The engine beam at Hester Pit snapped and fell into the shaft bringing with it a huge amount of debris. Because the pit was single-shaft and had no alternative exit a large number of miners were trapped underground. After several days rescuers thought they heard 'jowling' (the noise entombed miners make when they try to show that they are still alive) but later realised they were mistaken. When eventually, a week later, bodies were found it was clear that most of the victims had died from the effects of poisonous gases released by the original collapse of the beam.

The disaster attracted huge public interest. 20,000 sightseers joined the families waiting at the surface for news in the first days after the accident. 60,000, it is said, took part in the funeral procession to Earsdon churchyard on 26 January. When money was collected for the 407 widows and dependents of the victims, £82,000 was amassed, a sum so great that it was possible to send £20,000 for distribution in other coalfields.

The 'fatal catastrophe' had one beneficial outcome: legislation obliging owners to sink two shafts side by side was rushed through Parliament by the end of the year.[1]

History: the memorial was erected in Earsdon churchyard where some of the dead are buried.[2]

[1] Duckham, H. and Duckham, B., *Great Pit Disasters: Great Britain 1700 to the Present Day*, Newton Abbot, 1973, pp.95–108. [2] Pevsner, p.261.

Pemberton Bank

Pigeon Race

Sculptor: David Edwick
Writer: Linda France

Installed September 1998
Whole work: yellow Stanton Moor sandstone 3.1m high × 1.2m wide × 60cm deep
Incised lettering, south-east face: Never stop asking why. / Stay spry and keep / a weather eye.
Incised lettering, north-west face: See how the feathers fly / fall, lie – the birds / are home and dry.
Status: not listed
Condition: good
Commissioned by: City of Sunderland / Arts Resource
Owned by: City of Sunderland

Description: a large sculpture sited on the verge beside the road. An ashlar yellow stone column supports a large piece of the same stone bearing carved reliefs 5cm deep. On the south side is an eagle chasing a pigeon, with a pylon behind. On the north side is a pigeon with outstretched wings flying over a smiling woman.

History: Pigeon Race is the first of three large sculptures by Edwick to mark the boundary of Sunderland at Easington Lane. It was designed in consultation with the local Homing Pigeon Society and shows a hawk missing its strike on one side, with a loft and pigeon owner on the other. The other markers will have relief carvings of a woman and baby and a man and his pigeon, to be sited in mid-1999.

Carved across all three sculptures are lines

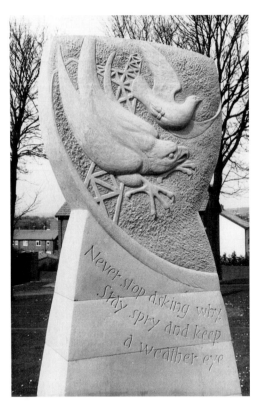

Edwick, *Pigeon Race*

written by Linda France. The poem reads in full: Never stop asking why. / Stay spry and keep a weather eye. / See how the feathers fly, / fall, lie – the birds are home and dry. / Hush now, baby, don't cry / You're my best little pigeon pie. / Let me show you how high / the sky is – teach you how to fly.

The public art project forms part of the Easington Lane Environmental Improvement Programme, managed by Arts Resource. Funding has come from the Single Regeneration Budget with assistance from Northern Arts. An Open Day was held in October 1998 to inaugurate *Pigeon Race* and library gates by Graeme Hopper. Further sculptures are planned, including a carved relief panel for the exterior of the library and seats in the form of pigeon baskets.[1]

[1] City of Sunderland, City Library display, April 1999.

GATESHEAD Gateshead MBC

A167 LOW EIGHTON

Near junction with A1(T), open ground

Angel of the North

Sculptor: Antony Gormley

Inaugurated 16 February 1998
Whole work: oxidising corten steel 20m high × 54m wide
Status: not listed
Condition: good
Commissioned and owned by: Gateshead Metropolitan Borough Council

Description: claimed, probably mistakenly, to be the 'largest free-standing sculpture in the world',[1] the *Angel* is a rust-brown figure of a naked, anonymous man (based on a cast of the artist's own body) with aeroplane wings instead of arms. The figure and wings are strengthened with vertical ribs on the outer 'skin', giving the sculpture its generalised appearance.

History: Angel of the North was erected in one day but had a gestation period of several years. Reclamation work on the small mound on which it stands started in 1989. The following July, at the time of a huge showing of sculpture at the National Garden Festival at Dunston (said to be the largest outdoor exhibition of sculpture ever held in Britain) Gateshead Council earmarked the site for a landmark sculpture and asked Northern Arts for £45,000 to allow it to select an artist and develop a design. As Gormley later commented, 'it may have been my design but the idea for the work was Gateshead's'.[2]

In 1993 the Council's Art in Public Places Panel in consultation with the Tate Gallery, Yorkshire Sculpture Park, Northern Arts and the Public Art Development Trust, invited a number of artists to submit proposals. In January 1994 Gormley was chosen on the basis of a slide of *A Case for an Angel* (1990), one of his life-size, body-case pieces made for a gallery setting. 'We want something like that, but not that', was how councillors put it. The fact that *A Case for an Angel*, like many of Gormley's gallery works, is a deliberately ambivalent and uncomfortable work which conveys futility rather than transcendence or regeneration was not perceived as a difficulty.

Initially, the artist was wary of becoming involved. His previous experience of public art projects had not been happy and, as he said at the time, he did not do 'roundabout art'. However, he changed his mind when he realised that certain members and officers of Gateshead Council were determined to see the project through to completion. Inevitably with so large a work there were huge engineering problems and from the first he worked closely with Ove Arup & Partners, a firm of engineering consultants who had helped him with his unrealised Leeds *Brick Man* project in 1987. Ove Arup's advice meant that the body was thickened up and the wings were made less like a glider's and more like a Spitfire's. It also meant a special 'weathering' steel was chosen for the sculpture, a kind of steel which after initial minor rusting is protected by surface patina. In addition, Ove Arup proposed the installation of eight 20-metre deep concrete piles, concrete slabs and 52 bolts which enable the 200-tonne structure to stand upright in winds of up to 160 km/h.

Initially, the public seemed to be mostly opposed to the proposed sculpture. 4,500 local residents signed a petition condemning it and a

reader's poll in a local paper suggested that popular feeling was overwhelmingly hostile. There seem to have been various anxieties: that the *Angel* would divert money from useful causes (not true in fact); that it would overlook people's homes (it is some distance from the nearest house); that it would fall victim to vandals and scrap merchants; that it would cause offence to Gateshead's large Jewish population on account of its alleged similarity to Albert Speer's *Icarus* statue at Doberitz;[3] and that it would be used for stunts by those seeking publicity. In the event only the last of these proved to be well-founded; during the run-up to Newcastle United's appearance at the 1998 FA Cup Final intrepid fans dressed the statue in a 9–metre replica of Shearer's shirt.[4] Meanwhile the sculpture's supporters, notably

Councillor Sid Henderson (Chair of Gateshead Council's Art in Public Places Panel), Lord Gowrie (Chairman of the Arts of England), Virginia Bottomley (Heritage Secretary) and the artist himself did their best to defend the project.

By March 1996 the tide of opinion seemed to be turning. The artist's spectacular *Field for the British Isles* attracted an unexpectedly large audience when it was exhibited at the former Greenesfield locomotive shed in Gateshead. Then at the local elections in May 1996 the handful of non-Labour members on Gateshead Council who had tried to use vigorous opposition to the *Angel* to hang on to their seats were soundly defeated. Shortly afterwards, Gateshead Council was able to secure funding for the sculpture: £584,000 from the Lottery,

£150,000 from the European Regional Development Fund and £45,000 from Northern Arts, and smaller sums from business.

In May 1997 Hartelpool Fabrications Ltd were chosen to make the *Angel* and four months later work began on preparing the foundations in preparation for sinking the piles needed to stabilise the giant structure. Meanwhile, in order to enlarge the artist's model to the required size a plaster cast of the 'body skin' was scanned into a computer from which a 3D digitalised model of the body could be developed to provide instructions for the fabricators' cutting machine.

By February 1998 the *Angel*'s body and each of the two wings were complete and on the night of Saturday 14 February these were transported from Hartlepool in trucks. Next day they were bolted and welded into place with the help of two enormous cranes, a task which provided an extraordinary spectacle for the thousands who had come to watch. Finally, on Monday 16 February, which by chance was a particularly stormy day, the sculpture *in situ* was shown off to the world's press by the artist and Lord Gowrie.

Even before it was erected there was uncertainty about what the title *Angel of the North* might imply. It should be noted, however, that this was actually coined by the Gateshead Council Art in Public Places Panel, not the artist. For his part, Gormley always seems to have viewed the sculpture as a winged figure rather than one or other of the angels of the Christian or classical tradition. 'It is an image of a being that might be more at home in the air, brought down to the earth,' he said on one occasion: 'an image of somebody who is fatally handicapped, who cannot pass through any door and is desperately burdened.'[5]

Some, including many of the press present at the inauguration, have wanted to see the *Angel* as a comment on the demise of the mining and shipbuilding industries which were once so

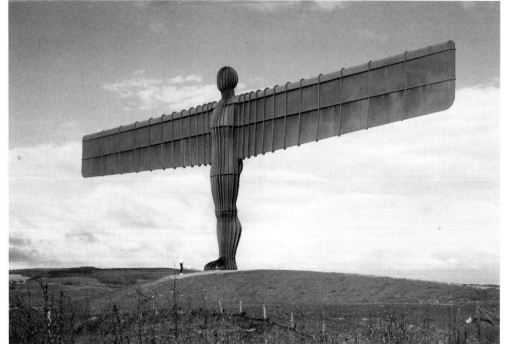

Gormley, *Angel of the North*

essential to Tyneside's economy; to see it as a kind of phoenix rising from the ashes of the area's post-war industrial decline. However, this again must be regarded as a problematic interpretation since it was Hartlepool rather than Tyneside where the sculpture was fabricated, and all traces of the old Teams Colliery on which the *Angel* stands were systematically obliterated before the sculpture's erection.

Nonetheless, such quandaries have never affected media or popular interest in the *Angel* in any way. Two years before it was erected it was found that its digitally simulated and much reproduced image was recognised by 74 per cent of the population of the Northern Arts region[6] and since then even periodicals which normally take no notice of art, such as the Newcastle United supporters' magazine, have featured it.[7] In 1998 the sculpture even appeared on the Eurovision Song Contest, as one of the sights of Britain along with Warwick Castle and Loch Ness. Indeed, as time passes, it seems increasingly possible that Gormley's *Angel* will eventually become, as its supporters always said it would, the equivalent of the Statue of Liberty or the Eiffel Tower, that is to say a structure which is regarded not as the work of a particular artist but as an integral, almost anonymous part of the landscape.

Angel of the North is one of the most viewed works of sculpture in Britain. It has been estimated that it is passed by up to 90,000 motorists a day. It can also be seen by passengers on the main London–Newcastle railway line in Team Valley and by residents in western parts of Gateshead and Newcastle.

[1] Information provided by Gateshead MBC, 8 March 1998. [2] Gormley, A., *Making An Angel*, London, 1998, *passim*. [3] *Gateshead Post*, 2 February 1995. [4] *Daily Telegraph*, 13 May 1998. [5] Usherwood, P, 'Monumental or Modernist? Categorising Gormley's Angel', *Sculpture Journal*, vol.III, pp.93–101. [6] Harris Research Centre for Northern Arts / The Arts Council of England, *Visual Arts UK: Public Attitudes Towards an Awareness of the Year of the Visual Arts in the North of England*, Newcastle, 1997, p.10. [7] *The Mag: the Independent Voice*, Newcastle, 8 March 1998.

Summit of small spoil heap to east of Angel View Inn

Viewing Platform
Sculptor: Maurice O'Connell

Installed 1996
Upper surface: bronze 1.4m diameter
Pedestal: stone walling 60cm high × 1.4m diameter
Status: not listed
Condition: good
Commissioned and owned by: Gateshead Metropolitan Borough Council

Description: a bronze relief plate set into the top of a low stone wall base. The relief consists of narrow ridges to a depth of 1cm, some of which make up lettering, to form people's names and words such as HOME.

History: O'Connell worked with children from Harlow Green Infants school to create three works: *Viewing Platform* overlooking the A167; paintings within a nearby underpass; and a time capsule which will remain buried for 30 years. He also wrote poetry and collaborated with composer Keith Morris to make music especially for the project. *Viewing Platform* is 'a map identifying landmarks and sites of historical, personal and future significance'.[1]

The platform was commissioned for 'Winter' as part of 'Four Seasons', a project organised by Gateshead MBC for the Year of Visual Arts UK in 1996. This was supported by Great North Forest, Northern Arts, the European Community Kaleidoscope Fund, European Regional Development Fund, Air UK and a number of other business sponsors. Its aim was to bring international sculptors to the borough's rural area, where local artists had

O'Connell, *Viewing Platform*

already been working since 1993 within the 'Marking the Ways' scheme. Each artist would respond to a different season and work with local groups to develop their creative ideas into community resources. The other works in the scheme are *Stones Garden* by Alberto Carneiro (see pp.52–3), *West Wind* and *Bridge* by Laurent Reynes (see pp.80–1 and 205) and *Circling Partridges* by Graciela Ainsworth (see pp.205–6).

[1] Gateshead, *Four Seasons*, p.4.

Bensham Road BENSHAM
Overlooking grassed area to north of road, behind petrol station

Monument to George Hawks
Sculptors: Joseph and Robert Craggs

Unveiled 2 October 1865; restored 1999
Statue: Sicilian Marble 1.9m high

Pedestal: Pruddom stone 1.83m high × 11cm square
Base: Pruddom stone 1.54m high × 1.48m square
Incised letters on north front of pedestal: [...] / FIRST MAYOR OF / GATESHEAD. / BORN JANUARY.7.1801 / DIED OCTOBER.15.1863 / ERECTED BY HIS FRIENDS / AND THE WORKMEN OF THE / GATESHEAD IRON WORKS / OF WHICH HE WAS THE / FIFTH SENIOR PARTNER / OF THE SAME NAME / AND FAMILY. / OCTOBER 2ND 1865.
Status: II
Condition: poor – removed for conservation by the council in 1999
Commissioned by: public subscription
Custodian: Gateshead Metropolitan Borough Council

Description: Hawks is depicted standing in his mayoral robes with a scroll in his right hand. The statue surmounts a white stone pedestal, the north face bearing the inscription, the east and west faces bearing the Gateshead coat of arms in relief, surrounded by the motto 'BOROUGH OF GATESHEAD'. There is evidence of an inscription on the lower face of the north base (including 'Newcastle' at its end), but this is completely worn away. The memorial originally had a drinking fountain and cups on each side to a newly patented design, with water supplied by pressing buttons.[1]

Subject: George Hawks (1801–63) was a leading partner in Hawks, Crawshay and Sons, a long-standing local firm responsible for building the High Level Bridge between Gateshead and Newcastle.[2] He was well known for his honesty and fairness to his workforce: 'Hawks and Hospitality were in him synonymous terms.'[3] However, Hawks was also regarded as a dandy, 'fond of associating with dignitaries, infatuated with civic honours' and was satirised as carefully brushing his clothes after talking to his workers.[4] He was elected Mayor of Gateshead twice and became Deputy Lieutenant of County Durham; his death was greeted with great dismay and was widely reported in local newspapers.[5]

History: a monument to Hawks was proposed by workmen from his Gateshead Ironworks, and a subscription was started. Joseph Craggs was credited with the design and he and Robert were listed as sculptors, though nothing is known of them beyond their working at a marble yard on Percy Street, Newcastle.

The statue was originally sited outside the Town Hall and inaugurated by Right Hon. William Hutt MP in front of a large crowd in which 'every class was well and truly represented'. The speeches concentrated on how the working classes 'under his control' had been most fulsome in their commitment to the memorial. An amusing song was written at the time by a 'young fellow' and set to a popular tune, ending 'May Gyetsed flourish, an then we'll see / Mair Moniments iv Gyetsed'.[6]

A photograph exists of the monument listed in 'Clasper Street and St Cuthberts developments', though it is unclear where this was exactly.[7] Thus it may have been moved twice since its original unveiling.

By early 1999 the marble figure had become badly corroded and stained black, whilst the pedestal was in a similarly poor condition, and the statue was removed by the GMBC for badly needed conservation; it will be returned to the same site which is being re-landscaped with new housing and open space.

[1] *Gateshead Observer,* 7 October 1865. [2] Lumley, D., *The Story of Gateshead Town,* Newcastle, 1932, p.113. [3] *Gateshead Observer,* 24 October 1863. [4] Manders, F.W.D., *A History of Gateshead,* Gateshead, 1973, pp.326–7. [5] *Gateshead Observer,* 17 October 1863. [6] *Gateshead Tracts,* vol.1, no.40. [7] Hardy, C., *Gateshead in Focus,* Huddersfield, 1990, ill.111.

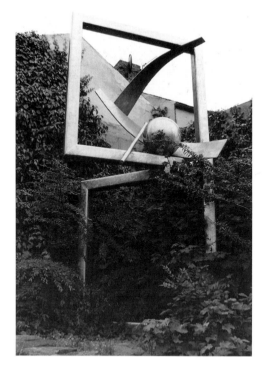

Junction with Rawling Road, next to Whickham House pub

Window

Sculptor: Colin Rose

Unveiled 9 October 1986
Whole work: stainless steel 5.6m high × 2.8m wide
Status: not listed
Condition: good
Condition details: naturally tarnished surface
Commissioned and owned by: Gateshead Metropolitan Borough Council

Description: steel sculpture standing on a small patch of land once known as a 'pocket park', hard against the side of the Whickham

Rose, *Window*

House pub. Hollow box steel sections form two open squares, one supporting the other. There are also a sphere, curved elements and a rod within the upper square.

History: following the demolition of houses in this area, the site was surrounded by advertising hoardings and used as a car park. The sculpture was commissioned by Gateshead MBC to complement re-landscaping of the corner.[1]

Referring to the work by a longer title of *Window on the World*, Rose stated at the time of installation that he saw it 'as a threshold between inside and outside, a passage of sensed activity'. Early photographs show the site as being very bare, and the sculptor felt that the work should have two viewpoints, one coming up Bensham Bank, the other for pedestrians chancing upon it round the corner. The three-dimensionality of this piece is best appreciated by moving around it.

Costing £7,600, with contributions from Whitbread Brewery, Northern Arts and the Arts Business Sponsorship Association, the sculpture was fabricated by Manpower Services Commission trainees. There was a last-minute rush to get the work delivered on site before its unveiling by Norman Buchan MP.

By the late 1990s encroaching vegetation meant that *Window* was becoming obscured. Gateshead Council therefore remodelled the plot and moved the sculpture about a metre to one side in 1999 to make it easy to see once again.

[1] *Gateshead Art Map.*

Carlisle Street FELLING
Junction of Carlisle Street and Sunderland Road, shop frontage

Victorian Baker's Shop
Sculptor: Neil Talbot

Erected 1986
Whole work: fired ceramic tiles 3.6m high × 4.66m wide
Incised on door lintel: DESIGNED AND MADE BY NEIL / TALBOT DEREK BENT 1986
Status: not listed
Condition: good
Condition details: dirt accumulation has blackened some surfaces
Commissioned and owned by: Gateshead Metropolitan Borough Council

Description: a relief depiction of a Victorian baker's shop extending the whole length of the façade of an ex-baker's shop on a street corner. It is carved to a depth of 4cm and constructed out of dark yellow ceramic tiles. Cakes and buns are shown in the windows and a dog escapes from the front door with a gingerbread man in its mouth.

History: the relief refers to the original use of the corner-shop site. The monochrome yellow 'accentuates the links between ceramics and the baker's produce' and the wealth of detail 'invite passers-by to weave their own story round the shop'.[1] However, it is easy to overlook amongst the surrounding, rather run-down, frontages.

Supported by Northern Arts, *Baker's Shop* is one of the earliest works in Gateshead's public art scheme.[2] The council has indicated that it is due to be cleaned as part of its rolling maintenance programme.

[1] *Gateshead Art Map.* [2] Shaw, P., *The Public Art Report*, London, 1990, p.6.

Talbot, *Victorian Baker's Shop*

Durham Road　　　LOW FELL

Outside Low Fell Post Office

South African War Memorial
Sculptor: Morrison

Erected 1903
Statue: limestone 1.83m high
Pedestal: sandstone 2.6m high × 1.4m wide × 1.06m deep
Incised Roman lettering on polished granite tablet inset into the pedestal: TO / THE MEMORY OF / SERGEANT W. CRONE / AND TROOPERS A. DODD, W.B.S. LEATHART / F. ENGLISH, A.

Morrison, *Low Fell South African War Memorial*

WILLIAMSON / WHO FELL DURING THE SOUTH / AFRICAN CAMPAIGN / 1899–1902 / "FAITHFUL UNTO DEATH" / ERECTED BY / THE INHABITANTS OF LOW FELL / 1903 / THE ABOVE MENTIONED / WERE ALL OF THE / IMPERIAL YEOMANRY
Status: II
Condition: fair
Condition details: missing bayonet on rifle; missing fingers from left hand; face very worn; algae on the north face of the pedestal
Commissioned by: public subscription
Custodian: Gateshead Metropolitan Borough Council

Description: a tapering cyclopean pedestal on a rusticated base supports a statue of a soldier in Boer War uniform standing in the easy position facing east towards the Durham Road.

History: the inscription was repaired and restored by Gateshead Council at a cost of £50 in 1967[1] and the rifle was replaced after it was broken off by vandals in 1986.

[1] *Gateshead Post*, 27 January 1967.

East Park Road　　　SALTWELL

Saltwell Park: pathway above grassed area to south of lake

Monument to John Lucas
Sculptor: W. Grant Stevenson

Unveiled 11 May 1903
Statue: bronze 2m high × 60cm deep
Pedestal: sandstone 1.64m high × 84cm square
Incised in Roman lettering on pedestal front dado: ALDERMAN / JOHN LUCAS / BORN DECEMBER 7TH 1837, / DIED AUGUST 2ND 1900. / ERECTED / BY PUBLIC SUBSCRIPTION / 1903
Signed on pedestal right dado: W.G. Stevenson r.s.a. / 1902
Status: II
Condition: fair
Condition details: chips on edge of pedestal

Stevenson, *Lucas Monument*

cornice; pedestal flaking particularly on inscription; statue and pedestal blackened by weathering
Commissioned by: public subscription
Custodian: Gateshead Metropolitan Borough Council

Description: Lucas is depicted standing in his mayoral robes on top of a yellow sandstone pedestal with triangular pediment and plain cornice.

Subject: John Lucas (1837–1900) was a vice-president of the Northern Reform League and colleague of Joseph Cowen (see pp.152–3). An advanced Liberal Unionist, he stood as

parliamentary candidate for Gateshead in 1895, but was defeated. In 1888 and 1889 he was elected Mayor of Gateshead and was long-standing chairman of the Dredging and River Works Committee for the Tyne. It was said that 'none can dispute his earnestness in any good cause'.[1]

History: the statue was raised by public subscription in honour of Lucas's prominent position in town life. A large crowd attended the unveiling ceremony, originally to be performed by Earl Grey, though he was too ill to attend. Alderman Richardson of Newcastle took his place and said that Lucas was 'a man who walked in the humbler spheres of life and yet exhibited a devotion to duty worthy of recognition, imitation and praise'.[2]

A bid to the Heritage Lottery Fund is being formulated for the regeneration of Saltwell Park in 1999, which will include provision for the restoration of Lucas's memorial.

[1] *Northern Worthies*, Gateshead, vol.4. [2] *Daily Chronicle*, Gateshead, 11 May 1903.

Prince Consort Road TOWN CENTRE
Shipley Art Gallery, portico roof

Allegories of Learning and Art
Sculptor: not known
Architect: Arthur Stockwell

Building opened 1917
Both figures: stone 1.6m high × 1.4m square
Status: II
Condition: fair
Condition details: encrusted with green algae
Commissioned and owned by: Gateshead Metropolitan Borough Council

Description: two seated figures set on thick bases at the corners of the Doric-columned portico roof. The male figure represents *Industry and Learning*. He holds a book and there is a naked cherub carrying a cog seated at

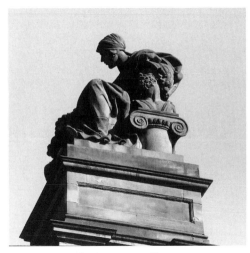

(above) *Art*, Shipley Art Gallery

(right) *Learning*, Shipley Art Gallery

his feet. The right-hand figure represents *Art*: she holds a quill as if to write, and a cherub offers up a scroll. To her right, a male bust is depicted on top of an Ionic capital and a palette rests at her side.

History: Newcastle solicitor J.A.D. Shipley (?–1909) bequeathed a collection of 2,500 paintings to Newcastle on the understanding that the city would build a gallery to house them. The works turned out to be copies rather than genuine old masters and the bequest was rejected by Newcastle Council. The collection defaulted to Gateshead in 1912 which built the art gallery in 1914–17, selling half of the works to help pay for it.[1] Designed by Arthur Stockwell in a neo-classical style, the Shipley Art Gallery is now part of Tyne and Wear Museums Service and its displays concentrate on local manufacturing output and craft-based exhibitions.

These two figures make obvious reference to the Shipley's role as an art gallery and cultural resource. The building is due for extensive renovation and it is expected that the figures

will be cleaned as part of this programme.

[1] Manders, F.W.D., *A History of Gateshead*, Gateshead, 1973, p.262.

Shipley Art Gallery, left of main entrance

Monument to James Renforth
Sculptor: George Burn

Erected *c.*1871; re-erected 1992
Group of figures and base: sandstone 80cm high × 1.85m wide × 1m deep
Sarcophagus: sandstone 52cm high × 1.89m wide × 1.04m deep
Pedestal: sandstone 1.42m high × 1.89m wide × 1.04m deep
Incised Roman letters on base of north face of statue: IN THE MIDST OF LIFE, WE ARE IN DEATH.
INCISED ROMAN LETTERS ON NORTH FACE OF PEDESTAL: ERECTED / BY PUBLIC SUBSCRIPTION / TO THE MEMORY OF / JAMES RENFORTH, / OF GATESHEAD; CHAMPION SCULLER OF THE WORLD

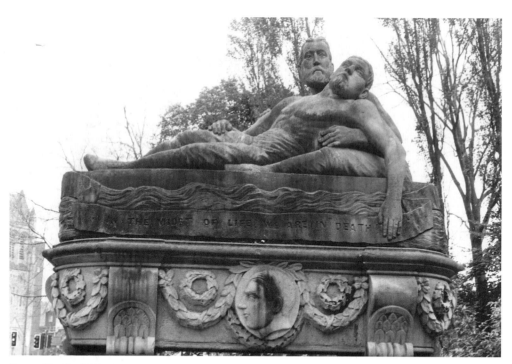

Burn, *Renforth Monument*

John's in Canada on the St Lawrence River winning for themselves a stake of £1,000. As a song of the time put it, 'An' Renforth, a brave hardy Son o'the North's / Browt the Championship back to the Tyne'.[1]

The next summer, after being seen off from Newcastle Central Station by a crowd of 3,000, Renforth again crossed the Atlantic to take on a North American crew, this time on the Kennebeccassis at New Brunswick. However, tragedy struck. During the race he collapsed into the arms of his crewmate, Henry Kelly, and died soon afterwards. 'The oar dropped from his stricken hand, his brawny arm fell like a withered branch in a storm.'[2] With huge prize money and bets at stake there was much talk of foul play, prompted in part by his dying words which seemed to refer to poisoning, 'It's not a fit, Harry. I've had somethin'.' In fact Renforth died of a heart attack and his words were a reference to the epileptic attacks from which he suffered. His body was brought back to Gateshead and buried in Gateshead East Cemetery, over 100,000 people lining the route of the funeral procession.

History: George Burn's elaborate monument is similar in its treatment of the figure to his earlier monument to Robert Chambers at Walker (see p.138). After it was vandalised in the mid-1980s Gateshead Council removed it from the cemetery and put it in storage. A number of sites were then considered including one at Dunston Staithes where the 1990 National Garden Festival was held. Eventually, it was installed in front of the Shipley Art Gallery in 1992, in what was decribed as 'a protected but visually pleasing location'.[3]

[1] Quoted in Dillon, P., *The Tyne Oarsmen. Harry Clasper, Robert Chambers, James Renforth*, Newcastle, 1993, p.36. [2] *Newcastle Daily Chronicle*, 24 August 1871. [3] *Gateshead Post*, 19 December 1991.

/ WHO DIED AUGUST 23RD 1871, AGED 29 YEARS, / WHILE ROWING IN AN INTERNATIONAL BOAT RACE / BETWEEN THE ENGLISH AND AMERICAN CREWS / ON THE KENNEBECASSIS RIVER NEAR ST JOHNS. N.B.
Incised in Roman letters on the base of the south face of the statue: KENNEBECASSIS
Signed: G.BURN.SC.
Status: II
Condition: good
Condition details: sculpture covered in algae; graffiti inked on east face of pedestal
Commissioned by: public subscription
Custodian: Gateshead Metropolitan Borough Council

Description: a sculpture of two seated rowers in a racing boat posed as if in a *Pieta*, Renforth slumped against the bearded Harry Kelly. Both men are bare-chested. The boat in which they sit rests on a sarcophagus decorated on each face with laurel garlands, with a roundel relief profile of Renforth on the reverse. Supporting the sarcophagus is a pedestal decorated with relief stars and rampant lions (symbols of Canada and England).

Subject: James Renforth (1842–71) was born at Rabbit Banks, Gateshead. A tall, muscular man, he first found employment as a smith's striker on Tyneside and as a soldier in the West Indies before becoming a boatman and professional sculler. In November 1868 he enjoyed his first great victory, over Henry Kelly of Putney in the World Sculling Championship. Two years later his four beat a crew from St

Junction with Durham Road

Gateshead War Memorial

Designer: J.W. Spink
Sculptor: Richard Goulden
Foundry: A.B. Burton, Thames Ditton

Dedicated 14 May 1922
Cenotaph: Heworth Burn Blue stone 10m high × 4.2m wide
Relief and door: bronze 2m high × 94cm wide
Incised over door in Roman letters: MORS JANUA VITAE [death is the gate of life]
Incised on block above this: IN MEMORY OF THE PEOPLE OF GATESHEAD / WHO MADE THE SUPREME SACRIFICE / FOR THEIR COUNTRY.
Relief lettering on bronze door: CAPUT INTER NUBILA CONDIT / IN THIS CHAMBER / ARE RECORDED THE / NAMES OF MEN OF / GATESHEAD WHO / GAVE THEIR LIVES / IN THE GREAT WAR / 1914–19 / THEIR NAME / LIVETH FOR / EVERMORE
Incised bottom left of cenotaph: J.W. SPINK / ARCHITECT
Status: II
Condition: good
Condition details: staining on bronze panels
Commissioned by: public subscription
Custodian: Gateshead Metropolitan Borough Council

Description: an imposing cenotaph at the junction of two main roads. Two Ionic pilasters frame Goulden's Art Deco-style bronze relief of a warrior. The bronze door has Gateshead's coat of arms in relief above the lettering. The walls behind bear standard inscriptions to the memory of those killed in the First and Second World Wars. Inside is a room of remembrance with a lectern upon which the book of names is always open.

History: a public meeting held in 1920 decided to raise a subscription for a War

Goulden, *Gateshead War Memorial* (detail)

Memorial, which should take the form of a cenotaph. £5,500 was raised and special note was made of the 9,232 people who made donations in a house-to-house collection and of the 20,000 children who did so through their schools.

The Souvenir Programme states that the happy end to 'the most terrible War … calls us to make the Memorial of such an impressive character as will keep before the eyes of future generations the knowledge of great deliverance'. The strong lines and Art Deco relief fulfil this function admirably, the bronze warrior depicting 'our "Manhood" in an attitude of "Defence", strong, motionless and unconquerable'.

Full details of the Service of Dedication are provided in the Programme along with a 'Retrospect and Reminder' by the noted local historian, John Oxberry.[1]

[1] *Souvenir Programme: Opening Ceremony of the Gateshead War Memorial*, Gateshead, 1922, *passim*.

Regent Street TOWN CENTRE

In grounds of Civic Centre, facing onto Regent Street

The Family

Sculptor: Gordon Young

Unveiled 9 October 1991

Young, *The Family* (detail)

Young, *The Family* **(detail)**

Young, *The Family* **(detail)**

Each figural group: Shap limestone 2.8m high ×
1.9m square (maximum)
Status: not listed
Condition: good
Commissioned and owned by: Gateshead
Metropolitan Borough Council

Description: three sets of paired figures
carved out of crystalline rock in a naïve style,
sited in a landscaped area fronting Gateshead's
Civic Centre. The groups reflect relationships
in the principal stages of life: childhood,
maturity and old age. There is a mother leaning
over to kiss her child; a man and a woman
together; and a man with his arms around an
older woman. Some surfaces have been given a
smooth finish, others are left rough, whilst
natural rock features such as quartz have been
left to provide interesting textures and colour
contrasts.

History: despite the sculptor's assertion that
'the essential content of the piece is that of
human affection',[1] the unveiling by Michael
Ignatieff was accompanied by protestors
complaining that money had been wasted and
homosexuality was not represented.[2] There
were many adverse letters in the press at the
time, one saying that the work 'resembles a
turtle being raped by a dwarf'.[3] However, the
sculptures have been left alone by vandals and

are now an accepted part of Gateshead.[4] *The
Family* cost £28,000, with £18,000 from the
council and £10,000 contributed by the Henry
Moore Foundation and Northern Arts. The
council periodically treats the stone surfaces
with a wax under the supervision of the
sculptor.

[1] *Evening Chronicle*, 15 October 1991. [2] *Ibid.*, 9
October 1991. [3] *Northern Echo*, 9 October 1991.
[4] *Gateshead Art Map.*

Riverside Sculpture Park

Gateshead's 'Riverside Sculpture Park' runs
along the banks of the Tyne west of the Tyne
Bridge, covering a previously derelict and
uninviting area that was once the site of iron
foundries and loading staithes. The area was
targeted for regeneration in the early 1980s
when *Bottle Bank* was commissioned as the
first sculpture to be installed in a
transformation process which has seen the
riverside turned into a wooded area popular
with joggers and fishermen. The 1990
Gateshead Garden Festival site at Dunstan
prompted further concentration on the river
frontage and a total of seven sculptures, as well
as *Phoenix Cobbles* mosaic by Maggie Howarth
on the road above *Once Upon A Time...*, had
been installed by 1999. With the regeneration of
Gateshead Quays further to the east, the
development of the Baltic Centre for
Contemporary Art and pubs nearer to the
Swing Bridge, it is expected that the Sculpture
Trail will continue to be the focus of re-
landscaping well beyond 2000.

Bottle Bank, along line of path

Bottle Bank

Sculptor: Richard Harris

Unveiled October 1986
Whole work: stone and steel 3.1m high × 1m

wide × 5.2m long
Status: not listed
Condition: good
Commissioned and owned by: Gateshead
Metropolitan Borough Council

Description: a number of stone piers on either side of a path, each with a steel beam arching out over the path. The height of the piers increases towards the centre of the work and the beams join up to form complete arches at this point. The work follows the line of the path for 50 metres and is mostly hidden by trees.

History: in 1982 Harris submitted a proposal to Newcastle City Council for 'a unique walk-in sculpture which would have looked like an upturned boat'.[1] This was narrowly rejected by the council's development control sub-committee, but he was subsequently invited by Gateshead to draw up ideas for a work to be sited between the High Level and Tyne bridges.[2] The artist had recently returned from Australia, and the design for *Bottle Bank* follows on from his work there which had close affinities with landscape and nature. Preparatory sketches for the sculpture are of structures which bear close resemblance to animal skeletons, but the stone buttresses were always intended to relate specifically to the piers of the two nearby bridges.[3] The sculpture follows the line of a footpath on the side of a 1 in 3 embankment, and the aim of the project was to 'invite exploration along the new path and to create a different experience walking through the sculpture'.[4]

Costing £6,400 to fabricate, *Bottle Bank* was funded by Northern Arts and sponsored by British Steel and International Paints, amongst others. Harris was assisted by Colin Rose and around 30 Manpower Services Commission trainees. Work on the project took four years to complete,[5] leading to some criticism of the delay.[6] However, the extended construction

period was due to a combination of factors: the scale of the civil engineering requirements; the trainee workforce; restrictions on budget; and Harris's absence in London creating a work for the South Bank (*Passage Paving*, 1983–4). *Bottle Bank* was eventually unveiled by Norman Buchan, shadow minister for the arts, as part of Gateshead's launch of 'Art in Public Places'.

Bottle Bank is built on the oldest part of Gateshead which had been an area of slums until clearance in the 1920s. Harris attached great importance to the site, which is evident in the way the arching steel forms reflect the Tyne Bridge in particular, and the way that the piece follows the curve of the hill. 'My aim is to present something that seems to "belong", yet which is outside normal experience,' he stated. The work is almost completely obscured from the road in high summer, but a clear path runs

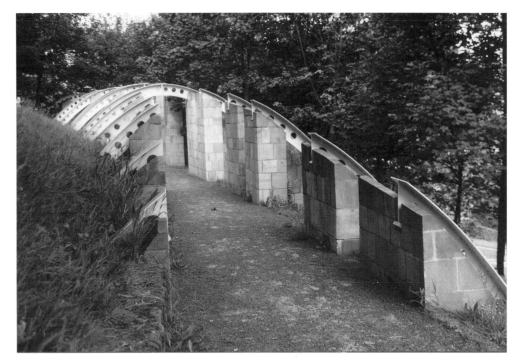

Harris, *Bottle Bank*

right through the middle of it, continuing on to other sculptures further down the riverside.

[1] *Evening Chronicle*, 24 May 1982. [2] Hooper, L., 'The Urban Grizedale', in Davies, P. and Knipe, T. (eds), *A Sense of Place*, pp.158–64. [3] Information provided by the artist, 1999. [4] Davies, P. in Harris, R., *A Space for Dreaming*. [5] *Northern Post*, 27 January 1994. [6] *Journal*, Newcastle, 24 January 1985.

Pipewellgate, amongst trees on bank above the road

Cone
Sculptor: Andy Goldsworthy

Installed 1990

Whole work: steel 2.7m high × 1.8m diameter
Status: not listed
Condition: good
Commissioned and owned by: Gateshead Metropolitan Borough Council

Description: a cone constructed out of layers of thin steel plate which have naturally oxidised to rust red. The sculpture is covered in a layer of cobwebs, fallen leaves and other dirt from the surrounding woodland.

Based on a fir cone, this is one of a number of similar pieces by Goldsworthy made from a variety of materials and sited in France, South Australia and Dumfriesshire[1]. The artist stated that 'the scrap steel cone stands on the site of an old foundry and touches the nature of an urban environment. This cone draws strength and meaning from the nature of steel, city and a site that is now grown over and wooded, where not so long ago people lived and worked.'[2]

History: costing £34,000, *Cone* was funded with the support of Northern Arts. In 1994 thieves attracted national press attention when they were caught removing much of the metal to sell as scrap.[3] The repairs cost a further £5,000.[4]

Cone is sited deep in a wooded area above Pipewellgate and is initially difficult to spot. However, once up close, its colour and scale seem a fitting addition to this little visited part of the riverside.

[1] *Gateshead Art Map.* [2] Goldsworthy, A., *Stone*, 1994, pp.35–6. [3] *The Times*, London, 14 January 1994. [4] *Northern Echo*, 14 January 1994.

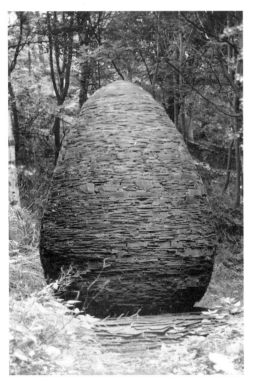

Goldsworthy, *Cone*

Pipewellgate, in bushes on southern banks of road

Goats

Sculptor: Sally Matthews

Installed 1992
Each goat: steel, concrete, scrap metal 1m high × 1.7m long
Status: not listed
Condition: good
Condition details: naturally oxidised surfaces and dirt accumulation
Commissioned and owned by: Gateshead Metropolitan Borough Council

Description: six goats constructed out of scrap metal, 'grazing' above the road. Their forms are lost among the bracken and bushes, but depending on the time of year can be picked out from the undergrowth above the road.

History: the name Gateshead is derived from 'goat herd', and there used to be a flock of wild goats grazing on this hillside in times gone by. The goats, which were made from industrial

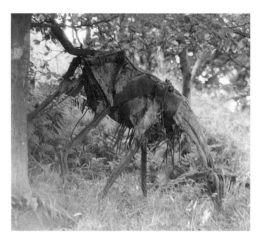

Matthews, *Goat*

scrap, were the result of Matthews's observation of animals at Bill Quay Community Farm. Costing £3,000,[1] they were funded with support from Northern Arts.[2] Matthews had previously made some goats for the 1990 Gateshead Garden Festival, which may explain why she was awarded the project. At that time she said, 'I try to make my animals as close to their true nature as I can through study and experience. Goats are inquisitive, agile and mischievous beasts, greedy for any scrap of food.'[3]

Matthews returned to Gateshead in 1999 to remove and refurbish the *Goats* before re-siting them on the same stretch of bank.

[1] *Gateshead Post*, 27 January 1994. [2] *Gateshead Art Map.* [3] *Festival Landmarks*, p.31.

Pipewellgate, amongst trees on bank

Rolling Moon

Sculptor: Colin Rose

Installed April 1990
Whole work: steel 11m high × 27m span
Raised lettering at base of eastern strut: Rolling Moon

Status: not listed
Condition: good, though some surface chips near ground level
Commissioned and owned by: Gateshead Metropolitan Borough Council

Description: a highly polished arch made of box steel and covered with silver-coloured aluminium paint. The title refers to a 1.3-metre-diameter ball 'balanced' at the apogee of the curve.

History: Rolling Moon was originally designed for a lake at the 1988 Glasgow Garden Festival.[1] It was subsequently re-sited by Gateshead MBC at its new Riverside Sculpture Park. The sculptor stated at the time of its installation that he 'had done a lot of work on the tides and the weather and the rolling moon fits in with that'.[2] The arc of the moon refers to its effect on the daily rhythm of the river or the seasons, suitable subjects for this location.

Rose envisaged that its site in Gateshead would span some housing near the centre,[3] but it is well situated emerging from the woodland on the south bank of the Tyne and is clearly visible from the Newcastle side across the water. Walking along the sculpture trail, its

Rose, *Rolling Moon*

sheer size comes as something of a surprise.

The £20,000 cost of *Rolling Moon* was sponsored by British Steel, Federation Brewery, International Paint plc, Mowlem Northern, Metal Spinners (Newcastle) Ltd, Spartan Redheigh Ltd, Northern Arts and ABSA. The steel is repainted every two years or so to maintain its shiny appearance.

[1] Murray, G. (ed.), *Art in the Garden: Installations*, Glasgow Garden Festival, Edinburgh, 1988, pp.90–1. [2] *Evening Chronicle*, 17 April 1989. [3] Rose, C., Lecture, Newcastle University, 1997.

Pipewellgate, on bank of Tyne
Gravel Artwork
Designer: David Tremlett

Installed 1991
Whole work: gravel 90m long × 8m wide
Status: not listed
Condition: good
Condition details: weeds grow through the gravel in several places
Commissioned and owned by: Gateshead Metropolitan Borough Council

Description: an expanse of pink and grey gravel in a linear abstract pattern, laid out along a grassed area beside the Tyne.

There is a strong resemblance between *Gravel Artwork* and designs in an exhibition of pastels by Tremlett in 1989 at London's Serpentine Gallery.[1] Known also by its variant title of *Flower Bed*, the abstract composition 'suggests nature tamed and domesticated in formal gardens'.[2] The work was in fact originally planned to consist of flower planting but gravel was substituted to ensure longevity. Whilst the design of *Gravel Artwork* can be seen on site, it is better appreciated when viewed from a little way off, for instance from the Newcastle side of the Tyne or from the bridges above.

Tremlett, *Gravel Artwork*

History: Gravel Artwork was commissioned as part of the first *Tyne International* exhibition of site-specific public art at the time of the 1990 Gateshead Garden Festival, funded by Gateshead MBC and Northern Arts, although it was only installed after the Festival had closed.[3]

[1] Tremlett, D., *1,9,8,7 Front Side*, London, 1989. [2] *Gateshead Art Map*. [3] Information provided by Anna Pepperall, GMBC, 1999.

Tyne Road East: Wall (former bridge abutment) facing over Tyne
Once Upon a Time...
Sculptor: Richard Deacon

Installed 1992
Whole work: mild steel 5.5m wide × 5.5m high × 3.3m deep
Status: not listed
Condition: fair
Condition details: flaking paint with rust showing through underneath
Commissioned and owned by: Gateshead Metropolitan Borough Council

Description: a pale green base plate, angled slightly off the vertical, with six reddish brown plates at right angles to it, all in Deacon's signature curvilinear style.

Representing 'the demise of heavy industry in the region'[1] the relationship of *Once Upon a*

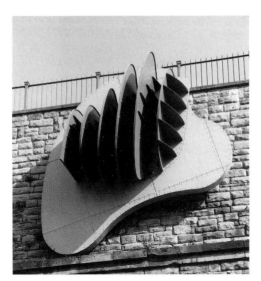

Deacon, *Once Upon a Time...*

Time... to the demolished bridge is claimed to 'hint at how industrial history can be fictionalised through the credibility gap' created by the lean of its structure away from the brick abutment.[2] There is some affinity between the brown vertical elements and the six bridges over the Tyne, whilst the green section could refer to the 'greening of the once industrial southern bank of the Tyne'.[3]

History: Once Upon A Time... was built by trainee metal workers and fabricated out of steel coated in marine paints.[4] Sited on the abutment of the former Redheugh Toll Bridge which had been demolished in the 1980s, it is best viewed either from the northern side of the river or from the Gateshead bank beneath it, though it can be approached at bridge level. Funding for *Once Upon A Time...* was provided by Northern Arts and Gateshead MBC and the council repaints the sculpture every two years or so.

[1] *Gateshead Post*, 27 January 1994. [2] *Gateshead Art Map*. [3] Usherwood, P., 'Deacon and Wodiczko on Tyneside', *Art Monthly*, February, 1991. [4] Ayris et al., p.70.

Walkway near east end of Dunstan Coal Staithes

Axiom

Sculptor: Hideo Furuta

Installed 1997
Whole work: white granite blocks on a bed of basalt chips 15m long × 8m wide × 1.6m at highest point
Status: not listed
Condition: good
Commissioned and owned by: Gateshead Metropolitan Borough Council

Description: sixteen blocks of white granite placed on a basalt gravel base at this isolated site near to Dunstan Staithes. Set in rows, many of the blocks are roughly cut, though others have been carved into wave patterns, and two are cylindrical.

With a form reminiscent of architectural fragments, the loose affinity between the blocks of the sculpture and the surrounding post-industrial landscape has been described as a 'force field'.[1] Furuta stated that, 'before starting the work I only have a vague idea, totally out of focus. From the nature and character of the form to the surface finishing, I do what the

Furuta, *Axiom*

stone is telling me.'[2]

History: the white blocks were provided by Tarmac Roadstone and weigh 80 tonnes in total. A computerised drawing of the artist's concept shows that he originally had in mind a black and white arch of granite which would span the other elements.[3] This has never been put in place though negotiations continue with the artist about completing the work.

The sculpture's site is a considerable walk westwards from the town centre along the river front. The formality of *Axiom* in such an isolated location is conducive of a spirit of contemplation, in keeping with Furuta's mystic outlook.

[1] *Gateshead Art Map*. [2] Gateshead MBC, Gateshead MBC Publicity, n.d. [3] Gateshead Libraries and Arts, *Introducing Art for Public Places*, Gateshead, n.d., p.6.

West Park Road SALTWELL

Saltwell Park, grassed area to south of Manor House

South African War Memorial

Sculptor: Francis William Doyle Jones

Unveiled October 1905
Peace: bronze 2.1m high approx
Pedestal: granite 3.2m high × 73cm wide
Base: granite 64cm high × 1.36m wide
Black raised letters on west face: SOUTH AFRICAN WAR / 1899–1902 / IN GRATEFUL REMEMBRANCE OF THE / GATESHEAD MEN WHO LOST THEIR / LIVES IN THEIR COUNTRY'S SERVICE. / THIS MEMORIAL WAS / ERECTED BY THEIR FELLOW / TOWNSMEN, OCTOBER 1905 / HOW SLEEP THE BRAVE WHO SINK TO REST / BY ALL THEIR COUNTRY'S WISHES BLEST, / BY FAIRY HANDS THEIR KNELL IS RUNG / BY FORMS UNSEEN THEIR DIRGE IS SUNG / COLLINS – LINES IN 1746.

Other faces: [regiments and names]
Signed on right base of sculpture: F.W. DOYLE-JONES.
Status: II
Condition: good
Condition details: statue naturally patinated green and black and the column is dirty in places
Commissioned by: public subscription
Custodian: Gateshead Metropolitan Borough Council

Description: a bronze figure of *Peace* holding out a wreath in both her hands surmounts a tapering grey granite column. This has a cartouche and drapery carved on each side at the top, beneath a capital consisting of wreaths and scrolls. The whole is set on two steps which lead up to a tapering base with palmate carving around the top edge.

History: 900 men were sent to the South African front from Gateshead and 77 are listed on this memorial as not having returned. In 1904 the Parks Committee sought permission to erect a memorial in Saltwell Park, which was duly granted.[1] Unveiled by Lieutenant General Sir John French, the bronze figure of *Peace* was described in a 1977 Council report as 'the most singularly fine statue in the Borough'.[2]

A finely-produced Souvenir Programme describes the Service of Dedication and gives details of the Memorial's design.[3] Speeches were made in memory of the fallen and the Mayor accepted the memorial, 'promising it would be preserved with veneration and care, and as sacredly kept in memory of these fallen heroes as if they lay buried in its base'.[4] The structure was repaired by the council in 1967.[5]

[1] *Daily Chronicle*, Gateshead, 7 January 1904.
[2] Gateshead MBC, *War and Other Memorials: Report of a Survey*, Gateshead, 1977, *passim*.
[3] *Gateshead South African War Memorial Official Souvenir*, Gateshead, 1905, *passim*. [4] *Northern Mail*, Tyneside, 13 November 1905. [5] *Gateshead Post*, 27 January 1967.

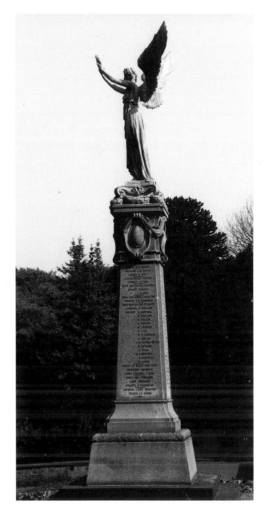

Jones, *Gateshead South African War Memorial*

Saltwell Park, to west of Mansion building

George Charlton Memorial Drinking Fountain

Designer: not known

Installed *c.* 1886
Base and steps: stone 1.4m high × 1.6m wide
Structure: stone and pink granite 2.95m high × 97cm wide
Each fountain: grey granite 60cm high × 70cm wide
Reliefs: marble each 40cm diameter
Incised on roundel on rear (north) face: TO GEORGE CHARLTON, ESQ, J.P. / MAYOR / OF GATESHEAD / 1874 AND 1875; / IN RECOGNITION / OF HIS LABOURS IN THE / CAUSE OF SOCIAL / REFORM
Status: II
Condition: poor
Condition details: missing metal spouts; stonework broken and missing in many areas; considerable spalling of stone surfaces on all sides; dirty; algal and lichen growth especially near base
Commissioned by: public subscription
Custodian: Gateshead Metropolitan Borough Council

Description: an ornate Gothic-style drinking fountain. The main structure is flanked by heavy granite drinking troughs topped by miniature pink marble columns (one missing). Above rises a spire with reliefs of sunflowers, roses, lilies and ferns. This was originally surmounted by a weathervane. Soft white marble reliefs are inset in three sides of the memorial, one being a deeply carved bust of Charlton (badly weathered), and the other two are Gateshead's coat of arms.

Subject: George Charlton (1808–85) followed his father into the butcher's trade in Newcastle. He became involved in the temperance movement and was an active

member of the 'Newcastle Teetotal Society' at a time when hard drinking was a widespread problem.[1] Later in life he moved to Bensham in Gateshead and was elected Mayor two years in a row, subsequently becoming an Alderman and JP. His death was widely mourned in the Borough.[2]

History: it is assumed that the fountain was installed soon after Charlton's death. A forthcoming bid to the Heritage Lottery Fund for the regeneration of Saltwell Park includes a proposal for the restoration of the memorial fountain.

[1] Walton, C.R., *Old Gateshead (collection of articles)*, vol.3, 29 August 1947. [2] *Newcastle Daily Chronicle*, 16 September 1885.

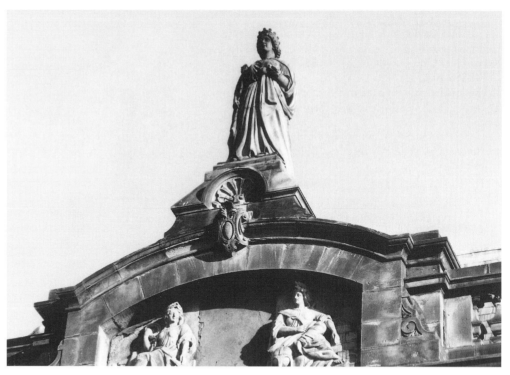

Johnstone, *Gateshead Town Hall* (detail)

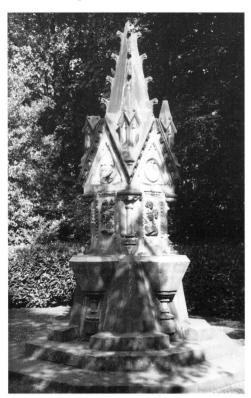

Charlton Fountain

West Street TOWN CENTRE
Old Town Hall, pediment

Queen Victoria and *Personifications of Arts and Industry*

Sculptor: not known
Architect: John Johnstone

Building opened 1870
Queen Victoria: stone 1.9m high × 60cm wide
Personifications: stone 1m high × 2m wide
Status: II
Condition: fair
Condition details: statue of Queen Victoria is dirty; reliefs are chipped and crumbling at edges

to supporting stonework
Commissioned and owned by: Gateshead Town (subsequently Metropolitan Borough) Council

Description: a Venetian Renaissance-style building decorated with relief floral motifs and goat heads, with coats of arms midway up Ionic pilasters.[1] The giant architrave has three Symbolist relief heads and the rounded pediment in the middle of a balustrade carries relief carvings of two female Personifications. The left-hand figure holds an anchor and coiled rope and is crowned with a laurel wreath (*Maritime Industry*); the right-hand figure holds a long quill pen and sits in front of a pile of packages (*Arts*).

A free-standing statue of Queen Victoria surmounts the roof. Carved in a fairly brusque manner, she is depicted as a young woman in a loose robe, holding an orb and sceptre.

History: built 1868–70 and costing £12,000, the Town Hall was opened amid great ceremony with the sculptural embellishments in place.[2] Typical of Victorian civic buildings, the decorations illustrate the borough's relationship to industry (the basis of its wealth), the arts (evidence of its cultural qualities) and the country, personified by the statue of Queen Victoria.

It is not a large building in comparison with many town halls, and the pedimental decorations are relatively restrained in character. A renovation scheme is being considered which would include cleaning of the sculptural embellishments.

[1] Pevsner, *Co. Durham*, p.286. [2] Manders, F.W.D., *A History of Gateshead*, Gateshead, 1973, p.46.

Junction with pedestrian walkway to Ellison Street

Maccoy Memorial Drinking Fountain

Designer: not known

Erected 1915
Whole work: pink granite 2.5m high × 60cm square
Incised in gilded lettering on east dado face:
1915 / THIS FOUNTAIN WAS / PRESENTED / TO THE PUBLIC BY / COUNCILLOR JOHN MACCOY / IN MEMORY OF HIS / LATE WIFE / REBECCA / MAYORESS OF GATESHEAD / 1912–13 1913–14
Status: II
Condition: good
Commissioned by: John Maccoy
Custodian: Gateshead Metropolitan Borough Council

Description: a four-sided fountain of polished pink granite on an octagonal plinth. A bowl is set on each side but the taps are no longer in place and the fountain does not work. Each face is topped with scalloped moulding and a triangular pediment, the whole is surmounted by an urn.

History: details of the commission are given in the freshly gilded inscription which indicates that the fountain has been renovated in the recent past.

Interchange Centre, pedestrian area in front

Sports Day

Sculptor: Mike Winstone

Unveiled 19 December 1986
Whole work: concrete with polystyrene core 3m high × 4m square
Metal plaque reads: SPORTS DAY / by / MIKE WINSTONE / unveiled by / BERNARD CRIBBINS / 19 DECEMBER 1986 / The sculptor has taken Gateshead's international / reputation for sport as his theme. His interpretation of / sport is a broad one. Using the Egg and Spoon and / Sack Races of childhood, and Aesop's Fable of the / Tortoise, the Hare and the Fox. He reminds us that / sport is more than just winning. / Funded by Gateshead MBC with the help of the / Government's Urban Programme, the Manpower / Services Commission and Northern Arts. Sponsored by / Blue Circle Industries PLC, Sealotach Ltd, and / Sunderland Polytechnic.
Status: not listed
Condition: fair
Condition details: paintwork is chipped, peeling and blistering; generally dirty
Commissioned and owned by: Gateshead Metropolitan Borough Council

Description: a large sculpture of a man with a Mohican-style haircut, carrying a sack on his

Winstone, *Sports Day*

back. A fox, a hare and a tortoise are entwined around him. The work is covered all over with matt black paint.

History: at the time of its unveiling *Sports Day* was thought to be one of the largest outdoor sculptures in Britain, and its bulk still dominates Gateshead's main street.[1] The artist's stated ambition was to show the more playful aspects of Gateshead's association with sporting prowess. The work was carved on site from a polystyrene block, then covered in concrete and originally painted red, green, orange and yellow. However, it attracted criticism from the outset, being set alight three times even before it had been cast, which left Winstone 'heartbroken'.[2] The finished work was eventually unveiled by children's presenter Bernard Cribbins, though too late for the official opening of Gateshead's 'Art in Public

Places' programme. *Sports Day* was painted black in 1991 'to see it through the winter'[3] and has remained like that since.[4]

[1] *Midweek Post*, no.425, 30 September 1986.
[2] *Northern Echo*, 10 October 1986. [3] *Evening Chronicle*, 16 October 1991. [4] Ayris et al., p.72.

Whitehill Drive HIGH HEWORTH
Crest of hill

Windy Nook
Sculptor: Richard Cole

Constructed on site 1986
Whole work: stone blocks and earth 30m long × 15m wide
Status: not listed
Condition: fair
Condition details: some breakage of stonework; generally scruffy condition; graffiti scratched and inked on most parts
Commissioned and owned by: Gateshead Metropolitan Borough Council

Description: a dramatically sited piece of 'land art'. Using 2,500 tonnes of granite reclaimed from the old Scotswood Bridge, the work consists of a number of interlocking stone walls and paving, making what seems to be a fortified position atop the windswept hill.

History: Windy Nook hill is a former pit slag heap, turned into an art work and unveiled as part of Gateshead's Sculpture Week in 1986. It was built with the help of workers on a Manpower Services Commission scheme with sponsorship provided by Northern Arts and a number of commercial and government bodies. Cole was assisted in construction by Ross Winning.

As *Windy Nook* is on an isolated spot high above surrounding housing estates it has inevitably attracted miscreants and vandals from the earliest days.[2] However, the robustness of the stone and earthworks means

Cole, *Windy Nook*

that little damage has been done. Children call the hill-top sculpture 'the fortress' and this is a popular area for residents from surrounding estates to exercise in, with a network of paths across the open ground. Gateshead Council have contacted Cole about renovating *Windy Nook* and hope that any necessary work will be undertaken in the not too distant future.

[1] *Gateshead Art Map*. [2] *Journal*, Newcastle, 19 September 1986.

Windy Nook Road HIGH HEWORTH
Tranwell Unit, courtyard within

Inside Outside
Sculptor: Fred Watson

Unveiled 12 December 1995
Whole work: granite 1.56m high × 2m long × 1.33m wide
Status: not listed
Condition: good
Condition details: green algae covers all upper surfaces
Commissioned by: Gateshead Healthcare
Custodian: Tranwell Unit

Description: a white granite sculpture consisting of an arch set at right-angles to a

stairway partly formed from books. A number of objects are carved within the overall composition: a telephone, a tablecloth, a vase and an apple. There is a contrast between the roughness of most of the surfaces and the smoothness of a few finely carved details. The sculpture is set within a small courtyard and is visible immediately upon entering the Tranwell Unit.

Subject: designed to show the delicate balance of mental health,[1] the artist has said that *Inside Outside* 'is an allegory of what is, uncertainly, inside the head or outside in the world'.[2] As such, it reflects its location in the mental health unit of Gateshead's main hospital. Each element of the sculpture has a meaning which relates to the whole: for example, the arch 'is a rational construct associated with social structures... It is shown here in a rather ruinous state.' It also stands for a threshold, which could introduce 'a landscape of the mind'. Smaller objects incorporated into the design imply a certain domesticity.

History: Watson won a competition to make *Inside Outside*, which was commissioned and funded by Gateshead MBC as part of its art programme for the Queen Elizabeth Hospital which also includes stained glass and murals in corridors and public areas.

Watson, *Inside Outside*

Anyone wishing to view the sculpture is recommended to ring the Tranwell Unit in advance on 0191-402 6222.

[1] *Journal*, Newcastle, 13 December 1995.
[2] Information supplied by the artist, 1999.

HEBBURN
South Tyneside MBC

Prince Consort Road
Hebburn Riverside Park, hillside above northernmost car park

Viewpoint Markers and Bench
Sculptors: Matthew Jarratt and Neil Canavan

Installed 1996
Each marker: steel 4m high × 1m wide
Bench: steel 90cm high × 2.4m wide × 80cm deep
Status: not listed
Condition: fair
Condition details: flaking paint and rust patches; all generally dirty; considerable amounts of graffiti scratched into metal
Commissioned by: Tyne and Wear Development Corporation
Custodian: South Tyneside Metropolitan Borough Council

Description: two cut steel sculptures and a steel bench located next to a cycle track crossing the park. Further south are another steel marker and a carved brick sculpture. The yellow- or red-painted markers are set on tall posts and incorporate a compass design surrounded by pictorial motifs inspired by the surroundings, such as a bird, diver's helmet, crane and lighthouse. The bench is painted green and has cut steel animal and plant motifs set into its back.

Jarratt, *Viewpoint Marker*

History: Hebburn Riverside Park was reclaimed from an area that had been used for ship building, alkali works and copper and sulphur factories until the 1970s. A Nature Trail was developed by Durham Wildlife Trust and South Tyneside Groundwork Trust with money from NatWest's Greenspace Initiative[1]. The park was part of Tyne and Wear Development Corporation's remit to regenerate previously run-down parts of the riverside.

Jarratt and Canavan were assisted by pupils from two schools and three community groups in designing the sculptures.[2]

[1] *South Tyneside Star*, 20 October 1994.
[2] Information provided by Matthew Jarratt, 1999.

JARROW
South Tyneside MBC

Ellison Place
Rohm and Haas chemical company, wall outside main entrance

Time Line
Sculptor: Wendy Scott

Unveiled 30 July 1998
Whole work: stainless steel; powder coated steel plate 2.12m high × 8.5m long
Status: not listed
Condition: good
Commissioned and owned by: Rohm and Haas (UK) Ltd

Description: polished and painted steel sculpture attached to a low brick wall. The overall form is abstracted from an amalgamation of the shape of a Viking narrow boat and Palmer's shipyard overhead cranes. Attached to the length of the main structure are five white-painted 'shields' depicting (from left to right): a Roman mosaic; Saxon knotwork; St Paul's Church rose window; Palmer's overhead cranes; and the crystalline lattice structure of salt. Below the shields is a long white-painted section described by the artist as a 'saxon wave'.

History: Groundwork South Tyneside was commissioned to develop an artwork for the renovated main entrance of the Rohm and Haas factory. A working party selected Wendy Scott to create a sculpture which would reflect the history of the site, as well as the views of current residents and workers. The sculpture took 18 months to make, with computers being used to cut the shields and wave. Moving from left to right, the shields refer to ancient history, Jarrow's industrial heritage, and salt as the basis of the present-day chemical plant.

The sculpture was unveiled by the Mayor of

Scott, *Time Line*

South Tyneside and the European Operations Manager for Rohm and Haas. It was jointly funded by Rohm and Haas, the European Regional Development Fund and the Post Office's 'Brightside Scheme'.[1]

[1] Rohm and Haas (UK) Ltd, *Unveiling of the Rohm and Haas Time Line Sculpture*, Jarrow, 1998, *passim.*

Grange Road

Viking shopping centre, exterior

Vikings

Sculptor: Colin Davidson

Unveiled 17 February 1962
Sculpture: concrete, fibreglass and bronze coating 2.6m high × 2.1m wide × 1.4m deep
Pedestal: stone and concrete 1.05m high
Inscribed on metal plaque attached to pedestal wall: THE VIKINGS / THIS SCULPTURE WAS PRESENTED TO THE / BOROUGH OF JARROW / BY / S.H. CHIPPINDALE ESQ. / ON BEHALF OF / THE ARNDALE PROPERTY TRUST / WAS UNVEILED ON 17TH FEBRUARY 1962 / BY / THE WORSHIPFUL MAYOR OF JARROW / COUNCILLOR MRS V.M. HOPE / COLIN M. DAVIDSON SCULPTOR / G.M. BAXTER AND SHINGLER RISBON ASSOCIATES / ARCHITECTS
Status: not listed
Condition: poor
Condition details: right leg of one figure broken; hole in rear of body-join; extensive cracks on both figures; salt stains, surface flaking, exposed interiors; green algae and lichen on upper surfaces
Commissioned by: Arndale Property Trust
Custodian: South Tyneside Metropolitan Borough Council

Description: two Viking raiders wearing helmets and holding shields, set on a high concrete base in front of the shopping centre. The flattened bodyforms are reminiscent of Lyn Chadwick's work of the same period. Whatever the original colour, the sculpture is now a pale dirty brown, with many sections cracked.

History: Vikings was unveiled by Mayor Mrs V.M. Hope at the same time as the shopping centre was opened, with more than 1,000 people in attendance.[1] Locals were unsure as to the artistic merit of the piece, with one report describing the *Vikings* as 'laughable, loveable, yet with a strange majesty that is all their own'.[2] Davidson said he was surprised by the criticism, explaining that the statue was not supposed to have any social significance but was just 'something decorative and pleasant to look at'. The *Journal*'s art critic praised it as a 'good, solid piece of sculpture',[3] and it has become a popular landmark over time.

[1] *Shields Daily News*, 19 February 1962.
[2] *Evening Chronicle*, 26 August 1970. [3] *Journal*, Newcastle, 19 February 1962.

Davidson, *Vikings*

Grant Street

Jarrow Metro station, west-bound platform

Jarrow March

Sculptor: Vincent Rea

Unveiled 28 April 1984
Whole work: silver painted steel plate 2.1m high × 2.5m wide × 3cm thick
Plaque at top left reads: The Jarrow March / by Vince Rea / Officially unveiled by / The Rt. Hon. NEIL KINNOCK M.P., P.C. / Leader of The Labour Party. / 28th April 1984
Status: not listed
Condition: fair
Condition details: graffiti scratched on all surfaces
Commissioned and owned by: Tyne and Wear Passenger Transport Executive (Nexus)

Description: a silver-painted steel sculpture in a 'cut-out' style, depicting the Jarrow March. It shows a group of marchers – men, women and a dog – beneath a banner. The form of the sculpture contrasts well with the pink-coloured wall to which it is attached.

Subject: the use of steel recycled from a scrapped ship makes a poignant link to the plight of the Jarrow Marchers, who walked from Tyneside to London in 1936 to protest about the lack of jobs. 207 men set out on 5 October, led by local MP Ellen Wilkinson, carrying a petition signed by 11,572 people asking for 'necessary active assistance for the provision of work in the town of Jarrow'. They received rousing support as they passed through England, though they were monitored by Special Branch as potential insurrection-aries.[1] Rea's image is adapted from an original photograph and was installed on the fiftieth anniversary of the March.[2]

History: the sculpture's unveiling was part of a weekend visit to Tyne and Wear by Labour

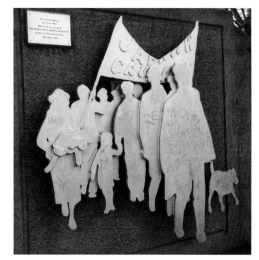

Rea, *Jarrow March*

opposition leader Neil Kinnock, who confidently predicted to a May Day rally, 'I am going to be Prime Minister of this country'. Kinnock first led a 2,000–strong march in Stockton and then went to Jarrow where he warned that the Conservative government was 'recreating the 1930s'. After unveiling the sculpture, he joined Jarrow March veterans on a half-mile commemorative walk from the Metro station.[3]

Co-funded by Northern Arts as part of TWPTE's ongoing 'Art on the Metro' programme.

[1] Nexus, *Public Art in Public Transport*, Newcastle, 1998. [2] Pickard, T., *Jarrow March*, London and New York, 1982, *passim*. [3] *Journal*, Newcastle, 3 April 1984.

Tyne Street JARROW RIVERSIDE PARK

Landscaped area overlooking Tyne

Monument to Sir Charles Mark Palmer

Sculptor: Albert Toft

Inaugurated 1903; re-erected 1982
Sculpture: bronze 3m high
Pedestal: stone 4.5m high × 1.76m square
Inscribed on north face of dado, incised lettering: SIR / CHARLES MARK PALMER / BARONET / BORN AT SOUTH SHIELDS / NOVEMBER 3RD 1822 / FOUNDER OF THE PALMER / WORKS & OF THE TOWN OF / JARROW OF WHICH HE WAS / FIRST MAYOR IN 1875 / ORIGINATOR OF THE FIRST / STEAM SCREW COLLIER / BUILT AT JARROW IN 1851 / MEMBER OF PARLIAMENT / FOR NORTH DURHAM FROM / 1874 AND SUBSEQUENTLY / FOR THE JARROW DIVISION / THIS STATUE ERECTED IN / 1903 BY THE WORKMEN OF / PALMER'S COMPANY & A FEW / FRIENDS COMMEMORATES / A LIFE DEVOTED TO THE / SOCIAL ADVANCEMENT OF / THE WORKING CLASSES, THE / PROSPERITY OF JARROW / & THE INDUSTRIAL / PROSPECTS OF / TYNESIDE
Status: II
Condition: poor
Condition details: three panels missing from east, south and west faces; blackening of stone and bronze surfaces; bronze pitted in areas; green stains from bronze leaching down front of pedestal; inked graffiti at lower levels of pedestal
Commissioned by: public subscription
Custodian: South Tyneside Metropolitan Borough Council

Description: commemorative statue of Palmer in mayoral robes with a scroll in his left hand. The white stone pedestal has Doric pilasters at each corner. The three bronze reliefs which decorated the south, east and west sides have been ripped off; these depicted the ships

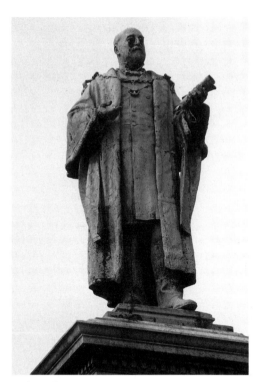

Toft, *Palmer Monument*

John Bowes and *HMS Resolution* and a miner.

Subject: Charles Mark Palmer (1822–1907) was the son of a South Shields shipowner. While still in his teens he started out in business in the coal trade before, in 1851, establishing a shipyard with his brother George in the small colliery village of Jarrow.[1] Commercial success came with the launch of the *John Bowes*, the first seagoing screw collier in 1852 and the development of rolled armour plates for warships during the Crimean War. This ensured the prosperity of Jarrow whose population rapidly rose, from 3,500 in 1850 to over 18,000 in 1872. Always keen to promote the town, Palmer became its first mayor in 1875 and its MP from 1885 until his death.

History: a public subscription for a statue

was begun in 1902 when Palmer reached the age of eighty. Most of the committee and eventual subscribers were Palmer Brothers' employees. On the advice of the art critic M.H. Spielmann, a limited competition was held with the sculptor Thomas Brock acting as judge. Albert Toft won and was so glad to find himself, for once, working from a living model that he eventually decided to make the statue slightly larger than agreed and to produce an extra three bronze relief panels for the pedestal. These depicted two of Palmer's ships, the *John Bowes* and *HMS Resolution*, as well as a pitman going off to work. The overall cost of the work was £2,000. Toft's later *Queen Victoria Monument* at Nottingham (1905) has a pedestal very similar to that of the *Palmer Monument*.[2]

The unveiling was performed by Lady Palmer who was later presented with a silver statuette version of Toft's depiction of her husband. A point made by more than one speaker at the unveiling was how unusual it was to have the subject of a monument on hand to see the work. At the end of the ceremony Sir Charles made a short speech and the band struck up 'For he's a jolly good fellow'.

In his speech at the unveiling, Spielmann expressed the hope 'that Jarrow having obtained a splendid statue the people would know how to keep it, and that, unlike London and other great cities, they would turn the fire hose upon it once a month, so that the atmospheric acid of Jarrow would not injure it. If that was done it would last to all eternity.'[3] Sadly this was not to be. The statue originally stood in the Palmer Memorial Hospital but was moved to its present isolated position in 1982, and was subsequently badly vandalised. In 1997 there was a call for Lottery funding to restore it at a cost of £60,000, but this appears to have come to nothing.

[1] Rea, V., *Palmer's Yard and the Town of Jarrow*, Jarrow, 1975, *passim*. [2] Beattie, p.206. [3] *Journal*, Newcastle, 1 February 1904.

<div style="background:gray">

KIBBLESWORTH
Gateshead MBC

</div>

Over 30 sculptures have been sited in the rural area around the village of Kibblesworth since 1992 as part of the 'Marking the Ways' scheme. Instigated and supported by Great North Forest, 'Marking the Ways' has also been funded by the Countryside Commission, Northern Arts and Gateshead MBC – the resulting works forming part of Gateshead's public art programme.[1] The project is intended to offer rural communities insights into artistic processes and many of the works are collaborative efforts with local volunteers. It also draws attention to the countryside as a resource, as reported in the local press: 'sculptors are taking culture into the countryside to highlight some of the region's natural assets'.[2] A number of artists have been involved over the years; main examples of their works are given as catalogue entries.

[1] *Marking the Ways in Gateshead.* [2] *Journal*, Newcastle, 18 March 1993.

Bowes Railway Path

Crossing of dirt roads beyond houses to south of Kibblesworth

Marker Post
Sculptor: Chris Sell

Installed 1995
Whole work: wood 2.7m high × 1.4m wide at top
Status: not listed
Condition: fair
Condition details: split at various points; details weathered; graffiti scratched on front and rear
Commissioned by: Great North Forest

Description: a marker post decorated with two relief carvings. One depicts a man taking

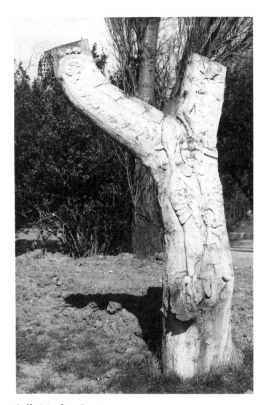

Sell, *Marker Post*

his dog for a walk through a tree-lined street, the other a miner down a pit. The wood is bleached white by the sun.

History: Sell wrote a story to fit around the sculptures to be found at Kibblesworth. He describes how 'Dawn the Great Detective' meets a retired miner walking his dog on the outskirts of the village: 'the dog, being rather wooden, barked'.[1]

The sculptor is quoted as saying, 'The opportunity to work in and around a community over many months, getting to know the people who live there and what they feel about their home, is an honour. I think it is also

a privilege to be trusted to create something that reflects the qualities of a particular place.'

[1] *Marking the Ways in Gateshead.*

500m north of Hedley Hill Farm, path next to crossing with road

Untitled Way-marker
Sculptor: Gilbert Ward

Installed 1995
Whole work: stone 3m high × 1.8m wide × 1m deep
Status: not listed
Condition: good

Ward, *Untitled Way-marker*

Condition details: green algae on upper surfaces
Commissioned by: Great North Forest

Description: a large boulder of yellow sandstone set at the junction of a bridleway and the road. Each side is carved to a depth of 2cm with a stylised foliate design.

History: this work is one of ten works by Ward in the 'Marking the Ways' scheme. He has said that 'the idea of making stone carvings which have a place and a purpose on the forest trails and footpaths makes it possible for the sculptor to reach people outside of the art circuit'.[1] This way-marker is one of the largest and most visible of the sculptures sited along the Bowes Railway Path. Ward has stated that 'sculpture which marks the way is given a function, and a reason for being there, outside its normal drives'.[2]

[1] *Marking the Ways in Gateshead, passim.* [2] GNF, *Arts in the Forest,* p.8.

Main road through Kibblesworth

300m along public footpath leading from Post Office to north of village

Cockerel and Sun Stile
Sculptor: Chris Sell

Carved 1993
Each post: wood 3.1m high × 40cm wide at top
Status: not listed
Condition: poor
Condition details: *Cockerel* broken off and removed; covered in algae and graffiti
Commissioned and owned by: Great North Forest

Description: a stile with two tall poles on either side. One has a carved sun's face on top, the other used to bear a carved cockerel. Set beside allotments on the edge of open countryside.

History: carved on site as part of 'Marking

Sell, *Cockerel and Sun Stile*

the Ways', the cockerel was inspired by birds which are kept in nearby allotments. Unfortunately this element of the stile has had to be recarved on several occasions because of vandalism, and the council is considering ways of ensuring its safety in the future.

Kibblesworth to Beamish road
Junction with Bowes Railway footpath

Sign Post
Sculptor: Chris Sell

Installed 1996
Whole work: wood 3m high × 25cm square

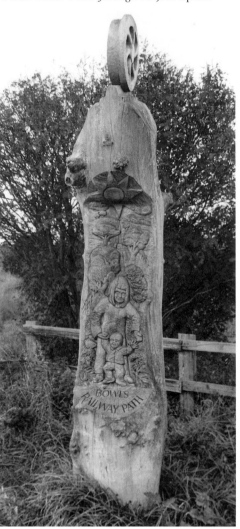

Sell, *Sign Post*

Status: not listed
Condition: good
Commissioned by: Great North Forest

Description: a sign post bearing two high-reliefs carved into the bleached wood. On one side there is a depiction of a Mother and Child with 'BOWES RAILWAY PATH' inscribed under it. On the rear is a man digging in a landscape.

History: carved as part of 'Marking the Ways', this decorative sign marks where the Bowes Railway Path crosses over the common and points the way to Laurent Reynes's *West Wind*.

Bowes Railway Path through field to
east of road

West Wind
Sculptor: Laurent Reynes

Installed 1996
Whole work: steel beams and ceramic inlay 2.8m high × 1.5m long
Status: not listed
Condition: fair
Condition details: tiles missing at various points; fire damage at base of some girders
Commissioned and owned by: Gateshead Metropolitan Borough Council

Description: a wave form consisting of twenty pairs of thin steel I-beams, each filled with concrete and set vertically in the ground at different angles. Blue ceramic pieces are embedded on each side of the dark red-brown beams. The work is sited on either side of a footpath which runs through agricultural land.

History: West Wind was commissioned as part of Gateshead's 'Four Seasons' programme for the 1996 Year of Visual Arts UK, supported by the European Community Kaleidoscope Fund. Forming the 'summer' section of the project along with another work by Reynes,

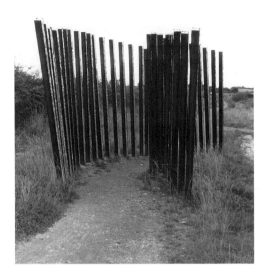

Reynes, *West Wind*

The Bridge (see p.205), it was inspired by a visit to the site on a blustery day. The artist said that 'the wind was very strong so I decided to "build" the wind'.[1] He has stated that he looks to the changes wrought by time in his works, so this piece may be intentionally impermanent.[2]

West Wind has been incorporated in the 'Marking the Ways' collection of sculptures and way-markers around Kibblesworth.[3] Its distinctive form draws the eye along the pathway across the open field, reminding ramblers of the coal wagon-way which once ran along here. The oxidised steel also refers to an industrial past, whilst Reynes has stated that the strong blue colours deliberately draw on 'Mediterranean' influences, in contrast to the more neutral skies over Gateshead.

[1] Gateshead, *Four Seasons*, p.12. [2] *Journal*, Newcastle, 2 September 1996. [3] *Marking the Ways in Gateshead*, no.15.

A6076 to Kibblesworth Common road

Start of footpath to north of road

Sign Post
Sculptor: Matthew Jarratt

Installed 1995
Frame and mobile: wood and iron 2.45m high × 95cm wide
Status: not listed
Condition: good
Commissioned by: Great North Forest

Description: a split wooden post with an ironwork design which includes the word 'WALK' in its upper section. A compass point

Jarratt, *Sign Post*

supports two free-hanging iron 'cut-outs' of a tractor and trees.

The sign post marks the beginning of a footpath across Burdon Moor and is one of a pair of way-markers on the moor: the other has the word 'VIEW' incorporated into it.[1] They are designed to give 'a flavour of local country life, whilst moving in the breeze'.[2]

[1] *Marking the Ways in Gateshead*, no.20. [2] GNF, *Arts in the Forest*, p.16.

Junction of road and path through Beamish High Moor

Boy with Wet Feet
Sculptor: David Edwick

Installed 1994
Whole work: stone 84cm high × 56cm wide × 76cm deep
Status: not listed
Condition: poor
Condition details: head broken off; lichen covers all surfaces
Commissioned by: Great North Forest
Custodian: Gateshead Metropolitan Borough Council

Description: a small carved stone sculpture which depicts a young boy removing his wellington boot. The original white colour of the stone has weathered to a deep yellow and the sculpture is now missing its head, making it hardly recognisable.

History: one of the 'Marking the Ways' sculptures. Edwick recalls taking a group of children along the Beamish Path and having to wait for a lad to wring out his socks, which he thought was 'an amusing subject for the carving'.[1] Unfortunately the head had to be permanently removed in order to prevent continuing vandalism.[2]

[1] *Marking the Ways in Gateshead*, no.27. [2] GNF, *Arts in the Forest*, p.18.

Edwick, *Boy with Wet Feet*

Junction of road and path through Beamish High Moor

Fossilised Insect

Sculptor: Gilbert Ward

Installed 1994
Whole work: stone 50cm high × 1.5m long × 46cm wide
Status: not listed

Ward, *Fossilised Insect*

Condition: good
Condition details: covered with algae and moss
Commissioned by: Great North Forest

Description: an insect carved into a low yellow stone boulder.
History: one of the ten works by Ward in the 'Marking the Ways' scheme, several of which take insects and other small animals as their subjects.

Kibblesworth to Birtley Road

Junction of footpath and road near Plough Inn public house

Carved Seats

Sculptor: Chris Sell
Assisted by: Primetime Sculptors

Carved 1994
Each chair: wood 3.5m high × 40cm wide
Signatures incised at top of left chair: T. BUSH / C. SELL / A. WATSON / T. WATSON
Signatures incised at top of right chair: 1994 / J. COATES / J. STOREY / A. JOHNSON
Status: not listed
Condition: fair

Condition details: riddled with woodworm; generally weathered; small amounts of graffiti inked on rear
Commissioned and owned by: Gateshead Metropolitan Borough Council

Description: two high-backed wooden chairs set against a hedge overlooking fields towards Birtley. Each is carved in relief with designs in contrasting colours. The left chair has a farmer in a tractor at the top and its back is carved with a plough and harness; the right chair has a miner in a bucket on top with miner's lamp, helmet and pick and shovel further down. All are stained in yellows and greens, though the colours have faded.

Sell and Primetime Sculptors, *Carved Seats*

History: one of five works by Sell in the 'Marking the Ways' scheme. Primetime Sculptors is a group of mostly retired volunteers, and Sell collaborated with them on both the design and manufacture of the chairs. They used a room at the local school, sounding like a 'bunch of demented woodpeckers' as they worked away.[1]

[1] GNF, *Arts in the Forest*, p.7.

LONGBENTON
North Tyneside Council

Benton Lane

Four Lane Ends Metro station, courtyard

Iron Horse Reconstructed
Sculptor: David Kemp

Installed 1982
Whole work: found and scrap metal 1.8m high × 5m long
Inscribed on accompanying sign: IRON HORSE / reconstructed 1982 / DAVID KEMP
Status: not listed
Condition: poor
Condition details: naturally oxidised surfaces now heavily decayed; loose elements
Commissioned and owned by: Nexus (TWPTE)

Description: a wide variety of scrap metal parts are utilised to create a horse and carriage, standing in the open-air central courtyard of the Metro station. The carriage has a large chimney suggesting that it forms a link between the horse-drawn era and that of steam trains. A note of humour is injected by the bucket set beneath the horse's rear, though whether or not this was an original element is not known. The

Kemp, *Iron Horse Reconstructed*

whole work has rusted to a distinct orange colour and many parts have disintegrated over the years.

Although clearly visible through the plate glass windows, *Iron Horse Reconstructed* is mostly obscured from users of the station by a direction board.

Railway pioneer George Stephenson lived in a cottage near this site, and the term 'Iron Horse' was often used to refer to trains in the early days of rail expansion. Kemp's imaginative use of discarded vehicle parts drew attention to the passing of old technologies, whilst its 'mythological status [is] reinforced by its separation from the viewer'.[1]

History: commissioned by Tyne and Wear Passenger Transport Executive (now Nexus) as part of its ongoing 'Art on the Metro' scheme, Kemp was invited to submit ideas for this atrium which acts 'like a large showcase'. Sponsorship was provided by Shepherds Metals Ltd and Newcastle Polytechnic.[2] After 17 years, *Iron Horse*'s condition is now so poor that Nexus have started to plan for its removal and eventual replacement with another work of art.[3]

[1] Nexus, *Public Art in Public Transport*, Newcastle, 1998. [2] Hooper, L., *Art in the Metro: Tyne and Wear*, Newcastle, 1985. [3] Information provided by Mr John Meagher, Nexus, 1999.

Edenbridge Crescent

Longbenton Community College, grounds to west of main building

Arum Lily
Sculptor: William Pym

Installed 1992
Whole work: painted steel 5m high approx × 3m wide
Status: not listed
Condition: fair
Condition details: small patches of rust and worn paintwork; graffiti scratched on some surfaces
Commissioned and owned by: North Tyneside Council

Description: polychrome sculpture made from forged tubular and plate steel. Its form seems to be an amalgamation between organic and mechanical shapes: a red-painted whisk-like structure rises from within three green leaves around its base. The sculpture is set into a circle of bricks in the grass.

Arum lilies flourish in damp and bog-like conditions and Pym has said that the sculpture's position at the college reflects this by representing 'the possibility of growth and the need for shelter and protection'. It was

Pym, *Arum Lily*

fabricated by AMARC welding trainees and funded by Northern Arts.[1]

[1] AXIS Artists' Register, 1999.

Whitley Road (A191)

Sustrans National Cycle Network: This comprises over 3,000 kilometres of traffic-free paths linking city to city, town to country and in the case of the Whitehaven to Sunderland route, sea to sea (C2C). Set up by Sustrans, a charity which advocates the use of sustainable transport, much of the network runs along disused railway lines, canals and towpaths. In the 1980s the organisation began to introduce art features along several of its routes with the aim of encouraging cyclists to use their 'friendly travelling landscape'. Many of the subsequent commissions for large-scale figurative sculptures embody Sustrans's ideals of ecological sustainability by recycling redundant materials, often using artefacts from local industries.

Junction with Killingworth Wagonway, west of hypermarket

Imago

Sculptor: William Pym
Writer: Kathleen Raine

Unveiled 17 December 1996
Moth Gate: galvanised steel 1.3m high × 8.4m wide
Imago: galvanised steel 3m high × 9m long
Inscribed in cut lettering on entrance-way: Patiently the earth's wounds close. The womb heals of its sons As bark over a torn branch grows.

Also: Me / Mine / Magic / Mirage / Imago
Also: I'm / I am / I age / Image / Imago
Status: not listed
Condition: good
Commissioned by: Sustrans
Custodian: North Tyneside Council

Description: a silver-coloured gate in the form of a moth, beyond which stretches Killingworth Wagonway. To the west of the gate is a panel containing local imagery, wildlife and everyday objects. To the east is another green-painted entrance-way structure echoing the organic shape of a moth imago. Beneath this are two silvered cages. The texts within the imago structure are from Kathleen Raine's poem 'The Healing Spring'.

Subject: situated at the start of a wagonway on which George Stephenson first tested steam engines, the gates incorporate imagery from the surrounding countryside. The Peppered Moth is used as the central motif because it symbolises changes in the surrounding

Pym, *Imago*

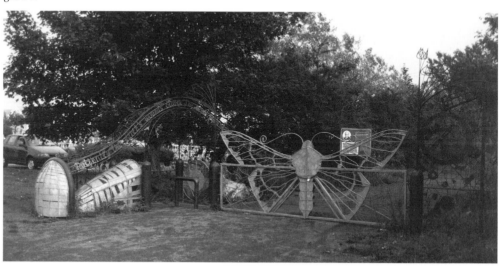

landscape through industrial melanism.[1] This is the process whereby a darkly-camouflaged strain became more prevalent through the nineteenth century, as tree-trunks were blackened by pollution.

Since the disappearance of smoke-producing industry the lighter strain of the moth has become more common once again. According to a press release, Raine's text gives 'the sense of entering a place of healing, peacefulness and growth', and Pym's idea of the 'cocoon as a state of transformation' encapsulates the 'natural healing of the land'.[2]

Imago was funded by Sustrans in partnership with North Tyneside '96 and the Rising Sun Countryside Park.[3]

[1] Information provided by the artist, 1999.
[2] *Journal*, Newcastle, 18 December 1996.
[3] Sustrans Press Release, 1996.

Rising Sun Country Park, main entrance

Rising Sun

Sculptor: Wendy Marshall

Installed 1997
Whole work: sandstone 1.45m high × 1.6m wide × 1.05m deep
Status: not listed
Condition: good
Commissioned by: North Tyneside Council and Countryside Commission
Custodian: Rising Sun Country Park

Description: a small stone carving showing the sun rising over billowing clouds, with oak leaves below. It is sited next to two rough-hewn signposts and marks the entrance to the park.

History: Rising Sun Country Park has been created out of spoil heaps and subsidence ponds resulting from mining activity which ended in 1969. There are a number of paths leading

Marshall, *Rising Sun*

through the site which has now become a haven for a variety of birds and small mammals. There is also a farm and activity centre.

North Tyneside Council has worked with the Countryside Commission, Sustrans, Northern Arts and Great North Forest to place works of art in the country park. The *Rising Sun* carving is the only work visible from the public highway, though there is a variety of sculptures within the park, including a bronze mole, a frog and a wooden climbing frame, as well as extensive wood carvings in the tearooms.

NEW SILKSWORTH
City of Sunderland

City Way
Doxford International Business Park, footpath to south-west of Moorside Industrial Estate

Inter Alia

Sculptor: Kenny Hunter

Installed *c.*1996
Each block: fibreglass and concrete 51cm high × 92cm long × 43cm wide
Status: not listed
Condition: poor
Condition details: three blocks severely burnt; generally dirty; painted with graffiti on west faces
Commissioned and owned by: City of Sunderland

Description: five creamy yellow blocks set into concrete alongside a footpath which forms part of the Stephenson Trail. Each has its upper surface moulded into variations on curves, cylinders and cubes. Three of the blocks are badly melted by fire.

Subject: Inter Alia is translated as 'among other things' in a leaflet, which also asks whether the sculpture 'is a memorial to the past or a celebration of the future'.[1]

History: commissioned to complement the Stephenson Trail which follows the line of the world's first railway designed for steam locomotives, from Easington Lane to the centre of Sunderland. *Inter Alia* is one of five sculptures along the trial

[1] City of Sunderland, *The Stephenson Trail* (leaflets), Sunderland, n.d., leaflet 4.

Monarch Avenue (B1286)
Doxford International Business Park, beside roundabout at access road

Quintisection
Sculptor: Robert Erskine

Unveiled 20 April 1993
Whole work: stainless steel 5.2m high approx × 3.3m wide × 2m deep
Status: not listed
Condition: good

quoted as saying that 'the sculpture was designed to echo the quality of the award-winning buildings at Doxford so the award is entirely appropriate'.[2]

Commissioned and paid for by Doxford International to act as a landmark at the entrance to its Business Park, the steel for *Quintisection* was rolled by the Section Building Company of Sheffield and put together by B&K Fabrications Ltd, Derbyshire. It was installed with help from children at Mill Hill Primary School.

[1] *Evening Chronicle*, 20 April 1993. [2] *Journal*, Newcastle, 18 January 1995.

Watts, *Russell Wood Sculpture*

Erskine, *Quintisection*

Commissioned and owned by: Doxford International Business Park

Description: a large polished steel sculpture located in a planted area next to the Business Park's main roundabout. Based on the cross-section of a ship, a curved 'hull' soars on either side of three box 'ribs'. The sculpture has a closed circuit TV camera bolted within its interior, looking out over the roundabout.

History: awarded the 1995 Royal Society of British Sculptors prize for the 'best sculpture outside London', beating international competition, *Quintisection* 'was designed as a monument to the region's shipbuilding heritage. It alludes to the massive rib beams of a large ship.'[1] The Business Park's marketing director is

NEWBOTTLE
City of Sunderland

Newbottle to Fence Houses road
Russell Wood

Russell Wood Sculptures
Sculptor: Felicity Watts

Carved on site 1997 to 1998
Each boulder: white, yellow or red stone up to 2m high × 1.5m diameter
Small plastic sign attached to gateway inscribed: Russell Wood covers 18.6 hectares (46 acres) and was planted in March 1996. It was designed to create an attractive woodland close to where people live and has new paths which you are welcome to walk along. It includes a number of art works and open areas for wildlife.
Status: not listed
Condition: good
Commissioned and owned by: City of Sunderland and Great North Forest

Description: eight boulders of different stone types, carved with a variety of abstract and pictorial motifs. All of the sculptures are by

Watts, *Russell Wood Sculpture*

paths, distributed across the undulating woodland site. The designs include: a yellow stone boulder carved to represent a pair of hands in the prayer position; a red stone block cut away into a whorl on one side, with imprints of hands carved on the rear face; a white stone block carved with abstract curving hemispherical incisions.

Subject: Watts's residency involved working with children at Newbottle Primary School and community groups such as Scien Raen Women's Group. The artist states that the works are linked by the theme of hands. 'For me, the holding hands represent an attitude of care for the wood and the environment generally, and vice versa, our dependence on our environment to provide for us.'[1]

History: Watts was commissioned to work *in situ* at the largest new block of woodland to be planted in Sunderland for several years. Currently looking more like an open field full of wildflowers than potential woodland, Russell Wood is situated next to an area of new housing on the west side of Newbottle. The large carved boulders are easily visible amongst the young trees, though they will eventually be hidden as the site matures.

[1] GNF, *Arts in the Forest*, p.21.

NEWBURN
Newcastle City Council

Newburn Road
Beside Dukes Cottages at Church Bank

Newburn First World War Memorial

Sculptor: Emley and Sons

Unveiled 15 July 1922
Statue: white limestone 1.9m high

Emley and Sons, *War Memorial*

Pedestal: white limestone 2.3m high × 3.08m square
Raised Roman letters on bronze tablets on south, east and west faces above lists of names: TO THE GLORY / OF GOD / AND IN MEMORY OF / THE MEN / OF NEWBURN / WHO FELL / IN THE GREAT WAR / 1914–1918
Raised Roman letters on bronze tablet on south face: THEIR NAMES SHALL LIVE FOREVER
Incised Roman letters on south face of pedestal: "GREATER LOVE HATH NO MAN / THAN THIS, THAT A MAN LAY / DOWN HIS LIFE FOR HIS FRIENDS"
Status: not listed
Condition: fair

Condition details: missing part of rifle, fingers of left hand and bronze tablet from north face; algal growth on figure's head
Commissioned by: Newburn War Memorial Committee
Custodian: Newcastle City Council

Description: a statue of a soldier stands on a slightly tapering pedestal at the top of a long flight of steps leading down to Newburn Road.

History: the memorial cost £550, most of which was raised by public donation. It was unveiled by the Duke of Northumberland.[1]

[1] N'land War Mems Survey, WMSN13.1.

NEWCASTLE
Newcastle City Council

Aidan Walk SOUTH GOSFORTH

Main Dike Stone

Stonemason: not known

Erected 1828
Stone: sandstone 1.45m high × 40cm wide × 15cm deep
Incised on east face: MAIN / DIKE / distance / from / Pit / 349 yards / Cut 3rd June / 1828.
Incised on west face: MAIN DIKE
Status: II
Condition: fair
Condition details: major chip on left of east face and other damage elsewhere; scratched on west face; dirty and weathered
Custodian: Newcastle City Council

Description: a simple block of yellow sandstone with a rounded top, now rather blackened, on the verge beside a row of houses at the eastern end of Aidan Walk.

History: a map of the coalfield from the 1840s shows a line running approximately south-east to north-west from West Denton to

Cullercoats, which is marked as 'Line of Great Dike, Down Cast to the North of 80 fathoms'.[1] This crosses through South Gosforth. Pevsner records that the conquering of this 'blight of mining engineers in South East Northumberland' was marked by this stone and celebrated in 1829 with a ball held a thousand feet below ground.[2]

[1] Bell, J.T.W., *Plan of Part of the Newcastle Coal District*, Newcastle, 1847. [2] Pevsner, *Northumberland*, p.504.

Armstrong Road BENWELL
Hodgkin Park, southern section

Metroland
Sculptor: Simon English

Constructed on site 1996
Whole work: stone blocks 37m long × 34m wide approx
Status: not listed
Condition: fair
Condition details: plant growth widespread, obscuring stonework
Commissioned and owned by: Newcastle City Council

Description: situated on an open expanse of Hodgkin Park with views over the Tyne to the MetroCentre, this large piece looks like the result of an archaeological dig. Stone blocks from dismantled buildings have been laid out to create what seems to be an excavated fort or maze. In its centre is a small arrangement of blocks which include broken pedimental pieces, evoking a temple form.
History: created as part of the regeneration of Hodgkin Park and surrounding Benwell, *Metroland* was funded by the West End Single Regeneration Budget project.

Hodgkin Park, north entrance to southern section

Metrolands Arbour and *Nine Lives*
Sculptor: William Pym

Installed 1996
Gate: wrought iron 3.13m high × 3.5m wide × 1.01m deep
Each panel: wrought iron 39cm square
Cut lettering on gate: Far beyond the here and now; URBAN ARBOUR; GREEN ARENA; METROLANDS
Status: not listed
Condition: fair
Condition details: rusting and peeling paint on many surfaces; graffiti scratched and inked onto gate
Commissioned and owned by: Newcastle City Council

Description: a decorative entrance to the park, these gates are formed from forged iron and brightly painted in green, blue and red. The designs incorporate floral motifs and cut lettering. Along the exterior railings of the park are a number of metal panels cut with portraits

Pym, *Metrolands Arbour*

of Pym's assistants and a title panel.
History: made in conjunction with other pieces by Pym in the northern section of Hodgkin Park, *Metrolands Arbour* reflects the form and style of entrances to the Paris Metro.[1] Its title also refers to Gateshead's MetroCentre, visible across the river from this vantage point.
Nine Lives was a community project in which local youngsters were helped to make portraits out of cut steel.
Benwell has been characterised as one of Newcastle's most troubled areas, and Newcastle City Council procured £19 million for a Single Regeneration Budget scheme to upgrade housing, shopping and leisure facilities in the area. Community-based art works have been an integral part of this project.

[1] Information supplied by the artist, 1999.

Hodgkin Park, north section

Paradise, Oasis and *Lovers' Gates*
Sculptor: William Pym

Paradise Gate: wrought iron 2.7m high × 1.04m wide
Railing: wrought iron 1m high × 2.36m wide
Cut lettering on gate: Paradise.
On railings: Hodgkin Park / dream of Paradise

Description: an arched gate painted in black, blue and green, depicting an industrial scene at the bottom with plant life arching over it. The railings are inside the park and show a bust of Dr Thomas Hodgkin against a green background.

Oasis Gate: Wrought iron 1.67m high × 8.37m wide

Description: cut lettering on screen: From a City to the Park / From a Garden to the Town / An Oasis in a Desert of Street and Stone
An ironwork screen, cut to show heads silhouetted against a background rural scene.

Pym, *Paradise Gates*

Condition: fair
Condition details (all gates): paint fading and
peeling off; slight rusting; graffiti scratched and
inked on most surfaces
Commissioned and owned by: Newcastle City
Council

History: the three gates to the northern
section of Hodgkin Park were installed as part
of the City Challenge regeneration project
along with *Sapling, Metrolands Arbour* and
Nine Lives.[1] The metal screens contain dreamy
words and images which, whilst made with the
history of the surrounding area in mind, are
also evocative of other, more general concerns.
They were designed in the style of William
Morris, whose Arts and Crafts ethos Pym was
anxious to emulate. Funding was provided by
the West End Single Regeneration Budget and
Metal Spinners Ltd.[2]

[1] Information supplied by the artist, 1999.
[2] *Journal*, Newcastle, 19 July 1997.

Hodgkin Park, *centre of northern section*

Sapling

Sculptor: William Pym

Unveiled 18 July 1997
Whole work: wrought iron 2.8m high × 1.3m
diameter
Status: not listed
Condition: good, though scratched all over
Commissioned by: Jacksons (law firm)
Custodian: Newcastle City Council

Description: a sinuous tree form made from
forged iron. Spiralling upwards, tiny figures in
various poses are welded all around the main
stem.
Dedicated to the memory of Dr Thomas
Hodgkin, who bequeathed the park to the city
in 1899, *Sapling* is protected by a spiral

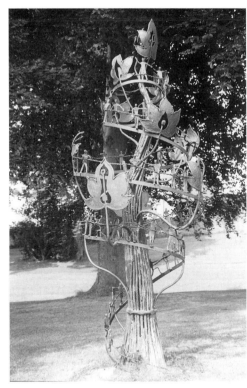

Pym, *Sapling*

containing motifs reflecting West End life. 'I
feel very privileged to have been given the scope
to contribute to the whole new look of the
park, and the tree stands for the new growth in
the west end,' said the sculptor.[1]
The artworks in Hodgkin Park and other
parts of Benwell resulted from a £19 million
Single Regeneration Budget package for the
area, which included upgrading housing, shops
and leisure facilities, as well as encouraging
community involvement in the arts.

[1] *Journal*, Newcastle, 19 July 1997.

Lovers' Gate (entrance on Benwell Lane): each
gate: wrought iron 2m high × 90cm wide
Cut lettering on left gate: Lover's Refuge /
Nature's Asylum.
On right gate: From Lover's Lane / To Gretna
Road
On screen: Adam's Ale / Eve's Well

Description: two permanently open gates
each decorated with a roundel of a man and
woman's heads in silhouette; these are
surrounded by brightly painted floral designs.
A small screen acts as a railing by the roadside.

Status: not listed

Corner of Barras Bridge and St Mary's Place

6th Northumberland Fusiliers War Memorial

Sculptor: John Reid

Unveiled 29 November 1924
Statue: bronze 1.8m high
Pedestal: Portland stone 2.8m high × 1.1m square
Screen and seats: Portland stone 7m wide
Raised Roman letters on bronze ribbons along top of seating: TO THE MEMORY OF THE OFFICERS NONCOM- / MISSIONED OFFICERS &

Reid, *War Memorial*

MEN OF THE 6TH (TERRITORIAL) / BATTALION NORTHUMBERLAND FUSILIERS / WHO GAVE THEIR LIVES IN THE GREAT WAR
Incised Roman lettering on left face of pedestal: 1914 and 43RD BN / ROYAL TANK REGT / 1939 / 1945
On right face of pedestal: 1918 and 49TH BN / ROYAL TANK REGT / 1939–1945
Status: II
Condition: good
Condition details: pedestal stonework is weathered and stained by bronze leaching
Commissioned by: public subscription
Custodian: Newcastle City Council

Description: a bronze figure of St George holding a sword, with a dragon's head at his feet on a stone pedestal. This has a circular enamel plate on a bronze inset (30cm dia.), depicting St George slaying the dragon. Around the circumference is painted: QUO FATA VOCANT. The pedestal also bears a bronze angel figure at each corner (20cm high) and is central to a low curving white stone screen on either side which has a bench set into it.

History: the memorial was unveiled by Major-General Sir Percival S. Wilson in front of a large gathering of military and civic authorities and ordinary citizens.[1] It cost £3,000 with Renée Bowman responsible for painting the enamel plaque and William Currie for the carved stone decorations on the pedestal.[2]

[1] *Evening Chronicle*, 29 November 1924. [2] Hall, M., *A Dictionary of Northumberland and Durham Painters*, Newcastle, 1973, p.143.

Grounds fronting Civic Centre

The Response 1914

Sculptor: William Goscombe John
Foundry: A.B. Burton, Thames Ditton
Stonemason: William Kirpatrick Ltd

Inaugurated 5 July 1923
Screen pedestal and decoration: Shap granite 8m high × 14m wide × 2.5m deep
Relief sculpture: bronze 3m high × 10m wide
Raised lettering on front of pedestal: NON SIBI SED PATRIAE / THE RESPONSE 1914.
Raised lettering on rear of pedestal: QUO FATA VOCANT
Under, incised Roman lettering: TO COMMEMORATE THE RAISING OF / THE B COY 9TH BATT & THE 16TH 18TH & 19TH / SERVICE BATTALIONS / NORTHUMBERLAND FUSILIERS / BY THE NEWCASTLE & GATESHEAD / CHAMBER OF COMMERCE AUG–OCT 1914; and under: THE GIFT OF SIR GEORGE RENWICK BT.D.L AND LADY RENWICK / MCMXXIII
Incised on southern pier of granite screen: SIR W. GOSCOMBE JOHN R.A.
Signed on base of bronze relief at south end: W. Goscombe John
Status: II
Condition: good
Condition details: drumsticks bent and loose at front of bronze relief; generally dirty; bronze surfaces naturally patinated green
Commissioned by: Sir George and Lady Renwick
Custodian: Newcastle City Council

Description: a large and striking memorial consisting of a rusticated granite screen on which is mounted a high-relief depiction of soldiers responding to the call-up for the First World War, modelled virtually in the round from black bronze. Two drummer boys lead the procession and further back are scenes of men taking leave of their wives and children who are torn between distress and patriotic fervour. The expectant soldiers and anxious loved-ones are portrayed with sympathetic naturalism, whilst the relief is given dynamic impetus by the crush to the left of the composition around the flag and figure of *Renown*, who flies above the crowd with raised trumpet. The stone above her

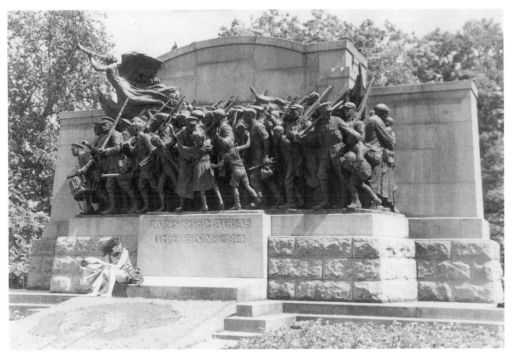

Goscombe John, *The Response 1914* (front)

is carved with a low-relief castle.

On the rear of the wall there are several low reliefs carved directly into the grey granite. St George is depicted in medieval military dress with lance and shield, standing on a pair of intertwined sea horses (the supporters on the City's coat of arms). On either side is a shield with heraldic castles, the Newcastle coat of arms. Flanking these are two figures: on the left an original Northumberland militiaman, with '1674' inscribed underneath; on the right a First World War fusilier, with '1919' inscribed under. The whole is set upon a flight of three shallow steps, amidst a carefully tended flower bed, situated against the background of the Civic Centre.

The Response has been described by Alan Borg (former Director General of the Imperial War Museum) as 'one of the finest sculptural ensembles on any British monument, [...] a magnificent statement displaying John's virtuosity to the full and deserving to be recognised as a key work in this genre.'[1]

History: Sir George Renwick, local shipowner and MP for Morpeth, proposed to donate the memorial to the city in 1922, in commemoration of three events: first, the raising of the Commercial Battalions of the Northumberland Fusiliers by the Chamber of Commerce Military Committee before the First World War; second, the safe return of all five of his sons from the war; third, his attainment of fifty years of commercial life on Newcastle Quayside in 1916. Goscombe John visited Newcastle in June 1922 to look at potential sites and Sir George felt confident that the monument would be a fine and imposing work

of art, worthy of a place among the many monuments in his native city. Sir George and Lady Renwick imposed only one condition, that the Corporation should provide a suitable site for the monument. Alderman Sir George Lunn said that the Council should gratefully accept the gift and provide a site ready for unveiling in the following year.[2] A meeting of the Council and Trustees of St Mary Magdalene Hospital in February 1923 agreed that a portion of the grounds at St Thomas's Church be given to the city for the monument.[3]

Although the title of the monument obviously refers to the call to arms in 1914, the subject matter for the bronze relief has been identified as the massing of the 5th Northumberland Fusiliers in April 1915. They marched from their camp in Gosforth Park down the Great North Road, through the Haymarket and on to the central station. 'Their route was lined by well-wishers and their parents, wives and children, some cheering,

Goscombe John, *The Response 1914* (detail)

Goscombe John, *The Response 1914* (rear)

some weeping, as the flower of their youth went out to sacrifice itself on Europe's battlefield.'[4]

The Response was unveiled by the Prince of Wales as part of a visit that he made to the city in July 1923. In the morning he visited St James's Park football ground to watch a spectacle 'unique in the history of Newcastle'. 42,000 children in the stands displayed flags of red, white and blue in different combinations at given signals and in perfect silence, with the Prince saying that it was the finest thing he had seen in his life. In the afternoon he proceeded to St Thomas's Church grounds where he met Sir George and Lady Renwick and the sculptor Sir William Goscombe John, among others. A guard of honour from the Northumberland Fusiliers was in attendance, along with a party

of blind ex-sailors and ex-soldiers and an 'enormous concourse of spectators' (recorded by a picture postcard of the ceremony).[5] The story is told of one bystander noting that it seemed odd that the soldiers should be resolutely marching off northwards, away from the front.[6]

The memorial was unveiled at midday by the Prince before he and his party went on to the Exchange buildings on the quayside. Here he made a speech drawing attention to the suffering of Newcastle during the war, before thanking the city for its record in service and wishing it better times ahead.[7]

[1] Borg, A., *War Memorials. From Antiquity to the Present*, London, 1991, p.121. [2] Newcastle City Council, *Proceedings*, 6 September 1922. [3] *Ibid.*, 7 February 1923. [4] Airey & Airey, p.158. [5] Airey, J., *Newcastle upon Tyne in Old Picture Postcards*, Newcastle, 1987, ill.56. [6] Information provided by Janet Brown. [7] *Proceedings*, July 1923.

Corner of Barras Bridge and Claremont Road

Monument to Lord Armstrong

Sculptor: William Hamo Thornycroft
Architect: William Henry Knowles

Unveiled 24 July 1906
Statue: bronze 2.5m high
Pedestal: Heworth stone 3m high × 1.5m square
Reliefs: bronze 80cm high × 1.8m wide
Screen walls: stone 1m wide
Incised on pedestal dado in Roman letters:
ARMSTRONG / 1810–1900
Incised on left of pedestal: HAMO THORNYCROFT
R.A. / Sc 1906
Signed on right base of sculptural plinth: HAMO
THORNYCROFT Sc / 1905
Status: II
Condition: fair
Condition details: pedestal stonework split and blackened by weathering; statue very black, combined with natural green patination
Commissioned by: public subscription
Custodian: Newcastle City Council

Description: bronze life-size figure of a pensive Armstrong, dressed in a frock coat, on an ashlar pedestal flanked by two screen walls with seats. He holds a roll of drawings in his left hand. There is a table to his right and a recumbent Scottish terrier at his feet. Aspects of Armstrong's career as a manufacturer are depicted on two bronze reliefs attached to the screens: a hydraulic crane and shear-legs lowering of a 12–inch gun onto a battleship at Elswick; and a ship being towed by two tugs through the Newcastle Swing Bridge. The whole is set at road level in front of the slight hill that rises to the Hancock Museum.

Subject: William George Armstrong (1810–1900) was born in Shieldfield, Newcastle, the son of a corn merchant. After attending several private schools in Newcastle, he was sent to Bishop Auckland Grammar School, Co.

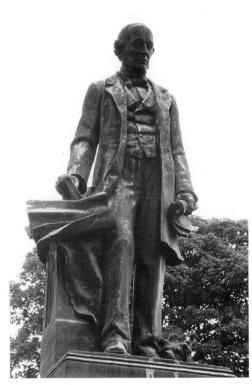

Thornycroft, *Armstrong Monument*

Durham. There he showed great aptitude for mathematics and mechanics, and experimented with hydraulic machines. In spite of his deep love of engineering he had to leave school to follow law at the wish of his father.

It was not until Armstrong was 37 that he abandoned law in favour of engineering. With other Newcastle businessmen, he formed a company to produce hydraulic cranes which he designed at a small factory at Elswick on the north bank of the River Tyne. Initially, the Elswick factory produced hydraulic equipment (used for Newcastle's Swing Bridge, for example) but following the outbreak of the Crimean War, there was a demand for improved field guns and he designed and manufactured the famous breech-loading 'Armstrong Gun', the forerunner of all modern guns. Subsequently he opened a shipyard at Elswick, and in 1868 built his first warship, *HMS Staunch*, for the Navy. The firm continued to prosper and played an important part in the First World War supplying vast quantities of armaments of all types. In 1887 Armstrong was created a Baron. After his retirement he continued to work on electrical experiments until he was well into his eighties.[1]

History: Newcastle Corporation chose the grounds of the Museum of the Natural History Society for the Monument because Armstrong had been particularly associated with the Society during his lifetime, joining it in 1846 and eventually becoming its President from 1893 until his death. He was also a key benefactor of the Museum, donating a rare fossil collection in 1859 and contributing £8,000 towards the cost of a new purpose-built home in 1882. In addition, Armstrong entertained the Prince of Wales on behalf of the Museum in 1884 when the latter came to perform the official opening. The Museum became the 'Hancock Museum' in 1891.

Thornycroft was invited to submit a model by Armstrong's great-nephew and heir, Watson Armstrong, in 1903.[2] The cost of the bronze casting was estimated at £300 in March 1905. The realism and relaxed pose met with approval, and the local press spoke of the statue being 'carried out with artistic skill and the boldness of a hand sure of its powers'. Commentators also liked the inclusion of one of Armstrong's favourite Scottish terriers, a detail which may have been inspired by the terrier in H.H. Emmerson's 1870s portrait of Armstrong reading a newspaper, in the dining room inglenook at his home at Cragside. Two models of the statue were left in Thornycroft's studio at his death.

At the unveiling on 24 July 1906 the Duke of Northumberland spoke of the monument as a 'noble tribute to the genius of Newcastle's greatest benefactor and one of England's most brilliant and honoured masters of industry'. This was followed by a speech tracing Armstrong's career by Sir Andrew Noble, the industrialist's right-hand man for forty years. A commemorative postcard shows that a large crowd was present.[3]

[1] Dougan, D., *The Great Gun-Maker*, Newcastle, 1970, p.124. [2] Manning, E., *Marble and Bronze. The Art and Life of Hamo Thornycroft*, London and New Jersey, 1982, p.196. [3] Airey, J., *Newcastle upon Tyne in Old Picture Postcards*, Newcastle, 1987, ill.58.

Civic Centre

Designed by George Kenyon and built 1960–8, the Civic Centre dominates the northern part of Newcastle city centre. Clad in white Portland stone, it has three main wings arranged round a large courtyard, a circular council chamber, banqueting hall and a ten-storey-high tower block. The Council explicitly focused on the Centre's quality of workmanship and art as evidence of its progressive and cultured attitude.[1] In addition to the sculptures by Wynne and McCheyne (see below) there are glass screens by John Hutton; metal screens and light fittings by Charles Sansbury; grilles, reveals and portals by Geoffrey Clarke; a tapestry in the banqueting hall by John Piper; murals in the marriage suite by Elizabeth Wise; and two abstract murals in the rates hall by Victor Pasmore.[2] There is also an extraordinary range of marbles, woods and stone finishes throughout the Centre, all of which have contributed to its Grade II* Listed Building status. King Olav V of Norway opened the Civic Centre on 14 November 1968.

[1] City Architect's Department, *Civic Centre*, Newcastle, 1972, *passim.* [2] Pevsner, *Northumberland*, p.443.

Exterior wall overlooking entrance

River God Tyne

Sculptor: David Wynne

Building opened 14 November 1968
Whole work: bronze 2.5m high × 1.5m wide
Inscribed on wall to left below: RIVER GOD TYNE
/ David Wynne Sculptor
Status of Building: II*
Condition: good; physically sound though
stained dull brown by running water
Commissioned and owned by: Newcastle City
Council

Description: a massive bronze figure attached
five metres up an exterior wall of the Civic

Wynne, *River God Tyne*

Centre. The head is bowed and a stream of
water continuously trickles from the raised
right arm (though this has not been in operation
since 1998). The sculpture was originally a dark
black colour, but with time has been stained
green and brown by the water.

History: the idea for a River God originates
from the representations of eight rivers on the
façade of Somerset House in London (1786),
where the head of River Tyne has three beards
and is surmounted by a basket of coals and fish.
A carved wooden version of the London
sculpture was made by Robert Sadler Scott in
the early nineteenth century and set on the shop
frontage of Moses Aaron Richardson in Grey
Street, Newcastle. It was subsequently
purchased by Reid Printers between 1854–63
and moved to new offices in 1926.[1] Wynne
changed the bearded head into a figure that
evokes the strength and centrality of the River
Tyne to Newcastle. Its sinuous and dramatic
shape contrasts with the straight, modernist
lines of the Civic Centre's forecourt.

[1] *Journal*, Newcastle, 6 July 1966.

Central courtyard

Swans In Flight

Sculptor: David Wynne

Installed 1968
Whole work: bronze 4.5m high × 8m long
Inscribed on paving slab at edge of pool: SWANS
IN FLIGHT / David Wynne Sculptor
Status of building: II*
Condition: good
Commissioned and owned by: Newcastle City
Council

Description: five swans each two metres long
are depicted taking off from a rectangular pool
within the Civic Centre courtyard. Coloured
black, some green patination has developed on
the upper sides of each bird.

Wynne, *Swans In Flight*

Subject: Swans in Flight is based on a poem
by Hans Hartvig Seedorff Pederson, 'The
Swans from the North', with each swan
representing a Scandinavian country.[1] The
sculpture celebrates the city's traditional links
with Scandinavia, which were reinforced when
the building was opened by the King of
Norway. The work can also be seen as depicting
the take-off of one swan, with each stage frozen
as in a film frame.

[1] Ayris et al., p.75.

Top of tower

Seahorse Heads

Sculptor: J.R.M. McCheyne
Architect: George Kenyon

Building opened 1968
Each head: bronze 1.4m high × 1.6m wide
Status: II*
Condition: good
Commissioned and owned by: Newcastle City
Council

Description: twelve identical light brown
casts of stylised seahorse heads, on top of the
thin vertical fins on the turret which surmounts
the Civic Centre tower.

The seahorse appears on Newcastle's coat of
arms and symbolises the city's maritime links.
The heads were cleaned in 1998.

**McCheyne, *Seahorse Heads* (before
installation)**

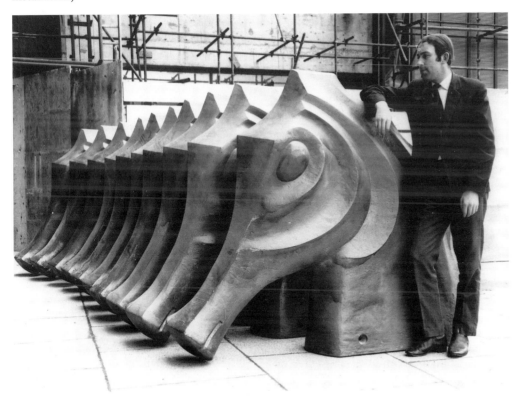

Bigg Market CITY CENTRE
Junction with Grainger Street

J.H. Rutherford Memorial Fountain
Designer: Charles Errington

Unveiled 12 September 1894
Whole fountain: red sandstone, brass fittings
5m high × 2.5m square
Incised Roman lettering around frieze at top:
ERECTED BY THE BAND OF HOPE UNION IN
MEMORY OF DR J.H. RUTHERFORD 1894
Incised Roman lettering on bottom of south
face of plinth: THIS FOUNTAIN WAS REMOVED /
FROM ST. NICHOLAS SQUARE / AND ERECTED IN
BIGG MARKET / 1901 / SIR JOHN BLYTH ESQ
MAYOR

Incised Roman lettering on bottom of north
face of plinth: PRESENTED TO THE CITY /
UNVEILED BY JOSEPH COWEN / SEPT. 12 1894 /
STEPHEN QUIN ESQ. MAYOR
Incised on modern metal door to inner
workings, bottom of north face of plinth: This
fountain was restored and moved to its /
present location in April 1998 with the /
support of Northumbria Water. / Councillor
Peter Laing / Chairman of Highways / and
Transportation committee.
Status: II
Condition: good
Commissioned by: public subscription
Custodian: Newcastle City Council

Description: a red sandstone Renaissance-
style memorial fountain, standing like a buoy at
the top of the busy Bigg Market. It consists of
an octagonal drinking trough from the centre of
which rises a panelled plinth, surmounted by a
concave base with gilded lion's-head taps, then
the main structure. Pilasters decorate the
corners, between which are recessed panels with
relief plaques of Newcastle's coat of arms, Band
of Hope Union coat of arms, an English coat of
arms, 'Water is Best', 'JHR' and 'BOHU', as well
as an amount of leaf tracery. Above these runs
the frieze with inscription and a moulded
entablature below a miniature pediment for
each face. A cupola and finial top the
monument.

Subject: J.H. Rutherford (1826–90) was a
Presbyterian Minister who founded Bath Lane
Church in 1860 and set up a number of schools
in Newcastle. Briefly involved in Liberal
politics as an ally of Joseph Cowen, he
promoted temperance and sanitation reform.
Over 5,000 people attended his funeral on 20
April 1890.[1]

History: paid for by public subscription,
Rutherford's memorial was unveiled outside St
Nicholas's Cathedral by Joseph Cowen, whose
speech was subseqently printed in a pamphlet

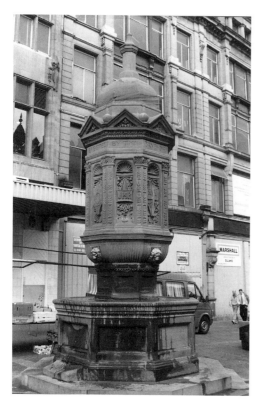

Errington, *Rutherford Fountain*

undertaken by Classic Masonry of Springwell Quarry, Gateshead.

The newly reinstated stonework is a considerably lighter shade than before, the carving is crisp and lettering has been picked out in gilding. New gilded lion's heads act as taps for a refreshing drink.

[1] Welford, vol.III, pp.338–41.

Blackett Street CITY CENTRE

Junction with Grey Street and Grainger Street

Grey's Monument

Sculptor: Edward Hodges Baily
Architect: Benjamin Green
Sculptor (replica): Roger Hedley

Statue installed 24 August 1838
Statue: Portland stone 3.9m high
Column: grit stone 40m high
Pedestal: grit stone 4m high
Incised on south face of column base in gilded lettering: THIS COLUMN WAS ERECTED IN 1838 / TO COMMEMORATE / THE SERVICES RENDERED TO HIS COUNTRY BY / CHARLES, EARL GREY K.G. / WHO, DURING AN ACTIVE POLITICAL CAREER OF / NEARLY HALF A CENTURY / WAS THE CONSTANT ADVOCATE OF PEACE / AND THE FEARLESS AND CONSISTENT CHAMPION OF / CIVIL AND RELIGIOUS LIBERTY. / HE FIRST DIRECTED HIS EFFORTS TO THE AMENDMENT / OF THE REPRESENTATION OF THE PEOPLE IN 1792 / AND WAS THE MINISTER / BY WHOSE ADVICE, AND UNDER WHOSE GUIDANCE, THE GREAT MEASURE OF PARLIAMENTARY REFORM / WAS, AFTER AN ARDUOUS AND PROTRACTED STRUGGLE / SAFELY AND TRIUMPHANTLY ACHIEVED / IN THE YEAR 1832.
On the north face: AFTER A CENTURY OF CIVIL PEACE, / THE PEOPLE RENEW / THEIR GRATITUDE TO THE AUTHOR / OF THE GREAT REFORM BILL / 1932.

Status: I
Condition: good
Condition details: column and base darkly stained by weathering; bird droppings on column and statue
Commissioned by: public subscription
Custodian: Newcastle City Council

Green and Baily, *Earl Grey Monument*

Description: a fluted Roman Doric column with statue on top. The pedestal of the column lacks a conventional base and therefore seems to rise from the ground somewhat abruptly. On the capital there is a balcony with railings surmounted by a high pedestal on top of which is a twice-life-size standing figure of Earl Grey, bald-headed, pensive and wearing court dress. Grey faces south down Grey Street. The shaft and pedestal of the column have become blackened by pollution and now contrast with the white of the pedestal and statue above. A 1995 survey found that the column sits on relatively shallow but secure foundations and sways up to 30cm in a high wind.

Subject: Charles, Earl Grey (1764–1845) was born into the Northumbrian aristocracy. After education in London and abroad, he was

along with an engraving of the memorial. Cowen said that it was 'a visible invitation to all to practical temperance', hoping that it would 'supply copious streams of that natural beverage whose consumption… would do much'. The monument was moved to the Bigg Market in 1903, ironically an area that, by the late twentieth century, has become notorious for its concentration of pubs and boisterous revelry. It had fallen into considerable disrepair by 1996 and was removed for conservation by the Council as part of its refurbishment plans for the Bigg Market. It was reinstalled 100 metres further up the hill. Restoration was

elected to represent Northumberland in Parliament, making his maiden speech at the age of 22. In 1806 he was appointed First Lord of the Admiralty. Later, as Leader of the House of Commons he guided legislation abolishing the slave trade through Parliament and gave support to the movement for Catholic emancipation. The main cause with which he is associated, however, is that of parliamentary reform; he made it a point of honour to refuse to be part of any government which opposed it.

Following a period of unrest in 1830 he was asked to form a government and he made the passing of the Great Reform Bill his central mission. After this was achieved in 1832 he retired two years later. How genuinely radical his intentions were at any stage in his career has been the subject of debate. Revisionist historians have argued that the true purpose of the various reforms he instituted was to reduce radical influence and thereby protect aristocratic privilege.[1]

History: although the monument has long been a cherished icon of Newcastle, it was some time before it won its way into local affections. It was in fact North Shields that first proposed to commemorate the author of the Great Reform Bill, not Newcastle. In June 1832 a public subscription was started for a column designed by the Newcastle architect John Green, Junior, on 'a Mound in or near the Area of Northumberland Square, North Shields'. This was to have a 'Colossal Statue of the Noble Earl, in his Parliamentary Robes, holding his Magna Charta [*sic*] in his Hand', and medallions of Lords Brougham, Althorp and Russell (other heroes of the movement for parliamentary reform) on the base.[2] 'Instead of expressing our grateful Joy in the childish Barbarism of wasteful and dangerous Illuminations, which blaze for an Hour and are forgotten for ever, let us erect a Monument that shall commemorate to future Ages our Gratitude to the Friend of the People! the

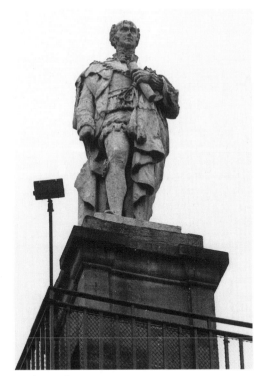

Baily, *Earl Grey Monument*

Prince of Patriots! and the Honour of Northumberland, EARL GREY!!!'[3] Two years later there was a proposal for a statue on the site of the present Grey's Monument in Newcastle, but this was for an ideal figure not a statue of Grey, as an 'Isometric Plan of the Improvement of Newcastle as proposed by Mr Grainger, June 14th 1834' makes clear.[4] Interestingly, when at last a Grey monument in Newcastle was mooted, in October 1834 (after the North Shields scheme had been abandoned), the proposal was still not taken up with any great enthusiasm. The necessary funds proved hard to raise and it was two years later, on 14 September 1836, that a column designed by John Green's brother, Benjamin was finally

agreed to by the Town Council. As the Tory Newcastle *Journal* at the time sneered, 'Whence all this ingratitude and lukewarmness on the part of the reformers towards the great father of their long cherished principles'.[5]

The slowness to realise the scheme seems to have been due to the fact that although the recently reformed council had a large Whig / Liberal majority, there were those who favoured other sites, such as the Town Moor, or preferred some other, more utilitarian kind of monument such as a mechanics institute.[6] Also, there were those who had reservations about Grey. Grey's popularity had never been great and quickly disappeared once the euphoria over the passing of the Great Reform Bill had faded.[7]

Even when in place, the monument – crowned with a twice-life-size statue of Grey by the distinguished London sculptor Edward Hodges Baily – by no means found universal approval. Despite flattering images by contemporary artists such as T.M. Richardson senior and J.W. Carmichael, it received considerable criticism in the press. 'This column was erected to Earl Grey, who, in order to aggrandise his own family, deceived the whole nation, to whom he promised real reform' was the verdict of one radical paper.[8] Furthermore, neither the ceremony at which the foundation stone was laid on 6 September 1837, nor the ceremony on 24 August 1838 at which Baily's statue was winched into place were well attended; even Grey himself, still living, was not present on either occasion.

Reservations about the monument continued into the second half of the century. When, for instance, the idea of a Stephenson monument (see pp.149–52 and 209) was being considered in 1857, one local writer commented 'the monument to Earl Grey is, to my mind, a huge mistake; you place an aged nobleman, dressed in court costume, on a high pillar, and, without a hat upon his bald head, expose him to the pelting of every storm that Heaven sends.'[9] The

inscription on the base with its implicit suggestion that Grey's career had always been marked by consistency and high principle was added in 1854. The text was probably written by Grey's friend, the Revd Sydney Smith, the Liberal writer and celebrated wit, whose support Grey had rewarded in 1831 with the canonry of St Paul's.[10]

The turning point in popular feeling towards the monument came in the late nineteenth century. Guide books suggest that from at least the 1870s sightseers began ascending the 164 steps to enjoy the view from the gallery, just as in our own time the writer Tony Harrison did when he came to write his celebrated 1960s poem 'Newcastle is Peru'.[11] However, although the monument eventually found a place in people's hearts, interest in the person whom it commemorates gradually waned.

One of the rare moments in the twentieth century when the significance of Grey's achievement was noted and the monument was invested with overtly political significance, albeit briefly, was in 1932 when the inscription on the north face of the pedestal celebrating the centenary of the Great Reform Act was added at the instigation of Sir Charles Trevelyan of Wallington, formerly a minister in Ramsay MacDonald's government. The words for this, penned by Viscount Grey, the former Foreign Secretary, were formally proposed and endorsed at a meeting at the City Hall, Newcastle, on 6 June 1932. Grey, Sir Charles and Sir Charles's brother, the distinguished Whig historian, G.M. Trevelyan, used the City Hall meeeting to contrast what they saw as the traditions of evolutionary democracy in Britain which the Reform Bill had inaugurated with the situation in contemporary Germany, where the extremes of Nazism and Communism were threatening the Weimar Republic.[12]

Apart from the addition of this inscription the monument has changed comparatively little in physical terms. The railings protecting the

base with four lamps at each corner disappeared at the start of this century[13] and in July 1941 Baily's statue was struck by lightning which caused the head to fall into a ladies' outfitters in Grainger Street. (This left the monument headless until 12 January 1948, when a replica weighing 303 kilograms was carved for it by Roger Hedley.[14])

Perhaps the most significant change to the monument occurred in the late 1970s when a Metro station was built beneath it and the top ends of Grey Street and Grainger Street were pedestrianized. The main effect of this was to give it a prominence in people's lives which it previously had never really had. The newly constructed low platform at the base became Newcastle's main meeting place and speakers' corner and various groups began to make requests to use the monument for stunts. For example, in 1986 the Northumberland National Park Fell Rescue Team made an unsuccessful bid to be allowed to abseil down the column three hundred times.[15] The building of the Metro station and the pedestrianisation also meant that local people tended not to refer to 'Grey's Monument' any more, but simply to 'The Monument', the name of the new Metro station. As a result Grey on his lofty perch found himself even more ignored by passers-by than before.

Following the construction of the Metro station there were calls in 1982, 1994 and 1998[16] for the monument 'to be spruced up'. However, surveys – notably that conducted by English Heritage in 1995 – found that the cost of cleaning and repairs would be too great, the reason being that previous renovations had replaced the original Pennine stone of the column with softer sandstone which has reacted badly to pollution.

A small plaster model of the figure of Grey, probably one of the thirty miniature casts of the statue which Baily made for sale as souvenirs in May 1838, is currently owned by R.D. Steed-

man's antiquarian booksellers, 9 Grey Street. It is invariably on display in the shop window.[17]

[1] Smith, E., *Lord Grey, 1764–1845*, Oxford, 1990, *passim.* [2] 'Statue of Earl Grey Northumbrian', newspaper cutting, Newcastle, vol.4, 817. [3] Anon, newspaper cutting, 11 June 1832. [4] Sopwith, T., *Manuscript in Laing Art Gallery*, Newcastle, 1834. [5] *Journal*, Newcastle, 14 February 1836. [6] *Tyne Mercury*, 11 September 1836. [7] Brett, R., 'The Grey Monument: The Making of a Regional Landmark', *Occasional Papers in North-East History*, (forthcoming). [8] *Northern Liberator*, Newcastle, 9 December 1837. [9] *Letter from William Newton to Lord Ravensworth*, Newcastle, 26 November 1857. [10] Brett, *op. cit.*, p.37. [11] Harrison, T., *Selected Poems*, London, 1984, p.65. [12] *Journal*, Newcastle, 7 June 1932. [13] Thompson, J. and Bond, D., *Victorian and Edwardian Northumbria from Old Photographs*, London, 1976, p.136. [14] Millard, J., *Ralph Hedley. Tyneside Painter*, Newcastle, 1990, pp.86–8. [15] *Evening Chronicle*, 11 March 1986. [16] *Evening Chronicle*, 26 February 1982. [17] Wilson Collection, Central Library, Newcastle, vol.6f 1415.

Junction with Blackett Place

Parsons Polygon
Sculptor: David Hamilton

Installed 1985
Whole work: brick and fired tile cladding 3m high × 2.2m square
Inscribed on paving slab nearby: PARSONS POLYGON / BY DAVID HAMILTON / A MONUMENT TO / SIR CHARLES PARSONS / 1854–1931 / CREATOR OF TURBINIA / MADE FOR ART IN THE METRO / SPONSORED BY BOSTOCK CLAYS / TYNE AND WEAR COUNTY COU / NCIL AND NORTHERN ARTS / WITH LJ COUVES & PARTNERS
Status: not listed
Condition: good
Commissioned and owned by: Tyne and Wear Passenger Transport Executive (Nexus)

Description: a hexagonal structure with sloping roof, covered in red tiles which are now rather blackened. These are moulded in two designs, each repeated three times around the

work, depicting abstracted cog and machine parts.

Subject: Charles Algernon Parsons (1854–1931) was born in London of wealthy parents and brought up in Ireland. He studied engineering at Cambridge before entering Armstrong's Elswick works as a 'premium apprentice' in 1877. He concentrated on increasing the power produced by steam turbine engines and by 1887 his turbo-alternator was supplying electricity to Newcastle. The period was one of intense competition between rival engineering firms and Parsons became embroiled in a number of patent disputes in the 1880s. However, he turned his attention to ship propulsion and built the *Turbinia*, a small, sleek turbine-

Hamilton, *Parsons Polygon*

powered vessel which could manage 35 knots with significant fuel savings. Parsons also experimented with artificial diamonds and astronomical telescopes. He died on holiday in the Caribbean and is buried in Kirkwhelpington cemetery.[1] Details of Parsons' life and achievements are displayed in Newcastle's Discovery Museum, where the carefully restored *Turbinia* takes pride of place.

History: Parsons Polygon is essentially a ventilator shaft for the Metro station below, with the terracotta cladding made from the same clay used for Eldon Square's bricks. Supported by the organisations listed on its accompanying plaque, it was commissioned by TWPTE for its 'Art on the Metro' scheme.[2] It is the only Metro artwork sited outside a station and in a public thoroughfare, and as such is not readily associated with the Metro below.

Hamilton wrote a comprehensive explanation of the *Polygon*'s genesis and meaning, in which he refers to Parsons' lack of fame compared with pioneers such as Watt, and states that he wanted to reflect the achievement of this local engineer by using early drawings of turbine designs as a source. He said that the work is 'a mixture of restraints and opportunities' and is 'not a statue of the man, but a symbol of his stature amongst engineers and the world at large'.[3] The designs pressed into the clay are abstracted from Parsons's engineering drawings.

The polygon's architectural presence is heightened by its light red colour which Hamilton hoped would 'stir the curiosity of Newcastle citizens'. In 1999 there is some concern for *Parsons Polygon*'s future, as plans for Blackett Street's redevelopment may mean that it will be removed.

[1] Appleyard, R., *Charles Parsons*, London, 1933, *passim*. [2] Nexus, *Public Art in Public Transport*, Newcastle, 1998. [3] Newcastle upon Tyne Association of City Guides, *Parsons Polygon by David Hamilton*, Newcastle, n.d.

Eldon Square

Newcastle First World War Memorial

Sculptor: Charles Leonard Hartwell

Unveiled 26 September 1923
Sculpture: bronze, painted black 2.5m high
Pedestal: Portland stone 6m high × 3.8m wide × 3.5m deep
Each relief panel: bronze 1.2m high × 50cm wide
Incised on front dado of pedestal: 1914–1918 / 1919–1945
Incised on east face pedestal dado: JUSTICE; rear: MEMORY / LINGERS HERE; west face: PEACE
Incised on base of pedestal at rear: A TRIBUTE OF AFFECTION / TO THE MEN OF / NEWCASTLE DISTRICT / WHO GAVE THEIR LIVES / IN THE CAUSE OF FREEDOM / THEIR NAME LIVETH FOR EVERMORE
Signed base of sculpture: C. HARTWELL A.R.A.
Signed at the base of each relief panel: C. HARTWELL A.R.A.
Status: II
Condition: fair
Condition details: spalling on pedestal on most surfaces; ledges covered in droppings; generally dirty; the bronze sculpture is particularly streaked; inked graffiti mainly on rear face
Commissioned by: public subscription
Custodian: Newcastle City Council

Description: a dynamic bronze depiction of St George on a rearing charger killing the dragon, on a tall white stone pedestal with a simple cornice and stepped base. The sculpture was originally over-painted in black, but is now patinated green. The pedestal carries a relief carving of a lion on the front dado face; on the left face, under PEACE, is a curved bronze relief depicting a mother and child and an angel; on the right face, under JUSTICE, the figure of Justice (holding scales) stands with another

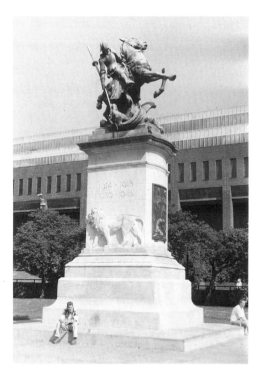

Hartwell, *War Memorial*

female figure, looking down at a semi-nude female figure on her knees. On the rear face of the pedestal is a bronze wreath, one metre square.

History: a monument for the centre of Eldon Square was projected at the time the square was first planned. An engraving of the square published in 1827 shows a standing statue of Lord Eldon wearing official robes.[1] However, a slightly later description of Eldon Square suggests that this was never in fact erected. Subsequent illustrations show a large and ornate lamp on a stone pedestal which was removed sometime during the First World War.[2]

In 1920 various ideas for a war memorial in the square were considered, among them a statue of Lord Kitchener,[3] and the leading London sculptor Alfred Drury was commissioned in January 1921. The agreement was that he should come to Newcastle and submit his final design for approval and that the work should be complete by Armistice Day 1922.[4] Subsequently, however, for reasons which have not been discovered, Drury withdrew and the commission was given instead to the less well known London sculptor, C.L. Hartwell. The Laing Art Gallery tried to keep Drury involved with a plan for bronze allegorical figures by him to be incorporated in Hartwell's design, but this was rejected. The Newcastle architects, Cackett & Burns Dick were responsible for the large pedestal of Hartwell's memorial. They believed that the memorial should be large. 'A sense of bigness is essential – not the bigness of arrogance or domination – but sufficient, relatively to the surroundings to typify the magnitude of the subject, and a certain mass is necessary beyond what is afforded by the more generally familiar forms of monument of moderate cost. To heighten the effect, all elaboration of architectural detail, however good in itself must be avoided, and the addition of anything suggestive of the trappings of military might would be destructive of the deep emotions that should be stirred at the sight of the Memorial.'[5]

Costing £13,260, the memorial was eventually unveiled by Earl Haig on 26 September 1923 at an elaborate ceremony with over one thousand people taking part in the official 'pilgrimage of homage'. Reviewing Hartwell's sculpture, a cast of which he had made for the Marylebone memorial outside Lord's cricket ground in London, the local press remarked on its colossal size and the allusion it makes to the George and Dragon on the crest of the Northumberland Fusiliers. After the ceremony Haig was taken to see Goscombe John's *The Response 1914* (see pp.90–2) at Barras Bridge whose realist approach to the subject of war it seems he preferred.[6]

In the early 1970s the memorial was the subject of a bitter dispute between Harry Faulkner-Brown, the architect appointed in 1971 to redesign Eldon Square, and the British Legion. Faulkner-Brown, supported by Councillor Walter Wilson and the City planners, wanted to turn the square into the 'Trafalgar Square of the North' and saw the removal of Hartwell's memorial as integral to his plans. The British Legion, however, were adamant that it should stay. The *Journal* tried to help by suggesting possible alternative locations for the memorial such as the lawns outside the Civic Centre or the strip of land between the carriageways in Pilgrim Street. This, however,

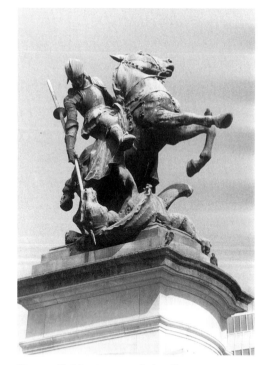

Hartwell, *War Memorial* (detail)

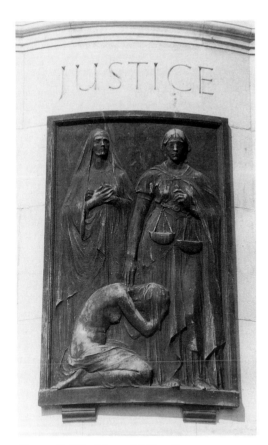

Hartwell, *War Memorial* (detail)

did little to pacify the opponents of the move. For example, an angry letter in the *Evening Chronicle* scornfully recommended locating it the green outside the home of Council Leader, T. Dan Smith in Spittal Tongues on the grounds that Smith was ultimately responsible for promoting Faulkner-Brown's proposal.[7] In the end, in 1974, despite threats by Faulkner-Brown that he would resign if the memorial were not removed, the British Legion were victorious and the memorial was allowed to stay.

In 1990 the Scottish-born, New York-based artist, Thomas Lawson produced a work featuring Hartwell's memorial for the First *Tyne International* exhibition which coincided with the National Garden Festival, Gateshead. Called *Memory Lingers Here* (quoting the memorial's inscription) it consisted of a vast mural painting of the memorial, temporarily installed on the outside of the old CWS paint factory at Dunston. Lawson intended it in part as a sardonic comment on what he saw as the forlorn, forgotten situation of the memorial after Eldon Square was surrounded in the 1970s by the 'fortress walls' of the new shopping centre.[8]

The square has been a popular meeting place for young people and skateboarders and the memorial suffered occasional spray-paint attacks. Rising concern for the memorial led to a one-metre-high fence being erected around it and a ban on skaters being implemented in July 1999.

[1] Mackenzie, E., *Descriptive and Historical Account of Newcastle upon Tyne*, Newcastle upon Tyne, 1827, p.201. [2] Collard, W. and Ross, M., *Architectural and Picturesque Views of Newcastle upon Tyne*, Newcastle upon Tyne, 1841, p.60. [3] *Journal*, Newcastle, 27 and 29 November, 1920. [4] *Ibid.*, 3 March 1921. [5] *Evening Chronicle*, 8 December 1921. [6] *Journal*, Newcastle, 26 September 1923. [7] *Ibid.*, 4 July 1974. [8] First Tyne International, *A New Necessity*, 1990, p.27.

Charlotte Square CITY CENTRE

Peace Sculpture

Sculptor: Dawn Whitworth

Unveiled 15 June 1990
Whole work: mixed metals 2.7m high × 1.7m square
Status: not listed
Condition: good
Condition details: small amounts of algal growth
Commissioned by: Northumbria Police
Custodian: Newcastle City Council

Description: cast in dark brown metal, the sculpture is an abstracted depiction of a dove emerging from the twisted wreckage of gun barrels. Sited on a scruffy pocket of grass in a busy quarter of the city centre, the shape and colour of the work are difficult to distinguish from the background of bushes and railings.

History: Whitworth's design won a £100 prize in a competition on the theme of peace, organised by Newcastle Polytechnic and sponsored by Northumbria Police.[1] The sculpture is cast from the metal of 1,000 guns handed in to police during a firearms amnesty in 1988. A planning proposal for the work was welcomed by council members in October

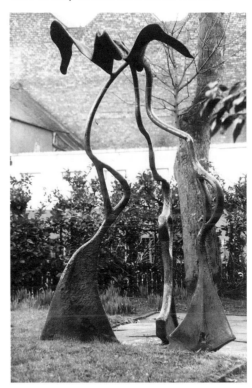

Whitworth, *Peace Sculpture*

1989[2] and the following June it was formally presented to the Lord Mayor of Newcastle by Sir Stanley Bailey, Chief Constable of Northumbria police, in a ceremony at which hopes were expressed for the future of depressed inner city areas. Whitworth said that she 'wanted to show dead steel turning into life, guns turning into peace'. Her sculpture was also described as representing 'the future community developing within the inner city'.[3]

[1] *Journal*, Newcastle, 22 June 1989. [2] *Evening Chronicle*, 18 October 1989. [3] *Journal*, Newcastle, 16 June 1990.

City Road CITY CENTRE

Outside Joicey Museum

Drinking Fountain

Designer: not known

Installed 1600s
Whole work: stone 2m high × 1.2m diameter
Status: II
Condition: poor
Condition details: stonework badly worn and very dirty; bowl filled with weeds
Custodian: Newcastle City Council

Description: a late seventeenth-century fountain consisting of a cyma-moulded plinth below a high arcaded pedestal with impost string, supporting a wide fountain with rounded coping on modillioned cornice.

History: this fountain is contemporaneous with the Grade II* Listed Building behind it which housed the Jesus Hospital from 1681, and later became the Joicey Museum. A description of the Hospital in 1890 says that: 'In front of the entrance to the upper floors is a large fountain or "pant", a singular structure which, considering the period of its erection, and the use for which it was designed, shows some evidence of taste on the part of the architect.'[1]

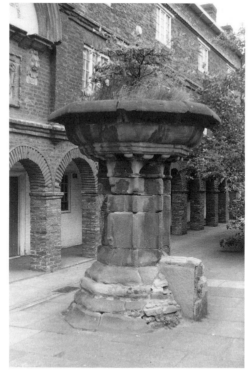

Drinking Fountain

[1] Knowles, W, *Vestiges of Old Newcastle*, Newcastle, 1890, p.270.

Claremont Road CITY CENTRE

Hancock Museum, grounds

Black Rhinoceros

Sculptor: Christine Hill

Unveiled 25 November 1991
Whole work: concrete with lacquer coating
3.2m long × 1.4m high
Inscribed on nearby plaque: THE BLACK RHINOCEROS / by Christine Hill / Armstrong World Industries Ltd / makers of Rhinofloor

and the Museums / and Galleries Commission helped us / put up this sculpture as a reminder / that the rhino, one of the world's great / animals is threatened with extinction / by the greed of mankind. / 1991
Status: not listed
Condition: good
Commissioned by: Hancock Museum
Owned by: Tyne and Wear Museums Service

Description: a life-size representation of an African black rhinoceros, naturalistically modelled, with a rough surface.

History: the Hancock Museum houses Newcastle's natural history collection and has an active education programme. Hill approached the Museum to sculpt a rhinoceros after a trip to Africa where she had seen the effects of poaching: 'I decided that if I made a sculpture for public display it might help people understand that we must do something to stop this senseless destruction of wildlife.'[1] She created the sculpture as her final honours project for Sunderland College of Art.[2]

The Museum was promised an initial £1,000 by Prism, a government fund that helps in the display of scientific specimens. However, the rest of the estimated £3,000 cost had still to be found in September 1991.[3] At this point, Armstrong World Industries donated £1,000 as a continuation of its commitment to rhino

Hill, *Black Rhinoceros*

conservation:[4] 'the rhino symbolises toughness and resilience though they are vulnerable too,' said Armstrong's General Manager. The rest of the money was found from a further donation by the National Museum of Science and Industry.

Built round a tubular steel core, the 2-tonne concrete form was covered with four layers of protective lacquering which makes it waterproof and graffiti-resistant. The Hancock's curator said at the time of the launch that the 'major objective is to show people the wonders of the natural world'. Its position standing outside the museum ensures that *Black Rhinoceros* acts as a landmark for adults and children alike.

[1] University of Newcastle Press Release, November 1991. [2] *Sunderland Echo*, 25 November 1991. [3] *Journal*, Newcastle, 14 September 1991. [4] *Ibid.*, 18 November 1991.

Close CITY CENTRE

Old Fish Market, on roof

Neptune and Fishwives

Sculptor: George Burn
Architect: A.M. Fowler

Building erected 1880
Whole work: stone 1.2m high × 2.8m wide
Status: II
Condition: good
Commissioned and maintained by: Newcastle City Council

Description: a somewhat crudely carved figure of Neptune holding a trident, standing on two dolphins on the roof overlooking the Tyne. On either side is a traditionally dressed fishwife with a basket, looking away from the centre of the building. Four urns also decorate

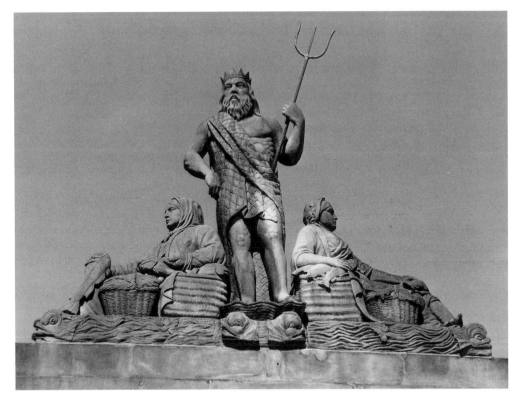

the pediment and a relief head projects from the apogee of the door arch beneath Neptune. There is also a highly coloured iron Newcastle coat of arms above the door, which is repeated on doors at either end of the building.

Subject: situated on the Fish Market, this pedimental group obviously refers to both Newcastle's strong maritime tradition (*Neptune*) and the building's use (*Fishwives*). Women working in the fish processing trade dressed in many layers of skirts – the number of layers indicating status. The iconic position of fishwives in the history of the area is demonstrated by the number of other representations throughout Tyne and Wear,

Burn, *Neptune and Fishwives*

including *Wooden Dollies* in North Shields (see pp.159–60, 160–1 and 166) and *Dolly Peel* in South Shields (see p.175).

History: George Burn's obituary gives him as the sculptor of this group, and stylistically it is similar to his Chambers, Clasper and Renforth monuments of the same period.[1] Since refurbishment the old fish market houses the firm of Mott MacDonald.

[1] Information provided by John Pendlebury, University of Newcastle, 1999.

Collingwood Street CITY CENTRE

Sun Life House, 23–29 Collingwood Street, junction of Westgate Road

Sun, Emblems of Insurance and Atlantes

Architects: Oliver, Leeson and Wood

Building 1904
Sun: metal (possibly brass) 1m high × 1.8m wide
Emblems: stone 60cm high × 40cm wide
Entrance frame: white stone 1.2m high
Status: II
Condition: good
Commissioned by: Sun Life Insurance Company

Description: a yellow stone office block, built in the Renaissance style with giant Corinthian pilasters, pedimented windows and a heavy cornice. The main door in the central bay has a fluted architrave, flanked by large boldly-carved *Atlantes*, on brackets with much leaf and flower carving, supporting a balcony above.[1] To the left of this is a stone sun set above one of the windows. On the Westgate Road façade, a number of small metal sun faces are incorporated into the window guards, and above all of this, in a semi-circular pediment, is a large stylised depiction of the sun. Just beneath this are two *Emblems of Insurance*, consisting of a fireman's helmet and the dates (left) 1904, (right) 1710, and a large sunflower.

History: the building was originally commissioned to house the offices of the Sun Life Insurance Company, founded in 1710. This and the date of the building's opening are illustrated by the firemen's helmets which are contemporaneous in design. Sun Life House was refurbished in the 1980s and now contains a number of businesses.[1]

[1] Lovie, p.36.

Sun Life House (detail)

Colston Street BENWELL

Gable end at junction with Wellfield Road

Untitled (The Benwell Bird)

Sculptor: William Pym

Installed June 1997
Relief: steel and iron 13m wide × 9m high
Ground area: concrete and iron 13m wide × 13m long × 2.4m high
Raised lettering on cast of book: RIGHT / WRONG BLACK / WHITE
On cast of cup and saucer: FROM DUSK TO DAWN
On cast of house: HOUSE / HOME
On mug: MORE TOON
Status: not listed
Condition: good, though paintwork is chipped
Commissioned by: Newcastle City Council

Description: relief sculpture of a tree made

Pym, Untitled (The Benwell Bird)


out of lengths of thin polished steel, at the top of which sits a black forged iron raven. A number of forged iron objects can be found on bollards around the floor area, all of them associated with the home: books, cups and saucers, mugs, and miniature houses. Part of the floor towards the back of the area is raised, on which stands a tall decorative steel column. A nest and egg beneath the raven were added 1999.

The gable-end sculpture reclaims the blind end of a terrace row for pedestrians: the bollards and other elements bring a domestic character to the paved area. The raven acts as a symbol of magic and transformation in an area which has been the centre of a regeneration project funded by West End Participation in Leisure since 1996. Other measures include paisley pattern mosaics designed by Debby Akam, which cover Arif's corner shop opposite.

Corporation Street CITY CENTRE
Junction with West Central Route

Wor Jackie
Sculptor: Susanna Robinson

Unveiled 15 November 1991; re-erected June 1999
Pedestal: slate 1.5m high × 2m long × 1.5m wide
Statue: bronze 1.8m high
Incised on south face of pedestal: WOR JACKIE / 1924–1988 / IN HONOUR OF / JOHN EDWARD / THOMPSON MILBURN / FOOTBALLER & GENTLEMAN / SCULPTURE BY SUSANNA ROBINSON / DONATED BY / THE READERS OF / THE EVENING CHRONICLE / ERECTED 1996
Status: not listed
Condition: good
Commissioned by: Evening Chronicle
Custodian: Newcastle City Council

Description: a freely modelled bronze representation of Jackie Milburn in the act of

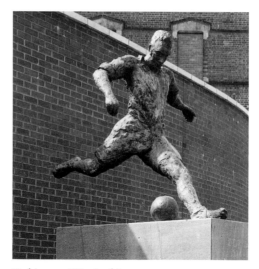

Robinson, *Wor Jackie*

kicking a football, atop a rectangular pedestal covered in grey slate.

Subject: for a biography of John Edward Thompson Milburn (1924–88), also known as 'Wor Jackie', see p.11.

History: in October 1990 planning permission was given for a statue of Milburn to cost £35,000, raised by the *Evening Chronicle* through public donations. The Council was quoted as saying that 'it is felt the siting of a statue such as this within one of the city's main public streets will prove very popular with the people of the city and will be beneficial to the street scene'.[1] The *Chronicle* ensured that the piece received a large amount of publicity. It published an in-depth background and diagram of its construction method,[2] as well as many other articles which focused on Milburn's iconic status in the city.[3]

Once installed however, the statue was not well treated. The ball was taken by thieves on several occasions, though usually found soon afterwards. After it was stolen in May 1996, a Council official said that 'we will have to get in

touch with the sculptor and our foundry experts and it will probably take quite drastic measures to make sure it can't be stolen again'.[4] Unfortunately, the ball was taken again after only two months and when it was found by a dog in Jesmond Dean was taken into safe keeping by the Council.

Eventually the statue and pedestal were completely removed before the re-paving of Northumberland Street which started in early 1998. It was re-sited beside the newly completed West Central Route in front of the Newcastle Breweries wall in June 1999.

Two further statues of Milburn have been installed in the region: one at Ashington by John Mills (see p.11) and one by Tom Maley in Newcastle, sited for a time outside the Newcastle United football ground (see pp.140–1).

[1] *Evening Chronicle*, 5 October 1990. [2] *Journal*, Newcastle, 15 November 1991. [3] *Evening Chronicle*, 15 November 1996. [4] *Journal*, Newcastle, 3 May 1996.

East Quayside

The 1990s saw the transformation of Newcastle's East Quayside from post-industrial dereliction to an area of restaurants, offices and housing, all linked by a riverside promenade. The former Co-operative Wholesale Society building was retained to become a Malmaison Hotel, but the rest of the kilometre-long site was levelled for the new development. Costing £170 million, Tyne and Wear Development Corporation's overall scheme was designed by Terry Farrell Associates, with public art seen as integral to the aesthetic appeal of the area. East Quayside received a Civic Trust award for urban design in 1998.

Wesley Square, riverside area below Crown Court building

Wesley Memorial Fountain

Designer: not known

Unveiled 29 October 1891
Whole work: pink and grey granites 2.6m high × 1.1m square
Incised on west face of pedestal: JOHN WESLEY / CENTENARY MEMORIAL / 1891. UTRICK ALEXANDER RITSON, J.P. / REV. JOSEPH BUSH, / CHAIRMAN OF THE / NEWCASTLE-ON-TYNE DISTRICT / JOSEPH BAXTER ELLIS, ESQ / MAYOR.
On east face: TEXT. / HE WAS WOUNDED FOR OUR TRANSGRESSIONS; / HE WAS BRUISED FOR OUR INIQUITIES; / THE CHASTISEMENT OF OUR PEACE WAS UPON HIM; / AND WITH HIS STRIPES WE ARE HEALED. / ISIAIH LIII 5
Base of obelisk, east side, incised: NEAR / THIS SPOT / JOHN WESLEY / PREACHED HIS FIRST / SERMON IN NEWCASTLE-ON-TYNE / SUNDAY, MAY 30TH 1742.
Status: II
Condition: good
Condition details: spouts missing on each trough; edges of obelisk chipped
Commissioned by: Utrick Alexander Ritson
Custodian: Newcastle City Council

Description: a slim obelisk of polished pink granite rises above a grey marble pedestal on which an organic pattern is carved and picked out in black paint. There is a water trough at the base of the east face and a drinking trough attached to the west face, above which is attached a separately carved lion's head.

Subject: John Wesley (1703–91) and his brother Charles underwent dramatic conversions to lives of religious piety. John sought to combine the essential elements in the Catholic and Evangelical traditions, and to restore to the laity a vital role in Church life. In so doing, he was primarily responsible for one of the most dynamic Christian movements in

Wesley Fountain

the history of modern Protestantism, Methodism. He travelled widely through Britain, preaching in the open air and setting up communities which had to live by strict rules including no swearing, drinking or gambling.

History: Wesley recorded his first visit to Newcastle in his Journal. The entry for Sunday 30 May 1742 reads: 'At seven in the morning I walked down to Sandgate, the poorest and most contemptible part of the town, and standing at the end of the street with John Taylor, began to sing the hundredth psalm.' It was a remarkable occurrence because people were not used to outdoor evangelical sermons. He preached again that evening to a large crowd and subsequently visited Tyneside another 50 times over the course of his life, taking a personal

interest in the religious and moral lives of its inhabitants.[1]

The memorial obelisk was commissioned on the centenary of Wesley's death by local Methodists and sited on ground given by the Town Improvement Committee. It was unveiled by Utrick Ritson, who said the drinking fountain was a fitting memorial to one of the most remarkable characters of the eighteenth century. He also acknowledged the city's free supply of water to the fountain. The Mayor accepted the memorial on behalf of the city, saying that the spot would be remembered by generations to come.[2]

The obelisk was cleaned and re-sited by Eura Conservation in 1992 as part of Tyne and Wear Development Corporation's regeneration of the river frontage. However, it is no longer connected to the water supply.

[1] Milburn, G.E., *The Travelling Preacher: John Wesley in the North East 1742–1790*, Newcastle, 1987, *passim*. [2] *Evening Chronicle*, 29 October 1891.

Retaining wall by Wesley Memorial

River Tyne

Sculptor: Neil Talbot

Carved on site summer 1996
Whole work: sandstone 30m long × 3m high
Status: not listed
Condition: good
Commissioned by: Tyne and Wear Development Corporation
Custodian: Newcastle City Council

Description: a depiction of the course of the River Tyne, carved directly into the retaining wall to a depth of 1cm. Whilst the Tyne is shown in map form, important sites along the River are shown as ground-level views. These are: Cawfields Roman mile castle, Haltwhistle; the mill at Bardon Mill; the bridge at Corbridge; Prudhoe Castle; Thomas Bewick's

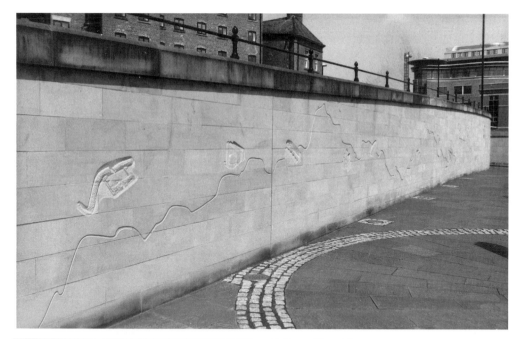

Talbot, *River Tyne*

Talbot, *River Tyne* (detail)

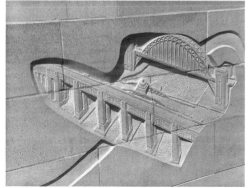

Swan Hunter shipyard; Jarrow monastery; South Shields Roman fort; North Shields Fish Quay and Tynemouth Priory.

History: Talbot worked on site helped by his sister Anna and son Jay, carving directly into a wall which follows the line of Newcastle's fourteenth-century Town Wall (demolished 1763).[1] Characterised as '30 miles of landmarks in a 100–foot stretch', the carving took many weeks to complete, with the sculptors often stopping to chat with interested passers-by. Despite the size of the relief, this is one of the more discreet works on the quayside.

[1] *Journal*, Newcastle, 22 August 1996.

birthplace, Cherryburn; George Stephenson's cottage at Wylam; Lemington glass cone; Newburn Church; Vicker's factory; Dunstan Staithes; the Swing and High Level bridges; the Keep and St Nicholas Cathedral, Newcastle;

Sandgate

River God
Sculptor: André Wallace

Unveiled 14 June 1996
Sculpture: bronze 1.5m high
Column: steel 4.5m high
Signed on base of sculpture: ANDRE WALLACE
Status: not listed
Condition: good
Condition details: surface staining particularly at base
Custodian: Newcastle City Council

Description: a half-length male figure patinated dull brown, set upon a tall cylindrical steel column. It holds a staff in the right hand and seems to be blowing towards the figure of the *Siren* at the top of Sandgate Steps. Chains hang down on either side of the column which is set in the middle of a small roundabout at the centre of East Quayside, with office buildings on one side and the Tyne on the other.

History: locals recall a time when a strongman used to perform on the Quayside, wrapping himself in chains and eating fire, but Wallace has not mentioned this in connection with creating this work.[1] At its design stage, *River God* incorporated a gas flame which was going to be exhaled by the figure.[2] However, technical difficulties and an inability to guarantee safety and long-term maintenance, meant that this feature was not incorporated. Wallace slyly suggested adding a coin meter which would ignite the flame if funds were too tight for its continuous operation.[3] His original conception also included a long spear (where there is now a shortish rod) and free-hanging chains. As installed the chains are welded to avoid any potential problems with noise.[4]

Wallace's ideas were selected from a list of 40 by a panel drawn from Terry Farrell Associates (architects), Branson McGuckin Associates

Wallace, *River God*

(landscape architects), TWDC, and Newcastle Planning Department; and unveiled by Sir Jeremy Beecham, chair of Newcastle City Council Development Committee.[5]

[1] Information provided by Mr William Edgar, 1998.
[2] *Art Review*, Dec./Jan. 1997/8, p.8. [3] Wallace, A., Correspondence with TWDC, 28 October 1995.
[4] Wallace, *op. cit.*, 9 October 1995. [5] Information provided by the artist, 1997.

Wallace, *Siren*

Sandgate

Siren

Sculptor: André Wallace

Installed 1995
Sculpture: bronze 1.3m high × 50cm wide
Column: steel 2.5m high
Metal plaque on wall beneath inscribed: River God & Siren / André Wallace / 1996 / Commissioned by the / Tyne & Wear Development Corporation
Inscribed on base of sculpture: ANDRE WALLACE 96 ©
Status: not listed

Condition: good
Condition details: small areas of the surface stained green
Commissioned by: Tyne and Wear Development Corporation
Custodian: Newcastle City Council

Description: a smoothly-modelled half-length female figure, with a stylised hairstyle or head-dress. Her hands seem to be in the act of clapping.

Siren is a companion piece to the *River God* at the bottom of Sandgate Steps (see above). It is not clear what allusion is being made to the Greek legend of the Sirens, who lured sailors to their death by the beauty of their singing.

Sandgate

Keelrow

Sculptor: Neil Talbot
Letter carver: Graciela Ainsworth

Carved on site 1996
Keelrow: sandstone 6m wide × 1.6m high
Incised lettering along top of wall above carving: As Aa cam thro Sandgit Aaa hard a lassie sing Weel may the keel row That ma laddies in.
Metal plaque to left of wall inscribed: Keelrow/ Neil Talbot / All Sandgate Lettering / Graciela Ainsworth / 1996 / Commissioned by the / Tyne & Wear Development Corporation
Status: not listed
Condition: good
Condition details: algal growth in carvings and at base of wall
Commissioned by: Tyne and Wear Development Corporation
Custodian: Newcastle City Council

Description: a low relief directly carved into the sandstone retaining wall beneath André Wallace's *Siren*. Ainsworth's lettering sets the scene for Talbot's depiction of three maritime

Talbot, *Keelrow* (detail)

locations: a wooden staith with docks; coal barges; and a coastal coal barge (keel). Carved ropework braiding completes the reliefs.

Around the wall, and leading off below it, Sandgate Steps consists of a series of undulating heavy iron balustrades designed by Alan Dawson. The flights of steps are broken so that there is no direct view down from the upper road to the quayside.

Subject: the folk song 'Weel may the keel row!' has been called the 'Tyneside National Anthem' and dates from before 1760. There are several dialect versions, of which the best known goes as follows:

> As I went up Sandgate, up Sandgate, up
> Sandgate,
> As I went up Sandgate I heard a lassie sing –
> Weel may the keel row, the keel row, the keel
> row,
> Weel may the keel row that my laddie's in!
>
> He wears a blue bonnet, blue bonnet, blue
> bonnet,
> He wears a blue bonnet, a dimple in his chin:
> And weel may the keel row, the keel row, the

keel row,
And weel may the keel row that my laddie's in![1]

Sandgate was formerly 'one of the principal thoroughfares by which Newcastle was entered' and became 'the *dulce domum* of that hardy race – the keelmen – who above all other dwellers in Newcastle gave character if not charm to the town'.[2] Keels were flat-bottomed boats which drew little water. Their name was derived from the weight of coal that they could carry, one keel equalling 21 tons and 4 cwts (21.5 tonnes). 'Each had a mast and a square sail but when a favourable breeze was lacking they were propelled by means of a long pole called a set, which had a forked iron prong at the end.'[3] Whilst the keels had crews of five men, they were often hauled against the tide by women, before their load was discharged into sea-going colliers. These distinctive boats are shown in one of Talbot's vignettes.

History: Keelrow is the second of Talbot's works incorporated in TWDC's regeneration programme for East Quayside.

[1] *Allan's Illustrated Edition of Tyneside Songs*, Newcastle, 1891, p.1. [2] Boyle, J.R., *Vestiges of Old Newcastle and Gateshead*, Newcastle upon Tyne and London, 1890, p.86. [3] Mitchell, W.C., *History of Sunderland*, Manchester, 1919, p.144.

Keelman Square

Column and Steps
Sculptor: Andrew Burton

Installed 1996
Column: steel 4.5m high × 40cm diameter
Steps: steel 2.6m square × 93cm high
Metal plaque on wall beneath inscribed:
Column & Steps / Andrew Burton / 1996 / Commissioned by the / Tyne & Wear Development Corporation
Status: not listed

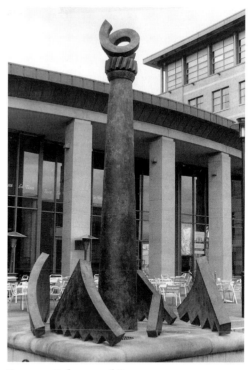

Burton, *Column and Steps*

Condition: good
Commissioned by: Tyne and Wear Development Corporation
Custodian: Newcastle City Council

Description: a tapering cylindrical column made of black steel, topped by an abstract motif. Six forms in the shape of overturned steps are grouped round its base which is set to the side of a flight of steps. The stepped forms at the base are reminiscent of waves around the bottom of a lighthouse. All of the sections are hollow.

History: installed as part of TWDC's regeneration programme, along with *Rudder*, also by Burton (see below).

Rudder

Sculptor: Andrew Burton

Installed 1996
Whole work: bronze 3.8m high × 2.9m wide ×
90cm deep
Plaque on wall beneath inscribed: Rudder /
Andrew Burton / 1996 / Commissioned by the
/ Tyne & Wear Development Corporation
Status: not listed
Condition: good
Commissioned by: Tyne and Wear
Development Corporation
Custodian: Newcastle City Council

Description: a hollow curving form,
embedded into a concrete base and leaning at a
slight angle. The top tapers to a curved abstract
design at its apex. Its surface is pitted and
naturally patinated a light bluish-green from the
casting process.

Subject: whilst the title of this work may
obviously allude to its shape, at first sight
Rudder has an abstract quality, enhanced by its
bulk and lean. The imperfections of the bronze
make closer inspection a revealing experience:
the tactility of the rough/smooth surface invites
handling by the viewer. Burton regards this as
the more successful of the two pieces he made
for this site, the other being *Column and Steps*
(see above).[1]

[1] Interview with artist, 1998.

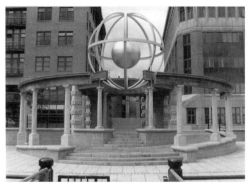

Fulcher, *Swirle Pavilion*

Promenade

Swirle Pavilion

Designer: Raf Fulcher

Erected April 1998
Whole work: stone, concrete and metal 10m
diameter × 9.5m high
Raised gilded lettering around inner rim of
ceiling: HAMBURG GENOA ABERDEEN
ROTTERDAM COPENHAGEN MALMO LONDON
ANTWERP HULL
Status: not listed
Condition: good
Condition details: stonework stained in several
places; many blocks are chipped
Commissioned by: Tyne and Wear
Development Corporation
Custodian: Newcastle City Council

Description: this architectural 'folly' exists as
both sculpture and building. Essentially it
comprises a circular chamber, broken on one
side and supported by Doric columns, with a
separate colonnade running round part of the
outside. The chamber's roof is open to the sky,
and is surmounted by a large gilded orb within
a spherical framework of girders. The ashlar

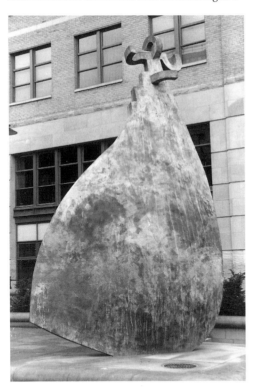

Burton, *Rudder*

stonework is a mix of light sandy-coloured
blocks, some of which are moulded rather like
rockfaces.

History: Fulcher stated that the *Pavilion*'s
theme is location and navigation, and he also
'made reference to the surrounding buildings
on the Quayside, in terms of materials and
general architectural form'.[1] The city names
around the rim are taken from a much faded
sign at Plummer Chare, approximately 500
metres west, advertising the major destinations
of the Tyne-Tees Steam Shipping Company Ltd
from Newcastle and Middlesbrough in the
nineteenth century.

The *Pavilion*'s name originates from a short
street called the Swirle that led from a point at
which Sandgate became St Mary's Street, where
the Half Moon tavern stood in the 1890s. 'The
name of the street is adopted from that of a
covered streamlet which here enters the Tyne,'
with the word Swirle 'according to the
respectable authority of John Trotter Brockett,
applied to express the meandering of a stream
of water.'[2] Interestingly, an eighteenth-century
source mentions 'The Swirle Houses' as being
closer to the city centre, 'near the burying
ground of the dissenters', and given that name
'from their situation near the swirl or runner

which at this place empties itself into Sidgate or Percy-Street'.[3]

Swirle Pavilion cost £100,000 and was funded as part of TWDC's regeneration of East Quayside. It provides a good place to sit, with commanding views along the river and across to where Gateshead's Baltic Centre for Contemporary Art will be completed in 2001.

[1] TWDC Press Release, 17 December 1997.
[2] Boyle, J.R., *Vestiges of Old Newcastle and Gateshead*, Newcastle upon Tyne and London, 1890, p.88. [3] Brand, J., *History and Antiquities of the Town and the County of Newcastle upon Tyne*, London, 1789, vol.1, p.423, note w.

Promenade

Blacksmiths' Needle

Sculptors: British Association of Blacksmith Artists

Unveiled Saturday 10 May 1997
Whole work: forged iron 5m high × 1.3m diameter
Inscribed on plaque on wall to west:
Blacksmiths Needle / British Artist Blacksmiths Association / 1996 / Commissioned by the / Tyne & Wear Development Corporation
Status: not listed
Condition: good
Commissioned by: Tyne and Wear Development Corporation
Custodian: Newcastle City Council

Description: a slim cone-shaped tower of open metal-work, with cast-iron objects welded all over the frame. There are six layers to the *Needle* and the objects are arranged within each according to senses such as touch or hearing. Finished in a lustrous blue patina, the *Needle* is set on a walkway in front of contemporaneous office buildings.

History: Blacksmiths' Needle was created from six sections made at public 'forge-ins' around the country. Each section represents one

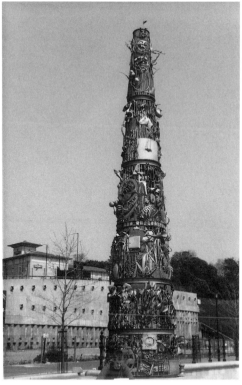

B.A.B.A., *Blacksmiths' Needle*

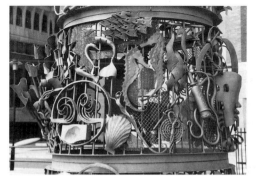

B.A.B.A., *Blacksmiths' Needle* (detail)

of the senses – including what was described as 'the mysterious sixth sense'. There are such a multitude of objects depicted that listing them becomes a game for passing families. However, the items have a predominately maritime theme, so the sculpture fits in with the overall concept for the quayside area.

Forging the *Needle* was described by Alan Dawson of the British Artist Blacksmiths Association as 'an exciting, unique experience for all involved with the project. It is a complex compilation formed by many talented people.'[1] The *Needle* was ceremonially inaugurated by the percussionist Evelyn Glennie, who clanked a bell that hangs inside it. The rope that made this possible broke off not long afterwards, but there is another bell attached to the outside which can still be used.

[1] TWDC Press Release, 6 May 1997.

Eldon Square Shopping Centre
CITY CENTRE

At the time of its construction from 1969 to 1975, Eldon Square was the largest indoor shopping mall in Europe. Designed by Chapman Taylor and Partners, its eight-acre site formed the centrepiece of extensive alterations to Newcastle's city centre, seen as essential to removing traffic congestion and increasing retail space. The walkways and access routes on two levels follow the lines of the old street map, and the city council retains legal control over the interior spaces. The shopping centre takes its name from Richard Grainger's neo-classical square (1825–31), two sides of which were demolished to accommodate the new plan.

Bainbridge store, window

E.M. Bainbridge, John Lewis and John Spedan Lewis

Sculptor: Michael Rizzello

Installed 1976
Each roundel: bronze 30cm diameter × 5cm deep
Painted between roundels of E.M. Bainbridge and J. Lewis: In 1838 at 12 Market Street Newcastle, / Emerson Muschamp Bainbridge opened a small / shop which quickly grew into the world's first / department store. The standards of John Lewis / and Bainbridge were similar and in 1953 / the Bainbridge business joined the John Lewis / Partnership. The move from Market Street / to this building was made in 1976.
Painted between roundels of J. Lewis and J.S. Lewis: In 1864 in London's Oxford Street John Lewis opened / a shop which prospered and developed into the present / business which

bears his name. In 1912 his son, / John Spedan Lewis, made a start on the far-sighted / experiments in industrial democracy that were to lead / by 1929 to the founding of the John Lewis Partnership – / the world's first large scale business enterprise / owned by all those who work in it.
Status: not listed
Condition: good
Commissioned and owned by: John Lewis Partnership

Description: three portrait roundels mounted behind a window set into the side of Bainbridge store in Eldon Square. From the left are depicted E.M. Bainbridge, J. Lewis and J.S. Lewis.
History: installed when Bainbridge moved its store to Eldon Square in 1976.[1] Details of E.M. Bainbridge's and the two Lewises' roles in the modern company are given in the inscriptions.

[1] Airey & Airey, p.192.

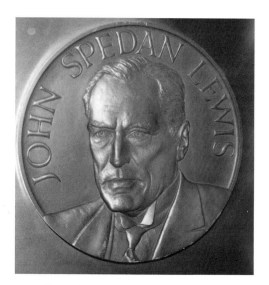

Rizzello, *John Spedan Lewis*

Rizzello, *E.M. Bainbridge*

Rizzello, *John Lewis*

Eldon Way

Flock of Swans

Sculptor: David Schofield

Installed 1986
Each swan: wire mesh 1.2m long × 1m wide approx
Status: not listed
Condition: good
Commissioned and owned by: Eldon Square

Description: forty swans made of wire mesh, suspended from the concourse roof between Bainbridge and Boots. Each bird is coloured pearlescent pink and is hung on invisible wires within a formation that swirls up into the roof space, above the heads of shoppers below.
History: installed as part of the refurbishment of Eldon Square in the mid-1980s, *Flock of Swans* has been described as 'filling the void' above an area where pedestrian walkways open out into a larger square. The

Schofield, *Flock of Swans* (detail)

work was commissioned by Eldon Associates marketing consultants, though the swans are not used in any promotional literature for the shopping centre. It was removed, cleaned and re-lacquered by the artist's workshop in 1996.[1]

[1] Information provided by Mr G. McDonald, Eldon Square Manager, 1999.

Hotspur Way, lift lobby

Man with Pigeons

Sculptor: André Wallace

Unveiled 4 March 1976
Statue: bronze 1.83m high × 23cm wide × 30cm deep
Raised letters on plaque attached to wall: MAN WITH PIGEONS BY ANDRÉ WALLACE / PRESENTED TO, ON BEHALF OF THE CITY / OF NEWCASTLE UPON TYNE, COUNCILLOR / MISS IRIS STEEDMAN LORD MAYOR, BY / SIR RICHARD THOMPSON, BART, CHAIRMAN / OF CAPITAL & COUNTIES PROPERTY / COMPANY LIMITED TO COMMEMORATE / THEIR PARTNERSHIP IN ELDON SQUARE / MARCH 4TH 1976
Status: not listed
Condition: good

Commissioned by: Newcastle City Council
Custodian: Eldon Square

Description: a life-size figure of an elderly man holding a pigeon in both his hands, with two others at his feet. He looks upwards with a slightly open mouth and closed eyes.

History: this smoothly-modelled statue was originally sited on the western external terrace of Eldon Square looking towards Blackett Street.[1] It was stolen in December 1994, but the thieves could not get very far because at least four men are needed to lift it. After being found

Wallace, *Man with Pigeons*

lying on the ground *Man with Pigeons* was repaired and installed in its current, more secure position.[2]

[1] *Brick Bulletin*, no.3, September 1978, ills. 9 and back cover. [2] *Journal*, Newcastle, 16 December 1994.

Elswick Road ELSWICK

Elswick Park, beside entrance to swimming pool

Drinking Fountain

Designer: not known

Erected 1881
Base: grey granite 78cm high × 74cm square
Fountain: grey and pink granites and stone 3.2m high × 1.06m square
Incised Gothic letters around entablature, starting from south-east face: They saved this park / for public use / for health beauty / and happiness / to elevate man / and honour God.
Incised on arches from south-east face: Jos COWEN / Thos FOSTER / Thos GRAY / Thos HODGKIN / Wm SMITH / Wm H STEPHENSON
Incised on south-east face of base: ERECTED BY PUBLIC / SUBSCRIPTION 1881
Status: II
Condition: good
Condition details: missing iron finial; graffiti inked on base
Commissioned by: public subscription
Owned by: Newcastle City Council

Description: hexagonal Gothic drinking fountain with canopy. The base and main structure is grey granite; pink granite pillars support the grey granite entablature and stone roof with arched tops.

Subject: the fountain commemorates the role played by six Newcastle public men who, in 1881, secured 'Elswick Park until the Corporation purchased it for the use of the public': Joseph Cowen (see pp.152–3); Thomas

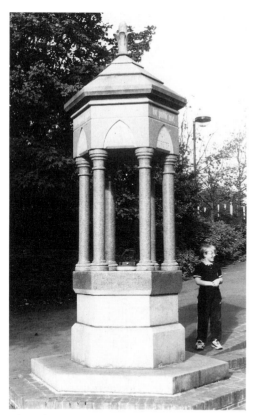

Elswick Drinking Fountain

Eslington Road JESMOND
Jesmond Metro station, exterior

Garden Front

Sculptor: Raf Fulcher

Installed 1978
Spires: steel and wood 4m high × 30cm square
Arch: stone 3.2m high × 1.5m wide
Status: not listed
Condition: good
Commissioned and owned by: Tyne and Wear
Passenger Transport Executive (Nexus)

Description: sculpture consisting of a central stone arch, flanked by four metal spires sitting on wooden planter boxes. Each spire is topped with a cockle shell (originally half of the finials were pineapple shapes).

History: Garden Front has been described as reminiscent of seventeenth- and eighteenth-century garden design, and was designed to contrast with the modernist Metro building behind it.[1] The combination of stark building, sandstone archway, rough-hewn bases and strange metal spires topped by pineapples and cockle-shells creates a coolly picturesque formality which makes the station less incongruous, assimilating it into Jesmond's genteel surroundings.

The sculpture was commissioned as part of Tyne and Wear Passenger Transport Executive's 'Art on the Metro' scheme, funded by Northern Arts.[2] Although Fulcher was commissioned in 1977, it was two years until *Garden Front* could be installed, as the Metro station had yet to be completed. The metal spires were removed about five years later because of vandalism to the shell and pineapple decorative finials. This left the stone arch on its own and looked rather out of place until the work was restored in 1998.

Fenella Crichton wrote an appreciation of *Garden Front* at the time of its installation: 'There are very few pieces of public sculpture which are neither ponderous nor whimsical. Raf Fulcher's work for Jesmond Metro Station in Newcastle is a strong example. One is first struck by its simplicity and elegance and how

Fulcher, *Garden Front*

Gray (Elswick councillor, died 1888); Willliam Haswell Stephenson (see p.120); Thomas Forster (Elswick councillor, died 1881); William Smith (councillor); and Thomas Hodgkin (banker and historian, 1831–1913).[1]

History: paid for by the inhabitants of the west of Newcastle and handed over to the Corporation at a formal ceremony on Easter Monday 1881, the fountain was restored when Elswick Swimming Pool was built in the 1980s.

[1] Newcastle City Council, *Proceedings*, 6 April 1881.

well it works in context, and then one perceives its distinctly mannerist quality, manifested not only in the architecture of the gate but also in the contrariness of the cockle shells and other details. We begin to see that with a deceptive lightness of touch Fulcher has achieved a subtly subversive piece of work, for it totally undermines our expectations of how a public sculpture in the twentieth century should behave.'[3]

[1] Abbott, V. and Chapman, R., *The Great Metro Guide to Tyne and Wear*, Hawes, 1990, p.56.
[2] Nexus, *Public Art in Public Transport*, Newcastle, 1998. [3] Arts Council of Great Britain, *The Sculpture Show*, Hayward and Serpentine Galleries, London, 1983, p.54.

Gallowgate CITY CENTRE

Magnet House, above third-floor windows

Scenes Illustrating the Power of Electricity

Designer: not known

Installed *c.*1938
Each panel: terracotta 1m square approx
Status: not listed
Condition: good
Commissioned by: General Electric Company Ltd.
Custodian: Storey Sons and Parker

Description: thirteen panels with art deco-style low reliefs of men harnessing the power of electricity, set about eight metres up the façade of Magnet House. There are four different scenes in the set: a cloaked figure; a figure and cog; a figure against a background of rocks; and a figure against the sun.
History: it would seem from trade directories that Magnet House was built for the General Electric Company in 1938. According to Pevsner there are similar panels inside G.G.

The Power of Electricity

Scott's Battersea Power Station (1932–4).[1]

[1] Pevsner, *Northumberland*, p.461.

Grainger Street CITY CENTRE

19–25 Grainger Street, pediments fronting Westgate Road and Grainger Street

City of Newcastle Coat of Arms and Cornucopia

Sculptor: not known
Architect: John Edward Watson

Building erected 1863
Coat of arms: yellow stone 1.2m high × 4m wide
Cornucopia: yellow stone 1.2m high × 4m wide
Status: II
Condition: good
Commissioned by: Newcastle Savings Bank

Description: Newcastle's *Coat of Arms* adapted to fit the space of the pediment on the façade fronting Westgate Road. Two passant couchant seahorses flank a shield bearing three

Watson, *Coat of Arms*

castles, topped by a crest of a further castle and demi Lion guardant. A ribbon below bears the city's motto 'Fortiter Defendit Triumphans' (Triumphing by Brave Defence). The group almost forms a mirror image, but there is evidence of individual carving in the details of each seahorse.

The pediment on the façade fronting Grainger Street contains a *Cornucopia* on each side of a wreath enclosing a bee hive, with 'Industry' in raised letters beneath.

History: the city's coat of arms has been in common use from the fourteenth century and is derived from Newcastle's role as a seaport and stronghold against northern invasion. The cornucopia and beehive refer to the benefits of commerce and industry which led to the city being commonly called 'the northern cornucopia'. This fine neo-classical building was built for the National Savings Bank and served as a solicitor's offices in the 1990s, but now stands empty.[1]

[1] Lovie, p.61.

Great North Road JESMOND
Junction with Clayton Road

Monument to W.D. Stephens
Sculptor: William Donaldson

Unveiled 2 May 1908
Whole work: stone and granite with iron details 4.5m high × 5.5m wide
Incised in italic sans serif letters below space for portrait: A CITIZEN OF LOFTY IDEALS & STRENUOUS ENDEAVOUR.
Incised in sans serif letters on front of monument: ERECTED BY PUBLIC SUBSCRIPTION / IN RECOGNITION OF THE OPEN HEARTED CHARITY / CEASELESS ACTIVITY & UNFAILING GENIALITY / WHICH MARKED THE PUBLIC LIFE OF / W.D. STEPHENS / ALDERMAN & J.P. OF THE CITY OF NEWCASTLE ON TYNE / SHERIFF 1879–80

Donaldson, *Stephens Monument*

MAYOR 1887–88 / DISTINGUISHED AS THE PRESIDENT OF GREAT / ORGANISATIONS FOR THE PROMOTION OF / MARITIME COMMERCE HE EARNED STILL HIGHER / APPRECIATION IN THE CAUSE OF TEMPERANCE / AND THE BETTERMENT OF THE POOR & NEEDY.
Incised on right pier end: MARSHALL & TWEEDY / ARCHITECTS / WILLIAM DONALDSON / SCULPTOR
Status: II
Condition: poor
Condition details: portrait relief missing; water spout missing; weathered with cracks at joints
Commissioned by: public subscription
Custodian: Newcastle City Council

Description: a neo-classical memorial

consisting of two piers with iron balustrades on top, flanking a central monumental panel which rises above a granite drinking trough, which in turn is flanked by two obelisks. The panel has a space where a portrait roundel once was, and above this is a broken-bed arched pediment framing the relief lettering '1827/1901'. The style of the monument is restrained, apart from two carved swags of fruit and leaves rather incongruously situated on either side of the panel.

Subject: William Davies Stephens (1827–1901), Methodist and temperance reformer, started out in business with a chemical firm, Hugh Lee Pattinson & Co., and later developed the Tyne Steam Shipping Co. with William Laing (see below). He was elected a Newcastle councillor in 1874, alderman in 1890 and mayor in 1879 and 1887.[1]

History: initially, in January 1906, the Stephens memorial committee considered erecting a monument in Newgate Street, where the medieval White Cross had been.[2] The present site was chosen in September 1907. Unfortunately this meant moving the Colvill fountain which stood on the site further north to Forsyth Road (see below), and also meant that the Stephens fountain was closer to Stephens's former home and 'those magnificent institutions on the Moor Edge in which he took such a deep interest, and in whose welfare he took such an active part during his lifetime'.[3]

With the building of the East Central Motorway the fountain had to be moved again by some six metres, at a cost of £1,000.[4] A photograph of the fountain before the move shows that it originally incorporated a bronze relief roundel portrait of Stephens.[5]

[1] Newcastle City Council, *Proceedings*, 1889–90, p.174 and 1901–2, record iv. [2] *Ibid.*, 10 January 1906. [3] *Ibid.*, 4 September 1907. [4] Newspaper cutting, Newcastle Central Library, n.d. [5] Davies, P., *Troughs and Drinking Fountains*, London, 1989, p.88.

Junction with Forsyth Road

Edwin Dodd Colvill Memorial Fountain

Designer: not known

Unveiled 22 August 1889
Whole work: stone and granite 2.1m high ×
1.1m wide × 60cm deep
Raised metal sans serif letters on tablet above
trough: [...]HIS / FOUNTAIN / WAS PRESENTED TO
THE / CITY OF NEWCASTLE / BY MISS CAROLINE
SOPHIA / RUSSELL COLVILL / IN LOVING
REMEMBRANCE OF / HER BROT[...]ER THE LATE /
EDWIN DODD COLVI[...]L / WHO WAS FOR
UPWARD[...] / [...] YEARS WELL AND
HONOURABLY / [...]OWN IN NEWCASTLE / MAYOR

Colvill Fountain

/ [...]D [...]TEPHENS ESQ / [...]888 / IN AS MUCH
AS YE DID IT UNTO / ONE OF THE LEAST OF THESE
MY BRETHREN / [...] IT UNTO M[...] MATTXX [...]
Status: not listed
Condition: poor
Condition details: stone badly weathered and
chipped; water spout missing; lettering missing
from inscription
Commissioned by: Miss Caroline Sophia
Russell Colvill
Custodian: Newcastle City Council

Description: a small memorial drinking
fountain with a circular basin. The tablet with
the inscription is set within a gothic arch. It is
sited on the corner of a busy road junction and
obviously neglected. It now has to be supported
by two iron posts.
Subject: despite the inscription's encomium,
all that has been discovered about Colvill was
that he was a coal-fitter with a business address
at the Exchange Buildings, Newcastle 1879–86.[1]
History: the fountain was formally presented
to the City on 22 August 1889 by Dr Whylock
of Folkestone in the name of his aunt, Miss
Colvill.[2]

[1] *Ward's Directory of Newcastle upon Tyne and
Gateshead*, Newcastle upon Tyne, 1879 and 1886.
[2] *Monthly Chronicle*, 1889, p.382.

Junction with Jesmond Dene Road

William Laing Memorial Fountain

Designer: not known

Erected *c.*1895
Whole work: pink granite 3m high × 1.5m wide
Incised on east face of base in Roman letters:
ERECTED / BY THE WIDOW OF THE LATE /
WILLIAM LAING / OF NEWCASTLE AND GOSFORTH
/ IN AFFECTIONATE REMEMBRANCE OF / HIS
LIFELONG INTEREST IN AND / KINDNESS TO ALL
DUMB ANIMALS / 1895
Status: not listed

Condition: poor
Condition details: stone split at joints;
discoloured by weathering; rusting metalwork;
overgrown with ivy
Commissioned by: the widow of William Laing
Custodian: Newcastle City Council

Description: a drinking fountain in the form
of a cubic base with an iron ball on top, to
which is attached a semi-circular trough at
ground level on one side, and a small stoop
approximately 60cm off the ground on the
other. There is also a metal fixture which could
have been a tap. The fountain is no longer
working.
Subject: a successful businessman, William
Laing developed the Tyne Steam Shipping Co.

Laing Fountain

with W.D. Stephens whose memorial is nearby (see p.116). It is possible that his role as founder of the temperance festival on the Town Moor is the reason for the fountain being sited where it is.[1]

[1] Newcastle City Council, *Proceedings*, 1901–2, record iv.

Grey Street CITY CENTRE
Theatre Royal, pediment

Royal Coat of Arms

Sculptor: Christopher Tate
Architects: Benjamin Green and John Green Senior

Building erected 1838
Whole work: stone 1.8m high × 5m wide approx
Raised lettering round edges of shield: HONI SOIT QUI MAL Y PENSE

Tate, *Royal Coat of Arms*

Status: II*
Condition: fair
Condition details: missing detail on top of plumage; weathered and generally dirty surfaces
Owned by: Theatre Royal

Description: set within the theatre's pediment and carved fully in the round, a coat of arms consisting of a central circular shield with the royal device, flanked by a couchant lion and unicorn. The pieces show an expressive and bold hand was at work, though the details are now unfortunately rather obscured.

History: as part of his redevelopment of Newcastle, Richard Grainger demolished the old theatre and commissioned John and Benjamin Green to construct this grand neo-classical building as its replacement. Tate's *Coat of Arms* was exhibited at the Northern Society of Artists in 1836 before being put in place. The local press commented that it was 'about the best we have ever seen for fine finishing, elegance of position in parts and beauty of arrangement in the whole'.[1]

[1] *Tyne Mercury*, 22 November 1836.

Horatio Road BYKER
Junction of Horatio Road and City Road

Monument to William Coulson

Sculptor: Arnold Frédéric Rechberg
Foundry: Alexis Rudier

Unveiled 27 May 1914
Bust: bronze 1.1m high
Pedestal: concrete and stone 1m high × 60cm high
Base: concrete and stone 1m high × 4m wide × 1.2m deep
Incised in Roman lettering on front face of pedestal: WILLIAM LISLE BLENKINSOPP / COULSON / 1841–1911 / ERECTED BY PUBLIC SUBSCRIPTION / IN MEMORY OF HIS EFFORTS / TO ASSIST THE WEAK AND DEFENCELESS / AMONG MANKIND AND IN THE ANIMAL WORLD.
Incised on rear face of pedestal: "WHAT IS REALLY NEEDED IS AN ALLROUND / EDUCATION OF THE HIGHER IMPULSES / TRUE MANLINESS, / JUSTICE, AND PITY. / TO TRY TO PROMOTE THESE HAS BEEN / MY HUMBLE BUT EARNEST ENDEAVOUR, AND UNTIL / THEY ARE MORE GENUINELY AROUSED, / THE LEGISLATURE IS USELESS, / FOR IT IS THE PEOPLE WHO MAKE THE LAWS" / (W.L.B.C.) / UNVEILED 27TH MAY 1914, / BY THE RIGHT HONOURABLE / JOHNSTON WALLACE, LORD MAYOR. / HERBERT SHAW. SHERIFF. / A.M. OLIVER, TOWN CLERK.
Signed on reverse of sculpture base: A RECHBERG 1912. Incised on west side of sculpture base: ALEXIS RUDIER / FONDEUR PARIS
Status: II
Condition: good
Condition details: leaching from the sculpture has stained areas of the pedestal green

Commissioned by: public subscription
Custodian: Newcastle City Council

Description: a double life-size bronze bust of Coulson swathed in a cloak is set upon a concrete pedestal, over which his cloak hangs down. The modelling is in the New Sculpture manner, the loose folds and organic bulk being similar to the work of Rodin. The pedestal stands on a large block of stone, which has been reconstituted with concrete, and the whole is set upon the original pink granite base with drinking troughs to front and rear. Newly carved lions' heads are attached over each basin.

Subject: William Lisle Blenkinsopp Coulson (1840–1911) was a prominent figure on

Rechberg, *Coulson Monument*

Tyneside, known for his 'untiring efforts for the kindly treatment of animals' and for the unusual plaid in which he habitually dressed. Born in Haltwhistle, he served in the army from 1860 to 1892, retiring as a colonel. Subsequently he served as a magistrate and on the boards of many charities concerning themselves with child and animal welfare. He toured schools and borstals throughout the country giving lectures on morality, published *Musings on Moor and Fell* and essays on the welfare of children and women.[1] He died in Newbrough, Northumberland, leaving a wife and daughter.[2]

History: a memorial to Colonel Coulson was suggested by George Grahame, the First Secretary to the British Embassy in Paris, in a letter to Newcastle City Council read out to members in October 1911. Mr Grahame indicated that he would be willing to donate £300 towards a fountain (at which cattle could drink) carrying a portrait medallion.[3]

By January 1912 the council was recommended to place the monument at the junction of Marlborough Crescent and Scotswood Road, but the Memorial Fund Committee did not feel this was suitable.[4] A site on Haymarket, opposite St Thomas's Street, was finally chosen in April, but arguments ensued over the potential spread of disease from a cattle trough, and the cost of supplying water to it.[5] However, these were eventually overcome and the monument was installed nearer to the Boer War Memorial than the council proceedings had indicated.[6]

The fountain was unveiled by the Lord Mayor before a large crowd on 27 May 1914. Sir Alfred Palmer, chairman of the Memorial Committee, said that Coulson had been 'worthy of every honour' and was 'no mere theorist' in his interest for 'dumb animals'. In accepting the memorial, the Lord Mayor said that 'it might with confidence be stated that it would be well kept by the Corporation' in the future.[7]

By the 1930s the corner of Haymarket was becoming extremely congested and it was proposed to move the monument 50 metres further down Percy Street. Other suggestions included resiting it in a park, but this was not felt to be appropriate. As far as can be ascertained, the memorial was moved as proposed, but was then moved to its current location in 1950. Having been moved several times in its life, it is not surprising that the stonework has suffered along the way. Substantial cracks and stone weathering were sympathetically restored in 1998, and the monument now stands as a landmark above a modern housing development on the Quayside.

[1] *Evening Chronicle*, 1 June 1911. [2] *Journal*, Newcastle, 2 June 1911. [3] Newcastle City Council, *Proceedings*, 4 October 1911. [4] *Ibid.*, 10 January 1912. [5] *Ibid.*, 3 April 1912. [6] Newcastle City Libraries, Photo no.41089; neg.1/3184. [7] Anon, *Evening Chronicle*, 27 May 1914.

Mosley Street CITY CENTRE
St Nicholas Square

Monument to Queen Victoria
Sculptor: Alfred Gilbert

Unveiled 24 April 1903
Canopy: bronze 2.85m high
Statue: bronze, coated with black paint 1.9m high × 3m deep
Base of sculpture: bronze, coated with black paint 1m high × 3.46m diameter
Pedestal: pink granite 91cm high × 3.46m diameter
Incised Gothic lettering on pedestal. Front (west) face: VICTORIA RI / 1837–1901 / THE THRONE IS ESTABLISHED BY / RIGHTEOUSNESS. South face: THINE IS THE KINGDOM O LORD AND / THOU ART EXALTED AS HEAD ABOVE ALL. North face: THINE O LORD IS THE GREATNESS / AND THE POWER AND THE GLORY / AND THE VICTORY AND THE MAJESTY.

Sans serif lettering, east face: ERECTED BY / SIR WILLIAM HASWELL STEPHENSON KNT DL / MAYOR / IN COMMEMORATION / OF THE 500TH ANNIVERSARY / OF THE SHRIEVALTY OF NEWCASTLE-UPON-TYNE / 1400–1900 / UNVEILED BY THE COUNTESS GREY / APRIL 24TH 1903

Status: II*

Condition: fair

Condition details: panel staved in at rear of bronze base, also small section cut away on base to the right of figure; bronze surfaces coated with black paint, but generally worn away to leave green surface; droppings on most surfaces and generally dirty

Commissioned and owned by: Newcastle City Council

Description: a bronze statue of the aged Queen Victoria which, in its balance of naturalism and fantasy, may be seen as a variant of the sculptor's 1887 *Jubilee Monument* at Winchester:[1] the figure is a replica although the canopy design is different.[2] The Queen sits with a crown on her head and orb and sceptre in either hand on an elaborate throne. Her diminutive figure nestles within the deeply-modelled folds of a huge, flowing cloak and her feet rest on a large tassled cushion. The back of the throne and, more particularly, the throne's canopy comprise a free arrangement of piled-up, curved pediments, brackets and pedestals which echoes the shape of the lantern of the steeple of St Nicholas Cathedral nearby. Perched on the top of the canopy is a plumed helmet with a crown on top. The statue rests on a bronze base whose gently swelling form and strange helmeted children's heads are a replica of the one on the 1887 *Shaftesbury Memorial* at Piccadilly Circus. This bronze base rests on polished pink granite pedestal, circular in shape with square projecting corners, designed by J.W. Dyson. The orb in the Queen's hand was meant to have an 'ideal representation of Victory' on top but this was lost in the casting.[3]

Gilbert, *Queen Victoria*

Subject: the statue, unveiled in 1903, celebrates the reign of the recently deceased Queen Victoria (1837–1901) and marks the 500th anniversary, on 23 May 1900, of the office of sheriff in Newcastle which was first granted by Henry IV. W.H. Stephenson explained that the role of the sheriff, the statue's commissioner, was to be 'lord and master over everything that relates to the Queen and the administration of the law'.[4]

It is perhaps rather surprising that Newcastle should have chosen to celebrate the Queen's reign in this way. The city in the late nineteenth century was reputedly rather republican in its sympathies, so much so that for a period the Queen always used to lower the blinds on her carriage whenever she passed through.[5]

History: the statue was the gift of Sir William Haswell Stephenson (1836–1918). The son of the founder of a fire clay and gas retort works at Throckley, Stephenson established the Throckley Coal Co. in 1867 and went on to become wealthy as the director of various utility companies in the region. He was also an important figure in local politics (mayor seven times) and a generous benefactor of the city: he paid for the libraries at Elswick, Walker and Heaton and the Methodist chapels at Throckley and Elswick.[6] As one speaker put it in 1899, 'To trace Alderman Stephenson's public career would be to give the history of the City'.[7]

In July 1899 Stephenson wrote to the press offering to erect a statue of the still-living Queen as a way of marking the 500th anniversary of Newcastle's shrievalty. On 2 May 1900 he reminded the Council of this offer and suggested that since Alexander Laing had recently given the city a municipal art gallery and since the cab shelter and public convenience which stood on St Nicholas Square were about to be removed, the time was possibly right for them to take up his offer. He explained that he had for some time wanted to show his appreciation of the singular honour he received when he was elected Sheriff in 1887, the year of the Queen's jubilee. The Council received Stephenson's offer with enthusiasm, although it was pointed out to him that a statue in the position he proposed would mean moving the recently installed Rutherford fountain (see pp.95–6).[8]

Later in the same month, Stephenson was able to report that he had succeeded in commissioning Gilbert. The sculptor had visited Newcastle and been taken to see various possible sites: opposite the Bigg Market, Eldon Square and the Museum grounds. To

Stephenson's satisfaction Gilbert had decided that his own preferred site, St Nicholas Square, was the most suitable if, that is, the statue was oriented properly. 'We cannot put Her Majesty with her back to the Church; the statue must be placed square with the tower, looking up Collingwood Street, with the left to the Church and the right to the Town Hall.' Gilbert said that he wanted the statue 'to be in harmony with the tower and the beautiful flying buttresses' supporting the tower. As for the time needed, he reckoned the modelling of the figure in clay would take six months and the 'bronze work' four to six months.[9]

Early in the following year all seemed to be going well. On 6 March 1901 Stephenson reported that Gilbert had told him the statue would be finished within a year as had been agreed, that is, by 23 May 1900.[10] A fortnight later the Newcastle, Gateshead and District Band of Hope Union agreed, albeit somewhat reluctantly, to move the Rutherford Fountain to the lower end of the Bigg Market.[11]

However, on 4 September Stephenson had to make an embarrassing announcement. The statue would not be ready on time after all. 'Mr Gilbert had got into financial difficulties' and had gone into voluntary exile in Bruges. The unveiling would therefore be in the spring of 1902.[12] In the event even that was not achieved. The statue (cast by the Compagnie des Bronzes of Brussels) was not unveiled until 1903. Gilbert perhaps wisely did not attend the ceremony, explaining in a letter which was read out at the unveiling, that 'he was not able to be with them that morning as he had been called from London to the Continent'.[13] He did, however, make efforts to placate Stephenson and the inhabitants of Newcastle by assuring them that the statue was the 'best thing he ever did', so good indeed that it would 'take the present generation thirty years to get educated up to it'.

Maps of Newcastle suggest that although the statue's orientation is as Gilbert intended, the raised paved area on which it now sits dates from the early 1960s when the corner of Mosley Sreet and St Nicholas Street was widened.

[1] Dorment, R, *Alfred Gilbert*, London and New Haven, 1985, p.72. [2] Beattie, pp.208–9, 213–14. [3] Newcastle City Council, *Proceedings*, 1902–3, p.xxi. [4] *Ibid.*, 1899–1900. p.412. [5] Ayris et al., p.28. [6] Jeremy, D. and Shaw, C. (eds), *Dictionary of Business Biography*, London, 1986, pp.301–2. [7] *Newcastle Yearbook. A local history, guide and annual review*, 1905, p.73. [8] Newcastle City Council, *Proceedings*, 1899–1900, pp.412 and 414. [9] *Ibid.*, p.440. [10] *Ibid.*, 1900–1, p.253. [11] *Ibid.*, p.303. [12] *Ibid.*, p.654. [13] *Ibid.*, 1902–3, p.xxi.

Neville Street · CITY CENTRE

Central Station, frieze above entrance archways, overlooking concourse

Queen Victoria, Prince Albert and King Edward VII

Sculptors: not known
Architects: John Dobson and George Hudson

Station opened 1850
Each roundel: stone 80cm diameter
Incised above Prince Albert in giant Roman lettering: XXVIII SEPTEMBER
Incised above Queen Victoria in giant Roman lettering: A.D. MDCCCXLIX
Status: I
Condition: fair

Condition details: weathered surfaces, particularly on *Prince Albert*; all roundels are dirty and stained
Commissioned by: Great North East Railway Company

Description: three portrait busts in roundels, relief carved to a depth of about 5cm. At the left is a young *Prince Albert*, looking to the right; in the middle is *King Edward*, looking to the left; and at the right is a portrait of the young *Queen Victoria*, looking to the left. All three are carved quite broadly, though the sculptor of King Edward is obviously different from that of the other two roundels.

History: a grand design for Newcastle's railway station was put forward by John Dobson and George Hudson in 1845, but Hudson's finances collapsed and the original scheme was abandoned. Even so, the vast train shed was built with a less grandiose façade and was in place for the official opening by Queen Victoria,[1] who stopped on her way to Scotland.[2] The portrait roundels were part of the original building. The station's present portico designed by Dobson and Prosser was added in 1863.

The portrait roundel of King Edward was probably added to commemorate his visit to the city in July 1906 when he unveiled a memorial statue of his mother and opened the new Royal Victoria Infirmary and an extension to

Queen Victoria, Prince Albert and King Edward VII

Armstrong College (see pp.135–6 and pp.141 and 144).

[1] Faulkner, T. and Greg, A., *John Dobson, Newcastle Architect 1787–1865*, Newcastle, 1987, p.80. [2] Fordyce, *passim*.

Newcastle Business Park

W.G. Armstrong (see pp.92–3) formed a partnership in 1847 to build cranes and bridges at Elswick. His first contract with the War Office was for submarine mines in 1854, and the battle of Inkerman in November of that year made it plain to him that more manœuverable heavy armaments were needed. Armstrong's designs were chosen over those of his rival Joseph Whitworth in 1858, and the Elswick Ordnance Company was founded in 1859. The works expanded into shipbuilding in the 1860s and steel production from 1884.[1] Productivity was raised considerably during both World Wars though the firm underwent a series of restructurings through the first half of the twentieth century, merging with Vickers in 1927. Orders dwindled in the 1950s and by the late 1970s the 1.5-kilometre-long complex was semi-derelict. The site was completely cleared and left empty for redevelopment in 1985.[2]

Tyne and Wear Development Company was charged with regenerating the area and created Newcastle Business Park at a cost of £140 million. Six works of sculpture were commissioned to be temporarily sited at the Gateshead Garden Festival from May to October 1990, before being moved north of the river to become part of a permanent riverside sculpture walk. Newcastle Business Park's sponsorship of *Festival Landmarks '90* was recognised by an ABSA award.[3]

[1] Vickers-Armstrong, *Elswick 1847–1947*, London, 1947, *passim*. [2] Warren, K., *Armstrongs of Elswick*, Basingstoke and London, 1989, *passim*. [3] *Festival Landmarks*.

Amethyst Road, opposite Sirius House

Lintzford
Sculptor: Nick Lloyd

Installed 1990
Whole work: limestone 3.2m square × 1.8m high at highest point
Plaque reads: LINTZFORD / by Nick Lloyd, 1990 / Ancaster Hardwhite Limestone / The title refers to the / Derwent Valley where the / sculptor lives and works.
Status: not listed
Condition: good
Commissioned and owned by: Newcastle Business Park

Description: a roughly H-shaped, low stone sculpture with a form abstracted from landscape, but also alluding to architectural remnants in its use of straight lines and curved sills. The work has many breaks and curves, and chisel marks are clearly visible on the surfaces which have weathered to different colours, ranging from honey to grey.

Lloyd's approach to the design and carving of *Lintzford* may be explained by his statement that 'the quality of light across stone and the manipulation of that light [is] a continuing pre-occupation'.[1] Although not a literal depiction of landscape, *Lintzford* is an attempt to portray

Lloyd, *Lintzford*

the 'bitter sweet' energies of the Northumberland and Durham countryside. Of his relationship to the North-East, Lloyd said 'I use the landscape because I live in it and because it is there and not out of some delusion or attempt to retrieve or achieve a vision of pastoral bliss'.[2]

History: originally sited by the river in the Gateshead Garden Festival, 1990.

[1] AXIS, *Artists Register*, 1999. [2] *Festival Landmarks*, p.20.

Amethyst Road, outside Mikasa House

Lion
Sculptor: Andrew Burton

Installed 1990
Sculpture: bronze 80cm high × 1.8m long
Pedestal: concrete 80cm high × 2.2m wide
Plaque attached to pedestal reads: The Lion by Andrew Burton 1990.
Status: not listed
Condition: good
Commissioned and owned by: Newcastle Business Park

Description: a small sculpture of a pacing lion, which contrasts with the formality of its surroundings through the tactile nature of the pitted and worked bronze surface. The lion's

Burton, *Lion*

mane is cast from lengths of chain.

Burton wrote about the three sculptures he contributed to the 1990 Gateshead Garden Festival: 'although not literally accurate the animals are realistic in their attempt to capture the feel and life of the creatures. I try to find equivalents for parts of their bodies.'[1] For example mechanical chains were made to suggest a lion's mane.

History: along with the two *Elephants* (see entry for Monarch Road below), the *Lion* was moved to at the Business Park after being located in the Riverside Section of the Gateshead Garden Festival. There is a similar sculpture of a lion by Burton at Minster Court, London.

[1] *Festival Landmarks*, p.17.

Walkway from Amethyst Road to bottom of William Armstrong Drive

Untitled
Sculptor: David McMillan

Installed 1990
Whole work: painted steel 28m long × 2.4m deep × up to 1.9m high
Status: not listed
Condition: good
Condition details: flaking of paint surface
Commissioned and owned by: Newcastle Business Park

Description: twenty-four steel sections fashioned like angular figures-of-eight make up this long, low work. They combine to create a rolling wave form which, according to the artist, reflects the silhouette of Gateshead opposite. The angularity of each section is lost in the more flowing nature of the whole, and the red paint stands out well against the greenness of summer vegetation.

McMillan was aware that he had to design a sculpture that would be 'comfortable' in both

McMillan, *Untitled*

the Garden Festival site and across the river in Newcastle Business Park. This work takes the theme of the North-East's rolling landscape and 'big sky' as its starting point, whilst fitting in with the narrow walkway on which it is located.[1]

History: originally sited in the Riverside section of the Gateshead Garden Festival, 1990.

[1] *Festival Landmarks*, p.21.

Amethyst Road, in front of unit housing Allied Dunbar

Elephant Under a Moroccan Edifice
Sculptor: Andrew Burton

Installed 1990
Sculpture: bronze 1.6m high × 1m long
Pedestal: concrete 1.1m high × 1.2m long ×

90cm wide
Plaque on pedestal inscribed: An Elephant Under a Tower by Andrew Burton 1990.
Status: not listed
Condition: good
Condition details: some lichen growth and generally dusty
Commissioned and owned by: Newcastle Business Park

Description: a walking elephant carrying a large tower on its back, with steps up one side, windows at the top and a projection at the front. The surface of the bronze is patinated a light green and has been left rough to the touch.

Burton has stated that his work combines 'disparate images to create a strong and arresting image with an underlying meaning or metaphorical sense'.[1] *Elephant Under a Moroccan Edifice* presents an intriguing subject in the protected enclave of the grassed area in

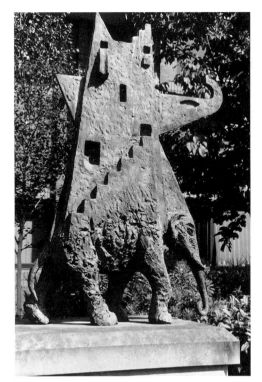

Burton, *Elephant Under a Moroccan Edifice*

front of a business unit. Despite its small size, it has a considerable sense of mass.

History: originally sited in the Riverside section of the Gateshead Garden Festival, 1990, along with *Lion* and *Tipping Off the World*.

[1] *Festival Landmarks*, p.21.

Amethyst Road, outside Weymouth House

Tipping Off the World
Sculptor: Andrew Burton

Installed 1990
Sculpture: bronze 1.2m high × 1m wide
Pedestal: concrete 1.1m long × 1.1m high
Plaque on pedestal reads: Tipping Off the World by Andrew Burton 1990
Status: not listed
Condition: good
Commissioned and owned by: Newcastle Business Park

Description: sculpture of a trumpeting elephant pushing forward on its feet, with a cliff-like attachment on its back.

Burton describes how elephants are used as work animals whilst also being 'venerated as holy and noble creatures'. He has stated that the two elephant sculptures are 'something of a paradox' in terms of subject matter, suggesting 'both triumph and oppression', dignity and the absurd.[1]

History: originally sited in the Riverside section of the Gateshead Garden Festival, 1990, along with *Lion* and *Elephant Under a Moroccan Edifice*.

[1] *Festival Landmarks*, p.17.

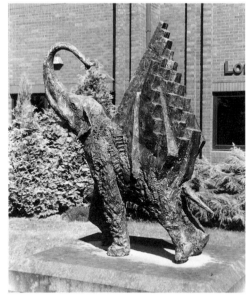

Burton, *Tipping Off the World*

Amethyst Road, river bank at east end

Spheres
Sculptor: Richard Cole

Installed 1990
All spheres: concrete up to 2.3m high × 2.1m diameter
Status: not listed
Condition: good
Commissioned and owned by: Newcastle Business Park

Description: a number of large spheres each made of horizontally layered concrete discs. They are sited in small groups at intervals along the riverside walkway, covering an area about 400 metres long. The texture of the concrete the spheres are made from ranges from coarse to smooth.

According to the artist, the shapes of the *Spheres* are derived from topiary and organic forms, and their scale and weight 'can offer a number of different meanings and interpretations'. The pale colouration of the sculptures blends in with the overall landscaping and brickwork of the surrounding area: 'they can playfully reflect, contain and even expand the existing characteristics of the context in which they are placed.'[1]

History: originally sited in the Norwood section of the Gateshead Garden Festival, 1990.

[1] *Festival Landmarks*, p.51.

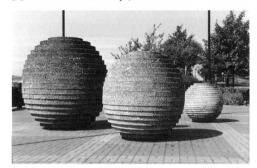

Cole, *Spheres*

William Armstrong Drive: parapet overlooking steps down to Amethyst Drive

Heraldic Head with Armaments
Sculptor: not known

Building *c.*1860; re-sited *c.*1990
Whole work: stone 90cm high × 2.2m wide
Status: not listed
Condition: good
Condition details: light covering of moss on top
Commissioned by: Armstrong Works
Re-sited by: Tyne and Wear Development Corporation
Owned by: Newcastle Business Park

Description: once the pedimental decoration to the Armstrong Works projectile shop, this lintel now crowns a set of steep stairs running from Amethyst Drive to William Armstrong Drive above. The relief carving consists of a heraldic arm and hammer, above a helmeted head which protrudes much further. Large gun barrels are carved either side of the head, which may be a representation of Mars, the Roman god of war.

History: this salvaged pediment was sited as part of the landscaping which links the quayside to the central part of Newcastle Business Park.

Heraldic Head with Armaments

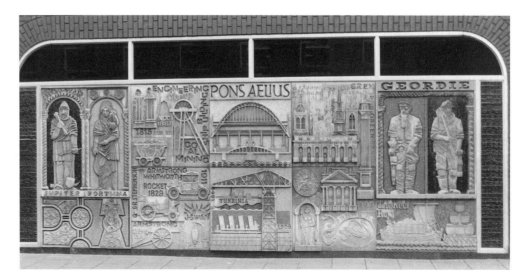

H & J Collins, *Newcastle Through the Ages* (right panel)

Northumberland Street
CITY CENTRE

Wall of BHS department store

Newcastle Through the Ages
Sculptors: Henry and Joyce Collins

Installed 1974
Left panel: polychrome ciment fondu and stone 2.3m high × 2.7m wide
Right panel: polychrome ciment fondu and stone 2.3m high × 6.4m wide
Status: not listed
Condition: good
Owned by: C&A Ltd

Description: two relief panels moulded to a depth of about 5cm are set into the wall of the shopping complex. Each contains a wealth of local historical detail.

Left panel includes: 'MONKCHESTER' with Roman head and Newcastle coat of arms; Roman ship and golden coin; 'COLLIER BRIG 1704–1880' with ship; 'OCEANUS' with anchor and seahorse with trident.

Right panel includes: 'JUPITER FORTUNA' with two figures; 'ENGINEERING'; 'DAVY AND STEPHENSON'; 'COAL MINING SHIP BUILDING' with images of same; 'G & R STEPHENSON'; 'ARMSTRONG WHITWORTH'; 'ROCKET 1829' with image of first steam engine; 'ARMSTRONG 12 POUNDER RA' with image of gun; '1878 J.SWAN'. 'PONS AELIUS' with bridges depicted below; 'TURBINIA' and image of ship; various churches with names carved about including 'GRAINGER DOBSON 1865'; '1838 GREEN STOKOE'; 'BEWICK' with a swan; a figure and 'BRIGANTIA'. Final section on far right has 'GEORDIE' over two figures, then 'THE KEEL ROW' with a loading boat at the bottom.

History: although this is a well-known work, there is virtually no record of its commissioning or subsequent history. The building was originally developed by C&A but it is unclear who funded the reliefs. Although the building is now occupied by BHS, C&A estates still own the site.

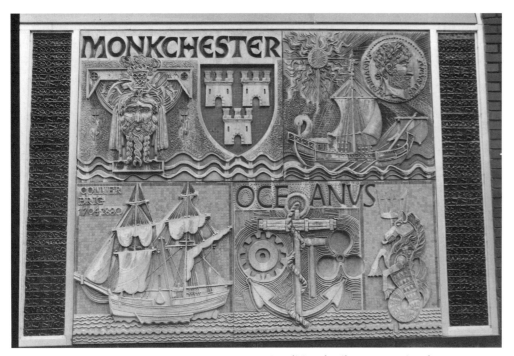

H & J Collins, *Newcastle Through the Ages* (left panel)

45 Northumberland Street, façade

Harry Hotspur, Roger Thornton, Sir John Marley and *Thomas Bewick*

Sculptor: not known
Architect: M.V. Treleaven

Building opened *c.*1912
Each statue: stone 1.2m high × 60cm wide
Incised in Roman letters painted black on the base of the relevant statue: THOMAS BEWICK; HARRY HOTSPUR; SIR JOHN MARLEY; ROGER THORNTON
Status: II
Condition: fair

Condition details: statues painted over; droppings and damaged areas on all figures
Commissioned by: Boots Cash Chemists
Custodian: British Steel Property

Description: ornate three-bay façade with four niches at the first and second storeys each containing a free-standing stone figure. The expressive quality of the sculptures has been partially obscured by the wholesale application of cream paint.

Subject: the four statues are of famous figures from Newcastle's past. Sir Henry Percy (1366–1403), known as 'Harry Hotspur', was knighted at the age of eleven and soon established a reputation as a fierce, but not especially skilful warrior; hence the name 'Hotspur'. His greatest exploit was at the Battle of Otterburn (see p.44). After a number of successful campaigns against the Scots he met his downfall at the Battle of Shrewsbury in 1403

where he supported the insurrection against Henry IV.[1]

Roger Thornton (?–1429) rose from impecunious beginnings to become an immensely wealthy Newcastle merchant and the town's mayor. As MP for Newcastle in 1400 he secured immunity for the burgesses of the town from the Sheriff of Northumberland, a key moment in the town's history.[2]

The main contribution of John Marley (1590–1673) to Newcastle's history was his defence of the King's interest in the town in the years preceding and during the Civil War. In 1644 he was imprisoned for his role defending the castle against besieging Scots. However, he was soon released and allowed to go into exile on the Continent. Later, following the Restoration, he was the town's mayor on several occasions.[3]

Thomas Bewick (1755–1828), artist-engraver, worked virtually all his life in Newcastle. He was renowned internationally even in his own lifetime for his wood engraving, most famously his illustrations for *A General History of Quadrupeds* and *A History of British Birds* (see also pp.139–40).[4]

History: the façade of No. 45 Northumberland Street has previously been attributed to Morley Horder on account of its similarity to his designs for Boots shops elsewhere in Britain in the 1920s.[5] However, plans presented to W.J. Steele, Newcastle Town Surveyor, on 30 October 1912 indicate that it was in fact designed by M.V. Treleaven, Architect and Surveyor for Boots at the time that the firm amalgamated with Inman's Stores Ltd and took over the premises. Boots owned No. 45 until 1977. Since then it has been either a jeweller's or shoe shop.

[1] *DNB*, 1960, vol. XV, pp.840–44. [2] Welford, vol.3, pp.517–21. [3] Welford, vol.2, pp.149–59. [4] Robinson, R., *Thomas Bewick, His Life and Times*, Newcastle, 1837. [5] Pevsner, *Northumberland*, p.483.

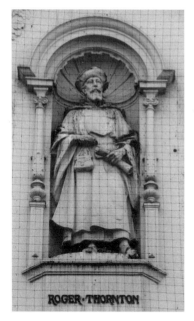
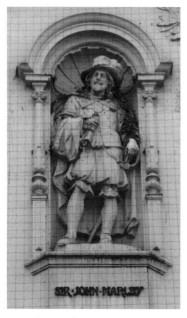

Roger Thornton Sir John Marley Harry Hotspur Thomas Bewick

Prudhoe Chare, wall along walkway to Eldon Square

Local Worthies, Mythical and *Allegorical Figures*

Sculptors: not known

Originally parts of buildings erected in the 1890s; re-sited *c.*1976
Each head: sandstone 90cm high × 50cm wide
Seahorse: sandstone 98cm high × 93cm wide
Cartouche panels: sandstone 2.46m high × 67cm wide
Main YMCA panel: sandstone 1.6m high × 1.57m wide
Each YMCA small panel: sandstone 1.1m high × 90cm wide
Status: not listed
Condition: good, though generally dirty with green algae on all upper surfaces; all surfaces weathered and chipped
Owned by: Newcastle City Council

Description: a variety of architectural features rescued from the demolition of buildings on Blackett Street and Eldon Square decorate the dark-red brick retaining wall of Prudhoe Chare.

From the top (western) end of Prudhoe Chare the architectural features are: seven high-relief heads of gods and goddesses on tapered keystones, arranged around a high-relief seahorse (the central head is *Neptune*; *Victory* and *Newcastle* are also depicted, though the others cannot be positively identified); two architectural scrolls surmounted by lions' heads, with a door lintel in between and a high-relief god's head on either side; two panels each containing three cartouches in vertical arrangement on either side of two blocks which have '18' and '98' carved in high-relief within cartouches; two architectural scrolls surmounted by lions' heads on either side of a modern doorway, above which are two relief head capitals with lion heads; two architectural scrolls surmounted by lions' heads, on either side of a high-relief cartouche, beneath a door lintel and high-relief carved god's head; three cartouches: one small with high-relief '1899' carved in an intertwined motif (one large with high-relief 'YMCA' carved in an intertwined motif, one small with high-relief 'YMCA' carved in an intertwined motif); seven high-relief heads of gods, goddesses and nineteenth-century pioneers on tapered keystones, arranged around a semicircular high-relief panel with '1881' in the middle of foliate carving.

Only three heads can be positively identified: Bewick, Stephenson and Collingwood. The others may be *River God Tyne*, *Bacchus*, *Neptune*, *Art and Literature*.

History: the reliefs were rescued from the old Central Library, the YMCA in Blackett Street and the old Town Hall, all of which were demolished in the early 1970s to make way for new buildings.[1] They now create a solemn but expressive counterpoint to the modernist lines of this side entrance to Eldon Square.

[1] Newcastle City Planning Department, *Information Sheet*, n.d.

Local Worthies

Mythical and Allegorical Figures

(opposite) YMCA panels

North and south ends

Heralds

Sculptor: Ray Smith

Installed October 1997 and March 1999
Each sculpture: steel 6m high × 1.1m wide
Flag suspended on nearby pole reads: All art
works by Ray Smith
Status: not listed
Condition: good
Condition details: some scratching and fly-
posting at ground level
Commissioned and owned by: Newcastle City
Council

Description: two identical large abstracted
outline figures made from box steel, painted
black. Each holds a brightly coloured banner.
One is located outside Haymarket Metro
station, the other is located at the south end of
Northumberland Street at the junction with

Blackett Street. Nearby railings inset with castle
designs are also designed by Smith, as is a water
feature to be installed around the foot of the
South African War Memorial.

History: commissioned and funded by
Newcastle City Council as part of its
pedestrianisation of Northumberland Street.
Smith was asked to provide artist-designed
elements for the top and bottom of the street
which also include new railings, seating and
litter bins. The new scheme for
Northumberland Street was launched in May
1997 with the two Heralds described as
'stunning sculptures which will greet people
visiting Tyneside's busiest shopping street'.[1]
'They aren't huge monolithic works,' said the
sculptor. 'We've tried to do something which
has impact without imposing itself on the
street.'[2]

[1] *Evening Chronicle*, 19 May 1997. [2] *Ibid.*, 2
October 1997.

South African War Memorial

Sculptor: Thomas Eyre Macklin
Foundry: Montacutelli

Unveiled 22 June 1908
Victory: bronze and fibreglass 4m high approx
Obelisk: stone 12m high × 3m diameter at
bottom
Base of obelisk: stone (each of six faces) 1.8m
high × 2.35m wide
Relief panels: bronze 1.8m high × 2.35m wide

Smith, *Heralds*

Northumbria: bronze and fibreglass 3m high × 1.6m wide
Incised on north face of upper base: "STEADFAST IN LIFE VALIANT IN DEATH".
Raised bronze letters on north face of obelisk: TO / THOSE WHO / DIED / IN THE / SERVICE OF / THEIR COUNTRY.
Raised bronze letters on south face of obelisk: TO / THE MEMORY / OF / THE OFFICERS / NON COMMISSIONED / OFFICERS AND / MEN OF THE / NORTHUMBRIAN REGIMENTS / WHO LOST /

Macklin, *South African War Memorial* **(Northumbria)**

THEIR LIVES / IN THE / SOUTH AFRICAN / WAR / 1899 1902 / ERECTED BY THEIR / COUNTY AND COMRADES.
Raised bronze letters on south face of obelisk base: DULCE ET DECORUM EST PRO PATRIA MORI
Signed at base of figure of *Northumbria*, north face: T.Eyre Macklin / Sculptor / NEWCASTLE & LONDON 1907. Signed on bronze relief, south face of column: T. Eyre Macklin 1907 Sc. Signed below bronze relief, south face of column: Montacutelli Broth / Founders London. Carved on north face of column: T. EYRE MACKLIN / INVT ET SCULP 1907
Status: II
Condition: fair
Condition details: wings of *Victory* replaced; bronze reliefs naturally patinated green; *Northumbria* is dirty brown/black; all stone surfaces are dirty and marked by rainfall; top of obelisk green due to bronze leaching, with other stains on stone and metal surfaces; all horizontal surfaces are covered in droppings; some graffiti inked on base
Commissioned by: public subscription
Custodian: Newcastle City Council

Description: a hexagonal ashlar obelisk sitting on a double hexagonal base and ringed in bronze at the top. On this stands the winged bronze figure of *Victory* on a stone base facing north, a down-turned sword in her left hand, a laurel crown in her outstretched right and a scabbard at her side. Since 1978 her wings have been made of fibreglass.

Attached to the north face of the obelisk there is a lion head in bronze above bronze and copper fasces. On the lower base of the obelisk on the north (the Northumberland) side there is the twice-life-sized, semi-naked figure of *Northumbria* reaching up to receive *Victory's* tribute. With her left hand the latter holds an unfurled military standard with a crown on top whilst steadying herself against the side of the obelisk. There is the fragment of a laurel crown

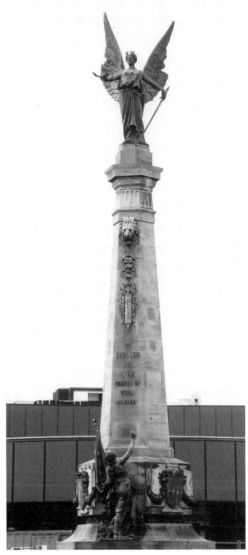

Macklin, *South African War Memorial*

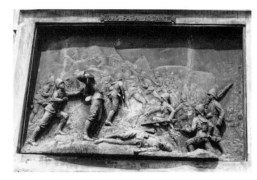

Macklin, *South African War Memorial* (relief panel)

in the palm of her up-stretched right hand.

Attached to each of the other faces of the obelisk are copper panels on which are bronze shields bearing the names of the dead listed by regiment. These are linked by bronze garlands of oak leaves and laurels, except for the south face which has a relief panel of helmeted British soldiers storming a Boer-held kopje with the words QUO FATA VOCANT inscribed on the upper frame. The whole is set on four wide and shallow steps in a pedestrianised area.

Subject: the 3,737 officers and men of the Northumbrian regiments who lost their lives in the South African War 1899–1902.

History: known originally as the *Northumberland War Memorial*, the monument had a troubled early history. It was erected by Newcastle Council at a cost of £4,707 which was almost double the estimated cost and considerably more than the £3,350 raised by public subscription. Completion was also very delayed; for years there were ugly hoardings, scaffolding and builders' refuse at the Haymarket.

It was eventually unveiled on 22 June 1908 by Lieut.-General Sir Laurence Oliphant, General Officer C.-in-C. Northern Command and 'received' by the Lord Mayor on behalf of the citizens of Newcastle. The latter declared it 'a thing of beauty' and 'an incentive to all to put their country's claims as one of the first objects of their lives'.[1] He also granted the honorary freedom of the city to every local soldier who had participated in the war.

When construction of the Metro station at the Haymarket began in December 1975 the figure of *Victory* (weighing seven tonnes) was removed to prevent it being damaged by vibrations from underground workings nearby.[2] It was put back three years later in December 1978, but with new fibreglass wings and a new bronze cast body.[3]

In July 1992 Gilbert Ward and a coppersmith, Jo Carr, working with Les Hooper of Pedalling Art and student assistants, were commissioned to repair the monument using photographs of the memorial as it was when first erected. They mended the stone steps and the bronze garlands and the relief battle scene on the upper base (although not the soldier's rifle in the foreground) and replaced the fasces on the obelisk (which had disappeared sometime previously) and the bronze crown on *Northumbria*'s standard. They also renewed the copper on the panels on the upper base. On aesthetic grounds they decided against giving *Northumbria* the laurel crown which she originally carried in her right hand. They also used copper and bronze to replace the steel rods which had been used to secure the bronze and copper panels.[4]

Newcastle City Council embarked on a pedestrianisation programme for Northumberland Street in 1999, which included the construction of a water feature designed by Ray Smith at the base of the War Memorial. The series of 'cut-out' concrete figures seem determinedly at odds with the grandiose dynamism of Macklin's bronze sculptures.

[1] Newcastle City Council, *Proceedings*, 1907–8, pp.lxix, 860 and 1039. [2] *Evening Chronicle*, 10 December 1975. [3] *Ibid.*, 9 February 1978. [4] Information provided by Gilbert Ward, 1999.

Eldon Square bus concourse, external wall

Memorial to T.H. Bainbridge
Sculptor: not known

Unveiled 6 October 1933
Panel: bronze 1.19m high × 71cm wide
Portrait roundel: bronze 32cm diameter
Incised in cream Roman lettering: THIS HALL IS ERECTED TO / THE GLORY OF GOD AND / IN LOVING MEMORY OF / THOMAS HUDSON BAINBRIDGE / WHOSE LIFE WORK AND / SIMPLE FAITH HELPED AND / BRIGHTENED THE LIVES OF / MANY IN THE NORTH-EAST COUNTRY / AND WHO ABOVE ALL LOVED / LITTLE CHILDREN. IT IS GIVEN / BY HILDA HIS DAUGHTER AND / HER HUSBAND GERALD FRANCE / TO HELP THE WORK AMONGST / CHILDREN. / 6TH OCTOBER 1933
Status: not listed
Condition: poor
Condition details: blistering of protective coating; dirty with graffiti and fly-posters all over
Commissioned by: Hilda and Gerald France
Custodian: Newcastle City Council

Bainbridge Memorial

Description: a plain bronze plate attached to the brick wall. The inscription runs beneath a separate roundel affixed to the main tablet, carrying a low-relief portrait of Bainbridge looking to the left. Next to this memorial is another commemorative plaque inscribed with the circumstances of the opening of PCHA headquarters by Prince George KG on 6 October 1933, but including no artistic detail.

Subject: Thomas Hudson Bainbridge (1842–1912) was the second son of Emerson Muschamp Bainbridge, founder of Europe's first department store. He ran the business for 20 years at the height of its success in the 1890s. T.H. Bainbridge was an enthusiastic farmer and a much respected and active Methodist, 'fulfilling every position open to a layman'. He supported the local YMCA and took a particular interest in the concerns of children, as well as sponsoring a covered wagon which was toured round the countryside to spread the Gospel.[1]

History: the tablet was commissioned for the opening of new headquarters for the Poor Children's Holiday Association (PCHA) in Newcastle by Prince George. The PCHA had been founded by J.H. Watson, who unfortunately died shortly before the ceremony. It established holiday homes, orphanages and sanatoriums for children. The headquarters was designed by Cackett, Burns Dick and MacKellar and paid for by a gift of £5,000 from Alderman and Mrs A. France, daughter of Thomas Bainbridge. Alderman France unveiled the memorial after Prince George had performed the opening ceremony.[2]

The PCHA headquarters was demolished to make way for Eldon Square in the 1970s, and the commemorative tablets were relocated to the wall of the bus station.

[1] Airey & Airey, pp.103–9. [2] *Journal*, Newcastle, 7 October 1933.

Pilgrim Street CITY CENTRE

2–8 Pilgrim Street, corner with Blackett Street, first-floor level

Progress (Northern Goldsmiths Clock)

Sculptor: Alfred Glover

Unveiled 31 July 1935
Statue: gilded iron 1m high approx
Clock: gilded iron 80cm square
Status: II
Condition: good
Commissioned and owned by: Northern Goldsmiths

Description: a gilded, naked female figure with up-stretched arms, set atop a bulky clock cantilevered out from the corner of the Northern Goldsmiths building. Cherubic winged heads are set at each corner of the clock's top edge. A replica is also in place on the corner of the company's premises on Westgate Road.

History: the Northern Goldsmiths Company building was designed by James Cackett and in place c.1895. It was subsequently altered by Burns Dick and Mackellor in 1935, at which time the clock and figure finished in gold leaf were added.[1] Glover's designs for the figure went through four different forms before finally being cast by Tudor Art Metal Co. The Lord Mayor of Newcastle unveiled the clock on 31 July 1935 accompanied by staff from the Northern Goldsmiths Company.[2] 'It is appropriate that this magnificent clock should be dedicated to Progress', stated an advertisement in a local newspaper. 'It is a symbol of the progress of the Northern Goldsmiths Company.' Particular attention was drawn to the electrical, rather than clockwork, movement.[3]

Acting as an effective advertisement for the

Glover, *Progress (Northern Goldsmiths Clock)*

row of jewellers below, the extent to which this figure has entered local consciousness is demonstrated by the recent publication of a children's Christmas story which tells how the 'golden fairy' wakes on New Year's Eve and allows various statues around town an hour to come alive and cause havoc, before they return to sleep for another year.[4]

[1] Lovie, *passim*. [2] *Goldsmiths Journal*, September 1935, p.591. [3] *Journal*, Newcastle, 1 August 1935. [4] Goulding, C., *Tinseltoon*, Newcastle, 1998, *passim*.

Carliol House, mounted on Pilgrim Street wall

Monument to Sir Joseph Swan
Sculptor: Richard Ray

Installed 1931
Whole work: bronze 1.5m high × 80cm wide × 6cm deep
Raised Roman letters: SIR JOSEPH WILSON SWAN / DSC, F.R.S. / INVENTOR OF THE ELECTIC / INCANDESCENT LAMP AND / A PIONEER IN THE SCIENCE OF / PHOTOGRAPHY. / HE WAS BORN IN SUNDERLAND 31ST OCT 1828 / AND DIED 27TH MAY 1914. / THIS TABLET WAS ERECTED BY THE / NEWCASTLE UPON TYNE ELECTRICITY SUPPLY CO

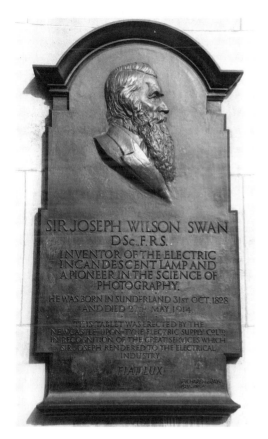

LTD. / IN RECOGNITION OF THE GREAT SERVICES WHICH / SIR JOSEPH RENDERED TO THE ELECTRICAL / INDUSTRY. / FIAT LUX
Signed bottom right: RICHARD A RAY / 1931 A.R.C.A.
Status: II
Condition: good
Commissioned by: Newcastle upon Tyne Electricity Supply Co. Ltd
Owned by: Northern Electric and Gas

Description: a plain rectangular bronze tablet with a rounded cornice at the top. Above the inscription is a relief profile bust of Sir Joseph, looking right. The dark bronze of the tablet stands out well against the grey of the building's stonework at this busy road junction.

Subject: Joseph Swan (1828–1914) was born in Sunderland and became famous for his experimental work with electrical and photographic processes. His inventions include artificial silk thread, the cellular lead plate battery and bromide printing paper for use in photography. He installed electric lights in Lord Armstrong's home at Cragside and in Newcastle's Mosley Street in 1881, the first street in the world to be lit by electricity.[1] Swan's factory at Benwell became the first commercial light bulb factory in the country.[2]

History: Carliol House was designed in 1927 by Tait, Burnet and Lorne with L.J. Couves and Partners for the Newcastle Electricity Supply Co.[3] There is another version of relief tablet in the entrance lobby to Sunderland Art Gallery.

[1] Swan, M.E. and Swan, K.R., *Sir Joseph Wilson Swan: Inventor and Scientist*, Newcastle, 1929, repr.1968, *passim*. [2] Foster, Newcastle, ill.100. [3] Lovie, p.18.

Ray, *Swan Monument*

Worswick House and Chambers, junction with Worswick Street

Twenty-Two Heads
Sculptor: J. Rogers
Architect: W. Lister Newcombe

Building erected 1900
Each head: white stone 20cm high approx
Status: not listed
Condition: fair
Condition details: all heads are dirty and some are chipped with missing details

Description: a red-brick building with façades on Pilgrim and Worswick Streets. The string course above the first floor has a high-relief carved head above each of twenty-two windows. Each head emerges from a roundel and is framed by an arch of white stonework. The heads are all different and include bearded nineteenth-century worthies, an Egyptian pharaoh and an African boy.

History: Worswick House and Chambers formed part of the estate of Alderman George Greig Archibold, a 'well known figure in local affairs at the turn of the century'.[1] He ran a pub called the 'Black House' within the building, which also contained several other commercial premises. Plans for Worswick Chambers submitted in 1899 show roundels set above each first-floor window, with scribbles to indicate carving.[2]

A newspaper article in 1961 described the subjects of these expressive heads as a mystery, though they were thought to be of celebrated people from the nineteenth century such as General Gordon. A lady subsequently wrote in claiming she had met the sculptor when he was an old man. She quoted Rogers: 'The funniest thing was when I was asked to sculpt the heads on Pilgrim and Worswick Streets. I thought for a long time and then had a brain wave. I brought out our famous family album of photographs. Then the work started and they

Rogers, *Twenty-Two Heads* (detail)

represented a few aunts and uncles of mine.' Her story was confirmed when Rogers's nephew also wrote to the *Journal*, saying that his uncle had been employed by the sculptural workshop of Robert Beall near the High Level Bridge for 55 years.[3] The firm is listed in trade directories of the time as 'architectural and monumental sculptor, granite and marble merchant, High Level Approach'.[4]

[1] *Evening Chronicle*, 1 November 1961. [2] Tyne and Wear Archive Service, T186/14575. [3] *Journal*, Newcastle, cuttings, late 1961. [4] *Ward's Directory for Newcastle and Gateshead*, Newcastle, 1889–90, p.787.

Swan House, courtyard

Articulated Opposites

Sculptor: Raymond Arnatt

Unveiled 16 September 1969
Whole work: bronze 2.4m high × 5.1m long × 2.7m wide
Inscribed on plaque attached to pool: Memorial to / Sir Joseph Wilson Swan / "Articulated Opposites" / by / Raymond Arnatt / Bronze 1969
Status: not listed
Condition: fair
Condition details: statuette removed from site; patina worn on smooth surfaces; slightly dirty overall; graffiti scratched onto smooth surfaces
Commissioned and owned by: Newcastle City Council

Description: a complex abstract piece of four elements consisting of large curves, blocks and smaller hemispheres. All the major structures are hollow, with solid forms attached. Surfaces range from smooth curves to roughly worked planes, and some seem to have been originally coated in gold paint, which has now mostly worn off. Much of the black bronze has weathered to a green colour. The sculpture is situated in an oblong pool which no longer contains any water.

A bronze statuette of Sir Joseph Swan was originally attached to the wall opposite along with a replica of his filament light bulb. These are no longer in place.

Subject: the sculpture is a 'visual analogy of Sir Joseph's invention, the electric filament light'.[1] This was first demonstrated at the Newcastle Literary and Philosophical Society on 3 February 1879, and its success soon led to mass manufacture.

For a biography of Joseph Swan (1828–1914) see p.133.

History: commissioned by Newcastle City Council as a memorial to Sir Joseph Swan, this sculpture is appropriately sited near the entrance to an office block also named after

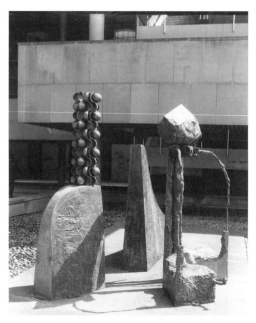

Arnatt, *Articulated Opposites*

him. A memorial to Sir Joseph was suggested by the Leader of Newcastle City Council, T. Dan Smith, sponsored by Mayor Henry Simm and funded by a memorial committee. The once-illuminated fountain was designed by Kenneth Graham, with Arnatt responsible for the sculpture, statuette and plaque, and was unveiled by Sir Joseph's son, Sir Kenneth Swan, on 16 September 1969.[2]

Swan House was originally occupied by the Post Office, then British Telecom. The roundabout and buildings are due for redevelopment in 2000 and the fate of the sculpture is uncertain.

[1] Swan, K., *Speech on the Occasion of the Unveiling of the Memorial to Sir Joseph Swan*, Newcastle, 16 September 1969, *passim*. [2] *Northern Echo*, 17 September 1969.

Quayside

Swing Bridge, outer sides of stone pillars at each end

Coats of Arms of Gateshead, Newcastle and Port of Tyne Authority

Sculptor: not known

Bridge opened 1876
Each coat of arms: stone 1.6m high × 1.2m wide
Status: not listed
Condition: fair
Condition details: bridge pier half removed on Gateshead side; each coat of arms is stained black by pollution
Commissioned by: Sir William Armstrong
Custodian: Port of Tyne Authority

Description: eight coats of arms, carved in relief onto the outside of piers at either end of the bridge, two on each side below the bridge

Newcastle Coat of Arms, **Swing Bridge**

Port of Tyne Authority, **Swing Bridge**

level. On the Newcastle side, there are the Newcastle and Port of Tyne Authority arms; on the Gateshead side there are the Gateshead and Port of Tyne Authority arms; one of the piers has been sliced through, resulting in loss of half of the arms.

History: opened in June 1876, the Swing Bridge between Gateshead and Newcastle is 170 metres long, 14.5 metres wide and weighs 1,450 tonnes. It is still moved by the original hydraulics, but the power is now electrical instead of steam.[1] The first ship went through in July 1876 on the way to Lord Armstrong's Elswick works, which was appropriate because his factory was responsible for building the bridge. Bronze plaques set into the stonework at bridge level list the members of the Port of Tyne Authority and the personnel involved in its building and engineering.

A description of the river in the 1890s has a traveller looking up towards the High Level Bridge, 'the Swing Bridge now revolving with slow majesty to admit his ocean steamer', and

exclaiming 'with pent-up surprise, "which is the greater marvel?" who could answer this?'.[2] Nowadays the bridge is only opened on very rare occasions.

[1] Pevsner, *Northumberland*, p.459. [2] Johnson, R.W., *The Making of the Tyne*, London, 1895, pp.40 and 96.

Queen Victoria Road CITY CENTRE

Royal Victoria Infirmary, grassed area in front of main entrance

Monument to Queen Victoria

Sculptor: George Frampton

Unveiled 11 July 1906
Statue: marble 2m high
Pedestal: marble 2.5m high × 2m wide
Incised on dado front of pedestal: VICTORIA / QUEEN EMPRESS / 1837–1901.
Incised on rear: UNVEILED BY / KING EDWARD VII / JULY 11, 1906 // THE GIFT OF / SIR RILEY LORD / 1906
Signed on bottom front of statue's base: GEO FRAMPTON R.A. / 1906
Status: II
Condition: good
Commissioned by: Sir Riley Lord
Custodian: Royal Victoria Infirmary

Description: an art nouveau-style statue of the young queen, holding the orb and sceptre of office. There is some fine detail on the bodice and face in particular, whilst the ashlar pedestal has been left plain except for buttresses at each face.

History: donated by Sir Riley Lord, the Mayor of Newcastle, who was responsible for launching the appeal to fund the new Infirmary (see below). The statue was described as making a 'very beautiful contrast against the duller red' of the hospital, and as having a 'dignified and impressive' position and expression.[1] It was unveiled on the occasion of the Infirmary's

Frampton, *Queen Victoria*

*Royal Victoria Infirmary, porte-cochère
and façade at second-floor level*

Symbolic Figures; Cockerel and Snake; Urns

Sculptor: not known
Architects: W. Lister Newcombe and Percy Adams

Building opened 11 July 1906
Each figure: stone 1.6m high × 90cm wide
Each relief: stone 50cm high × 70cm wide
Status: II
Condition: good
Commissioned and owned by: Royal Victoria
Infirmary

Newcombe & Adams, *Symbolic Figures* **(detail)**

Description: six individually modelled half-life-size relief figures, one on each of the spandrels of the prostyle entrance portico to the hospital. The two on the front are winged and clasp a wreath of victory; on the west side, one figure holds bread and the other a fish; on the east, one figure holds a shell with water overflowing and the other pours wine from an amphora.

About eight metres up on the façade of the main building are three sets of reliefs depicting at the centre, a cockerel and a snake winding round a tree trunk, with foliate decoration in panels at each side; at the further extremities of the façade on each side is an urn with decorative foliage.

Subject: the relief figures on the east and west of the portico are stylised and highly unusual allusions to the miracles of Christ. The figures carrying loaves and fishes refer to the

inauguration by King Edward VII who, despite continuous rain, ordered that his carriage top be thrown open and pulled the unveiling cord without leaving his seat. Following this Frampton was presented to the King amidst much cheering.[2] A gilt bronze maquette was also donated to the Infirmary.

[1] *Daily Chronicle*, Gateshead, 11 July 1906.
[2] *Newcastle Daily Chronicle*, 12 July 1906.

Feeding of the Five Thousand (John 6:1–13); and the water and wine carriers to the Marriage at Cana (John 1:1–12). The combination of cockerel and snake in the small relief panel is also unusual: the cock may allude to the denial and repentance of St Peter in the face of the evil signified by the snake.[1]

History: an appeal was launched to fund a new hospital in 1896 by Sir Riley Lord, Mayor of Newcastle, as a commemoration of Queen Victoria's Diamond Jubilee. A public meeting on 6 October 1896 raised £38,000 in immediate promises and the figure had reached £100,000 by Jubilee Day on 22 June 1897. Much of this came from very small donations collected and exhaustively documented by the *Chronicle*. The building fund was considerably boosted by donations of £100,000 from both John Hall and Lord Armstrong, and the City Council and Freemen gifted ten acres of the Town Moor to the hospital.[2] The foundation stone was laid on 20 June 1900 by the Prince of Wales, who later opened the hospital as King Edward VII on 11 July 1906, at which he also unveiled a statue of his mother (see above).[3]

As well as the external decoration, the hospital has a number of Doulton tile pictures in the children's wards depicting nursery rhymes and landscapes.

[1] Hall, J., *A Dictionary of Subjects and Symbols in Art*, London, 1996, pp.121, 200 and 285. [2] *The Royal Victoria Infirmary, Newcastle upon Tyne: Official Souvenir on the Silver Jubilee of King George V*, Newcastle, 1935, *passim*. [3] Foster, Newcastle, ill.118.

Sandhill CITY CENTRE

Guildhall, niche on staircase

Charles II

Sculptor: not known

Installed *c.*1660; re-sited *c.*1770
Statue: lead 2.07m high

Incised on base in Roman letters painted black: CAROLUS. II. REX
Status: I
Condition: fair
Condition details: scratches on the bronze surface
Commissioned by: Newcastle Common Council
Owned by: Newcastle City Council

Description: a standing figure of Charles II in Roman tunic, without mantle or toga, holding a baton signifying authority in his right hand and resting his left hand on his hip.

Subject: Charles II (1630–85) was 'restored' to the throne in 1660 after having spent much of his youth in exile on the Continent. As king he favoured absolutism, toleration for Catholics and war with Holland, but unlike other members of the Stuart family he was astute enough to back down when faced with determined opposition. Accordingly, in 1673 he agreed to the Test Act excluding Catholics from office and in 1674 made peace with Holland. Eventually thanks to secret subsidies from Louis XIV in France he was able to fulfil his political ambitions by dispensing with Parliament, and at his death he left the throne to his openly Catholic brother, James, Duke of York.

History: the statue was installed by the Newcastle Common Council in a niche on the south front of the Magazine Gate of the medieval Tyne Bridge 'soon after the restoration' of 1660.[1] There it was one of the most prominent pieces of public sculpture in the region and for a time had a decidedly political character: witness the motto it bore, 'Adventus Regis solamen gregis' ('the coming of the king is the comfort of the people'). The statue of the first Stuart king, James I, had previously occupied this key site but had been removed by Parliament in 1651 to make way for the arms of the Commonwealth (motto, 'True Liberty takes away no man's right, or hinders no man's right').

Charles II

Unlike William Larson's equestrian statue of James II (see p.219) the statue of Charles II survived the aftermath of the Glorious Revolution. It was moved to its present position inside the Guildhall when eventually the Magazine Gate was demolished in 1770 so that the north entrance to the bridge could be widened. However, according to one writer it was already in a poor state by the 1730s. '[The statue] was wont to look exceedingly beautiful,

and in coming along the Bridge from the South, was a very worthy and conspicuous Ornament to the Town; but of late it is pretty much obscur'd with Dust, if not defac'd with the Weather, through the Want of being put into a little Order and Regularity.'[2] It has been suggested on stylistic grounds that the statue may be by William Larson.[3]

[1] Brand, J., *History and Antiquities of the Town and the County of the Town of Newcastle upon Tyne*, London, 1789, vol. i, p.48. [2] Bourne, H., *History of Newcastle upon Tyne*, Newcastle, 1736, p.131. [3] Information provided by Lady Gibson, 1999.

Scrogg Road · WALKER
Christ Church churchyard

Monument to Robert Chambers
Sculptor: George Burn

Installed 1869
Pedestal: sandstone 1.9m high × 5m long × 2.79m wide
Statue: sandstone 1.09m high × 1.7m long × 80cm wide
Incised Roman letters on stone base of protective railings: RESTORED 1890
Incised Roman letters on south face of pedestal dado: THIS MONUMENT WAS ERECTED / BY THE FRIENDS AND ADMIRERS / OF THE LATE / ROBERT CHAMBERS; / WHO FOR A NUMBER OF YEARS / UPHELD THE HONOUR OF TYNESIDE / AS AQUATIC CHAMPION OF ENGLAND / HE DIED AT ST ANTHONY'S JUNE 4TH 1868; / AGED 37 YEARS
Incised on east face of dado: BORN JUNE 14TH 1831
Incised Roman letters on left-hand side of south base of pedestal: G.BURN SCULPR / NEWCASTLE
Status: not listed
Condition: poor
Condition details: head of statue missing; noses of corbel heads missing; finials missing from canopy; blackened by soot; algal growth; graffiti painted on south and west faces

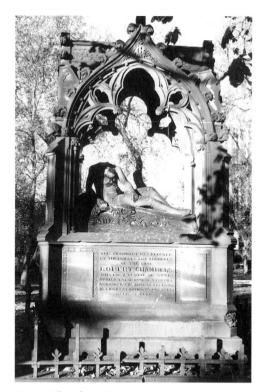

Burn, *Chambers Monument*

Commissioned by: public subscription
Custodian: Christ Church

Description: a statue of Chambers, now headless, under a vaulted Decorated Gothic style canopy. This has ogee crocketed arches on four sides and corbel heads (two female and two male) at each corner. Dressed for rowing (breeches, bare torso), Chambers rests on a verdant bank beside the river, his oar by his side. The oar has a masonic emblem on the blade maybe hinting that the freemasons were one of his sponsors. It is also broken at the handle, possibly a reference to his untimely death.

Subject: Robert Chambers (1831–68), from Pottery Bank, Walker, was one of the most successful oarsmen in the 1850s and 1860s when professional rowing was Tyneside's major spectator sport. A protégé of the legendary Harry Clasper, he specialised in single sculls. His most famous feat occurred on the Tyne in 1859 when he managed to pull back his opponent's seemingly unassailable hundred-metre lead to win the race. He later went on to win the World Sculling Championship, the first Tynesider to do so. When he died of tuberculosis five years later, he was given what at that time was the most elaborate funeral ever accorded to a sportsman in the area; over 50,000 people lined the route from Pottery Bank to Walker Cemetery.[1] 'Revered be the name, unalloyed be the glory / Of honest "Bob Chambers", the pride of the Tyne.'[2]

History: this was the first of three monuments to renowned Tyneside oarsmen which George Burn produced. Those to Renforth and Clasper followed within two years (see pp.63–4 and 215–16).

[1] Clasper, D., *Harry Clasper. Hero of the North*, Exeter, 1990, p.56. [2] McGill, J., *On the Death of Robert Chambers*, Newcastle, 7 June 1868. [3] *ILN*, 26 November 1869.

Side · CITY CENTRE
Milburn House, niche above doorway to floor D

Admiral Lord Collingwood
Sculptor: not known
Architects: Oliver, Leeson and Wood

Building 1905
Bust: bronze 60cm high × 30cm wide
Inscribed on base: COLLINGWOOD / SITE OF BIRTH PLACE / 1748
Status: II
Condition: good

Description: a small bust of Collingwood in his admiral's uniform set in a niche above the

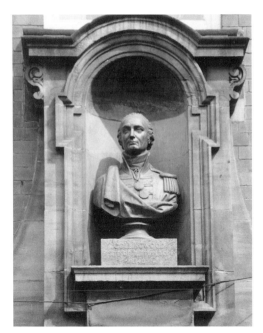

Admiral Lord Collingwood

doorway to Milburn House, built 1902–5 by Oliver, Leeson and Wood.

Subject: for a biography of Cuthbert Collingwood (1748–1810) see p.208.

History: Collingwood was born on the Side. As a writer commented, *c.*1880, 'The future commander of the fleet at Trafalgar scampered hereabouts in happy childish ignorance of all evils to come.'[1]

Milburn House has been described as 'an example of the early diversification of coal and shipping capital into office property'.[2] It is built on the steep slope of the Side and its floors are numbered like the decks on a ship. There is much Arts and Crafts detailing inside, especially low-relief panels, glass and woodwork.

[1] Charleton, R.J., *Streets of Newcastle*, Newcastle, *c.*1880, p.181. [2] Benwell Community Project, *The Making of a Ruling Class*, Newcastle, 1978, p.50.

St Mary's Place CITY CENTRE
Park area between St Thomas's Church and Civic Centre

Burma Campaign War Memorial
Sculptor: Nicholas Whitmore

Unveiled 18 August 1991
Sculpture: bronze 50cm high × 60cm wide
Pedestal: sandstone 90cm high × 60cm wide × 30cm deep
Incised on sculpture, panel to right of soldier's head: When you go home / tell them of us and say / for your tomorrow / We gave our today.
Incised sans serif letters on front of pedestal: IN HONOURED MEMORY / OF ALL THOSE / FROM THE NORTH EAST / WHO GAVE THEIR LIVES / IN THE BURMA CAMPAIGNS / 1941 1945
Inscribed on brass plaque fixed at bottom front of pedestal: THIS MEMORIAL WAS ERECTED BY THE TYNESIDE AND / DISTRICT BRANCH OF THE BURMA STAR ASSOCIATION / AND UNVEILED ON SUNDAY 18 AUGUST 1991.
Status: not listed
Condition: good
Commissioned by: Tyneside and District Burma Star Association
Custodian: Newcastle City Council

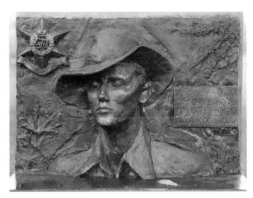

Whitmore, *Burma Campaign War Memorial*

Description: a small memorial standing in a quiet area near the Civic Centre's registry office. The bronze relief shows the head and shoulders of a soldier with his eyes shut and wearing the standard jungle hat, modelled out of the background to a depth of 10cm. The emblem of the Burma Star Association is found at the top left of the background, whilst foliage runs down from top right. The relief is mounted on a yellow-brown stone pedestal.

History: the sculptor's model was Piper James Turner, one of his students at the time. Commissioned by ex-servicemen's groups and paid for by donations, the memorial cost £5,000.[1] It was unveiled by Colonel Sir Ralph Carr-Ellison and Brigadier Leaske in the presence of 350 ex-servicemen and a detachment of Gurkhas.[2]

[1] *Journal*, Newcastle, 14 August 1991. [2] *Evening Chronicle*, 22 August 1991.

St Nicholas's churchyard
 CITY CENTRE

Millburn House, niche to the right of 21 St Nicholas's churchyard

Thomas Bewick
Original sculptor: Edward Hodges Baily
Architects: Oliver, Leeson and Wood
Copy by: not known

Building erected 1902–5
Bust: bronze 60cm high × 40cm wide
Base: pink granite 40cm square
Raised letters on stone block below niche: BEWICK / SITE OF WORKSHOP
Status: not listed
Condition: good

Description: a portrait bust of Bewick on a pink marble pedestal, set into a niche approximately three metres up on the building's façade. A low-relief wreath is carved in the

niche's pediment above.

Subject: for a biography of Thomas Bewick (1753–1828) see p.127.

History: Bewick's workshop was situated in the south-east corner of St Nicholas's churchyard, as shown in an engraving of 1839.[1]

This bust is based on the marble bust of Bewick in the Newcastle Literary and Philosophical Society, signed by Bailey and dated 1825. Like the bust of Admiral Lord Collingwood (see p.138–9), this sculpture can be seen as a deliberate attempt to make the office block on which it is set seem appropriate for its site.

Its presence characterises the self-conscious celebration of Newcastle's history at the turn of the century, illustrated by statues of Bewick and other local heroes on the façade of No. 45 Northumberland Street (see pp.126–7).

[1] Foster, J., *Newcastle upon Tyne, An Illustrated History*, 1995, ill.41.

Rear of 27 Dean Street, middle of architrave above door

Vampire Rabbit

Sculptor: not known

Architects: Oliver, Leeson and Wood
Building erected 1901
Whole work: stone, painted 30cm high × 50cm long approx
Status: not listed
Condition: good

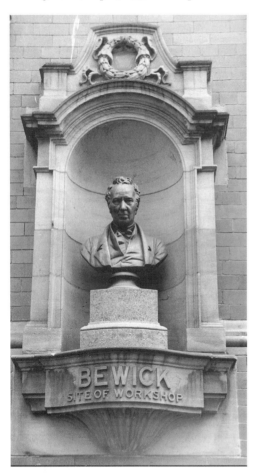

Thomas Bewick

Vampire Rabbit

Description: painted pink and cream, the 'exuberant' Cathedral buildings fronting on Dean Street have a mass of Jacobean-style detailing.[1] The colour scheme continues at the rear of the building on St Nicholas's churchyard. Above the rear door is a large circular window and the architrave surmounting this has a dark grey-painted sculpture of a rabbit set in the middle.

Subject: the presence of this rabbit does not seem to have any relationship to the quiet cloistered atmosphere of St Nicholas's churchyard. 'The animal sports a pair of impossibly large canine teeth and these, along with the manic expression of its face, have led to the beast being popularly known as "The Vampire Rabbit".'[2]

[1] Pevsner, *Northumberland*, p.486. [2] Goulding, C., *Hidden Newcastle*, Newcastle, 1995, p.40.

Strawberry Place CITY CENTRE

Newcastle United Football Club main entrance

Jackie Milburn

Sculptor: Tom Maley

Installed December 1996
Figure: fibreglass 1.8m high
Pedestal: stone 80cm high × 2.2m long × 90cm wide
Status: not listed
Condition: good
Commissioned by: Newcastle United Football Club
Owned by: Tom Maley

Description: a smoothly modelled statue of Milburn, with particular attention given to the period detail of his kit. Milburn is depicted running with a football at his feet.

Subject: for a biography of John Edward Thompson Milburn (1924–88), also known as 'Wor Jackie', see p.11.

Maley, *Jackie Milburn*

History: Maley took part in the competition for a memorial statue to Milburn in Ashington, which was won by John Mills. However, he decided to make a statue anyway at his own expense, building it out of fibreglass at his house in Longhirst. Newcastle United Chairman Sir John Hall saw the sculpture at a memorial exhibition and offered to fund a pedestal for it outside the football club, though the figure would remain Maley's property. He also indicated that a bronze casting was a possibility.[1]

The statue was popular with fans entering the grounds on match days.[2] However, Maley removed it in February 1999, complaining that sponsorship for a bronze version had not materialised, and that the fibreglass was too fragile to remain *in situ*. Newcastle United's response was that removal was safest whilst the stand behind it was being rebuilt, and that funding would be found for a bronze version to be put back once the site was clear in 2000.[3]

[1] *Journal*, Newcastle, 14 December 1996.
[2] *Evening Chronicle*, 5 December 1996. [3] *Journal*, Newcastle, 20 February 1999.

University of Newcastle
CITY CENTRE

Before 1963 Newcastle University had been a college attached to Durham University. In 1883 it became the Durham College of Science, subsequently changing its name to Armstrong College in 1904 to commemorate Lord Armstrong and as a means of raising money for new buildings. Containing a number of buildings dating from the late nineteenth century to the 1960s, the University's campus is ranged along King's Road, with a northern frontage on Queen Victoria Road (see p.122).

King's Road: The Arches and Hatton Gallery

Edward VII and *Royal Coat of Arms*

Sculptor: not known
Architect: William Henry Knowles

The Arches opened 1911; School of Art opened 1913
Statue: bronze 1m high approx × 30cm wide approx
Incised on pedestal: EDWARD / VII REX
Status: not listed
Condition: fair
Condition details: both sculptures are covered in bird droppings
Commissioned by: Armstrong College, Durham University
Owned by: Newcastle University

Knowles, *Edward VII* and *Royal Coat of Arms*

Description: a statuette of *King Edward* set within a recessed niche on the façade of The Arches. The work is structurally sound in spite of its covering of bird droppings and forms part of the overall decoration of the arch, which also includes much carved lettering.

The *Royal Coat of Arms* is located within the arched pediment over the entrance to the School of Art and Hatton Gallery (through The Arches). It is carved to a depth of about 5cm with fine attention to detail.

History: The Arches, part of the original School of Art, was designed by W.H. Knowles and financed by John Bell Simpson, a mine owner from Ryton in Co. Durham. He gave £10,000 to the School in memory of King

Edward VII so that 'wood, metal and craft design could be taught'.[1] The foundation stone was laid on 25 April 1911.[2] The Council had previously discussed the possibility of a life-size statue of the late King, though this scheme was never realised because the £1,750 raised was not considered sufficient for something worthy of his memory.[3]

The *Royal Coat of Arms* is part of the later addition to the School of Art, a Tudor-inspired design of 1913 by W.H. Knowles.[4]

[1] Pevsner, *Northumberland*, p.451. [2] Newcastle City Council, *Proceedings*, 25 April 1911. [3] *Ibid.*, 5 February 1913. [4] Roberts, A.R., 'The Quadrangle, University of Newcastle upon Tyne: An Architectural History 1881–1958', unpub. BArch. thesis, University of Newcastle, 1988, p.86.

King's Road: *School of Architecture, gable end*

Louis Pasteur

Sculptor: not known
Architect: Knowles, Oliver, Leeson

Building opened 1924
Whole work: stone 80cm high approx
Condition: fair
Commissioned by: Armstrong College, Durham University
Owned by: Newcastle University

Description: a half-length figure at the head of the Dutch gable over the entrance to the School of Architecture. Pasteur is depicted gripping a lectern with an open book upon it. Although structurally sound, the features of this statue are difficult to discern under its covering of algae.
Subject: French chemist and microbiologist Louis Pasteur (1822–95) was responsible for identifying the role of micro-organisms in disease and fermentation. He pioneered vaccines for rabies and anthrax and discovered that heat treatment of beer and wine prevented

their deterioration over time. Abandoning the strictures of laboratory conditions in favour of field observations, Pasteur's revolutionary advances in both method and knowledge were greeted with international acclaim.[1]

History: this building originally housed the School of Bacteriology and was formally opened on 24 May 1923.[2]

[1] *New Encyclopaedia Britannica*, 15th ed., vol.25, pp.454–6. [2] Roberts, A.R., 'The Quadrangle, University of Newcastle upon Tyne: An Architectural History 1881–1958', unpub. B.Arch. thesis, University of Newcastle, 1988, p.102.

Whitfield, *Cross and Lion Rampant*

King's Road: *Student debating chamber, exterior wall over road adjacent to refectory*

Cross and Lion Rampant

Sculptor: not known
Architect: William Whitfield

Building erected 1964
Lions: ciment fondu (?) 1m high × 2.4m wide
Crosses: ciment fondu (?) 2.4m square
Status: not listed
Condition: good
Commissioned and owned by: Newcastle University

Description: two emblems which make up the University's coat of arms , modelled in a rough and expressive manner. There are two casts of each, one on either side of the block.
History: these have been in place since the building's opening.[1]

[1] Pevsner, *Northumberland*, pp.449–52.

Percy Street: *Herschel Physics Building, exterior*

Spiral Nebula

Sculptor: Geoffrey Clarke

Inaugurated 17 March 1962
Whole work: steel 10.5m high × 4.5m long × 2m wide
Status: not listed
Condition: fair
Condition details: some small panels have dropped off; the platform is covered in green algae; droppings have led to the deterioration of some surfaces
Commissioned and owned by: Newcastle University

Description: a large work seemingly constructed out of wooden slats, until closer

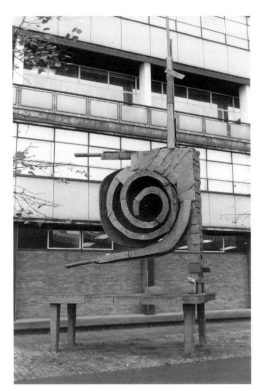

Clarke, *Spiral Nebula*

inspection reveals grey-painted steel to be its material. The shape of the main section is based on some form of electrical equipment or receiving dish. A shield makes up one side, and a coil the other, with antennae-like struts at top and bottom. This is mounted on a horizontal platform, itself 1.2 metres off the ground, and the whole is topped with a spire rising approximately 4 metres.

History: Spiral Nebula is the title commonly used for this work within the University, though *Swirling Nebula* has also been given.[1] It stands in front of Newcastle University's Herschel Physics Building, designed by Sir Basil Spence and opened in March 1962.[2] (Spence and Clarke collaborated on a range of

other projects in the 1960s, notably at Coventry Cathedral and Newcastle Civic Centre.)

Spiral Nebula was originally finished in a shiny aluminium coating, but Spence thought that this distracted attention from the physics block and after a month the sculpture was flame blasted, waxed and painted grey.[3] Viewed in relation to the Herschel Building's use, the sculpture can be taken as a symbol of the scientific advances made in the 1960s, especially in relation to space travel.

[1] Rosenburg, E., *Architect's Choice: Art and Architecture in Great Britain since 1945*, London, 1992, p.90. [2] University of Durham, Kings College, *Official Opening of the New Physics Building*, Newcastle, March 1962, *passim*. [3] Information provided by Harriet Curnow, 1999.

Queen Victoria Road: Armstrong Building façade

Personifications of Science and Art, and two Coats of Arms

Sculptor: W. Birnie Rhind
Architect: William Henry Knowles

Building opened 1906
Each figure: stone 90cm high × 50cm wide
University Coat of Arms: stone 80cm high × 90cm wide
Armstrong Coat of Arms: stone 80cm high × 90cm wide
Status: not listed
Condition: fair
Condition details: stone weathered at edges of *Science* and *Art* and broken away on putti of lower *Coat of Arms*; droppings on figure surfaces with considerable accretion on upper parts of both Coats of Arms; green algae on most surfaces of both figures; all pieces generally dirty
Commissioned by: Armstrong College, Durham University
Owned by: Newcastle University

Description: the main façade of this brick and stone building is decorated with four levels of

(above) Rhind, *Art*

Rhind, *Science*

Corinthian and Doric orders. In the broken pediment above the doorway is the University Coat of Arms bearing the motto 'MENS AGITAT MOLEM', with a putto at each side. At the second-storey level, a male (right) and female (left) figure are seated on abutments to the tower, with a rounded cupola above each. The bearded male, representing *Science*, holds a book and is dressed in classical drapes. The female personfication of *Art* has dress and hairstyle contemporary with the date of her carving. Above these at the level of the third storey is a relief carving of the Armstrong Coat of Arms with swags of fruit on either side.

History: the north-west wing of Armstrong College was designed by W.H. Knowles on the basis of R.J. Johnson's earlier drawings.[1] The foundation stone was laid on 2 May 1904 by Alderman T. Gibson. The façade has been described as 'perhaps the most intellectual in Newcastle, a very sophisticated interpretation of classical forms in the light of Art Nouveau'.[2] It was opened on 11 July 1906 by King Edward VII after he had performed a similar duty at the Royal Victoria Infirmary (see p.136).

[1] *Builder*, 30 June 1906, p.733–4. [2] Allsopp, B. and Clarke, U., *Historical Architecture of Northumberland*, pp.59–64.

University of Northumbria
CITY CENTRE

Formerly Newcastle Polytechnic, the University of Northumbria has two campuses in Newcastle as well as campuses in Carlisle and near Morpeth. Its city-centre campus is spread across a large area from Sandyford Road to Ellison Place and consists of buildings mostly erected in the 1970s and 1980s. However, several departments are housed in nineteenth-century buildings on Northumberland Road.

Northumberland Road: Burt Hall, roof top

Miner

Sculptor: Canavan
Architect: John Dyson

Building erected 1895
Whole work: stone 1.8m high approx
Status: II
Condition: fair
Condition details: generally dirty; green algal growth on most surfaces; delamination, especially on left arm and side of body
Commissioned by: Northumberland Miners' Union
Owned by: University of Northumbria

Description: a three-quarter-life-size depiction of a miner in hat and 'hoggers' (the characteristic shorts miners wore at the time) with a bronze pick over his right shoulder and a lamp in his left hand. The figure stands on a small heap of coal and is supported by a roughly hewn pillar.

Canavan, *Miner*

History: plans from 1893 show the *Miner* in striding pose, whilst revised drawings from 1894 depict him standing as eventually installed. The figure is based on the younger of two miners depicted in *Going Home*, a painting by Ralph Hedley of 1888, now in Newcastle's Laing Gallery.[1] The *Newcastle Weekly Chronicle* issued a print of *Going Home* in its Christmas 1889 edition, along with the following verses: 'Geordy in a youthful dream, / His pick upon his shoulder borne; / An' by hiz side the bluff aad Ralph / Enjoys hiz pipe an' thinks ov hyem'.[2] The print became so popular that 'it decorated the walls of many a humble home'.[3]

Commissioned to embellish the Miners' Association Hall: a marble plaque at road level records the building's dedication to Thomas Burt, General Secretary of the Northumberland Miners' Association, in 1895. The building is now used by the University of Northumbria to house trainee picture conservators. No information about the sculptor 'Canavan' has been found.

[1] Pevsner, *Northumberland*, p.494. [2] Millard, J., *Ralph Hedley. Tyneside Painter*, Newcastle upon Tyne, 1990, p.47. [3] Goulding, C., *Hidden Newcastle*, Newcastle, 1995, p.45.

Northumberland Road: College House, west façade

Dame Allan

Sculptor: not known
Architect: R.J. Johnson

Building erected 1882
Statue: stone or plaster 1.6m high × 40cm wide approx
Incised on base of statue: MI[...]
Incised on base of statue: [illegible]
Status: II
Condition: poor
Condition details: considerable decay of aedicule and stonework; statue and niche

Dame Allan

extremely dirty; one column of the aedicule is broken; inscription at the niche base has been totally erased; droppings on exposed surfaces
Commissioned by: Dame Allan's School
Custodian: University of Northumbria

Description: placed high on the gable end wall of the Norman Shaw-style College House,[1] a yellow stone aedicule, consisting of base, columns and domed cupola, is attached to the red brickwork. Within this is a statue of Dame Allan which seems to be carved from white stone or plaster, though it is very

blackened by weathering. The figure is depicted in medieval cloak and holds a book in her left hand. Above this, set into the brickwork, is a sandstone panel which may have originally been carved in relief, though is now worn smooth.

Subject: Eleanor Allan was the widow of John Allan and ran a tobacconist's business in Newcastle in the late 1600s. She purchased a farm in Wallsend and then sold it to establish a school in the parish of St Nicholas for 40 boys and 20 girls. She died in 1708, and the school opened in 1709.

History: Dame Allan's school moved from its original site in 1786, then again in 1821, and then once more to the Northumberland Road site in 1882 when compulsory education was introduced. It can be assumed that the statue was in place when the buildings were put up. By the 1920s the school had outgrown its premises once more, and a fund was set up for a move to Fenham, leaving the buildings and the statue of Dame Allan *in situ*.[2]

[1] Pevsner, *Northumberland*, p.453. [2] Dame Allan's School, *A Brief History 1705–1929*, Newcastle, 1929, *passim*.

Northumberland Road: Outside Ellison Building

Bookstack

Sculptor: Fred Watson

Unveiled 1 September 1992
Sculpture: grey granite 2.3m high × 74cm wide × 60cm deep
Base: black granite 1.5m square
Inscribed on small plaque attached to base:
BOOKSTACK BY F. WATSON / LECTURER AT / NEWCASTLE POLYTECHNIC . 1964–1988
Inscribed on plaque attached to granite block next to sculpture: UNIVERSITY OF NORTHUMBRIA AT NEWCASTLE / INAUGURATION, SEPTEMBER 1, 1992 / COMMEMORATIVE SCULPTURE UNVEILED

Watson, *Bookstack*

BY / HER GRACE THE DUCHESS OF NORTHUMBERLAND
Status: not listed
Condition: good
Condition details: rusting around top of internal strut
Commissioned by: Newcastle Polytechnic
Owned by: University of Northumbria

Description: a simple depiction of fifteen books piled on each other, with the granite polished to a very smooth finish. The work is attached to its base by an iron rod which is drilled through the the sculpture and visible at its top.

History: made whilst the artist was on a Fellowship at the Scottish Sculpture Workshop, *Bookstack* was subsequently purchased when Newcastle Polytechnic became a University in 1992. One hundred civic and academic dignitaries gathered for the inauguration, with a church service in St Thomas's Church followed by a ceremony in which the Duchess of Northumberland received the new university's first honorary degree.[1] She then unveiled the sculpture, which has become a popular background to photographs taken after graduation ceremonies.

[1] *Evening Chronicle*, 1 September 1992.

Sandyford Road: Fashion Building, exterior wall

Untitled

Sculptor: Austin Wright

Installed 1981
Whole work: polished aluminium 19m long × 8.5m high
Status: not listed
Condition: good
Commissioned by: Newcastle Polytechnic
Owned by: University of Northumbria

Description: an abstract work consisting of a number of separate aluminium pieces bolted to the brick wall. The linear, planar and circular forms evoke rhythms of landscape photographed from above.

History: the sculpture was installed after extended negotiations between Newcastle Polytechnic's Dean of Art and Design, Professor Tom Bromly, and the Arts Council. When Professor Bromly approached the Arts Council to fund a major work of art, he had in mind a free-standing piece in the quadrangle. The Arts Council suggested that Eduardo Paolozzi be given the commission and he visited Newcastle to prepare plans. However,

Wright, *Untitled*

the cost involved proved to be too much, so Wright was approached and asked to submit a new design. He preferred the idea of a work attached to the exterior of the Polytechnic.[1] Costing about £5,000, the sculpture was forged at Wright's studio in Yorkshire and installed with the assistance of Colin Rose.[2]

The understated forms of polished metal reflect Wright's concerns with carefully shaping internal and external spaces. Trees were planted in front of the wall not long after the sculpture's installation, and these were renewed in the mid-1990s. However, the University has now removed one of these to provide an unobscured view of the work from the road.

[1] Information provided by Professor T. Bromly, 1999. [2] Information provided by Nicholas Whitmore, 1998.

Sandyford Road: Outside visual arts exhibition space

Flat Fish

Sculptor: Piper James Turner

Installed 1991
Whole work: yellow stone 72cm high × 2m long × 2m wide
Status: not listed
Condition: good
Condition details: extensively covered in brown lichen and moss
Commissioned and owned by: University of Northumbria

Description: a large slab of yellow stone carved to represent a flat fish, set on a concrete base on a grassed area outside the University's Squires Building. Chisel marks are discernible all over the work and the carving is bold but detailed.

Turner, *Flat Fish*

History: exhibited in its present position as part of Turner's degree exhibition at the University of Northumbria, *Flat Fish* was initially given a temporary wooden base. It remained on this for a number of years before being set on a permanent concrete base. The subject-matter was partly inspired by the sculptor's background in a Cornish fishing community.[1]

[1] Information provided by Nicholas Whitmore, 1999.

Waterloo Street CITY CENTRE

Junction with Forth Place

Richard and Rachel Grainger Memorial Fountain

Designed by: Elswick Court Marble Works

Installed 1892
Memorial: pink and grey marble 3m high × 80cm square
Trough: pink marble 55cm high × 1.16m long × 60cm wide
Incised in gilded Roman letters on west face: ERECTED / IN MEMORY OF / RICHARD AND

RACHEL / GRAINGER / BY THEIR DAUGHTER / RACHEL ELIZABETH BURNS / ACCORDING TO / INSTRUCTIONS / CONTAINED IN HER WILL / 1892
Incised on bottom of south face: ELSWICK COURT / MARBLE WORKS CO / NEWCASTLE
Status: II
Condition: fair
Condition details: spout missing at rear bowl; modern replacement for scroll at bottom rear; tracery details eroded; trough pitted and worn; litter collection in trough and drinking bowl on rear; graffiti inked on south face
Commissioned by: Rachel Burns
Custodian: Newcastle City Council

Elswick Court Marble Works, *Grainger Fountain*

Description: a pink marble fountain with contrasting grey facing, set on a modern brick base. There is a small drinking bowl on the rear and a rough-hewn trough projects from the west side, though neither are now functional.

Subject: Richard Grainger (1797–1861), builder and entrepreneur, is largely responsible for developing Newcastle city centre as it is today. Over a period of twenty years he rose from a joiner's apprentice to be the biggest property developer in the North-East of England. Among his achievements are old Eldon Square, Leazes Terrace, Royal Arcade and Grainger Market, as well as the street plans of Grey Street, Pilgrim Street, Westgate Street, Clayton Street and the Bigg Market. However, his various schemes eventually led to financial ruin and he spent the last 20 years of his life in relative obscurity.[1]

History: the fountain was originally sited behind the Stephenson Monument on Westgate Road.[2] It was moved from there to Wellington Street in the 1950s and then re-set on a modern brick base as part of redevelopments in the 1980s.[3]

[1] Ayris, I., *A City of Palaces: Richard Grainger and the Making of Newcastle upon Tyne*, Newcastle, 1997, pp.7 and 37. [2] Airey, J., *Newcastle upon Tyne in Old Picture Postcards*, Newcastle, 1987, ill.24. [3] Lovie, *passim.*

West Jesmond Avenue JESMOND

69–99 Lonsdale Court, high on north facing wall

Heraldic Dragon

Sculptor: not known

Building erected 1970s
Whole work: metal 1.5m high × 50cm wide
Status: not listed
Condition: good

Description: a small metal relief sculpture

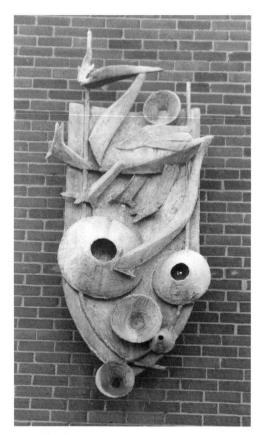

Heraldic Dragon

attached to the blank brick wall of the end of a block of flats. A dragon is shown against a shield, with a staff and a number of cones. The whole is a uniform grey and the surface seems to have been left rough.

Figure, Griffins and *Lion Heads*

Sculptor: not known
Architect: Archibald M. Dunn

Installed 1871
Miner: sandstone 70cm high approx
Each lion head: sandstone 60cm approx
Each griffin: sandstone 70cm approx
Status: II
Condition: poor
Condition details: figure of miner worn in parts; three griffins missing
Commissioned by: the Coal Owners' Association
Custodian: North of England Institute of Mining and Mechanical Engineers

Description: the ornate Italian Gothic offices and library of the North of England Institute of Mining and Mechanical Engineers. Beneath a corbel over the entrance there is a high-relief carving of a kneeling figure, possibly a miner, in medieval tunic holding a hammer and chisel. Seven griffins adorn pilasters flanking the first-storey windows. (Three griffins have at some time been removed and two of these now guard the entrance to the builders, Easten Stephen Ltd, 275 Westgate Road.) Eight drainpipes are decorated with lions' heads and the ground floor spandrels contain shields with coats of arms. Elsewhere, corbels, capitals, windows and the string-course have rich foliate decoration.

History: the *Stones of Venice*-inspired Miners' Institute (unusual in terms of Newcastle's secular architecture) was built on the site of Neville Hall which took its name from the Nevilles, earls of Westmorland, the original owners of the land.[1] It has been suggested that the Newcastle architect Dunn (1832–1917) probably obtained the commission because his father, Matthias Dunn, a colliery

Figure

viewer and one of the first Government Inspectors of Mines, was a prominent member of the Institute.[2] The Laing Art Gallery owns a lithograph of the Hall after a drawing by Dunn which was first printed in *Building News*, 30 May 1870.[3]

[1] *Newcastle Daily Chronicle*, Newcastle Upon Tyne, 30 May 1872. [2] Information provided by Thomas Faulkner, UNN, 1999. [3] Information provided by Andrew Greg, Laing Art Gallery, 1999.

Junction with Neville Street

Monument to George Stephenson
Sculptor: John Graham Lough

Inaugurated 2 October 1862
Statue of Stephenson: bronze 2.1m high
Base and pedestal: grit stone 8m high × 5m
square
Each supporting figure: bronze 2.5m high
Raised letters on east face of pedestal:
STEPHENSON
Signed on base of statue: J.G. LOUGH / 1862
Status: II*
Condition: fair
Condition details: main pedestal is dirty and
water-stained; four supporters are weathered
and have red-painted eyes; pedestal is splitting
at some joints; Stephenson statue is very dirty
Commissioned by: public subscription
Custodian: Newcastle City Council

Description: bronze statue of Stephenson,
presented in late middle age with pensive
expression, rolled-up plan in hand and a huge
toga-like scarf over his shoulder which
commentators described as a 'Northumbrian
plaid'. He stands on top of a tapering rostral
pedestal which rests on a plinth of rusticated
blocks. At the corners of the base there are four
over-life-size reclining figures, half-Greek hero,
half-contemporary worker: a *plate-layer* with a
model of Stephenson's 'fish-bellied rail'; a *miner*
with Stephenson's patent safety-lamp; a
blacksmith with a small anvil; and a *locomotive
engineer* leaning on a relatively up-to-date
model of a locomotive. There appears to have
been some uncertainty amongst contemporaries
as to whether these were 'emblematic' of
Stephenson's career, or 'typical of the new class
of operatives created by the invention of the
locomotive'.

Subject: George Stephenson (1781–1848), the
builder of the first successful steam locomotive,

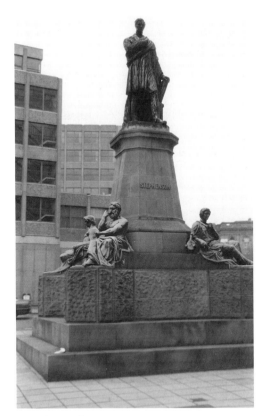

Lough, *Stephenson Monument*

was born in extreme poverty in a cottage near
Wylam, Northumberland. In his twenties he
became an engineman at various pits in the
Newcastle area and in 1815 invented a safety
lamp (the 'Geordie' lamp) for use in mines. At
around this time he also developed a type of
steam locomotive for use on colliery tram lines
which was the basis of the world's first
passenger railways, the Stockton–Darlington
(1825) and the Manchester–Liverpool (1830) for
which he was the surveyor. Later in life he
surveyed many thousands of miles of railways
and died a wealthy landowner near

Chesterfield. Probably the North-East's most
famous son (his face is on the current £5 note)
he was dubbed the 'Father of Railways' in his
lifetime, although there have always been those
who contend that he does not entirely deserve
such a title.[1]

History: following his death in 1848
Stephenson was commemorated by two major
statues, both unveiled in 1854: one by John
Gibson in St George's Hall, Liverpool, which
showed him as a severely classical Archimedes-
like figure; the other by E.H. Baily as a
successful man of the world in contemporary
frock coat in the Great Hall of Hardwick's
Euston Station (now in the National Railway
Museum, York). In addition, a monument was

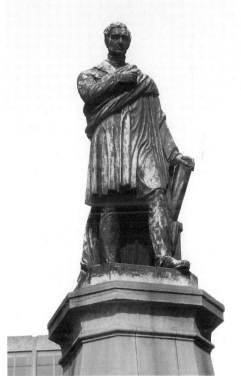

Lough, *Stephenson Monument* (detail)

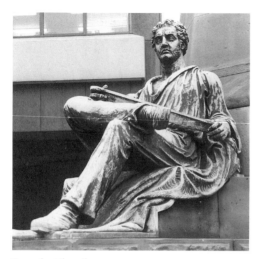

Lough, *Plate-layer*

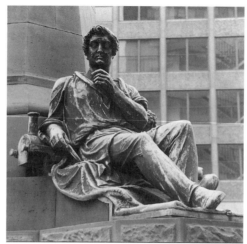

Lough, *Locomotive Engineer*

proposed but never executed for a site in Derbyshire, where Stephenson lived at the end of his life.[2] However, Stephenson's own home-town was slow to erect a large-scale monument.

There had been a number of abortive, temporary or smaller monuments on Tyneside. In 1849, for instance, there was an idea to have statues of Stephenson and George Hudson, the notorious 'Railway King', at either end of the High Level Bridge but this came to nothing when Hudson's business operations suddenly collapsed. In 1850 giant images of George and his engineer son Robert were temporarily displayed when the Central Station was opened, and a year later Robert Stephenson presented a bust of his father by Charles Moore, dated 1832, to the Literary and Philosophical Society. Early in 1858 work was also started on the Stephenson Memorial School at Willington Quay. However, it was only in August 1858 at a meeting of the Institution of Mechanical Engineers in Newcastle presided over by Robert Stephenson and the industrialist William Armstrong that serious steps were taken to

erect a large-scale monument in Newcastle.

Two factors probably prompted action at this particular moment ten years after Stephenson's death. Firstly there was a desire to celebrate Newcastle's sudden emergence as a leading manufacturing centre in the 1850s. Secondly a new idea was emerging of Stephenson as someone who was worthy of respect less for his feats as an engineer and railway surveyor than as the classic example of the self-made man. Certainly the successful publication of Samuel Smiles's 500-page *Life of George Stephenson, Railway Engineer* in July 1857 seems to have brought a new urgency to the project,[3] and it is noticeable that in committee meetings as well as at the inauguration much emphasis was put on Stephenson being 'the architect of his own fortunes'.[4] As Lord Ravensworth, son of Stephenson's former leading patron, said, 'Great as were the genius and skill of Stephenson and wonderful as were the results which had been brought about by his industry, it was not for these alone that they were desirous of erecting a

monument to his memory. The life of George Stephenson would prove to after ages what could be done with perseverance and industry.' Speakers repeatedly claimed the purpose of the monument was to provide an incentive to 'the efforts of those who move in a lower station in life'. 'He stands there before you as you knew him in life – an earnest, simple, thoughtful man, thinking of the duties of his station.'[5] It was said that as a young man Stephenson 'might have smoked, or drank, or played at quoits after he completed his daily task of brakesman at Killingworth Colliery; but, while he performed his duties to the engine at the pit, he did not forget what was due to himself. Without any profit in a pecuniary way at the moment, he laboured in his leisure hours to master those simple arts … of reading, writing and arithmetic.'[6] Nor, supposedly, was he resentful towards those more fortunate than himself: 'generous man that he was, he never failed to acknowledge the value of [the assistance he received from patrons]'.

Given this emphasis on Stephenson as an exemplar of self-help, the monument's site was regarded as particularly appropriate. It was near the newly-completed Newcastle Central Station but also close to the Literary and Philosophical Society, where in 1815 Stephenson had demonstrated what was perhaps his only true invention, a miner's safety lamp. More important, it was en route to Robert Stephenson's locomotive factory in South Street which meant workers there would be able to glance up at the statue each day on their way to and from work and, as one speaker put it, say 'There stands the monument of a great and good man, and he was one of us!'[7]

A formal meeting to establish a public subscription for a memorial was held in the Town Hall on 26 October 1858. It was chaired by Lord Ravensworth who made a point of tracing what he called the extraordinary 'Now and Then' of Stephenson's career. 'Now he is a

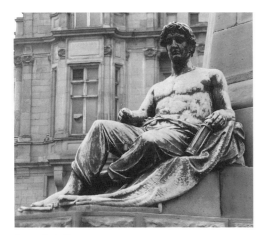

Lough, *Miner*

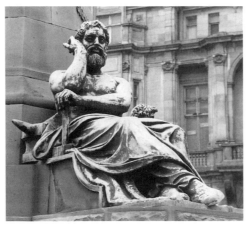

Lough, *Blacksmith*

farmer's boy at 2d. a day; then he is the owner of landed estates and large personal property. Now he mends the watches of brother coal-miners; then he sits among railway magnates, the greatest of them all…'[8] By April 1859 'upwards of £4,500' had been subscribed. The sculptor John Graham Lough, always a favourite candidate for the job, was then asked to submit a model for inspection, despite the objections of the *Gateshead Observer* and the Newcastle architect Thomas Oliver, both of whom would have preferred a competition.[9] Apart from his merits as a sculptor, what especially recommended Lough, it seems, was that he had lived and worked in the neighbourhood earlier in his career and, like Stephenson, was a self-made man.[10] In addition, there was already a twice-life-size statue of James Losh by Lough of 1836 on the staircase of the nearby Literary and Philosophical Society.

Lough's design was a variant of one he had submitted earlier, unsuccessfully, in the competition for the Nelson Monument in Trafalgar Square, which in turn was much indebted to Giovanni Bandinelli and Pietro Tacca's Monument to Ferdinand I in the Piazza della Darsena, Leghorn (1599–1623).[11] Robert Stephenson, George's son, a key figure in all discussions relating to the Stephenson Monument, made an attempt to persuade the Committee to modify the design. He wanted the pedestal to take the form of a globe which, he claimed, would symbolise 'the world-wide extension of the railway system'. The Committee, however, decided to stick with the design Lough had submitted. In the autumn of 1859 when Lough's model was publicly exhibited, the *Gateshead Observer* was unimpressed: 'some of the details may be open for criticism – as, for instance, the too "classic" aspect of the "pitman" and his companions'.[12] However, on the whole it met with approval, and in March 1861 a review of progress on the project in the *Builder* particularly commended the treatment of the four subsidiary figures, at the time 'still in clay'. 'This step towards reality is an admirable one. The figures will tell their own story to the multitude, and require no gloss.'[13]

Relatively little comment was made on the monument as such at the inauguration on 2 October 1862. On the other hand, the ceremony was an elaborate, carefully orchestrated affair, extensively reported. It was preceded by a procession of workers carrying technical models, flags and banners sporting slogans such as 'Peace promotes Industry', 'By hammer in hand, all Arts do stand', 'May Honest Industry ever be fairly rewarded' and 'The name of Stephenson universally known'. The workers came from various engineering firms in the neighbourhood, Stephenson's, Crowley Millington, Hawk's Crawshay, Hawthorn's, Thompson's, Abbott's and Armstrong's as well as the North Eastern Railway Company. The Volunteers and two mutual aid societies, the Manchester Unity of Odd Fellows and the Ancient Order of Foresters were also represented.[14]

Ten thousand people took part and a further 100,000 (almost as many as at the Queen's coronation) looked on: figures which a photograph taken at the time seems to confirm.[15] To the satisfaction of the authorities, there was no crowd trouble. Indeed, as one speaker commented, the occasion with its extraordinary spectacle of 'countless thousands of industrious persons' parading through the streets bore eloquent testimony to the fact that Newcastle was now 'the centre of a large mining, manufacturing, and commercial district'.

A report says that a Mr Currie from Robert Stephenson's Locomotive Works organised the procession and the special trains which were needed to bring workers in from outlying parts. The day was rounded off with various amusements in the evening, a promenade soirée at the new town hall, a ball and musical entertainment in a nearby park and a series of gas-lit tableaux at the Theatre Royal, illustrating episodes from Stephenson's early life.[16] Afterwards, several music hall songs

commemorated the inauguration: 'George Stephenson was as great a man / As any in the North; / Ye'll find his Monument stannin' now / In a place it's near the Forth.'[17] Sadly, since 1971 the statue has been partially obscured by Westgate House, which juts out over Westgate Road.

[1] E.M.S.P., *The Two James's and the Two Stephensons: The Earliest History of Passenger Transit on Railways*, London, 1861, *passim*. [2] *ILN*, 2 November 1850. [3] Smiles, S., *Life of George Stephenson, Railway Engineer*, July 1857. [4] *Newcastle Daily Express*, 27 October 1862. [5] *Newcastle Daily Chronicle*, 3 October 1862. [6] Harle, W.L., 'George Stephenson: or, Memorials to Genius', lecture delivered at a meeting, 1 October 1859. [7] *Chronicle*, 3 October 1862. [8] *Chronicle.*, 5 November 1858. [9] *Builder*, 11 December 1858; 7th May 1859. [10] Lough, J. and Merson, E., *John Graham Lough 1798–1876, A Northumbrian Sculptor*, Woodbridge, 1987. [11] Yarrington, *Commemoration*, 1988, p.35. [12] *Gateshead Observer*, 3 September 1859. [13] *Builder*, 31 March 1861. [14] *Chronicle*, 3 October 1862. [15] Manders, F., *A Selection of the Earliest Photographs*, Newcastle, 1995, p.28. [16] *Chronicle*, 3 October 1862. [17] *Allan's Illustrated Edition of Tyneside Songs*, Newcastle, 1891, p.461.

56 Westgate Road, old County Court building, façade

Keystone Heads and *Coat of Arms*

Architects: Scott and Reed

Building erected 1864
Each head: yellow stone 45cm high × 20cm wide
Coat of arms: (artificial?) white stone 80cm high × 2.3m wide
Status: II
Condition: *Keystone Heads*, good; *Coat of Arms*, fair
Condition details: the *Coat of Arms* is cracked and missing top of crest; blackened and covered with green algae. *Queen Victoria's* head is blackened with eroded details

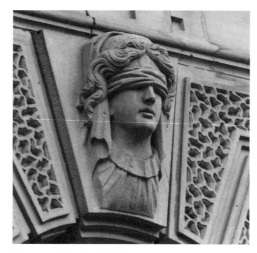

Keystone Heads (detail)

Commissioned by: City of Newcastle

Description: five finely carved heads form the keystones of the ground floor arches of the neo-classical former County Court. The central head with bandaged eyes is *Justice*; another head wears a Phrygian cap symbolising *Liberty*. The others are less easy to identify with certainty.

A free-standing coat of arms of the City of Newcastle is set upon an arch that spans a path

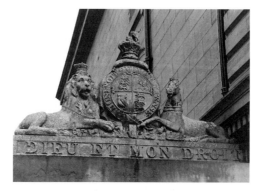

Coat of Arms

leading down the side of the west end of the building. The keystone below this is the head of the young *Queen Victoria*.

History: the status of this former County Court building is indicated by the coat of arms and symbolic keystone heads. Whilst the building's style is neo-classical, it has been described as 'novel and unexpected' in its organic feel, particularly with regard to the window surrounds.[1]

[1] Lovie, p.76.

Junction with Fenkle Street

Monument to Joseph Cowen

Sculptor: John Tweed

Unveiled 7 July 1906
Statue: bronze 1.8m high
Pedestal: grit stone 5m high × 1.8m square
Incised on east face: JOSEPH COWEN / 1829–1900; and below: ERECTED BY PUBLIC SUBSCRIPTION 1906
Status: II
Condition: fair
Condition details: pedestal dirty and split in places; considerable algal growth
Commissioned by: public subscription
Custodian: Newcastle City Council

Description: Cowen is depicted standing in an oratorical pose, one arm outstretched, the other holding his lapel. The statue is set upon a curved ashlar yellow stone pedestal, which in turn rises from two steps. The statue is sympathetically modelled, conveying a real sense of Cowen's vitality.

Subject: Joseph Cowen (1829–1900) was born at Blaydon Burn. He went to Edinburgh University where his political sympathies began to take root, and as early as 1848 began to take part in agitations for Parliamentary Reform in Newcastle's 'Complete Suffrage Association'. In 1856 Cowen was appointed treasurer of the

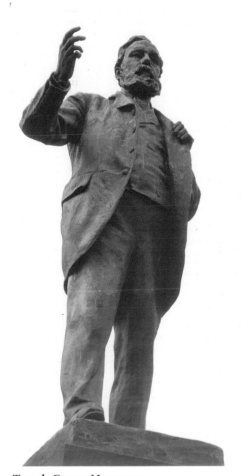

Tweed, *Cowen Monument*

Northern Reform Union. He wrote occasionally for the *Newcastle Chronicle* before becoming its proprietor in 1860. Always a progressive, he was a Liberal member of Parliament from 1873 to 1886. Cowen was a famous speaker, though it was claimed his accent was so strong that on delivering his maiden speech in the Commons some MPs thought he was speaking in Latin.

He also served as a councillor and alderman for 24 years and was a figure of considerable standing and respect in the local community. His library at Stella Hall was 'decorated with portraits and busts of Cromwell and Milton, Mazzini, Garibaldi and Lincoln, and the demi-gods who have lived to some purpose'.[1] He was particularly active in support of the Italian revolutionary Garibaldi (see p.54). Cowen retired in 1886 soon after the publication of his collected speeches,[2] and disappeared from public life.[3]

History: a Cowen Memorial Committee was set up in 1903 with Earl Grey as its president, in the hope of raising between £4,000 and £5,000 for a bronze statue.[4] Lord Ridley was asked to choose between three designs put before the committee and eventually decided on the London-based Tweed, whose work was described as having 'a strong individuality and elevated character'. Referring to the way in which Tweed's design faithfully caught Cowen's oratorial stance, a newspaper reported that 'the whole bearing of the figure and the gesture are very characteristic. Mr Tweed is an earnest disciple of the great French sculptor Auguste Rodin in his endeavour to infuse life into art.'[5] There is an equally lively statue by Tweed in Hexham, of Colonel Benson (see pp.30–1).[6] The figure of Cowen was cast by Messrs Singer and Co. of Frome and the pedestal was designed by C.R.B. Clark of London.[7]

Cowen's memorial is sited to suggest his representation of West Newcastle in Parliament and his involvement in the foundation of the nearby Tyne Theatre. It was unveiled by Lord Ridley at 2 o'clock on 7 July 1906 before a large crowd in something of a carnival atmosphere, as decorations were already in place for an impending royal visit to the city. Ridley declared that Newcastle would not be complete without a memorial to 'the distinguished citizen' and that the statue was a 'worthy addition to the sights of the city'.

Following the main proceedings, the Italian Consul laid a wreath in his national colours at the foot of the pedestal in remembrance of Cowen as the 'fearless friend of Italy', whilst the band played the Italian national anthem and a few bars of 'Garibaldi's Hymn'.[8] A photograph of the unveiling ceremony shows that there was a lot more space around the statue in 1906 than at present, though there was a considerable crush of people filling every available vantage point for the occasion.[9]

The statue of Cowen was cleaned *c.*1990 as part of a regeneration scheme for this part of Westgate Road.

[1] Howell, R., 'Cromwell and the Imagery of Nineteenth Century Radicalism: the Example of Joseph Cowen', *Archaeologia Aeliania*, 5th series, vol.X, p.196.[2] Jones, E.R., *The Life and Speeches of Joseph Cowen M.P.*, London, 1885, *passim*. [3] Stapleton, J., *The Life of Joseph Cowen Esq.*, repr. from *Newcastle Critic*, 24 January 1874, *passim*. [4] Ayris et al., p.24. [5] Quoted in *Ibid*. [6] Tweed, L., *John Tweed: Sculptor. A Memoir*, London, 1936. [7] *Builder*, 14 July 1906, p.54. [8] *Evening Chronicle*, 7 July 1906. [9] Airey, J., *Newcastle upon Tyne in Old Picture Postcards*, Newcastle, 1987, ill.99.

Cross House, gable above main door

Allegorical Figures

Architects: Cackett and Burns Dick

Building erected 1911
Whole work: white stone 1.6m high × 1.2m wide
Status: not listed
Condition: fair
Condition details: details considerably weathered and stained black in parts

Description: semi-heraldic relief group on the gable above the main door to Cross House, about six metres from the ground. A figure stands on either side of a shield bearing the words 'Cross House'. The left, male, figure

Allegorical Figures

holds a long hammer and an anchor can be seen at his feet. On the right, a female figure holds a caduceus.

History: replacing buildings which had dated back to the eighteenth century, Cross House fills a 'difficult triangular site', forming a wedge between Westgate Road and Fenkle Street.[1] It was built using a reinforced concrete system patented by the local firm of Hennebique and Co. and clad in Portland Stone. The relief group on the gable provides a visual focus for the narrow façade: the male figure symbolises industry and maritime links, whilst the caduceus held by a female figure usually signifies Hygeia, the goddess of health.[2]

[1] Lovie, p.75. [2] Hall. J, *A Dictionary of Subjects and Symbols in Art*, London, 1996, p.55.

NORTH SHIELDS
North Tyneside Council

Albion Road

Junction with Preston Road

Monument to Thomas Haswell
Designer: not known

Installed 1989

Haswell Monument

Base and obelisk: grey painted stone 2.7m high × 74cm square

Metal plaque on east face inscribed: JUBILEE CORNER / Formerly the site of Royal Jubilee School / founded 10 June 1810. / Dedicated for new use / as a public garden by Cllr. Mrs E.M. Bennett / Mayor of North Tyneside / 10 June 1989.

Metal plaque on west face inscribed: To commemorate / THOMAS HASWELL (1807–1889) / Headmaster of Royal Jubilee School / between 1839 and 1886. / Under "The Maister's" guidance / the school became renowned / for its innovation, learning, and care for its pupils. / "Learning grew beneath his care, a thriving, vigorous plant."

Status: not listed

Condition: good

Commissioned and owned by: North Tyneside Council

Description: a squat obelisk rising above four spheres which separate it from the cornice of the panelled pedestal. The stone is covered in grey paint.

Subject: the son of a North Shields ferryman, Thomas Haswell (1807–89) was educated at the Royal Jubilee School. After briefly teaching south of the river, he moved back to his former school as headmaster in 1839. Haswell's enlightened attitudes overcame the decrepit condition of the buildings and poverty of his pupils. He especially encouraged music, setting many local ditties to tunes of his own making. A former pupil recalled: 'He was a born teacher, and being unfettered by code regulations, he adapted his instructions to the needs of the day. He certainly taught the three Rs, but he taught much more, for under him we learned both the sciences and the fine arts.'[1] The School eventually came under government control and Haswell retired in 1886. On his death bed his last words were 'the formula with which he had closed the Jubilee School every day for nearly fifty years – "Slates away, boys!"'.[2]

History: two memorials are mentioned as having been commissioned immediately after Haswell's death: a portrait painting was unveiled at the Public Library in 1890 and a tablet of red Penrith stone was inaugurated by the Mayor. In addition, a commemorative medal was presented for academic excellence on a yearly basis.

As the inscription on this obelisk records, it stands on the site of Haswell's school, which was closed in 1935 and demolished in 1971.[3]

[1] Welford, vol.2, pp.466–72. [2] Haswell, G.H., *"The Maister": A Century of Tyneside Life*, London, 1895, *passim.* [3] *Evening Chronicle*, 18 February 1991.

Benton Road WEST ALLOTMENT

Near junction with New York Road, in walled garden

West Allotment First World War Memorial

Designer: Andrew Scoular

Unveiled 10 April 1925
Victory: white stone 1.8m square
Pedestal: granite 2.35m high × 1.2m square
Steps: concrete 2.42m square
Front face of dado, raised metal letters:
1914.1919 / THIS MONUMENT WAS ERECTED / IN HONOURED MEMORY OF / THE GALLANT MEN OF / WEST ALLOTMENT, OLD / ALLOTMENT, AND DISTRICT / WHO SACRIFICED THEIR LIVES / IN THE GREAT WAR. / THEY DIED THAT WE MIGHT LIVE / "LEST WE FORGET"
Other faces: [names and ranks of dead]
Status: II
Condition: fair
Condition details: inscription missing at rear (holes visible), may have been maker's name; figure weathered with loss of detail; dirty with dark algal growth on figure and pedestal
Commissioned by: public subscription

Custodian: North Tyneside Council

Description: a white granite pedestal and cornice support a stone figure of *Victory* holding out a laurel wreath in her right hand and a flag in the crook of her left arm. Originally white, the figure is blackened from the effects of weathering.

History: the £475 that this memorial cost was raised by public subscription. It was unveiled by Captain F.A. Laing Gibbon with £32 still outstanding at the time.[1] Its designer was a local schoolboy, asked to draw the figure and promised 10 shillings for his efforts. However, he was never paid.[2]

[1] *Shields Daily News*, 11 April 1925. [2] N'land War Mems Survey, WMSW102.1.

Scoular, *First World War Memorial*

Burdon Road MEADOW WELL

Percy Main Metro station, on side of building 100m along track to west

Steam (see illustration in following page)

Sculptor: Aidan Doyle

Installed 1997
Whole work: cut and painted steel 10m long × 3.5m high approx
Status: not listed
Condition: good
Commissioned and owned by: North Tyneside Council

Description: a relief sculpture made of cut and forged steel, attached to the side of an abandoned storage shed, next to the Metro tracks. The central motif of an early steam engine is painted bright yellow. To the left is a grey-painted horse-drawn wagon team, and to the right is a steam engine and wagons. One of these has the word JUPITER cut through its side.

History: Steam was constructed by Doyle with the help of local trainees. The work has relevance both to the old railway and modern Metro, alongside which it is situated. It was commissioned and funded by North Tyneside Council as the first in a proposed scheme to site sculptures along the route of the old steam railway. However, the project did not continue after *Steam* was installed.[1]

[1] Information provided by Mike Campbell, NTC, 1999.

Chirton Green

Monument to Ralph Gardner

Designer: Gilbert Park

Installed 1882
Pedestal: stone walling 82cm high × 1.05m square

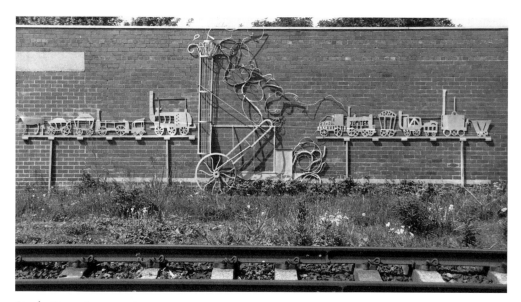

Doyle, *Steam* (see p.155)

Park, *Gardner Monument*

Obelisk: sandstone 3m high × 90cm square at base
Incised on north side of dado: RALPH GARDNER / CHIRTON COTTAGE / AUTHOR OF "ENGLAND'S GRIEVANCE DISCOVERED" / 1655 / ERECTED BY SUBSCRIPTION / 1882.
Incised on west face: "A FAITHFUL SON OF FATHER TYNE" / D.B. Lietch
Incised on south face: "I APPEAR TO GOD AND THE WORLD" GARDNER
Incised on east face: "WHO SUFFERED COUNTLESS ILLS / WHO BATTLED FOR THE TRUE AND JUST / TENNYSON"
Status: II
Condition: poor
Condition details: crack on south side of obelisk; edges chipped; considerable spalling on dado; green algae on many surfaces; dark soot residue and unknown paint/plaster remains on dado; graffiti inked on some surfaces
Commissioned by: public subscription
Custodian: North Tyneside Council

Description: tapering sandstone obelisk on a square pedestal made from stone walling.
Subject: Ralph Gardner (1625–*c.*late 1680s) fought long and hard against the seventeenth-century monopoly held on baking, brewing and shipbuilding on the Tyne by the 'tyrannical oppression' of Newcastle City Corporation. Born in Ponteland, he became a brewer in North Shields at the age of 23. At that time the Free Hostmen of Newcastle laid claim to exclusive rights of baking and brewing on the Tyne and brought a legal action against Gardner in 1650. He was heavily fined and thrown into jail, though he was never taken to trial, and escaped in 1652. He was recaptured after a fight, escaped and was recaptured once more.

Gardner published an appeal to Parliament, 'England's Grievance Discovered in Relation to the Coal Trade', but was thwarted by Cromwell's dissolution of the Long Parliament. He eventually regained his freedom and may have returned to the area before probably joining the Horse Guards, after which nothing is known of his fate.[1]

History: the obelisk was erected after a public subscription was raised by T.T. Clark. It was built by Shotton Brothers to Park's design[2] and is sited where Gardner's cottage stood until it was demolished in 1948.[3]

[1] Welford, vol.2, pp.266–71. [2] *Shields Daily News*, 2 April 1940. [3] *Evening Chronicle*, 7 December 1978.

Coast Road

Crossing of cycle path beneath road, east of Silverlink Retail Park

The Natural Cycle

Sculptor: Walter Bailey

Installed late 1996
Whole work: weathered steel 3.4m high × 1.6m wide × 45cm deep
Status: not listed
Condition: fair
Condition details: weathered and dirty; overgrown with grass and weeds; graffiti painted onto several surfaces
Commissioned by: Sustrans
Custodian: North Tyneside Council

Description: a torso and head made from rolled steel, set into the bank next to the cycle path. The body is constructed from circular strips of steel set on a radiating framework, and the head from several discs of metal. Weathered to a red-brown colour, some sections of the body are covered in what appears to be original blue and red paintwork, though this has deteriorated badly.

History: commissioned by Sustrans in conjunction with a work by William Pym at the north end of the footpath (see p.84) and

Bailey, *The Natural Cycle*

installed at the same time as a community event at Rising Sun country park.[1] Volunteers assisted in making the sculpture, which is reminiscent in form of Gormley's *Angel of the North* (see pp.57–9).

[1] Information provided by Mike Campbell, NTC, 1999.

Dockwray Square

Centre of grassed area

Stan Laurel

Sculptor: Robert Olley

Unveiled 29 March 1992
Statue: fibreglass 2.6m high
Pedestal: stone 1.4m high × 1.3m square
Relief: fibreglass 50cm high × 60cm wide
Incised on relief panel: LAUREL AND HARDY / THE GREAT DUO
Signed on relief: Robert Olley
Status: not listed
Condition: good
Commissioned by: Persimmon Homes
Custodian: North Tyneside Council

Description: a life-size sculpture of Stan Laurel set on an ashlar pedestal. The sculptor has exaggerated the comedian's features and the bagginess of his clothes. On the front of the pedestal is a small relief showing the heads of both Laurel and Hardy, and the whole is surrounded by railings with a locked gate.

Subject: Stan Laurel (1890–1965) was born Arthur Stanley Jefferson in Lancashire and lived in the original 8 Dockwray Square from 1897 to 1901. His early career was spent in British variety before going to the USA in 1913 where he made his first film, *Nuts in May* in 1917. He teamed up with Oliver Hardy in 1926 with his first official Laurel and Hardy film *Putting Pants on Philip* shot in 1927.[1] The pair rose to fame in the 1930s with their bumbling comedy characterisations.[2]

Olley, *Stan Laurel*

Dockwray Square dates back to 1763 when it was laid out by Thomas Dockwray, vicar of Stamfordham. However, none of the original buildings remain and the houses now surrounding the square date from 1986.[3]

History: The Times published a photograph of Olley with his statue at Fish Quay early in 1992.[4] It was unveiled on 29 March,[5] when the local press made great play of the sculptor's surname and 'Olly' Hardy. Sponsored in part by Tyne and Wear Development Corporation, the statue was commissioned by the developer of the new Dockwray houses.[6]

Olley, *Stan Laurel* (relief)

The park is now slightly down at heel and a set of railings tightly surrounds the sculpture, making it 'seemingly inaccessible to the general public who once made up his audience – in which context his quizzical expression seems appropriate'.[7]

[1] McCabe, J., *The Comedy World of Stan Laurel*, London, 1975, p.2. [2] Barr, C., *Laurel and Hardy*, p.9. [3] Pevsner, *Northumberland*, p.530. [4] *Times*, London, 16 March 1992. [5] *Evening Chronicle*, 29 March 1992. [6] *Shields Daily News*, 14 August 1990. [7] Ayris et al., p.83.

Fish Quay
New Dolphin public house, exterior

Dolphin Mooring Post
Artists: Northern Freeform

Installed 1993
Whole work: timber, brick and metal 4m high × 1.9m wide each side
Incised in ceramic on side 1: DOLPHIN

MOORING POST AS TRADITIONALLY USED IN THE RIVER TYNE; on side 2: DESIGNED AND BUILT BY FREEFORM ARTISTS WITH THE HELP OF JOHN SPENCE SCHOOL; on side 3: SPONSORED BY THE TWDC WITH SUPPORT FROM THE SWARLAND BRICK COMPANY, NORTH TYNESIDE COUNCIL AND SCOTTISH AND NEWCASTLE BREWERIES
Status: not listed
Condition: good
Commissioned by: Tyne and Wear Development Corporation
Custodian: North Tyneside Council

Description: a three-sided base is faced with ceramic tiles depicting sea creatures and carrying the inscriptions. Three wooden staves are joined together at the top, where a

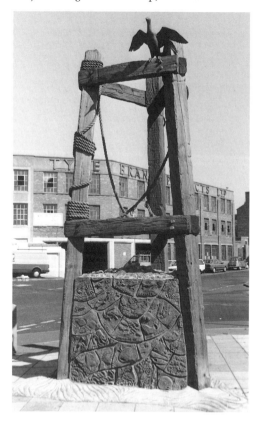

Northern Freeform, *Dolphin Mooring Post*

cormorant sits drying its wings.

Subject: based on mooring staithes which are used in the Tyne the *Dolphin Mooring Post* is placed outside the pub from which it gets its name and not far from where Freeform has its offices. 'Colin' the cormorant was sculpted by Richard Broderick and added rather later to the main structure.[1] This piece depicts matters of local concern, in common with a number of decorative public artworks along the river frontage. These include seating, bollards and lighting designed by Northern Freeform, and metal grilles in the retaining wall to the landing stage depicting *Herring Girls*, by Maureen Black for Northern Freeform.[2]

History: North Shields' quayside had been in long-term decline with the loss of fishing and other industries in the area. However, since the early 1990s it has been 'reinvented' as the Fish Quay, with river-front warehouses adapted for use as commercial units, new landscaping and the siting of public artworks. There is also a very successful Fish Quay Festival, held every summer. *Dolphin Mooring Post* was commissioned by TWDC as part of this regeneration programme and funded by the organisations listed on the inscription.

[1] Information provided by Richard Broderick, 1999. [2] *Evening Chronicle*, 27 April 1991.

Hawkey's Lane
Opposite junction to Highbury Place

North Shields First World War Memorial
Sculptors: John Reid and Alex Proudfoot
Architects: Cackett, Burns Dick and McKellar

Unveiled 28 April 1923
Cenotaph: Portland stone 3.2m high × 3.6m wide

Relief: bronze 2m high × 3.6m wide
Walls: stone 1.47m high × 11.5m wide
Incised on left hand wall: TO THE MEMORY OF /
THOSE WHO FELL IN THE GREAT WAR / THEIR
NAMES ARE RECORDED / IN THE BOOK OF
HONOUR / TREASURED IN THE PUBLIC LIBRARY.
On right wall: THIS MONUMENT / AND THE
INFIRMARY EXTENSION / WERE ERECTED AS THE
TOWNS WAR MEMORIAL / IN HONOUR OF THOSE
/ WHO DIED THAT WE MIGHT LIVE.
Bronze letters attached to face of cenotaph:
1914.1919; incised into stone: 1939.1945.
Status: II
Condition: fair
Condition details: stonework weathered; green
leaching from bronze panel down stonework of
cenotaph
Commissioned by: public subscription
Custodian: North Tyneside Council

Description: War Memorial consisting of a
central cenotaph block with a low screen wall
on either side, each carrying an inscription. A
bronze relief panel is attached to the cenotaph,

Reid and Proudfoot, *North Shields First World
War Memorial* **(detail)**

depicting the Angel of Healing and Peace
bringing solace to the world. Members of the
armed forces and nurses are shown on a bronze
relief frieze behind her head. Foliate designs
decorate the bands to either side.

History: built at the end of 1922 by the
contractor Gilbert Park (see p.155),[1] the
monument was described as being 'modest in
scale' so as to complement the Infirmary
extension which also acted as a memorial. 1,700
people from Tynemouth Borough lost their
lives and the frieze depicts their various
branches of the services, a 'delicate piece of
modelling'.[2] The memorial was unveiled by the
Duke of Northumberland on 28 April 1923
with full military honours and the Mayor
accepted it on behalf of local citizens.[3]

Vandalism was noted as early as 1925 and the
structure had fallen into considerable disrepair
by 1992. This was drawn to the attention of
councillors and the memorial was subsequently
cleaned.[4]

[1] N'land War Mems Survey, WMSN34.1. [2] *Shields
Daily News*, 24 November 1922. [3] *Ibid.*, 28 April
1923. [4] *Evening Chronicle*, 17 August 1992.

Liddell Street
Outside Prince of Wales pub

Wooden Dolly
Sculptors: Martyn and Jane Grubb

Installed 1992
Sculpture: oak wood 2.3m high × 74cm square
Base: concrete 28cm high
Status: not listed
Condition: good
Commissioned by: Samuel Smith Breweries
Custodian: Prince of Wales pub

Description: a buxom female figure without
any arms, brightly painted in a red dress with a
pink face and black hair.
Subject: a Wooden Dolly has traditionally

M & J Grubb, *Wooden Dolly*

stood in this spot on the quayside since the
early 1800s, when a figurehead from the collier
brig *Alexander and Margaret*, which had been
attacked and ransomed on the north-east coast
by a privateer in 1781, was placed here.[1] Seamen
would chip a little of the wood to make into
good luck charms, and also embrace the effigy
when they found themselves 'in a heavy sea and
staggering along under all canvas' (in other
words, drunk).
History: as described in 1890, 'Dolly has

stood in the Low Street, North Shields, through all the changes and vicissitudes incidental to the development and decay of an old seaport town'.[2] The original figurehead was replaced c.1850, and when that wore away a third version was made in 1864. This lasted until 1901 when a newly designed statue was made and sited in central North Shields. A replica was made of this in 1958 (see p.161) but it was not until 1992 that a 'true' dolly was restored to its rightful place on the quayside.[3] The Dolly's presence on the quayside has been marked by her name commonly being given to the Prince of Wales pub and surrounding streets.

After being closed for 25 years, the pub reopened in 1992 with this 1½-tonne sculpture placed outside. Costing £5,000 it was paid for by Samuel Smiths brewery. A series of colour photographs inside the pub shows the carving in progress.

[1] Craven, D., *The Mystery of the Wooden Dollies*, North Tyneside, 1990, *passim*. [2] *Monthly Chronicle*, 1890, pp.161–2. [3] Armstrong, K., *The Wooden Dolly*, North Shields, 1994, *passim*.

Nile Street

Outside North Shields Metro station

Wave

Sculptor: Richard Broderick for Northern Freeform

Unveiled 24 April 1998
Whole work: polished steel 2.7m high × 3m long × 1.7m wide
Plaque on west face of brick plinth: ART IN THE COMMUNITY / "WAVE" / Designed by Richard Broderick, / Northern Freeform / PAVEMENT ART / Designed by children from Ashleigh School / Official unveiling by Councillor Eddie Darke, Mayor of North Tyneside / on 24th April 1998.
Status: not listed

Broderick, *Wave*

Condition: good
Commissioned and owned by: North Tyneside Council

Description: a curving sheet of shining steel, with one side polished (though marked by handling) and the other roughened. It is set up on a brick pedestal which is a continuation of a pedestrianised area, two metres high. There are a number of contemporaneous small cast metal designs set into the pavement between *Wave* and the Metro station.

History: installed as part of improvements to the area fronting North Shields Metro station,

Wave was commissioned once the brick wall had been in place for some time. The metal features inset into the pavement were made to the designs of local schoolchildren.

Northumberland Square

Entrance to park

Wooden Dolly

Sculptor: Robert Thompson Ltd

Unveiled 22 October 1958
Sculpture: wood 1.7m high × 70cm square
Pedestal: brick 70cm square
Status: not listed
Condition: good
Commissioned and owned by: North Tyneside Council

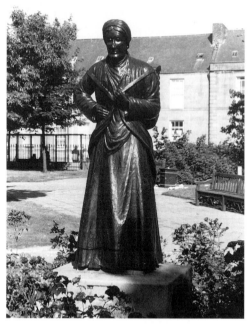

Thompson Ltd, *Wooden Dolly*

Description: carved from wood and painted brown, a life-size statue of a fisherwoman, carrying a basket and wearing traditional shawl and full skirts. The sculpture has two mice carved into it as Thompson's 'trademark', but these cannot be seen beneath the modern covering of paint.

Subject: traditionally known as a 'Wooden Dolly', the sculpture stands as a tribute to the part that women have played in the economic life of North Tyneside. It is a modern version of a type that goes back to a dolly erected by an Alexander Bartleman or William Bartram in the early 1800s.[1] Others were set up over time, based on the figureheads on ships, and providing shavings that the sailors could take to sea for good luck.

History: commissioned by North Tyneside Council to replace an earlier version which had stood on this spot since 1902, this is the fifth in a series of 'Wooden Dollies'; the others have been sited on the quayside (see pp.159–60). The current version was 'restored' in 1986, when a thick layer of brown paint was added to the wood.[2]

[1] Armstrong, K., *The Wooden Dolly*, North Shields, 1994, p.8. [2] Craven, D., *The Mystery of the Wooden Dollies*, North Tyneside, 1990, *passim*.

Rake Lane
North Tyneside General Hospital, courtyard through main entrance

Water Sculpture
Sculptor: Pete Auty

Installed 1996
Whole work: copper pipe 4.5m high × 3m square
Status: not listed
Condition: good
Commissioned and owned by: North Tyneside General Hospital

Auty, *Water Sculpture*

Description: a frame of green-patinated copper pipes which has two intersecting circles set on top. Some of the pipes form water jets through which a curtain of water falls to a brick-walled pond beneath. There are two sets of lights within the structure.

History: Auty was selected from a short-list of three artists to create a water feature as part of the hospital's refurbishment in 1996.[1] In his submission to the Trust Board, he outlined the difference between a solid mass which would dominate the space and his idea of a more open, linear work. 'In this commission movement, continuity and notions of passage have to be an important element in the design.' Auty's brief also recognised the different sorts of people

circulating in the hospital: the work would have to intrigue a passing visitor whilst delivering something new each time to those more used to its presence.[2] The play of water and variety of viewpoints mean that the sculpture is well integrated into the light-filled atrium of the hospital's entrance.

[1] Information provided by Mr Bernard McGlen, May 1999. [2] Artist's submission to North Tyneside General Hospital, December 1995.

Royal Quays

By the 1980s the area around the Tyne Commission Quay had become mostly disused and derelict, except where North Sea ferries continued to dock. Tyne and Wear Development Corporation (TWDC) were charged with reclaiming the land, and invested £245 million in partnership with the private sector and the local council so as to create Royal Quays which includes new housing, a water theme park, an outlet shopping centre and a marina. Chirton and Redburn Denes follow the natural course of waterways and have been created out of old dock areas.

Lock island between dock and river

Sea Dreamer's Rest
Sculptor: Gilly Rogers

Unveiled 16 December 1998
Capstan: steel, resin, clay pipes 1.04m high × 95cm diameter
Shoes: bronze 20cm long × 10cm high
Status: not listed
Condition: good
Commissioned by: North Tyneside Arts
Custodian: North Tyneside Council

Description: a multi-element work. At either end of the lock island are two old capstans, each with eight resin blocks inset round their tops. These contain clay pipes (northern capstan) and

white feathers (southern capstan). On the other side of rails at the edge of the water, are two pairs of bronze cast shoes: a lady's at the north end and a man's at the southern end. The capstans are lit from within at night.

History: Rogers spent a year as artist-in-residence at Royal Quays working with local community groups and school children. She described *Sea Dreamer's Rest* as a 'site specific intervention'.[1] The pipes were originally smoked by sailors in the area and the feathers are those of local sea-birds. Rogers had requested that members of the public submit shoes for selection as models. Though no specific meaning was attributed to them, it may be that the bronze casts of empty shoes refer to land-lubbers' aspirations for a life at sea.

Sea Dreamer's Rest was commissioned by North Tyneside Arts on behalf of the Public Art Joint Committee, as part of the regeneration of Royal Quays.

[1] *Journal*, Newcastle, 15 December 1998.

Rogers, *Sea Dreamer's Rest*

Pier end

Tyne Anew
Sculptor: Mark Di Suvero

Installed 30 July 1999
Whole work: painted steel 21m high approx × 15m wide approx
Status: not listed
Commissioned by: North Tyneside Arts
Custodian: North Tyneside Council

Description: a bright orange-red abstract sculpture made from steel I-beams. Three legs form a tripod beneath a 'vane' consisting of two beams jutting out in a V-shape, balanced by a figure-of-eight shaped section. The whole upper element moves gently in the wind.

History: almost immediately dubbed the Tripod of the North, Di Suvero's sculpture is in keeping with his trademark style of balancing heavy wooden or steel elements so that they dynamically interact with the surrounding space. The form of *Tyne Anew* is obviously similar to the many shipyard cranes that tower over the river frontage, though its bright orange-red coating of paint ensures that it stands out against the background. Its size and shape are particularly reminiscent of works such as *Mahatma* (1978–9) and *Huru* (1984–5), both of which counterbalance V-shaped horizontal sections with curved forms.[1] *Tyne Anew*'s moving vane resembles a compass point and its gentle movement means that the sculpture's shape constantly changes as the wind swings round.

Di Suvero enthused about the location at Royal Quays, saying 'You get to see certain sites and they really are glorious. This is one of them. It's a worker's site and it appeals to me because I live by a river, the East River in New York.'[2] After an initial visit in 1997, he returned

Di Suvero, *Tyne Anew*

to New York and constructed the sculpture from spare elements that were stored at his yard. These were then shipped to Liverpool and taken to the Shildon works of Barrier Ltd to be sandblasted and painted in its distinctive orange-red colour.[3] The sculpture was then installed on site under the supervision of Di Suvero over the last weekend of July 1999.

North Tyneside Council emphasised the fact that *Tyne Anew* is the first commission in the UK for a work by Di Suvero. Council Leader Rita Stringfellow said that 'the transformation at Royal Quays is amazing and I believe that a major sculpture by an internationally renowned artist is the icing on the cake'.[4] Its installation attracted inevitable press comparisons with Gormley's *Angel of the North*, with much being made of how the new work was about two

metres taller. However, the *Independent on Sunday* reported that the record was soon to be overtaken by a giant steel herring in Yarmouth.[5] Its sister paper even suggested that the people of Tyneside would suffer from 'sculpture fatigue' – 'the effect of disgorging too much grandeur from a surfeit of lottery money'.[6] The £3.5 million Arts Council Lottery grant to 'Art on the Riverside' had already funded the installation of Wilbourn et al.'s *Shadows in Another Light* (see pp.191–3) and Muñoz's *Conversation Piece* (see p.172). The £614,000 cost of *Tyne Anew* was met by the Lottery Fund, TWDC and Morrisons Developments Ltd.

The relationship of *Tyne Anew* to the North-East and its site at Royal Quays was of particular concern to Di Suvero and the commissioners. It is located very near to the pontoons where Scandinavian ferries dock and an estimated 600,000 visitors will see it each year as they arrive in North Shields. 'The North-East is rich in history and the legacy of heavy industry is visible everywhere you look,' said the sculptor. 'I wanted to add to this feeling of the past impacting on the present. *Tyne Anew* will be a constant reminder to people of the industrial foundations the North East is built on.'[7] However, by the time the sculpture was installed, Di Suvero was considering giving it a new title because his sense that the work's relationship to its location had subtly changed.[8] There is no confirmation of the sculpture's new name at the time of writing.

[1] Osterwold, T., *Mark Di Suvero* (exhib. cat.), Stuttgart, 1988, *passim*. [2] *Journal*, Newcastle, 30 July 1999. [3] *North Shields News Guardian*, 17 June 1999. [4] North Tyneside Arts, Press Release, July 1999. [5] *Independent on Sunday*, 1 August 1999. [6] *Independent*, 19 June 1999. [7] *Journal*, Newcastle, 24 June 1999. [8] Information provided by Mike Campbell, NTC, 1999.

France & Peever, *Kin*

Chirton Dene

Chirton Dene has been developed from the derelict Albert Edward Dock.[1] It was opened in 1994 as part of Tyne and Wear Development Corporation's regeneration of the Royal Quays area.[2] The Dene was designed by SGS Environment with water as its central theme and there are a number of different environments within it, each containing one of the text projects (see below).

[1] Tyne and Wear Development Corporation, *The Art of Regeneration*, Newcastle, n.d., pp.14–15. [2] Green, F., *A Guide to the Historic Parks and Gardens of Tyne and Wear*, Newcastle, 1995, pp.61ff.

Bridge over stream in centre of Dene

Kin

Letter carver: Alec Peever
Writer: Linda France

Installed 1994
Text on bridge: metal panel 20cm wide × 10cm high
Sculpture: stone with metal bolts 1.1m square × 30cm high

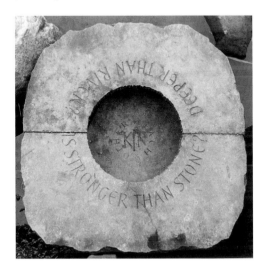

Inscribed on bridge plaque: WHAT
Incised round rim of sculpture: WHAT IS STRONGER THAN STONE? / DEEPER THAN RIVER? / EACH OTHER / KIN
Status: not listed
Condition: fair
Condition details: stone weathered and covered in algae; crack running through bottom slab; worn plaque on bridge
Commissioned by: Tyne and Wear Development Corporation
Custodian: North Tyneside Council

Description: a small plastic plaque is attached to the bridge which, once read, leads the eye to a sculpture set on the stream bed below. This consists of two circular pieces of stone held one above the other by metal bolts. The upper one has a hole in its middle and carries the inscription.

History: commissioned to complement the regeneration of Chirton Dene. The work links with other carved poetry further down the Dene (see below) and is based on France's collaboration with local women in creating texts based on life in North Shields.[1]

[1] Information provided by The Newcastle Initiative, 1998.

Pond at south end of Dene

The Tide is Turning

Letter carver: Alec Peever
Writer: Linda France

Installed 1994
Texts set on wall: stone 5m high × 15m long
Text in pond: stainless steel 4m long × 70cm wide
Inscribed on stone tablets attached to retaining wall: IF WATER WERE WORDS WHAT WOULD THE TYNE SAY?
Raised metal letters in pond: THE TIDE IS TURNING

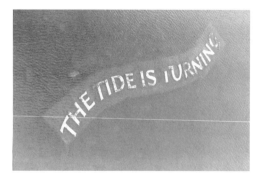

France & Peever, *The Tide is Turning*

Status: not listed
Condition: good, though green algae lightly covers surfaces
Commissioned by: Tyne and Wear Development Corporation
Custodian: North Tyneside Council

Description: two relief texts set in and next to an artificial pond at the south end of the Dene. The retaining wall carries a number of soft yellow stone tablets along its length, each with a word from the quote. The metal lettering is situated on the river bed beneath, glinting up through the water.

Subject: the two phrases were developed by France in collaboration with local women's groups and have obvious connections with the location and its former and current states.

Off Howden Road, north end of Dene

Play Area

Artists: Richard Broderick and Graham Robinson for Northern Freeform

Installed *c.*1995
Play sculptures: concrete; mosaic up to 2m high
Statue: fibreglass 80cm high approx

Status: not listed
Condition: fair
Condition details: head of statue covered with droppings; playground pieces worn, scratched and dirty; considerable amounts of incised and inked graffiti
Commissioned by: Tyne and Wear Development Corporation
Custodian: North Tyneside Council

Description: a circular playground within wooden stockade fencing containing many colourful sculptures in the form of cars, buses, shops and a castle. There is also a large amount of mosaic set into the ground around play equipment and on some of the sculptures. At the south end of the area is a mound with a silver-coloured column, looking like a chimney, mounted on it. Set at its top is a small fibreglass figure in a striding and pointing pose.

History: the design of the play area was based on the theme of transport and produced in consultation with children from four local schools.[1] They had been much taken with the 'Crystal Maze' television programme, so puzzles were also built into the design. Because a strong vertical element was required, Robinson set a child's figure on top of the polished column: it points directly out to sea between the piers at either side of the Tyne.[2]

[1] Information provided by The Newcastle Initiative, 1998. [2] Information provided by Richard Broderick, 1999.

Broderick and Robinson for Northern Freeform, *Play Area*

Redburn Dene

Landscaped as a walkway from the outlet shopping centre to the marina, Redburn Dene contains cut-steel entrance-ways designed by local schoolchildren and a pebble-dash map of Europe at a look-out point, as well as *Prophecy Monolith* listed below.

Redburn Dene, south end

Prophecy Monolith

Letter carver: Alec Peever

Installed October 1996
Whole work: sandstone 1.85m high × 2.4m wide × 1.6m long
Incised curvilinear lettering around all sides of the stone: Instead of the thornbush will grow the pine tree and instead of briars the myrtle will grow. This will be for the Lord's renown for an everlasting sign which will not be destroyed. ISAIAH 55V13.
Status: not listed
Condition: good
Condition details: small vertical crack approx 20cm from base; some letters are chipped; graffiti inked on top
Commissioned by: Tyne and Wear Development Corporation
Custodian: North Tyneside Council

Peever, *Prophecy Monolith*

Description: a three-sided slab of yellow sandstone, carved with Isaiah's prophecy.

History: costing £4,000, this standing stone joins a number of landscape features within Redburn Dene's overall design by SGS Environment. Its inscription refers to the care required to maintain the environment. Other features in the Dene include wooden staithes reclaimed from the Tyne; metal entrance-ways designed by local schoolchildren; a pebble mosaic depicting the British Isles and directional markers to five European countries; and other stone, metal and wooden features. The C2C cycle path runs through the Dene as it nears its end in Tynemouth.[1]

[1] Information provided by The Newcastle Initiative, 1998.

Tyne Street

Nater's Bank to east of Light House

Nater's Bank Seascape

Designer: Maggie Howarth
Sculptors: Richard Broderick and Graham Robinson for Freeform Arts Trust

Constructed on site 1987 to 1988
Whole work: stone, concrete, ceramics 3m long × 10m wide
Status: not listed
Condition: good
Commissioned and owned by: North Tyneside Council

Description: set into the steep bank below Tyne Road, a large design depicting the sea life that North Shields is famous for, constructed using a 'mosaic' technique with stones, poured

Howarth et al, *Nater's Bank Seascape*

concrete and ceramic squares. Two large cod dominate the composition, frolicking among highly coloured fish and other creatures. The whole is given a three dimensionality by moulded concrete being used for fins and wave forms.

The work can be viewed by walking around the paths set into the hillside but to see it in its entirety it is best to look up from the end of the fishermen's wharf below.

History: initially designed by Howarth and based on a double-cod motif used by the local fishermen's association, *Seascape* was created by members of the locally-based Freeform Arts Trust. The sculpture incorporates smaller mosaic fish which were made by local school-children. Commissioned by North Tyneside Council and funded by Northern Arts as part of the regeneration of the Fish Quay area.

Junction with Hudson Street, outside Wooden Dolly public house

Wooden Dolly

Sculptor: not known

Installed *c.*1980s
Sculpture: plaster or terracotta 80cm high
Pedestal: brick 1m high × 45cm square
Status: not listed
Condition: fair
Condition details: flaking paint and some loss of detail due to weathering

Description: a younger version of the Wooden Dolly in Northumberland Square (see pp.160–1), also painted brown but cut to bust length.

A183

Penshaw Hill

Penshaw Monument

Architects: John Green Senior and Benjamin Green

Completed 1844
Whole monument: stone 21m high × 45m long × 16m wide
Engraved on brass plate set on foundation stone: This stone was laid by / THOMAS, EARL OF ZETLAND, / Grand Master of the Free and Accepted Masons of / England, assisted by /

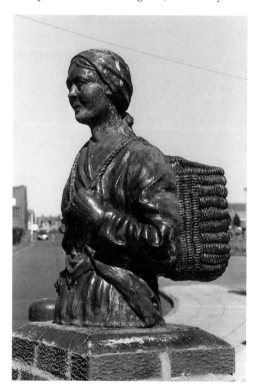

Wooden Dolly

The Brethren of the Provinces of Durham and North- / umberland, on the 28th of August, 1844, / Being the Foundation Stone of a Memorial to be erected / To the Memory of / JOHN GEORGE, EARL OF DURHAM, who, / After representing the County of Durham in Parliament / For fifteen years, Was raised to the Peerage, And subsequently held the offices of / Lord Privy Seal, Ambassador Extraordinary and / Minister at the Court of St. Petersburgh, and / Governor-General of Canada. / He died on the 28th July, 1840, in the 49th year of his age. / – / This Monument will be erected / By the private subscriptions of his fellow-countrymen, / Admirers of his distinguished talents and / Exemplary private Virtues. / – / John and Benjamin Green, Architects.[1]

Status: I
Condition: fair
Condition details: intermittent problems with the hill's stability; blackened by weathering; graffiti scratched and inked on many surfaces
Commissioned by: public subscription
Owned by: The National Trust

Description: a double-size replica of the Temple of Theseus in Athens, situated on the top of a steep hill. Eighteen Doric columns are set on a 2-metre high base, tapering as they rise up to a massive pedimental structure with its roof open to the sky. The monument's stone would originally have been yellow, but it has blackened over the years. One of the columns has a staircase within it (though access to the roof has been closed for several years) and most of the walls and columns are hollow.

Penshaw Monument is the largest structure functioning solely as a memorial in the North-East survey region. It was described in 1855 as 'remarkable for its grandeur, simplicity, and imposing effect, nothing in the shape of ornament or meretricious decoration being introduced; for, as it is intended to be viewed principally from a distance, any enrichment

Green & Green, *Penshaw Monument*

after being accused of providing prompts for someone else's speech.

The Earl became Ambassador to Russia in 1835 and upon his return was asked to deal with the Canadian revolt of 1837. His Durham Report of 1839 led to limited self-government for Canada, Britain's first experiment in colonial emancipation. Affectionately known as 'Radical Jack' or 'The King of the Colliers', Lambton's death was greeted with an outpouring of public sympathy: 'he was a good friend to the poor', exclaimed one labourer.[4]

History: after the Earl's death a subscription fund raised £3,000 in Newcastle and Sunderland, augmented by the efforts of a London committee. Four years later the monument was built on a hill donated by the Marquess of Londonderry. Its foundation stone was laid on 28 August 1844 by Thomas, Earl of Zetland in front of a 30,000 crowd which included some 400 members of the Provincial Grand Lodge of Free Masons.

A number of legends grew up around this famous landmark – a common belief is that it was erected by farmers to impress one of the earls of Lambton who, surmising that his tenants could afford the extra, promptly raised their rents – hence the popular name of 'Farmers' Folly' (see the similar, but true story about the Percy Tenantry Column in Alnwick, pp.1–2). There has also been confusion between Penshaw Hill and another hill at nearby Fatfield around which, according to the legend, the Lambton Worm coiled itself.[5]

Penshaw's name derives from the ancient British 'pen', a head or hill; and 'shaw', Saxon for a wood or thicket.[6] After belonging to the Lambton family for many years, the site is now managed by the National Trust. In the early 1990s its was realised that the hill was subsiding, though there was 'no cause for alarm'. Concrete was injected underneath to stabilise the structure and further work was carried out on the superstructure in 1996.[7] The

Monument has been floodlit at night since 1988, when Sunderland Borough Council installed 12 lights at a cost of £50,000.[8]

[1] Hind, A.L., *Penshaw Monument*, 1978, *passim.* [2] Fordyce, W., *The History and Antiquities of the County Palatine of Durham*, Newcastle, 1855, vol.II, p.567. [3] Pevsner, *Co. Durham*, p.371. [4] *Monthly Chronicle*, 1888, pp.400–1. [5] Todd, S., 'Penshaw Monument', *Northern Life*, April 1956, p.19. [6] Hind, A.L., *The River Wear: History and Legend of Long Ago*, Washington, 1979, p.142. [7] *Journal*, Newcastle, 8 August 1996. [8] *Ibid.*, 23 September 1988.

Herrington opencast mine

David Paton was artist-in-residence at Herrington opencast mine from 1997 to 1999. His remit was to 'work with local people, reclamation and mining teams to produce a series of artworks that utilise the excavated stone and reflect the changing usage of the site'. English Partnerships have overall responsibility for the site and say that its association with arts projects 'is a natural extension of [its] role in promoting regeneration'.[1] Additional funding and support were provided by RJB Mining and Crouch Engineering.

The massive excavations will be turned into a country park by 2001 which, it is envisaged, will include a number of other artworks by Paton. Access to the site is limited until then, and members of the public are advised to ask at reception if they want to view the sculptures.

[1] City of Sunderland, *publicart.sunderland.com*, Sunderland, 1998, pp.8–9

Spires
Sculptor: David Paton

Carved on site 1998–9
Each element: Portland stone, sandstone, local sandstone up to 5m long × 3m wide × 1.8m high
Incised across several boulders: BLACK SEAMS

would be lost.'[2] Its hill-top site means that it is visible from the Wear and Tyne plains up to a distance of about 15 kilometres, looming 'as an apparition of the Acropolis under hyperborean skies', in the words of Pevsner.[3]

Subject: John George Lambton (1792–1840), the 8th Earl of Durham, was a humane and generous landlord responsible for the Durham coalfield. His collieries were the first to test the Davy Safety Lamp, and he objected to unnecessarily harsh treatment of miners. He spoke in the Commons and the Lords in favour of Parliamentary reform and led a life full of incident, once duelling on Bamburgh Sands

Paton, *Spires* (detail)

PAY FOR ALL WE SURVEY
Status: not listed
Condition: good
Commissioned by: City of Sunderland, English
Partnerships and RJB Mining (UK) Ltd
Owned by: City of Sunderland

Description: a multi-element sculpture
consisting of a main part carved from non-local
stones with eight other blocks ranged alongside
(all locally-hewn heavily laminated sandstone).
The main element is carved with abstracted
representations of spires visible from the
mining site. All the boulders also have designs
carved on them, such as trefoil windows and
columns, inspired by visits to Durham
Cathedral. The inscription runs across the
'subsidiary' boulders, with a few letters on each.
Four of the letters also have additional carving
to draw attention to them: they spell out COAL.
History: this complex piece was created by
Paton over the life of his two-year residency at
the mine. The apt inscription was made up by
one of the site managers.[1] Paton started his
residency in May 1997 and has visited local
schools to demonstrate his sculptural
techniques and explain about the site's
development. An exhibition of work in

progress was held at Sunderland City Library
and Art Centre in February 1999, and the
project has been documented by well-known
local photographer, Keith Pattison.

[1] Information supplied by the artist, 1999.

John's Rock
Sculptor: David Paton

Unveiled 16 July 1998
Boulder: locally quarried stone 2.5m high × 5m
long × 3m wide approx
Each portrait: Portland stone with galvanised
steel frame 30cm square × 30cm deep
Status: not listed
Condition: good, though restored
Commissioned by: City of Sunderland, English
Partnerships and RJB Mining (UK) Ltd
Owned by: City of Sunderland

Description: ten high-relief portraits of local
men in white Portland stone, each with a lintel
projecting over. They are attached by steel
frames to a large yellow boulder, which is sited
on top of a bank overlooking the Herrington
stone quarry.
History: two men gave their names to *John's
Rock*: one was the site worker who moved the
boulder to its current position, the other had his
portrait carved and subsequently incorporated
into the sculpture. All of the carvings portray
men who have worked at the site over the years.
At the time of making the heads Paton said, 'I
wanted to do a piece which celebrated the
mining culture both past and present so I asked
some of the miners to pose for me'.[1]
John's Rock was unveiled on 16 July 1998 by
the Mayor of Sunderland, Councillor Wally
Scott. However, the day before it had been

Paton, *John's Rock*

attacked by vandals, with some of the noses chipped off and mud splattered over the work,[2] but Paton managed to glue the noses back in place with resin before the ceremony.[3] Subsequent vandalism led to the rock being moved in its entirety to a safer location before being restored by the sculptor.

[1] *Journal*, Newcastle, 4 June 1998. [2] *Evening Chronicle*, 15 July 1998. [3] *Journal*, Newcastle, 16 July 1998.

ROWLANDS GILL
Gateshead MBC

Rowlands Gill Bank (B6314)

William C. Rippon Memorial Fountain

Designer: not known

Installed 1906
Base and trough: pink granite 1.2m deep × 1.1m wide
Drum: pink granite 2m high ×.1.1m wide
Incised letters on drum: ERECTED BY / MISS. A. RIPPON, / IN REMEMBRANCE OF HER BROTHER / WILLIAM. C. RIPPON, OF HIS LIFE'S RESIDENCE IN BURNOPFIELD / AND IN KINDNESS TO DUMB ANIMALS / 1906. / THE DONOR OF THIS FOUNTAIN / DIED 3RD. OCT.R BEFORE ITS COMPLETION
Incised on base: ACCEPTED / ON BEHALF OF PARK COMMITTEE BY / H. C. WOOD C.C./ ACCEPTED ON BEHALF OF TANFIELD U.D. COUNCIL BY / W. BULMER J.P.
Status: not listed
Condition: poor
Condition details: one trough and spout missing; large abrasion on trough 5cm in length; algae on trough and column; small chips on base and column
Commissioned by: M.A. Rippon

Rippon Fountain

Custodian: Gateshead Metropolitan Borough Council

Description: fountain consisting of a drum atop a cubic base and trough. The drum carries the inscription on its north face and is surmounted by an iron finial.

Subject: according to the 1881 census Rippon was a 50-year-old butcher and inn keeper. He lived with his unmarried sister Mary A. Rippon in Burnopfield.[1] The inscription referring to Rippon's 'kindness to dumb animals' seems surprising, given his trade.

History: details of the commissioning of this memorial are given in the inscription. Locals say that it was originally placed at this location until it fell over in a gale some years ago. It is said to have rolled down the nearby hill and lost its trough and original lamp en route. The council relocated it in 1996.

[1] Census, 1881.

RYHOPE City of Sunderland

Lansdowne RYHOPE COLLIERY
Open ground next to club house

Pit Wheel

Sculptor: Wilma Eaton

Unveiled 11 September 1995
Whole work: steel 3.5m high × 7m wide × 24cm deep
Metal plaque at bottom front: RYHOPE PIT WHEEL SCULPTURE / This sculpture was unveiled on the / 11 September 1995 / by His Worship The Mayor of the City of Sunderland, Councillor Eric Bramfitt / and retired Ryhope miner Mr R Reid, Secretary of Ryhope N.U.M. Lodge. / Sunderland Libraries and Arts with support from Northern Arts commissioned artist Wilma Eaton / to work with the local community to create this sculpture as a tribute to all those who worked at / Ryhope Colliery between 1856–1966.
Status: not listed
Condition: good
Condition details: paint flaking and rust patches; graffiti inked on some surfaces
Commissioned and owned by: City of Sunderland

Description: two half pit-wheels set in parallel, with a third slightly smaller steel

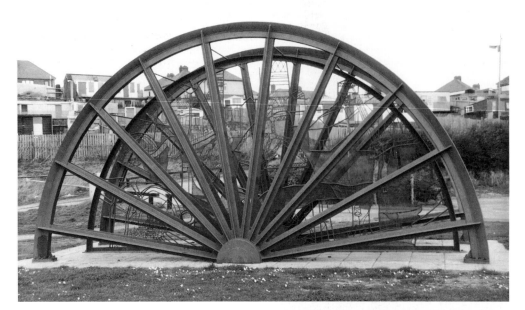

Eaton, *Pit Wheel*

B6317 BAR MOOR
Memorial Hall, façade

Emma Colliery War Memorial
Designer: not known

Building erected 1924
Figurative panels: bronze 95cm high × 39cm
wide
Central names panel: bronze 95cm high × 97cm
wide
Outer names panels: bronze 46cm high × 48cm
wide
Incised on lintel above memorial: EMMA
COLLIERY WORKMEN'S MEMORIAL HALL
Raised lettering on central panel: A tribute of
affection to / the men of Emma Colliery / who
gave their lives in the / Great War 1914 1918 /

hemicircle in between. This incorporates
forged-steel designs of miners at the coalface,
winding gear and coal seams.

 History: Eaton spent six months as artist-in-
residence at Ryhope, working with primary
schools, youth clubs and community groups to
create designs for a tribute to the village's
mining past. Having salvaged the main structure
from the nearby Easington Colliery, 'residents
realised their creative dreams when a
commemorative pit wheel was unveiled'. Over
100 prints and a number of small sculptures
were also created for the local library.[1]

[1] *Sunderland Echo*, 12 September 1995.

Emma Colliery War Memorial

[names] / THEIR NAME LIVETH FOR EVER MORE / MEMORY LINGERS HERE
Status: not listed
Condition: good
Commissioned by: public subscription
Custodian: Emma Colliery Workmen's Memorial Hall

Description: inscribed bronze plaque flanked by bronze relief figures of miners' wives, set on the road-side façade of the memorial hall.

History: the Emma Memorial Hall was opened in 1924 with the reliefs *in situ*.[1]

[1] Harrison, A., *A History of Ryton*, Gateshead, 1990, p.96.

SHIREMOOR
North Tyneside Council

New York Road (A191)
SILVERLINK COUNTRYSIDE PARK

Sundial

Designer: Graham Robinson for Northern Freeform
Architects: Anthony Walker & Partners

Unveiled 2 November 1998
Dial: stone and iron slabs 20m diameter
Gnomon: iron 5.5m high × 1.98m wide × 30cm deep
Lettering around base of gnomon, on iron sun plate: NORTH TYNESIDE MCMXCVIII CITY CHALLENGE
Raised letters on each side of gnomon: HOLYSTONE FIRST SCHOOL
Status: not listed
Condition: good
Commissioned by: North Tyneside City Challenge and English Partnerships
Custodian: North Tyneside Council

Robinson for Northern Freeform, *Sundial*

Description: a sundial formed out of the summit of a modern, artificial hill, approximately 15 metres high. The 'face' consists of paving slabs in a variety of shades, with iron numbers around a central disk with a sun motif. The gnomon is a large, slanting slab of orange-brown iron weighing over four tonnes, with relief designs of natural forms imprinted on either side. The site overlooks large areas of open land with factory buildings in the distance.

History: pupils assisted Robinson in creating moulds of countryside motifs to be incorporated on the gnomon, which was cast by Hargreaves of Halifax. The *Sundial* was

unveiled by David Bellamy with the schoolchildren in attendance.[1] Silverlink Country Park cost £1.1 million to develop and the new hill is now the highest point in North Tyneside.[2] The *Sundial* was funded by North Tyneside City Challenge and English Partnerships as part of the area's regeneration from a post-industrial landscape.

[1] *Evening Chronicle*, 3 November 1998. [2] *Journal*, Newcastle, 11 July 1998.

SILKSWORTH

Silksworth Park

Silksworth War Memorial

Designer: not known

Installed *c.*1922
Incised on front dado of pedestal, black painted letters: THIS MEMORIAL / WAS ERECTED IN LOVING MEMORY OF / THE MEN OF THE SILKSWORTH AND / TUNSTALL PARISHES WHO MADE THE SUPREME / SACRIFICE IN THE GREAT WAR. 1914–1918 / [names below]
On upper base of pedestal: NOT ONCE OR TWICE IN OUR ROUGH ISLAND STORY / THE PATH OF DUTY WAS THE WAY TO GLORY
On lower base of pedestal: ALSO / IN PROUD AND LOVING MEMORY OF / THOSE OF THESE PARISHES WHO FELL IN THE / SECOND WORLD WAR / 1939 – 1945
Condition: fair
Condition details: rifle broken and statue weathered
Commissioned by: public subscription
Custodian: City of Sunderland

Description: white stone or marble statue of a Tommy in a floppy hat carved with particular attention to detail. He holds a rifle at the ready, though this has been broken in two. The statue surmounts a square grey/white granite pedestal

with foliate carving around the architrave, on a two-tier base of the same stone above two concrete steps. Names of the dead are inscribed on all four dado faces of the pedestal, as well as on three faces of its lower base.

Silksworth War Memorial

Harbour Drive

Littlehaven Beach

Conversation Piece

Sculptor: Juan Muñoz

Installed early December 1998
Each figure: bronze 1.58m high × 80cm diameter
Status: not listed
Condition: good
Commissioned by: Tyne and Wear Development Corporation
Custodian: South Tyneside Metropolitan Borough Council

Muñoz, *Conversation Piece* **(detail)**

Description: twenty-two bronze figures arranged in groups or separately around a 40-metre wide paved area, behind a small beach. The head, arms and torso of each emerge from what appears to be a filled sack. The facial features are childish but rather indistinct. Each figure is depicted in a different pose, listening, leaning or talking, and they are all patinated light blue-green over the brown of the bronze. The sculptures are situated near the mouth of the Tyne with spectacular views of Tynemouth and the estuary.

History: this arrangement of figures in a landscape has been likened to *fête champêtre* scenes by the eighteenth-century painter Watteau, in which young people idle away their time in romantic settings. Muñoz had created similar semi-human figures made from fibreglass and set them around the ramparts of Berwick-upon-Tweed as part of the year of Visual Arts UK in 1996. He was initially sceptical about working at South Shields until he saw the beach overlooking the mouth of the Tyne.[1] The figures were delivered to South Tyneside in May 1998[2] and finally installed in early December.[3]

Commenting on the strange appearance of the figures, Muñoz said that 'laughter and pain are very close and I like the idea of tragi-comedy. They look like rolling figures, like tumblers, and they are about movement, but they can't move.'[4] The work was commissioned as part of the 'Art on the Riverside' project, using part of the £3.5 million lottery award for public art won by TWDC in 1997.

[1] *Journal*, Newcastle, 17 September 1997. [2] *Ibid.*, 19 May 1998. [3] *The Times*, London, 4 December 1998. [4] *Journal*, Newcastle, 12 November 1997.

Mill Dam

Customs House Arts Centre, exterior

Merchant Navy Memorial

Sculptor: Robert Olley
Foundry: Burleighfield

Unveiled 19 September 1990
Statue: bronze 2.5m high
Pedestal: stone 1.8m square × 1.74m high
Incised on plaque on front of pedestal:
MERCHANT NAVY MEMORIAL / This statue was
unveiled by / Countess Mountbatten of Burma
/ on 19th September, 1990 / in memory of the
thousands of merchant seamen / who sailed
from this port and lost their lives in World War
II. / Unrecognized, you put us in your debt; /
Unthanked, you enter or escape, the grave; /
Whether your land remember or forget / You
saved the land, or died to try to save. / JOHN
MASEFIELD Poet Laureate.
Incised on rear of sculpture base:
BURLEIGHFIELD
Status: not listed
Condition: good
Commissioned by: public subscription
Custodian: South Tyneside Metropolitan
Borough Council

Description: a one-and-a-half-life-size
depiction of a sailor at the wheel, on a sloping
base to give the impression of what it is like to
stand on a ship's deck in a choppy sea.
Overlooking the Tyne, he gazes keenly ahead to
the dangers that may come. The pedestal is
yellow ashlar with a simple square-cut cornice.
History: the idea for a memorial to the
region's merchant seamen lost in war was first
mooted in 1988 by the retired President of the
National Union of Seamen, Jim Slater.[1] The
£56,000 needed was raised by public
subscription,[2] whilst the plinth was paid for by
Tyne and Wear Development Corporation as a
contribution to its regeneration of the

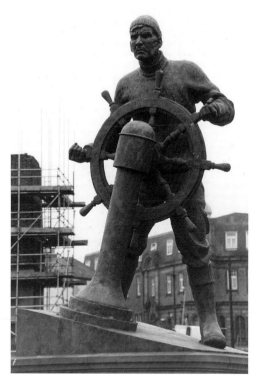

Olley, *Merchant Navy Memorial*

surrounding area.[3]
 As stated in the inscription, the memorial
was unveiled by the Duchess of Mountbatten,
wife of the distinguished naval commander.

[1] *Journal*, Newcastle, 17 December 1988. [2] *Ibid.*,
20 September 1990. [3] *Evening Chronicle*, 7
February 1990.

Ocean Road

Museum and Art Gallery, exterior

'Golden' Lion

Sculptor: not known

Originally part of building erected *c.* 1870
Sculpture: stone 1m high
Pedestal: stone 1.4m high × 1.77m wide × 70cm
deep
Status: not listed
Condition: good
Commissioned by: Golden Lion pub
Custodian: South Tyneside Metropolitan
Borough Council

Description: a boldly carved lion, at rest with
paws laid out in front, situated on a low
pedestal in front of South Shields Museum and
Art Gallery. The stone is covered with a layer of
green algae.
History: originally part of the Golden Lion
Public House on Ocean Road, the *Lion* was
located in the pedestal above the front door.
Rumours were rife about demolition as the
building deteriorated, with one press article
suggesting that the lion should be preserved.[1]
The pub was knocked down in April 1973, but
the *Lion* was rescued.[2] Possibly made of Coade
stone, the *Lion* was covered in gold paint when

'Golden' Lion

first erected. It is said that its tongue was painted green out of spite because the sculptor was not paid enough. Most of the paint has long ago worn off although minute traces remain on some areas.

Plans for Ocean Road in 1998 include the restoration and cleaning of the sculpture.

[1] *Shields Daily News*, 6 March 1973. [2] *Shields Daily News*, 24 April 1973.

Pedestrianised area

Monument to John Simpson Kirkpatrick

Sculptor: Robert Olley

Installed 26 January 1988
Sculpture: fibreglass 2.5m high
Pedestal: stone 1.6m high × 2.5m wide × 1.7m deep
Inscription on bronze plaque on pedestal: JOHN SIMPSON KIRKPATRICK/ "THE MAN WITH THE DONKEY" / 202 Pte. J. Simpson / Aust. Army Medical Corps / born South Shields 6, July 1892 / died Gallipoli 19, May 1915 / A HERO OF THE GREAT WAR
Status: not listed
Condition: fair
Condition details: fabric of fibreglass is splitting and worn in many places, particularly back of donkey and figure; pedestal stained and weathered
Commissioned by: public subscription
Custodian: South Tyneside Metropolitan Borough Council

Description: a one-and-a-half-life-size depiction of Kirkpatrick with the donkey he used to carry people to safety in the Gallipoli campaign. Centrally located in the main shopping street, the soldier is boldly modelled in brown painted fibreglass.

Subject: John Kirkpatrick (1892–1915) was born in South Shields and emigrated to

Olley, *Kirkpatrick Monument*

Australia at the age of 18.[1] At the outbreak of the First World War he signed up with the 3rd Australian Field Ambulance under the name of Simpson and travelled to Egypt in 1914.

During ANZAC operations at Gallipoli it proved very difficult to remove wounded men to safety. Kirkpatrick, a natural with animals, tamed a donkey, calling it Murphy or Abdul. He cheerfully went about ferrying the injured back from the front through a dangerous route called Snipers Alley, usually whistling or singing as he did so. For three weeks he led a charmed life, rescuing over 300 soldiers, until he was shot dead by a Turkish sniper on 19 May 1915. The donkey apparently escaped without

injury, but its fate is not known. Kirkpatrick was buried near the sea shore by tearful comrades, and his Captain wrote that 'he gave his life in a gallant and cheerful service that has been excelled by none'.[2]

History: Kirkpatrick's bravery had long been recognised, indeed almost mythologised, by ANZAC forces; he is depicted on a frieze at Gallipoli and by a full-size bronze statue at the Shrine of Remembrance at Australia's National War Memorial. However, he was not honoured in his home town of South Shields, much to the consternation of locals in the mid-1980s.[3] When approached about this South Tyneside council stated that a memorial 'should not be discouraged' but money would not be forthcoming.[4] Councillor Gladys Hobson therefore started a memorial trust fund, which rapidly collected enough money for the commissioning of Olley to make a maquette and then sculpt the full-size memorial.

There was some controversy over whether Kirkpatrick should be depicted wearing a helmet or not,[5] and also whether the donkey should have an injured soldier on it. According to one report, in addition to the statue, the memorial was supposed to have a full-sized relief portrait of Kirkpatrick and a relief battle scene on the side of the pedestal.[6] However, these appear not to have been executed.

Unveiled in late January 1988 by Mayor Albert Tate, the memorial has attracted particular attention in Australia.[7] Olley cast a limited edition 10cm-high bronze reproduction of the sculpture and sent one to Australian Prime Minister Bob Hawke on the 75th anniversary of Gallipoli in 1990.

Popularly referred to as 'The Man and the Donkey', the monument's glass fibre skin is particularly vulnerable to vandalism and weathering.

[1] Jones, J., 'Hail a hero on a donkey', *Shields Daily News*, 19 May 1994. [2] Benson, Sir I., *The Man with the Donkey: J.S. Kirkpatrick the Good Samaritan of*

Gallipoli, London, 1965. [3] *Gateshead Post*, 14 November 1985. [4] *Shields Daily News*, 14 March 1986. [5] *Ibid.*, 18 January 1988. [6] *Ibid.*, 7 January 1988. [7] *Sunderland Echo*, 27 January 1988.

River Drive

Grassed area facing river Tyne near junction with Palatine Street

Dolly Peel

Sculptor: Billy Gofton

Unveiled 24 April 1987
Sculpture: ciment fondu 1.8m high
Pedestal: concrete 2.1m high × 90cm square
Front and rear metal plates: [the life story of Dolly Peel]

Gofton, *Dolly Peel*

Lettering on metal plates on left and right sides of pedestal: DOLLY/ PEEL / 1782–1857 / THIS STATUE / WAS UNVEILED / BY / cllr. GLADYS / HOBSON / ON / 29th APRIL / 1987
Signed on bronze plate, lower back of sculpture: SCULPTOR / B. GOFTON.
Status: not listed
Condition: fair
Condition details: statue very dirty with cracks runing up the skirt; droppings on head
Commissioned and owned by: South Tyneside Metropolitan Borough Council

Description: a life-size depiction of a well-known local character, whose life story is told on tablets on each side of the rough pebble and concrete pedestal. Dolly is depicted laughing and holding a basket, with a fish lying at her feet.

Subject: according to the two tablets on the side of the pedestal, Dorothy (Dolly) Peel was a South Shields fishwife and smuggler in the early 1800s. There are numerous stories about how she helped men evade press gangs, eventually going to sea with her husband where she worked as a nurse. She was famous for her wit and poetry, and died aged 75 from bronchitis.

History: the fishwives of Tynemouth have a special place in local history and it was felt that there was no adequate memorial to them in South Shields. This sculpture of Dolly, a colourful semi-folkloric character, was commissioned by her distant relative Reg Peel, and unveiled on 29 April 1987 by Councillor Gladys Hobson.[1]

[1] *Journal*, Newcastle, 30 April 1987.

Tyne Slipway and Engineering premises, overlooking Tyne

Hand

Sculptor: David Gross

Unveiled 23 September 1998
Whole work: wood and steel plate 3.3m high ×

Gross, *Hand*

1.6m wide × 80cm deep
Status: not listed
Condition: good
Commissioned by: South Tyneside Metropolitan Borough Council
Custodian: Tyne Slipway and Engineering Ltd

Description: a large wooden hand stained a dull red, with a propeller in its palm. Sited above the river bank in a privately owned shipyard, it is visible both from the road outside and the bank of the Tyne in North Tyneside opposite.

History: designed in collaboration with pupils from SS Peter and Paul's Roman

Catholic Primary School, the wood was saved from the demolition of Sunderland's riverside. *Hand* is 'meant to be a symbolic greeting' to ships entering the River Tyne.[1] It is part of the 'Art on the Riverside' scheme, and was commissioned by the Customs House Charitable Trust on behalf of the Council. The company on whose land the work stands may use the *Hand* in the future as a new logo.[2]

Members of the public will usually be admitted to the yard to see the work if they ask at the gate first.

[1] *Independent*, 24 September 1998. [2] *Journal*, Newcastle, 24 September 1998.

Riverside Court

Customs House Arts Centre, car park wall at rear

Nautical Objects

Sculptor: Matthew Jarratt

Installed 1995
Each sculpture: steel 1.4m wide × 1m high approx
Status: not listed
Condition: good
Commissioned and owned by: South Tyneside Metropolitan Borough Council

Description: seventeen individual reliefs made from cut steel, painted white. Mounted on the brick retaining wall behind the car park, covering approximately 41 metres, the sculptures depict a number of nautical themes including ships, an anchor, a bell, an old fashioned steering wheel, pressure gauges and a crane. The wall below still carries an old painted sign, 'Middle Docks'.

History: produced as the result of Jarratt's residency at Tyne Dock Engineering Ship Repair Yard.[1] Children from St Joseph's School helped in making the designs.

[1] Information supplied by the artist, 1999.

Jarratt, *Nautical Objects* (detail)

Sea Road

Monument to W. Wouldhave and H. Greathead

Sculptor: R. Farbridge

Unveiled 25 June 1890
Whole work: red sandstone 12.5m high × 4.17m square
Incised on panel at lower section, Roman letters: ERECTED / IN COMMEMORATION / OF THE JUBILEE OF HER MAJESTY / QUEEN VICTORIA / JUNE 25th 1887 / AND AS A MEMORIAL / OF THE BENEFICENT WORK OF THE / LIFEBOAT / FIRST DESIGNED AND BUILT / AT SOUTH SHIELDS IN THE YEAR 1790.
Incised under: INAUGURATED JUNE 1890
Incised under each portrait at upper level: COURAGE HUMANITY COMMERCE
Incised under each portrait panel at upper level: WOULDHAVE / GREATHEAD
Incised on lower plinth: R. B. FARBRIDGE / SCULPTOR

Status: II
Condition: fair
Condition details: splitting and spalling in many places, especially at joints; rusting metal work; dirty at upper levels; graffiti inked at lower levels
Commissioned by: public subscription
Custodian: South Tyneside Metropolitan Borough Council

Description: a large three-tiered neo-baroque memorial set in the middle of a wide road. The first level has drinking fountains on two faces and the main inscription panel on another. The next level rises above a cornice, with pilasters set on each corner. Relief portrait busts of Wouldhave and Greathead with decorative scrolls and inscriptions are carved on the east and west faces and there is an entrance door under Greathead's portrait. The other faces carry two relief scenes of lifeboats at sea within scalloped frames (approx 1m square). Above another heavy cornice rises a tower with balustrading at two levels and a clock on each side. This is topped with a pilastered cupola and a wind vane. The lifeboat *Tyne* is situated behind the memorial, along with an explanatory panel.

Subject: both William Wouldhave (1751–1824) and Henry Greathead (1757–c.1816) were involved in the development of the first lifeboat *Original* and each could lay claim to its conception. Greathead gained fame as 'inventor of the lifeboat' but his lifeboats achieved little more than limited acceptance. However, their example raised public awareness of the need for lifesaving services and did much to spur on others in the field.[1] Greathead's reputation was eventually eclipsed by that of William Wouldhave, who was also hailed as the true and unrewarded 'inventor' of the lifeboat.

History: the memorial was commissioned as the centre-piece of the new South Shields Marine Parks, opened in June 1890.[2] At the

Farbridge, *Wouldhave and Greathead Monument*

elaborate inauguration a number of speeches were made praising the general layout of the parks and the efforts of the two pioneers, who were being rewarded with a memorial, albeit a century late. Happy sentiments were also expressed by the 'hearty cheers' of the crowd for the memorial's other role which was to commemorate Queen Victoria's successful jubilee in 1887.[3]

[1] Osler, A.G., *Mr Greathead's Lifeboats*, Newcastle, 1990, pp.28 and 82. [2] *Newcastle Daily Chronicle*, 25 June 1890. [3] *Shields Daily News*, 26 June 1890.

Westoe Road
Town Hall, plaza in front
Monument to Queen Victoria
Sculptor: Albert Toft

Toft, *Queen Victoria*

Unveiled 8 May 1913
Sculpture: bronze 3.2m high × 1.5m wide
Pedestal: stone 3.2m high × 1.6m square
Raised metal letters on front of pedestal:
VICTORIA / QUEEN EMPRESS / 1837–1901
Incised on rear of pedestal: ERECTED / BY / PUBLIC SUBSCRIPTION / 1913
Additional bronze plaque at the base of Queen Victoria's pedestal comments on the remodelling of the forecourt in 1990.
Status: II
Condition: good
Commissioned by: public subscription
Custodian: South Tyneside Metropolitan Borough Council

Description: a twice-life-size depiction of the aged Queen in full royal regalia with orb and sceptre. Cast in brown bronze with finely detailed patterns on her robes, the whole is a very imposing composition, contrasting with the pedestal's white stone. The figure is a replica of Toft's statues of the Queen in Leamington (1902) and Nottingham (1905). On either side of the statue are black-painted figurative *Lampholders* (sculptor unknown) in the form of female nudes representing *Night* and *Day* (each approximately 1m high), on top of pedestals which bear recent inscriptions.

History: at the Queen's death in 1901 a subscription list was opened for a memorial statue but there was considerable delay due to the lack of a site. Toft was chosen in 1908 as the result of a competition and allocated £1,000 for a statue, with the groundwork costs to be borne by the borough. He actually signed the contract for the work in 1911. Messrs Kirkpatrick Bros of Clifford Park, Manchester were responsible for the fabrication of the memorial, and gave the weights of the statue as about 1.5 tonnes and of the pedestal as 6.5 tonnes. The memorial was eventually unveiled on 18 May 1913 by Sir Hedworth Williamson, who delivered a 'fine

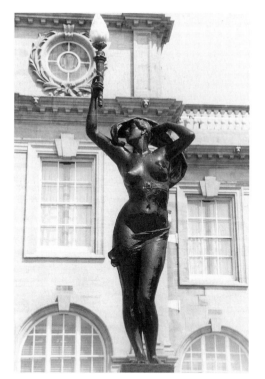

Lampholder

Town Hall

Architect: Ernest Edward Fetch
Sculptor: J.G. Binney

Building opened 1910
Status: II
Commissioned by: Borough of South Tyneside

Description: described as a 'comprehensive and massive pile of buildings', South Shields Town Hall was only built after protracted arguments about its potential site, the cost and the builder's expertise.[1] The first scheme for a new Town Hall was put forward in 1884. Ideas resurfaced in 1900 but a limit of £25,000 was put on expenditure, which was not seen as enough for a building of sufficient grandeur. The first premium was awarded to E.E. Fetch in 1901, but costs allowed were amended to £45,000 and in 1902 Fetch was selected once again out of six short-listed architects. The foundation stone was laid in 1905 and the tower was capped out by the Mayor three years later on 23 April 1908. The completed neo-baroque building was opened on 19 October 1910 at a final cost of £78,386.[2]

As Cunningham has noted, town halls 'have to mirror the history of their town as well as proclaim its wealth and future'.[3] South Shields Town Hall was erected at a time of prosperity for the borough, which the sculptural embellishments reflect through a mix of national and local symbols. The pedimental group, reliefs around the main entrance and sculptures on the tower all reinforce the message of civic responsibility. With the building fronted by Toft's statue of *Queen Victoria*, it makes an impressive ensemble.

[1] Hewitt, L.W., 'South Shields Town Hall 1905–1910', unpub. BA dissertation, University of Newcastle, 1990, *passim*. [2] *Shields Daily News*, 19 October 1910. [3] Cunningham, C., *Victorian and Edwardian Town Halls*, London, 1981, p.xviii.

eulogy' to a dense crowd and an honour guard of local infantry.[1]

The statue became increasingly dirty and was thoroughly cleaned and relaquered in 1980 by Camrex of Sunderland, being reinstalled in February. However, it was soon removed again because of road works, and although a number of other sites were mooted as being suitable, public pressure ensured the statue's return to the Town Hall site in May 1981.[2]

[1] *Shields Daily News*, 8 May 1913. [2] Dryden, M., *The New Town Hall and Municipal Buildings*, South Shields, 1981, *passim*.

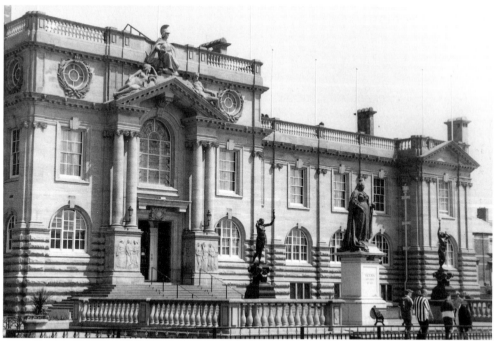

Fetch, *South Shields Town Hall*

Pediment

Britannia, Neptune and Nymph

Sculptural group: stone 7.8m wide × 2.2m high
Condition: fair
Condition details: considerable cracks in each figure have been cemented together; algal growth on all surfaces; droppings on tops of figures

Description: pedimental sculpture with *Britannia* seated on a cannon at its apex holding a shield in one hand and a ship in the other. To her right is a *Nymph* with a water jug; to her left the supine figure of *Neptune* with an oar and a large shell. The whole surmounts the columned doorway of the Town Hall.

Subject: the sculptural embellishments are typical of the Victorian and Edwardian era, establishing the borough's connection with the sea through the figure of *Neptune*, and its

Binney, *Britannia,* **Neptune and** *Nymph*

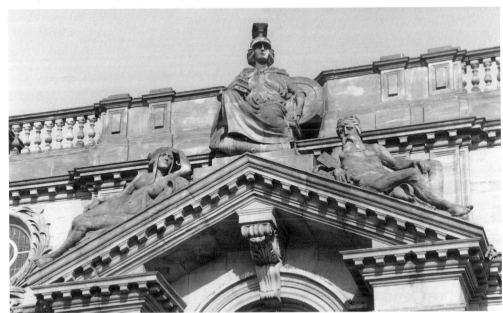

Binney, *dado frieze*

position within the British Empire through *Britannia*. A contemporary report describes the sculptural features: 'On each side of the entrance, resting upon huge blocks and over the archway, are sculptural figures including a huge figure of Britannia, a fine architectural effect having been obtained'.[1]

[1] *Shields Daily News,* 8 May 1913.

Dado frieze on column supports either side of main door

Personifications of South Shields, Industry, Arts, Crafts and Labour

Each dado face: stone 1.8m wide × 1.9m high
Condition: good

Condition details: spalling along bottom of frieze

Description: two cubic plinths each support two columns on either side of the main door. The nine dado faces of the plinths carry a frieze of robed figures across them. The reliefs are carved to a depth of up to 5cm in a restrained, neo-classical style.

From left to right, facing the building:

North plinth: *South Shields Encouraging the Crafts and Industries of the County*

Left face: female figure with a bushel of corn; female figure with a bowl of food.

Front face: female figure with a dish; female figure with a small amphora; female figure with a box.

Right face: female figure with a model of a ship; female figure with back-pack; female figure with model of a sailing ship.

South plinth: *South Shields and Municipality Promotes Labour and Encourages the Arts*

Left face: female figure playing violin; female figure holding a model of an ideal city hall; female figure holding an open book.

Front face: female figure holding a sculptural bust; female figure crowned, holding sceptre, with chain of office; female figure holding artist's palette; part-hidden female figure.

Right face: crowned female figure, holding hand of male figure in working clothes; part-hidden male figure with hammer.

Subject: integral to the building's design, these finely carved bas-reliefs illustrate the relationship of the borough to a well-ordered life of industry, commerce and education,[1] the wealth, taste and moral standing of the municipality.[2]

[1] Dryden, M., *The New Town Hall and Municipal Buildings*, South Shields, 1981, *passim.* [2] Hewitt, L.W., 'South Shields Town Hall 1905–1910', unpub. BA dissertation, University of Newcastle, 1990, *passim.*

Clock tower

Allegories of the Four Seasons

Each figure: stone 2.5m high approx
Condition: good

Description: a twice-life-size female figure situated at each corner of the tower between buttressed Ionic columns. Only two are positively identifiable: north-east corner, Autumn (with sheaf of corn); south-west corner, Winter (pulls her cloak round her). The other two are in similar half-clad poses.

Binney, *Four Seasons* **(detail)**

Beneath each figure at each corner of the tower's main cornice is a head in the Egyptian style, with wings behind.

On top of the tower is a copper weather vane in the pattern of an Elizabethan galleon which originally had rigging and canvas sails.[1]

[1] Dryden, M, *The New Town Hall and Municipal Buildings*, South Shields, 1981, *passim.*

SUNDERLAND
City of Sunderland

Burdon Road CITY CENTRE

Mowbray Park, north section

Sunderland First and Second World War Memorial

Sculptor: Richard Ray

Unveiled 26 December 1922
Victory: bronze 2m high approx
Column: grey granite 10m high approx × 1.5m dia. approx
Pedestal: white granite 3.4m high × 2.43m square
Raised bronze lettering on north face: A TRIBUTE TO OUR / GLORIOUS DEAD
South face: 1939–1945
North face: 1914–1918
Raised lettering on west face of pedestal: R.A.RAY A.R.C.A. / ARC & SCULPT.
Status: II
Condition: fair
Condition details: corrosion of figure
Commissioned by: public subscription
Custodian: City of Sunderland

Description: war memorial with a light-green patinated winged figure of *Victory* atop a tall polished Tuscan column. This rises above an ashlar pedestal, on which are carved low-relief down-turned torches and wreathes beneath the

Ray, *War Memorial*

thousands will cast an upward glance at it and when they see the figure of Victory they will think of the horrors of war, and be grateful for the blessings of peace.'[2]

The dates of the Second World War were added to the Memorial at the end of that conflict.

[1] Milburn, G.E. and Miller, S.T. (eds), *Sunderland: River, Town and People*, Sunderland, 1988, *passim.*
[2] *Sunderland Echo*, 26 December 1922.

Mowbray Park, north section

Monument to John Candlish
Sculptor: C. Bacon
Foundry: H. Young & Co

Unveiled 6 October 1875
Statue: bronze 2.3m high
Pedestal: pink granite 2.1m high × 1.6m square
Incised on south face of pedestal dado: JOHN CANDLISH M.P. / BORN / 1815 / DIED / 1874
Signed on right side of sculpture base: C. BACON SC / LONDON 1875
Foundry mark on base of sculpture: H YOUNG & CO / ART FOUNDERS / PIMLICO
Status: II
Condition: good
Condition details: graffiti inked on dado on all sides; some paint splashes on face of statue
Commissioned by: public subscription
Custodian: City of Sunderland

Description: an over-life-size statue of Candlish in contemporary dress standing on a plainly-dressed pedestal of polished porphyritic granite. Situated in well-kept parkland, 'the figure is so placed that the light from the south falls upon it, and is represented holding a scroll in his hand as if about to address an assembly'.[1] The bronze is naturally patinated to a light green colour. There are reclining stone lions at the end of the railings on either side, which are also Listed Grade II.

inscription panels. Victory holds out a laurel wreath in her right hand and a torch in her left. The whole is set on two steps within a raised and fenced enclosure on the edge of Mowbray Park.

History: described as 'possibly the most impressive ceremony ever seen in Sunderland', the inauguration was an affecting occasion for the city. A large procession of military and associated units preceeded the unveiling by Colonel Ernest Vaux CMG, DSO and dedication by the Bishop of Durham. Credit was paid to Ray, head of the local art school, who was both sculptor and architect of the monument.[1] Walter Raine MP asked the Mayor to accept the memorial: 'I believe that many

Subject: John Candlish (1816–74) was born near Bellingham in Northumberland and moved to Ayres Quay in Sunderland as a young lad. He was apprenticed to a draper at 14, but still managed to learn French and join debating classes. After some false starts he became co-editor of the *Sunderland Beacon* in 1842. He then started a bottle-making business at Seaham, eventually making his fortune from supplying bottles to exporters of food to the colonies. Conservative for the first half of his life, Candlish later converted to Radicalism and Free Trade principles. He was elected as Liberal councillor in 1848, Mayor in 1858, and MP in

Bacon, *Candlish Monument*

1866. Sunderland was indebted to him for sanitary reforms, and he was also widely respected for his donations to libraries, hospitals and schools. Candlish's funeral in March 1874 was a particularly well-attended occasion.

History: shortly after Candlish's death a memorial was proposed 'so as to perpetuate in some suitable form the memory of a man who had done so much for the benefit of the town'. Ideas for scholarships, a school or a convalescent home were abandoned in favour of a statue.[2] £1,000 was raised quickly from public subscription. The life-size bronze was described as 'a contribution to modern art [and] an added ornament to [Sunderland's] noble parks… A grateful tribute, as lasting as it is appropriate, to the ablest man who ever filled her civic chair'.[3]

Upwards of 15,000 people were said to have attended the unveiling, which was extensively covered in the local newspaper and in the *Builder*: 'last week a statue was erected to one of those men, who at the time he entered life was only a lonely, friendless boy, who toiling early and late at the bottle factory, died a member of Parliament for his native town.'[4] Sunderland was decked out with flags and there was a festive mood as a procession set off to the park at 3 o'clock in the afternoon. The memorial was unveiled by Sir Henry Havelock, who made a long and detailed speech in praise of Candlish, followed by the usual formalities in handing it over to the Mayor.

[1] *Builder*, 16 October 1875, p.934. [2] Brockie, pp.321–33. [3] *Sunderland Echo*, 6 October 1875. [4] *Builder, op. cit.*

Mowbray Park, south section

Monument to Jack Crawford

Sculptor: Percy Wood
Foundry: Coalbrookdale

Unveiled 7 April 1890
Statue: bronze 2.1m high
Pedestal: grey granite 2m high × 1.2m long × 66cm wide
Steps: grey granite 86cm high × 2.65m square
Incised on north face of dado, Roman letters: JACK CRAWFORD / THE / HERO / OF / CAMPERDOWN.
Incised on plinth, Roman letters: THE SAILOR WHO SO HEROICALLY NAILED ADMIRAL DUNCANS / FLAG TO THE MAIN-TOP-GALLANT-MAST OF H.M.S. VENERABLE IN THE / GLORIOUS ACTION OFF CAMPERDOWN IN OCTOBER 11TH 1797 /

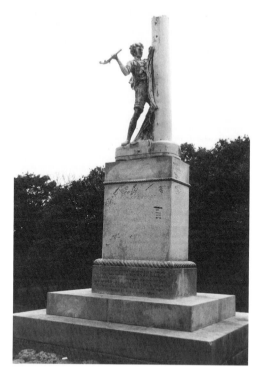

Wood, *Crawford Monument*

JACK CRAWFORD WAS BORN AT THE POTTERY BANK SUNDERLAND 1775 / AND DIED IN HIS NATIVE TOWN 1831 AGED 56 YEARS / ERECTED BY PUBLIC SUBSCRIPTION
Foundry mark on base of statue: COALBROOKDALE.
Incised lettering on top of pedestal west face: PERCY WOOD / FECIT 1889–90
Status: II
Condition: fair
Condition details: colour lost from incised lettering; statue eroded in places; graffiti inked on most pedestal faces
Commissioned by: public subscription
Custodian: City of Sunderland

Description: a statue of the young Crawford in the act of nailing a flag to the mast with his pistol butt. It is a work of some vivacity and naturalism, with folds of the colours billowing over Crawford's shoulder as he steps forward in shabby garb. However, the bronze surface has a very light green patina and is in need of conservation. Sited across Burdon Road from the Civic Centre, the memorial is raised on a hillock overlooking the park. The steps leading up to it are set upon a bed of rough stone, and the plainly-dressed pedestal has ropework moulding around the top.

Subject: Jack Crawford (1775–1831) was a Sunderland-born lad serving in the navy at the Battle of Camperdown in 1797. When the British colours were shot away from the flagship he nailed them back to the mast, thus ensuring that the rest of the fleet did not lose heart. He returned a hero and was awarded a silver medal and an annual pension of £30. However, Crawford's fortunes did not continue and he was forced to sell his medal. He died in a cholera epidemic and is buried in Trinity Churchyard, Sunderland (see p.185).

History: paid for by a public fund which started to take subscriptions in 1887, 90 years after Crawford's exploits,[1] the monument was

unveiled on 7 April 1890 by the Earl of Camperdown. Three hundred seamen were in attendance along with many other members of trade associations and the public.[2] The ceremony was of a 'most imposing character' and a subsequent bazaar raised £540, of which £200 was needed to clear the fund's debts with the remainder going to a local orphanage.[3] Crawford's exploits were well known enough outside Sunderland for the monument to receive attention in the national press.[4]

[1] *Monthly Chronicle*, 1887, pp.8 and 91. [2] *Ibid.*, 1890, pp.239–40. [3] *ILN*, 12 April 1890, p.454. [4] *The Times*, London, 8 April 1890.

Mowbray Park, south section, Building Hill

Monument to Major-General Sir Henry Havelock

Sculptor: William Behnes
Foundry: H. Young & Co

Unveiled 21 May 1861
Statue: bronze 3.5m high
Pedestal: Aberdeen granite 4m high × 2.2m square
Incised on front (west) of dado: HAVELOCK.
Incised on front of plinth: BORN 5. APRIL 1795 / AT FORD HALL / BISHOPWEARMOUTH / DIED 24. NOVEMBER 1857 / AT DIL-KOOSHA / LUCKNOW.
Incised on front of statue base: BEHNES SC.
Founder's mark on statue base: The Statue Foundry, Pimlico, London.
Status: II
Condition: good
Condition details: statue weathered and natural green patination is stained brown in places
Commissioned by: public subscription
Custodian: City of Sunderland

Description: a giant representation of Havelock, showing him in his general's uniform, wearing the insignia of the Order of

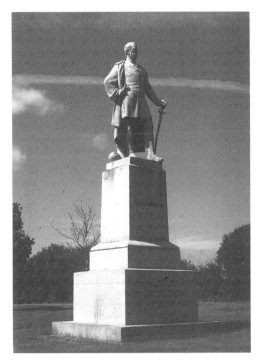

Behnes, *Havelock Monument*

Bath. His right hand grips his sword, emblematic of valour, whilst his left holds a telescope which indicates foresight.[1] This is a second cast of Behnes's statue erected in Trafalgar Square on 10 April 1861.[2]

Subject: Sir Henry Havelock (1795–1857) was born at Bishopwearmouth. He was a devoutly religious soldier who served mostly in India, but also in Europe and Persia. Previously unknown despite publishing some memoirs of the Afghan war, his role in crushing the Indian Mutiny of 1857 earned him considerable press attention in England. He was held up as an example of military excellence and devout character, and was created first a knight then a baron in late 1857. Upon hearing of his death in Lucknow due to dysentery, Parliament

unanimously voted a £1,000 annuity to his widow.[3] A bust was placed in Guildhall and a public subscription paid for the Trafalgar Square statue.

History: paid for by public subscription and cast from cannon taken from Indian rebels, the 2½-tonne statue was erected on 5 April 1861, being the late Sir Henry's birthday. It was officially inaugurated on 21 May, in front of 'the greatest multitude of people that ever assembled' in Sunderland. Lady Havelock was reported to approve of the 'fine and bold' profile, which was said to credit the sculptor's art.[4] Another source records the statue's countenance as being 'striking and impressive, a very accurate likeness, and the hero has his eyes turned towards the place of his birth'.[5] However, Behnes's obituary in the *Art Journal* opined that his statues of Havelock were 'the least worthy of all ... forming one of the most melancholy chapters in the artist's life'.[6]

[1] *Art Journal*, 1861, p.152. [2] *ILN*, 20 April 1861. [3] *DNB*, 1898, vol.XXV, pp.174–9. [4] Fordyce, pp.384 and 387. [5] Brockie, p.170. [6] *Art Journal*, 1864, p.84.

Chester Road BISHOPWEARMOUTH
Bishopwearmouth Cemetery

Victoria Hall Tragedy Memorial
Sculptor: W.G. Brooker

Erected 1884
Sculpture: white stone 1.82m high × 66cm square
Pedestal: grey stone 1.27m high × 94cm square
Incised on stone tablet in front of statue:
INSCRIPTION ON MEMORIAL / ERECTED TO COMMEMORATE / THE CALAMITY WHICH TOOK PLACE / IN THE VICTORIA HALL SUNDERLAND / ON SATURDAY 16TH JUNE 1883 / BY WHICH 183 CHILDREN LOST THEIR LIVES
Status: II
Condition: poor

Condition details: child's feet broken off and hand chipped; generally weathered and dirty; considerable brown and grey lichen growth all over
Commissioned by: public subscription
Custodian: City of Sunderland

Description: an expressive sculpture of a woman with a dead child in her lap, derived from classical figures of Niobe mourning her dead children: she throws her head and arm back in despair. The pedestal has a stepped base and a wreath carved onto its front dado face.

Subject: the sculpture of a 'mother frantic with grief, lifting up her voice in bitter lamentation' commemorates Sunderland's most deeply felt disaster of the nineteenth century.[1] 191 children between the ages of 3 and 12 were crushed to death trying to leave the Victoria Hall after an afternoon's entertainment which went horribly wrong.

'A Victorian town with any pretensions needed something for the gregarious entertainment of the age', so the Victoria Hall was built to rival the Crystal Palace and Albert Hall in size and architectural style.[2] Seating 3,000 people, it was built in 1872[3] and stood on the corner of Toward Road and Laura Street on the east side of Mowbray Park.[4]

The Fays 'from Tynemouth Aquarium' advertised a children's entertainment for the afternoon of 16 June 1883, at which jokes, tricks and songs were promised along with the chance to win prizes to take home. School-teachers were given free tickets encouraging them to bring their charges. Two thousand children were crammed into the pit and gallery of the Victoria Hall (100 more than capacity), with the dress circle closed. The crowd of children were extremely boisterous and had to be admonished by Mr Fay in the interval.

'At the close of the entertainment it was announced that those children who held tickets marked with certain lottery numbers would

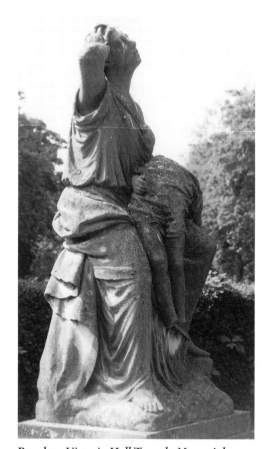

Brooker, *Victoria Hall Tragedy Memorial*

receive prizes in the shape of books, toys etc. as they were going out.' Considering the poverty of most of them, it is not surprising that 'this filled the juvenile audience with a spirit of eager expectancy and excited hope. In this mood the vast number of boys and girls who had occupied the gallery made for the door.'[5] Unfortunately the door at the bottom of the stairs was wedged open only a foot wide facing inwards, allowing only one person past at a time. 'The narrow opening became choked at

once with troops of excited children whose one thought was to get forward to reach the goal where pleasure awaited them.'

The boisterous children piled upon each other and were crushed or suffocated to death, turning the Hall into 'one vast mourning chamber. Mothers fainted away and strong men in their agony wept over the stark, stiff remains of their little ones.' 191 children lost their lives behind the stuck-fast door and news of the disaster made national headlines.[6] The discrepancy between this figure and the 183 deaths mentioned in the inscription is explained by eight gypsy children not having their deaths registered properly at the time.

The following week all businesses were closed and blinds were drawn in private homes as the children were buried in a series of services. Queen Victoria sent a wreath, after having been in daily correspondence with the Mayor about the horrible events. Inquests into the deaths were opened and adjourned to the following month, split between the two wards of Bishopwearmouth in the south and Monkwearmouth north of the Wear.

The Bishopwearmouth inquest returned a verdict of death without blame attached to a specific person, though the Hall's manager was censured. The Monkwearmouth inquest called for 'sufficient means of exit, all doors both internal and external, to open outwards' at places of entertainment. This requirement became law not long afterwards.

History: a large gathering on the 18 June started a subscription fund for the relief of the families involved and to pay for some sort of memorial to the dead. By 14 August, £5,769 had been collected – Queen Victoria giving £50. The gleaming white sculpture was 'passed about from pillar to post' upon its arrival in Sunderland, as it seems no site could be agreed upon for the memorial. Eventually it was set inside a glass and ironwork gazebo (approximately six metres high and four metres

diameter) outside the Victoria Hall.[7]

It was removed in 1929 and an alternative site inside the City Library mooted, though it seems that local sensitivities determined its move to Bishopwearmouth cemetery in 1934.[8] It was installed there without its protective canopy and has subsequently been vandalised and become very weathered. The inscription which used to be on the pedestal's front dado has been copied onto a tablet which now lies at the foot of the memorial.

[1] Anderson, A.E., *Victoria Hall Disaster*, Sunderland City Library Local Studies, n.d., p.159, quoting *Sunderland Citizen*, 1898. [2] Corfe, T., *A History of Sunderland*, Newcastle, 1973, *passim*. [3] Mitchell, W.C., *History of Sunderland*, Manchester, 1919, *passim*. [4] Anderson, *op. cit.*, *passim*. [5] Herald and Daily Post, *The Victoria Hall Disaster*, Sunderland, 1883, *passim*. [6] *ILN*, 23 June 1883. [7] Thompson, J. and Bond, D., *Victorian and Edwardian Northumbria from Old Photographs*, London, 1976, ill.120. [8] *Sunderland Echo*, centenary commemorative issue, 16 June 1983.

Church Street HENDON
Trinity Churchyard

Monumental Grave Stone to Jack Crawford

Designer: not known

Erected 6 August 1888
Whole work: pink marble 2.6m high × 1.1m wide × 70cm deep
Incised on front of dado: THE / GRAVE / OF / JACK CRAWFORD / THE HERO OF / CAMPERDOWN
Incised on front of base: THE SAILOR WHO HEROICALLY NAILED / ADMIRAL DUNCAN'S FLAG / TO THE MAIN-TOP-GALLANT-MAST OF / HMS VENERABLE / AFTER IT HAD BEEN SHOT AWAY / IN THE GLORIOUS ACTION OFF CAMPERDOWN / OCTOBER 11TH 1797 / JACK CRAWFORD WAS BORN IN THE / POTTERY BANK SUNDERLAND 1775 / AND DIED IN HIS NATIVE TOWN 1831 /

AGED 56 YEARS
Incised on lower base: ERECTED BY PUBLIC SUBSCRIPTION / 1888
Status: not listed
Condition: good
Commissioned by: public subscription
Custodian: City of Sunderland

Description: an oblong block of polished pink marble, above a base and plinth. The front is carved with a relief Union Jack on a broken flag pole, with a cannon and ammunition on the pediment. The gravestone is leaning to one side.
Subject: for a biography of Jack Crawford (1775–1831) see p.182.

Crawford Grave

History: Brockie records Crawford's miserable death in unsettling detail. 'Jack's demise took place on the 10th November 1831. He was the second victim of the cholera morbus in the town, and it is said that ten minutes after he died his corpse turned quite black, but so little was known about the terrible Oriental disease at that time, when it paid its first visit to this country, that his body was kept three days before it was interred. The Hero of Camperdown was then "left alone in his glory" in an unmarked spot in Sunderland Churchyard until 6th August 1888, when a headstone was placed at the grave.'[1]

Holy Trinity Church was designed by W. Etty as Sunderland's parish church in 1719 and is Listed Grade I. The large churchyard is notable as the haunt of grave-robbers Burke and Hare, 1824–5.[2] Now unused it is empty and grassed over except for Crawford's grave and an obelisk commemorating victims of the same cholera epidemic that claimed his life.

[1] Brockie, pp.83–9. [2] Pickersgill, A., *Discovering Sunderland*, Durham, 1977, *passim*.

Farringdon Row DEPTFORD
By the Wear, west of Wear Bridge

Standing Stones

Sculptor: Rosie Leventon

Installed *c.*1997
Each boulder: sandstone 1.78m high × 65cm deep × 1.5m wide (max)
Incised letters on west face of smallest boulder: Here is the end of the line: / staithes and the start of the sea, / the worm in the water.
Status: not listed
Condition: good
Condition details: chipped edges, especially on small boulder; graffiti scratched on various faces
Commissioned by: Tyne and Wear Development Corporation

Custodian: City of Sunderland

Description: four large boulders are set in a line across the grass from the river bank back to a line of trees. A fifth, smaller boulder is set separately and carries the inscription. The four main stones are cut with a single vertical stripe across each one, otherwise they are roughly hewn. Set within a newly created park which also contains some brightly painted steel 'architectural' features.

History: in the mid-nineteenth century this site was 'one of the busiest and most intense industrial landscapes in the country'. Now it has been reclaimed as parkland, and Leventon's *Standing Stones* act as 'a metaphor for time passing'. Leventon has stated that many of her pieces 'allude – often metaphorically – to things which have consequently been lost, hidden or forgotten, which exist only in our subconsciousness'.[1] In keeping with this, the groove across the four boulders is intended to represent the long-worked-out coal seam.[2]

The *Standing Stones* were commissioned as one of the sculptural features along the Stephenson Trail, which runs from Easington Lane in the south, to the banks of the Wear in the centre of Sunderland. The route follows the line of the world's first railway designed for steam locomotives, which opened in 1822 taking coal from Hetton Colliery to the staithes

Leventon, *Standing Stones* (detail)

on the Wear. The railway remained in use until 1959 and the coal-loading facilities on the river were closed in 1972.

[1] AXIS, *Artists Register*, 1999. [2] City of Sunderland, *The Stephenson Trail* (leaflets), Sunderland, n.d., *passim*.

High Street CITY CENTRE
Gibbons's Butcher Shop, façade

Lot's Wives and *Relief Heads*
Sculptor: not known

Building *c.*1859; restored 1996
Each wife: painted wood 95cm high × 40cm wide
Each head: painted wood 10cm square
Status: not listed
Condition: good
Owned by: A.G. Gibbons Shipping and Catering Supplies

Description: two boldly carved female figures act as caryatids on opposite corners of the shop façade. Each is painted with a lilac dress, blonde hair and blue necklace and is shown in a dancing pose. There are also a number of brightly painted relief heads, including those of a king and a queen, along the right-hand side of the façade.

Subject: according to *Genesis* 19.26, Lot only had one wife, who was turned to a pillar of salt when she turned back to look at the destruction of Sodom and Gomorrah. However, he subsequently fathered children by his two daughters who had induced him into drunken stupors. Although it is unclear as to how the wooden carvings on Gibbons's shop came by their name, the provocative style of dress could relate to the latter story.

History: the building dates from 1859, originally functioning as residential or commercial premises. The firm of Gibbons took it over in 1936, at which time there was a

Lot's Wives (detail)

hoarding on the frontage. This was removed in 1996 and the relief carvings and figures discovered underneath. In addition to those visible today, there were also a full-size 'King' and 'Queen' (in the same style as the *Wives*), but these were removed because they had badly decayed. The remaining woodwork was then repainted.[1]

[1] Information provided by Mr Ian Gibbons, 5 October 1998.

Park Parade ROKER

Roker Park

Sir Hedworth Williamson Memorial Drinking Fountain

Designer: not known

Inaugurated 23 June 1880
Whole work: stone and granite 3.8m high ×
1.08m square
Incised letters on south face: ERECTED / BY THE
SCHOLARS / TEACHERS AND / FRIENDS OF
SUNDAY SCHOOLS / IN SUNDERLAND / TO
COMMEMORATE THE / CELEBRATION OF THE /
CENTENARY OF SUNDAY SCHOOLS / AND THE
OPENING OF / ROKER PARK, / JUNE 23RD 1880.
On north face: THIS / MEMORIAL / IS FURTHER
INTENDED / GRATEFULLY TO KEEP IN / MEMORY
THE FACT THAT / SIR H. WILLIAMSON, BART /
AND THE ECCLESIASTICAL / COMMISSIONERS OF
ENGLAND / GAVE 17 ACRES OF LAND / FOR THE
PURPOSE OF FORMING / THIS PUBLIC PARK / AND
PLEASURE GROUND / FOR THE FREE USE OF THE
PEOPLE OF SUNDERLAND / FOR EVER.
Status: II
Condition: poor
Condition details: west face covered with
modern cement; severe erosion of inscribed
faces; spalling of vertical surfaces; water spouts
missing; green algae on all surfaces; some
graffiti inked around structure
Commissioned by: public subscription
Custodian: City of Sunderland

Description: an ashlar sandstone and granite
memorial standing centrally in the park. It
consists of a central column with drinking
troughs on all four sides, surmounted by a
lantern with a carved eagle on top. The
inscribed faces of the dado are badly weathered,
the eastern face is completely obliterated, and
the west face has modern cement skimmed
over it.
Subject: Sir Hedworth Williamson

(1827–1900) was the 8th Baronet of a title
created in 1642. Educated at Eton and Oxford
he was appointed attaché to the embassy at St
Petersburg at the age of 21. He later represented
Sunderland in Parliament for many years. A
politician of 'decidedly liberal views' he was not
known as a great debater.[1] However, his
speeches on home ground in Sunderland were
always humorous and well received. Williamson
was a strong opponent of Home Rule and

Williamson Fountain

quitted the Liberal Party in 1886 in protest at
Gladstone's measures. He was a River Wear
Commissioner for many years and a highly
respected JP.[2] Living in Whitburn Hall, he
owned most of Monkwearmouth, presenting a
large portion of it to the city to make Roker
Extension Park.

History: as described on the monument, the
fountain commemorates Williamson's gift of
land for Roker Park to the people of
Sunderland. The park was opened on 23 June
1880 when Sir Hedworth handed its keys to the
Mayor. This was followed by a procession of
12,000 children from Sunday Schools past a
reviewing platform.[3] A number of
commemorative trees were also planted, though
there is no mention of the fountain in reports of
the occasion.

[1] Moses, E.W., 'The Williamsons of East Markham,
Nottinghamshire, and Monkwearmouth, Co.
Durham', *Antiquities of Sunderland*, vol XXIII, 1964,
pp.54–72, *passim*. [2] *Sunderland Echo*, 27 August
1900. [3] *Ibid.*, 24 June 1880.

Premier Road PLAINS FARM

*Bank near junction with Silksworth
Lane*

Locomotive

Sculptor: Lynne Regan

Installed *c.*1997
Whole work: steel 2.8m high at chimney × 4m
long
Status: not listed
Condition: fair
Condition details: paint peeling; extensive rust
Commissioned and owned by: City of
Sunderland

Description: steel relief sculpture of George
Stephenson's first locomotive and coal truck, set
into the grassed bank overlooking a small dene.
The steel plates are cut and bolted together to a

Regan, *Locomotive*

depth of 7cm. Smoke billowing from the locomotive's chimney is depicted in concrete. The work is overgrown with grass and is only visible by looking upwards towards Premier Road from the path through the dene.

Subject: Regan has stated that her work 'often traces experiences of past and present (built) environments, as well as geological formations'.[1] *Locomotive* was commissioned as one of the sculptural features along the Stephenson Trail, which runs from Easington Lane in the south, to the banks of the Wear in the centre of Sunderland. The route follows the line of the world's first railway designed for steam locomotives, which opened in 1822 taking coal from Hetton Colliery to the staithes on the Wear.[2]

[1] AXIS, *Artists Register*, 1999. [2] City of Sunderland, *The Stephenson Trail* (leaflets), Sunderland, n.d., leaflet 5.

Jarratt, *East End Community Sculpture*

The Quadrant HENDON
East End Community Garden

East End Community Sculpture
Sculptor: Matthew Jarratt

Installed 1993
Two large walls: brick and fired clay 1.56m high × 3.6m wide × 22cm deep
Raised bed: brick and fired clay 65cm high × 4m long × 1.7m wide
Small wall: brick and fired clay 1.56m high × 1.5m wide × 22cm deep
A number of initials and names are carved on the clay panels
Status: not listed
Condition: good
Commissioned and owned by: City of Sunderland

Description: three well-head shaped walls built out of red brick with contrasting yellow fired clay panels set into them. The carvings in the walls or panels are naïve in style and show a crane, a house, a ship on its launchway, bridges and a lighthouse, with 'VEDRA' in raised letters above. On the other side of the concreted area is a boat-shaped raised planter bed constructed in red brick, with multi-coloured mosaics set into concrete slabs in the ground around it. The bed has carved bricks inset along its top depicting a number of scenes, such as a balloon and colliery winding gear. The work is set in a wildlife garden to the rear of the community centre.

History: this sculpture and garden were created in collaboration with local community groups when Jarratt worked as artist-in-residence in the area.

Redcar Road MARLEY POTS
Junction with Maplewood Avenue, across entry to cut-through

Untitled Boulders
Sculptor: Mary Bourne

Carved on site 1997
Each boulder: stone up to 77cm high × 1.3m wide
Status: not listed
Condition: poor
Condition details: some surfaces split and edges chipped; covered in painted and scratched graffiti
Commissioned by: City of Sunderland and City Challenge

Description: nine boulders across the entrance to the cut-through, with another two set at the rear of the tarred area. Each stone is carved with shallow relief patterns and pictures of animals such as fish and birds and structures such as the Wear bridge, brickwork and bicycles. The whole area is strewn with litter and the stones are in a very poor state due to attacks by vandals.

History: commissioned as part of a landscaping project for the footpath. The artist worked on the boulders *in situ*, developing ideas from discussions with local residents as she did so.

Roker Terrace ROKER
Near junction with Sidecliff Road, verge on seaward side of road

Bede Memorial Cross
**Sculptor: Charles Clement Hodges
Repaired and replaced by: G.W. Milburn**

Unveiled 11 October 1904
Cross: stone 7.5m high approx × 56cm wide ×

44cm deep at base

Base: stone 59cm high × 1.58m square

Incised on west face of column: TO THE HO / LY BISHOP / EADFRITH / AND THE / BRETHREN / WHO SERVE / CHRIST IN / THE ISLAND / OF LINDIS / FARNE. I HAVE NOT / PRESUMED TO / WRITE DOWN / ANYTHING OF / SUCH A MAN / AS OUR FATHER / CUTHBERT WITH / OUT THE CLOSEST / ENQUIRY INTO / THE FACTS NOR / TO PUBLISH WHAT / I HAD WRITTEN / WITHOUT THE / MOST CAREFUL / SCRUTINY OF / SURE WITNESSES / – / TO THE MOST / GLORIOUS KING / CEOLUULF / BEADA SERVANT / OF CHRIST / AND PRIEST / AT YOUR REQUEST / O KING I GLADLY / SENT SOME TIME / AGO MY DRAFT / OF THE CHURCH / HISTORY OF THE / ENGLISH RACE / THAT YOU MIGHT / READ AND APPROVE / IT. I NOW SEND / IT TO YOU AGAIN / TO BE COPIED /

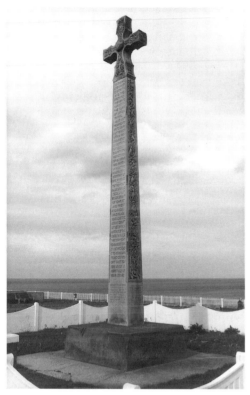

OUT THAT YOU / MAY STUDY IT / MORE FULLY AT / YOUR LEISURE. [Latin inscription below]

Incised on south face of column: Minuscule inscription

Incised on east face of column: ERE A MAN GO HENCE / FARING AS ALL NEED FARE / NONE IS THERE MORE WISE / MORE THAN HE OUGHT TO BE / IN WELL BETHINKING / WHAT TO HIS SPIRIT / OF GOOD OR OF EVIL / AFTER HIS DEATH DAY / DOOMED MAY BE

Incised on north face of column: Runic inscription

Incised on west (front) of base: UNVEILED 11TH OCTOBER 1904

Incised on south face of base: THIS MEMORIAL CROSS WAS REMOVED IN 1914 / FOR SAFETY DURING THE GREAT WAR / AND RE-ERECTED IN 1921. / G.W. MILBURN / YORK SCULPT

Incised on east face of base: TO THE GLORY OF GOD AND IN MEMORY OF / HIS SERVANT BAEDA THE VENERABLE WHO / WAS BORN BETWEEN WEAR AND TYNE DCLXXIII / AND DIED AT JARROW ASCENSION DAY DCXXXV

Incised north face of base at bottom: C.C. HODGES HEXHAM / INV ET DIREX

Status: II

Condition: good

Condition details: some carving details have been restored; green algae on upper surface of base

Commissioned by: public subscription

Custodian: City of Sunderland

Description: a large grey stone Northumbrian cross on a grey stone base, surrounded by a low wooden fence. The wealth of detailed carving on all faces is particularly notable. The west face is carved with the main inscription. The south face is carved to a depth of 3cm with a relief of birds and animals

Hodges, *Bede Cross*

Hodges, *Bede Cross* (detail)

intertwined within foliage. The east face is carved with scenes from the life of Bede, with their titles under each: Baeda comes to Jarrow; Benedict and Siggfrith; The Codex Amiatinus; Baeda Writing the History; Baeda's Last Moments. Between each scene are further intricately carved patterns based on the porch in the tower of St Peter's Church. The north face has relief carvings of eleven bishops: Trumbergt; Benedict Biscop; Eggfrith; John; Fosterwinn; Siggfrith; Geolfrith; Agga; Hvaegbergt; Geowulf; Eggbert. A foliate pattern links each head.

The scroll ornamentation is taken from the

Hodges, *Bede Cross* (detail)

Lindisfarne Gospels; the birds and animals 'springing from a harp emblematic of his poetic gifts' illustrate Bede's love of nature. The main inscription on the west face is extracts from Bede's *Ecclesiastical History* and from his *Life of St Cuthbert*. The verse repeated in Latin, Runic, Minuscule and English scripts was written on his deathbed.[1] The cross is carved with a rope tracery design on the arms and boss.

Subject: the Venerable Bede (672–735) was born on monastery land at Wearmouth and joined the monastery at Jarrow in 681, where he was one of only two monks to survive a plague. Christianity had only been fully accepted in Northumbria in 627 and Bede's life coincided with a flourishing period of Northumbrian culture. Cured of his stammer by St Cuthbert in 687 he became a priest in 703 and published *The History of the English Church and People* in 731. Revered in his lifetime as a holy man, upon his death in 735 Bede was buried at Jarrow monastery.[2] However, within 100 years the monastery was raided by Vikings and Benedictine rule was only restored in 1083 after the Norman conquest. Bede's remains were smuggled to Durham and placed in the same coffin as St Cuthbert. In 1370 the miraculously preserved body was placed in a tomb of its own in the Galilee Chapel of Durham Cathedral where it was again despoiled during the Reformation although some of the skeleton still remained in 1830. Bede's resting place in Durham Cathedral is marked by a solid tomb of blue marble.[3]

History: despite his status in the English church, there was no memorial to Bede in the North-East until the installation of this Northumbrian cross. A memorial movement was inaugurated by the Dean of Durham Cathedral in 1903 and a committee under the Mayor of Sunderland easily raised the requisite £300. The cross was unveiled by the Archbishop of York and the close attention to detail in the carving was much admired.

As one of the inscriptions records, the Cross was removed for safe keeping during the Great War, but there is no record of similar precautions being taken during the Second World War, although Sunderland was repeatedly targeted by the Luftwaffe.

[1] *Sunderland Echo*, 11 October 1904. [2] Whiting, C.E., '*The Life of the Venerable Bede*', in Thompson, A. Hamilton (ed.), *Bede, His Life, Times and Writings*, Oxford, 1935, *passim*. [3] Stranks, C.J., *The Venerable Bede*, London, 1955, pp.31–2.

St Peter's Riverside

Originally the site of shipyards, sawmills, engineering yards and a brewery, the stretch of land along the north bank of the Wear had become derelict and unsavoury by the early 1980s. Tyne and Wear Development Corporation (TWDC) spent £150 million between 1990 and 1998 transforming the area into St Peter's Riverside – building new homes, remodelling the harbour into a marina, developing a new campus for Sunderland University and creating the National Glass Centre.

Artists' Agency were commissioned to manage St Peter's Riverside Sculpture Project, a long-term artists' residency which would encourage community participation in the regeneration of the area. Funding was provided by TWDC, Northern Rock Building Society, North Haven Developments and latterly by the Arts Council Lottery Fund.

The fact that Colin Wilbourn and his fellow artists have been on site for so long has meant that relations with locals, the council and commercial interests have been more fruitful than is the case with some other, shorter residencies.[1] Over six years a number of works have been installed by the team of artists, often involving children or local history groups in the development of ideas: 'in an area undergoing great change as traditional industries decline, Wilbourn's sculptures acknowledge the past without sentimentalising it.'[2] The project has also been successful in training Karl Fisher, an ex-engineer, as a skilled stone-carver, and in using the talents of blacksmith Craig Knowles and novelist Chaz Brenchley.

Thematically, the works are linked by references to the sea and navigation, and also by Wilbourn's fascination with perspective. Later works such as *Passing Through* and *Shadows in Another Light* are ambitious attempts to combine two- and three-dimensional art in

readily enjoyable and lasting forms. A number of other pieces have been made by local people themselves, such as a mural on the sea front and carved fence panels.

There is now a feeling that the works form a special 'collection', unique to this area of Sunderland, or indeed Tyne and Wear and the St Peter's scheme has been used as an example of good practice by critics and at conferences on public art held at the National Glass Centre and the University.[3] Wilbourn and his colleagues are planning further works for St Peter's Riverside and it is hoped that the residency will continue for some time to come.

[1] Shaw, P. and Thompson, I., *St. Peter's Riverside Sculpture Project*, Sunderland, 1996, *passim*. [2] Mead, A., *Architects' Journal*, 'Seeking Future Prosperity for the Visual Arts', 31 October 1996, pp.30–3. [3] Miles, M., *Art, Space and the City. Public Art and Urban Futures*, London, 1997, pp.125–8.

National Glass Centre, on roof (level with car park)

Light Transformer

Sculptors: Zora Palova and Stepan Pala

Installed 1998
Sculpture: cast glass 2m high × 1.6m wide
Pedestal: concrete blocks 2.4m high × 1.47m wide × 52cm deep
Status: not listed
Condition: good
Commissioned by: City of Sunderland and National Glass Centre
Custodian: National Glass Centre

Description: three slabs of dusky blue glass make up an oval shape, the largest work of cast glass in the UK. The glass has a textured surface with small cracks running through it. The deep blue colour contrasts well with the grey surface of the National Glass Centre's roof on which it is sited.

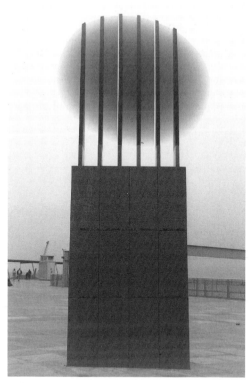

Palova & Pala, *Light Transformer*

Subject: though not commenting directly on this sculpture, Palova has written of her work: 'I express my perception of the world and of the relationship between a man and a woman using simple forms, strong colours and contrasting negative and positive spaces.'[1]

History: commissioned as part of Sunderland's commitment to public art within capital projects, *Light Transformer* is one of a small number of works made specifically for the National Glass Centre (the others are inside). It was fabricated at a glass kiln in Bratislava with the firing process taking six weeks. The surface is covered with a special wax which reacts with salty air to renew the glass surface.[2]

[1] AXIS, *Artists Register*, 1999. [2] City of Sunderland, *publicart.sunderland.com*, Sunderland, 1998, p.11.

Walkway by river, between Wear Bridge and Sunderland University

Shadows in Another Light

Sculptors: Colin Wilbourn, Karl Fisher and Craig Knowles
Writer: Chaz Brenchley

Unveiled 7 August 1998
Tree sculpture: steel 7m high approx × 8m wide approx
Pedestal: concrete 5m high approx × 5m diameter approx
Each roundel on pedestal: moulded clay and carved stone 60cm diameter
Telescope: steel 1m high
Stool: stone 40cm high × 40cm diameter
Crane relief: sand-blasted paving 12m long approx × 3m wide
Each nut or bolt: concrete, stone, wood, metal up to 80cm high × 1.6m long
Incised on paving slab at eastern end of anamorphic carving: LIGHT / BREAKS THE / SHADOW / BUT CAREFUL FEET / CAN FIND A PATH / TO FOLLOW
Incised on seat of stool next to telescope: LOOK UP, / AND SEE / BEHIND YOU; / A SHADOW / CAN RAISE / A MEMORY / THAT / NOTHING / CAN ERASE [also in braille]
Incised on roundel on eastern face of concrete drum: SHADOWS IN ANOTHER LIGHT 1997–1998 / St. Peter's / Riverside Sculpture / Project: Colin Wilbourn, / Karl Fisher, Craig Knowles / and Chaz Brenchley. / SUPPORTED BY THE NATIONAL LOTTERY / THROUGH THE ARTS COUNCIL OF / ENGLAND, TYNE AND WEAR DEVELOPMENT / CORPORATION, NORTHERN ROCK AND / STRUCTURAL & CIVIL CONSULTANTS LTD OF / NORTHALLERTON; MANAGED BY

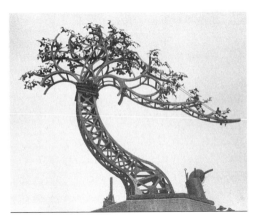

Wilbourn et al, *Shadows in Another Light*
(detail)

ARTISTS' AGENCY. / To all who helped and
assisted, particularly Henry Lyall / for his
enthusiasm / advice about optics; Structural and
/ Civil Consultants, crazy enough to give
structural / advice! Sokkia, Marland, Reprotec,
'A' Plant, Hilti and / Herrington Industrial
Services; Bob Shields; / Drak, Lee and Kat; Tom
for / sticking down tape. . . .
Incised on stone block attached next to roundel:
. . . Jim, Nigel / and Graham as / always; Lucy
and / Janet; Lynn / and Paula and / our Support
Team / THANKS! / [signatures]
Incised on roundel on eastern face of concrete
drum: Betty Carr, / Jenny Crosby, / Dorothy
Dewart & / Margaret Alexander, / Martin
Brennan, / Mavis Brennan, / Ethal Chambers,
Phil Copus / Tom Waggot, Graham Bowes, /
Alan Carpenter, Carol Copus / Jean Richardson
and / Elaine & George Davison. / FOLLOW THE
/ FOOTSTEPS TO SEE / WHAT THESE PEOPLE SAW /
AND THEN PASS FROM / SHADOW INTO LIGHT
[also in braille]
Signatures incised on block attached to east side
of concrete drum: Karl / Craig / Chaz / Colin
Condition: good

Commissioned by: Tyne and Wear
Development Corporation
Custodian: City of Sunderland

Description: a composite artwork consisting
of various elements in steel, concrete, wood and
stone; moulded and carved stone roundels; a
working telescope; sand-blasted paving and
carved lettering. *Shadows In Another Light* is
set on the quiet north bank of the Wear
between the Wear Bridge and Sunderland
University's St Peter's campus and takes up
approximately 200 metres of the walkway.

An octagonal concrete drum about five

Wilbourn et al, *Shadows in Another Light*
(detail)

metres high acts as the pedestal for a large
forged steel sculpture of a tree-form. This is
constructed out of cross-braced box sections,
rather like the nearby bridge, and curves out
over the pavement below. Set about one metre
high onto the faces of the drum are 16 roundels
made of moulded fired clay, held in place by
steel frames rather like portholes. Two of the
roundels carry the inscriptions, and the others
show a windmill; a cormorant; a lighthouse; a
buoy, undersea life; a sailing ship; the Wear
Bridge; Penshaw hill, the Monument and
Lambton Worm; Noah's Ark; boats on the sea;
a beach scene; tools and a hand; a 1:20 scale
diagram of the tree sculpture; and a scale
diagram of a crane.

About three metres away from the eastern
side of the drum is a telescope with a stone
stool next to it. The stool has an inscription
carved on its top exhorting people to 'look up'.
The telescope is aimed at a convex mirror which
is positioned on top of the concrete drum (at
the base of the tree). By looking through the
telescope one can make out the shape of a crane.
This is in fact a reflection of a 100-metre long
anamorphic carving of a crane, made up of dark
segments sand-blasted onto the white paving
that stretches to the east of the tree and drum.
Also sited along the walkway eastwards are
sculptures of nuts and bolts, some partially
'buried' in the ground: a white stone nut; a
wooden nut; a red gritstone nut; a metal bolt; a
concrete nut. The furthest of these is about 200
metres from the telescope. There are some
additional small collections of forged metal,
seemingly randomly piled around the base of
the tree and up against some of the nuts and
bolts.

*Subject and History: Shadows In Another
Light* represents the culmination of seven years
of work by Wilbourn, Fisher, Knowles and
Brenchley on St Peter's Riverside. The team-
based approach that proved so successful with
earlier pieces has created an artwork within

Wilbourn et al, *Shadows in Another Light*
(detail)

which the different skills of stone-carving, metal sculpting and creative writing are combined in one work. The piece is also notable for the involvement of local residents in the conception and execution of various elements.

The tree set on its high pedestal picks up a theme first explored in a story written by local schoolchildren for *Windows and Walls*, another work in St Peter's about a kilometre away (see p.198). The story tells how the last tree by a river was cut down and made into a boat, leading to the immediate decline of the town's fortunes. Upon salvaging the boat and hauling it onto dry land the wood proved to be magic, and new trees sprouted in its place.

The huge metal tree that forms part of *Shadows in Another Light* could thus be seen as a 'tree of life', especially as the shadow that it casts is that of a ship-building crane rather than an organic form. The anamorphic carving on the pavement is a direct representation of the few remaining, highly distinctive cranes on the south bank of the Wear. With the loss of ship-building from the river, new skills and interests have had to replace old jobs. The fact that Fisher and Knowles have both become accomplished artists as the result of on-the-job training with Wilbourn illustrates this process. The tree could also represent knowledge, referring to Sunderland University's campus

nearby where one of Wilbourn's earlier sculptures, *Pathways of Knowledge*, is sited directly outside the Library (see p.194).

Twelve of the roundels on the base of the huge concrete pedestal were carved by local residents, listed on one of the inscriptions. Encouraged by Artists' Agency, who have managed the overall arts project, locals have actively involved themselves in both creating and looking after the sculptures at St Peter's. Being mostly older people, their responses to the surroundings are more lyrical and nostalgic than those of the artists, as is demonstrated in the roundels' subject matter. The scenes are of

Wilbourn et al, *Shadows in Another Light*
(detail)

the sea, its wildlife and human interaction. Again, these hark back to some of the stories told by *Windows and Walls*. The use of a storyline and the addition of evocative lines of poetry result from Brenchley's involvement in the project.

In formal terms, *Shadows in Another Light* has developed from earlier sculptures sited elsewhere in St Peter's Riverside. An anamorphic projection was used within the 1997 piece *Passing Through*, and Wilbourn set out a temporary relief of a house on reclaimed ground at the very beginning of his residency in 1992. The bravura use of forged steel for the tree demonstrates how Knowles's confidence with the material has increased since taking on solo projects in 1997; for example, *Taking Flight* has a cormorant metamorphosing from steel I-beams (see p.199).

Shadows in Another Light was commissioned by TWDC and is one of the major 'Art on the Riverside' pieces funded by a grant from the National Lottery as well as other bodies listed in one of the inscriptions.[1]

[1] *Journal*, Newcastle, 7 August 1998.

Junction of Dame Dorothy Street and Liberty Way

Always Open Gates

Sculptors: Colin Wilbourn and Karl Fisher

Installed 1992
Whole work: painted steel 2.2m high × 5.6m wide
Incised on a steel plate: 'Always Open Gates'/ 1992 / This sculpture was created as part of the St. Peter's / Riverside Sculpture / Project by: / Colin Wilbourn / Karl Fisher / Fabrication by / A.D.C. Welding.
Incised on steel plate attached to gate: Meet me after work, here / we'll take the boat out.

Wilbourn and Fisher, *Always Open Gates*

Attached plaque records that the work was sponsored by TWDC, North of England Building Society, Wearside TEC and City of Sunderland.
Status: not listed
Condition: good
Condition details: paint peeling off all surfaces
Commissioned by: Tyne and Wear Development Corporation
Custodian: City of Sunderland

Description: a cut-steel sculpture creating the illusion of two gates opening onto a promenade, with ships out at sea. A sculpted bicycle rests against the railings at each side. The metal is painted in black and various shades of blue to heighten the illusion. However, the steel's dark colouring means that the gates do not stand out particularly from the line of fencing.
History: forming a decorative corner to the railings around the North Sands Business Centre, *Always Open Gates* was the first work completed for the St Peter's Riverside Sculpture Project. Neither Wilbourn nor his new assistant Fisher had worked with steel before, so were apprehensive of the reception this piece would have. Wilbourn's interest in perspective demonstrated by these gates is apparent in later works in the area.

Manor Quay East promenade, outside Sunderland University Prospect Building

Pathways of Knowledge

Sculptor: Colin Wilbourn
Assistant: Karl Fisher

Unveiled 18 May 1993
Whole work: yellow sandstone with polychrome inlay 1.8m high × 3.5m long × 1.5m wide
Incised on open book face, gilt lettering: THIS SCULPTURE / WAS UNVEILED BY / HER MAJESTY / THE QUEEN / ON / 18 MAY 1993 / TO CELEBRATE / A NEW CAMPUS FOR / THE UNIVERSITY OF / SUNDERLAND / AT / ST PETER'S RIVERSIDE
Status: not listed
Condition: fair
Condition details: stonework stained, splitting and worn in several places; some algal growth in damper areas
Commissioned by: Tyne and Wear Development Corporation
Custodian: University of Sunderland

Description: a pile of books carved from soft yellow sandstone, set in the grounds of Sunderland University. The end book (1m square) is open. There is a relief carving of Bede at his desk on one leaf, and a multicoloured

Wilbourn and Fisher, *Pathways of Knowledge*

mosaic inlay on the other, taken from an illuminated manuscript in the Scriptorium at St Peter's Church nearby.
Subject: Wilbourn stated that *Pathways of Knowledge* was made 'with stone and glass, two key materials used by Benedict Biscop when he founded St Peter's Monastery on this site'.[1] Historically St Peter's Church has been an important centre of learning, and the sculpture celebrates the university's continuation of that tradition.[2]
History: one of the earliest works on the St Peter's Riverside sculpture trail, *Pathways of Knowledge* was originally sited further along the river front. However, it did not relate to the new university there: it 'was a work made to order and was not the result of Wilbourn's response to a site'.[2] After a site within the grounds of St Peter's Church was considered, it was eventually placed outside the university's new library building, thus evoking a direct link with reading and scholarship.

Wilbourn and Fisher worked round the clock on the 15-tonne sculpture to have it ready for unveiling by the Queen on the same day that Sunderland was granted city status.[3]

[1] Shaw, P. and Thompson, I., *St. Peter's Riverside Sculpture Project*, Sunderland, 1996, p.23. [2] *The Times*, London, 18 May 1993. [3] *Journal*, Newcastle, 14 May 1993.

(opposite) Wilbourn et al, *The Red House*

Riverside walkway at edge of Port of Sunderland basin

The Red House

Sculptors: Colin Wilbourn and Karl Fisher
Writer: Chaz Brenchley

Carved on site 1995
Whole work: red sandstone 1.8m high × 8.2m wide × 11m long
Inscribed on a stone block outside walls of piece: The Red House / Folly End / Monkwearmouth / Dear Peter / The house is so empty without / you. Only the fish are glad. Life / is no use, now youre gone; nothing / goes right, nothing works. / And you, how must it be for you? / This bad for me; it must be worse / for you, so far away. I go down / to the water every day just to / touch it, to hope that you might be / touching it too, that we can touch /

each other through the sea.
Status: not listed
Condition: good
Condition details: widespread green algal growth; some loss of detail due to breakage
Commissioned by: Tyne and Wear Development Corporation
Custodian: City of Sunderland

Description: a large sculpture which represents the ground floor of a house, left open to the elements. Large blocks of red sandstone are carved into features such a fireplace, a coat hanging behind a door and a table. A rug on the floor has 'WHAT GOES AROUND COMES AROUND' carved around its edges. There are also books, tools, and a secretaire. Scattered beyond the walls are other fragments of sandstone, one with a letter inscribed into it. The colour of the Red House reflects that of the new brick houses behind, and the whole is sited within a planted

area beside a riverside pathway.

History: The Red House is the second work by Wilbourn in this area, and the first to use fully the principle of working in public, allowing locals and passers-by to comment on progress, add ideas and appreciate the skills being used to create it. It also saw the full-hearted involvement of Fisher as Wilbourn's equal, not just as a trainee. The work took almost a year to complete and is constructed out of soft red sandstone from the old Queen Alexandra Bridge over the Wear. The objects scattered around the interior are seen as a kind of 'tray game', recognised by some people, wondered about by others. The words on the carpet and the unfinished letter outside also create questions, drawing the visitor into an interaction with the piece based on their own perceptions of home and personal relationships.

More often than not, the casual visitor will be approached by a local who will be more than willing to discuss the work. This is a testimony to the semi-formal 'ownership' of the work by those living in the estate behind, evidenced by a complete lack of vandalism and notable pride in the sculpture project overall.

Junction of Dame Dorothy Street and Sand Point Road

Watching & Waiting

Sculptors: Colin Wilbourn, Karl Fisher and Craig Knowles
Writer: Chaz Brenchley

Installed June 1995
Rug: 4m square
Stone elements: up to 5m × 5m square
Telescope: steel 1.1m high
Various inscriptions on steel plates (texts by Brenchley)
Incised on one plate: WATCHING & WAITING 1995 / Produced by / The St. Peter's Riverside / Sculpture Project: / Colin Wilbourn, Karl

Wilbourn et al, *Watching & Waiting*

Fisher / Chaz Brenchley & Craig Knowles /
Managed by– / Artists' Agency / funded by /
Tyne and Wear / Development Corporation /
with substantial support from / Northern Rock
/ Building Society.
Status: not listed
Condition: fair
Condition details: damage to edges of stone
carvings; green algal growth on most stone
areas
Commissioned by: Tyne and Wear
Development Corporation
Custodian: City of Sunderland

Description: a stylised sculpture depicting
the objects associated with a picnic. Twenty-five
blocks of stone are carved to represent a rug.

Placed on this are stone sculptures of a
travelling bag and stool, a hamper basket with a
coat on top, and an open book made from steel.
A steel map carries the details of commission
and the book has a piece of writing by
Brenchley on the theme of the sea. One of the
'loose leaves' is in braille. In addition there is a
steel telescope on a tripod, aimed towards the
harbour entrance.

History: Wilbourn found a reference to
'Look Out Hill' on old maps of the area and
asked the developers to create a new mound to
look out over the Wear.[1] The title implies a
sense of hope like the wistful poetry at *The Red
House* (see p.195): it could also suggest
someone waiting for the return of a sailor, or a
more general need for the return of full
employment in the area. Visitors complete
Watching and Waiting by sitting on the stool
and becoming part of the picnic ensemble. It is

quite possible to walk all over the sculpture and
look through the telescope to the sea beyond,
and the work has tactile qualities which
encourage physical engagement. However, the
braille text could be difficult for an unaided
blind person to find.

[1] *Northern Rock Newsround*, Autumn 1995.

North Dock, esplanade

Passing Through

Sculptors: Colin Wilbourn, Karl Fisher and Craig Knowles

Unveiled 14 July 1997
Relief: stone, steel, mortar 13m long × 5m high
Seat and viewing point: stone, wooden sleepers,
steel 1.5m square × 1m high
Doorway attached to wall: stone, stained glass,
steel, slate 2.8m high × 2m wide × 1m deep
Free standing door: stone, stained glass, steel
2.8m high × 3m wide
Inscribed on stainless steel plate attached to
main wall: 'PASSING THROUGH' / 1996 / 97 /
THIS SCULPTURE WAS CREATED / AS PART OF THE
ST. PETER'S / RIVERSIDE PROJECT: / COLIN
WILBOURN / KARL FISHER / CRAIG KNOWLES
Status: not listed

Wilbourn et al, *Passing Through* (detail)

Wilbourn et al, *Passing Through* (detail)

stands separately, carved from soft white stone with two steel oars leaning up against it. This door also has stained glass designs incorporated into it, depicting a sailing boat and a seagull in flight.

The work continues the general maritime theme of sculptures around the redevelopment area, but also represents a new level of complexity in the visual games which Wilbourn plays in his sculpture. Referring to the anamorphic carving on the wall, Wilbourn said, 'It's an optical illusion and it will be interesting to see how many people actually peek through the keyhole'.[1]

[1] Journal, Newcastle, 15 July 1997.

Condition: good
Commissioned by: Tyne and Wear Development Corporation
Custodian: City of Sunderland

Description: a composite sculpture comprising various elements, all dealing with the theme of doorways. Firstly, there is a large anamorphic projection of a sailing ship carved onto the retaining wall at the rear of North Dock, with the details picked out in coloured mortars. Although the relief seems askew when seen face on, the perspective can be brought into correct alignment by sitting on a nearby bench to look through the keyhole of a half-door. Secondly, set into the retaining wall to the left of the relief is a stone doorway with a laminated stained glass design of the rising sun, lit from within by a lamp. A third doorway

Wilbourn et al, *Passing Through* (detail)

Knowles, *Paddle Gate*
and *Tree Guard Railings*

Paddle Gate and *Tree Guard Railings*
Metal worker: Craig Knowles

Installed 1997
Gate: steel 3.6m wide × 2.6m high
Tree guard railings: steel 1.8m high × 50cm diameter
Inscribed on stainless steel plate attached to wall nearby: 'Paddle Gate' / 1995 / This sculpture was created / as part of the St. Peter's / Riverside Sculpture Project by / Craig Knowles
Status: not listed
Condition: good

Description: a forged steel gate standing between the end of the lifeboat centre and the

cliff face, made up of lifeboat oars connected with intertwining rope. The gate posts arch inwards in an art nouveau manner. The railings are formed from a similar motif, and are used to protect young trees along the esplanade. The steel is a dark grey colour, protected by a smooth enamelling, and the furniture is of a solid and tactile nature.

North Dock, esplanade, wall fronting housing development

Windows and Walls

Sculptors: Colin Wilbourn and Karl Fisher
Writer: Chaz Brenchley
Assisted by: Volunteers

Installed 1996
Each relief panel: fired clay 90cm square
Retaining wall: brick 20m long approx
Incised on stainless steel plate at centre of wall: 'Windows and Walls' / 1995 / This sculpture was created as part of the St. Peter's / Riverside Sculpture Project. / Colin Wilbourn / Karl Fisher, Craig Knowles, / Chaz Brechley. / With help from Redland Bricks, Throckley. / Joanne Gourley, / Dave Paton and the / 'Brickies' David, Norman / and John.
Status: not listed
Condition: good
Commissioned by: Tyne and Wear

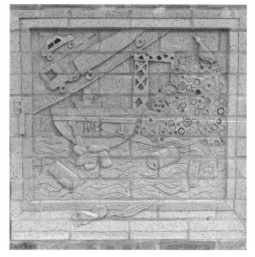

Wilbourn et al, *Windows and Walls* (detail)

Development Corporation
Custodian: City of Sunderland

Description: twenty-six relief panels, moulded out of yellow fired clay and set into the red brick retaining wall of the esplanade. The panels are grouped into six sets of four, each set illustrating a story which is inscribed on small metal plates attached between them. The additional two panels have the signatures of those involved carved into them. Each panel has a frame with a latch to the left so that the image

Wilbourn et al, *Windows and Walls* (detail)

is 'seen' through a window. Stainless steel plates are attached next to each set of reliefs, detailing the group responsible and a particular story.

The location of *Windows and Walls* along a wall at the side of the marina means that visitors can pause to read the stories as they stroll to the river front. The naïve-style scenes are based on fantastical stories depicting sea and country life, written by schoolchildren with Brenchley's help. These are: a story about a magic tree, by year 5 and year 6 pupils from Fulwell Junior School; a story about a battle between two witches, by year 6 pupils from Dame Dorothy Primary School; a story about memories of the area by sixteen members of the Monkwearmouth Local History Group; a story about a flying fish by year 5 and year 6 pupils from St Benet's Roman Catholic school; a story by year 6 pupils from Redby Primary School. Most of the shallow moulds were created by the children at sculpture workshops, except for the central four panels which were made by the sculptural team without assistance.

North Dock, pedestrian walkway on west side

Flight

Sculptor: Craig Knowles

Installed 1997
Base and pole: concrete, steel 7.2m high
Weather vane: steel 80cm high × 3.1m wide approx
Inscribed on steel plate attached to bottom of pole: 'FLIGHT' / 1997 / This sculpture was created / as part of the St. Peter's / Riverside Sculpture Project / Craig Knowles
Status: not listed
Condition: good
Commissioned by: Tyne and Wear Development Corporation
Custodian: City of Sunderland

Knowles, *Flight*

Description: a forged steel weather vane set on a black-painted steel pole which rises from a concrete base within a circular wooden bench. Two cormorants in a polished silver finish are shown flying through stylised clouds and the vane rotates above a north–south pointer. The piece seems rather austere in relation to others in the area because of its height and lack of tactile qualities.

North Dock, central pedestrian walkway

Taking Flight
Sculptor: Craig Knowles

Unveiled 14 July 1997
Each base: steel 3.5m high × 25cm square
Each sculpture: steel 1.5m long × 2.4m wide
Incised on stainless steel plate attached at bottom of final column: Taking Flight / 1996–97 / This sculpture was created as part of the St Peter's / Riverside Sculpture Project / Craig Knowles.
Incised on stainless steel plate on reverse side of base of final column: GRAHAM and NIGE, / THANKS FOR HELPING OUT! / I'LL SEE YOU IN THE 'IVY' / TO SETTLE UP. / CRAIG
Status: not listed

Knowles, *Taking Flight*

Condition: good
Commissioned by: Tyne and Wear Development Corporation
Custodian: City of Sunderland

Description: a multi-element sculpture comprising five steel I-beam columns ranged north to south along the esplanade. The work progresses through the 'birth' and 'flight' of a cormorant, with the first column being just 1.2 metres tall, with no bird on top, and the last being 3.5 metres tall with a flying bird setting off from the top. Finished in a smooth dark grey coating, the steel has been beaten and forged to create sinuous forms which gradually emerge to form the cormorant's shape.

Subject: inspired by the birds which roost and fish in the dock, often seen flying low over the water, this work is also symbolic of change. 'The sculpture suggests the transition of the St. Peter's area from an industrial past into something more natural,' stated Knowles.[1]

[1] *Journal*, Newcastle, 15 July 1997.

North Dock, off pedestrian walkway to east

Stone Stair Carpet
Sculptor: Colin Wilbourn

Carved on site 1992
Whole work: stone 4m long × 1m wide
Status: not listed
Condition: poor
Condition details: elements now lost include a pair of shoes and a pair of wellington boots; considerably eroded by sea and weather; stonework split in several places; extensive green algal growth on whole work
Commissioned by: Tyne and Wear Development Corporation
Custodian: City of Sunderland

Description: eleven steps leading from the walkway down into the marina basin, carved as if a rug were running down them. This has a key pattern and rope styled edging, which changes to chains and seaweed nearer to the water level. The carving is to a depth of approx 1cm, but there used to be two vertical elements in addition, a pair of shoes at the top and a pair of wellington boots near the bottom. These have disappeared, probably stolen, and the rest of the work is in considerable disrepair. The original yellow colouring of the stone has now weathered to various shades of brown.

History: the flight of stone steps were once part of the original docks. Having become delapidated, they were re-carved by Wilbourn as one of his earliest works for the St Peter's Riverside Sculpture Project. According to a booklet on the project, 'as the works weather and blend into the landscape, as the stone stairway has been designed to do, they will become an increasingly familiar part of that landscape and are more likely to be claimed by the community as theirs'.[1] However, the stairway was cut off from public access from 1995–7 as building work went on around it, and there are now railings along the jetty to prevent people from walking on the relief.

[1] Shaw, P. and Thompson, I., *St. Peter's Riverside Sculpture Project*, Sunderland, 1996, *passim.*

Sunderland Enterprise Park

Sunderland Enterprise Park has replaced an area of dereliction which had previously been occupied by shipbuilding and associated industries. It has cost £115 million to develop. The 'Riverside Exposed' art programme has aims to encourage local residents to explore the site on foot. Funding was provided by TWDC, Terrace Hill Developments Ltd, the Business Innovation Centre, Durham Wildlife Trust, Sunderland City Challenge, Northern Arts and Sunderland Libraries and Arts. A number of artists were involved in residencies from 1996 to 1997, managed by Deborah Hunter Associates.

Wilbourn, *Stone Stair Carpet*

(below) Hunter, *Tempesta*

Alexandra Avenue: opposite technology park

Tempesta: Where the River Meets the Sea

Sculptor: Douglas Hunter

Installed 1998
Whole work: painted steel and aluminium lettering 30m long × 12m high
Attached plaque reads: Tempesta: where the river meets the sea / by artist Douglas Hunter / This project is part of Art on the Riverside, a public art programme funded by / Tyne and Wear Development Corporation / Arts Council Lottery Fund / Thanks to: North East of England Business and Innovation Centre / [Text of Pound's poem Fish and the Shadow beneath]
Status: not listed
Condition: good
Commissioned by: Tyne and Wear Development Corporation
Custodian: City of Sunderland

Description: a large artwork consisting of a

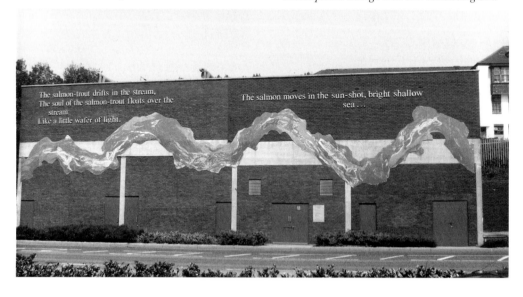

strip of steel brightly painted in oranges, reds, blues and greens, mounted on the south wall of the building. Set above it in aluminium letters are the first lines to Ezra Pound's poem 'Fish and the Shadow': The salmon-trout drifts in the stream, / The soul of the salmon-trout floats over the stream / Like a little wafer of light / The salmon moves in the sun-shot, bright shallow / sea.

Junction of Timber Beach Road with Colima Avenue

Endless Column

Sculptor: Gilbert Ward

Installed 1997
Whole work: sandstone 4.2m high × 60cm square
Status: not listed
Condition: good
Commissioned by: Tyne and Wear Development Corporation
Custodian: City of Sunderland

Description: a tall yellow sandstone column, carved in a modular form reminiscent of Brancusi's much larger steel *Endless Column* at Tirgu-Jiu, Romania (1937). There is a split at the base of the sculpture.

History: this is one of a number of works by Ward distributed among the business units, most of which are carved out of sandstone and have maritime or organic themes.

Within planting at sides of Timber Beach Road, Defender Court and Hylton Park Road

Abstracted Natural Forms

Sculptor: Gilbert Ward

Installed 1997
Each work: sandstone 95cm high × 1.4m long ×

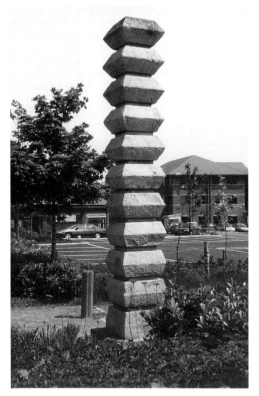

Ward, *Endless Column*

Ward, *Abstracted Natural Forms*

1m wide (maximum)
Status: not listed
Condition: good
Commissioned by: Tyne and Wear Development Corporation
Custodian: City of Sunderland

Description: three sculptures in yellow stone which are related in form and size, situated within planted areas to either side of the main road through the site. The designs are abstracted from animal or botanic forms. All are rather dirty and covered with a layer of green algae and their low, curved shapes make them difficult to spot amongst roadside foliage.

Wearfield: old slipway to Wear

Pontoon

Sculptor: David Stewart

Carved on site summer and autumn 1996
Each block: red sandstone 1m high × 1.9m long × 40cm deep
Status: not listed
Condition: good
Commissioned by: Tyne and Wear Development Corporation
Custodian: Sunderland Enterprise Park

Description: five blocks of red sandstone set at an angle sloping into the River Wear. Each is carved with different detailing, such as a netting pattern, deep pitting or abstract marks. Sited behind some office units with views in both directions along the river.

History: like Colin Wilbourn's *Red House* at St Peter's Riverside (see p.195) *Pontoon* was carved out of stone reclaimed from the nearby Queen Alexandra Bridge. The work is a response to the sight of demolished shipyards and new business units. It 'explores the history and implications of those materials which represent a declining and redeveloping urban

Stewart, *Pontoon*

Stewart, *Docker* (detail)

one side is convex and the other concave. It is sited at a picturesque spot overlooking the Wear.

History: This is one of a number of works by Ward distributed among the business units, created for the 'Riverside Revealed' scheme. All of them are carved out of sandstone and have maritime or organic themes.

landscape [and] deals with the contradiction of the permanence of architecture and stone set against the transient nature of floating bridges and boats.'[1]

Construction work on new industrial units has continued near to the site of *Pontoon* and large amounts of rubble were tipped over the sculpture in mid-1999, partially obscuring it and potentially causing damage in the future.

[1] Information supplied by the artist, 1999.

Docker

Sculptor: David Stewart

Carved on site 1997
Each block: pink granite 1m high × 1.9m long × 60cm deep
Status: not listed
Condition: good
Commissioned by: Tyne and Wear Development Corporation
Custodian: Sunderland Enterprise Park

Description: two blocks of pink granite polished to a very light grey, set about 100 metres back from the river beside a path. Each block is carved with deep incisions in an abstract style.

History: Stewart has laughingly claimed that

the title of *Docker* was inspired by a new pair of boots he had at the time. Though an abstract work, it can be seen as a response to the ship-yards round about, most of which have been abandoned. The sculptor has stated that his work 'seeks equivalents in forms, buildings, monuments and engineering environments to interiors, furniture and ornaments', though not necessarily directly related to any particular site.[1]

[1] Information supplied by the artist, 1999.

Wearfield: behind Royal Mail building, on path by river

Link Column

Sculptor: Gilbert Ward

Installed 1997
Whole work: sandstone 2.8m high × 75cm × 42cm deep
Status: not listed
Condition: good
Commissioned by: Tyne and Wear Development Corporation
Custodian: City of Sunderland

Description: a large boulder with relief carving of chain links on both faces, although

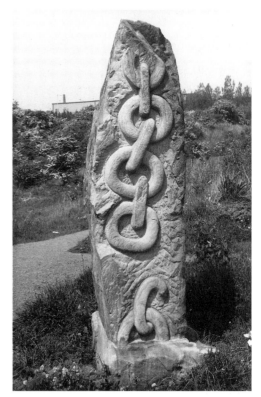

Ward, *Link Column*

Washington Road HYLTON DENE

Hylton Dene, various locations

Sleeping Dragon, Dragon's Footprints, Dragon's Eggs

Sculptor: Abigail Downer

Installed 1988
Sleeping Dragon: concrete polymer 7.1m diameter
Each *Dragon's Footprint*: concrete polymer 1.3m long × 85cm wide
Dragon's Nest: concrete polymer 3.1m square
Status: not listed
Condition: poor
Condition details: *Dragon*: concrete layers badly split and flaking away with loss of detail, graffiti inked on all surfaces; *Footprints*: one missing. *Eggs*: smashed by vandals
Commissioned by: Northern Arts and City of Sunderland Environmental Department
Owned by: City of Sunderland

Description: three moulded concrete sculptures situated in three different areas of Hylton Dene. The largest, a concrete *Sleeping Dragon* curled up asleep, is on a hillside in the central western part. Four *Footprints* are further east near the lake, though only two are now visible. Even further east, in an area which is now fenced off and not easily accessible, are the remains of the the *Dragon's Nest*, a group of concrete eggs which are now smashed.

History: the idea for a work in Hylton Dene was proposed by the Artists' Agency in 1987, with approval given by the Planning Committee in July 1988. An open competition was advertised in the *Guardian*, leading to the appointment of Downer for a three-month residency. Working with local school children who talked of dragon myths, the sculptor saw a sleeping dragon as 'the centrepiece of a dragon trail in Hylton Dene'.[1] The materials were provided by local businesses including Wimpey Homes, Northern Aggragates, Tilcon and Brown Brothers Polystyrene Ltd. The Territorial Army and the Manpower Services Commission were also drawn upon to provide labour.

Downer's work within both primary and secondary schools was seen as a great success, with the children making scale models and contributing to story telling. One of the footprints was the winning design in a competition for local children.[2]

[1] *Journal*, Newcastle, 24 February 1989. [2] Shaw, P., *The Public Art Report*, London, 1990, p.28.

Downer, *Sleeping Dragon*

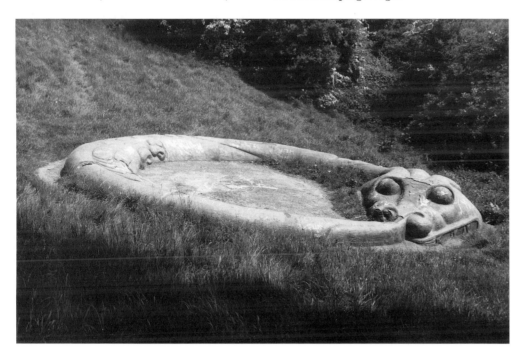

Wellington Lane DEPTFORD

Junction with Hanover Place, outside the Saltgrass Public House

Philip Laing Memorial Drinking Fountain

Designer: not known

Installed 23 September 1893
Whole fountain: pink granite 1.6m high × 62cm square
Incised on front of dado: PRESENTED TO THE INHABITANTS OF / DEPTFORD / IN MEMORY OF / PHILIP LAING SHIPBUILDER / (1793–1843) / BY HIS SON / JAMES LAING / (1843–1893) / ON THE CENTENARY OF HIS FIRM / DEPTFORD YARDS / SEPTEMBER 23 1893
Status: II
Condition: fair
Condition details: iron bolts on top denote missing element; fountain does not work; lion's head badly rusted
Commissioned by: James Laing

Custodian: City of Sunderland

Description: a gently tapering polished block of stone with an iron drinking bowl and lion's-head spout set into the front face. At the foot is a hole where a drinking trough for animals would have been. Originally surmounted by a female figure, now lost.

Subject: Philip Laing (1770–1854) moved to Sunderland from Fife in 1792. Previously a farmer and shipowner, he set up business with his brother John, and lived in Monkwearmouth.

After moving site several times they crossed to Deptford in 1818. Philip Laing built a house which stood in the Deptford shipyard until 1856. His son James (1823–1901) took over the business in 1843 and 'came to exercise a more powerful influence than perhaps any other man has done on the development of Sunderland's shipbuilding'.[1]

History: as described in the inscription, this drinking fountain was the gift of James Laing to the people of Deptford in commemoration of his father Philip and the founding of Laing's shipbuilding yard. It is not known when its surmounting figure was removed.

[1] Smith, J.W. and Holden, T.S., *Where Ships are Born*, Sunderland, 1953, pp.20–1.

Laing Fountain

Whitburn Bents Road SEABURN

Verge on seaward side of road, opposite amusement arcades

Millennium Mile Post

Designer: Jon Mills

Installed *c.*1998
Whole work: black painted steel 2.1m high × 1.1m wide at top × 7cm deep
All raised lettering: north spar: 5½ NORTH SHIELDS; south spar: CITY CENTRE 2½
At branching: NATIONAL CYCLE NETWORK 1
On column: THE ROYAL BANK / OF SCOTLAND / This is one of / 1000 mile posts / funded by The / Royal Bank of / Scotland to / mark the / creation of / the / National / Cycle / Network
Raised letters at bottom of post: CASTING BY / TAYLORS FOUNDRY / HAVERHILL / FROM AN ORIGINAL BY / JON MILLS
Status: not listed
Condition: good
Commissioned by: Millennium Lottery Fund
Custodian: City of Sunderland

Description: a black column in the shape of a fish tail, with a design stamped on the main face

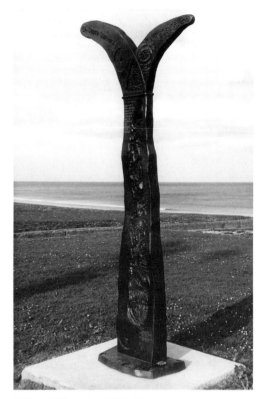

Mills, *Millennium Mile Post*

depicting an undersea scene, with sea creatures, bones, a petrol pump and car tyre at the top. The column is set into concrete.

History: details of the commission are given in the inscriptions. There are several other similar mile posts within the North-East survey region.

SUNNISIDE Gateshead MBC

Broome Lane off A692
Washingwell Wood at bottom of valley

Bridge
Sculptor: Laurent Reynes

Installed 1 September 1996
Whole work: wood and stone 3.8m high × 1.3m wide
Status: not listed
Condition: fair
Condition details: wooden poles splitting as paint peels off; graffiti incised on poles
Commissioned and owned by: Gateshead Metropolitan Borough Council

Description: a bridge over a small stream, situated in a quiet woodland clearing at the bottom of a footpath from the main road. It consists of four pairs of blue-painted telegraph poles as the supportive struts for the wooden bridge. The poles are sheathed in pebbles set

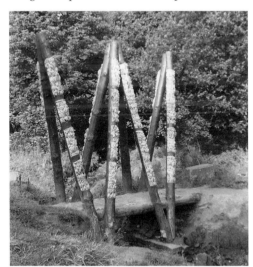

Reynes, *Bridge*

into concrete in a decorative manner.

Subject: intended to represent Summer, *Bridge* was made in collaboration with local schools and two assistants, Jean François Chaine and Simon Donald. It was commissioned by Gateshead MBC as part of its 'Four Seasons' initiative for the year of Visual Arts UK and is paired with *West Wind* (see p.80). As part of its documentation, Reynes supplied a short poem about the work: 'It crosses the frontiers / From the water to the sky / From the river to the clouds / Will it take you away?'[1]

History: one of the largest pieces Reynes has made, the *Bridge* took a month to construct. The sculptor said that he liked the idea of being able to walk through the work and that it would be interesting to return to see how it was changed by time.[2] It was due to be repainted in 1999.

[1] Gateshead, *Four Seasons*, p.15. [2] *Journal*, Newcastle, 2 September 1996.

Hedley Lane
Road off A6076, on farmland at side of road

Circling Partridges
Sculptor: Graciela Ainsworth

Installed 1996
Base: steel and concrete 80cm high × 85cm diameter
Upper part: stainless steel 1.7m high
Partridges: stone 70cm long
Soldered lettering on outer drum: The naked earth warm with spring bursting trees's lean to the suns kiss.
Status: not listed
Condition: fair
Condition details: beak of one partridge chipped; droppings on most surfaces; salt staining on steel drum; algal and moss growth

Ainsworth, *Circling Partridges*

on some surfaces
Commissioned and owned by: Gateshead Metropolitian Borough Council

Description: a heavy concrete-filled drum suspended between two steel rings allowing free movement so that it will rock if pushed. A gimbal arrangement allows circular movement of the whole structure. Two steel supports rise up from the drum, each supporting a partridge boldly carved from yellow stone in a naïve style. The work is situated in a field of newly planted trees on a hilltop, which will grow up and eventually obscure it.

History: visiting the hilltop site in winter, Ainsworth was startled by a covey of partridges

rising from the field, and created the work to reflect 'Spring' within Gateshead's 'Four Seasons' project. The words on the drum are taken from lines by the First World War poet Julian Grenfell, and Ainsworth has contributed her own written statement which deals with the relationship between nature, words and sculpture, as well as the following poem: 'Re-claimed coal site, green fields where once there had been machinery. / Surrounding railway once with many wheels. / Partridges pair-off, flying close together, with wings flying in a circular motion. / Nests when found in early Spring circled on the keeper's map. / Words written on a circle creating human movement. / In years the birds will lean to the newly planted trees when they are fully grown.'[1]

Commissioned as part of Gateshead MBC's contribution to 1996 Year of Visual Arts UK, *Circling Partridges* has become part of Kibblesworth area's 'Marking the Ways' project (see p.78). However, its use of steel and concrete is unusual within this scheme.[2]

[1] Gateshead, *Four Seasons*, pp. 8–11. [2] *Marking the Ways in Gateshead*, passim.

Front Street

Monument to Queen Victoria
Sculptor: Alfred Turner

Unveiled 25 October 1902
Sculpture: bronze 2.1m high × 3.2m square
Pedestal: stone 2.1m high × 3.7m square
Incised on ribbon round top of pedestal, front: VICTORIA DEI GRATIA; right: BRITANNIA UMBREGINA; left: INDIA IMPERATRIX.
Incised on dado front of pedestal: ERECTED BY PUBLIC SUBSCRIPTION / TO THE MEMORY OF OUR

Turner, *Queen Victoria*

LATE BELOVED QUEEN / VICTORIA / BY THE INHABITANTS OF THE / BOROUGH OF TYNEMOUTH / DURING THE MAYORALTY OF / ALDERMAN DAGLISH J.P. / 1901–02 AND UNVEILED BY THE MAYORESS OCTOBER 25TH 1902 / A BENEFICENT WISE AND GLORIOUS REIGN / ANNO DOMINI 1837 TO 1901.
Incised on rear of bronze throne: HONI SOIT QUI MAL Y PENSE
Signed bottom right of bronze base: ALFRED TURNER / 1902 / FOUNDRY / A. PARLANTI
Status: II
Condition: good
Condition details: pedestal badly stained green by bronze leaching
Commissioned by: public subscription
Custodian: North Tyneside Council

Description: depicting the Queen in the

midst of voluminous robes, this statue shows her in the twilight years of her reign. The work now lacks the Queen's crown and one of the figures on the finials of her throne. The remaining figure (about 25cm tall) is of a mother and child.

History: proving that the people of Tynemouth were 'second to none in their patriotism', this was the second memorial to the late Queen unveiled in the north of England. The £1,000 cost of the statue was collected despite it being a time of financial strictures imposed by the Boer War. Difficulties arose in agreeing a site, but eventually the village green was decided upon.

Heavily indebted to the style of Alfred Gilbert,[1] the statue was a second cast from the mould used for Turner's monument to the Queen in Delhi, resulting in a significant saving of cost. The design of the throne is similar to that of George Frampton's *Queen Victoria Monument* in Calcutta (1897).[2]

The day of the inauguration was marred by heavy rain, but a large crowd was in attendance nonetheless. The Mayor gave a valedictory speech and the Mayoress – who had been much involved in the statue's fundraising – performed the unveiling. She was presented with a pendant as a souvenir of the day. The ceremony was followed by an exhibition drill by the Tynemouth Volunteer Life Brigade, a 'sumptuous tea' in Tynemouth Palace and then a torchlight procession through the rain to the park, followed by fireworks.[3]

In 1909 a meeting of the Town Improvement Committee reported the unsatisfactory appearance of the memorial due to staining of the pedestal from the bronze above. Letters to the sculptor had not been answered and it was resolved that the surveyor 'do what is necessary', though it is not clear what this resulted in.

The memorial was renovated in 1994, when the statue was given a protective coating and the

railings around it replaced. This work was funded by the Council and European regional development money.[4]

[1] Beattie, p.213. [2] *Ibid.*, p.210. [3] *Shields Daily News*, 27 October 1902. [4] *News Guardian*, North Shields, 10 February 1994.

Pier Road

Open ground overlooking river

Monument to Admiral Lord Collingwood

Sculptor: John Graham Lough
Architect: John Dobson

Statue installed August 1845
Statue: Portland stone 7m high
Pedestal: sandstone 6m high × 5.5m square
Steps to pedestal: stone 2.25m high × 12.9m square
Base (terrace) and steps: 5m high × 24m wide
Incised on black marble slab on south face of dado: THIS MONUMENT / was erected in 1845 by Public Subscription to the memory of / ADMIRAL LORD COLLINGWOOD, / who in the "Royal Sovereign" on the 21st October 1805, led the British Fleet / into action at Trafalgar and sustained the Sea Fight for upwards of an hour / before the other ships were within gunshot, which caused Nelson to exclaim / "SEE HOW THAT NOBLE FELLOW COLLINGWOOD TAKES HIS SHIP INTO ACTION" / He was born at Newcastle Upon Tyne 1748 and died in service / of his country, on board of the "VILLE DE PARIS" on 7th March 1810 / AND WAS BURIED IN ST. PAUL'S CATHEDRAL. / THE FOUR GUNS UPON THIS MONUMENT BELONGED TO HIS SHIP THE / "ROYAL SOVEREIGN"
Status: II*
Condition: fair

Lough, *Collingwood Monument*

Condition details: details of statue very badly weathered on face and hands, with extensive surface pitting; green algae and lichen growth all over supporting structure; railings missing (bases evident on top step); spalling of cornice stonework; small amount inked graffiti on rear of pedestal
Commissioned by: public subscription
Custodian: North Tyneside Council

Description: a giant statue of Lord Collingwood overlooking the mouth of the River Tyne. The figure is broadly treated and massive enough to be viewed by mariners at sea. Collingwood, dressed in an admiral's uniform and draped in a cloak, stands on top of a high yellow stone pedestal. On either side of the pedestal are four cannon taken from the *Royal Sovereign*.

Subject: Cuthbert Collingwood (1748–1810) was born at the Side, Newcastle and educated at the Grammar School. He joined the Navy at the age of thirteen and from 1761 to 1786 was almost constantly at sea. In 1791 he married a member of the Blackett family and settled in Morpeth. During the French Wars he again saw almost continuous service, particularly distinguishing himself at the battles of Cape St Vincent (1797) and Trafalgar (1805) where he was Nelson's second-in-command. For his 'valour, judgement and skill' at Trafalgar he was rewarded with a peerage and the freedom of various cities. He died at sea and was given a state funeral and a monument in St Paul's.[1]

History: at the close of the French Wars, Newcastle, unlike other towns and cities in England, had its own home-grown naval hero to commemorate, Admiral Lord Collingwood.[2] Accordingly, there is an elaborate Collingwood monument by Rossi in St Nicholas' Church (1821) and a full-length portrait by Lonsdale in the Exchange in Sandhill.[3] In addition one of the first of Newcastle's modern streets, laid out in 1809–10, is named after him.

However, it was not until 1838 that, inspired by the publication of G.L. Newnham's *Memoirs of Vice-Admiral Lord Collingwood*, a writer to the local press proposed a large outdoor monument in the shape of a column, with or without a statue, on the western part of Newcastle Town Moor. This was given support later in the year at a meeting in Newcastle Assembly Rooms, much being made of the fact that Newcastle seemed in danger of being upstaged by London where plans were afoot to erect a monument to Nelson in Trafalgar Square. It was therefore resolved to establish immediately a public subscription for a 'Memorial in some eligible Situation'.[4]

In September 1838 subscribers were shown the model which Lough had submitted (unsuccessfully) to the judges in the Nelson Monument competition and decided that this would be suitable if sited in St Nicholas's Square, Newcastle. 'It was stated that the expense of the Monument, according to the design for the Nelson Statue, would be about £2,600; but as the Committee were of the opinion that the four recumbent figures could be dispensed with the expense would be very much reduced.'[5]

However, in September 1839 an altogether different site was proposed: at the south-east corner of the burying ground at Tynemouth.[6] Two letters appeared in the Newcastle *Journal* explaining why this was preferable. The first from 'Blue Jacket' cited the newly erected Nelson monument at Yarmouth to argue that a monument on a marine site, rather than in 'some vile confluence of brick and mortar avenues' in Newcastle, would be 'worth a dozen press gangs'. The second from 'an ardent admirer of the noble admiral and an old sailor' made a similar point; a Newcastle monument would be nothing more than an ornament for Richard Grainger's 'City of Palaces', whereas one at the coast would be seen by the crews of 'upwards of twenty thousand ships' a year. The

letter also noted how as a boy sailor Collingwood had looked out with tear-filled eyes from his ship at 'the fast receding image of that ancient "Sea Mark", the ruined Priory of Tynemouth'.[7]

Eventually, in August 1840, the Memorial Committee decided that the Tynemouth site was indeed the better option and at the same time confirmed the London-based but locally-born Lough as sculptor.[8] By 23 April 1842 Lough had completed a model for the statue at his studio which was described as being 'of the heroic size, but much less than the statue itself'. Lough, an anonymous writer reported, 'has given a classical appearance to the statue, by partly clothing the figure in a boat-cloak, the folds of which are boldly modelled, and made to hang with grace and dignity. By this means the angular lines and uncompromising inelegance of modern dress are got rid of, and yet the character of the portrait preserved as to costume.'[9]

The statue, weighing 30 tonnes and 6.5 metres in height, was landed at Tynemouth three years later in August 1845 from the *Halcyon*, a London trader (the same ship that had brought E.H. Baily's *Earl Grey* to Newcastle in 1838) and straightaway placed on its pedestal. The latter, designed by the Newcastle architect John Dobson, was by then complete except for the flight of steps leading up to the terrace at its foot, on which it was planned to place cannon taken from the *Royal Sovereign*, Collingwood's ship at Trafalgar.[10]

From the start the Monument was badly received. Firstly, there were worries about the site. A letter in November 1842 to the Committee from the Junior Honorary Secretary, John Fenwick, claimed that engineers and the Board of Ordnance were convinced that the cliff was gradually falling into the sea and thus 'no one can insure [the Monument's] standing beyond a Period equal to the existence of the present Generation'.[11] Secondly, when at

last the Monument was finished, there was disappointment with the design itself. 'The proportions,' it was said, 'are colossal, and the pillar on which it stands is comparatively low. The effect, therefore, is not so good as it might be. "Thrift, thrift, Horatio." The lowness of the pillar arises from the lowness of the funds.'[12]

Indeed, by the end of the 1850s when plans for a George Stephenson Monument in Newcastle (see pp.97 and 149–52) were being discussed, there was general agreement that the Collingwood Monument, and in particular Dobson's pedestal, was a disaster.[13] Even the addition of the four cannon in 1848 was criticised; they did nothing more, it was said, than furnish 'lounges for our quiet Tynemouth visitors, and our sonnet-mongers with subjects for their muse'.[14]

[1] *Monthly Chronicle*, 1891, pp.512–16.
[2] Yarrington, A., 'Nelson the citizen hero: state and public patronage of monumental sculpture 1805–18', *Art History*, vol. 6, Number 3, September, 1983, pp.315–29. [3] Welford, R., *Monuments and Tombstones in the Church of St. Nicholas*, Newcastle, 1880, p.268. [4] Volume of Collingwood newspaper cuttings, 1838–40, 25 August 1838. [5] *Ibid.* [6] *Ibid.*, 10 September 1838. [7] *Ibid.*, 24 October 1840. [8] *Journal*, Newcastle, 31 August 1840. [9] *Ibid.*, 23 April 1842, quoting from a contemporary report in *The Times*. [10] *Ibid.*, 23 August 1845. [11] *Ibid.*, 3 November 1842. [12] *Ibid.*, 6 September 1845. [13] *Newcastle Daily Express*, 2 October 1858. [14] *Ibid.*, no date.

Station Terrace

Tynemouth Metro station, suspended from ceiling of westbound platform

Fish

Artist: Northern Freeform

Installed 1996
Whole work: wood, aluminium and papier mâché 9m long × 1.4m high
Attached sticker reads: Northern Freeform

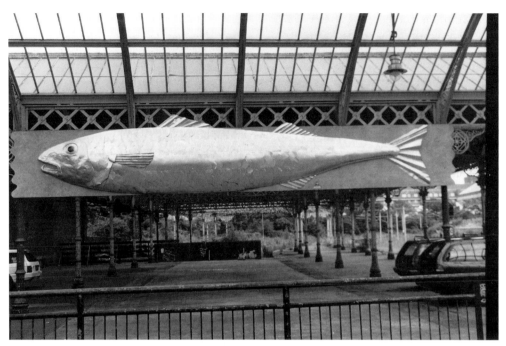

Northern Freeform, *Fish*

Status: not listed
Condition: good
Commissioned by: Fish Quay Festival
Custodian: North Tyneside Council

Description: a huge silver fish suspended above an area given over to a flea market at weekends. The body is made of a number of interlocked, very thin aluminium sheets and the head is moulded from papier mâché. The shiny fish stands out well against the blue of the station's wooden frame.

History: commissioned and made by Northern Freeform as part of their decorations for the 1996 Fish Quay Festival, this work was only intended to be in place for a few days. However, it has remained in the station ever since. The Fish Quay Festival was started in 1987 and has grown in popularity over the years: 1996 Year of Visual Arts UK gave extra impetus to the flamboyant nature of the event.

Tynemouth Metro station, interior wall of westbound platform

Mask

Sculptor: David Gross

Unveiled 27 October 1995
Whole work: lime-wood 1.3m high × 50cm wide
Status: not listed
Condition: good
Commissioned and owned by: Tyne and Wear Passenger Transport Executive (Nexus)

Description: a large lime-wood mask, set on a steel support in the middle of the wall above the

eastern concourse of the Metro station.

On one of the walls near the *Mask* is a mosaic made from highly coloured ceramic pieces and depicting a mermaid amongst a number of people.

Subject: the sculpture's fierce expression may be a reference either to fetish masks from the South Seas, or the actor's mask of tragedy.

History: carved by Gross with the help of a number of pupils from Norham Community High School, whose names were listed on a plaque nearby until this was removed when the mask itself was moved from a position further along the wall.

Mask was funded by a number of business sponsors and unveiled by the Mayor of North Tyneside.[1]

[1] *Journal*, Newcastle, 22 August 1995.

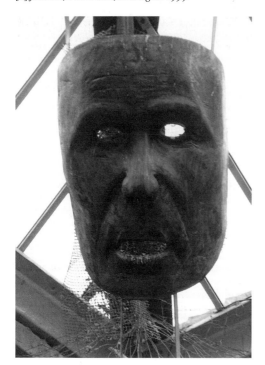

Gross, *Mask*

Tynemouth Road
Master Mariners' Homes, garden in front

Monument to the 3rd Duke of Northumberland

Sculptor: Christopher Tate
Completed by: Richard George Davies

Installed 1841
Sculpture: stone 2m high
Pedestal: stone 1.9m high × 1.1m square
Incised on front dado of pedestal:
NORTHUMBERLAND.
Metal plaque on pedestal: Unveiled 11th September 1937 by Duchess of Northumberland to celebrate the Master Mariners' Homes centenary.
Plastic plaque on pedestal: Unveiled by the Duke of Northumberland 7th July 1997.
Status: II
Condition: fair
Condition details: statue weathered to a dark grey with some loss of detail; droppings on statue head
Commissioned by: public subscription
Custodian: North Tyneside Council

Description: a white stone portrait statue of the 3rd Duke of Northumberland, standing in a proud pose and dressed in the robes of the Order of the Garter. Set on a yellow stone pedestal, the statue's dimension makes its subject look curiously insignificant.

Subject: Hugh, 3rd Duke of Northumberland (1785–1847) studied at Cambridge before being elected to Parliament in 1806. He become MP for Northumberland and Lancashire in 1807, speaking in favour of the Colonies Anti-Slavery Bill. Succeeding to the Dukedom in 1817, he was a man of moderate views, welcoming Catholic

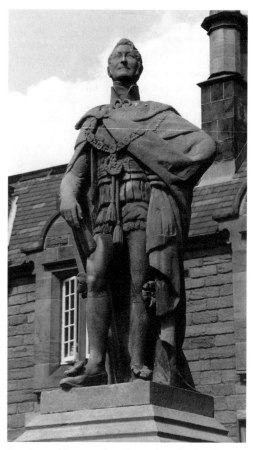

Davies & Tate, *Duke of Northumberland Monument*

emancipation and paying for most of his state duties out of his own purse. He was Viceroy of Ireland from 1829 but returned to England in 1830 after calls for Parliamentary reform led to civil unrest.[1]

In his capacity as Vice-Admiral of the Coast he took an interest in the exploits of Grace Darling and her father William in rescuing nine people from the wreck of the steamer *Forfarshire* off Bamburgh on 7 September 1838.

She was already fêted as a national hero, and the Duke became her guardian after presenting her with gold medals, money and household goods for her family.[2] He died at Alnwick Castle and is buried in Westminster Abbey.[3]

History: the presence of a statue to the Duke at the Masters Mariners' retirement homes is explained by his donation of the ground upon which they were built. In October 1839 the Master Mariners' committee resolved to erect a statue by voluntary subscription to perpetuate the Duke's memory, selecting Tate for the job.[4] The Duke sat for Tate several times and a visit was made to the sculptor's studio. After the Duke was made Lord Lieutenant of Northumberland, the anchor on which he was shown leaning was changed to a sword.[5]

Tate died before he could complete the commission, and his work was finished by Davies (under whom Tate had studied) before the statue's installation in 1841.[6]

[1] Society of Antiquaries, *Archaeologia Aeliana: Miscellaneous Tracts relating to Antiquity*, 3rd series, Newcastle, vol. X, p.151. [2] Smedley, C., *Grace Darling and Her Times*, London, 1932, *passim.* [3] Brennan, G., *A History of the House of Percy* (2 vols), London, 1902, *passim.* [4] *Port of Tyne Pilot*, North Shields, 18 April 1840. [5] *Ibid.*, 6 June 1840. [6] Latimer, p.118.

Master Mariners' Homes, niche on façade beneath clock

Master Mariners' Coat of Arms

Sculptor: not known
Architect: not known

Building opened 1841
Whole work: stone 2m high × 1m wide
Motto in raised letters: DEUS DABIT VELA
Incised in Roman letters on main block: MASTER MARINERS ASYLUM / THE FOUNDATION STONE OF THIS BUILDING / WAS LAID 18TH OCTOBER 1837 / UNDER THE AUSPICES OF THE / PATRON / HIS GRACE THE DUKE OF NORTHUMBERLAND /

TRUSTEES / JOHN FENWICK ESQ JP HENRY METCALFE ESQ JP / THOMAS YOUNG ESQ JP HENRY HEWITSON ESQ / ROBERT SPENCE ESQ / JOHN AND BENJAMIN GREEN / ROBERT POPPELWELL / ARCHITECTS NEWCASTLE JOSIAH [...]
Status: II
Condition: fair
Condition details: upper half extensively covered in droppings; weathered inscription stone
Commissioned by: Master Mariners' Committee
Custodian: North Tyneside Council

Description: a coat of arms set into a niche on the main façade of the almshouses. The horizontally-bisected shield is carved in relief with a grappling hook and anchor, and a curling motto underneath. Above this, a ship carved

Master Mariners' Coat of Arms

in the round tops the shield; and a stone beneath the shield carries the inscription, which also lists a number of benefactors including famous architects and bridge builders from the region.

History: completed in 1840, the Master Mariners' homes were for retired or incapacitated seamen. Seafarers were encouraged to subscribe to pension funds and local worthies contributed to the institution's coffers. The homes are in the Tudor style. The addition to the existing frontage of a 'well-sculpted shield... surmounted with a sculptural hull of a vessel' was recorded in 1841.[1]

[1] *Port of Tyne Pilot*, North Shields, 31 July 1841.

WALLSEND
North Tyneside Council

Archer Street
Memorial garden overlooking Burn Close

Wallsend First World War Memorial

Sculptor: not known
Designer: Newbury A. Trent of Chelsea

Unveiled 11 November 1925
Statue: bronze on polished granite 2m high
Obelisk: granite 6.5m high × 1.55m square
Incised Roman letters painted gold on string-course of obelisk: (south face) AT THE GOING DOWN (east face) OF THE SUN AND IN (north face) THE MORNING WE WILL (west face) REMEMBER THEM.
On south face of obelisk base: TO THE / GLORY / OF GOD / AND IN MEMORY / OF / THE MEN OF THE BOROUGH OF / WALLSEND / WHO GAVE /

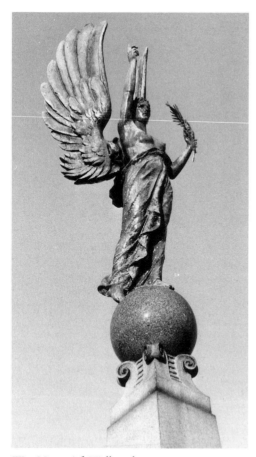

War Memorial, Wallsend

winged figure of *Peace*. Her arms are raised and she holds a palm leaf in her left hand. In low relief on the pedestal on the north face there is a cross and two palm leaves are on either side of the south face inscription.

History: permission to use the site was granted in June 1925. The memorial was unveiled in November 1925 by Mr Summers Hunter CBE[1] and cost £1,200.[2]

[1] *Shields Daily News*, 10 September 1925.
[2] N'land War Mems Survey, WMSW7.1.

Frank Street

Wallsend Memorial Hall, niche in façade

Swan Hunter War Memorial

Sculptor: Roger Hedley

Unveiled 15 August 1925
Cenotaph: stone, painted and bronze 2.95m high × 2m wide × 75cm deep
Each figure: bronze 2.95m high
Incised lettering on base of stone cenotaph:
THIS HALL IS ERECTED TO THE MEMORY / OF MEMBERS OF THE STAFF & WORKMEN OF / SWAN HUNTER & WIGHAM RICHARDSON LTD / WHO FELL IN THE GREAT WAR 1914–1918.
Signed on base of naval figure: R.HEDLEY SCULPTOR 1925 / SINGERS FOUNDRY
Signed on base of army gunner: R.HEDLEY SCULPTOR / 1925
Status: II
Condition: good
Commissioned by: Swan Hunter
Custodian: North Tyneside Council

Description: war memorial set into a whitewashed niche in the wall of the Memorial Hall. The central screen holds four bronze plaques with the names and regiments of the dead arranged around a carved relief depicting the Swan Hunter factory. The arch above contains a carved relief of a steamer at sea. To

THEIR LIVES / IN THE / GREAT WAR / 1914–1918 / ALSO 1939–45
Status: II
Condition: good
Condition details: graffiti inked on south face
Commissioned by: Wallsend War Memorial Sub-Committee
Custodian: North Tyneside Council

Description: a tall obelisk surmounted by a polished grey granite orb on which stands a

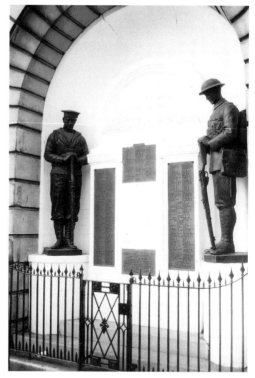

Hedley, *War Memorial*

either side are bronze life-size figures of a seaman and a gunner with reversed rifles. The whole is set behind railings.

History: this memorial, combined with the Hall and a Winter Garden, resulted from ongoing discussions between Wallsend Council and Sir G.B. Hunter as to a suitable monument to the town's war dead.[1] It was unveiled on Saturday 15 August 1925 by General C.H. Harington, who made a speech deploring North Tyneside's unemployment and the 'sickness' of the shipbuilding trade. Although formulaic in some respects, the relief carvings add a local poignancy to the memorial. It was described as 'both commemorative and

utilitarian' because it comprises 'the magnificent hall with an arresting monument'.[2]

[1] *Shields Daily News*, 4 May 1923. [2] *Ibid.*, 17 August 1925.

High Street

Junction with Station Road, pedestrian area

Market Woman

Sculptor: Hans Schwarz

Installed 1966
Statue: bronze 2.6m high × 80cm square
Base: bronze 92cm square
Signed on base: [illegible]
Status: not listed
Condition: good
Commissioned and owned by: North Tyneside Council

Description: a female figure holding a basket containing chickens on her head. Robustly modelled in a manner reminiscent of the work of Elizabeth Frink, the green-black bronze has weathered extremely well. The sculpture stands in a flower bed to one side of the Forum shopping precinct.

History: Schwarz explained the thinking behind this sculpture in a letter to a local schoolgirl. He said he was looking for realism, wanting the woman 'to appear as a tough, hardworking peasant, not a graceful girl'. The roughness of the surface was a deliberate attempt to indicate its hand-worked nature, and its 'patchy' colouration was a method of giving a pre-weathered look to the statue.[1]

Market Woman was commissioned by J. Seymour Harris and Partners, developers of the Forum shopping centre which was built in 1966 complete with 'eye-catching' mosaics.[2] The statue was originally sited on a low brick base, but was moved to its present position when the area was redeveloped in 1993. Greeted

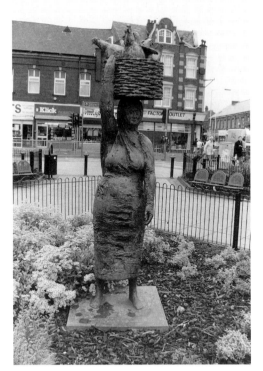

Schwarz, *Market Woman*

by a storm of criticism from locals, the sculpture was regarded by some as 'shameful' in its blunt portrayal of a working class woman.[3] However, it has proved to be just as resiliant to denigration and change as the woman it depicts, and remains an integral feature of central Wallsend.

[1] *Shields Weekly News*, North Shields, 8 September 1967. [2] *Ibid.*, 19 August 1966. [3] *Evening Chronicle*, 28 April 1967.

Station Road

Buddle Arts Centre, car park to rear

Groove

Sculptor: Richard Broderick

Installed 1998
Whole work: concrete wall and copper strip 1.2m high × 4.25m long × 28cm deep
Incised along copper strip: Groove (gruiv) n1. a long narrow channel or furrow especially one cut into wood by a tool. 2. the spiral channel in a gramophone record. 3. a settled existence, routine to which one is suited or accustomed. 4. sl. an experience, event etc that is groovy. 5. in the groove. a. Jazz. playing very well & apparently effortlessly with a good beat, etc. b. U.S. fashionable. Vb 6.(tr.) to form or cut a groove in. 7.(intr.) to enjoy oneself or feel in rapport with one's surroundings. 8.(tr.) sl. to excite 9.(intr.) sl. to progress or develop 10.(intr.) Jazz. to play well, with a good beat etc. Groove.
Status: not listed
Condition: good
Commissioned and owned by: North Tyneside Council

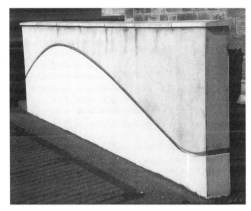

Broderick, *Groove*

Description: a concrete wall bisected by a curved groove, within which a narrow copper strip is laid upon the horizontal surface. The upper part of the wall has been left rough (and has a layer of algae) whilst the lower part is smooth and painted white.

History: this low wall had already been in place for about three years before it was decided to commission an artwork to embellish it. Costing £750, *Groove* alludes to the Buddle Art Centre's role in the community, with classes and exhibitions being held inside on a regular basis.[1]

[1] Information provided by Mike Campbell, NTC, 1999.

WHICKHAM
Gateshead MBC

B6314

Gibside, in wood at end of the Great Walk

Monument to British Liberty

Sculptor: Christopher Richardson
Designers: Daniel Garrett and James Paine

Completed by November 1757
Statue: stone 3.96m high
Column: stone 44.5m high × 6.15m square
Status: I
Condition: good
Commissioned by: George Bowes
Owned by: The National Trust

Description: a Roman Doric column surmounted by a drum with a statue of *Liberty* on top, dressed in classical drapery with hair drawn back in a knot. She holds in her right hand the staff of Maintenance with a bronze cap of Liberty on top and looks south-west along

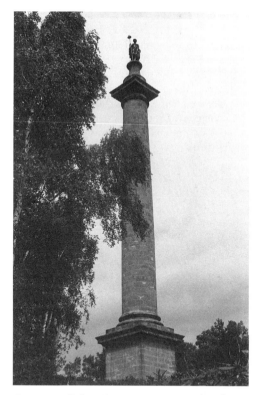

Garrett & Paine, *Monument to British Liberty*

the Great Walk towards Gibside Chapel. The column is remarkably tall, taller even than Nelson's Column in Trafalgar Square (1839–41).

Subject: it has been suggested that the choice of *Liberty* sprang from the spirit of exuberant nationalism in the country following the defeat of the Jacobite Rebellion in 1745, and which saw the composition of 'Rule Britannia' and 'God save the Queen'.[1] Interestingly James Thomson in his poem 'Liberty' refers to the staff of Maintenance and the cap of Liberty which indicates that the figure of Britannia may have been associated with Liberty. However, nowhere in the Gibside records is there any reference to Richardson's statue as 'British

Liberty'. Most likely the name was coined slightly later.

History: the column was commissioned by the coal-owner George Bowes (1701–60). On inheriting Gibside in 1722 Bowes used his enormous wealth to buy his way into politics, becoming mayor of both Hartlepool and Durham on several occasions and MP for Durham (1727–60). He also set about improving Gibside, first employing the architect Daniel Garrett (from 1744), and then James Paine (from 1753).[2]

The column rounds off the Great Walk (1746–9), the centrepiece of these improvements. A recent detailed and authoritative account of its construction suggests that it was probably designed by Garrett who had previously built a similar but

Richardson, *Monument to British Liberty* **(detail)**

smaller column with an *Apollo Belvedere* on top to celebrate the Peace of Aix-la-Chapelle in 1748 for Bowes's friend, Sir Hugh Smithson (later 1st Duke of Northumberland) at Stanwick Hall, North Yorkshire.[3] After Garrett's death in 1753 the column was completed under the supervision of James Paine.

Work began in September 1750 with boring for foundations and winning stones at Wheatleys Quarry, a kilometre from the site. Two years later in September 1752 scaffolding was erected. However, work then seems to have stopped for a while; there are records of the scaffolding being removed in October and November 1753.

As regards the statue, Bowes made a point of taking the best advice available; in 1751 he consulted the sculptor John Cheere in his workshop in the Haymarket, London (incidentally, the subject of a celebrated engraving in William Hogarth's *Analysis of Beauty*, 1753). Cheere suggested that a figure of Jupiter, Diana or Aurora would be appropriate but warned that whatever it was it should not be more than 12 feet high or else it would be too heavy to winch into position. He also recommended that Bowes should have a look at various statues on buildings in London including those on St Paul's Cathedral.

Three years later Bowes followed this advice and made a careful inspection of each of the statues Cheere had cited. Having calculated the size of the blocks needed for the task, he then commissioned Christopher Richardson of Doncaster to undertake the carving, presumably on Paine's recommendation, Richardson having earlier worked with Paine at Chatsworth. It should be noted, however, that, a letter from Paine to Bowes dated 27 July 1757 suggests that the design was Paine's rather than Richardson's: 'think the cap & Staff rising Abo the head of the figure make a better Group and particularizes the caracter preferable to the

height in the model. I think the proportion of the Cap & Staff in this drawing is not to be mended. The Joints also I think, do very well and can see no Objection to any one part, nor to the Whole.' Stone for the statue was quarried in February and March 1757.

By November 1757 the column and statue were complete. There is a record dated November 1757 that £8 14s. was paid 'For a Copper Staff and Cap for the Figure' and £5 15s. 6d. 'for 66 books of Leaf Gold for Gilding the figure' (the statue of Liberty may have been originally gilt). The final overall cost of the column and statue, as recorded in December 1759, was £1,601 18s. 9d., Richardson being paid £40 for his work.

In the 1990s the column was repointed and the statue repaired at a cost of £77,000.[4]

[1] Colley, L., *Britons. Forging the Nation 1707–1837*, New Haven and London, 1992. [2] Pevsner, *Co. Durham*, p.294. [3] Willis, M., *Gibside and the Bowes Family*, Newcastle, 1995, *passim*. [4] Information provided by Pamela Wallhead, National Trust, 1999.

B6317

St Mary's churchyard, north-west section

Monument to Harry Clasper

Sculptor: George Burn

Erected 1871
Statue: sandstone 1.8m high
Pedestal: sandstone 1.8m high × 3.5m wide
Incised black painted Roman letters on pedestal dado east face: BENEATH THIS MONUMENT, REARED TO HIS MEMORY, / BY THE ARDENT AFFECTION OF HIS FRIENDS AND ADMIRERS / FROM EVERY CLASS, AND FROM ALL PARTS OF THE / KINGDOM, AND IN THIS SACRED SPOT COMMANDING / A FULL VIEW OF THE NOBLE RIVER, THE WELL LOVED / SCENE OF FORMER TRIUMPHS, REST THE MORTAL / REMAINS OF / HENRY (HARRY) CLASPER, THE ACCOMPLISHED

Burn, *Clasper Monument*

OARSMAN AND BOAT BUILDER, / OF DERWENTHAUGH, / WHO DIED JULY 12TH 1870, AGED 58 YEARS. / KNOW YE NOT THAT THEY WHICH RUN IN A / RACE RUN ALL, BUT ONE RECEIVETH THE PRICE, SO / RUN THAT YE MAY OBTAIN, I COR IX, 24
Incised black painted Roman letters on pedestal base: G.BURN.M.S.A.
Status: II
Condition: fair
Condition details: part of Clasper's nose is missing and the statue generally eroded; chain protection missing; algae on west face of

pedestal and reverse of figure
Commissioned by: public subscription
Custodian: St Mary's Church, Whickham

Description: a statue of Clasper, depicted as a stocky figure dressed in normal day-to-day clothes. He stands on a high pedestal underneath a canopy in the Decorated Gothic style with crocketed arches, finials and central spirelet. His right arm rests on a bollard with a rope curled round and bullrushes growing up the side. His left hand holds a piece of paper with a design on it.

Subject: Harry Clasper (1812–70) was born at Dunston, worked briefly in his youth as a pitman at Jarrow, and then in 1831 moved back to Dunston to become a boatbuilder and professional oarsman. In July 1842 his four-man crew challenged the London Watermen on the Tyne and were beaten. This experience prompted him to adopt a new and revolutionary approach to boat design (keel-less boats, outriggers and scooped oars) and crew preparation (controlled diet and organised training).

On 26 June 1845 his efforts and ingenuity were rewarded when his boat, 'The Lord Ravensworth' beat the London Watermen on the Thames.[1] This confirmed him as the popular hero of Tyneside. In the words of one song at the time, 'Ov a' your grand rowers in skiff or in skull, / There's nyen wi' wor Harry has chance for to pull / Man he sits like a duke an' he fetchrs se fre, / Oh! Harry's the lad, Harry Clasper for me! HAUD AWAY HARRY! CANNY HARRY! HARRY'S THE KING OF THE TYEMS AN' THE TYNE.'

Over the next two decades rowing on the Tyne flourished as industry along the river prospered. Until association football replaced it in the 1870s and Armstrong's dredged the river at Dunston, rowing was a mass spectator sport in the district involving vast crowds, enormous sponsorship money, huge purses and massive

bets. During this period Clasper was universally recognised and fêted as the sport's pivotal figure: 'what Frederick the Great was of military matters, Harry Clasper is in boat racing.' He won £2,600 in prize money during his career and came to own a string of eight pubs (the drinking trade was closely linked to rowing), one of which, the palatial Clasper Hotel on Scotswood Road, was presented to him as a testimonial on 27 November 1862.[2] Well over 100,000 people lined the route of his funeral procession.

History: this is the second of three elaborate monuments to Tyneside rowing heroes executed by the local sculptor, George Burn, the others being to Robert Chambers at Walker (see p.138) and to James Renforth outside the Shipley Art Gallery (see pp.63–4). Clasper's non-rowing dress distinguishes him from these other figures. The monument stands near the gravestones of several members of the Clasper family. In the early 1990s, along with the tomb of Clasper's mother which stands nearby, it was repaired and cleaned by the council at a cost of £40,000, which was provided by English Heritage. Unfortunately the view down to the Tyne referred to in the inscription is nowadays partially obscured by buildings.

[1] Newspaper report 26 June 1845, quoted in Dillon, P., *The Tyne Oarsmen. Harry Clasper, Robert Chambers, James Renforth*, Newcastle, 1993, pp.21–2. [2] Clasper, D., *Harry Clasper. Hero of the North*, Exeter, 1990, *passim.*

Front Street

Opposite junction with Rectory Lane

Monument to John English

Sculptor: John Norvell
Restorer: Aidan Wallace

Installed 1854; restored 1977
Bust: sandstone 90cm high

Column: sandstone 3.2m high × 50cm square
Incised at top of column: J ENGLISH / 1854.
Incised lower down column: Donated by / BELLWAY to / Whickham Village MCMLXXVII / This monument / formerly stood in / Woodhouses Lane / Fellside
Status: II
Condition: good
Condition details: spalling of column; algal growth on bust
Commissioned by: public subscription
Custodian: Gateshead Metropolitan Borough Council

Description: a boldly-carved bust of English sandstone supported by a socle on a slim yellow sandstone column.

Subject: John English (c.1800–60) was

Norvell, *English Monument*

commonly known as 'Lang Jack' on account of his massive physical presence and natural strength. He lived in the Whickham area from 1830 onwards working on a number of construction projects as well as building his own house. Able to carry stones which would usually need four men to lift them, he was widely known for his displays of strength when out on a 'spree', and also for his involvement in marches supporting the Reform Bill. He died from over-exertion.

History: Lang Jack's popularity ensured that his likeness was installed on its tall column in his lifetime. Described as 'certainly an excellent likeness',[1] the bust stood in the garden of his house at Gibside unharmed until the late 1970s, when it was discovered broken in three pieces by vandals. The council informed the landowners, Bellway Homes, and the monument was subsequently restored by Wallace for the Tyne and Wear joint conservation team. It was then donated to the town by Bellway Homes and moved to the site in the middle of Whickham in January 1978 to ensure its long-term safety.[2]

[1] Thomson, A., *'House that Jack Built'*, *passim.*
[2] *Gateshead Post*, 12 January 1978.

Hexham Road
Entrance to Derwent Walk Country Park, top of wall

Derwent Walk Express
Sculptor: Andy Frost

Unveiled 9 October 1986
Whole work: plywood and steel 33m long × 1.5m high
Metal plaque on wall below: DERWENT WALK EXPRESS / by / ANDY FROST / unveiled by / NORMAN BUCHAN MP / 9 Oct 1986 / Funded by Tyne and Wear County Council / Gateshead MBC and Northern Arts

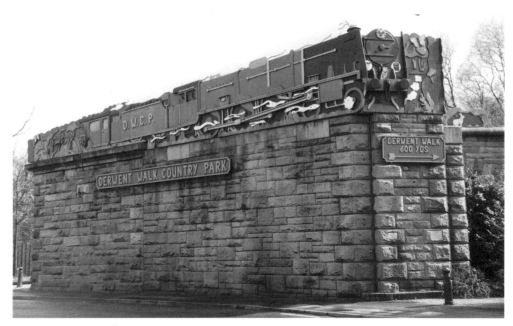

Frost, *Derwent Walk Express*

Metal plaque on wall below: BBC / TOWNSCAPE / AWARD / 1988
Status: not listed
Condition: good
Condition details: the paintwork has faded due to weathering
Commissioned and owned by: Gateshead Metropolitan Borough Council

Description: a two-thirds-life-size representation of a steam train in polychrome relief, set approximately five metres up on top of a stone wall. This forms a highly visible gateway to the Derwent Walk pathway which leads to the south. The wall turns several corners so that there are additional façades to the main length which fronts the road. Painted in bright primary colours, the train is depicted moving through an industrial and rural landscape, and small tableaux of animals and vegetation are sited on other angles of the wall.

Described as 'probably the only locomotive which tows its own passing landscape behind it', this colourful sculpture of a steam train also includes vignettes of wildlife and a power station.[1] Derwent Walk Country Park follows the line of an old railway used to transport coal, which has been replaced by a cycle and footpath. This ends in Rowlands Gill, about four kilometres to the south.

History: Derwent Walk Express was commissioned by Gateshead MBC as part of its public art programme in the mid-1980s and financed by the organisations credited on the plaque. The marine plywood construction was originally estimated to have a 30-year life-span and its cleaning and repainting are scheduled within the council's rolling maintenance programme.

[1] *Gateshead Art Map*, p.71.

Promenade

Spanish City amusement arcade, roof towers

Bacchanalian Figures

Sculptor: not known
Architects: Cackett and Burns Dick

Installed 1910
Each figure: lead 1.2m high
Status: II
Condition: fair
Condition details: thick green paint covers shiny silver metal surfaces, now weathered; splitting of metal where feet join the roof top; extensively covered in guano
Privately owned

Bacchanalian Figures (detail)

Bacchanalian Figures (detail)

Description: two half-life-size female figures situated on towers to each side of the entrance of the amusement arcade. Both are clad in animal pelts; one carries a cymbal, the other a tambourine. They adopt sinuous poses and have expressive, merry expressions. The sculptures are securely bolted to the tower roof tops but have some flexibility to cope with the sea winds.

Subject: sometimes referred to as *Terpsichorean Figures*,[1] though neither of the two dancers carries a harp or lyre (the usual attribute of the Muse of dancing and song),[2] the two dancers seem to be caught up in a bacchanalian frenzy.

History: Spanish City fairground was founded in 1908 and a dancing hall was added in 1910. The hall took only 82 days to build, being an early use of the Hennebique ferro-concrete system. Burns designed the dome which was apparently the second-largest unsupported one made from concrete in the country.[3] There have been a number of alterations over the years, including the removal of a roof garden, colonnade and domed canopies to the two towers, which the *Bacchanalian Figures* originally surmounted.[4]

[1] Henderson, P., *Whitley Bay, Past and Present*, 1989, *passim*. [2] Hall, J., *Dictionary of Subjects and Symbols in Art*, 1995 ed., p.217. [3] Information provided by Mr Paul Burrows, 1998 and 1999. [4] Makepeace, J., 'The Spanish City, Whitley Bay', unpub. BA dissertation, Newcastle University, 1992, *passim*.

Lost works

James II

Sculptors: William Larson and Jan Wijck

Erected 1688; removed 1689
Horse and rider: lifesize bronze
Commissioned by: Newcastle Common
Council

Description: there has been some debate as to
what the equestrian statue of James II looked
like. It is now thought that it was similar to a
statuette of the King by Larson which is in the
National Gallery of Ireland in Dublin.[1] Recent
research suggests that the statue was begun as a
portrait of Charles II and then adapted as the
new king. The face of the Dublin statuette is
too round for James II and also lacks James's
cleft chin.[1]

The pose of the horse with its front feet off
the ground in the *levade* position, symbolising
the idea of rulership, appears to have been
derived from Pietro Tacca's equestrian portraits
of Philip IV of Spain (1636–40) and Louis XIII
of France (1617). These in turn were derived
from Leonardo da Vinci's studies for equestrian
monuments at the end of the fifteenth century.
If indeed the full-scale work was in this pose it
would have been the first time an unsupported
levade was achieved in a large-scale equestrian
statue.[2]

Subject: James II (1633–1701), second son of
Charles I, converted to Roman Catholicism
during Charles II's reign (1660–85). Following
his own accession in 1685, his attempted

Larson and Wyck, *James II* (National Gallery
of Ireland)

arbitrary rule and favour to Catholics led Whig
and Tory leaders to invite William of Orange to
take the throne in 1688 forcing him to spend his
remaining years in exile in France.

History: early in 1686, following the example
of a number of bodies in the country, the
Newcastle Common Council decided to show
their loyalty to James II by erecting 'His
Ma:ties Statue' (*sic*). On 12 April 1686 a

contract was duly drawn up stipulating that
William Larson of London was to be the
sculptor and that the overall cost was not to
exceed £800 nor to take more than five months.
'William Larson shall and will at his owne costs
and charges according to such direccion and
advice as shall be given him by Sir Christopher
Wren (his Majestyes Surveyour generall) make
and cast the ffigure of his majesty King James
the Second in good Cannon Brass in moderne
habitt on a Capering Horse as large as that of
his late Majesty King Charles the First at
Charing Cross on a Pedestall of Black and
White Marble of equall height and Magnitude
to the said ffigure.' However, despite these
stipulations, the statue, it seems, took longer
than the five months allowed, the last payment
being made to Larson on 4 September 1688.
Larson, it is now thought, was probably helped
with the modelling of the horse by Jan Wijck
who was renowned at the time for his painting
of equestrian subjects.

The completed statue enjoyed an
exceedingly short life. There had always been
those who saw its erection as papist propaganda
and, following the Glorious Revolution, it was
pulled down by an unruly mob on 11 May
1689. The metal for the horse was given to All
Saints Church, Newcastle, to be cast into a set
of bells.[3]

[1] Information provided by Lady Gibson, 1999.
[2] Liedtke, W., *The Royal Horse and Ruler in
Painting, Sculpture and Horsemanship 1500–1800*,
New York, 1989, *passim*. [3] Toynbee, M, 'Fresh
Light on William Larson's Statue of James II at
Newcastle upon Tyne', *Archaeolgia Aeliana*, 4th
series, XXIX, 1951, pp.108–17.

Barrack Road SPITTAL TONGUES

50m north-east of lodge in Leazes Park

Monument to Alderman Hamond
Sculptor: not known

Erected 1 February 1908; removed 1990
Statue: bronze
Pedestal: stone 90cm high × 50cm square
Incised on pedestal: ALDERMAN / CHAS FRED
HAMOND / JP DL / ERECTED 1ST FEB 1908 / TO /
COMMEMORATE / HIS SERVICES / IN OBTAINING /
THIS PARK / IN / 1872 / PALMAM QUI MERUIT
FERAT
Status: II
Custodian: Newcastle City Council

Description: a bronze bust of Hamond atop a
plain stone pedestal.
Subject: Sir Charles Frederick Hamond
(1817–1905) was born at Blackheath and came
to Newcastle in 1838 as a businessman
connected with the Spanish silver lead trade. He
was elected a Councillor in 1852 and became a
key figure in the public life of the town.
Hamond represented Newcastle in Parliament
from 1887 to 1900 and from 1892 to 1900, and
was knighted in 1896.[1]
History: the bust commemorated Hamond's
part in piloting the Town Improvement Act of
1870 through Parliament which gave Newcastle
its first public park, Leazes Park. It was stolen
*c.*1990, though the pedestal remains *in situ.*

[1] Pike, W. (ed.), *A Dictionary of Edwardian
Biography – Northumberland*, Edinburgh, 1985,
p.270.

Heaton Park View HEATON

Heaton Park

Rabbie Burns
Sculptor: not known

Erected 1901; re-sited 1975; removed 1984
Pedestal: stone 2m high approx
Statue: bronze 1.8m high approx
An inscription recording the donation of the
statue by members of the Burns Club ran
around the bronze base to the
figure.
Commissioned by: Burns Club
Custodian: Newcastle City Council

Description: bronze statue of Burns atop a
stone pedestal.
History: a statue of the Scottish poet Rabbie
Burns was originally erected in Walker Park in
1901, as the result of fund-raising efforts of the
local Burns Club, possibly through charity
football matches. The bronze figure stood with
outstretched arm on top of a circular pedestal.
It was the subject of vandalism, and was
removed and repaired in 1975, before being re-
sited to Heaton Park, about 1½ kilometres
away. Vandalism continued to be a problem and
the statue was finally broken into several pieces,
which were eventually taken away to be stored
by the Council in 1984. Despite a resurgence of
interest in the piece in 1994, it was deemed too
damaged to repair.[1]

[1] *Journal*, Newcastle, 18, 22 and 26 March 1994.

Scotswood Road CRUDDAS PARK

Untitled
Sculptor: Ken Ford

Unveiled 1962; removed 1975
Whole work: bronze 4m high approx
Commissioned by: Newcastle City Council

Description: an abstract form reminiscent of
work by Henry Moore.
History: Cruddas Park is a development of
six high-rise blocks around an open space to the
west of the city centre which formed part of
city council leader T. Dan Smith's concept for a

'Brasilia of the North'. Landscaped to the
design of Professor J.S. Allan and Peter
Spooner, a 1960 council press release advertising
the scheme described it thus: 'Whilst at the
present time the site has no pleasant
characteristics, it is the firm intention of the
housing committee to lay out the new Cruddas
Park with landscaping and other features which
will ensure that the whole development shall be
as attractive as possible as a background to
living and as an amenity to the city.'[1] A
competition for a sculpture was launched at this
time, with the Council offering a prize of
£1,250 and up to £1,000 for materials.
 The sculpture was unveiled by the Labour
leader Hugh Gaitskell. However, 13 years on it
was removed without consultation by the
recreation department for urgent repairs to its
base, as it was thought in danger of toppling
over.[2] It was never replaced. Councillor Arthur
Stabler later said, 'It was meant to be modern
art. We all thought it was an early-warning
system'. Enquiries by the *Journal* did not
manage to trace either the sculpture or Ford, its
maker.[3]

[1] City and County of Newcastle upon Tyne,
*Competition for a Work of Sculpture to be Placed in
the Redeveloped Cruddas Park*, Newcastle, 1960,
passim. [2] *Evening Chronicle*, 11 April 1975.
[3] *Journal*, Newcastle, 31 July 1993.

Citadel East

Stephenson Shopping Centre, façade

Locomotive
Sculptor: Charles Sansbury

Installed 3 October 1971; removed *c.*1986
Whole work: galvanised steel 4m high × 20m
wide approx

Commissioned by: North Tyneside Council

Description: a large cut-steel relief attached to a pedestrian overpass above the road, which also contained the 'Puffing Billy' pub. The sculpture depicted one of Stephenson's early locomotives with 'force lines' to illustrate its movement along the track.

History: Locomotive was commissioned by Costain Property Investments Ltd to decorate the side of a pub which formed a bridge over the main road through Killingworth's centre.[1] It symbolised the town's association with the railway pioneer George Stephenson, who lived there from 1804 working as a brakesman with the West Moor Colliery. His early locomotive 'Blucher' was tested at Killingworth in 1814. Vickers loaned the biggest galvanising bath in the world in order to rust-proof the work[2] before installing it with a crane.[3]

Killingworth township was built on the site of demolished mine workings to the designs of Roy Gazzard, though concrete towers replaced his original vision of brick and ivy-clad houses. Begun in 1963, it was opened in 1972 by Henry Cooper, and by 1974 the development was 'clearly a big success'.

Unfortunately, the optimism was short-lived. Concrete started to crumble, roofs leaked and there were continuous problems with litter and noise. Demolition of the towers started in 1986, and the shopping centre was knocked down after several arson attacks.[4] *Locomotive* must have been removed at this time, though nothing is known of its fate.

[1] *Killingworth Development Group Newsletter*, 2 November 1971. [2] *Northern Echo*, 22 May 1971. [3] *Journal*, Newcastle, 4 October 1971. [4] *Ibid.*, 22 October 1987.

Northumbrian Way

Norgas House

Horns of Minos

Architects: Ryder, Yates and Partners

Building erected 1966; work removed at an unknown date
Whole work: fibreglass 8m high × 5m wide approx
Commissioned by: Northern Gas

Description: a striking architectural element of Norgas House, originally functioning as an air inlet. Made from smooth white fibreglass and plastic, its sweeping white curve resembled the horns of a bull, and was positioned on top of the restaurant.

History: there is some disagreement as to the classification of this work as it is variously referred to as a 'sculpture'[1] and an 'architectural element'. What is clear is that the original design of Norgas House was regarded as innovative and modern, winning an RIBA regional award in 1966.[2] Special attention was drawn to *The Horns of Minos*, a replica of a work at the Temple of Minos, which was the idea of architect Peter Yates who had been on holiday in Crete.[3]

Originally, the sculpture acted as a roof-light, diffusing daylight into the servery and restaurant located on the south side of the main building.[4] However, a later though undated picture shows the *Horns* relocated to the grass verge on the north side of the building by the lake shore.

Norgas House and the *Horns of Minos* were a notable example of modernist design, fitting a vision of Killingworth as a place of style and opportunity. Unfortunately the sculpture is no longer present at the building, and research has failed to determine its fate.

[1] Pevsner, *Northumberland*, p.363. [2] *RIBA Journal*, vol.73, no.7, July 1966, p.303. [3] *Journal*, Newcastle, 1 July 1966. [4] *Architectural Review*, vol.139, no.830, April 1966, pp.256–61.

Ryder, Yates and Partners, *Horns of Minos*

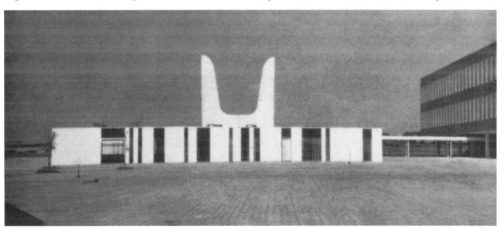

County Durham

ANNFIELD PLAIN

B6168

C2C cycle route

Kyo Undercurrent
Artist: Richard Harris

Installed June 1989
Whole work: reclaimed stone 80m square
approx

Status: not listed
Condition: fair
Condition details: grass, moss and other
biological growth
Commissioned and owned by: Sustrans

Description: a series of curvilinear walls of
reclaimed stone set into a large area of sandy
hills. Sited at the meeting point of several paths,
the structures have attracted a build-up of litter
and debris.

History: unlike other sculptures along the
Whitehaven to Sunderland C2C cycle route (see
p.84) which refer to the locality or connect with
the heritage of the district on a conceptual level,
Kyo Undercurrent relates to the particular
geographical features of its site. The sculpture is
based in and around a sand-hill formed in the
last ice age, the cycle track and an existing
network of paths made by people crossing the
land. In a statement about the work Harris
wrote: 'The sculpture acts as a mediator
between the track and the surrounding land. It
is important that people can experience the
sculpture in their own time – it needs to be
there for people to discover.' [1]

[1] Artist's statement, Sustrans, 1998.

Harris, *Kyo Undercurrent*

BARNARD CASTLE

Flats Road

*Barnard Castle, Roman Ford Picnic
Site*

The Dive, The Surface, The Roll
Sculptor: Keith Alexander

Installed January 1998
Each work: grey and yellow stone 2.14m high
approx × 2.8m wide × 60cm deep
Incised on the leg of each seat the respective
title of the work: THE DIVE / THE SURFACE / THE
ROLL
Status: not listed
Condition: good
Commissioned and owned by: Teesdale District
Council

Description: three figurative seats carved in

grey and yellow stone. *The Dive* features the torso of a female figure diving into water, *The Surface* portrays the same figure returning to the surface, and *The Roll* represents a dead sheep. Sited in a paved picnic area the seats surround a circular mosaic of clay fish, waves and ducks.

History: under Teesdale District Council's Artist-in-Residence Scheme, Alexander was based at a quarry near Staindrop where he designed and produced three functional sculptures for sites at Cockfield, Holwick and Barnard Castle. Each community-based work is a response to subject-matter suggested by local people and connects with one of three themes: village; moor; river (*Green Seat, Moor or Less,* see pp.228–9 and 261–2).

A former gasworks site at the base of Barnard Castle was chosen as the first location for Alexander's work. Situated near to the River Tees, the seats and mosaic refer to local stories of 'the roll', a large wave of water that, before the making of the Cow Green Reservoir, regularly caused havoc on its journey down stream from Middleton-in-Teesdale. While local children enjoyed the benefits of extra water in the Tees (the nearby river was not usually deep enough to swim in), the roll was known to drown animals and damage crops en route.

The Roman Ford Picnic Site sculptures were sponsored by Glaxo Wellcome as part of their celebrations of 50 years in Teesdale and by Marshalls Clay Products. Additional funding for the year-long Teesdale Sculpture Residency was received from the Association for Business Sponsorship for the Arts; Dunhouse Quarry; Durham County Council, the Regional Development Fund; Northern Arts and the Northern Sponsors Club.[1]

[1] Information provided by Teesdale District Council, 1999.

Harmire Road (B6278)

Glaxo Wellcome factory, car park entrance

Glaxo Gate
Sculptor: Keith Alexander

Installed 1993
Whole work: oak and stone 62cm high × 2.55m wide × 1.4m deep
Status: not listed
Condition: good
Commissioned and owned by: Glaxo Wellcome UK Ltd

Alexander, *Glaxo Gate*

Description: a sculptural entrance feature in stone and oak. The work comprises two parts: at the rear a representation of a wooden gate, in fact immovable and made of stone; at the front a swinging gate carved into the form of three sheep, painted and varnished.

History: in Teesdale's 'first per cent for art scheme', Glaxo commissioned the local artist Keith Alexander to design an entrance feature to their new extension.[1]

[1] Information provided by Keith Alexander, 1999.

BEAMISH

A693

C2C cycle route, under bridge, near Beamish Open Air Museum

Beamish Shorthorns
Sculptor: Sally Matthews

Installed 1990
Each cow: JCB parts and other scrap metal approx 1.3m high × 3m long × 80cm wide
Status: not listed
Condition: good
Commissioned and owned by: Sustrans

Description: four cows welded from scrap metal parts. Each rust-coloured animal stands alongside the pathway as though grazing.

History: made in the winter of 1990, *Beamish Shorthorns* were modelled on local animals and made of Consett steel. An old train shed at Beamish Museum, with its accompanying views of a herd of rust-coloured shorthorns became the artist's workshop in the initial stages of the

Matthews, *Beamish Shorthorn*

sculptures' construction. Later a pipe factory at Hebburn was used.

Matthews, who chose this part of the C2C pathway (see p.84) in order that the adjacent bridges and trees would provide a 'frame' for her work, described the installation of the sculptures as 'like putting the cows out to pasture after a long winter in the shed'.[1]

[1] Information provided by Sustrans, 1998.

Shepherd and Shepherdess Inn, above entrance door

Shepherd and Shepherdess
Sculptor: not known

Cast *c.*1796–1815; installed at this site *c.*1870
Each figure: painted lead 1.7m high approx × 50cm wide approx
Status: II
Condition: good
Condition details: damaged crook; some cracks to paint work; dirty
Custodian: Vaux Brewery, Sunderland

Description: situated above the door to the pub, two life-size lead figures representing a shepherd and shepherdess in period costume. The shepherd appears to be playing the pipe to the shepherdess who holds a lamb in one arm and a crook in the other.

History: the figures are said to date from the Napoleonic Wars (1796–1815) when the production of England's armaments and munitions was restricted by a French blockade on lead. As part of clandestine measures to import the metal without detection, lead works of art were commissioned abroad. One of ten pairs of figures brought from the Continent to be melted down for weaponry, the *Shepherd and Shepherdess* escaped their intended fate when the squire of Beamish Hall purchased them.

Originally installed above the entrance to the

Shepherd and Shepherdess

Hall, they were later moved to the lawn when a storm destroyed the accompanying figure of a dog. In 1870, according to local legend, the squire was returning home after a night's drinking and stumbled on the figures in the dark. The experience was such a shock that he gave the pair to the inn at Beamish. Thereafter the pub was known as the Shepherd and Shepherdess Inn.[1]

[1] Perry, P. and Dodds, D., *Curiosities of County Durham*, Seaford, 1996, p.53.

Edenhill Plantation

Stone Cone
Sculptor: Colin Rose

Installed 1996
Whole work: stone and mortar 5m high × 2.6m diameter
Status: not listed
Condition: good
Condition details: covering of green algae at base
Commissioned and owned by: Great North Forest

Rose, Stone Cone

Description: a large conical form made of horizontally-laid shallow slabs of stone. Algal growth has coloured the base a deep green. The sculpture stands in a glade of trees at the meeting point of three paths.

History: Rose was the winner of a national competition to find an artist-in-residence for Great North Forest's 'Marking the Ways' Scheme. Having worked on several outdoor sculptures in the North-East using steel or wood he found that his work was susceptible to vandalism and, according to the commissioner, this prompted his decision to work with stone.[1] The idea of a cone was a response to the particular character of the forest site (chosen by

the sculptor himself) and to such regional architectural features as cairns and church spires.[2]

Stone Cone was constructed on location. Work began with a central metal pole around which an armature of metal and rocks was attached. Using techniques similar to those employed in dry stone walling layers of stone were built from the ground upwards around the central mass.

[1] Information provided by Chris Growcott, Great North Forest, 1999. [2] GNF, *Arts in the Forest*, p.14.

CHESTER-LE-STREET

A693

C2C cycle route, under main road as it enters Chester-le-Street

Lambton Earthwork

Sculptor: Andy Goldsworthy
Assistant: Steve Fox

Completed December 1988
Whole work: spoil and waste materials 3m high × 400m long approx
Status: not listed
Condition: fair
Condition details: large cracks and splits on some banks; water collection; loose spoil; weeds, thistles and wildflowers grow on work
Commissioned and owned by: Sustrans

Description: a large earthwork of raised and moulded spoil arranged in a serpentine form along the course of a former railway track. Pools of water have collected between the loops and plants and weeds now grow on the sculpture.

History: when Sustrans (see p.84) invited proposals from artists for sculptures to be sited on their Consett and Sunderland C2C Cycle

Goldsworthy, *Lambton Earthwork*

Path in 1988, they stipulated that each work should reflect, in some way, the history of the local area. Goldsworthy's design of a serpentine earthwork to be located near the site of the killing of the legendary gargantuan Lambton Worm, apparently matched the criteria and the artist was given the first commission.[1]

A well-known north-east song has immortalised the centuries-old story of the Lambton Worm. The tale goes that the wayward son of Lord Lambton, out fishing in the Wear one Sunday caught only a worm. Disappointed, he threw his catch into a nearby well. Over the years the worm grew until, the size of a gigantic dragon, its appetite could only be satisfied by feeding on man, child and beast. Lambton's son eventually rid the county of the terrifying creature after wrestling with it in the Wear.[2]

Interestingly the sculptor claims that he had no previous knowledge of the legend when designing the work. His intention was to construct an abstract form which would respond to the extant site and materials and comment on the notion of travel and distance suggested by the nearby disused railway: 'The work starts narrow and ends wide – giving a sense of direction. I wanted a feeling of movement – of earth rising up and flowing – a river of earth.'[3] Despite Goldsworthy's intention, his earthwork, which at some 400m in length, is large enough to be included on some Ordnance Survey maps, is now popularly known as *The Lambton Worm*.

[1] Information provided by Sustrans, 1998. [2] Hind, A., *History and Folklore of Old Washington*, Coxhoe, 1976, pp.120–2. [3] Artist's statement, Sustrans, 2 December, 1988.

Front Street TOWN CENTRE

St Cuthbert's Walk Shopping Mall, rear entrance

Dainty Dinah

Sculptor: not known
Designer: William Barribal

Originally erected 1911; installed at present location on 21 March 1991
Bust on base: painted ceramic 1.25m high
Pedestal: brick 1.23m high × 1.53m wide × 1.54m deep
Incised in Roman letters on a nearby bronze plaque: DAINTY DINAH / DAINTY DINAH WAS 'BORN' AT THE STAG TOFFEE WORKS, CHESTER-LE-STREET, IN 1911, THE CREATION OF GEORGE W HORNER, / A LOCAL CONFECTIONER. IN 1917 HE COMMISSIONED THE ARTIST WILLIAM BARRIBAL TO REFINE DAINTY DINAH'S IMAGE AND PRODUCE / AN EYE-CATCHING TRADE MARK THAT STOOD LITERALLY HEAD AND SHOULDERS ABOVE ITS COMPETITORS. / THIS POTTERY REPLICA OF BARRIBAL'S PORTRAIT SAT HIGH ABOVE THE FACTORY WORKSHOPS AND DAINTY DINAH BECAME / A HOUSEHOLD NAME, BRINGING A HALF CENTURY OF FAME AND FORTUNE TO THE HORNER COMPANY. WHEN THE FACTORY FINALLY / CLOSED THE FAMOUS LANDMARK FELL FROM PUBLIC VIEW / DAINTY DINAH HAS NOW BEEN RESTORED BY CHESTER-LE-STREET DISTRICT COUNCIL AND REINSTATED TO A PROMINENT POSITION / IN ST. CUTHBERT'S WALK SHOPPING MALL, ONLY A FEW HUNDRED YARDS EAST OF WHERE SHE WAS IN FORMER DAYS – A PIECE OF OLD / CHESTER-LE-STREET HAPPILY MARRIED TO THE NEW. / 21 MARCH 1991 DAINTY DINAH WAS UNVEILED BY BRYAN ROBSON, CAPTAIN OF THE ENGLAND FOOTBALL TEAM, TO MARK THE OFFICIAL OPENING / OF THE ST. CUTHBERT'S WALK SHOPPING MALL, DEVELOPED BY FORD SELLAR MORRIS PROPERTIES PLC.
Status: not listed

Dainty Dinah

Condition: good
Commissioned by: George W. Horner
Custodian: Chester-le-Street District Council

Description: a polychrome painted ceramic bust of a bonneted lady in period costume. The figure is encased in a clear plastic box and set on a brick base.
History: in the 1920s Horner's Chester-le-Street factory produced up to 2 million sweets a day and employed as many as 2,000 workers. Dainty Dinah toffee, its most popular line, became a big seller on the British market and was eventually exported to 150 countries worldwide.[1]

In 1989 a small display case of Horner memorabilia exhibited in Chester-le-Street library generated such interest in the town's old factory that a much larger exhibition was organised a year later. Promotion literature for the 'Sweet Memories' event, held to coincide with the 30th year since closure of the factory, included the question 'Who was the real Dainty Dinah?' Several people phoned the library to claim their mothers as the inspiration of George Horner's bonneted lady. The exhibition brought visitors from across the British Isles and attracted interest as far away as Canada and Germany.[2]

Meanwhile *Dainty Dinah* had been found surrounded by a heap of tyres in a council depot. Restored by the council for the opening of the new £4.5 million shopping mall in 1991, the bust was unveiled in a ceremony attended by approximately 1,000 people.[3]

[1] Durham County Council, *Sweet Memories of George Horner & Co. Ltd., Manufacturer of Confectionery Specialities*, Durham, 1990.
[2] Information provided by Joan Robinson, Chester-le-Street Library, 1999. [3] *Northern Echo*, 22 March 1991.

Park Road South RIVERSIDE

Chester-le-Street's 'Art in the Landscape' project began in 1993. Alongside plans for a major redevelopment of the riverside, which were to include a footpath, wildlife area, housing and a new ground for County Durham Cricket Club, six artists were commissioned by the local council to explore ways of introducing a number of design features into the 50-hectare site. Working in collaboration with local residents and schoolchildren, the designers produced a series of decorative railings, gates and seats.

In 1996, in celebration of the year of Visual Arts UK, Chester-le-Street District Council invited several artists to produce a further scheme of sculptures, seats and way-markers

for the Riverside walk. The second stage of the redevelopment of the riverside area began in 1998 when two artists and a writer were commissioned to work with landscape designers on the creation of decorative features for the old Riverside Gardens, a park originally laid out in the 1930s. With a brief to connect their work to the ideas of the local astronomer and local landscape designer, Thomas Wright (1711–86), a series of sculptures relating to the theme of the solar system was installed.[1]

[1] Chester-le-Street District Council, *Chester-le-Street Riverside*, 1996.

Riverside South, *wildlife area*
Carved Seats
Sculptor: Keith Barrett

Installed 1995
Each work: oak and beech wood 1m high × 2.37m wide × 1.8m deep approx
Status: not listed
Condition: poor
Condition details: loose elements where rot has set in; small cracks and splits in many areas; superficial algal growth; large areas of inked graffiti
Commissioned and owned by: Chester-le-Street District Council

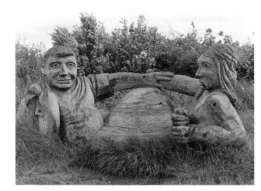

Barrett, *Carved Seat*

Description: two carved seats located in the wildlife area of the Riverside Walk. One represents two frogs frolicking with a ball, the other a reclining couple linking arms. Both seats consist of large pieces of roughly carved wood fixed together with metal bolts and wooden pegs.

Riverside South, *pathway*
Way-markers and Seat
Sculptor: Fred Watson

Installed 1996
Each way-marker: granite 2.2m high × 50cm wide × 28cm deep average
Seat: granite 55cm high × 2.42m long × 49cm deep
Status: not listed
Condition: good
Condition details: algal growth on granite seat
Commissioned and owned by: Chester-le-Street District Council

Description: three grey granite sculptures approximately 30 metres apart alongside the riverside footpath. Two are way-markers and the third is a seat. Each way-marker takes the form of a tapering column and is carved with diagonal striations and curved ridges. The seat comprises two polished blocks of curvilinear stone, laid horizontally side to side.

Watson won a commission to execute a series of sculptural works for the Riverside walk through a national competition organised by Chester-le-Street Council in 1996, year of Visual Arts UK. The undulating forms evident in each seat or sculpture relate to the theme of water.[1]

[1] Chester-le-Street District Council, *Chester-le-Street Riverside*, 1996.

Watson, *Way-marker*

Park Road Central
Riverside Gardens

Mars Garden
Sculptor: Roger Dickinson

Installed October 1998
Whole work: glass fibre, powdered rusted steel 2.25m high × 1.8m diameter approx
Status: not listed
Condition: fair
Condition details: surface layer crumbling in

Dickinson, *Mars Garden* (detail)

some areas
Commissioned and owned by: Chester-le-Street
District Council

Description: the main work comprises a
spherical form with spikes above a curved
pedestal. It stands at the centre of two related
works, a steel plated seat and a table.

Dickinson's designs for *Mars Garden*
comprise a seat, chessboard table and sculpture
each coated in rusted steel in imitation of the
red-coloured planet. The central sculpture,
which the artist describes as being 'part chess
piece, part medieval mace' also makes reference
to Mars, the Roman god of war. Nearby
architectural features, the *Root House* and *Sun
Temple* also designed by Dickinson, are
intended to be symbolic of the Earth and Sun.[1]

[1] Information provided by Roger Dickinson, 1999.

Lockett, *The Milky Way*

The Milky Way
Sculptor: Isabella Lockett

Installed 1998
Whole work: stone and fibreglass 1.6m high ×
20m wide × 15m deep approx
Incised on one of the largest spherical forms at
the rear and apex of the work: THE MILKY WAY
Incised on its counterpart: VIA LACTEA
Incised on steps from apex to base: three of the
finest Sights in Nature / a rising Sun at Sea / a
verdant Landscape with a Rainbow / and a clear
Starlit evening … Thomas Wright
Status: not listed
Condition: good
Commissioned and owned by: Chester-le-Street
District Council

Description: a sculptural representation of
the Milky Way comprising hundreds of stones
and man-made spheres of various sizes, many
of which bear one-word inscriptions.

Lockett's work for the Riverside Gardens
responds to the theories of the local astronomer
Thomas Wright (1711–86) who discovered that
the Milky Way, or Via Lactea, was an optical
effect caused by the layering of stars. Wright is
quoted on the steps of the sculpture.[1]

[1] Chester-le-Street District Council, *Chester-le-
Street Riverside*, 1996.

COCKFIELD

Front Street
Village Green

Green Seat
Sculptor: Keith Alexander

Installed March 1999
Whole work: grey and yellow stone 1.4m high
× 2.47m wide × 50cm deep

Status: not listed
Condition: fair
Condition details: dirt-stained
Commissioned and owned by: Teesdale District
Council

Description: a sculptural seat carved from
grey and yellow stone. The figures of two boys
at one end of the seat appear to chase a football
at the other. The work is decorated with floral
reliefs.

Subject: Green Seat was Alexander's
response to interviews he held with members of
the Cockfield community. A theme of leisure
and sport was chosen after discussions revealed
that the local football team reached the FA Cup
Final in the 1920s. Cockfield is also unusual in
that the right to play ball games on the green is
protected under local law. The seat was
commissioned by the district council in the final
phase of the Teesdale Sculpture Residency *(The
Dive, The Surface, The Roll* and *Moor or Less,*
see pages 222–3 and 261–2).[1]

[1] Information provided by Teesdale District
Council, 1999.

CONSETT

A692

*C2C cycle route, above Templetown
roundabout*

Terris Novalis

Sculptor: Tony Cragg

Unveiled 22 September 1997
Theodolite: stainless steel 5.6m high × 2.8m
diameter approx
Surveying equipment: stainless steel 5.45m high
× 3.2m diameter approx
Status: not listed
Condition: good
Condition details: slight corrosion in parts;

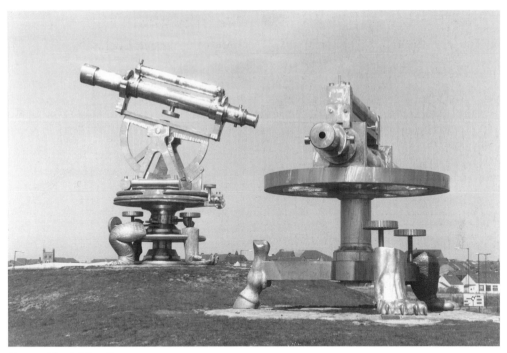

Cragg, *Terris Novalis*

pockets of rust at base
Commissioned and owned by: Sustrans

Description: giant versions of two
nineteenth-century surveyor's instruments in
stainless steel: a theodolite (used for measuring
horizontal angles) and a level (used for
establishing the relationship between a surface
to the horizontal). The base of the theodolite
has been fitted with steel representations of
severed limbs, a human hand, a horse's foot and
the foot of a lizard-like creature. The level
stands on a horse's foot, a lion's paw and the
foot of a lizard-like creature. The two pieces are
positioned slightly apart and stand on the site of
the former Consett steelworks beside the
Sustrans C2C cycle path (see p.316).

History: Terris Novalis (literally 'in newly
cultivated lands') is based on a gallery work of

the same title of 1992, in which, to quote the
words of one critic, 'animal and
anthropomorphic magnetically enter into a
dreamlike, ecstatic dialogue with the object'.[1]
However, in its setting at Consett the work is
more a comment on the character and history
of a particular place, as the manager of Sustrans
in the North East has remarked.[2] That is, it
draws attention to the fact that Consett is at a
point on the C2C route where one 'leaves the
high hills and enters the North East's industrial
area',[3] where a railway line once ran and
extensive land reclamation has taken place
following the closure of the once mighty
Consett steelworks in 1979.[4] The level and the
theodolite, it should be noted, are similar to
instruments used to survey the Paris to Brussels
railway line in the last century.[5] However, the
artist does not seem to see the change of setting

as especially important, saying that he does not think of his sculpture as either indoor or outdoor, any more than he thinks of books as indoor or outdoor.

The sculpture was commissioned by Sustrans and paid for with money from the National Lottery, Northern Arts, Derwentside Council, the Henry Moore Foundation, Consett's Genesis Project and industrial sponsors. Component parts were cast in Sheffield and Germany and kept in storage for a while at Beamish Museum, before being transported to Consett by truck and assembled on site. The piece was eventually unveiled, after a gestation period of some four years, by the local MP, Hilary Armstrong, on 22 September 1997.

[1] Celant, G., *Tony Cragg*, London, 1996, pp.23–4, 286–7. [2] Information provided by Sustrans, 1999. [3] *Journal*, Newcastle, 12 September 1997. [4] Moore, T., *Consett: A Town in the Making*, Durham, 1992, pp.120–3. [5] *Journal*, Newcastle, 11 September 1997.

Medomsley Road (B6308)

1 Industrial Estate, Derwent Valley Foods, car park

Derwent Valley sculptures

Sculptor: Gilbert Ward

Installed 1989
Each work: stone 2.15m high approx × 1m wide × 70cm deep
Status: not listed
Condition: good
Commissioned and owned by: Derwent Valley Foods Ltd

Description: three organic-shaped carved stones standing upright on square bases. The sculptures, which are located around the perimeter of the factory, are similar in form but one bears foliate reliefs carved to a depth of approximately ¹/₂cm.

Ward, *Derwent Valley sculpture*

The sculptures are Ward's response to the landscape and flora of Derwentside. Derwent Valley Foods commissioned the work through the agency Sculpture North which declared itself bankrupt shortly after the installation. As a result the sculptor was not paid for his work.[1]

[1] Information supplied by the artist, 1999.

DARLINGTON

Bull Wynd TOWN CENTRE

13 Horsemarket, side elevation

Bull

Stonemason: not known

Carved 1600s
Relief panel: stone 32cm high × 72cm wide
Inscription panel: stone 30cm high × 38cm wide
Incised in capitals on nearby stone panel:
ANTHON / BVLMER / AND MARIE / LASINBIE
Status: II
Condition: fair
Condition details: detail lost due to weathering
Custodian: Darlington Borough Council

Description: two small stone panels inset on the side elevation of the Tourist Information building. One bears the crudely carved relief of a seemingly mythical creature, in fact a seventeenth-century representation of a bull, the other an inscription from the same era.

History: Longstaffe, the Victorian historian of Darlington, describes the relief as a 'long brute of a bull with a tail exactly like a fire-shovel'. According to his records, the bull was a family crest belonging to the Bulmers who owned the Bull Inn at this site in 1617.[1] Whilst

Bull

it seems reasonable to suppose that the beast may have served as a sign to their drinking establishment, the accompanying inscription is a puzzle. The name of the street commemorates the same family of innkeepers.[2]

[1] Longstaffe, W.H.D., *The History and Antiquities of Darlington*, Stockton, 1973, p.lxxxviii. [2] *Ibid.*, p.192.

Crown Street TOWN CENTRE
Public library, outside

Monument to William Thomas Stead

Installed early 1950s
Tethering stone: granite 45cm high × 45cm square
Pedestal: stone 45cm high × 64cm wide × 48cm deep
Raised white capitals inscribed on nearby metal plaque: THIS STONE, ORIGINALLY IN POSSESSION OF / MR W.T. STEAD WHEN RESIDENT AT GRAINEY HILL & TO / WHICH HE TETHERED HIS DOGS AND PONY, IS PROBABLY THE ONLY / MONUMENT IN GRANITE TO HIS MEMORY IN DARLINGTON. THE / BOULDER IS A FITTING SYMBOL OF HIS INDOMITABLE COURAGE / & STRENGTH OF CHARACTER & MAY KEEP GREEN THE MEMORY / OF ONE OF ENGLAND'S GREATEST MEN. HIS BODY PERISHED / ON THE TITANIC, WHEN SHE SANK APRIL 15TH 1912. / HIS SPIRIT STILL LIVES.
Status: II
Condition: fair
Condition details: metallic staining at the apex of stone
Custodian: Darlington Borough Council

Description: the memorial comprises a short rock-faced stone pedestal surmounted by a boulder of granite and a metal tethering ring. It stands between the library's low perimeter wall and the building itself. A plaque attached to the wall of the library, above the stone, details its commemoration.

Subject: acclaimed the founding father of modern investigative journalism, William Thomas Stead (1849–1912) was born the son of a Congregational minister in Embleton, Northumberland.[1] Educated at home until the age of 11, Stead continued his studies at Silcoates, near Wakefield, and at 14 left school to start work as an office boy in a Newcastle counting house. In 1871, having written a number of articles for the newly-established halfpenny paper, the *Northern Echo*, he was invited to be its editor. Although he was only 22 and had never set foot inside a newspaper office, Stead took up the post.[2]

Under Stead's control not only did the paper's circulation rise, but its readership spread beyond the region to the rest of the country. His articles on atrocities in Bulgaria were quoted in the Houses of Parliament and Gladstone, on meeting him, is said to have told Stead, 'To read the *Echo* is to dispense with the

Stead Monument

necessity of reading other papers.'[3]

In 1880 Stead left Darlington to take up the assistant editorship of the *Pall Mall Gazette*. Promoted to editor five years later, his series of exposés of child prostitution shocked the nation and eventually led to his own imprisonment. In his fight to raise the legal age of consent from 13 to 16, he had procured a child to prove his point, and was the first to be arrested when the legislation was passed. He spent nine weeks in prison. From then on, in celebration of his successful campaign against prostitution, he wore his prison clothes to the office each year on the anniversary of his arrest.[4]

His passage to America in 1912 was to attend a Peace Conference in New York. Despite being booked on another ship and against the advice of a clairvoyant in London he was persuaded by a friend to join the *Titanic*'s maiden voyage. It is said that when the ship hit an iceberg he was playing bridge, and as it sank he continued with the game.[5]

History: the tethering stone was probably retrieved as a keepsake when Stead's house at Grainey Hill was demolished following his departure for London in 1880. From there it made its way to the Coniscliffe Road garden of Mr W.G. Mitchell who turned the stone into a memorial by installing at its side a commemorative plaque. It was moved to its present position, opposite the *Northern Echo* office building, in the early 1950s.

There are at least three other public memorials to W.T. Stead: an engraving above the corner door of the *Northern Echo* office building, Crown Street, Darlington; a wall plaque in Wallsend in Tyne and Wear; and a bronze relief on a wall in Central Park, New York City.

[1] *Northern Echo*, 25 April 1985. [2] Information provided by Mr L. Watson, 1999. [3] *Northern Echo*, 30 May 1985. [4] *Ibid.*, 25 April 1985. [5] *Ibid.*, 30 August 1996.

High Row TOWN CENTRE
Junction with Bondgate and Northgate

Monument to Joseph Pease

Sculptor: George Anderson Lawson
Foundry: Cox and Sons

Unveiled 28 September 1875
Statue: bronze 2.5m high
Pedestal: pink and grey granite 2.2m high ×
1.4m square
Incised in large Roman letters on south face of
base of pedestal: JOSEPH PEASE

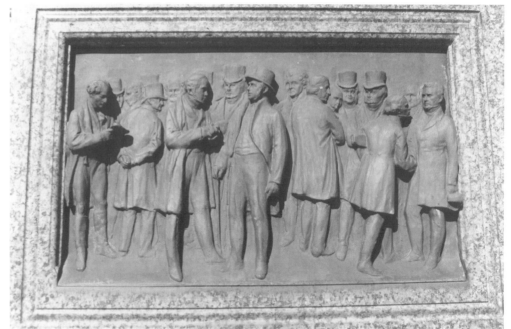

Lawson, *Pease Monument*

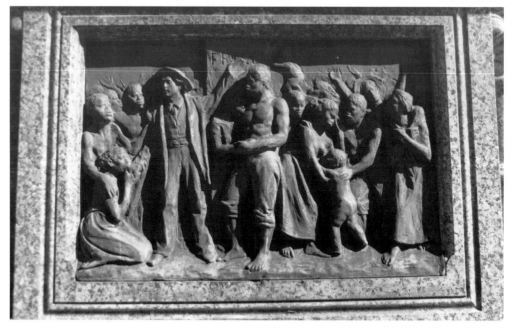

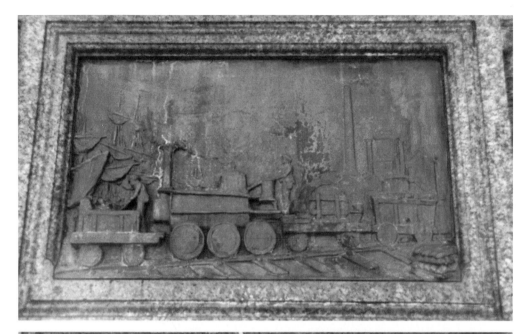

Lawson, *Pease Monument* **(relief panels)**

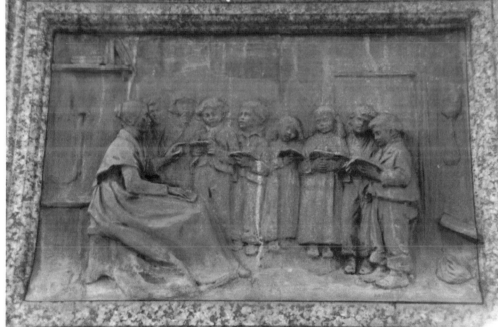

Incised on base of statue: G.A. LAWSON SC. /
LONDON 1875 / COX & SONS / FOUNDERS
Status: II
Condition: fair
Condition details: dirty pedestal and figure;
statue stained brown; rust at the exterior of the
statue
Commissioned by: Pease Memorial Committee
Custodian: Darlington Borough Council

Description: a one-and-a-half-life-size
bronze statue of Joseph Pease. Represented in
middle age with short side whiskers and wear-
ing contemporary dress, he faces south towards
the Old Town Hall and Clock Tower. His pose,
standing with one arm at rest, the other tucked
into the breast of his waistcoat, was one he
typically assumed when speaking in public.[1]
The now brown-streaked figure surmounts a
polished pink granite pedestal on a grey granite
base. Each face of the dado bears a bronze panel
in relief. These depict scenes from Pease's
public life. South face: figures standing in the
lobby of the Houses of Parliament; west face:
slaves celebrating their freedom with William
Wilberforce; north face: a locomotive engine
arriving at the docks; east face: a schoolmistress
teaching young children.
Subject: born the second son of Edward
Pease, a prominent Darlington Quaker,
prosperous businessman and 'Father of the
Railways', Joseph Pease (1799–1872) assisted
his father in the development of the Stockton
and Darlington Railway becoming its first
treasurer at the age of 19.[2] He bought farmland
in Middlesbrough, extended the railway there
and helped establish the town as an industrial
centre (see *Monument to John Vaughan*, p.289).
In his attempts to persuade mineral owners of
the merits of using locomotive transport he
bought collieries and conveyed coals by rail. By

the time he came to retire in 1870 rail had become the principal mode of coal transportation.[3]

The first Quaker MP to sit in the Houses of Parliament, Joseph Pease represented South Durham in the years 1832–41. It is said that he refused to canvas for votes or spend any money on his election. In the House he spoke frequently against the slave trade and was an advocate of political and social reforms.[4]

A philanthropist with a keen interest in promoting Darlington's health, education and temperance, he was the town's first president of the General Board of Health. He established three schools and donated to the town eight drinking fountains, the market tower clock and a large plot in South Park.[5] When Darlington obtained the Royal Charter of Incorporation in 1867 he was invited to become the first mayor, a position he was unable to accept. At the time of his death in February 1872, he employed approximately 10,000 men and his personal wealth was estimated at £350,000.[6]

History: soon after Pease's death in 1872 a committee of 43 local businessmen decided to commemorate his life and achievements by commissioning two portraits: one a Town Hall painting, the other a statue. Funds were quickly raised and the artist and sculptor engaged.[7] Following an initial scheme to erect the statue of Pease outside his former home in Grange Road, a site at Bondgate was selected.[8]

The statue was unveiled to a mass of spectators amid the festivities of Darlington's 'Jubilee Day' on 28 September 1875, when 100,000 people are said to have thronged the streets in celebration of the fiftieth anniversary of the opening of the Stockton and Darlington Railway. A public holiday was declared throughout the district, businesses shut down and special trains laid on to deliver some of the 80,000 visitors arriving from out of town. As passengers poured into the festooned streets for the exhibitions, processions, fireworks and illuminations, the *Northern Echo* remarked upon the efficiency of the railway system, pronouncing its veneration well-founded.

At 5 o'clock crowds gathered at High Row for the unveiling of the statue. Amongst those present were the Lord Mayor of London and all the mayors of the United Kingdom. The Duke of Cleveland, whose family had thwarted many of Pease's railway projects, performed the unveiling to loud applause and cheering. Contemporary reports agreed that although the figure was an accurate portrait of Pease in both gesture and features, its portly frame was an exaggeration.[9] The sculptor, who had not met his subject, appears to have used a photograph of Pease aged 63.[10]

Early photographs of the statue show it surrounded by iron railings and four gas lamps at the bottom of Bondgate.[11] Later the lamps were replaced and railings removed. In 1958 as part of a road redevelopment scheme it was moved several metres to the site it now occupies.

[1] *Northern Echo*, 28 September 1875. [2] Letter from J.D. Sinclair to *Northern Echo*, 8 April 1956. [3] *The British Workman* in Local Project Book Number 2: The Pease Family and Darlington, February 1892, no.446, p.14. [4] *The Compact Edition of the National Biography*, volume 11, Oxford, 1975, p.1620. [5] Sinclair, *op. cit.* [6] *Darlington and Stockton Times*, 1 October 1955. [7] *Northern Echo*, 5 February 1996, p.9. [8] *Darlington and Stockton Times*, 1 October 1955. [9] *Northern Echo*, 28 September 1875. [10] Darlington Library Local Studies Centre Picture Index, Ref. no: L389 PH1015. [11] Darlington Library Local Studies Centre Picture Index, Ref. no: 100114/6.

Northgate　　　　　　TOWN CENTRE
Central House, gables

Personifications of Art and Science
Sculptor: not known

Building inaugurated 8 October 1897

Each figure: stone 1.5m high approx
Status: II
Condition: fair
Condition details: weathering has caused some corrosion to both statues
Custodian: Darlington Borough Council

Description: two female figures carved in stone atop the gables on the façade of Central House. To the left stands the personification of *Art* clothed in classical drapery and holding a palette; the severed head at her feet is probably an expressive head as might be used by a student of art. To the right, also in classical robes, stands *Science* bearing a divider in one hand and a centrifugal governor in the other.

History: designed by the local architect G.G. Hoskins, the Darlington Technical College and Art School was built in 1897. The figures of *Art* and *Science*, executed by a now unknown sculptor, appropriately conveyed the original purpose of the building until 1963 when the technical college moved its premises to Cleveland Avenue.[1] The building has served as premises for various organisations over the last three decades and is now the offices of Darlington Borough Council.

[1] Flynn, G., *Darlington in Old Picture Postcards*, II, Zoltbomnel, 1994, p.47.

Central House, exterior

Bulmer's Stone

Installed here 29 June 1923
Whole work: Shap Granite 1m high × 1.3m square approx
Status: II
Condition: good
Condition details: slight covering of algae
Custodian: Darlington Borough Council

Description: a large square-shaped boulder of granite mounted on an iron shelf behind railings between the pavement and Central House. An

Bulmer's Stone

information board recording its history is located on the wall behind.

History: Darlington's oldest monument is a boulder of granite which bears neither plaque nor ornament and commemorates no individual person or event. The well-known street feature is said to have drifted to this site some 12,000 years ago.[1] Like other erratics at Piercebridge and Whitby, it originates more than 100 kilometres away in Shap and geologists suppose that it was brought here by glacial movement during the Great Ice Age.[2]

There are those who believe that the town of Darlington was built around the ancient stone and legend has it that it turns around nine times when it hears the clock strike twelve.[3] One

story is that George Stephenson (see pp.149–52) and Nicholas Wood sat on the stone to tie their boots, having walked from Stockton to Darlington barefoot.

For centuries the boulder was a significant local landmark, occupying a prominent position on Northgate's pavement, close to the road. Once called the 'Battling Stone', for a time it was used by weavers to flax their yarn. In the nineteenth century Willy Bulmer, Darlington's unofficial town crier, read the London news standing on the boulder and it is probably from him that its name is derived.[4]

In 1923 its landmark status diminished when it was moved just six metres. Deemed a traffic hazard the stone was installed behind iron railings in the shadow of the Technical College. Outraged Darlingtonians wrote to the local paper in protest, some declaring that it was 'desecration' and 'vandalism' to move the stone from the spot where it had stood for many thousands of years.[5]

[1] Durham County Council Museum Education Service. [2] *Northern Echo*, 11 October 1987. [3] Woodhouse, R., *Darlington: A Pictorial History*, Chichester, West Sussex, 1998, p.4. [4] Bowes, P., *Picturesque Weardale*, Bishop Auckland, County Durham, 1996, p.38. [5] Woodhouse, *op. cit.*, p.36.

Parkside
South Park, next to the aviary

Fothergill Memorial Fountain
Designer: Septimus Hind

Unveiled 10 June 1862
Whole work: grey stone 4m high approx × 1.7m square
Stepped base: grey stone 30cm high × 3.7m square
Incised in capitals on the panels of the north-east panel of pedestal: ERECTED IN MEMORY OF THE LATE JOHN FOTHERGILL M.R.C.S. / WHO WAS BORN MAY 13TH 1785 / AND DIED JANUARY […]

1858
Incised in capitals on the north-west panel:
HIGHLY ESTEEMED / FOR HIS PROFESSIONAL SKILL / AND PRACTICAL […]ANTHROPY
Incised in capitals on the south-west panel:
ERECTED BY THE VOLUNTARY / SUBSCRIPTION OF HIS / FELLOW TOWNSMEN 1862
Incised in capitals on the south-east panel:
PRESIDENT OF THE DARLINGTON / TOTAL ABSTINENCE SOCIETY FROM / IT'S FORMATION IN AUGUST 4TH 1835 / UNTIL HIS DEATH IN 1858
Status: II
Condition: poor
Condition details: spalling on most of the extremities and particularly on the scrolls at the base; dirty; algae, moss and lichen; superficial cracks, some large chips and pitting in some areas; inked and scratched graffiti
Commissioned by: Darlington Total Abstinence Society
Custodian: Darlington Borough Council

Description: a commemorative drinking fountain carved in grey stone and decorated with mouldings. Standing on a two-stepped base, the now worn and non-functional fountain comprises a four-panelled pedestal supporting four semi-circular arches with attached columns at each corner. A corniced canopy and urn cover a white marble bowl at the centre of the structure. Four ornate dog bowls at the base have been filled in with concrete.

Subject: a locally respected medical practitioner and Quaker, Dr John Fothergill (1785–1858) campaigned for anti-slavery legislation and the abolition of capital punishment. In his home town of Darlington he was a well-known public speaker and pamphleteer on the subject of temperance. At a time when it was unpopular to do so he declined to prescribe alcohol-based medications, and in 1835 he founded the Darlington Total Abstinence Society.[1]

History: Septimus Hind, a Darlington boy of 17, won two guineas for the design of the

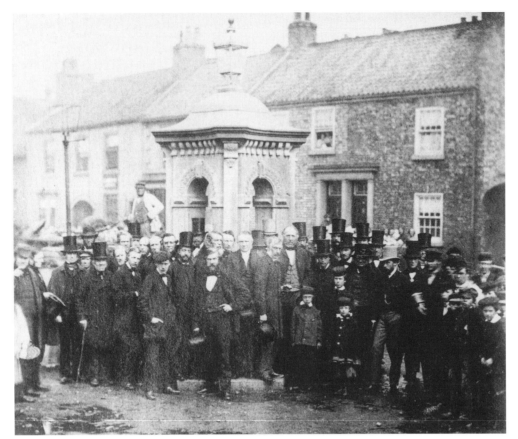

Hind, *Fothergill Fountain*, unveiling ceremony

monument. One of many drinking fountains in Darlington, it was erected on 10 June 1862 by the Society of Friends as a tribute to their fellow Quaker and advocate of temperance. On the day of its inauguration members of the Total Abstinence Society met in their headquarters at the Mechanics' Institute and walked in procession to Bondgate, accompanied by the Darlington Sax Horn Band. At 1 o'clock William Thompson, the president of the Total Abstinence Society, drank the first glass of

water and declared the fountain open.[2] Missing from the assembled party was Hind, the young designer, who had died in a drowning accident less than a year previously.

The memorial, which had replaced a large cattle fountain, was situated in the centre of the thoroughfare at Bondgate until it became a traffic hazard. Then, in the approach to the Railway Jubilee in 1875, it was moved to South Park. Five years later the gas lamp was removed from its apex and an urn placed there at the expense of a Mr Ross.

[1] *Darlington and Stockton Times*, 9 June 1962.
[2] *Northern Despatch*, 8 November 1960.

St Cuthbert Parish Church grounds

South African War Memorial

**Sculptor: not known
Stonemasons: Leeds Slate and Granite Company**

Unveiled 5 August 1905
Figure: bronze 1.8m high approx
Pedestal: Peterhead granite 2.15m high × 1.8m square
Steps: stone 80cm high × 2.7m square
Incised on irregular-shaped brass plaque on north face of pedestal: THIS MEMORIAL / WAS ERECTED BY 5576 / SUBSCRIBERS AS A TRIBUTE TO / THE MEMORY OF THE BRAVE MEN / OF DARLINGTON WHO VOLUNTEERED AND SERVED / THE EMPIRE IN THE SOUTH AFRICAN WAR / 1899–1902. / KILLED IN ACTION [names below]
Incised on three other brass plaques: [names of those who served]
Status: II
Condition: fair
Condition details: bayonet missing; blue metallic streaks over whole figure and part of pedestal; chipped steps; algae
Commissioned by: public subscription
Custodian: Darlington Borough Council

Description: surmounting a pedestal of rugged Peterhead granite, a bronze figure of a soldier in khaki and helmet on top of a kopje. The moustached private stands, with bayonet rifle in both hands, as though to charge the enemy. The statue is streaked blue with metallic stains and the bayonet is missing.

History: the idea of erecting a commemorative statue to the 88 Darlington men who had served in the War in South Africa was mooted shortly after the end of the conflict. Of those who saw action eleven soldiers failed to return home to Darlington in 1902.

The memorial fund was soon set up and

South African War Memorial

inauguration was well-attended, 70 of the town's Quakers effectively boycotted the event by going to a Peace Association meeting arranged at the Friends' Meeting House for the same time. Their objection to the overtly aggressive representation of a soldier 'ready to thrust his bayonet through the enemy' was the subject of several letters to the *Northern Echo*.[4] Ironically the same image was later used by the makers of 'Ye Old Boys Scotch' to sell their whisky.[5]

Since the removal of his bayonet in the 1950s the soldier is said to appear less fearsome. The weapon, which has never been replaced, was accidentally broken off by children who threw a rope around it for use as a swing.[6]

[1] *Darlington and Stockton Times*, 5 August 1905.
[2] *Northern Echo*, 24 April 1995. [3] *Darlington and Stockton Times*, 2 November 1904. [4] *Northern Echo*, 7 August 1905. [5] Flynn, G., *Darlington in Old Picture Postcards*, II, Zoltbomnel, 1994, p.107. [6] *Northern Echo*, 24 April 1995.

Town Hall forecourt
TOWN CENTRE

Resurgence

Sculptor: John Hoskin

Unveiled 20 May 1970
Whole work: steel, blue paint 5m high × 6m wide × 3.5m deep
On a nearby wall, incised in capitals on a steel plaque: 'RESURGENCE' BY JOHN HOSKIN, PROVIDED / BY PUBLIC SUBSCRIPTION AND ERECTED BY / THE CIVIC PROJECT COMMITTEE SPONSORED / BY THE DARLINGTON LIONS CLUB / THIS PLAQUE WAS UNVEILED BY HER ROYAL / HIGHNESS THE PRINCESS ANNE TO MARK / THE HANDING OVER ON THE 27TH MAY 1970.
Status: not listed
Condition: good
Condition details: dirty; pockets of rust in parts, paint peeling way in some areas;

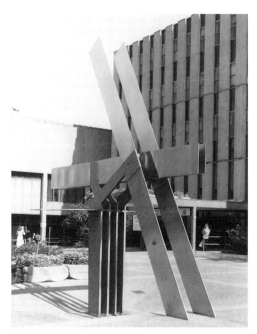

Hoskin, *Resurgence*

scratched graffiti
Commissioned by: Darlington Lions Club
Custodian: Darlington Borough Council

Description: a large geometric sculpture of stainless steel stands in a slight dip at the centre of the Town Hall forecourt. Two diagonal rectilinear sheets of steel are bolted to two horizontal sheets, both supported by a central column of four blue-painted beams.

History: Hoskin's *Resurgence* was the winning entry in a 1967 competition to design a large-scale metal sculpture for Darlington's new Town Hall. Organised by the Lions Club, the project's purpose was to provide the town with a distinctive modern work of art to symbolise Darlington's escape from the threat of industrial decline. It was also the commissioners' intention that the competition should provoke

received £500 from over 5,000 subscribers. After several delays and to the disapproval of the town's pacifist Quakers, work began on its construction in 1904.[1]

The same year, Darlington's Mayor, W.E. Pease, encountered Lord Roberts, the celebrated hero of wars in Afghanistan, India and South Africa, on a bridge over the Zambesi River. Pease took the opportunity to ask the veteran commander if he would consider honouring his town by unveiling the South African War Memorial, jokingly threatening to throw Roberts into the river if he did not oblige. Lord Roberts accepted, fulfilling his promise the following year.[2]

The memorial, built by the Leeds Slate and Granite Company and executed by a now unknown Italian sculptor, was unveiled in a civic ceremony on 5 August 1905.[3] Though the

discussion about art in the locality and promote art practice in the north of England.[1] The first objective, at least, was realised. The scheme, which attracted 86 design entries in the first round, created a small controversy in the town. Letters written to the local paper suggested that a new public lavatory would be preferable to 'an ambiguous abortion in steel' and the Mayor of Darlington, having seen the shortlist of five non-figurative works, declared them all 'rubbish' and appeared on television to voice his fierce opposition to the scheme.[2]

With £3,000 raised by public subscription and a contribution of £2,000 by the Arts Council, the project went ahead. In June 1969, at a special showing of the finalists' maquettes in Darlington Art Gallery, the winner was announced.[3] Hoskin explained that his sculpture was designed with Darlington's 'resurgence' in mind, and that its form not only related to the town's engineering heritage but was also a response to the vertical lines of the Town Hall. It was his intention that passers-by should be able to walk in and around the work, viewing it at varying angles.[4]

The two-and-a-half-tonne sculpture was erected on site and handed over to the council in a formal ceremony on 20 May 1970, and a plaque detailing its commission was unveiled by Princess Anne the following week.

A year later *Resurgence* was removed when the sculptor discovered a fault in one of the steel plates. It was disassembled and spent several months in Preston being repaired before returning to Darlington. Ironically its reinstallation on 1 December 1971 coincided with the news that more Teesside redundancies were soon to be announced.[5]

[1] The Civic Project Committee of Darlington Lions Club, *Darlington Sculpture*, Darlington, 1967, *passim.* [2] *Journal*, Newcastle, 14 January 1969. [3] *Northern Despatch*, 7 June 1969. [4] *Evening Despatch*, 24 June 1969. [5] *Northern Echo*, 2 December, 1971.

Yarm Road
Aldi supermarket, entrance to car park

Untitled
Sculptor: Matthew Jarratt

Installed 1994
Each work: brick and clay 2.25m high approx × 1.7m wide × 1m deep
Status: not listed
Condition: good
Condition details: small amount of graffiti
Commissioned and owned by: Aldi Stores

Description: six brick structures in the form of well-heads stand at right angles to one another. Each façade supports a clay relief raised on a brick corbel and a plant box at its base. The reliefs represent various railway images: cogs; wheels; signposts; the workings of a locomotive.

History: the supermarket chain Aldi commissioned the artist to build an entrance feature for their new store as part of a 'percent for art' scheme organised by Darlington Borough Council. Responding to a brief which dictated that the sculptures relate to the locality, Jarratt drew on Darlington's railway heritage as a source of imagery.[1]

[1] AXIS, Artists Register, 1999.

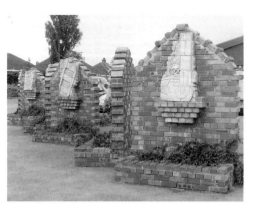

Darlington Retail Park, centre of car park

Tree
Sculptor: Keith Bridgewood

Installed January 1994
Whole work: steel, ceramic pieces 3.05m high approx × 70cm wide × 32cm deep
Status: not listed
Condition: good
Commissioned and owned by: Darlington Retail Park

Description: a sculpture of a tree set in a brick flower bed. The trunk and lower branches are represented in oxidised, welded steel and the upper branches and foliage in a mosaic of irregularly-shaped, pink, ochre and earth-

(above) Bridgewood, *Tree*

Jarratt, *Untitled*

coloured ceramic tiles.

History: the artist was commissioned to design and construct the sculpture by the building contractors of the retail park with funding from a 'percent for art' scheme. Bridgewood constructed the steel frame in his studio and the ceramic tiles were added after the structure had been fixed into the ground.[1]

[1] AXIS, Artists Register, 1998.

Kvaerner Cleveland Bridge, verge and car park

Figure Form; Pictogram; Zenga Dogs; Zen Column; Totem Group

Sculptor: Tom Taylor

Installed 1993–7
Figure Form: painted steel 6.5m long × 2.4m wide × 70cm high
Pictogram: painted steel 5.6m high × 7m wide × 4.7m deep
Zenga Dogs: painted steel 1.9m high × 90cm wide
Zen Column: painted steel 2.1m high × 80cm wide
Totem Group: painted steel 3.5m high × 3.2m

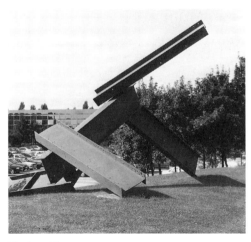

Taylor, *Pictogram*

Taylor, *Zen Column*

Taylor, *Figure Form*

Taylor, *Zenga Dogs*

wide × 1.2m deep
Status: not listed
Condition: good
Commissioned and owned by: Kvaerner Cleveland Bridge Ltd

Description: a series of welded steel sculptures set at some distance from one another on a wide grass verge between the factory and the road. Five are visible from the public highway. From east to west: *Figure Form*, a figurative, horizontal form combining

industrial and organic-shaped elements, painted in various colours; a large pictogrammatic work comprising five I-sections of steel balanced and welded at various angles to one another and finished in rust red paint; two playful *Zenga Dogs* in box steel, rusted and varnished and mounted on a steel pedestal; a steel column with an oval aperture at its apex, rusted and varnished, entitled *Zen Column*; flat steel figurative forms, rusted, varnished and raised vertically on a platform of steel, entitled *Totem Group*.

History: the sculptures are amongst a

Taylor, *Totem Group*

collection of indoor and outdoor works executed by Taylor for Kvaerner Cleveland Bridge Ltd. Produced in the period 1993–7 as part of an artist-in-residence scheme organised by the company to assist their apprentices in welding and construction skills, the sculptures relate to the artist's doctoral research in 'minimal and reductive graphological structures'.[1]

[1] Information provided by the artist, 1998.

At rear of Morrison's supermarket, by main road

Train

Sculptor: David Mach

Unveiled 23 June 1997
Whole work: brick 7.05m high × 39m long × 6.38m wide
Incised in letters painted black on plaque on low wall nearby: TRAIN / A Sculpture / by / David Mach / Unveiled by Lord Palumbo of Walbrook / 23 June 1997 / Commissioned by / Wm. Morrison Supermarkets P.L.C. and Darlington Borough Council / and supported by the National Lottery through / the Arts Council of England.
Incised in painted black letters on plaque on low wall nearby, a poem 'The Train Journey' by David Quick (aged 7) from Middleton St George
Status: not listed
Condition: good
Commissioned by: Darlington Borough Council and Wm Morrison Supermarkets plc
Custodian: Darlington Borough Council

Description: said to be 'Britain's largest piece of sculpture',[1] an actual-size representation of a 1930s streamlined locomotive hurtling out of a tunnel with steam billowing from its funnel. The whole sculpture including the 'steam' is made of 181,754 orange-brown house bricks

resting on pre-cast concrete slab floors. There is a viewing platform on top of the grassy bank representing the 'tunnel'. *Train* can be seen by motorists passing on the nearby A66 Darlington bypass, which is parallel to it, and by pedestrians if they walk round from the front of Morrison's Morton Park supermarket along a specially landscaped path. A further feature of the sculpture is that it is hollow, and bats have been encouraged to nest inside through twenty specially approved bat bricks.

History: in 1994 Darlington Borough Council and Wm Morrison Supermarkets plc with support from Northern Arts commissioned David Mach to design a landmark sculpture as Darlington's contribution to Visual Arts UK 1996. The artist's idea of a speeding locomotive trailing clouds of steam was based on *Running out of Steam* (1982), an earlier, much smaller gallery piece, a miniature model of a locomotive made out of magazines. This in turn was modelled on the *Mallard*, a streamlined A4 locomotive designed by Sir Nigel Gresley for the LNER, which broke the world steam speed record in July 1938 and is now in the National Railway Museum at York. *Mallard* used to pass through Darlington on its way from London to Edinburgh but otherwise does not have any particular links with the town. The subject-matter stems from the fact that the site is close to (but not actually on) the route of George Stephenson's 1825 Stockton and Darlington railway, the first passenger railway in the world. As the artist said, 'This is where trains were born and where an engineering heritage was forged. This is where people had ideas and the skills and imagination to realise them.'[2]

The complexity of *Train*'s shape, and of the plumes of steam in particular – no two bricks have a common line – necessitated the use of sophisticated technology and computers provided by the Leeds-based architects, Fletcher Joseph, and the engineers, Hutter

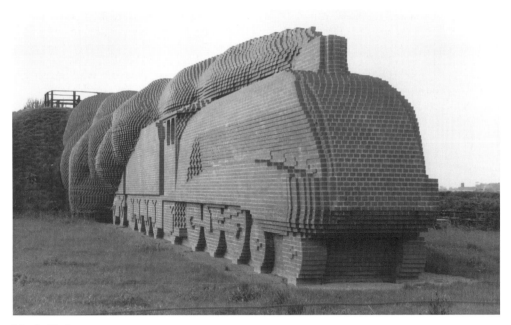

Mach, *Train*

Jennings and Titchmarch. The working drawings comprised 176 vertically aligned cross-sectional drawings and 94 plans (one for each course of bricks) based on a 3 1/2–metre scale model of the sculpture which was made in 1995. The laying of the 181,754 bricks was undertaken by 34 apprentices from Shepherds Construction. They took 18 weeks and used a type of brick produced by Marshalls Mono Ltd, Halifax which was thought to have an attractive appearance and proven durability. The sculpture as eventually built, however, was significantly smaller than had originally been envisaged and used over 100,000 fewer bricks. This though did not prevent it from being considerably more expensive than initially estimated.[3]

The overall cost of *Train* was £760,000 of which Wm Morrison Supermarkets plc contributed £40,000, the Department of National Heritage £20,000, Darlington Borough Council £10,000, Northern Arts £30,000 and the National Lottery £570,250 and £90,000 in other forms of sponsorship. The land on which it sits was provided by Morrison's who had previously made a feature of Darlington's railway heritage in the prints decorating their new out-of-town store. 'We expect people to come to the site and then to dwell and spend some money with us,' the firm's property developer explained.[4]

Train was inaugurated by Lord Palumbo, the chairman of the Arts Council, on 23 June 1997 by blowing a guard's whistle and waving a green flag in appropriate railway style which was the signal for two giant cranes to lift a white covering. Mach expressed himself delighted. 'It's a gorgeous sexy thing,' he said. 'People are going to love it.'[5]

Predictably, however, the much-publicised project came in for its share of criticism, notably from a former Durham County Council Conservative councillor, Peter Jones, who at one point organised a petition against the commission which was signed by 2,200 people.[6] 'The last man to get away with something like this' Jones said, 'was Ronnie Biggs and we are still chasing him. Instead of a static brick train, we should have had a real train or a museum where people could have learned about the history of the area.'[7] There were also complaints about the huge cost of the bricklaying which it was alleged might have been undertaken more cheaply by a local firm.[8] In addition, one local paper noted that it was ironic that the sculpture should be sited beside a new road which 'serves to whisk people away from the town's core to the soulless retail park (and beyond) and looks like hundreds of similar out-of-town developments throughout the country.'[9] Even the bat bricks were attacked on the grounds that having bats so near a supermarket might constitute a health hazard.[10]

In response, Mach declared 'In years to come people will come to see the train in the same way they go to Trafalgar Square or the Pyramids.'[11] Others, meanwhile, noted that the making of the sculpture had required the skills of a host of 'non-arty' people and had had the effect of boosting tourism and trade in Darlington.[12] One reviewer spoke of it as a surreal image 'worthy of Magritte' carrying 'wagonloads of metaphor'.[13] It is generally agreed that *Train* looks particularly dramatic when lit up at night.

[1] *Guardian*, 28 June 1997. [2] Anon, *Train*, Darlington, 1997. [3] *Northern Echo*, 16 December 1996. [4] *Evening Gazette*, Middlesbrough, 29 May 1995. [5] *Darlington and Stockton Times*, 27 June 1997. [6] *Northern Echo*, 2 May 1996. [7] *Ibid.*, 12 April 1996. [8] *Ibid.*, 15 December 1995. [9] *Darlington and Stockton Times*, 27 June 1997. [10] *Independent on Sunday*, 2 February 1997. [11] *Journal*, Newcastle, 24 June 1997. [12] *Darlington and Stockton Times*, 27 June 1997; *Daily Mail*, 24 June 1997; *Mirror*, 24 June 1997. [13] *Scotland on Sunday*, 29 June 1997.

Crossgate (A690) NEVILLE'S CROSS
Near junction with Great North Road

Battle of Neville's Cross
Stonemason: not known

Installed c.1346
Shaft of cross: stone 1m high approx × 35cm
long × 25cm deep
Two-tiered base and socket: stone 90cm high ×
1m square
Lower base: sandstone and cement 1m high ×
3.1m square
Wall and railings: stone and cast iron railings
2.3m high × 6m square
Status: II; scheduled as Ancient Monument
Condition: poor
Condition details: cross and part of its shaft
missing; south-west and north-east carved
heads missing from socket; detailing lost to
remaining heads at base; spalling to the original
base and shaft; blackened by soot deposits
Commissioned by: Ralph Neville
Custodian: Durham County Council

Description: the remnants of a fourteenth-
century cross standing on a multi-layered base.
The head of the cross and most of the shaft are
missing, vandalised in 1589. Its shaft, about a
metre in height, is set in an octagonal stone
socket and base. Under this a base of sandstone
blocks and cement, probably added in the late
nineteenth or early twentieth century, raises the
structure above eye level. The whole work
stands on a mound and is surrounded by a wall
and sharp-pointed railings.

A detailed description of the cross, written
in the 1593 *Rites of Durham*, has enabled a
twentieth-century historian to reconstruct the
original work in the form of a drawing. From
this it seems that the cross surmounted eight

Battle of Neville's Cross

steps and was perhaps more than five metres
high. At the corners of its socket were carvings
of the heads of the four evangelists (the eroded
remains of two are still visible). The shaft
supported a boss with representations of the
Neville heraldic cross and bulls head. Its apex
featured a carving of the crucified Christ with
Our Lady and St John on either side.[1]

Subject: Redhills in Durham reputedly owes
its name to the amount of blood spilt in one of
the most ferocious battles fought in the region,[2]
the Battle of Neville's Cross, a conflict between
the English and the Scots which took place on
17 October 1346. It lasted some three hours and
resulted in the deaths of thousands.

In response to heavy losses at the Battle of
Crécy, the French King Philip VI appealed to
his allies, the Scots, to invade England as a

diversion to encourage King Edward III to
return home. The Scots advanced into England
with an army of nearly 12,000 under the
command of King David II. Having plundered
Hexham Abbey en route they subsequently set
up camp in Beaurepaire (Bearpark) on 15
October 1346. On the following day there was
a skirmish in which over 300 men lost their
lives.[3]

On 17 October three divisions of the English
army, possibly numbering only 5,000 soldiers,
moved forward to attack the Scots. In the
course of the ensuing battle the Scots suffered
devastating losses, their King was captured,
most of their soldiers fell and the remaining
men retreated. The victorious English army is
said to have marched through Durham to the
sound of trumpets. There is no record of how
many of its ranks were killed.

History: a cross existed on the site before the
Battle of Neville's Cross. After the battle Ralph,
4th Lord of Neville, one of the commanders of
the Northumberland division of men, erected a
new cross to commemorate the victory of the
English army over the Scots, and since then this
district of Durham has come to be known as
Neville's Cross.

It was once customary to walk around the
monument nine times and put one's head to the
ground so as to listen to the battle cries, but the
cross now backs onto a neighbouring garden
and this is no longer possible.[4]

[1] Butler, D., *Battle of Neville's Cross: An Illustrated
History*, Durham, 1996, *passim*. [2] *Northern Echo*, 19
October 1996. [3] Dufferwiel, M., *Durham: A
Thousand Years of History and Legend*, Edinburgh
and London, 1996, pp.54–61; [4] Wapperley, N.,
'Folklore of the County of Durham', *Society of
Antiquaries Proceedings*, vol. 1, Gateshead, 1951–6,
p.55.

Crossgate Moor

Durham Johnston Comprehensive School, upper school car park

Untitled

Sculptor: Graeme Hopper

Installed October 1996
Whole work: galvanised steel 4.8m high × 2m wide × 80cm deep approx
Raised letters on a metal band on one of the metal poles: HOPPER 96
Incised on plaque set aside from work: THIS SCULPTURE WAS CREATED IN 1996 / VISUAL ARTS YEAR IN THE NORTH OF ENGLAND / BY / GRAEME HOPPER / FROM DESIGNS BY DURHAM JOHNSTON SCHOOL STUDENTS / IT COMMEMORATES THE 650TH ANNIVERSARY OF / THE BATTLE OF NEVILLE'S CROSS / FOUGHT BETWEEN THE ENGLISH AND THE SCOTS IN 1346
Status: not listed
Condition: good
Commissioned by: Durham County and City Councils and Durham City Arts
Custodian: Durham County Council

Description: a large galvanised steel sculpture comprising six poles supporting abstracted depictions of shields and flags. The poles are interlinked by horizontal sheets of steel.

Subject: see the entry for the fourteenth-century cross, above.

History: the Battle of Neville's Cross has, until recently, received little recognition as a British conflict of historical significance. Notice began to be taken of it in 1995 when English Heritage included it in their Register of Historic Battlefields and again in 1996, when events were held in Durham to celebrate its 650th anniversary. Although the precise location of the battle is unknown, it is believed that the school's grounds may have formed part of the battlefield.[1]

Hopper was appointed as artist in residence

Hopper, *Untitled*

at the school in 1996, year of Visual Arts UK. Collaborating with pupils, the sculptor designed and constructed the sculpture as a memorial to the soldiers who died in the conflict.[2]

[1] *Northern Echo*, 19 October 1996. [2] Crosby, J., *Durham City Art Map*, Durham, 1998.

Kasuga Lantern

Elvet Hill

Oriental Museum, outside

Kasuga Lantern

Stonemason: not known

Carved pre-1880; installed here 1986
Whole work: granite 2.8m high × 1m diameter
Status: not listed
Condition: fair
Condition details: loss of detail due to weathering; lichen and moss in many areas
Custodian: Durham University, Oriental Museum

Description: a large ornamental lantern made of granite and decorated with the now much-

weathered relief carvings of a deer, lotus symbol and holy dog face.

History: though its age is not known, stone lanterns of this type have been in use in Japanese temples since the sixth century. The approaches to Shinto shrines, such as that at Kasuga, were lined with similarly-shaped lamps. Bought by a Scottish merchant named Sharp whilst on his honeymoon in Japan in 1880, the *Kasuga Lantern* was shipped back to Britain and placed in the grounds of his stately home, Balruderry House, near Dundee. It remained there until 1985 when Durham University Oriental Museum bought it.[1] The lantern's six parts were transported from Dundee to Durham by road, then reassembled and fork-lifted into position outside the museum on 8 January 1986.[2]

[1] *Journal*, Newcastle, 9 January 1986. [2] Oriental Museum of the University of Durham, notes (unpub.), 1998.

Lafcadio Hearn Cultural Centre, outside

Patrick Lafcadio Hearn

Sculptor: Masataka Sekiguchi

Unveiled 25 April 1990
Medallion relief: bronze 69cm diameter
Granite slab: polished granite 1.99m high × 1.4m wide × 43cm deep
Base: polished granite 28cm high × 2m long × 70cm
Signed above shoulder of relief: SEKIGUCHI
Incised in granite slab below relief: LAFCADIO HEARN / This relief is / Presented by / Teikyo University / To mark the opening of its Center [sic] / In the University of Durham, / April, 1990.
A nearby granite stone bears a metal plaque with the inscription: LAFCADIO HEARN / 1850–1904 / For half a century the most gifted interpreter of Japan to the West, Lafcadio

Sekiguchi, *Patrick Lafcadio Hearn*

Hearn / was born in Levkas in the Aegean in 1850, raised in Dublin, and educated in / England at Ushaw College, Durham from 1862 to 1867, where his gifts as a writer / were first revealed. / He emigrated to the USA at the age of 19, and left for Japan in 1890. A teacher of / English in Matsue, Kumamoto and Kobe, he was appointed Professor of English in the Imperial University of Tokyo. / His books include Glimpses of Unfamiliar Japan (1894), Out of the East (1895), Kokoro (1896), Gleanings in Buddha Fields (1897), Exotics and Retrospectives (1898), / A Japanese Miscellany (1901), Kwaidan (1904) and Japan: An Interpretation (1904) / In 1896 he married a Japanese woman, Koizumi Setsu, taking her family name / as his name, adopting Japanese nationality. In an age of modernisation, he / was concerned above all to teach the Japanese not to forget their past.
Status: not listed
Condition: good
Condition details: algae and dirt, mostly on inscription

Commissioned and owned by: Teikyo University of Japan at Durham

Description: a bronze medallion portrait relief of Lafcadio Hearn set into a large polished granite slab. The subject's right eye appears to be disproportionately large.

Subject: details relating to the person commemorated are given in the inscription.

History: the director of the Teikyo University in Durham invited his brother, a sculptor in Japan, to execute the relief for the exterior of the newly-erected Lafcadio Hearn Cultural Centre. Sekiguchi started by researching the life of his subject, visiting the town where he lived and interviewing his grandson.[1] Hearn is said not to have enjoyed the four years he spent in Durham and it was here that an accident deprived him of the sight in one eye and left him with a deformity in the other.[2] The relief is based on photographs of Hearn in later life and depicts his facial disfigurement.

[1] Information provided by Minh Chung, Teikyo University, 1998. [2] Teikyo University of Japan in Durham, *Teikyo University of Japan in Durham*, n.d.

Market Place TOWN CENTRE
Facing south towards Silver Street

Neptune

Sculptor: not known

Erected 1729; reinstalled 1863; reinstalled 1902; re-sited 1923; removed 1979; re-sited 1986; reinstalled 1991
Figure: lead 1.5m high approx
Column: sandstone 3m high × 1.2m square
Incised on south facing metal plaque in black letters: NEPTUNE / This statue was given to the city in 1729 / by George Bowes MP of Gibside and Streathlam / as a symbol of the scheme to link Durham to the sea / by improved navigation of the River Wear. / It stood on top

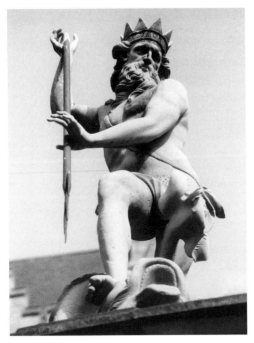

Neptune (1999)

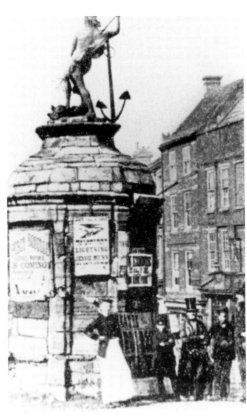

Neptune (c.1860)

Neptune (c.1890–1900)

of the Market Place wellheads until 1923 / when it was moved to Wharton Park. / It was restored in 1986 following an appeal / initiated by the City of Durham Trust.

Incised on north facing metal plaque: NEPTUNE / This statue was restored to its original home / in the market place by the City of Durham Council on the 16th May 1991. / It was unveiled by the Right Worshipful the Mayor of Durham, / Councillor W.H. Hartwell. / Present were many of the individuals and / representatives of local and national organisations / who had generously supported / the restoration appeal and the resiting.
Status: II
Condition: good

Condition details: anchor missing and original trident replaced; pitted in many areas of figure; lichen and algal growth on head and torso; soot deposits between grooves and on upper hand; small chipped areas on figure
Commissioned by: George Bowes MP
Custodian: City of Durham Council

Description: life-size lead statue of Neptune. In heroic pose the long-haired, bearded figure stands astride a dolphin, raising his trident as though to strike. The statue has recently been restored and re-sited on a square column of sandstone ashlar.
Subject: in classical mythology Neptune ruled the sea and its inhabitants. As the personification of Water the statue was erected

to symbolise Durham's aspirations to be linked to the sea by making the Wear navigable. When communication between the city and the coast was improved by the development of railway transport any such sea link was deemed unnecessary.[1]

History: Durham's *Neptune* has had a troubled history. Presented to the city by George Bowes in 1729, the lead figure, possibly from the workshops of Van Nost or Andrew Carpenter, was added to a large octagonal stone pant already on site.[2] Whilst providing an important source of water for the community, the pant was also a popular meeting place in the eighteenth and nineteenth centuries. In the 1850s, it had come to look shabby, its pipes

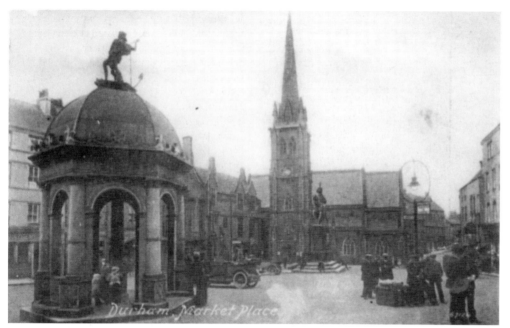

Neptune (1914)

were deemed unsafe and there were calls for the demolition of the whole structure. Letters to the local paper supporting the preservation of the figure, some supposedly signed by Neptune himself, led to the decision to replace the fountain yet retain the statue.[3]

In 1860 the Local Board of Health's Pant Committee held a design competition for a new fountain. E.R. Robson won with a Gothic structure, which was finally erected in 1863 with the 'Sea King' at its apex,[4] but by then the Londonderry statue (see p.246) had been erected and *Neptune* was no longer the focal point of the Market Place.

The lead figure's base was replaced again in 1902 by a domed, classical pant erected by the executors of the will of Miss Ellen Elizabeth Gibson. Twenty-one years later this too was demolished and *Neptune* was removed to

Wharton Park. Photographs show the statue supported by makeshift 'crutches', sited high on the hill above the railway track facing down towards the Cathedral.[5] Although there was a 1971 plan to re-erect the figure on a roundabout at Milburngate this came to nothing, and *Neptune* remained in the park until 1979 when it was put into council storage after being badly damaged by lightning.

As the result of an appeal organised by the Durham Trust *Neptune* returned to the city centre in 1986. After spending most of the next five years in a gas showroom in Claypath, on 16 May 1991 the restored figure was re-erected in its original site on top of a newly carved column of stone.[6]

[1] Roberts, M., *The Book of Durham*, London, 1994, *passim.* [2] Darke, p.229. [3] Crosby, J., *Durham in Old Photographs*, Stroud, 1990, *passim.* [4] Clank. P., *The Book of Durham* City, Buckingham, 1985, p.105. [5] Durham University Library, Gibby Photograph Collection, Reference no: N2. [6] *Northern Echo*, 17 May 1991.

Monument to the 3rd Marquis of Londonderry
Sculptor: Raffaelle Monti
Stonemason: T. Winter

Unveiled 2 December 1861
Statue: electro-plated copper 3.2m high approx × 4.4m long approx × 2.2m wide approx
Pedestal: sandstone 3.4m high × 4.4m long × 2.2m wide
Steps: 70cm high × 7m long × 5m wide
Incised in capitals on east-facing granite plaque:
CHARLES WILLIAM VANE STEWART / 3RD MARQUIS OF LONDONDERRY / 1ST EARL VANE AND BARON STEWART / OF STEWARTS COURT K.G.G.C.B. / LORD LIEUTENANT COUNTY OF DURHAM / AND FOUNDER OF SEAHAM HARBOUR / GENERAL IN THE ARMY / BORN MAY 8TH 1778 DIED MARCH 6TH 1854.
Incised in capitals on south-facing metal plaque:
THIS PLAQUE WAS UNVEILED ON / THE 9TH DAY OF APRIL, 1952 BY THE / EIGHTH MARQUESS OF LONDONDERRY / TO COMMEMORATE THE RESTORATION / OF THE STATUE FROM FUNDS RAISED BY / THE CITY COUNCIL.
Signed on the east side of the copper base: Monti
Status: II
Condition: fair
Condition details: badly weathered steps; spalling on pedestal; large cracks at base of statue; verdigris has formed over much of the statue; guano
Commissioned by: public subscription
Custodian: City of Durham Council

Description: an over-life-size equestrian statue of the 3rd Marquis of Londonderry, aged 42, clothed in Hussar uniform.[1] Reining in his mount, the now green copper figure stands high above a tall sandstone pedestal in the centre of Durham's Market Place. The sculptor is said to

have used a picture by Sanders at Wynard Park, the Londonderry home, for details of features and dress.[2]

Subject: Charles Stewart (1788–1854) was educated at Eton before embarking on a distinguished and active military career which included 25 battles between 1796 and 1814.[3] In 1803 he was briefly under-secretary for Ireland, and four years later served as under-secretary for war alongside his half-brother, Lord Castlereagh, the 2nd Marquis of Londonderry. However, as a contemporary said, 'his nature was chivalrous rather than administrative' and he took every opportunity to see action with his regiment, the 5th Dragoons (the Royal Irish), even though his defective eyesight and hearing on occasion led him into difficulties.[4] After the defeat of Napoleon he became ambassador in Vienna and played an important role in the Vienna Congress negotiations. In 1819 his marriage to the Irish heiress, Frances Anne Vane-Tempest brought him the surname Vane and possession of large estates in Co. Durham and Ireland, to which three years later he added the Seaham estate. Thereafter he threw himself into developing the economic potential of his estates, completing the new harbour and docks at Seaham in 1831. By the time of his death his business acumen and energy had made him immensely wealthy, with £75,000 a year from his estates, three-quarters of that from coal.[5]

History: in 1858, four years after the Marquis's death, there is a report that the memorial committee had received £2,000 from subscribers and therefore recommended a double-life-size equestrian statue by Raffaelle Monti using the 'copper bronze by the galvano plastic process' in which Monti specialised.[6] Various towns were considered for siting the memorial, including Sunderland and the Marquis's creation, Seaham Harbour, before Durham was agreed upon.[7] There was also some debate about the exact location of the

Monti, *Londonderry Monument*

statue in Durham; at one point the council believed that the work would be too large for the Market Place and tried to persuade the University to allow it be erected on Palace Green near the Cathedral.[8] Eventually, in accordance with the wishes of the Marquis's widow, work began at the present site, although only after several delays, the first of which was a court case in which five local tradesmen filed a suit against the mason claiming that the statue would interfere with free passage to the markets and thus affect their businesses.

The statue was said to be the largest ever produced using the electro-plating process, and the *Durham County Advertiser* gives a detailed

account of what this entailed, emphasising that the sculptor personally assisted at every stage.[9] Unfortunately before the statue could be delivered other commissions on which Monti was engaged drove him to bankruptcy, with the result that creditors seized the statue, and the Marquis's widow had to pay £1,000 to retrieve it.[10] (The Londonderry papers lodged at the Durham County Record Office give no further details about this episode or indeed any other aspect of the commission.)

The statue was erected and unveiled to a throng of spectators who filled the Market Place on 2 December 1861. The Marquis's friend, Benjamin Disraeli and Monti were among those present, as well as the staff of the North Durham Militia, the 2nd Durham Artillery, the 3rd and 7th Durham Rifles. The *Durham County Advertiser* was impressed, declaring the statue 'lasting proof of the general regard in which the brave and generous [Marquis] was held by all classes and parties of the people of Durham'.[10] Local residents, however, have always tended to see it rather differently, as commemorating someone who for all his military derring-do could also be a ruthless colliery owner. On one occasion, for instance, the Marquis sent a letter threatening to evict any merchant in Seaham found to have supplied provisions to striking pitmen – the 'Seaham Letter'.

Initially the statue did not have an inscription, but judging from photographs of the Market Place dating c.1870, the main inscription was added several years after the statue was in place.[11]

In 1951 the whole work was taken down and sent to London for a full-scale overhaul by J. Starkie Gardner Ltd. A set of photographs recording the operation shows that in places the copper had worn paper-thin.[12]

Contrary to one of the most persistent local legends concerning the statue, the horse does have a tongue.[13]

[1] *Durham County Advertiser*, 6 February 1861.
[2] *Ibid.* [3] Londonderry, E., *Frances Anne*, London 1958, p.294. [4] *DNB.*, 1917, vol.XVIII, pp.1165–8.
[5] Sturgess, R, *Aristocrat in Business: the Third Marquis of Londonderry as Coalowner and Portbuilder*, Durham, 1975, p.8. [6] *Builder*, 1858, p.200. [7] Anon, undated newspaper article.
[8] Crosby, J., *Durham in Old Photographs*, Stroud, 1990. [9] *Durham County Advertiser, op. cit.*
[10] Anon, undated newspaper article.
[11] Londonderry Papers, Durham County Record Office. [12] *Ibid.* [13] Anon, *Some Erroneous Stories Connected with Durham*, n.d., p.20.

North Road

Wharton Park, North Road entrance

Albert the Good

Sculptor: J. Gibson

Carved 1800s; probably re-sited here after 1863
Statue: stone 1.6m high × 55cm wide × 58cm deep
Base: stone and brick 2m high × 4m wide × 4.8m deep
Signed at the base of the statue: J. GIBSON 18[...]
Incised stone tablet below figure: ALBERT THE GOOD
Incised marble plaque on base: WHILE WE HAVE TIME / LET US DO GOOD / UNTO ALL MEN.
Incised stone tablet at rear of base: THIS OAK WAS PLANTED MARCH 10TH 1863 / THE MARRIAGE DAY OF ALBERT EDWARD PRINCE [...] / [...] AL.
Status: not listed
Condition: poor
Condition details: head and several fingers on left hand missing; tip of sceptre or sword missing; surface spalling to statue; areas of base crumbling; cracks of stone on base of figure; signature barely legible due to erosion
Custodian: City of Durham Council

Description: a life-size figure clothed in medieval robes and bearing orb and sceptre or sword. Carved from three blocks of stone, the statue is now without a head leaving its metal armature exposed at the apex. It stands on a steep mound above a rock-faced stone base which surrounds a mature oak. The base bears two tablets with inscriptions, one at the front, another at the rear.

History: it is not clear who the figure represents, who commissioned it or when it was installed. Carved by a now unknown sculptor or stonemason for whom no records are to be found, the statue appears to be a nineteenth-century Gothic style representation of a medieval king or prince bishop.

While the inscription suggests that the figure is Prince Albert (Tennyson dedicated his new edition of the *Idylls of the King* to 'Albert the Good' after the death of the Prince Consort in 1861), the subject's orb indicates a sovereign. One source claims that the figure is a representation of the young Queen Victoria,[1] but there is no documentary evidence to support this.

Gibson, *Albert the Good*

It seems likely that the statue was previously sited elsewhere and installed above the unrelated inscription some time after 1863. In that year W.L. Wharton (see p.250) planted the oak and erected two commemorative tablets to mark the wedding day of the Prince of Wales to Alexandra of Denmark, and honour the memory of Prince Albert. Detailed coverage of the celebratory event in the new park on 10 March 1863, however, makes no mention of a statue so it was surely added later.[2]

It is worth noting that, whilst there were plans in 1862 to erect 'a memorial of a monumental character' to Albert in Durham[3] these appear to have come to nothing, possibly because the Hartley Colliery disaster (see pp.55–6) diverted potential subscription funds. Thus, with the exception of a roundel portrait relief of Albert in Newcastle Central Station (see p.21), the region lacks the monuments to Albert found elsewhere.

[1] Durham University Library, Gibby Photograph Collection, Ref no. W2. [2] *Durham County Advertiser*, 13 March 1863. [3] *Ibid.*, 17 January 1862.

Wharton Park, Windy Hill

The Way

Sculptor: Hamish Horsley

Erected 1990; re-sited 1994; unveiled 22 September 1994
Whole work: Portland stone and pebbles 14.4m long × 2.35m × 4.94m wide
Incised on nearby metal plaque: 995 (Durham Coat of Arms) 1995 / THE WAY / HAMISH HORSLEY / THIS SCULPTURE HAS BEEN GENEROUSLY DONATED BY BRITISH RAIL / TO THE CITY OF DURHAM COUNCIL ON LONG-TERM LOAN. IT WAS / ORIGINALLY EXHIBITED AT THE 1990 INTERNATIONAL GARDEN / FESTIVAL, GATESHEAD AND HAS BEEN REMODELLED HERE TO / COMMEMORATE THE THOUSAND YEAR ANNIVERSARY OF THE ARRIVAL / OF THE

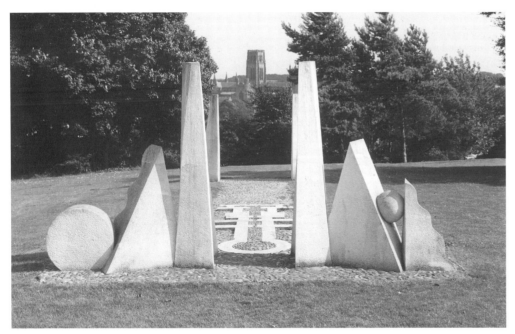

Horsley, *The Way*

COMMUNITY OF ST. CUTHBERT ON THE DURHAM
PENINSULA / IN 995 AD. / THE CITY COUNCIL
GRATEFULLY AKNOWLEDGES THE ASSISTANCE OF
/ BRITISH RAIL COMMUNITY UNIT THE ORIGINAL
COMMISSIONING / AGENTS, THE PUBLIC ART
DEVELOPMENT TRUST, NORTHERN / ARTS AND
NORTHERN AGGREGATES LIMITED IN THE
SCULPTURE'S INSTALLATION. / IT WAS UNVEILED
ON 22ND SEPTERMBER 1994 BY / THE RIGHT
WORSHIPFUL / THE MAYOR OF DURHAM /
COUNCILLOR W. D. CAVANAGH. M.A.

Status: not listed
Condition: good
Condition details: lichen and algal growth in
some areas
Commissioned by: British Rail Community
Unit and the Public Art Development Trust
Owner: British Railways Board
Custodian: City of Durham Council

Description: a large symmetrical arrangement
of abstract forms in Portland stone either side
of a pathway of pebbles.

History: originally exhibited in 1990 under
the title of *Aion* at Gateshead's National
Garden Festival, the work was one of ten
sculptures featured in the British Rail
sponsored 'Time Garden'. Divided into two
parts by the River Team the work was intended
to symbolise the beginning, stillness and
movement of time.[1] In 1994, a year before the
1,000th anniversary of the arrival of the body of
St Cuthbert in Durham, the sculpture was given
to the City of Durham on a ten-year loan for a
site at Windy Hill which has views of the
Cathedral in the distance. The sculptor
modified the work in certain ways so as make it
suitable for this new setting which, as he
acknowledged, in effect gives it an entirely new
meaning. 'I wanted [it] to symbolise the life and
journey of St. Cuthbert, which led in time to his
remains being carried to the Durham Peninsula

and the building of the Cathedral [...] The
largest gateway, the steps and the two columns
all focus, not just on that wonderful building,
but also on the idea of the journey of our
individual ways through life and the
expectations we carry with us.'[2]

[1] *Festival Landmarks*, p.39. [2] Crosby, J., *Durham
City Art Map*, Durham, 1998.

Obelisk Lane
Approximately 30m north of road

The Obelisk
Designer: not known

Constructed 1850
Obelisk: sandstone 25m high approx
Pedestal: sandstone 3.85m square
Base: limestone 5.37m square × 3.15m high
Incised on tablet of south-facing dado: WLW /
ASTRONOMIÆ / DICAVIT / MDC CCL
Incised in stone on south face of base: N.
LATITUDE 54° 46', 54" / W.LONGITUDE 4° 34',
56.25 / MAGNETIC DIP 70° 36' / VARIATION 23°
45' / SEA LEVEL HALF TIDE 292 feet
Status: II
Condition: fair
Condition details: extensive spalling on south
cornice of pedestal and base; cracks in some
areas; dirty; algal growth and moss in areas;
graffiti incised and inked into stone of base and
pedestal
Commissioned by: William Lloyd Wharton
Custodian: Trustees of the Diocese of Hexham
and Newcastle

Description: a tall obelisk of sandstone
surrounded by shrubbery and metal fencing on
all sides. The column stands on a panelled
pedestal and limestone base. A half-bricked-in
entrance allows access to a central staircase.

History: despite its height, the obelisk is not
a prominent city landmark, located as it is near
the base of a hill and screened by trees on three

sides. It stands in a former field owned by the wealthy Wharton brothers, William and John. William Lloyd Wharton lived at nearby Dryburn Hall (now the Dryburn Hospital) and erected the 30-metre-high structure in 1850 as a gift to the Observatory at the University of Durham.[1] It is claimed that its construction was also intended to provide 'employment for idle men during a bad period of depression'.[2]

As a northern meridian marker or reference point for the university's Observatory over a kilometre away, the structure assisted observation of the night sky. Theoretical astronomy had been taught at Durham since 1835, and observational astronomy began with the building of the Observatory five years later. In the following decade, astronomical 'observations of considerable significance were made in Durham'.[3]

Now that the Observatory is no longer in use, the obelisk's only function is as an unintended monument to Durham University's involvement and achievements in the field of astronomy.

[1] Rochester, G.D. and Parton, G.M., 'The Durham Obelisk' (unpub.), Durham Library, 1995, p.3.
[2] F.H. Rushford, *In and Around Durham*, Durham, p.20. [3] Rochester and Parton, *op. cit.*, p.5.

Prebends Bridge

Durham Cathedral's Artist-in-Residence Scheme began in 1983. Studio space, accommodation and administrative support are made available to an artist, who is invited to respond to the Cathedral's architecture, its community and the surrounding riverbank site. The annual project ends with an end-of-year show or, in some cases, the installation of a public sculpture in the Cathedral grounds. Co-ordinated by the Chaplaincy to the Arts and Recreation, the residency receives additional sponsorship and support from the Dean and Chapter of Durham Cathedral, Northern Arts, the Universities of Sunderland and Durham, and Durham County Council.

Riverside pathway, north

Kathedra
Sculptor: Colin Wilbourn

Installed 1988
Whole work: sandstone 2.9m high × 2.1m wide × 1.5m wide
Status: not listed
Condition: good
Condition details: gargoyle missing from the rear of the work; small cracks in some areas; algal growth; inked graffiti in areas
Commissioned and owned by: Dean and Chapter of Durham Cathedral

The Obelisk

Wilbourn, *Kathedra*

Description: a sculptural throne. At the front, facing the river, an arch surrounds a niche and seat. Stone carved gargoyles extend from the rear of the work.

History: Kathedra, also known as *Peace Seat* or *Order and Chaos*, is the second of two sculptures made by Wilbourn during his residency at Durham Cathedral (see below). The work makes reference to the Bishop's throne or cathedra which is normally located in the Cathedral of a Diocese. A bishop's official seat or see is also the title given to the town or place where the Cathedral is situated.[1]

[1] Cross, F.L. and Livingstone, E.A., *The Oxford Dictionary of the Christian Church*, London, 1974, p.1256.

The Upper Room
Sculptor: Colin Wilbourn

Erected 1988
Whole work: wood, reinforced in parts with metal, concrete base and roofing felt 4m high × 3.2m wide × 10m long
Incised in capitals inside seat: THE UPPER ROOM / COLIN WILBOURN / 1988.
Status: not listed
Condition: fair
Condition details: large chips of wood missing; woodworm damage to some areas; small amounts of fungi, lichen and moss in many areas; rusted metal in parts; large amounts of incised graffiti
Commissioned and owned by: Dean and Chapter of Durham Cathedral

Wilbourn, *The Upper Room*

Description: a sculpture comprising the trunks of thirteen diseased elms. The trees stand in an oval with twelve bearing a carved relief. If viewed simultaneously from a seat within the thirteenth tree, the carvings represent an unoccupied room with arched windows, tables, jugs of water, leftover food and a bag of silver.

History: carved from diseased trees felled from the riverbank wood, the combined reliefs depict the scene of Christ's Last Supper in the upper room of a house. The bag of silver refers to Judas Iscariot's betrayal of Christ for 30 pieces of silver.[1]

The sculpture is one of two outdoor works executed by Wilbourn during a one-year artist-in-residency at Durham Cathedral (see above).

[1] Cross, F.L. and Livingstone, E.A., *The Oxford Dictionary of the Christian Church*, London, 1974, p.801.

Riverside pathway, south

Reveal
Sculptor: Richard Cole

Unveiled 15 July 1997
Whole work: reclaimed sandstone 4.5m high × 2.5m square
Status: not listed
Condition: good
Condition details: moss in some areas
Commissioned by: Dean and Chapter of Durham Cathedral
Custodian: Dean and Chapter of Durham Cathedral

Description: a conical column of irregularly textured stone. The structure contains six shallow niches and a long narrow aperture at its centre. It stands opposite the Cathedral beneath a canopy of trees.

History: Cole proposed the sculpture during his residency four years previously. Constructed using centuries-old stone from one

Cole, *Reveal*

of the Cathedral's former turrets, the sculpture stands a short distance from the edifice where the newly-erected tower is an obvious addition. The work's conical form and use of apertures suggest its former architectural use. It was unveiled by the Mayor of Durham, Councillor Neil Griffin on the same day as the *Durham Cow* (see p.254) further down river.[1]

[1] Information provided by Dean and Chapter of Durham Cathedral, 28 August 1998 and the artist, 1999.

Redhills Lane

*Durham Miners' Association offices,
atop gateposts at entrance*

Durham Miners

Sculptor: Robert Olley

Installed 1989
Each work: concrete and cold cast bronze
coating 70cm high
Incised on metal plaque beneath figures:
DURHAM / MINERS
Status: not listed
Condition: poor
Condition details: outer layer of bronze coating
much weathered
Commissioned and owned by: National Union
of Mineworkers

Description: two identical figures of

Olley, *Durham Miners*

twentieth-century miners decorate the
gateposts to the headquarters of the Durham
Miners' Association. Dressed in work clothes
and wearing a helmet, safety lamp, battery pack
and water flask, each miner sits on his haunches
resting both hands on a pickaxe.

*Durham Miners' Association offices,
outside entrance*

Miners' Leaders

Sculptor: J. Whitehead

Installed 1876, moved to present location *c.*1915
Each figure: marble 2.25m high × 72cm square
approx
Each pedestal: sandstone and granite 2.25m
high × 1.44m square
Incised on base of statue of *Macdonald*: J.
WHITEHEAD / WESTMINSTER / LONDON
Incised Roman letters on pedestals: FORMAN /
PATTERSON / MACDONALD / CRAWFORD
Status: II
Condition: fair
Condition details: cracks on each pedestal;
lichen and algal growth on all figures and
pedestals; minor spalling on all pedestals
Commissioned by: Durham Miners'
Association
Custodian: National Union of Mineworkers

Description: four life-size marble statues
stand side-by-side on short granite pedestals
above tapered sandstone bases. The figures,
representing nineteenth-century miners' leaders
Forman, Patterson, Macdonald and Crawford
wear frock coats and trousers, and now
overlook a modern sculpture of a miner
struggling with his load (see below).

Subjects: John Forman (1822/3–1900), born
at Allerton Burn, Northumberland, moved to
County Durham in the 1850s, working as a
checkweighman at Grahamsley colliery in the
district of Crook. One of the founding

Whitehead, *Forman* **Whitehead,** *Patterson*

members of the Durham Miners' Association,
Forman was appointed an agent for the union
and a member of the first executive committee.
In 1874 he was made permanent chairman of
the DMA. As well as playing a key part in
explosion investigations and developing a viable
theory on the ignition of coal dust, he also
assisted in the rescue of men from the Seaham
explosions of 1871 and 1880 (see pp.269–71).[1]

William Hammond Patterson (1847–96).
Born in Durham, the son of a quarryman, he
was involved in the founding of the Durham
Miners' Association in 1869 and was made
agent and vice-president in 1878. In the years
1872–90 he brought organisational and financial
stability to the DMA. Patterson was appointed
general secretary of the organisation on the
death of Crawford in 1890.[2]

Alexander Macdonald (1821–81). Born in
Lanarkshire, he began work in the mines at the
age of eight. In his twenties he attended
Glasgow University, paying for his tuition from
savings and by working in the mines in the

 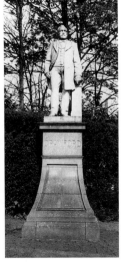

Whitehead, *Macdonald* Whitehead, *Crawford*

summer months. He went on to become a mine manager and then a teacher. Some time in the 1850s Macdonald decided to devote his time to the improvement of miners' conditions. In 1856 he came to England to 'advocate a better Mines Act, true weighing, the education of the young, the restriction of the age to twelve years, the reduction of the working hours to eight in every twenty-four, the training of managers, the payment of wages weekly in the coin of the realm'. An advocate of strike action and parliamentary reforms, he lobbied Parliament to secure the Coal Mines Regulation Act of 1860. This allowed the election of checkweighmen by the miners themselves and was also intended to improve the inspection of pit safety measures. In November 1863, the Miners' National Association was established with Macdonald appointed as president, a position he held until his death. Elected as Liberal MP for Stafford in 1874 and 1881, he continued to support improved conditions for miners in Parliament.[3]

William Crawford (1833–90) was born in Northumberland, the son of a miner. Working in the pits from an early age, he became involved in trade union activity in his twenties. Appointed as one of the full-time agents of the Durham Miners' Association soon after its formation in 1869 he was later made its general secretary, a position he held until his death in 1890. He is credited with encouraging the rapid growth of the DMA membership in its early years. Under his leadership the organisation procured the abolition of the yearly bond (a legally binding agreement between colliery owner and miner which imposed harsh terms on the employee). In 1885 he was elected MP for Mid-Durham.[4]

History: each of the leaders represented here played a pivotal role in either the formation or the managership of the Durham Miners' Association in its early years (1869–74). The marble figures formerly stood on the façade of the first Miners' Hall (now a Bingo Hall) in nearby North Road which opened on 3 June 1876, but were moved and re-erected on pedestals outside the new association headquarters in Redhills soon after its construction in 1915.[5]

[1] Bellamy, J.M. and Saville, J., *Dictionary of Labour History, London, 1972*, p.123. [2] *Ibid.* pp.263–4. [3] *Ibid.* pp.219–21. [4]*Ibid.*, p.93. [5] Durham County Environmental Education Curriculum Group in Co-operation with *Northern Echo, Coal Mining in County Durham*, 1993, p.102.

Durham Miners' Association offices, outside entrance

The Putter

Sculptor: Brian Brown

Installed 1995
Whole work: recycled metals 4m long × 2.8m wide × 2.3m high
Status: not listed

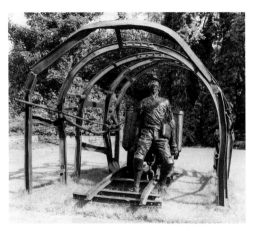

Brown, *The Putter*

Condition: fair
Condition details: rusting in parts; paint cracked in some areas
Commissioned by: Easington District Council
Owned by: Brian Brown

Description: life-size representation of an apprentice miner down the pit shifting a derailed tub of coal. The sculpture is made of recycled metals and painted black. It faces the entrance to the Durham Miners' Association Hall and is overlooked by the statues of nineteenth-century miners' leaders.

History: originally commissioned by Easington District Council to commemorate the closure of the Easington Colliery in 1993, the work was constructed in the colliery's engineering workshop using on-site scrap. Following the decision not to install it at its intended site for fear of vandalism, the sculptor, himself an ex-miner, gave it to the National Union of Mineworkers at Durham on temporary loan.[1]

[1] Information provided by the artist, 1999.

The Racecourse

Between Baths Bridge and the Bandstand

Durham Cow

Sculptor: Andrew Burton

Unveiled 15 July 1997
Sculpture: bronze 1.8m high × 2.7m long × 1.8m wide
Base: stone 2.2m square
Signed on the front right leg: ANDREW BURTON / 1997
Incised in capitals on a slab of stone nearby: DURHAM COW / LEGEND WOULD HAVE YOU RUMINATING UP BY THOSE / MASSIVE PILES BUT WHAT COW PREFERS A ROCKY MOUND / TO A RIVER BANK AND WHO BELIEVES THAT STORY OF A / DREAM AN OX TWO MILKMAIDS SOME FOOTSORE MONKS AND A HAPHAZZARD ENCOUNTER THAT PUTS STOP TO THEIR ENDLESS ZIGZAGGING AND SEEDS A BUILDING BEYOND ALL THEIR COLOSSAL IMAGINING. HERE AND NOW YOU SEEM REAL ENOUGH / Andrew Burton 1997
Status: not listed
Condition: good
Condition details: small amount of inked graffiti
Commissioned and owned by: City of Durham Council

Description: a life-size bronze cow settling down to rest. The gold-horned beast looks down river towards the Cathedral. It sits on a base of six square slabs of stone and is surrounded by three cog-like ceramic sculptures.

History: Burton's idea for the *Durham Cow* came about in the early 1990s when he was invited to make a sculpture for another city site. However the project fell through and it was not until 1996, when additional funding became available through the Visual Arts Year budget, that the commission was finally realised.[1]

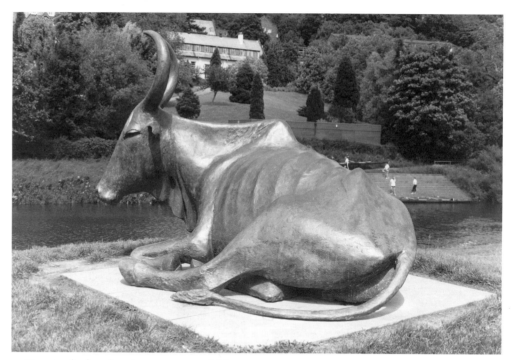

Burton, *Durham Cow*

Despite the fact that the cow or ox, which takes the form of a hybrid of western and occidental beasts, is not intended to be seen as a 'specifically Christian piece'[2] it makes obvious references to the story of the Dun Cow. This centuries-old legend explains how the body of St Cuthbert, 'Northern England's most popular saint', came to rest at Durham. Several centuries after the death of Cuthbert in 687, Vikings invaded Lindisfarne and Cuthbert's remains were brought by a community of monks to the mainland for safe-keeping.[3] According to local folklore a revelation instructed the monks to move the holy relics to Dunholme (Durham) and a milkmaid, bringing her cow to the town, directed the way.[4] Though the tale remains popular, it is now generally acknowledged that Cuthbert's body was brought to Durham after some planning and fortification of the site in advance.[5] The Norman Cathedral was built around the saint's shrine and a high-relief on the exterior north wall of the edifice depicts two milkmaids and the Dun Cow.

The *Durham Cow* and its satellite works (made by the European Ceramic Centre in the Netherlands and based on the cross-sections of the Cathedral columns) were unveiled by the Mayor of Durham on a summer's evening in 1997. Funding for the project came from Durham City Arts, Northern Arts and the European Regional Development Fund.[6]

[1] Information provided by Durham City Arts, 1998. [2] *Journal*, Newcastle, 16 July 1997. [3] Farmer, D., *Oxford Dictionary of Saints*, Oxford, 1997, p.120. [4] Cockburn, F.N., *The Legends of Durham*, p.66. [5] Roberts, M., *The Book of Durham*, London, 1994, p.14. [6] *Journal, op. cit.*

EASINGTON COLLIERY

Crawlaw Road

Easington Colliery Cemetery, Garden of Remembrance

1953 Easington Colliery Disaster Memorial

Sculptor: not known

Inaugurated 29 May 1953
Main screen: brick and stone 82cm high × 1.05m wide × 31cm deep
Base: stone 17cm high × 1.51m wide × 61cm deep
Incised on stone panel of smaller screen in Roman letters: THIS TABLET IS ERECTED TO THE MEMORY OF / EIGHTY THREE MEN WHO GAVE THEIR LIVES IN THE / EASINGTON COLLIERY DISASTER / TWENTY NINTH MAY NINETEEN HUNDRED & FIFTY ONE / SEVENTY TWO GRAVES ARE IN THIS CEMETERY / THE FOLLOWING NINE MEN ARE BURIED ELSEWHERE [names] / AND ALSO TO THE MEMORY OF TWO BRAVE MEN / JOHN YOUNG WALLACE AND HENRY BURDESS / WHO GAVE THEIR LIVES IN PERFORMANCE OF THEIR DUTIES / AS RESCUE WORKERS AND WHO ARE BURIED ELSEWHERE.
Incised on panel of main screen: REMEMBER BEFORE GOD THOSE WHO GAVE THEIR / LIVES IN THE EASINGTON COLLIERY DISASTER IN / MAY NINETEEN HUNDRED AND FIFTY ONE TO WHOM / THIS GARDEN OF REMEMBRANCE IS DEDICATED.
Status: not listed
Condition: good
Condition details: replaced plaque on main screen; dirty
Commissioned by: Memorial Grave Committee
Custodian: Easington Colliery Parish Council

Description: two stone and brick screens face one another across a large coal-cutting machine. Each bears a figurative relief and an inscription.

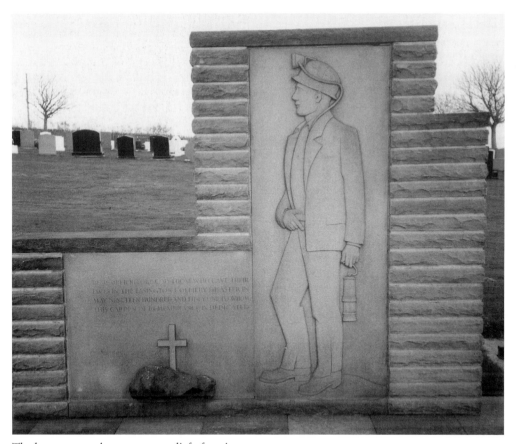

1953 Easington Colliery Disaster Memorial

The larger screen bears a stone relief of a miner in his work clothes, holding a lamp. Represented in profile the figure is carved to a depth of approximately 2cm. The opposite wall bears the main inscription and two low-reliefs of miners' lamps.

Subject: the most disastrous post-war mining accident in the region occurred at Easington Colliery on 29 May 1951. An explosion at dawn in the Duckhill district entombed 81 men. Despite a well-organised and intensive 10-day rescue operation, during which two men lost their lives, only one miner was brought out alive and he died later. The other 80 men were found dead in the pit.[1]

A government inquiry found that the explosion had occurred when the picks of a coal-cutting machine struck pyrites and ignited firedamp.[2]

History: the garden of remembrance was opened two years after the disaster, on 29 May 1953, and is sited above the communal grave of those killed. Interestingly a coal-cutting machine, similar to the one which is said to have caused the accident, was moved in front of the memorial at the time that Easington Colliery closed in 1994.[3]

[1] Purdin, J., *Explosion at Easington, A Durham Mine Disaster Remembered*, Beamish, *passim*.
[2] Roberts, H.C.W., *Explosion at Easington Colliery*, County Durham, 1952, *passim*. [3] Information provided by Easington Parish Council, 1999.

Memorial Avenue
Welfare Park

1952 Easington Colliery Disaster Memorial

Designer: not known

Installed 22 March 1952
Whole work: stone 1.2m high × 1.03m wide × 1.6m deep
Raised lettering on a metal plaque: ON THE 29TH MAY 1951 / EIGHTY ONE MEN / DIED TOGETHER /

1952 Easington Colliery Disaster Memorial

IN / EASINGTON COLLIERY / FOLLOWING AN EXPLOSION / AND IN THE RESCUE BID / TWO MEN GAVE THEIR LIVES / THE TREES HEREABOUT / WERE PLANTED THE MEMORIAL / AVENUE WAS MADE AND THIS / TABLET PLACED ON A STONE FROM / THE SCENE OF THE ACCIDENT / TO HONOUR THE / MEMORY / OF THOSE / WHO LOST THEIR LIVES / LET PASSERS-BY / DO LIKEWISE GET / UNDERSTANDING AND PROMOTE GOODWILL IN ALL THINGS
Status: not listed
Condition: good
Custodian: Coal Industry Social Welfare Organisation

Description: a memorial comprising a large carved triangular rock painted white. It bears a tablet of stone removed from the scene of the disaster, and a metal plaque with an inscription.

History: the memorial was inaugurated on 22 March 1952, less than one year after the explosion (see above). On the same occasion, Easington Colliery's youngest miner, a boy of 16, planted the first of 83 trees to line the newly constructed Memorial Avenue. Each of the now fully-grown trees is intended to symbolise a life lost in the disaster. [1]

[1] Information provided by Jack Cummings and John Surtees, 1999.

Seaside Lane

'Looking Beyond', Easington District Council's community art programme for Visual Arts UK, began in January 1996. A number of individual art projects around the district were set up with the aim of enhancing the environment, reaffirming local identity and bringing new perspectives that would 'look ahead and reach out towards a new future'. Artists were commissioned to work with the local community on a variety of initiatives including the construction of a temporary sculpture on Seaham beach, the creation of a tapestry banner, a horticultural scheme and the publication of a book about the project, as well as the installation of a number of permanent sculptures. By July 1996 five permanent pieces were in place.

Aerial photographs of the district, taken at the beginning and end of the project, aimed to encourage a new perspective that 'looked beyond' local boundaries, as well as record the changes that had taken place. The artworks were officially opened by Dan Myers, Chairman of Easington District Council, in July 1996. Funded by Easington District Council, Visual Arts UK and the European Regional Development Fund, it is estimated that over 3,000 local people were involved in the £250,000 'Looking Beyond' scheme. [1]

[1] *Looking Beyond*, *passim*.

Easington Library, outside

Brick Boat

Sculptor: Matthew Jarratt

Installed July 1996
Whole work: brick 8m square × 2.05m high
Status: not listed
Condition: good
Commissioned and owned by: Easington District Council

Description: rendered in brick, a child-like representation of a small boat bobbing on the sea. The sculpture comprises four pieces, some of which contain childrens' relief carvings of the village, pets and abstract forms.

History: 300 residents and schoolchildren assisted Matthew Jarrett in the construction of the *Brick Boat*. They designed and carved individual clay bricks which were then fired and assembled into the form of the boat and waves by the sculptor. [1]

[1] University of Northumbria, Visual Arts UK Archive: Durham, 1999.

EASINGTON VILLAGE

Village Green
The Roundels
Artist: Amanda Randall

Installed 1996
Whole work: artificial stone 3m long approx
Status: not listed
Condition: fair
Commissioned and owned by: Easington
District Council

Description: seven roundels interlinked by a
sinuous line of bricks sunk into a grass verge on
the Village Green. Each bears a relief which has
been cast in artificial stone and depicts a scene
of Easington life.

History: The Roundels are one of a series of
community participation artworks erected in

1996 for the Easington-based 'Looking
Beyond' project (see above). Randall involved
several hundred local people in the design and
casting of the sculptures, hoping to 'create an
artwork which would celebrate aspects of the
village community that the villagers themselves
value'. The seven-month project was sponsored
by Easington District Council, Northern Arts
and the European Regional Development Fund
at a cost of £6,000.[1]

[1] University of Northumbria, Visual Arts UK
Archive: Durham, 1999.

EAST CASTLE

Stony Heap, C2C cycle route

The Old Transformers: Miner and Ironmaster
Sculptor: David Kemp
Assisted by: Tom Leaper

Randall, *The Roundels*

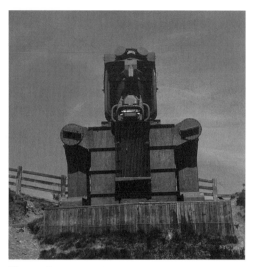

Kemp, *Ironmaster*

Installed April 1990
Each work: recycled transformer and found
metals 6m high × 5m wide × 1.5m deep
Incised lettering burnt into red metal: THE MEN
[…] LIVED HERE DUG INTO THE […] BLACK /
STONE. IN GIANT HUTS THEY BURNED EARTH /
TURNING IT INTO IRON. THEY / TURNED THE SKY
RED. A RIVER OF STEEL RAN DOWN TO / THE SEA
AND TRANSFORMED / INTO […] SHIPS AND
MACHINES WHICH / TRANSFORMED THE WORLD.
Inscription on steel plate, cut lettering: THE /
OLD / TRANS / FORMERS / DAVID KEMP / 1990
Status: not listed
Condition: good
Condition details: peeling and blistering paint
in parts; rust visible in small areas; inscription
eroded
Commissioned and owned by: Sustrans

Description: two large busts of industrial
workers stand side by side. Made from recycled
electricity transformers and used metals, on the
left is an ironmaster with goggles resting on his
forehead, coated in black paint with splashes of

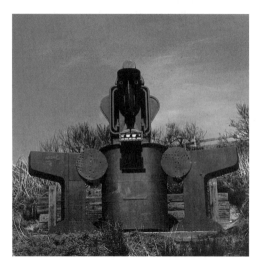

Kemp, *Miner*

red; to the right, a miner with helmet and torch.

History: The Old Transformers have been described as being reminiscent of Easter Island heads in both their scale and presence.[1] Located on a hill, overlooking the Durham Moors, on a site where there are no visual traces of the former mining and steel industries, the figures of a miner and ironmaster stand midway between the old colliery town of Stanley and Consett, once the site of the largest steelworks in Europe.

The 14-tonne sculptures were built from two electricity transformers at the North East Electricity depot in Newcastle in the winter of 1990. Dismantled and brought to East Castle by low loader they were installed alongside the Sustrans C2C cycle route (see pp.84 and 316) in April of the same year. 'People have asked me if the sculptures are permanent, how long will they last?' wrote Kemp, 'I think of the steel-works three miles long. Everything changes.'[2]

[1] Ellis, M., 'New Exhibitions: Putting Art in its Place', *Art and Design*, May/ June 1994, pp.xiv–xv.
[2] Information provided by Sustrans, 1998.

EAST LENDINGS

Rokeby Park to Barnard Castle road

Egglestone Abbey, either side of bridge

Boundary Markers

Letter carver: Karl Fisher
Sculptor: Richard Wentworth

Installed 1996
Each work: cast iron 76.2cm high × 35.6cm wide
Incised vertically in Roman letters on the side of each half post: the name of the parish on which it stands.
Status: not listed
Condition: good
Commissioned and owned by: Teesdale District Council

Description: one of twelve iron posts or bollards looking like chimney pots which mark parish boundaries along the north and south banks of the Tees between Middleton and Gainford. Each cast iron post has been split in two and the two halves stood on either side of a boundary (usually a hedge, ditch, stile, wall, beck, stepping stone or fence) in such a way as to allow passers-by to reunite the posts in their mind's eye each time they cross from one parish to another. Although essentially a repeated form, each post is rendered unique by being installed at a particular site.

In addition, the top of each post carries the negative impression of a half plate or bowl, a feature which the artist has explained is intended to be suggestive of the fact that 'plates and bowls are containers which we associate with sharing and generosity'.[1]

History: Boundary Markers was the first public art project in Britain to be supported by the National Lottery. Wentworth was commissioned in 1995 to develop the idea of

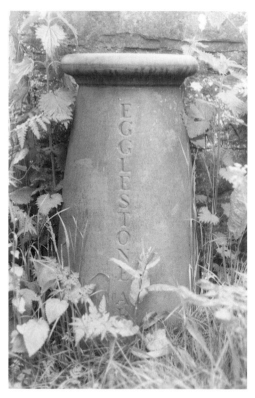

Wentworth & Fisher, *Boundary Markers*

cast iron boundary posts after making a series of visits to the area. He has subsequently explained that his intention was to draw attention to the varied nature of the different boundary points – some exposed, some hidden, some private, some public – and to the wealth of nineteenth-century artefacts in the area; he particularly likes the slim, cruciform nineteenth-century cast iron bollards at Barnard Castle.

The casting of each post was undertaken by the Stockton Casting Company and the letter cutting by Karl Fisher. The project as a whole was supervised by Cleveland Arts. In addition

to Lottery funding, it received support from Northern Arts, the European Commission Regional Development Fund, the Rural Development Commission, Glaxo Wellcome and the Henry Moore Foundation. Considerable efforts were made to win public support with a broad education programme which included a Rogationtide walk, the creation of a series of community banners and projects in local schools.[2]

The posts are sited on the following parish boundaries: Middleton / Eggleston; Eggleston / Marwood; Romaldkirk / Hunderthwaite; Hunderthwaite / Cotherstone; Cotherstone / Lartington; Marwood / Barnard Castle; Lartington / Startforth; Startforth / Egglestone Abbey; Egglestone Abbey / Rokeby; Westwick / Whorlton; Rokeby / Wycliffe with Thorpe; and Winston / Gainford.

[1] Information provided by Teesdale District Council, 1999. [2] Anon, *Marking Parish Boundaries along the Teesdale Way*, 1997, *passim*.

FERRYHILL

Chapel Terrace TOWN CENTRE
Town Hall, rear

Beacon Of Europe

**Sculptor: Robert Olley
Designer: Bill Kataky**

Unveiled 30 December 1992
Arch: steel 5m high
Base: marble clad 84cm high × 3.4m square
Paving: brick 10.4m diameter
Incised on metal plaque at top of base: ON BEHALF OF THE PEOPLE / JANUARY 1993 / FERRYHILL / TOWN COUNCIL / COMMISSIONED / THIS BEACON OF EUROPE / TO SYMBOLISE / A LIGHT TO OUR FUTURE / INTO EUROPE AND / REMEMBER WITH PRIDE OUR PAST.

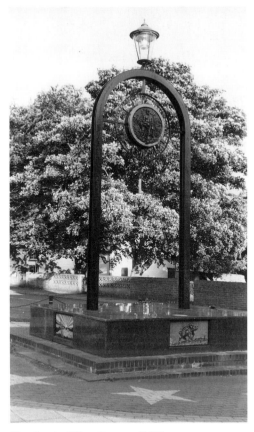

Kataky & Olley, *Beacon Of Europe*

Status: not listed
Condition: good
Commissioned and owned by: Ferryhill Town Council

Description: a large steel arch and lantern above a granite clad base. The centre of the arch contains a fibreglass relief of a miner inserted into a cast iron skeleton of the old town hall clock. The base bears a rectilinear panel with an etching in granite on each of its four sides. Facing west, a wild boar; north, a sunrise; east, a

miner and pit pony; south, rail tracks. The whole work surmounts a brick base and is surrounded by decorative paving featuring the 12 yellow stars of Europe.

Subject: erected to commemorate the advent of the Single European Market on 31 December 1992.

History: eleven organisations and council departments were involved in the design and construction of Ferryhill's £25,000 *Beacon*. Commissioned by the local council to celebrate a single market in Europe, the monument also commemorates the mining, railway and agricultural history of the town. It was unveiled by Tony Blair, the local MP, on 30 December 1992. The scheme was funded by Ferryhill Town Council with the assistance of private donations.[1]

[1] Information provided by Ferryhill Town Council, 1999.

Market Place TOWN CENTRE
Town Hall, front

Monument to William Walton

Stonemason: R. Swinburn

Installed *c.* 1906
Base and pedestal: sandstone 2.45m high × 1.25m square
Obelisk: sandstone 1.1m high
Incised in Gothic and Roman capitals on south-east face of pedestal: ERECTED / BY THE / OFFICIALS AND WORKMEN / OF DEAN & CHAPTER COLLLIERY / TO THE MEMORY / OF THE LATE / WILLIAM WALTON (OVERMAN) / WHO SACRIFICED HIS LIFE / IN SAVING THE LIVES / OF TWO BOYS / AT DEAN BANK / AUGUST 8TH 1906.
Status: II
Condition: poor
Condition details: obelisk missing; extensive spalling; minor cracks and chips; slight covering of lichen and algae; dirty
Commissioned by: officials and workmen of

Dean and Chapter Colliery
Custodian: Ferryhill Town Council

Description: a panelled pedestal decorated with foliate buttresses at each corner. This is surmounted by the base of an obelisk. The main shaft of the obelisk now lies in nearby shrubbery.

Subject: William Walton, 39, was returning home from Dean and Chapter colliery on 8 August 1906 when he saw two boys playing with electrical wires. He was electrocuted whilst deterring the children from a similar fate. Attempts at artificial respiration were unsuccessful. He left a widow and four children.[1]

[1] *Evening Chronicle,* 9 August 1906.

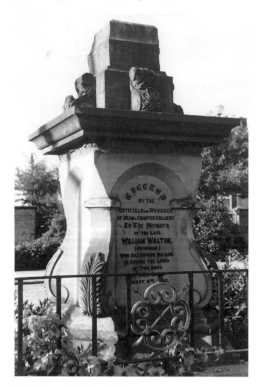

Swinburn, *Walton Monument*

HAMSTERLEY

Forest Drive HAMSTERLEY FOREST
Visitor centre, south east

The Green Man

Sculptor: Philip Townsend

Unveiled September 1996
Each pole: wood 3.5m high approx × 1.9m circumference
Incised in lower case italics: Summer / of '96.
Incised on nearby seats: GREENFATHER / GREENSON / GREENMAN
Status: not listed
Condition: good
Condition details: colour staining has eroded in parts; some of bark separating; small chips and cracks to wood; small amount of graffiti
Commissioned and owned by: Teesdale District Council

Description: six columns of roughly carved wood, stained green, stand vertically in a triangular formation. Seen together from a short distance away, each corner of this sculpture represents the face of a man (Greenfather, Greenson, Greenman). The work also features carved birds' heads, foliage and other organic shapes.

Subject: although the Green Man has many differing forms and meanings, he is essentially a pagan symbol of nature. His carved, often foliated and menacing head features as an apotropaic figure in many churches across Britain and France.

History: made from the wood of six Grand Firs cut from Hamsterley Forest, the sculpture was carved on site using a chainsaw and chisels. Townsend's decision to depict a face in wood stemmed from childhood memories: 'I recall a fascination with illustrations in certain storybooks where semi-human features seemed

Townsend, *The Green Man*

to appear in the trunks of trees, knotty eyes where branches had been shed, noses from stubby cut-off limbs, mouths within wrinkled folds of bark.'

The sculpture's completion in the autumn of 1996 marked the end of an artist-in-residency scheme organised by Teesdale District Council in celebration of Visual Arts UK. It was unveiled by the writer and celebrity Hannah Hauxwell in a ceremony during which David Bellamy gave a talk on legends and current environmental issues.

The project received funding from Forest Enterprise, Durham County Council, Northern Arts, the Rural Development Programme and

Teesdale District Council with sponsorship from Henry Taylor Tools, Partner Jonsered, and Black and Decker.[1]

[1] Teesdale District Council, *The Green Man: A Life Cycle*, 1996, *passim*.

HASWELL

Mazine Terrace
The old winding house

The Spirit of Haswell
Sculptor: Michael Disley

Installed 1996
Sculpture: stone 1.6m high × 1.03m wide × 60cm deep
Base: stone 52cm high × 1m wide × 60cm deep
Incised on south-west facing base: IN 1844 / AN EXPLOSION ON / THIS SITE KILLED / 95 MEN AND BOYS / THEIR SPIRIT LIVES ON.
Incised on south-east face: EASINGTON / COUNCIL / Looking Beyond
Status: not listed
Condition: good
Condition details: noses of heads chipped; small amount of painted graffiti
Commissioned and owned by: Easington District Council

Description: a roughly-hewn boulder of white stone with a carved frieze of the heads of miners, their wives and children at its base. The stone surmounts a polished square pedestal and is surrounded by steel railings, the spikes of which bear small moulded figurative heads. There are 95 heads in all.

Subject: the memorial commemorates 95 men and boys killed in an explosion at Haswell Colliery on 28 September 1844. A blast in the 'Little Pit' killed 19 boys and 76 men; 4 miners survived. Most households in the nearby village lost a friend or relative in the explosion, and many women were left widowed and without income.[1]

The inquest's jury concluded that the explosion, the region's most devastating in twenty years, was an accident and found no-one culpable. However the Prime Minister, Sir Robert Peel, was so alarmed by the disaster that he sent two scientists, one of them the eminent Michael Faraday, to Haswell to investigate further. They were unable to establish the cause of the blast,[2] but a committee to investigate the subject of accidents in coal mines was formed as a result of the disaster.[3]

History: the sculpture was the last in a series of community participation artworks erected in 1996 for the Easington-based 'Looking Beyond' project (see p.256). After early consultations between the artist and the villagers it was decided that Haswell's art project should be a 'long overdue' memorial to those who lost their lives in the mining accident of 1844. The design was developed in a series of workshops on sculpture techniques run for local children by the artist and the stone was carved and erected on site. A formal dedication ceremony led by Haswell's vicar accompanied the memorial's inauguration.

[1] *Northern Echo*, 20 July 1996. [2] Home Office, *Haswell Collieries*, London, 18 April 1845. [3] *Sunderland and Durham County Herald*, 28 September 1844.

Disley, *The Spirit of Haswell*

HOLWICK

Holwick Road
The Fell Road, footpath running opposite the Holwick Scars

Moor or Less
Sculptor: Keith Alexander

Unveiled 26 June 1998
Whole work: grey stone, clay-coloured stone, wood 1.9m high × 2.3m wide × 1.7m deep
Incised on wooden stile: MOOR OR LESS
Status: not listed
Condition: good
Condition details: dirty; algae
Commissioned and owned by: Teesdale District Council

Description: a wooden stile supported by two stone carved sheep and columns. Carved red grouse nestle in the clay-coloured capitals.

History: the sculpture 'depicts the conflict of interest between the sheep and grouse on the high moor'. Unveiled by the Polar explorer Robert Swan in June 1998, it was the second

Alexander, *Moor or Less*

work in a series of community sculptures sited across the district as part of the Teesdale Sculpture Residency (see *The Dive, The Surface, The Roll* and *Green Seat*, pages 222–3 and 228–9).[1]

[1] Information provided by Teesdale District Council, 1999.

HORDEN

B1283 HORDEN CLIFF TOPS

North of Horden Roundabout, along works road to south-bound lane, past Scots pine planting, at the peak of the col

Sea Spirals

Artist: Julia Barton

Installed 1996
Whole work: limestone 50cm high × 18m diameter
Status: not listed

Condition: good
Commissioned and owned by: Easington District Council

Description: an earthwork comprising three half-spirals of limestone rocks, set in spoil and raised approximately 50cm from the ground.

History: a colliery spoil heap once occupied the now green site at Horden Cliffs. In 1996, as part of the £10m 'Turning the Tide' scheme to improve the coastline in this area, artist Julia Barton was invited to work with local schoolchildren on a sculpture for the cliff.[1] The resulting 'earthmound' is intended to create a microclimate from which children can monitor the progress of various plants and fauna.[2]

[1] *Northern Echo*, 23 October 1998. [2] Information provided by Easington District Council, 1999.

IRESHOPEBURN

A689

Junction with New House

John Wesley Pillar

Stonemason: not known

Installed *c.*1950s
Whole work: stone 1.85m high × 75cm square
Incised on the south-facing metal plaque at the apex of the column: THE REV. JOHN WESLEY / (1703–1791) RENOWNED EVANGELIST AND / FOUNDER OF METHODISM / PREACHED IN THIS VICINITY / ON SOME OF HIS FREQUENT VISITS TO WEARDALE.
Status: II
Condition: fair
Condition details: slight algal growth; dirty
Commissioned and owned by: Wear Valley District Council

Description: an old tapering limestone pillar erected on a two-stepped base of the same stone and surmounted by a square abacus. The whole column is capped by a carved triangular stone bearing a twentieth-century metal plaque. It stands to the side of two trees in a small grassy enclosure.

Subject: despite the difficult terrain John Wesley made regular biannual trips to Weardale in the period 1752–90. He is said to have stopped off at up to five village greens a day to give outdoor sermons to the unconverted, and in his first visit to Ireshopeburn he preached

Wesley Pillar

beneath a thorn bush. There is some debate as to whether the present hawthorn, located behind the pillar, is the same bush but it is now known as 'Wesley's Tree' and merits protection under a preservation order.

One of dozens of chapels in the area, Ireshopeburn High House, which opened in 1760, soon became the centre of Methodism in the area. Wesley preached there on several occasions, making his last visit in 1790, a year before his death.[1] The building stills exists and is the oldest Methodist chapel in the country still in continuous use.[2]

History: the pillar, which probably formerly functioned as an eighteenth-century sundial, is thought to have been re-sited and erected here as a memorial by the local council in the 1950s. It is one of two Wesley memorials in the region (see also p.106).

[1] Wear Valley District Council, *Wesley's Weardale 1752–1790*, 1982, *passim.* [2] Information provided by Weardale Museum, 1999.

Goldsworthy, *Jolly Drover's Maze*

A692

C2C cycle route, near roundabout as it enters Leadgate

Jolly Drover's Maze

Sculptor: Andy Goldsworthy
Assistant: Steve Fox

Completed July 1989
Whole work: spoil and waste materials 2m high approx × 30m long approx × 10m wide approx
Status: not listed
Condition: fair
Condition details: large holes and breaks in soil; parts eroded away due to regular public use and weathering; weeds
Commissioned and owned by: Sustrans

Description: a large earthwork made from materials and spoil found on site. The sculpture takes the form of numerous concentric soil pathways enclosed by grassy banks of spoil. Regular inlets lead the pedestrian or cyclist through and around the work to the centre. From ground level an overall view of the much eroded maze is not possible.

History: Jolly Drover's Maze, one of two earthworks by Goldsworthy along the Sustrans C2C pathway (see pp.84 and 316), was built on the site of the former Eden Colliery. Following the closure of the pit in 1980 the land became a local dumping ground. Some say that the form of the earthwork mimics the shape of the old mine-workings below.[1]

[1] Ellis, M., 'News Exhibitions: Putting Art in its Place', *Art and Design*, May/June, 1994, pp.xiv–xv.

MURTON

Woods Terrace
Murton Club, perimeter walls

Unity is Strength
Artist: Vivien Mousdell

Installed 1996
Each wall panel: sandstone 60cm high × 30cm wide
Seat panel: sandstone 54cm square
Status: not listed
Condition: good
Commissioned and owned by: Easington District Council

Description: five sandstone panels set into a

Mousdell, *Unity is Strength* (detail)

wall and another in an octagonal seat nearby. Each panel bears a carved low relief: hands holding a pick; holding a pigeon; playing the tuba; gardening; one had reaching for another.

History: Mousdell was commissioned to work with a landscape designer on the enhancement of Murton's main shopping area as part of Easington District Council's 1996 'Looking Beyond' project for the village (see p.256).The panels are one element in a scheme which includes new paving, decorative ironwork, trees and seats.

The idea for the motif of hands came about as a result of her photographic studies of local people engaged in various activities but was also influenced by the imagery of clasped hands on miners' banners.[1]

[1] *Looking Beyond*, p.25.

NEWTON AYCLIFFE

Newton Aycliffe was one of twenty-eight new towns built in Britain after the war. In 1998, in celebration of the town's fiftieth anniversary, Great Aycliffe Town Council and Sedgefield Council constructed an 8 kilometre circular walk on the outskirts of the conurbation calling it the Great Aycliffe Way. With additional funding from local business sponsors a number of artists were commissioned to design functional way-markers, seats and sculptures for the walk.

Hopper, *Bug and Mushrooms*

Burnhill Way
Great Aycliffe Way, past Rope Moor
Wood towards Middridge Road

Bug and Mushrooms

Sculptor: Graeme Hopper

Installed 1998
Main work: galvanised steel 2.15m high × 4m long × 2m wide
Satellite works: galvanised steel 3.1m high approx × 60cm diameter approx
Status: not listed
Condition: good
Condition details: brown metallic staining on head of insect
Commissioned and owned by: Great Aycliffe Town Council and Sedgefield Borough Council

Description: a large imaginary insect and two groups of spindly fungi in galvanised mild steel. The sculptures are surrounded by grass in an area set back from the pathway.

Sponsored by the local company 3M UK, *Bug and Mushrooms* cost £4,000.[1]

[1] Information provided by Great Aycliffe Town Council, 1998.

Stephenson Way
Great Aycliffe Way

Sleeping Deer and *Newt*
Sculptor: Gilbert Ward

Installed 1998
Each work: yellow stone 80cm high approx ×
1.6m long × 1.2m wide
Status: not listed
Condition: fair
Condition details: dirt; algae; some graffiti
Commissioned and owned by: Great Aycliffe
Town Council and Sedgefield Borough Council

Description: two carved stones with
figurative relief carvings. Barely visible amid
trees, the first represents a sleeping deer. The
other, situated near the river, depicts a newt.
Sleeping Deer and *Newt* were sponsored by
Northumbrian Water at a cost of £4,000.[1]

[1] Information provided by Great Aycliffe Town
Council, 1998.

Ward, *Newt*

Station Lane
C2C cycle route

King Coal
Sculptor: David Kemp
Stonemason: Burt Hunter
Assisted by: volunteers

Completed 15 October 1992
Whole work: recycled bricks, stone and steel
15m high approx × 5m wide
Incised in various places on work: D. KEMP / B.
HUNTER 16/10/92 / K. LIDDLE 1992 / S. BONE / A.
HAMILTON 1992 / J. MILLAR / R. LESHMAN 1992
Status: not listed
Condition: good

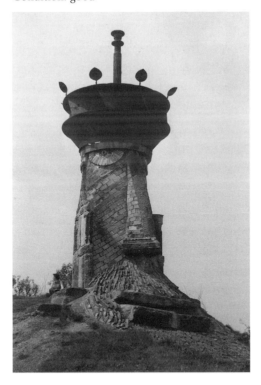

Kemp, *King Coal*

Commissioned and owned by: Sustrans

Description: a large crowned head of a
bearded man, made of recycled bricks, stone,
mining shovels and a fan impeller.
History: King Coal is one of two sculptures
executed by Kemp for the Sustrans C2C cycle
route between Sunderland and Whitehaven (see
pp.84 and 316). Sited near the former coalfields
and made from locally found industrial relics,
the work was constructed on site by the
sculptor, a stonemason and local volunteers,
some of whom had been left unemployed when
the nearby collieries shut down. Its completion
on 15 October 1992 coincided with the
announcement that the last pits in the Durham
coalfield were to be closed.[1]

[1] Information provided by Sustrans, 1998.

Helford Road
SUNNY BLUNTS COUNCIL ESTATE

Apollo Pavilion
Artist: Victor Pasmore

Constructed *c.*1963–70
Pavilion: reinforced concrete, steel, brick,
pebbles 6.4m high approx × 25m wide × 11.3m
deep
Satellite work: reinforced concrete, 2m high
approx × 5m wide approx
Status: not listed
Condition: poor
Condition details: light fittings missing; plaque
appears to have been removed from south-
facing wall; steps removed and entrance to
upper level bricked-in; water collection on
upper level; cracks in concrete in most areas;
areas of concrete friable; rust stains, particularly
on underside of lower level; two murals eroded

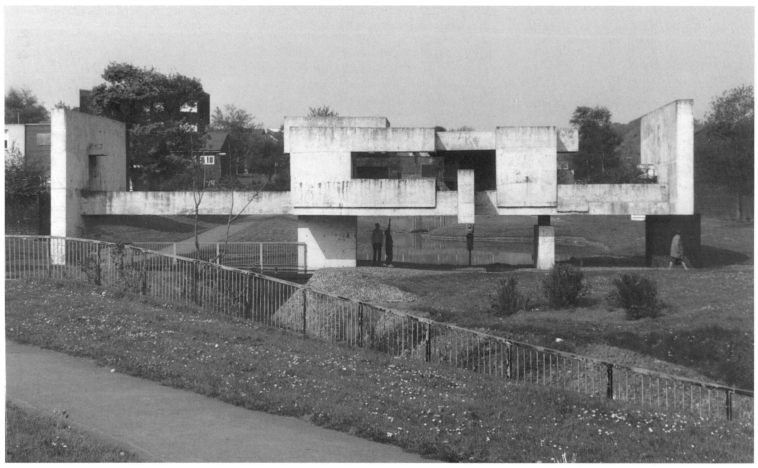

Pasmore, *Apollo Pavilion*

and vandalised; painted and inked graffiti in large amounts on many areas
Commissioned by: Peterlee Development Corporation
Custodian: Easington District Council

Description: a large free-standing sculpture consisting of rectilinear planes of reinforced concrete. It stands in the middle of a housing estate and functions as a footbridge over a small man-made lake. In its original state two staircases at either end allowed access to an upper platform and the whole structure was painted white and decorated with biomorphic murals. Now grey with dirt, the murals are barely visible amid the build-up of graffiti; the concrete has come adrift in parts leaving the rusting steel armature exposed. An additional sculpture, a concrete pillar of geometric planes, stands in the water about a metre from the main work.

History: remarkably, despite its size,

innovation, and the eminence of its designer, (Pasmore was described by Kenneth Clark as the greatest English painter since Turner), the *Apollo Pavilion* is little known outside the region, or indeed outside the town.

It was constructed circa 1963–70 as an urban feature for a new housing estate in Sunny Blunts in the new town of Peterlee. In 1948, the Peterlee Development Corporation, keen to apply a progressive design policy to the planning of the town, appointed Berthold Lubetkin, one of Europe's leading Modernist

architects, as its Chief Planner and Architect. His utopian Corbusian-style master plan for the 'miners' capital of the world' went unrealised, and, two years into his post he resigned. In 1955, disillusioned with the 'unadventurous' results of the Corporation's own architects' designs, their General Manager, A.V. Williams, invited Victor Pasmore, then Master of Painting at King's College Newcastle, to take a lead in the planning of the south-west area of the town.[1] The artist accepted and, in collaboration with a team of architects over a period of a decade, produced housing that Pevsner likened to the work of the 1920s De Stijl movement.[2]

The concept of the pavilion, it seems, arose out of an alliance of two concerns: A.V. Williams's determination to highlight the natural landscape within the new urban environment and Pasmore's desire to construct a 'synthesis of architecture, painting and sculpture'. A site at Castle Eden Dene in Sunny Blunts with its natural stream and wooded gorge was chosen for the construction of a man-made lake, and plans for an additional 'highlight' feature went ahead with the building of the pavilion at an estimated cost of £33,000.[3]

Pasmore hoped that the work would be 'an architecture and sculpture of purely abstract form through which to walk, in which to linger and on which to play; a free anonymous monument which, because of its independence, can lift the activity and psychology of an urban housing community on to a universal plane.'[4] However locals viewed it differently and in the next decade the newly-established council did little to prevent it from being vandalised and falling into disrepair.

In 1982, following calls for its demolition, Victor Pasmore visited Peterlee. Having agreed to meet the complainants on site, he told an assembled crowd that he thought the pavilion's excess of graffiti had 'humanised and improved it more than I could ever have done' (see photograph, p.xiv). His suggestion was that neighbouring houses should be demolished instead. The apparently good-humoured meeting ended with an agreement that the demolition of steps to the upper platform might reduce access and therefore its misuse. Accordingly Easington District Council removed the pavilion's staircase and planted shrubs on the first storey.[5]

Three decades after its construction, the sculpture still attracts controversy. Loathed by the majority of local people the pavilion has come to be known as 'Pasmore's Folly'. Its most vociferous opponent, councillor Joan Maslin, has described it as 'a heap of dirty, slimy concrete'. In a campaign to have the work pulled down she has contacted Prince Charles and Tony Blair for support, and written to the Territorial Army requesting that they blow it up. However the pavilion has been acclaimed by English Heritage as 'a masterpiece of international importance' and in 1998, the 50th anniversary of Peterlee and the year of Pasmore's death, they recommended the sculpture for a grade II* listing. The application was rejected by the Heritage Minister and the work may now be demolished.[6]

[1] Philipson, G., *Aycliffe and Peterlee New Towns 1946–1988*, Cambridge, 1988, *passim*. [2] Pevsner, *Co. Durham*, p.372. [3] Henderson, T., *Journal*, Newcastle, 4 June 1996. [4] Philipson, *op. cit.*, p.117. [5] *Ibid.*, p.119. [6] Henderson, T., *Journal*, Newcastle, 17 April 1998, p.5.

Surtees Road
Lee House, façade

Peter Lee
Sculptor: not known

Erected *c.*1978
Whole work: stone 40cm square approx
Status: not listed
Condition: good

Commissioned by: Peterlee Development Corporation
Custodian: Helical Properties

Description: a relief head of Peter Lee in profile. Attached to the façade of Lee House, it is located approximately three metres from the ground.

Subject: Peter Lee (1864–1935), County Durham's celebrated miners' leader, lay preacher, social reformer and county councillor, began working in the pits at the age of ten. At twenty, having spent the previous decade living a nomadic existence moving from one pit to another, he resolved to find a better life than that of a miner's. He gave up alcohol and fighting and embarked on a course of self-education, attending night classes to learn to read and write. Later he travelled, working in America and South Africa. Shortly before his marriage he converted to Primitive Methodism.

His involvement in trade unionism began at the age of 23 when he was elected Wingate's delegate to the Miners' Council in Durham.

Peter Lee

The next two decades saw him become more prominent in local and regional politics. In 1909 he was elected Labour councillor for Durham County Council and ten years later he became Council Chairman. As well as being largely responsible for the formation of the Durham County Water Board, Lee was instrumental in bringing about improved standards in the county's education, housing and sanitation. His participation in union affairs continued with vigour until his death. In 1932 he became president of the Mining Federation of Great Britain and in the inter-war years was Chairman of the Miners' International Conference. At the time of his death he was Secretary of the Durham Miners' Association. He was buried in the old pit village of Wheatley Hill.[1] The new town of Peterlee is named after him.

History: one of two new towns built in County Durham in the post-war years, Peterlee was established to provide alternative employment and housing in an area where the traditional coalmining industry was in steep decline. The town acquired its name in 1948 at the suggestion of C.W. Clarke, the author of *Farewell Squalor.*

In 1976 the government agency set up to administer the conurbation, the Peterlee Development Corporation, moved its headquarters from the outskirts of the town to the newly-erected Lee House. It is assumed that the relief of Peter Lee was already installed on the office block which Prince Charles officially opened on 31 May 1978.[2] A replica relief is located indoors and on the front elevation of the nearby Methodist Church.

[1] Bellamy, J.M. and Saville, J., *Dictionary of Labour History*, London, 1972, pp.230–2. [2] Philipson, G., *Aycliffe and Peterlee New Towns 1946–1988*, Cambridge, 1988, *passim.*

North Road

Outside police station

Monument to the 6th Marquis of Londonderry

Sculptor: John Tweed

Installed *c.*1919
Statue: bronze 2.2m high
Pedestal: sandstone 2.75m high × 1.68m wide × 1.62m deep
Incised in Roman letters on west face of pedestal: CHARLES STEWART / VANE TEMPEST STEWART / SIXTH MARQUESS OF LONDONDERRY, K.G., G.C.V.O. / VICEROY OF IRELAND 1886–1889. / CHAIRMAN OF LONDON SCHOOL BOARD 1895–1897, POSTMASTER GENERAL 1900–1902. / PRESIDENT OF THE BOARD OF EDUCATION 1902–1905. / LORD PRESIDENT COUNCIL 1903–1905. / BORN 1852 DIED 1915. / THIS STATUE IS PLACED HERE / BY HIS SON AND HIS DAUGHTER / AMONGST THOSE HE LOVED SO WELL / AND WHOSE WELFARE AND HAPPINESS WERE TO HIM / THE PRINCIPAL OBJECTS OF HIS LIFE.
Incised on east face, within relief of coat of arms, the motto: METUENDA COROLLA DRACONIS
Signed on west of base: J. TWEED
Status: II
Condition: good
Condition details: considerable spalling and crumbling to pedestal; dirty
Commissioned by: the 7th Marquis of Londonderry and Lady Helen Vane Tempest Stewart
Custodian: Easington District Council

Description: an over-life-size bronze statue of the 6th Marquis of Londonderry at the top of a sandstone pedestal. The moustached figure

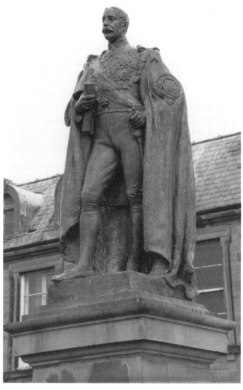

Tweed, *Londonderry Monument*

stands outside the former Londonderry Offices, poised as though to survey his town and colliery. The rear of the pedestal supports a relief of the Marquis' coat of arms with the motto: 'Metuenda Corolla Draconis' (Beware of the Dragon's Crest).

Subject: born 16 July 1852, educated at Eton and Christ Church, Oxford, Charles Stewart was elected MP for the County of Down as Lord Castlereagh in 1878. Two years later, on the death of his father, he entered the House of Lords. A steadfast Conservative and an opponent of Home Rule in Ireland, much of his

political life was occupied with defending the Union.

In 1886, at a time of high nationalist feeling, he was appointed Viceroy of Ireland. For his services in Ireland (1886–9) he was created Knight of the Order of the Garter. In 1900, under Lord Salisbury's government he was made Postmaster-General and in 1902 President of the Board of Education.[1]

As Lord Lieutenant of Durham and a landlord of considerable wealth (he inherited 23,000 acres in England), the Marquis' country house at Wynard Park near Stockton was host to gatherings of eminent politicians and members of the royal family. It has been rumoured that Lord Reginald, the

Londonderrys' third child, was in reality the son of Edward VII.[2]

One of the major coal-owners of the county, the Marquis was said to have been liberal in the provision of churches, schools, colliery institutes and club premises.[3] However, in a number of mining disputes his actions were deemed ill-judged. Most notable amongst these was the Silksworth strike of 1891 during which his decision to evict miners from their homes resulted in a violent struggle between candymen or bailiffs and townspeople. The police made a charge on protesters and 30 people, including women and children, were injured and admitted to the Sunderland Infirmary.[4] The 6th Marquis died of pneumonia at Wynard Park on 8 February 1915. He is buried at Long Newton.[5]

History: details of the private commission are not known, but the statue was probably erected *c.*1919. It is one of several works executed by Tweed for the Londonderry family; his memorial bronze relief of the 6th Marquis and Marchioness is situated in Durham Cathedral, and he is listed as having produced portrait busts of the 7th Marquis and Marchioness.[6]

[1] *DNB 1912–1921*, pp.541–2. [2] McNee, T., *Seaham Harbour: The First 100 Years, 1828–1928*, 1985, p.36. [3] *The Times*, 9 February 1915. [4] Silkworth Heritage Group, *The Story of Silkworth*, no page numbers, n.d. [5] *The Times, op. cit.* [6] Tweed, L., *John Tweed: Sculptor. A Memoir*, London, 1936, p.206.

Station Road

Christ Church churchyard, memorial garden

1871 Seaham Colliery Disaster Memorial

Stonemason: W. Robson

Installed *c.*1871
Whole work: stone 5.6m high × 90cm square

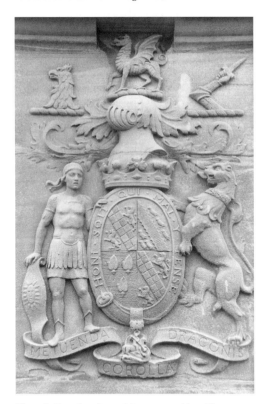

Tweed, *Londonderry Monument* (detail)

Robson, *1871 Seaham Colliery Disaster Memorial*

Incised black letters on east face of dado: THIS MONUMENT IS / ERECTED BY THE / CONTRIBUTIONS OF / THEIR FELLOW WORK / MEN AND OTHERS / IN LOVING MEMORY OF / TWENTY SIX MEN AND / BOYS WHO WERE KILLED / BY AN EXPLOSION AT / SEAHAM COLLIERY, / OCTOBER 25TH 1871, / AND WHOSE NAMES / ARE INSCRIBED HEREIN. [names and ages of dead on north, south and west faces]
Signed at base of pedestal: W. ROBSON / SEAHAM
Status: II
Condition: good
Condition details: surface crack running down west face of spirelet; lichen on most surfaces
Commissioned by: fellow workmen and friends of those killed in the disaster
Custodian: Christ Church, Diocese of Durham

Description: a cross raised above an octagonal decorated spirelet atop a panelled, tapering pedestal and base.
Subject: nicknamed 'Nicky Nack', the Seaham collieries suffered three explosions within three months of starting coal production. The worst of these early accidents occurred in 1852 and resulted in the deaths of five men and one boy. In the wake of the explosion Mr Dunn, the Government Inspector of the Mine, found that naked lights had been in use at the Seaham pits.

The memorial here commemorates those who were killed in Seaham's second major explosion, the worst in County Durham for over 20 years. The blast struck at 11.30p.m. on Wednesday 25 October 1871. According to Hutchinson, one of the survivors, this was precisely when he and his son fired a shot.

Though four bodies were brought to the surface within a short time of the explosion, it was not possible to recover the remaining 22 until two months later. In the meantime, to the dismay of some, coal production resumed. The inquest found that the 26 men died 'accidentally from an explosion caused by an outburst of

gas'.[1] No recommendations regarding the practice of shot-firing were made, an omission that was to have devastating repercussions nine years later when the firing of a shot in the same pit caused an explosion which killed 164 men (see below).

[1] McCucheon, J., *Troubled Seams: The Story of a Pit and its People*, 1994, pp.22–70.

1880 Seaham and Rainton Colliery Disaster Memorial

Stonemason: G. Ryder

Installed *c.* 1880
Whole work: sandstone and granite 5m high approx × 1.2m square
Incised on east face in black Roman letters: THERE IS / BUT A STEP / BETWEEN ME AND / DEATH. / [list of names incised on plaque below]
Incised in black Roman letters at base of east face: ERECTED BY THE WORKMEN OF / SEAHAM AND RAINTON COLLIERIES / AND OTHER FRIENDS / IN MEMORY OF THE 164 ABOVE NAMED MEN AND BOYS WHO LOST THEIR LIVES / IN AN EXPLOSION AT SEAHAM COLLIERY ON 8TH SEPTEMBER 1880.
Incised on north face in black Roman letters: HE WILL / SWALLOW / UP DEATH IN / VICTORY / [list of names incised on plaque below]
Incised on west face in black Roman letters: BLESSED / ARE THE DEAD / WHICH DIE IN THE LORD [list of names incised on plaque below]
Incised on west face in black Roman letters: WHAT MAN / IS HE THAT / LIVETH AND SHALL / NOT SEE DEATH
Incised on south face in black Roman letters: THIS GARDEN OF REST / WAS PROVIDED BY PUBLIC SUBSCRIPTION / IN MEMORY OF ALL SEAHAM MINERS / WHO HAVE GIVEN THEIR LIVES IN THE COURSE OF THEIR DUTY / DEDICATED 1965

Ryder, *1880 Seaham and Rainton Colliery Disaster Memorial*

Incised on south face at base of pedestal: C. Ryder & Son BP. AUCKLAND
Status: II
Condition: fair
Condition details: plaques replaced on each face; moderate amount of spalling; minor cracks; dirty; small amounts of algae and lichen

Commissioned by: fellow workmen and friends of those killed in the disaster
Custodian: Christ Church, Diocese of Durham

Description: a sandstone memorial in the Gothic style. It is decorated with foliate mouldings and attached columns in granite.

Subject: an explosion at the Seaham colliery at 2.30a.m. on 8 September 1880 was the first of eight devastating blasts to hit the Durham coalfield in the 1880s. Over 200 miners were working underground when the pit 'blew'. News of the accident spread quickly around the county and by 4a.m. a crowd of thousands stood at the pit mouth. It was not known or recorded how many men and boys were trapped below ground, but early estimates based on the number of lamps issued at the beginning of the shift indicated 240. By noon a rescue party of five men had been lowered into the pit with a basket of provisions. Within two hours they brought the first survivors to the surface, and by midnight 67 men had been recovered. Others were rescued during the next day and night.

The rescuers found the remaining men dead or entombed. Many had been mutilated or burnt by the blast, some beyond recognition. There were also men who had died through inhaling the gas known as afterdamp.[1] It became apparent that some of those trapped below ground had not died instantly. One miner, Richard Cole, recorded the time on a chalk board, revealing that he had been underground for at least 24 hours before his death. Michael Smith, also found dead, had scratched a message on his tin water-bottle: 'Dear Margaret there were 40 of [us] alltogether at 7am. Some was singing Hymns, but my thoughts was on my little Michael that him and I would meet in heaven at the same time [...] Dear Wife Farewell, my last thoughts are about you and the children, be shure and learn the

children to pray for me. Oh what an awfull position we are in.'[2]

During the next three weeks 136 corpses were recovered. Others were removed when the Maudlin Seam was re-opened the following June. Over 150 ponies also failed to survive the blast.[3]

The disaster received national news coverage. An engraving of the rescue appeared on the front page of the *Illustrated London News.*[4] Though the inquest proved inconclusive, the Government Inspectors of Mines, miners' representatives and the chief Government representative of the inquiry, Mr R.S. Wright, favoured the theory that the explosion was generated by the firing of a shot. Mr Wright's report cited the 'urgent necessity for prohibiting the firing of shots when any large numbers of men are underground'.[5]

History: the bodies of those killed in the 1880 disaster were interred together next to the grave of those killed in the previous explosion at Seaham (see p.269). It is said that when the memorial was unveiled no less than 60,000 people attended the ceremony.[6]

[1] *Durham County Advertiser,* 10 September 1880. [2] McCucheon, J., Troubled Seams: *The Story of a Pit and its People,* 1994, pp.128–9. [3] *Durham County Advertiser, op. cit.* [4] *ILN,* 18 September 1880. [5] McCucheon, *op. cit.,* pp.90–4. [6] McCucheon, *op. cit.,* p.81.

SHILDON

Church Street TOWN CENTRE
New Town Square

Monument to Timothy Hackworth
Sculptor: Graham Ibbeson

Unveiled 7 September 1998
Sculpture: bronze 1.84m high

Pedestal: yellow stone 1.77m high × 91cm square
Incised on front dado of pedestal: TIMOTHY HACKWORTH / PIONEERING / RAILWAY ENGINEER / SHILDON / 1786–1850
Status: not listed
Condition: good
Commissioned and owned by: Sedgefield District Council

Description: a life-size bronze statue of Timothy Hackworth holding a model of the *Royal George* in his right hand and a pouch in his left. The standing figure, clothed in his formal work clothes, surmounts a plain dressed stone pedestal and is set beneath a bandstand-type canopy in the newly-built square.

Ibbeson, *Hackworth Monument*

Subject: although Timothy Hackworth (1786–1850) was an important figure in early locomotive design and safety improvements, his achievements were much overshadowed by those of his contemporary George Stephenson (see pp.149–52). The two engineers, both born in Wylam in Northumberland, collaborated on a number of ventures including the construction of *Locomotion* which was built by Hackworth to Stephenson's design. Both were contenders in the famous 1827 Rainhill Trials and although Stephenson was the winner with *The Rocket*, Hackworth's *Sans Pareil* was only unable to complete the course because of faulty cylinders made by Stephenson's son, Robert. While *The Rocket* ran for another seven years, the *Sans Pareil*, once fixed, continued to be in use for another 30.[1]

Employed at the recommendation of Stephenson as locomotive superintendent for the Stockton and Darlington Railway Company, Hackworth chose New Shildon as the site for their wagon works. Within a year of the opening of the Stockton to Darlington line, share prices dropped and the owners, concerned that the performance of their locomotives was proving to be unreliable, considered abandoning steam engines in favour of horses. They changed their minds when Hackworth built the *Royal George*, the first reliable steam locomotive to be cheaper than horse power.[2]

In 1840 he left the company to devote more time to his own locomotive-building workshop, the Soho Engine Works at Shildon.[3] An active Methodist preacher and family man, he remained in the town until his death in 1850 and is buried in St John's churchyard. The achievements of both Stephenson and Hackworth are recalled in a national commemoration: Stephenson's head appears on the reverse of five pound notes and Hackworth's plug wheel features on the face.

History: Hackworth is remembered in Shildon not only as a pioneering railway engineer but as the new town's founder. Until he established the locomotive works in New Shildon the small community comprised four households. Thereafter it expanded rapidly as he built more workshops, a foundry and houses for his workers.[4] The wagon works, subsequently bought by British Rail, continued to bring steady employment to the area until 1984 when they were closed down.

Since then the town has suffered high unemployment and the council, keen to restore commercial confidence, has embarked on a six-year urban regeneration programme. The newly-built £1-million square, one element of a scheme which includes a new bus station and street railings, is based on an open air theatre. Its design features, which include decorative grilles, a water fountain and two bandstand canopies, reflect both the railway and brass band heritage of the town. Hackworth, already commemorated in the names of a pub, a park, two streets, a residential home and a museum, now has a monument erected to his memory, the second commemorative bronze statue to be sited in his adopted town. The first, raised by public subscription in 1925, was toppled from its pedestal in the early eighties, some say in vengeful protest against the anticipated British Rail redundancies. Although the statue was neither repaired nor reinstalled in Recreation Park a copy of its bust can be found at the Timothy Hackworth Museum in Soho Street, Shildon.

[1] *The Record*, 'Shildon Town Centre Opening Celebrations: Programme of Events', 1998, *passim*. [2] Young, R., *Timothy Hackworth and the Locomotive*, London, 1923, pp. 104–46. [3] Brooks, P.R.B., *Wylam and its Railway Pioneers*, Wylam, 1975, p.30. [4] Young, *op. cit.*, p.134.

High Street TOWN CENTRE
Parkwood Precinct

Meeting Point
Sculptor: Michael Disley

Installed 1992
Each figure: limestone 80cm high × 1.4m wide maximum
Base and steps: limestone 1.9m high × 3.55m square
Incised in Roman letters on north-west face:
1841 SPENNYMOOR 150 1991
Incised in Roman letters on south-east face:
MEETING POINT
Status: not listed
Condition: poor

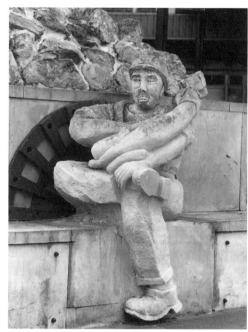

Disley, *Meeting Point* (detail)

Condition details: head of female figure missing; plaque at south-east face missing; large chips; dirty; slight covering of algae and lichen in some areas; metallic staining in parts; inked graffiti on many areas
Commissioned and owned by: Sedgefield District Council

Description: carved in limestone two over-life-size figures are seated either side of stone steps beneath a cairn supporting a flagpole. The male represents a miner holding a greyhound. The female figure, her head now missing, is dressed in contemporary clothing.

Subject: the sculpture commemorates the 150-year history of the town. Before 1836 all that existed at Spennymoor was one house at Four Lane Ends. Following the extraction of coal from the Whitworth pit in 1841 and the opening of the Weardale Iron and Co. ironworks at Tudhoe over a decade later it became something of a boom town. By 1890 the ironworks were producing 25,000 tons of steel annually.[1] The carved figures are intended to contrast Spennymoor's industrial past (signified by the male figure) with its future (the female figure).[2]

History: commissioned in 1991 as part of a redevelopment scheme for Spennymoor town centre, the sculpture was constructed in three months with stone donated by Steetley Quarries.[3] It cost £11,000 and was part-funded by Northern Arts.[4]

[1] Coia, A., *Spennymoor in Old Picture Postcards*, Zoltbomnel, Netherlands, 1983, *passim*. [2] *Northern Echo*, 25 February 1992. [3] *Ibid*.[4] Information provided by Cleveland Arts, 1998.

Cleveland Memorial Fountain

Front Street (A688)

Village Green, eastern section

Duke and Duchess of Cleveland Memorial Fountain

Stonemason: not known

Installed May 1865
Whole work: sandstone 3m high × 90cm square
Incised on east face: GIFT / TO THE / PARISH OF / STAINDROP / FROM / THE LADY / AUGUSTA /

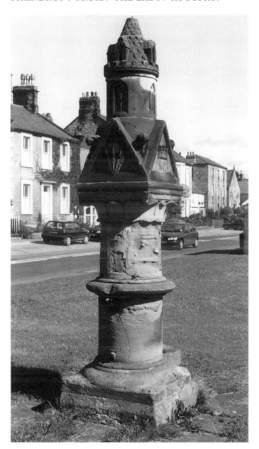

MARY POULETT / AND IN MEMORY OF / HENRY AND SOPHIA / DUKE AND DUCHESS / OF CLEVELAND MAY 1865.
Raised lettering on north face: HC
Raised lettering on south face: SC
Status: II
Condition: poor
Condition details: spout and iron bowl missing; modern stonework replacements in small sections; bricked-in at base; whole structure badly weathered; spalling especially at base; slight covering of algae at apex
Commissioned by: Lady Augusta Mary Poulett
Custodian: Staindrop Parish Council

Description: a memorial drinking fountain consisting of a cylindrical two-tiered pedestal surmounted by high gabled coping and capped by a drum and canopy. Standing on a square base with a drinking bowl at its foot, its west face bears the remains of a shield and three daggers in relief. Now badly weathered, the fountain is no longer functional.

Subject: Henry Vane (1788–1864), the 2nd Viscount and Duke of Cleveland married Lady Sophia Poulett in 1809. Residing at the nearby Raby Castle with the Duchess's sister, Lady Augusta Mary Poulett, the family are said to have been generous benefactors to the local village. The Duke erected 12 almshouses for the poor and the two sisters took a keen and active interest in Staindrop's church, school and social life. Sophia died in 1859 aged 73, her husband died five years later; Lady Augusta Mary Poulett survived them both.

History: before the erection of the pant in 1865 the village had no piped water supply, so many villagers had to walk a considerable distance to draw water.[1] Lady Augusta's gift to the parish thus served a double function: providing both a useful amenity and a public memorial to her sister and brother-in-law.

[1] Broumley, J.W., *The Lords of Raby and Staindrop*, Staindrop, 1957, *passim*.

STANHOPE

Road Terrace

Off the A689

J.J. Roddam Memorial Fountain

Stonemason: not known

Erected 1877; re-sited *c.*1900
Whole work: stone 3.8m high approx × 1.42m
square
Incised letters on north-facing panel: ERECTED /
BY PUBLIC SUBSCRIPTION / IN MEMORY OF THE
LATE / J.J. RODDAM / NEW-TOWN / 1877.
Status: II
Condition: fair

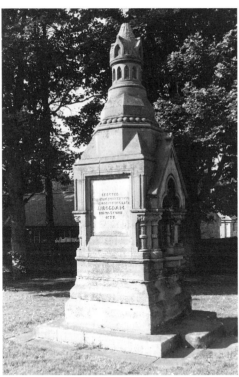

Roddam Memorial Fountain

Condition details: attached columns broken in
parts; moderate spalling; lichen and algae; detail
lost due to weathering
Commissioned by: public subscription
Custodian: Durham County Council

Description: a square pillar fountain made
from sandstone. Standing on a shallow base, it
bears attached columns at each corner and is
surmounted by an octagonal drum and lancet-
arched canopy. It no longer functions.

Subject: John Joseph Roddam, a wealthy
land agent for regional coal and lead owners,
moved to Weardale from Newcastle in the
1830s. A well-known and respected resident of
Stanhope, he built and owned nearby Newtown
House which was demolished and rebuilt
around 1900. He died aged 48 in 1874.[1]

History: the memorial fountain was erected
three years after the death of J.J. Roddam and
formerly occupied a central position in the
village green until it was moved to the side of
Newtown House at the turn of the century.[2]

[1] St Thomas, Stanhope, Burial Index 1854–1904.
[2] Information provided by Peter Bowes, 1999.

STANLEY

East Parade

Stanley Cemetery, near entrance gates

1913 West Stanley Colliery Disaster Memorial

Stonemason: not known

Inaugurated 15 February 1913; re-sited 1936
Whole work: pink and grey marble 3.5m high ×
1.22m square
Incised in gilded letters on the south-west dado:
IN MEMORIAM / THIS MONUMENT WAS / ERECTED
BY / THE SOCIAL CLUBS, / IN THE DISTRICT, /
FEBRUARY 15th 1913, / TO THE MEMORY OF /
THE 168 MEN AND BOYS, / WHO LOST THEIR
LIVES, / BY THE EXPLOSION, / AT THE / WEST
STANLEY COLLIERY / FEBRUARY 16TH 1909
Status: not listed
Condition: good
Condition details: columns loose; dirty
Commissioned by: Social Clubs of the district
Custodian: Derwentside District Council

Description: an ornate marble memorial
comprising a four-tiered base supporting a grey
marble pedestal with pink attached columns at
each corner and moulded entablature at its
peak. This is surmounted by four urns, one at
each corner, a drum with swag and cupola
capped by a festooned urn.

Subject: County Durham's worst mining
disaster this century occurred at the Burns Pit,
West Stanley on 16 February 1909. At 3.45p.m.
townspeople heard a muffled bang shortly
followed by a loud roar.

An exploration of the shafts began almost
immediately, but attempts at a rescue were
hindered by several significant factors. No
trained rescue team was available; there was no
on-site equipment to remove wreckage; it was
not known how many men were below ground
or where they were located.

Fourteen hours after the blast, the survivors
were brought to safety. Meanwhile 168 miners
lay dead underground, killed by the force of the
explosion or from burns or carbon monoxide
poisoning. Fifty-nine of those who died were
under the age of 21.

As bodies were being recovered, news of the
disaster spread throughout the country, and
hundreds of the press and curious onlookers
made their way to the town. Photographs and
postcards were produced as souvenirs and
200,000 people are said to have arrived in West
Stanley for the mass burial several days later. By
27 February, 166 bodies had been recovered.
Though two men were unaccounted for, the
colliery officials, unable to locate their bodies,

1913 West Stanley Colliery Disaster Memorial

of J.B. Atkinson were heard. Atkinson, a government mining inspector from Newcastle, believed that there were important omissions in the first inquest and that a so-called safety lamp had caused the pit to explode. His own experiments had proved that the Howart's Patent Deflector Safety Lamp was unfit for use in mines.[1]

History: James Smith, secretary of the Empire Working Members' Club and Institute of West Stanley, asked the council to provide a site for a disaster memorial in 1909. Less than four years later, the memorial, paid for by club subscriptions, was erected outside the new council chambers in Front Street. It was re-sited in the new burial ground in 1936.[2]

[1] Forster, E., *The Death Pit: The Untold Story of Mass Death in a Mine*, Newcastle, 1970, *passim*.
[2] Information provided by Robert Drake, 1999.

High Street
Near junction of Slaidburn Road

1995 West Stanley Colliery Disaster Memorial

Artist: Ann Brady
Designer: Derwentside District Council

Unveiled 16 February 1995
Winding wheel: cast iron 1.4m radius
Wall: yellow and red brick 1.32m high × 5.76m long × 3.2m wide
Plaques: black marble 66cm high × 1.2m wide
Raised gold lettering in Roman capitals on

1995 West Stanley Colliery Disaster Memorial

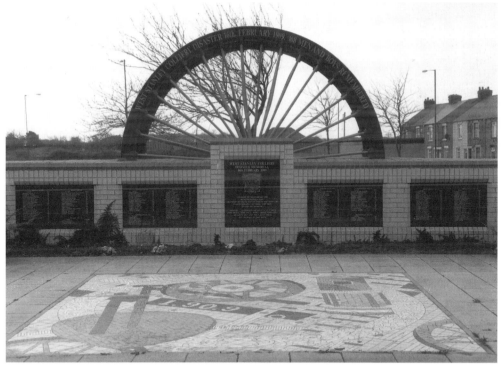

closed the mine down.

At the inquest, the jury, having heard 195 witnesses, were unable to establish a cause for the explosion and found no one culpable. The coroner, in view of the confusion caused in the immediate aftermath of the disaster, made a significant recommendation: at the beginning of each shift numbered discs should be issued to miners in exchange for lamps. This practice, being an effective register of men below ground, was later adopted by all collieries in Britain, and was eventually made law.

Following the re-opening of the mine in 1933 the two remaining bodies were found. A second inquest was held at which the comments

wheel: WEST STANLEY COLLIERY DISASTER 16TH FEBRUARY 1909. 168 MEN AND BOYS REMEMBERED

Incised capitals in Roman lettering, painted gold on black marble plaque beneath centre of wheel: WEST STANLEY COLLIERY / DISASTER MEMORIAL / 16th February 1909 / DURHAM MINER'S ASSOCIATION / WEST STANLEY LODGE / UNVEILED ON 16TH FEBRUARY 1995 BY KEVIN KEEGAN O.B.E. / GRANDSON OF FRANK KEEGAN ONE OF THE RESCUERS / IN REMEMBRANCE OF THOSE WHO DIED / IN THE PIT DISASTER /

Incised in upper case italics: FAREWELL, FAREWELL, NO TONGUE CAN TELL / HOW BRAVE, HOW TRUE, WERE THOSE WHO FELL / WE KNOW YOU DID YOUR DUTY WELL / YOU HEROES OF THE MINE.

Incised in gold lettering on small plaque on east wall: THIS MEMORIAL IS ALSO / DEDICATED TO ALL MINERS / AND THEIR COMMUNITIES.

Incised in Roman gold lettering on small plaque on west wall: THIS PROJECT WAS / DESIGNED-BUILT BY / DERWENTSIDE DISTRICT COUNCIL / D.S.O. / 1995

Status: not listed
Condition: good
Commissioned and owned by: Derwentside District Council

Description: half a former colliery winding wheel set into a brick base, the front face of which bears black marble plaques. Four plaques list the names and ages of those killed in the disaster, the fifth represents an image of the 'unknown miner' in the form of an engraving. The whole work surrounds a tile mosaic which depicts mining tools and is set in a landscaped area of paving stones, shrubbery and benches.

History: the memorial was unveiled 86 years after the disaster (see pp.274–5) by the Newcastle football manager Kevin Keegan, a grandson of one of the rescuers. Sponsored and erected by Derwentside District Council's Direct Service Organisation from funds raised by a voluntary committee, it is the second memorial to the disaster in the town. Ann Brady, a local artist, designed and constructed the foreground mosaic.[1]

[1] Information provided by Derwentside District Council, 1998.

SUNNYBROW

Prospect Place

Rocking Strike Memorial
Designer: not known

Unveiled 19 March 1976
Tub: metal 1m high approx × 1.1m long × 80cm wide
Column and base: stone 2.25m high × 2.22m long × 1.85m wide
Incised on south facing metal plaque: WEAR VALLEY DISTRICT COUNCIL / ERECTED TO COMMEMORATE THE ROCKING STRIKE / OF 1863 WHICH WAS THE FORERUNNER / OF THE CHECKWEIGH SYSTEM / IN THE COLLIERIES OF COUNTY DURHAM / AND / IN MEMORY OF THE MEN AND BOYS KILLED IN THE MINES OF SUNNYBROW, BRANCEPETH AND OAKENSHAW. / UNVEILED 19TH MARCH 1976 BY / J. GORMLEY O.B.E. PRESIDENT OF THE NATIONAL UNION OF MINEWORKERS
Status: not listed
Condition: fair
Condition details: paint on tub corroded in parts; dirty; chipped areas to base; green stains on base from metal plaque
Commissioned and owned by: Wear Valley District Council

Description: situated at the brow of a hill a tapering column of stone blocks surmounted by a colliery tub.
Subject: the 1863 strike, involving over 200 miners, was called to challenge the existing

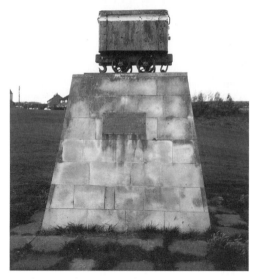

Rocking Strike Memorial

wage system which allowed ruthless coal owners to short-change their employees. It eventually led to the introduction of a fairer checkweigh system where union officials rather than colliery agents measured and checked the quality of coal before issuing payment (see p.253).

History: constructed by Wear Valley District Council, the memorial stands on the former shaft of the Old Prospect pit and marks the spot where the dispute began.[1]

[1] Newcastle City Libraries, 'Monuments and Memorials 1968–1993', newspaper cuttings, unpub. p.195.

TRIMDON

East Lane
Cemetery

Trimdon Colliery Disaster Memorial
Stonemason: G. Ryder

Installed *c.*1882
Whole work: sandstone 5m high × 1.1m square
Incised in Roman letters on panel of north face
of dado of pedestal: IN MEMORY OF / THE 74
MEN AND / BOYS WHO LOST THEIR LIVES BY THE

Ryder, *Trimdon Colliery Disaster Memorial*

EXPLOSION AT TRIMDON GRANGE / COLLIERY /
THURSDAY FEBRY 16TH / 1882 / THE FOLLOWING
/ FORTY FOUR OF WHOM ARE HERE INTERRED /
[names and ages of those who died on north,
south, west and east panels of dado of pedestal]
Incised in Roman lettering on north pedestal
base: ERECTED / BY THEIR FELLOW / WORKMEN
AND FRIENDS / AS A TOKEN OF THEIR SINCERE /
RESPECT / G. RYDER & SONS / BP AUCKLAND.
Status: II
Condition: fair
Condition details: weathered reliefs particularly
on the west and east faces; dirty; chipped areas;
algae and lichen in some parts
Commissioned by: fellow workmen and friends
of those killed in the disaster

Description: a sandstone memorial in the
Gothic style. The shaft bears low-relief carvings
on each of its four faces. These represent: a
miner walking to work, an injured miner being
rescued from the pit, a grieving widow at her
husband's grave and a scroll with clasped hands
inscribed with the word 'FRIENDSHIP'. Four
new stones lie at the base of the memorial and
bear the same names of those now eroded on
the pedestal.

Subject: the second in a series of major blasts
to hit the Northern Coalfield in the 1880s, the
Trimdon Grange explosion occurred within
eighteen months of the great pit disaster at
Seaham (see pp.270–1). Around 100 men were
working 250 metres underground when the
blast occurred in the afternoon of 16 February
1882. News of the accident spread quickly and
miners from Trimdon and neighbouring villages
arrived at the colliery to assist in the rescue.[1]

In the next four days more than 26 survivors
were brought to the pit mouth. The remaining
67 men and boys were found dead. Most had
been killed by the force of the explosion or from
burns; others died from afterdamp poisoning.
The explosion blasted open a door which
divided Trimdon from its neighbouring colliery

at Kelloe, with the result that afterdamp also
spread into the seams there, killing six men.[2]

Herman Schier and Thomas Blenkinsop
attempted to rescue their fellow workers at
Kelloe but were overcome by the deadly gas.[3]
One survivor died several days later. In his song
about the accident pitman poet Tommy
Armstrong tells of one mother's tragic loss: 'Let
us think of Mrs Burnett / Once had sons but
now has none / By the Trimdon Grange
explosion / Joseph, George and James are
gone.'[4] Shortly after the disaster, the *Durham
County Advertiser* reported the strange account
of a young woman who, whilst attending the
funeral of her fiancé, requested that the minister
marry her to the deceased.

Many of the bodies were interred together at
Trimdon Cemetery,[5] and others were buried at
Kelloe, Cassop-cum-Quarrington and
Shadforth.[6] An inquiry failed to reach a definite
conclusion as to the cause of the explosion.[7]

[1] *Durham County Advertiser*, 24 February 1882.
[2] Durham County Environmental Education
Curriculum Group in Co-operation with Northern
Echo, *Coal Mining in County Durham*, 1993, p.105.
[3] *Newcastle Weekly Chronicle*, 18 February 1882.
[4] Forbes, R. *Polisses and Candymen: The Complete
Works of Tommy Armstrong the Pitman Poet*,
Consett, 1982, p.20. [5] *Durham County Advertiser*,
op. cit. [6] Durham County Environmental Education
Curriculum Group in Co-operation with Northern
Echo, *op. cit.* [7] Emery, N. *The Coalminers of
County Durham*, Stroud, 1992, p.90.

TUDHOE

North Road
Cemetery

Tudhoe Colliery Disaster Memorial
Stonemason: G. Ryder

Installed *c.*1882
Whole work: sandstone 5m high × 1.1m square

Cross bears inscription: I H S
Incised in Roman letters on west face: IN / MEMORY OF / THE 37 MEN AND BOYS / WHO LOST THEIR LIVES / IN THE LAMENTABLE / EXPLOSION AT TUDHOE / APRIL 18TH 1882 / ERECTED BY THEIR FELLOW WORKMEN AND FRIENDS AS A / TOKEN OF SINCERE RESPECT [names of dead below and on north, east and south faces].
Status: II
Condition: fair
Condition details: west-facing plaque has been replaced; loss of detail due to weathering; algae, lichen and moss in many areas
Commissioned by: fellow workmen and friends of those killed in the disaster
Custodian: Spennymoor District Council

Description: a sandstone memorial in the Gothic style. The shaft bears low-relief carvings on each of its four faces. These represent: a miner walking to work, an injured miner being rescued from the pit, a grieving widow at her husband's grave and a scroll with clasped hands inscribed with the word 'FRIENDSHIP'. The memorial is a replica of one located at Trimdon Cemetery (see p.277).

Subject: County Durham's third major mining accident in the 1880s occurred only two months after the nearby Trimdon explosion, and preceded a similar blast at West Stanley by only a few days. Though its seams had long been considered 'fiery', Tudhoe's explosion on 28 April 1882 was the colliery's first accident of any magnitude.[1]

Sixty miners were underground when the 'Black Horse' blew at 1.15a.m. Rescuers began an exploration of the pit almost immediately, their labours much hampered by a jammed cage and fallen debris. William White, one of the first to descend, was overcome by afterdamp fumes and died instantly. As massive crowds gathered at the pit mouth over the course of the day, dozens of burnt and injured survivors were brought up to safety. Thirty-seven boys and men were discovered dead.

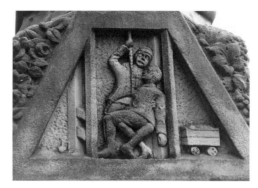

Ryder, *Tudhoe Colliery Disaster Memorial* (detail)

Most had died from injuries caused by burns, the remainder from afterdamp or carbon monoxide poisoning.[2]

Having discussed several possible causes for the explosion at the inquiry, the coroner dismissed the idea that a tobacco pipe found near to one of the deceased men may have sparked gas. The jury was unanimous in the opinion that the explosion was caused by a fall of stone.[3]

[1] *Newcastle Weekly Chronicle*, Newcastle, 22 April 1882. [2] *Ibid.* [3] Morley, A., *Parliamentary Report on the Tudhoe Colliery Explosion*, London, 1882.

WINGATE

Front Street
Opposite Wingate County Infant School

Wingate Grange Colliery Disaster Memorial

Stonemason: Borrowdale Brothers
Architect: Douglas Crawford

Unveiled 21 December 1907

Obelisk: sandstone 4m high × 60cm wide at base
Steps and pedestal: sandstone 2.16m high × 2.22m wide
Incised on east face of pedestal: THIS MONUMENT WAS ERECTED / BY PUBLIC SUBSCRIPTION / TO THE MEMORY OF THE / 26 MEN WHO LOST THEIR LIVES / IN THE EXPLOSION AT / WINGATE GRANGE COLLIERY; / OCTOBER 14TH 1906 / LET THEM REST FROM THEIR LABOURS
Incised on east face of base of pedestal: BORROWDALE BROS. / SCULPTORS / SUNDERLAND. / DOUGLAS CRAWFORD / ARCHITECT
Incised on the north, south and west faces: the

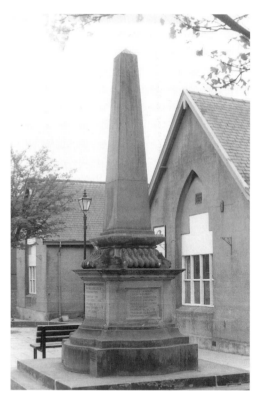

Crawford, *Wingate Grange Colliery Disaster Memorial*

names of those killed in the disaster
Status: II
Condition: poor
Condition details: small amount of restoration
work; minor spalling; large chips and some
pitting; covered in algae; dirty
Commissioned by: public subscription

Description: a sandstone obelisk stands upon
a corniced base with scroll brackets. This
surmounts a panelled pedestal and a two-
stepped base.

Subject: before its first and only major
explosion in 1906, Wingate Grange colliery was,
unlike many of County Durham's pits,
untroubled by 'fiery seams'. Then, at around
midnight on 14 October, a blast struck the Lady
Shaft entombing all the men working
underground. Although rescuers brought 119
survivors to the surface, the blast killed 26 men.
Many were overcome by the noxious gas
known as afterdamp, others were killed by the
force of the explosion.[1]

An inquiry found that the explosion was
caused by the firing of a shot, probably by a
miner named Maddison. In a discussion paper
written a year later, it was suggested that shot-
firers should be made aware of professional
papers and reports concerning the dangers of
their practice.[2]

History: in the wake of the explosion a
Memorial Committee was set up with Mr
William Glass as its chairman. The *Durham
County Advertiser* records that on the Saturday
afternoon of 21 December 1907, the banner and
band of the Wingate Miners' Lodge headed a
procession to the newly-erected memorial. A
prayer was followed by a financial statement
showing that the full cost of the memorial had
been £155. The obelisk was unveiled by Mr
F.W. Lambton MP, who told the large crowd
that 'No-one would be able to pass it with

indifference. It would bring to mind the
dangers which beset a miner's life.'[3]

[1] *Durham County Advertiser*, 19 October 1906.
[2] Institute of Mining Engineers, Transactions, vol.
XXXIII, 1906–7, p.191. [3] *Durham County
Advertiser*, 27 December 1907.

WOLSINGHAM

B6296

Redgate Bank

Duckett's Cross

Stonemason: G. Ryder

Installed 1899
Whole work: sandstone 2.16m high × 66cm
wide × 42cm diameter
Incised on south-facing shaft of cross in Roman
capitals: NEAR THIS SPOT / VENERABLE JOHN
DUCKETT / WAS ARRESTED. / HE WAS AFTERWARDS
TRIED AT SUNDERLAND AND TAKEN / TO TYBURN
WHERE HE WAS / EXECUTED FOR BEING A /
PRIEST SEP 7TH 1644.
Incised at base of cross in Roman capitals:
G.RYDER & SONS BP AUCKLAND
Status: not listed
Condition: fair
Condition details: slight weathering; lichen and
algae
Commissioned by: Revd Mother Mary Clare
Custodian: Wolsingham Parish Council.

Subject: John Duckett (1613–44) was born at
Underwinder in Yorkshire[1] and ordained a
Catholic priest in 1639. He studied in Paris for
several years and then returned to the English
mission in Durham where he worked until his
arrest. He was beatified as an English martyr in
1929.[2]

Ryder, *Duckett's Cross*

History: the cross marks the spot where
Duckett was arrested by Roundhead soldiers on
2 July 1644[3] and was commissioned by the
Revd Mother Mary Clare of St Anne's Convent
of Mercy, Wolsingham in 1899.

[1] Bowes, P., *Picturesque Weardale*, Bishop
Auckland, County Durham, 1996, p.80.
[2] Information provided by Wolsingham Parish
Council, 1999. [3] Wolsingham Parish Council, *Old
Photographs of Wolsingham*, Wolsingham, 1980.

Cleveland Area

BILLINGHAM
Stockton-on-Tees BC

Queensway TOWN CENTRE
Town Square

Family Group

Sculptor: Edward Bainbridge Copnall

Unveiled 19 October 1967
Sculpture: fibreglass 3m high approx × 2.1m square
Pedestal: granite tiles 1.83m long × 2.1m square
Base: stone 3.09m square × 33cm deep
Signed on base of sculpture: Copnall, 67 SCULPT ASSTS- B. Ball / G. Perry
Incised on slate plaque on base: UNVEILED BY / HER MAJESTY QUEEN ELIZABETH II / ACCOMPANIED BY / HIS ROYAL HIGHNESS THE PRINCE PHILIP DUKE OF EDINBURGH / 19TH OCTOBER 1967.
Status: not listed
Condition: fair
Condition details: some tiles missing; dirty base and pedestal; tiles of pedestal chipped; green discoloration on figures; small amount of inked graffiti on base
Commissioned by: Billingham Urban District Council
Custodian: Stockton Borough Council

Description: a large figurative sculpture atop a cross-plan tiled pedestal and square base. The copper-green, thick-set figures represent a family in summer-time clothes.

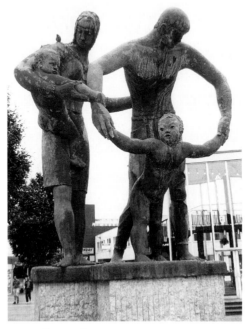

Copnall, *Family Group*

History: Billingham, a town built in the 1920s for the workers of ICI's vast chemical plant, underwent its second major phase of building development in the period 1945–67. Financed by ICI's sizeable contribution towards the rates, the local council built 6,000 new homes, created a new town centre (complete with under-pavement heating) and in 1965 commissioned the architects Elder, Lester and Partners to design the Forum, Britain's first major combined sports and arts centre.[1]

With an ice-rink, swimming pool and theatre, the 'Grandfather of Leisure Centres' was intended as a venue where the whole family could find entertainment and recreation.[2] As an additional statement of Billingham Urban District Council's commitment to the 'care and culture' of the family unit, Bainbridge Copnall was invited to execute a sculpture which would embody these ideals.

The Forum and *Family Group* were both inaugurated on 19 October 1967, when Her Majesty the Queen performed the ceremonies accompanied by the Duke of Edinburgh who is said to have asked Councillor Bill Allen, 'The man on the statue looks rather careworn. Did you pose for it ?'[3]

[1] Pevsner, *Co. Durham*, pp.98–100. [2] *Architect's Journal*, 22 November 1967, p.1313. [3] *Evening Gazette*, Middlesbrough, 19 October 1967.

GREATHAM Hartlepool BC

The Green
The Sheaf Thrower

Sculptor: Michael Disley

Installed 19 June 1995
Sculpture: Cadeby stone 1.95m high × 64cm wide × 78cm deep
Base: Cadeby stone 70cm long × 72cm wide × 14cm deep
Status: not listed
Condition: good
Condition details: broken bird's head on south side replaced; guano and dirt on sculpture and

base; small chip on base
Commissioned by: Sculpture Support Group, Greatham
Custodian: Greatham in Bloom

Description: a one-and-a-half-times-life-size figure of a man wearing old-fashioned work clothes and clogs. He holds a large bundle of sheaves in both hands and two birds perch in his hair. Carved from Cadeby stone the figure surmounts a stone base decorated with floral reliefs.

History: when Disley was invited to produce a sculpture that would 'typify the spirit of Greatham and its rural setting' he decided to base his work on the village's annual sheaf-throwing contest, a game that has been played at the Greatham Feast for over 500 years. The birds refer to a well-known rookery in nearby woodland.[1]

During the installation of the £4,000 figure on 19 June 1995, just days before the 534th Feast, a large piece of one of the birds broke off (it has since been repaired). The sculpture project was co-ordinated by Cleveland Arts with stone donated by Cadeby Stone and funding from Northern Arts, Greatham Parish Council and Teesside Arts Awards.[2]

[1] *Northern Echo*, 21 June 1995. [2] *Evening Gazette*, Middlesbrough, 20 June 1995.

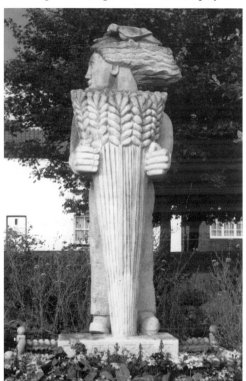

Disley, *The Sheaf Thrower*

HARTLEPOOL
Hartlepool BC

Church Square TOWN CENTRE

Monument to Sir William Gray

Sculptor: William Day Keyworth
Foundry: Rovini and Partanti

Unveiled 26 March 1898
Figure: bronze 2m high × 1.2m long × 85cm wide approx
Pedestal: marble 1.45m high × 1.34m long × 99cm wide
Steps: sandstone 2.66m length × 2.27m wide × 27cm deep
In capitals at south-facing base of bronze, in Roman capitals: W. D. KEYWORTH. JUNR Sc. / LONDON & HULL, 1898.
Incised on south face of pedestal: SIR WILLIAM GRAY. J.P., D.L., / FIRST MAYOR OF WEST HARTLEPOOL, / 1887–88. / ERECTED BY PUBLIC SUBSRIPTION / 1898.
Status: II
Condition: good
Condition details: minor spalling and chips to steps; dirty; discoloration of metal; inked graffiti on pedestal

Commissioned by: public subscription
Custodian: Hartlepool Borough Council

Description: an over-life-size bronze figure of Gray. Dressed in mayoral robes and wearing his chain of office he is represented seated in the Chief Magistrate's chair, with one leg resting on a footstool. He faces towards West Hartlepool's Municipal Buildings, the plans of which he bears in his right hand.

Subject: it has been said that although Ralph Ward Jackson (see below) founded the town of West Hartlepool, it was William Gray who made it. Born the son of a draper, in Blyth, Northumberland, Gray (1823–98) was educated in Newcastle and moved to Hartlepool at the

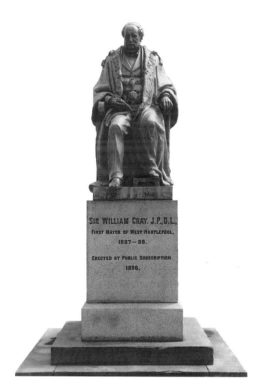

Keyworth, *Gray Monument*

age of 20. Having established a draper's shop at Victoria Street he, like other tradesmen in the town, then began to 'dabble' in shipping.

In 1863 Gray teamed up with a successful local shipbuilder, John Denton, to form Denton, Gray & Co., and on the death of Denton less than a decade later, he became sole partner. Under his management the newly-named William Gray & Co. became West Hartlepool's largest producer of clipper barques, sailing ships and steamers. Orders flooded in from home and abroad, and the company's vessels worked the oceans of the world. A new shipyard and engineering works were opened, and the firm, employer to some 2,000 men in the 1880s, won the Blue Riband for the maximum output of any British yard in 1878, '82, '88, '95, '98, and 1900. In 1891 Gray became the President of the Chamber of Shipping for the United Kingdom.

West Hartlepool honoured their most illustrious shipbuilder by creating him the first Mayor and an Alderman of the first Town Council. He was also twice Mayor of Hartlepool. Knighted in 1890, Gray was appointed High Sheriff of the County Durham two years later.[1]

History: the statue was funded by public subscription and erected during the lifetime of Sir William Gray. Although he requested that there be no public ceremony, a large crowd gathered in Church Square for the unveiling at 12 noon on 26 March 1898. Alderman Clarkson, the Chairman of the subscription committee, was due to remove the drapery, but was denied the honour when 'as the clock struck 12 and [he] was about to step from the door of the Municipal building to perform the duty, the wind, which was blowing a terrific gale, got under the covering, and most unceremoniously [...] completely unveiled the statue.' Sir William, who was not present at the inauguration, died on 13 September later that year.[2]

[1] Wood, R., *West Hartlepool: The Rise and Development of a Victorian New Town*, West Hartlepool, 1967, *passim*. [2] *Northern Echo*, 28 March 1898

Church Street TOWN CENTRE
Near junction to Church Square

Monument to Ralph Ward Jackson
Sculptor: Edward Onslow Ford

Unveiled 12 June 1897
Figure: bronze 2.5m high approx
Pedestal and base: Portland stone 3.5m high × 1.66m square
Signed on south-facing base of bronze:
E. Onslow Ford London 1897
Raised letters on east-facing bronze relief:
RALPH / WARD JACKSON / FOUNDER / OF THIS TOWN / AND FIRST MP / FOR THE / HARTLEPOOLS / BORN 7TH JUNE 1806 / DIED 6 AUGUST / 1880
Raised letters on west-facing bronze relief: THIS / STATUE / WAS PRESENTED TO THE TOWN / OF / WEST HARTLEPOOL / BY / COL. J. W. CAMERON J.P. / IN THE JUBILEE YEAR OF / THE OPENING OF THE / FIRST / HARBOUR AND DOCK / AS A TRIBUTE OF / ADMIRATION / FOR THE ENTERPRISE / AND PERSEVERANCE / OF ITS / FOUNDER / JUNE / 1897
In bronze cartouches on pedestal's north and south faces: Hartlepool's Coat of Arms, with the wording: MAL O PATI QUAM FOEDARI and: E MARE EX INDUSTRIA.
Status: II
Condition: fair
Condition details: splits and cracks on base and pedestal; general corrosion and loss of detail on base and pedestal; dirty; extensive guano staining on statue; verdigris on relief panels and statue
Commissioned by: Colonel John W. Cameron
Custodian: Hartlepool Borough Council

Description: a bronze statue of Ralph Ward

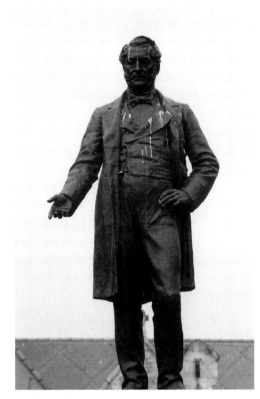

Ford, *Ward Jackson Monument*

Jackson represented in late middle age wearing frock coat and trousers. With one hand on hip, the other held out as though giving a speech, he looks east, down West Hartlepool's main street. Behind him is Christ Church which he erected in 1854.[1] The figure stands atop a tapering stone pedestal and base. Each face of the square pedestal bears a bronze cartouche with an inscription or coat of arms. The statue is enclosed by a shallow wall and plants.

Subject: it is said of Ralph Ward Jackson (1806–80) that 'he was not a child of West Hartlepool, West Hartlepool was a child of his.'[2] Born in Normanby and educated at

Rugby, Ralph Ward Jackson trained as a solicitor before joining a legal practice in Stockton. It was there that he became associated with the Stockton and Hartlepool Railway Company, an enterprise which had gained considerable commercial success with their rail connection between the collieries of South West Durham and the port of Hartlepool. Jackson proposed that they construct a line to nearby West Hartlepool and develop the small fishing port and holiday resort into coal docks. On an undeveloped site of 'sandy banks, mossy swamps and agricultural fields' he envisioned a new port, a Liverpool of the east coast. In 1844 Parliament granted him permission to construct the West Harbour Dock and building work began soon after.[3]

Within a year of its completion in 1847, West Hartlepool was seeing 169,000 tonnes of coal traffic pass through its port. In 1849 this amount had more than doubled and a second dock was opened in 1853. By 1860 the value of merchandise shipped from West Hartlepool was more than three times as much as the combined total for all other North East ports.[4]

Ward Jackson encouraged the port's industrial growth by persuading shipowners, sailmakers and iron foundries to establish themselves at West Hartlepool. He also initiated a building programme for the new town. Streets were laid out and shops, a school, Christ Church and the Athenaeum erected. Indeed houses were constructed in such quick succession that one area became known as 'California'. Soon the population grew until it was greater than that of the old town of Hartlepool; 4,700 by 1851, 21,000 by 1871.[5]

Problems beset Ward Jackson when in the early 1860s a Committee of Investigation found that he and his fellow directors had 'irregularly' managed the financial affairs of the West Hartlepool Harbour and Railway Company. However his reputation remained intact and in 1868 he was elected the borough's first MP.

History: in 1875, five years before the death of Jackson, an actor at the Gaiety Theatre in Mainsforth Road informed his audience that to erect a memorial to their town's founder would be futile: 'Do we forget? Does Memory decay? When viewing "Jackson Town" from yonder bay / Who built that town where sand-hills stood before / Who gave it life, and thronged its busy shore? / [...] No need for pillar raised to him in brass or stone, / His Monument's a Town, it stands alone!' However, in 1895, fifteen years after Jackson's death, the owner of the local Lion Brewery, Colonel Cameron decided that a memorial to West Hartlepool's illustrious founder was necessary after all, and wrote to the mayor offering to present one to the town. The council agreed to his request that a site at the top of Church Street be set aside, and in June 1897, the year of West Hartlepool's Jubilee, the Marquis of Londonderry unveiled the newly-erected monument to a large crowd of between 2,000 and 3,000 people.[6]

Some time before 1974 the council, in their efforts to inhibit the formation of verdigris on the statue, covered the work in a matte black paint.[7] The bronze was removed for cleaning and restoration in 1994.[8]

[1] Wood, R., *West Hartlepool: The Rise and Development of a Victorian New Town*, West Hartlepool, 1967, *passim.* [2] *South Durham and Cleveland Mercury*, 14 August 1880. [3] Waggot, E., *Jackson's Town: The Story of the Creation of West Hartlepool and the Success and Downfall of its Founder, Ralph Ward Jackson*, Hartlepool, 1980, *passim.* [4] Wood, *op. cit.* [5] Pevsner, *Co. Durham*, p.305. [6] Wood, *op. cit., passim.* [7] Letter from Borough of Hartlepool 22 December 1987, in Darke, J., County Durham Notes (unpub.). [8] *Northern Echo*, 9 June 1994.

Museum Road TOWN CENTRE
Sir William Gray House, outside

The Watcher
Sculptor: John Atkin

Installed summer 1989
Whole work: expanded metal, concrete, steel
3m high × 3m circumference
Status: not listed
Condition: good
Condition details: paint has eroded in small areas to both head and base; dirty
Commissioned and owned by: Hartlepool Borough Council

Atkin, *The Watcher*

Description: a larger than life-size head of a bald man facing towards the sea across Hartlepool. Both the head and its concave pedestal are painted terracotta and made with a mixture of concrete, cut profile steel (from British Steel) and expanded metal.

History: Atkin's maquette of *The Watcher*, which was said to bear a striking resemblance to the Conservative MP Norman Tebbit, was the winning entry in an open competition held by the West Hartlepool Business Group in 1987. Commissioned to celebrate the centenary of West Hartlepool's incorporation, it was hoped that the sculpture might be sited at the marina with the head looking out to sea. This idea was rejected by the owners of the marina and *The Watcher* found itself outside the museum entrance of Sir William Gray House, facing towards the coast but further inland. It was built by a local welding company and completed by the artist for installation in 1989.[1]

[1] Information provided by Hartlepool Borough Council, 1999.

The Highlight

MARINA

Jackson's Landing

Seaton High Light Memorial

Builder: not known

Installed 1838–9; re-sited 1995
Column: sandstone 20m high approx
Incised on keystone above the doorway: 1839
Raised metal letters attached to the base: IN MEMORY OF THOSE / WHO HAVE LOST THEIR LIVES AT SEA.
Status: not listed
Condition: fair
Condition details: plaques dirty; superficial but extensive spalling and chips to column; splits and cracks to whole structure
Commissioned by: Teesside Development Corporation

Custodian: Hartlepool Borough Council

Description: the memorial, a former lighthouse with an internal staircase, takes the form of a large Tuscan column of 1,300 blocks of Magnesian limestone. Eleven black marble plaques surround the column at its base. Each bears approximately 70 names.

History: the High Light, originally located at Windermere Road, south Hartlepool, was built as a navigational aid in 1838. Incoming ships would line up the red-lit High Light with its accompanying white-lit Low Light so as to avoid rocks and sandbanks at the mouth of the Tees. At the end of the century, with the erection of a new lighthouse at South Gare, the Seaton Lights were no longer required. The Low Light was demolished and the High Light fell into disrepair.

By the early 1990s not only had the Light lost its lantern, it was barely noticeable amid the tin processing plant that had grown around it. In 1995, the Teesside Development Corporation dismantled the column stone by stone and re-sited it at Jackson's Landing, two kilometres away from its former site. It now functions as a memorial to those in Hartlepool who have lost their lives at sea.[1]

[1] Information provided by Hartlepool Museum Services, 1998.

HILTON
Redcar and Cleveland BC

Seamer road

Hilton Village Hall, outside

Hilton Wheel

Sculptor: Alain Ayers

Installed 1987
Whole work: stone 1.2m high × 1.65m wide ×

Ayers, *Hilton Wheel*

15cm deep
Status: not listed
Condition: good
Condition details: lichen and algae
Commissioned and owned by: Hilton Parish Council

Description: a large flat round stone raised vertically between two gateposts. Its face bears carved low reliefs arranged in a circle: a ram's head; a bird; the pattern made by a bird's feet in the snow; intertwined horse shoes; oak leaves; flowers; a fish or flame motif taken from a painting in the nearby church; a wheel and a cross.

History: Ayers was commissioned to execute a series of sculptures for Hilton by the parish council in 1987. Made in collaboration with local people over a two-year period, each of the eight works indicates the parish boundary, marks a footpath or functions as a gatepost. The sculptures are carved from locally quarried stone and bear a relief which depicts or symbolises an element of the area's landscape or history. Some, such as the *Brewsdale Stepping Stones*, use local schoolchildrens' drawings as the basis of their design.

Sited on the village green the *Hilton Wheel* is

at the centre of the scheme. The sculptor's decision to use the form of a wheel was influenced by his grandfather's occupation as a wheelwright, and by a wooden cart found in an old smithy in the village. Local fauna and flora, and images and motifs from the church interior are represented in the wheel's carved reliefs.

Funded by Northern Arts, ISL Scaffolding and Tarmac, the 'Hilton New Milestones' project was part of a nationwide Common Ground 'Arts in Rural Areas' initiative.[1]

[1] Cleveland Arts, *Hilton New Milestones: A Sculpture Commission by Alain Ayers*, Middlesbrough, 1987.

KIRKLEATHAM
Redcar and Cleveland BC

Kirkleatham Lane
Sir William Turner's Hospital

Turner's Hospital Inhabitants
Sculptor: not known

Installed 1676–1742
Two figures in niches: lead, painted off-white
1.6m high × 85cm wide approx
Two figures on chapel pediment: lead, painted off-white 1m high approx
Status: I
Condition: fair
Condition details: fingers on right hand of elderly man broken; part of elderly lady's stick replaced; paint erosion, peeling and cracks on all figures; cracks to stonework of bases
Custodian: Board of Trustees, Sir William Turner's Hospital

Description: four life-size lead statues decorating a Grade I listed building. The hospital forms three sides of a quadrangle of which the main structure is a north-facing

Old Woman

Old Man

chapel designed by James Gibb in 1742. The remainder of the building was largely rebuilt in 1720–50.[1]

Two figures of a girl and a boy stand on top of the corners of the chapel's pediment. Each holds a book, possibly a bible, in one hand and a hat or scroll of paper in the other. They overlook a central courtyard and down towards the east and west wings, where in niches above the first floor, two elderly figures face each other across the quadrangle. The 'sister' holds a walking stick, the 'brother' a staff. The figures were repainted in 1986.

History: founded in 1676 by Sir William Turner (1615–92), a native of Cleveland and Lord Mayor of London in 1668, the hospital at Kirkleatham provided almshouses 'for the relief of ten poor aged men and ten poor aged women' and a school 'for the relief and bringing up of ten poor boys and ten poor girls'. Until the closure of the school in the 1930s, the inhabitants were governed by the same rules as those set down at its establishment in 1673. Only those baptised in the Church of England were eligible for accommodation and schooling. Men and women, or the brethren and sisters as they were known, occupied single accommodation in the east and west wings, and orphaned children lived in dormitories above. All residents were obliged to attend chapel,

Girl *Boy*

wear an institutional blue gown and keep their rooms and person tidy. Swearing and drinking were forbidden, and permission had to be sought before leaving the premises.[2]

The lead figures represent inhabitants of the hospital and are believed to date from around 1742 when the hospital was remodelled by Sir William Turner's great nephew, Chomley Turner. Chomley's only son, Marwood died in 1739 and whilst it is thought that Peter Scheemakers, who executed a marble effigy of Marwood for the newly-erected mausoleum, might have been responsible for the statues of the pensioners and children, there is no documentary evidence to support this.[3]

Sir William Turner's Hospital still exists, providing sheltered accommodation for elderly single people aged 63 or above.[4]

[1] Department of Environment, 'List of Buildings of Special Architectural or Historic Interest: Borough of Langbaurgh and Cleveland', 1988, p.39. [2] Williams, B., *Inhabitants of Sir William Turner Hospital, Kirkleatham*, 1841–81, Kirkleatham, 1984, p.1.
[3] Information provided by Ingrid Roscoe, 1999.
[4] Information provided by Allan Wordsworth, Clerk to the Trustees, Sir William Turner's Hospital, 1999.

Justice
Sculptor: not known

Executed early-to-mid-1700s; installed *c.*1740s
Pedestal: sandstone 1.5m high × 1m square
Statue: lead 2m high
Status: II*
Condition: fair
Condition details: missing sword and scales replaced with modern replicas; generally very weathered; figure dirty; spalling to pedestal and figure crumbling at base
Custodian: Board of Trustees, Sir William Turner's Hospital

Description: an over-life-size lead statue of *Justice* in classical robes standing in languid

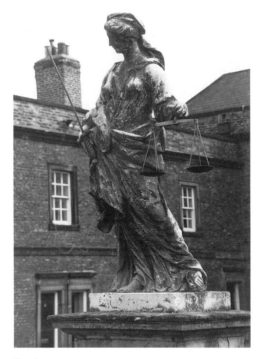

Justice

pose atop a square, panelled pedestal of stone. Sited at the centre of the hospital courtyard, the much weathered figure holds a sword in one hand and scales in the other.

History: the courtyard was once the place for dismissing residents who had failed to obey the hospital's stringent regulations (see above). Minor offences resulted in a shilling fine, with a 2 shilling fine for a second offence. However, were adults or children seriously to infringe the rules of the establishment they faced a humiliating expulsion: with the whole community as witness, the individual was taken outside, stripped of his or her institutional blue gown and ordered to return to the parish.[1]

The figure of *Justice*, said formerly to have occupied the grounds of a stately home in another part of the country, was sited in the courtyard around the time the building was remodelled in 1742. Although Gunnis believed the statue to be the work of John Cheere (1709–87), no known records confirm his attribution.[2]

Both the sword and scales are modern replacements for the original attributes. The scales were donated by a local fruiterer and the sword's blade is a plastic replica bought from a Woolworths store in the 1970s.[3]

[1] Baldwin. A., *A Short History of the Turner Family and their Descendants*, Kirkleatham, *passim*.
[2] Conway Library, Courtauld Institute.
[3] Information provided by Allan Wordsworth, Clerk to the Trustees, Sir William Turner's Hospital, 1999.

Stokesley Road

Stewart Park, between Captain Cook Birthplace Museum and Middlesbrough Council Depot

Discovery Wood Sculpture
Carver: Phil Meadows

Inaugurated 30 October 1997
Main work: oak 2.3m high × 2.8m wide × 1.56m deep
Status: not listed
Condition: fair
Condition details: bark split in areas, dirty; graffiti on the face of the figure

Meadows, *Discovery Wood Sculpture*

Commissioned and owned by: Middlesbrough Borough Council

Description: a short trail of wooden posts in a wooded area of the park each with a carving of a different creature: grasshopper, squirrel, spider, fly, cricket, frog, owl, lizard, snail and goblin. A cartoon-style tree creature guards the entrance.

History: the posts are part of Stewart Park Discovery Wood and are intended to be educational. The accompanying information leaflet asks 'Can you find all the creatures in our Discovery Wood?' The opening ceremony on 30 October 1997 was attended by the artist, Cllr Chris Robson, a representative of British Steel and children from the Captain Cook Primary School and Easterside Primary School. The Wood was co-sponsored by British Steel, Cleveland Community Forest and Middlesbrough BC, who supplied an explanatory leaflet and map.[1]

[1] Middlesbrough BC, *Stewart Park Discovery Wood*, Middlesbrough, n.d.

Stewart Park, Captain Cook Birthplace Museum, outside entrance

Totem Pole
Carver: not known

Installed 1979
Whole work: wood and paint 5.5m high approx × 2.5m circumference
Status: not listed
Condition: good
Condition details: paint eroded in parts; small cracks in wood; algal growth; graffiti incised on beak of bird
Commissioned by: Government and People of British Columbia
Custodian: Middlesbrough Borough Council

Description: a wooden totem pole representing from top to bottom a thunderbird, bear and man. The thunderbird is a mythical creature which hunts whales and causes thunder and lightning. Stained in black and painted in six colours, the pole is mounted on a four-footed metal base set in concrete.

History: the pole was presented to the Museum by the Government and People of British Columbia in honour of Captain Cook (see pp.288–9) who went to North West Canada in 1778 on his third and last voyage. It is based on two traditional carvings of the Nootka Indians of Vancouver Island. The bear appears on a pole in the abandoned village of Ehatisaht, north of Friendly Cove, which Cook visited.[1]

[1] Information provided by Hilary Wade, The Captain Cook Birthplace Museum, 1998.

Totem Pole

*Stewart Park, near Captain Cook
Birthplace Museum*

Captain Cook Vase

Designer: not known

Installed 1858
Vase: pink granite 85cm high × 3.9m
circumference
Pedestal: pink granite 86cm high × 77cm square
Incised in capitals: THIS GRANITE VASE / WAS
ERECTED BY / H.W.F. BOLCKOW / OF MARTON
HALL. AD. 1858 / TO MARK THE SITE / OF THE
COTTAGE IN WHICH / CAPTAIN JAMES COOK /
THE WORLD CIRCUMNAVIGATOR, / WAS BORN
OCT. 27TH 1728
Status: II
Condition: good
Condition details: lichen on base and pedestal,
algae on pedestal; two moderately sized chips to
vase; paint on inscription has eroded in parts
Commissioned by: Henry Bolckow
Custodian: Middlesbrough Borough Council

Description: a large broad-rimmed polished
granite vase with narrow trumpet stem, on
chamfered plinth and raised on stepped base. It
is enclosed within railings and surrounded by a
bed of plants.

History: the vase marks the birthplace and
early home of the famous explorer, Captain
Cook (see below). Described as a 'low cottage
of two rooms, one within the other the walls of
mud and covered with thatch' the building was
demolished and marked with a quadrangle of
stones by Major Rudd when he bought the
Marton estate in 1786.

After a fire in 1832 Marton Hall remained
empty and derelict until 1853, when it was
bought by Henry Bolckow (see pp.296–7) who
replaced it with an imposing new Hall and
converted the surrounding fields into a
landscaped private park. Bolckow erected the
vase in 1858.

In 1923 Marton Hall was bought by T.D.

Captain Cook Vase

Stewart, a local businessman, in order that he
might present the Hall and estate to
Middlesbrough for use by the public; Stewart
Park was opened in 1928. The Hall remained
until 1960 when the Council decided to
demolish it and replace it with a conservatory.
The building was accidentally burnt down
during demolition and all that now remains is a
stone colonnade and the vase.[1]

[1] Wade, H., *The Captain Cook Birthplace Museum*,
Middlesbrough, 1982, *passim*.

The Grove
Village green

Monument to Captain Cook

Stonemason: not known

Unveiled 1 April 1968
Stone: granite 70cm high × 94cm wide × 50cm
deep
Incised on plaque in white Roman letters:
CAPTAIN JAMES COOK. R.N. F.R.S. / BORN IN THIS
VILLAGE OF MARTON-IN-CLEVELAND, 27TH
OCTOBER 1728. / BAPTISED IN MARTON PARISH
CHURCH, 3RD NOVEMBER, 1728. / RECEIVED HIS
FIRST EDUCATION AT MARTON GRANGE. / DIED
AT OHWHYEHEE 14TH FEBRUARY, 1779 / THE
STONE ON WHICH THIS PLAQUE IS MOUNTED IS
FROM POINT HICKS HILL, / NEAR CAPE EVERAND
VICTORIA, THE FIRST POINT OF LAND ON THE
EAST COAST / OF AUSTRALIA SIGHTED AT
DAYBREAK ON 20TH APRIL 1770, FROM HMS /
ENDEAVOUR ON CAPTAIN COOK'S FIRST VOYAGE
TO THE SOUTH SEAS. / THIS MEMORIAL IS
ERECTED AS A TRIBUTE TO A GREAT PERSONALITY
OF MARTON- / IN-CLEVELAND, BY THE MARTON
PARISH COUNCIL / PRIOR TO THE
INCORPORATION / OF THE PARISH IN TEESSIDE
COUNTY BOROUGH 1ST APRIL 1968.
Status: II
Condition: good
Condition details: dirty; some algal growth
Commissioned by: Marton Parish Council
Custodian: Middlesbrough Borough Council

Description: a rough-hewn block of granite
bearing a metal plaque mounted on a square
concrete base.

Subject: James Cook (1728–79) joined the
merchant navy in 1746 and the Royal Navy in
1755. In 1768 he commanded his first
expedition to the South Pacific to witness the
transit of Venus, in the course of which he
charted the coasts of New Zealand and made a
detailed survey of the eastern coast of Australia.

Captain Cook Monument

MIDDLESBROUGH
Middlesbrough BC

Albert Road　　　　TOWN CENTRE
Victoria Square

Monument to John Vaughan
Sculptor: George Anderson Lawson

Unveiled 2 June 1884; re-erected 23 October 1914
Figure: bronze 2m high
Pedestal: stone 3m high
Each panel: bronze 30cm high × 60cm wide
Signed on base of bronze: G.A. LAWSON Sc. 1884
Incised on plaque on north face of pedestal:
JOHN VAUGHAN / 1799–1808 / MAYOR OF

Lawson, *Vaughan Monument*

MIDDLESBROUGH 1855 / DISCOVERED IRONSTONE IN THE / CLEVELAND HILLS: FOUNDER OF THE IRON / TRADE IN CLEVELAND. PARTNER IN BOLCKOW, VAUGHAN & CO., LTD, WHO BUILT / ONE OF THE FIRST IRON WORKS IN / MIDDLESBROUGH IN 1840.
Status: II
Condition: fair
Condition details: figure dirty; figure pitted with loss of detail; bronze panels have suffered some decay
Commissioned by: public subscription
Custodian: Middlesbrough Borough Council

Description: a bronze figure of Vaughan with coat over his arm. The pedestal bears bronze panels depicting in low relief: on the north face, a coal pithead; on the east, a dock scene with a coal train; on the south, a rolled steel mill interior; and on the west, a steelworks.

Subject: along with his business partner Henry Bolckow (see pp.296–7), 'Jacky' Vaughan was the founder of the 'Ironopolis' of modern Middlesbrough.[1] Born in Worcester in 1799, the son of a Welsh ironworker, Vaughan first found work as a puddler at the Dowlais ironworks in South Wales before moving to Carlisle *c.*1825. In 1832 he became manager for Losh, Wilson and Bell at their Walker works outside Newcastle and there befriended Bolckow, agent with a successful Newcastle corn merchant.

In 1839 Vaughan and Bolckow went into partnership and then, on 1 May 1841, at the suggestion of Joseph Pease (see pp.232–4), set up as brass and iron founders, anchor, chain, cable and rail makers, steam-engine manufacturers and wagon builders in Middlesbrough.[2] Success did not come immediately; in fact in 1847 Pease had to bail out the two men. However, when on 8 June 1850, Vaughan discovered a ready source of good quality ironstone (it was alleged whilst out shooting rabbits on Eston Moor in the Cleveland Hills) success quickly followed. In

Four years later he made a second voyage to the South Pacific on which he did not achieve his central goal, that of discovering the southern continent, but he did discover a number of islands. In 1776 he set off on a third voyage, this time in the hope of finding the North West Passage from the Pacific end. He succeeded in making a survey of much of the north American and Siberian coasts. However, in 1779 the expedition was cut short when he was tragically killed in a scuffle with islanders on the beach at Kealakekua Bay, Hawaii.[1]

[1] Wade, H., *The Captain Cook Birthplace Museum*, Middlesbrough, 1982, *passim.*

January 1851 the two men opened Eston mine and in 1852 they set up blast furnaces at Eston and Middlesbrough.

By 1864 when Bolckow Vaughan Ltd was established it was the largest company in Britain, and Vaughan was enormously wealthy (at his death four years later he left nearly £1 million). Meanwhile on the strength of the firm's success Middlesbrough grew at a prodigious rate. In 1831 its population was 154, in 1851 7,893 and in 1861 18,273.

Vaughan's Smilesian rags-to-riches story was central to the town's sense of confidence and identity and he was three times elected mayor. When, however, in 1878 his son and heir, Thomas Vaughan, was declared bankrupt there was a profound feeling of shock in the community, so much so that Thomas for a time was obliged to live elsewhere.

History: the statue came about as part of the backlash against the attempt following his bankruptcy in 1878 to erase Vaughan's name from Middlesbrough's golden jubilee celebrations in 1881. Many in the town, particularly working men, continued to think of John Vaughan as at least as important to the story of Middlesbrough's extraordinary emergence as Bolckow, and at the Jubilee Banquet they showed their feelings by making Joseph Cowen (see p.152) cut short his speech so that Thomas Vaughan could say a few words. He rose to the occasion and acquitted himself with dignity, and as a result a 'Vaughan Memorial Committee' was established straightaway.

In June 1881 a letter to the *North-East Daily Gazette* recommended a memorial, and at a public meeting in the Town Hall in August it was decided to commission a statue by G.A. Lawson. By May 1882 subscriptions were flowing in 'from all classes',[3] and in June 1883 members of the memorial committee were able to inspect the clay model in Lawson's London studio.[4]

On 2 June 1884 the statue was unveiled by Sir Joseph Pease in Exchange Square in front of a crowd of 15,000.[5] In his speech Pease marvelled at the way the Middlesbrough area had been transformed from a small hamlet into 'the greatest iron-producing district in the world', and dubbed Bolckow and Vaughan the town's Romulus and Remus. He also claimed that the iron trade was contributing to peace between nations by supplying rails for railways around the world.[6]

Thomas Vaughan was unable to attend the unveiling. However, John Marley, the mining engineer who had accompanied Vaughan on his outing to Eston Moor in 1850, was present and he duly crowned the occasion by reciting once more the, by then oft-told, rabbit-shooting story which in effect had become Middlesbrough's creation myth.

On 23 October 1914 the statue, which had stood at one end of Exchange Square near the statue of Bolckow, was moved to its present position in Victoria Square which had been laid out as a public space in 1901.

[1] Pollard, A. (ed.), *Middlesbrough: Town and Community 1830–1950*, 1996, pp.32–52. [2] Burnett, W., *Old Cleveland: being a collection of papers of local writers and local worthies*, Middlesbrough, 1886, pp.93–8. [3] *North-Eastern Daily Gazette*, Middlesbrough, 4 May 1882. [4] *Ibid.*, 24 March 1883. [5] *Ibid.*, 2 June 1884. [6] *Ibid.*

Monument to Sir Samuel Sadler
Sculptor: Édouard Lantèri

Unveiled 21 June 1913
Figure: bronze 1.8m high
Pedestal: pink marble 3.1m high × 1.6m square
Flanking wall: pink marble 7.3m wide
Raised Roman letters on bronze panel on pedestal: SIR SAMUEL / ALEXANDER SADLER / KNIGHT / V.D. / 1842–1911
Incised on bronze panel on left wing of bay: THIS MONUMENT / WAS ERECTED BY / PUBLIC SUBSCRIPTION / TO COMMEMORATE / A CAREER DEVOTED / TO THE SERVICE OF / THE COMMUNITY / UNVEILED AD 1913.
Incised on right wing bronze panel: SIR SAMUEL SADLER / WAS A MEMBER OF / THE TOWN COUNCIL OF / MIDDLESBROUGH 1873–1911 / MAYOR 1877–1896 AND 1910 / MEMBER OF PARLIAMENT FOR MIDDLESBROUGH / 1900–1906 – HE SERVED / IN THE VOLUNTEER AND / TERRITORIAL FORCES / 1860–1911 AND AS COLONEL / AND HON COLONEL OF / THE 1ST V.B.D.L.I. AND / 5TH DURHAM L.I. 1876–1911
Signed on base of bronze figure: Ed. Lantèri Sc
Status: II
Condition: good
Condition details: bronze plate loose on west pillar; figure dirty; west pillar damaged by vandalism
Commissioned by: public subscription
Custodian: Middlesbrough Borough Council

Description: a bronze statue of Sadler in court dress and mayoral robes with a scroll in his right hand. The pedestal is decorated with the town's coat of arms in bronze. A low semi-circular wall of pink marble flanking the pedestal on either side carries bronze panels at each end.

Subject: industrial chemist, alderman and Conservative MP, Sir Samuel Sadler (1842–1911) played a key role in establishing the chemical industry on Teesside. Born at Oldbury near Birmingham, he studied medicine in Birmingham for four years, and then took a doctorate in science at London University. His first job was supervising commercial laboratories in the Midlands investigating synthetic dyes from coal tar products.[1]

In 1862 he went to Middlesbrough and set up his own small business for the distillation of tar in Marton Road, six years later founding the Cleveland Chemical Works, in Cargo Fleet Road. Sadler also took a leading part in local affairs and was three times mayor of

Lantèri, *Sadler Monument*

Middlesbrough, successfully projecting himself as a defender of the popular pastimes of the working men of the town. An obituary in a local paper said the explanation of his success as a politician lay in his open, generous spirit, his 'bonhommie'.[2] A keen supporter of the Volunteers, Sadler was often known locally as 'the Colonel'.[3]

History: in 1912 when a public subscription for a memorial to Sadler was instituted there was some anxiety whether sufficient funds would be raised. However, Sadler's long-standing popularity in the town was such that within 80 days 15,000 people had subscribed, and £2,500 was collected.[4]

The memorial committee sought the advice of Hamo Thornycroft who, interestingly, recommended that with £2,500 at their disposal they should opt for a standing figure in bronze to resist the effects of the Middlesbrough climate, '8 or 9 feet in height', with 'panels in bronze, reliefs of appropriate subjects, inserted in the pedestal'; in other words, something very similar to what was eventually erected.[5] They chose Lantèri, professor of sculpture at the Royal College of Art, after visiting a number of sculptors' studios in London, consulting Sir William Richmond and gaining the approval of Sadler's widow.

In his design Lantèri strove 'to represent a genial, lively, hearty, generous gentleman'. Although some of the committee had expressed a preference for a modern frock coat, he insisted on court dress as a way of suggesting Sadler's knighthood, and mayoral robes to indicate his contribution to civic life, in the belief that these were 'more worthy of the man and at the same time more sculptural'. Lantèri also added a semi-circular wall so as to avoid 'the impression so often felt in isolated statues of a pawn on a chessboard to be removed at will'.[6]

[1] Tomlin, D. and Williams, M., *Who was Who in Nineteenth-Century Cleveland*, Redcar, 1987, p.36. [2] *North-Eastern Daily Gazette*, 29 September 1911. [3] Cook, H., *Momento of Col. Sir Samuel A. Sadler V.D., D.L., J.P.*, Middlesbrough, 1913, *passim*. [4] *North-Eastern Daily Gazette*, 12 January 1912. [5] *Ibid.*, 13 November 1911. [6] *Ibid.*, 21 June 1913.

Albert Street TOWN CENTRE

42 Albert Street, former National Provincial Bank

Relief Doors

Designer: not known

Bank opened 1939
Whole work: bronze 4m high × 2.1m wide
Each panel inscribed with Greek lettering

Status: not listed
Condition: good
Condition details: slight flaking of patina at edges
Commissioned by: National Provincial Bank
Custodian: Club Zantia

Description: twenty-four low-relief panels on the doors of the main entrance of the bank building. These show motifs on ancient coins found in the Mediterranean area. The inscription on a bronze tablet on the left door frame gives the origins and date of each motif.

Relief Doors

History: the doors belong to what was formerly the National Provincial Bank. They were commissioned from the Birmingham Guild Ltd and probably designed by the Albert Street branch's architect, W.F.C. Holden, the National Provincial's chief architect between 1935 and 1947. The coin department of the British Museum was consulted to ensure their historical accuracy.[1] The premises became a bar, the Club Zantia, in 1997.

[1] Information provided by NatWest Archives, London, 1999.

Central Gardens　　TOWN CENTRE

Bottle of Notes

Sculptors: Claes Oldenburg and Coosje van Bruggen

Inaugurated 24 September 1993
Whole work: painted steel 9.14m high × 3m diameter
Signature welded on inside of work: C O. Cos
Status: not listed
Condition: fair
Condition details: dirty; paint weathered or scratched away in places; graffiti at lower levels
Commissioned and owned by: Middlesbrough Borough Council

Description: a lattice-like steel structure in the shape of a bottle set at an angle in a bed of bark chips. The bottle has a steel 'cork'. The 22mm-thick lattice is formed of a hand-written message (Claes Oldenburg) which has inside it another hand-written message arranged in a spiral. The bottle, the inner text and the cork are all painted in polyurethane enamel – white, blue and black respectively. The outer text is taken from the log of Captain Cook's first voyage to the South Pacific in 1768. It reads, 'We had every advantage we could desire in

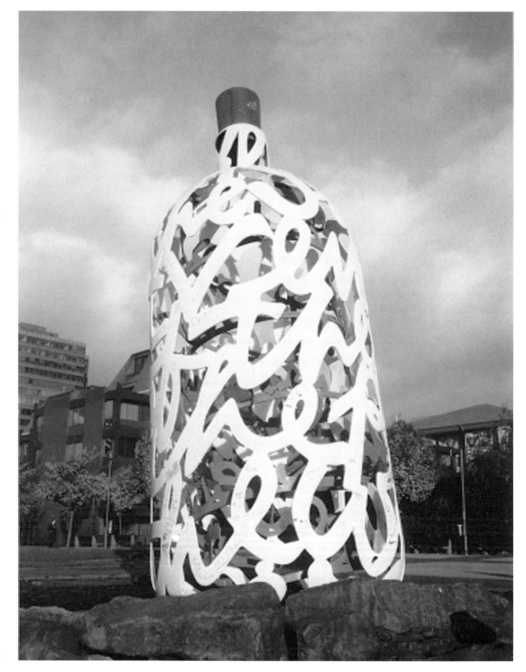

Oldenburg & van Bruggen, *Bottle of Notes*

observing the whole passage of the planet Venus over the Sun's disk'. The inner text is from a 1987 poem, 'Memos of a Gadfly', by van Bruggen about her childhood in Amsterdam: 'I like to remember seagulls in full flight gliding over the ring of canals.' Appropriately, the sculpture is sited beside a small ornamental lake in a new, centrally-located park.

Subject: a tribute to Captain Cook (for his biography see pp.288–9).

History: the commission arose from Northern Arts' determination in the mid-1980s 'to set a new benchmark of quality' for public sculpture in the region with a major work by an internationally renowned artist.[1] Having contacted Oldenburg in 1986 at the time of a UK touring exhibition of his plans and drawings for large-scale projects, they first tried to interest Gateshead with the idea of a work on the site of the National Garden Festival which was then imminent.[2] When this came to nothing they approached Middlesbrough, who rapidly decided to commission the artist on the strength of his previous work and reputation and the fact that it would not be a financial burden on Middlesbrough ratepayers. Of the £135,000 the sculpture eventually cost, only £5,000 actually came from ratepayers, the rest being provided by Northern Arts and business sponsors.[3] However, as is usually the way, this did not prevent the Council, which was being rate-capped at the time, from being accused of wasting public money.[4]

The decision to adopt a Captain Cook theme derived from Oldenburg's first visit to Middlesbrough in July 1986.[5] His initial idea was to have Cook turning out his pockets like Lemuel Gulliver in Swift's famous satire (one of his favourite books), and he later toyed with idea of a vessel, but rejected this because it would require some kind of 'simplification and some connection to the idea of scale'.

It was at this point that the idea of a bottle emerged. 'We [the artists] were reminded of Edgar Allan Poe's "Ms in a Bottle". A bottle is a kind of ship, and ships are often built in a bottle. This provided the Swiftian reversal which authorised a very large bottle, or one as large as a civic sculpture needs to be [...] instead of containing sheets of paper on which there was writing, the bottle would be "made of writing"[...] We decided to use both our "hands", which are quite different. I would do the drawing / writing surface of the *Bottle* in an angular style with ink blots, using some lines from Captain Cook's journals, in one colour. Inside would be a spiralling structure made of Coosje's rounded script in another colour, using a more personal text. We felt there should be a cork in the *Bottle*; this would be the only solid part of the sculpture.'[6] (Two models used in the preparation of the work are owned by the Henry Moore Institute in Leeds.)

As for the angle at which the sculpture is set, Oldenburg and van Bruggen thought it appropriate for the *Bottle* to resemble the Tower of Pisa 'stuck in sand by a receding wave'. 'The first model,' the artist later explained, 'was made by grabbing an empty Evian bottle, tearing off the label and scribbling over the surface with a felt tip pen. I cut the bottle, telescoped it to the desired proportion, and stuck it in a box of Pelliculite. It turned out that a certain scale of writing had to be maintained for the visual effect of the sculpture so as not to reduce it to a kind of filigree.'[7]

Oldenburg and van Bruggen saw the relationship of inner and outer texts in the sculpture as especially important. 'The fusion of each sentence within the other in which opposites are dissolved, and both images and words become, to quote Swift, "bodies of much weight and gravity".'[8] In the event, however, it is perhaps colour which achieves this effect: on the one hand, the blue of the inner text and the blue of the sky seem to merge together and, on the other, the blue and the white of the two texts combine to create an almost glass-like effect.

Fabrication proved difficult. A four-metre-high model in mild steel plate had to be produced by AMARC's training school for previously unemployed youngsters and adults, at Cargo Fleet, Middlesbrough. Subsequently another model of the same proportions was produced in aluminium by Don Lippincott, an American fabricator. The full-scale *Bottle of Notes* was fabricated at Hawthorn Leslie Fabrication Ltd in Hebburn, Tyne and Wear, with the curved part at the top constructed out of segments and welded together, and the main body made from rolled steel sections. For the 'handwriting', a giant stencil enlargement of a drawing was made which could be cut out by a computerised profile-burning machine and plasma arc cutter, and then finished off by the artist. During this whole lengthy and difficult process all kinds of problems were encountered. For instance, at one point it was found that the inner text had been rolled the wrong way by mistake (something which interestingly, Oldenburg felt was unimportant and did not need correcting). The artist later revealed that it had been difficult to find men in the area with the technical skills required. Also, one of the companies involved in the fabrication process went bankrupt.'[9]

In December 1992 Oldenburg again visited Middlesbrough to decide on the precise way that the *Bottle* should be erected. He was somewhat disconcerted to find that the site chosen was beside a small lake in a newly laid-out park rather than by the North Sea as he had expected. However, he managed to persuade the Council to make the selected site 'rougher' and 'less municipal'.[10] Finally, on 10 September 1993, the giant sculpture was transported from Hebburn for its inauguration by Lord Palumbo, Chairman of the Arts Council, a fortnight later.

At every point in its history the *Bottle of*

Notes has attracted considerable publicity. Tyne Tees Television documented its fabrication from beginning to end. British Gas gave it their Award for Art in Public Places, and the Northern Electric gave it their Champions Award. It also won second prize in the Art Outside the Gallery category at the National Art Collections Fund Awards.[11] In addition, in 1988 the Northern Centre for Contemporary Art, Sunderland, and Leeds City Art Gallery staged an exhibition of preparatory drawings entitled 'A Bottle of Notes and Some Voyages' which later toured Europe.

[1] Oldenburg, C. and van Bruggen, C., *Bottle of Notes*, Middlesbrough, 1997, p.8. [2] Bickers, P., 'Interview with Claes Oldenburg' *Art Monthly*, November 1993 p.3. [3] Newspaper cutting, Central Library, Newcastle, 24 April 1994. [4] *Northern Echo*, 25 April 1988. [5] Information provided by Middlesbrough Borough Council, 1998. [6] Oldenburg, C, *Bottle of Notes and Some Voyages* (exhib. cat), Sunderland and Leeds, 1988. [7] *Ibid.* p.226. [8] Bickers, *op. cit.* p.5. [9] *Sunday Sun*, Newcastle, 24 April 1988. [10] Bickers, *op. cit.* [11] Oldenburg, *op. cit.*

Middlesbrough Combined Court Centre, exterior

Scales of Justice

Sculptor: Graham Ibbeson

Unveiled 22 June 1991
Figures: bronze 1.2m high
Pedestal: concrete 1.2m high × 80cm square
Status: not listed
Condition: good
Condition details: woman's face stained white / green; small amount of graffiti to plinth
Commissioned by: Street Art Works
Custodian: Middlesbrough Borough Council

Description: a lively, almost caricature-like bronze sculpture of a woman holding apart two squabbling children set on a concrete pedestal outside Middlesbrough's law courts.

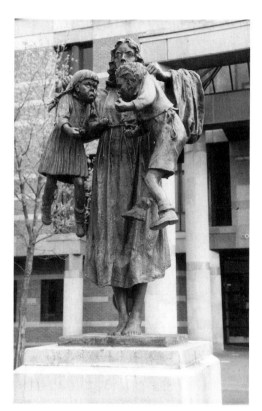

Ibbeson, *Scales of Justice*

History: the subject was thought appropriate to the site in front of the law courts. As with many of Ibbeson's works the figure of the woman was modelled from the artist's wife, Carol, who is shown, he has said, 'as completely impartial in her off-springs' quarrels'. The two squabbling children are based on Ibbeson's memories of himself and his sister when young.

The £15,000 sculpture, part-funded by Middlesbrough's Urban Programme, was the third of the artist's works to be erected in the town (*The Gardener* and *Shopper and Child* once occupied Linthorpe Road but have now been removed). At the time of its unveiling in 1991 one jaundiced review quoted a barrister as saying that it would serve as a reminder of the Cleveland child abuse case which was then much in the news.[1]

[1] *Northern Echo*, 10 July 1991.

Corporation Road TOWN CENTRE
Town Hall, façade

St George and Personifications of Music, Painting, Literature and Commerce

Sculptor: W. Margetson
Architect: G.G. Hoskins

Margetson, *Commerce*

Margetson, *Music*

Margetson, *Painting*

laid in 1881, when a local paper made a strong plea for the inclusion of sculptural decoration, quoting the lines, 'Everywhere I see around me rise the wondrous world of Art. / Buildings wrought with richest sculpture standing in the common mart.'[1]

A description of Hoskins's building as 'in the style of the thirteenth century suffused with the feeling and spirit of the present times' could be applied equally to Margetson's figures.[2]

[1] Briggs, A., *Victorian Cities*, Harmondsworth, 1968, pp.261–2. [2] *Weekly Gazette*, Middlesbrough, 29 October 1881.

Dunning Street TOWN CENTRE
Police station, front elevation

Untitled
Sculptor: Eddie Hawking

Installed 1962
Whole work: cast aluminium 1.9m high × 1m wide
Status: not listed
Condition: good
Commissioned by: Middlesbrough Borough Council
Custodian: Cleveland Constabulary

Description: abstract bas-relief attached to front elevation of the police station.

History: the relief was the first piece of public sculpture to be commissioned in Middlesbrough for over half a century. It was intended to be in keeping with the series of repetitive pre-cast concrete panels topping the new, avowedly modernist police station by Norman Best, Middlesbrough Borough Architect. One critic at the time felt it had 'Egyptian' overtones: 'Mr Hawking has offset the more dominant horizontals and verticals of the building and delighted our senses with deep incisions, swelling, often sensuous curves, and some subtle variations, from soft modelling to

Installed *c.*1881
Each work: sandstone 1.8m high approx
Status: II*
Condition: fair
Condition details: fingers of St George missing; some loss of detail due to spalling particularly on the wings of the dragon; dirty
Custodian: Middlesbrough Borough Council

Description: five life-size stone statues in canopied niches, approximately six metres above the street, flanking the main entrance to the Town Hall. In keeping with the building's Gothic revival architecture, they are clothed in nineteenth-century versions of medieval attire.

Four of these represent, respectively, *Music*, *Painting*, *Literature* and *Commerce*. The fifth, above the pinnacle of an arch on the west face of the building depicts *St George* slaying the dragon with a bronze lance.

History: it was initially intended that the celebrated and prolific architect, Alfred Waterhouse should design Middlesbrough's Town Hall. However the commission went to George Gordon Hoskins, a local architect who had designed numerous villas in County Durham and Yorkshire.

The decision to make the arts and commerce the subjects of the four sculptures may date from the time that the foundation stone was

shining bright, on the textural possibilities of the material itself.' According to the same critic, the piece was not 'as appreciated locally as it might have been'.[1]

[1] Information provided by Cleveland Arts, 1998.

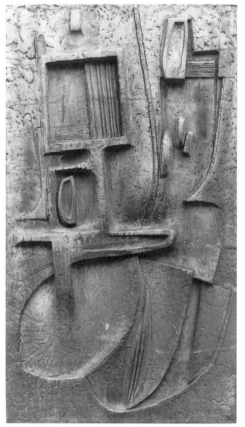

Hawking, *Untitled*

Keystone Heads

Stonemason: not known
Architect: Charles John Adams

Originally part of building erected 1868; re-sited 1985
Each work: sandstone 88cm high × 53cm wide × 71cm deep
Base: brick and iron 50cm wide × 60cm high
Status: not listed
Condition: fair
Condition details: some faces chipped; spalling on most pieces, some extensive; algae and lichen in parts; severe erosion to peripheries of some heads
Custodian: Middlesbrough Borough Council

Description: sandstone mask heads supported by iron rods set in brick bases. At the west end of the square three of the heads have been arranged in a cluster. The remaining eight are arranged in pairs back-to-back at the top of a flight of steps.

History: the heads were originally situated as keystones above the ground floor windows of the Royal Exchange which was designed by the architect Charles John Adams in 1868. This Grade II listed building, which was demolished in 1985 to make way for the A66 flyover, stood on the site of what is now the Royal Exchange Pub, housing offices, shops and the Cleveland Club. In 1936 it became the offices of Dorman Long & Co. and subsequently was occupied by the British Steel Corporation.[1]

[1] Joint TCS: RIBA: MBC, *Historic Public Buildings: Middlesbrough Inner Area*, Middlesbrough, 1981, p.107.

Adams, *Keystone Head*

Monument to Henry Bolckow
Sculptor: David W.S. Stevenson

Unveiled 6 October 1881
Figure: bronze 2.5m high
Pedestal: pink granite 4.5m high × 2m square
Signed on base of figure: D.W. Stevenson
A.R.S.A. / Sc. / Edinburgh:
Incised letters on front of pedestal: H.W.F.
BOLCKOW
Incised on bronze panel at rear of pedestal: THIS
STATUE WAS UNVEILED BY / LORD FREDERICK
CAVENDISH / ON THE 6TH OCTOBER, 1881
Incised letters at base of plinth: ERECTED 1881
Status: II
Condition: fair
Condition details: figure is dirty
Commissioned by: public subscription
Custodian: Middlesbrough Borough Council

Description: bronze statue on pedestal of
Bolckow in frock coat handing over the charter
of the town's incorporation.[1] Facial features are
indistinct due to dirt.

Subject: co-founder of modern
Middlesbrough, with his business partner, John
Vaughan (see pp.289–90), Bolckow was born in
Sulten, Mecklenburg in northern Germany in
1806, the son of a country gentleman. He first
went into business in Rostock before moving to
Newcastle in 1827 to work as an accountant,
foreign correspondent and commission agent
with Christian Allhusen, a Newcastle corn
merchant. In 1832 he met Vaughan, the sister of
whose fiancée he was courting at the time.
Seven years later the two men went into
business together, drawing upon the capital
Bolckow had amassed (over £40,000 whilst with
Allhusen) and Vaughan's iron-working
expertise. (For an account of their business
activities and its impact on Middlesbrough, see
the entry on Vaughan, p.289). Bolckow's
contribution to Middlesbrough was recognised
in 1853 when he was elected the town's first
mayor, and in 1867 its first MP. From 1856 he

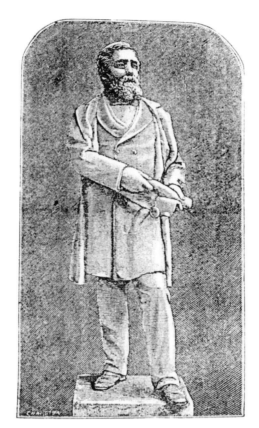

Bolckow Monument (ILN October 1881)

lived at Marton Hall, the palatial house he built
for himself on the southern fringes of the town.
He died in Ramsgate, Kent, on 18 June 1878.

History: the Bolckow memorial committee
first met on 10 July 1878, a month after
Bolckow's death. Various schemes were
considered before it was resolved to erect a
statue by the Edinburgh sculptor D.W.S.
Stevenson in Albert Park, the public park which
Bolckow had presented to the town in 1868.[2]

At a meeting on 19 July 1881 it was decided
that the unveiling should take place in
September as the centrepiece of the festivities
planned to mark the fiftieth anniversary of the

first modern house in Middlesbrough.
However, as it was alleged that arrangements
had been made in an 'an exclusive way' without
sufficient 'general consultation',[3] the unveiling
had to wait until 6 October 1881 when Lord
Frederick Cavendish was the main speaker and
a vast crowd 65,000 strong was present, 'whose
calm and good-natured behaviour throughout
[…] was in the highest degree praiseworthy'.
Before the actual ceremony there were
processions of school children and dignitaries
through the streets, and in the evening there
was a banquet at Royal Exchange Hall and
fireworks in Albert Park. Subscribers to the
statue, reporters noted with satisfaction,
embraced 'all classes, from the rich ironmaster
to the horny-handed working man'.[4]

The statue was erected behind the new
Exchange buildings rather than in Albert Park
as originally planned on land which was
presented by the family of Joseph Pease, the
businessman who in 1841 had encouraged
Bolckow and Vaughan to set up an ironworks
in Middlesbrough and had bailed them out in
1847 when their business nearly foundered. It
remained in Exchange Square, at the junction of
Marton Road and Wilson Street, until 1924,
when it was moved to behind the Sundial (see
p.171) in Albert Park.

Despite what might be seen as the
appropriateness of the latter site – a cartoon in
1875 in *Dominie*, Middlesbrough's short-lived
answer to *Punch*, had depicted an imaginary
statue of Bolckow in Albert Park on a pedestal
inscribed 'Si monumentum requeris circum-
spice' – it returned to Exchange Square follow-
ing the building of the A66 flyover in 1986.[5]

[1] Briggs, A., *Victorian Cities*, Harmondsworth,
1968, pp.253–4. [2] Burnett, W., *Old Cleveland: being
a collection of papers of local writers and local
worthies*, Middlesbrough, 1886, p.96. [3] *North-
Eastern Daily Gazette*, 6 October 1881. [4] Reid, H.
(ed.), *Middlesbrough and its Jubilee*, London, 1881,
p.256. [5] *The Dominie: A local Serio-Comic Journal*,
Middlesbrough, No.4, vol. 1, 5 June 1875.

Linthorpe Road

Albert Park, 100m east from Park Road South entrance

The Voyages of Captain Cook
Sculptor: Phil Meadows

Installed *c.*1996
Main work: wood 2.4m high × 60cm diameter
Additional works: painted wood 1.7m × 30cm diameter approx
Incised in carved relief image of open book:

Meadows, *The Voyages of Captain Cook*

Once under sail I / opened my secret / orders we are [...] transit of Venus / Then sail south east / from Tahiti into unknown / waters charting and discovering new land / [...] / James Cook.
Incised in piece with image of Boomerang:
BOTANY BAY
Incised in piece depicting tools: REPAIRS
Incised in work depicting lemons: LEMONS KEEP / SCURVY AWAY
Status: not listed
Condition: good
Condition details: small cracks evident
Commissioned and owned by: Middlesbrough Borough Council

Description: the stumps of six living trees. Forming a semi-circle around a bed of flowers,
each has been carved to depict a scene relating to the journey of Captain James Cook's voyages. The main stump represents in painted relief a seascape with an albatross and sailing ship. East of this are two carved stumps, one representing the sun, Saturn and bottle, the other an ink well, quill pen and an open book with text. To the west are three stumps with images of a boomerang and lizard, a saw, a mallet and plan, and a still life with lemons.

Subject: the sculpture commemorates the three voyages to the South Pacific of the locally-born explorer, Captain James Cook (for his biography see pp.288–9).[1]

[1] Duggan, A., 'Public Art in Middlesbrough' (unpub.), 1998, p.3.

Queen's Square TOWN CENTRE

Former National Provincial Bank, tympanum

Britannia and Supporters

Sculptor: [?C.H.] Mabey
Architect: John Gibson

Installed *c*.1872
Whole work: stone 1.6m high approx × 4m wide approx
Status: II
Condition: poor
Condition details: very dirty; spalling; loss of detail due to weathering
Commissioned by: National Provincial Bank
Custodian: Goodname Estates Ltd

Description: seated figures of Britannia and an ironworker and a miner, set in the tympanum of this one-storey cinquecento-style bank. The figures are surrounded by tools and machinery appropriate to Middlesbrough's industries.

History: the figures decorate the former National Provincial Bank designed by the London-based architect, John Gibson. They were erected in 1872 and replaced an earlier bank which had stood on the site of the home of John Gilbert Holmes, shipbuilder and well-known teetotaller, who had bought the land in 1831.[1] The fact that the work celebrates Middlesbrough's nineteenth-century industrial prowess in the way it does may owe something to the fact that the building was erected opposite the house in which Henry Bolckow and John Vaughan, the town's founding fathers, had lived from 1841 to 1860 (see pp.289–90 and 296–7). The sculptor's name has been given as Mabey, possibly the C.H. Mabey whom Beattie describes as 'an excellent carver of ordinary

architectural subjects'.[2]
From 1938 Gibson's building housed the Cleveland Club after its move from the Royal Exchange. It is now occupied by a second-hand furniture dealer, the Bankrupt Warehouse.

[1] Pollard, A. (ed.), *Middlesbrough: Town and Community 1830–1950*, 1996, p.157.[2] Beattie, p.108.

Riverside Park Road

Teessaurus Park

Teessaurus

Sculptor: Genevieve Glatt

Installed September 1979
Main work: painted steel 3.5m high × 7m long × 2.4m deep approx
Satellite works: painted steel 90cm high × 1.9m long × 50cm wide

Status: not listed
Condition: fair
Condition details: paint eroded in parts; rust visible in small areas; sprayed-on paint and scratched graffiti on work; nearby signboard removed
Commissioned by: Middlesbrough Borough Council
Custodian: Middlesbrough Borough Council

Description: a painted steel life-size figure of a triceratops guarding her young. Looking east towards the Transporter Bridge, the animals are made of steel, plates, pipes and bolts suggestive of the industrial activity which previously existed in the area.

History: Teessaurus Park, a ten-acre riverside development park, was opened in 1979, the

Glatt, *Teessaurus*

(opposite) Mabey, *Britannia and Supporters*

result of a national 'Art into Landscape' competition organised by the *Sunday Times* and the Arts Council. Formerly the Ironmasters District, which at one time produced one-third of Britain's pig iron, the site had become a slag heap until landscaping transformed it into a 'pleasant green area where people might go to watch traffic on the river'.

The six-tonne 'monster' was commissioned by Middlesbrough Council and fabricated by Hart's of Stockton at a cost of £16,000.[1] The baby triceratops were added later. Oddly enough, the obvious allusion that the subject-matter seems to make to the extinction of heavy industry in the area has not been commented on by either the artist or officials.

[1] *Northern Echo*, Newcastle, 7 September 1979.

Dinosaurs and Mammoth

Designer: not known

Installed from 1987
Each work: painted steel: 4m high approx × 8m wide approx × 2.5m deep approx
Status: not listed
Condition: fair
Condition details: paint erosion in many parts; rust evident in small areas; moderate amounts of graffiti on each piece; signboard missing from brick wall at entrance
Commissioned and owned by: Middlesbrough Borough Council

Description: forming a semicircle at the base of the hill around the earlier sculpture *Teessaurus* (see above), the life-size, steel skeletons of two baby tyrannosaurus rex, a stegosaurus, a brontosaurus, a brachiasaurus and a mammoth are each painted a different colour.

History: the dinosaurs were produced by workers on the Government Youth and Employment Training Scheme at Amarc

Training and Safety Ltd, East Middlesbrough Trading Estate from 1987 onwards. Gordon Angel, manager of Community Industry, Amarc, said 'Building the dinosaurs means unemployed people gain experience to enhance their work projects and do something of benefit to the community'.[1]

[1] Information provided by Cleveland Arts, 1999.

Dinosaur

Mammoth

Head, Hand and Tool

Sculptor: Lee Grandjean

Installed 1983
Head: York Stone 1.5m high × 58cm wide × 38cm deep
Hand and Tool: York Stone 1.44m high × 82cm wide × 46 cm deep
Incised on metal plaque on gate beside sculpture: Head, Hand and Tool. Lee Grandjean, 1983 / This sculpture of a stonemason celebrates the three / essential elements in all creativity, whether in the / studio or in the factory. The face is that of a / fellow-

Grandjean, *Head, Hand and Tool*

sculptor, and the hand grips a mason's chisel. /
The work relates to tradition of stone-carving /
which has flourished in Britain since the early
Middle Ages. / Cleveland County Museum
Service.1
Incised on respective works: Grandjean 83 'The
Hand and [...]'; 'The Head' Grandjean 83
Status: not listed
Condition: fair
Condition details: west end of chisel missing;
large chip to west side of base; rust on end of
remaining chisel; lichen growth on both works,
algae and moss on *Head*
Commissioned by: Cleveland County Council
Custodian: Middlesbrough Borough Council

Description: a massive scowling head along-
side a similarly massive hand holding a chisel.
The sculpture cost approx £3,000.[1]

[1] Information provided by Cleveland Arts, 7 April
1999.

Mechanical Arch
Sculptor: Roy Kitchin

Installed 1983
Whole work: painted steel 2.8m high × 5.8m
wide × 64cm deep
Status: not listed

Kitchin, *Mechanical Arch*

Condition: fair
Condition details: paint erosion in small areas;
rust visible in parts, particularly to underside of
bridge; scratched graffiti on west pillar
Commissioned by: Cleveland County Council
Custodian: Middlesbrough Borough Council

Description: a bridge-like structure
suggestive of the forms of Cleveland's steel
rolling mills and Tees Transporter Bridge. The
whole work is painted blue and stands at an
angle between the entrance gates and the
gallery.
History: the piece cost £8,000, £5,500 of
which came from Cleveland County Council,
£1,400 from Northern Arts and the rest along
with materials from British Steel.[1]

[1] Information provided by Cleveland Arts, 1999.

Maine, *Solid State*

Solid State
Sculptor: John Maine

Installed 18 March 1985
Base: concrete 35cm high × 43cm square
Sculpture: concrete 60cm high × 60 cm diameter
Status: not listed
Condition: fair
Condition details: dirty; lichen on top
Custodian: Middlesbrough Borough Council

Description: a carved star-like form made of
concrete. At first glance it seems to be
composed of small facets, but on further
inspection it becomes apparent that these are
pieces of three larger volumes which cut into
each other.
History: produced in 1978, *Solid State* was
purchased in 1985 for £4,000 with the help of
Northern Arts, Cleveland County Council and
a Government Purchase Grant Fund, and forms
part of the Cleveland Gallery's permanent
outdoor collection. The artist has commented
that the star-shaped form hovers between being
crystalline and like the bud of a plant.[1]

[1] Information provided by Cleveland Arts, 7 April
1999.

Vulcan Street

Tugboat
Sculptor: Victoria Brailsford

Installed *c.*1991
Whole work: painted wood 2.4m high × 29cm
wide × 22cm deep
Status: not listed
Condition: fair
Commissioned by: Cleveland Arts
Custodian: Middlesbrough Borough Council

Description: a marker post with the top
carved as a tugboat.
History: the sculpture is one of a series of

Brailsford, *Tugboat*

permanent craftworks sited along the Teesdale
Way, a riverside footpath between Cargo Fleet,
Middlesbrough and Low Middleton. The series
includes marker posts, stiles, signs, carved
entrances and seating. Erected at a cost of
£30,000 by Cleveland Arts, Cleveland County
Council and Northern Arts with financial
assistance from Northumbrian water and advice
from Common Ground's 'Campaign for Local
Distinctiveness', the aim of the scheme is to
encourage people to walk along the banks of
the Tees. By April 1993 there were 22 works in
place between Middleton and the Transporter
Bridge in Middlesbrough. With the exception of
the *Cormorant* marker post at Cargo Fleet
viewing platform and Ayers's *Oak Leaf*, these
were all erected in 1991.[1]

[1] Information provided by Cleveland Arts, 1998.

Esplanade

Seafront

Picture Postcard Railings

Designer: Chris Topp

Installed *c.* 1994
Each panel: painted steel 86cm high × 1.32m
wide
Signed: in stencil-cut lettering on several panels:
Chris Topp, Thirsk
Stencil-cut lettering on panel depicting
fairground: Weather is here wish you were nice.
Status: not listed
Condition: fair
Condition details: paint erosion in parts; rust
on all panels
Commissioned by: Langbaurgh Borough
Council
Custodian: Redcar and Cleveland Borough
Council

Description: thirteen steel relief panels
incorporated into the promenade railings. Each
brightly-painted relief takes the form of a
picture postcard on the theme of Redcar's
seaside: the steelworks; fairground rides; fishing
boat in the high seas; an old style lifeboat; a

Topp, *Picture Postcard Railings*

Punch and Judy Show; cones of ice cream;
donkey rides; fish and chip shop; a disco scene.
History: with a brief to design railings that
would suggest something of the history of
Redcar, Topp's picture postcard reliefs were the
winning entry in a competition held by the
former Langbaurgh Council. Installed in 1994,
the railings form one part a scheme of public
pop-art features which decorate the
redeveloped esplanade.[1]

[1] Redcar and Cleveland Borough Council, 'Public
Art Sites, Redcar' (unpub.), 1998, *passim*.

Regent Cinema, side elevation

Showtime

Artist: John Clinch

Installed August 1997
Main work: painted steel and fibreglass 12m
high × 3.6m wide
Satellite works: painted steel figures 1.6m high
approx
Status: not listed
Condition: good
Condition details: building in poor condition;
paint eroded in small areas; dirty
Commissioned and owned by: Redcar and
Cleveland Borough Council

Description: a large fibreglass and steel relief
of cut-out figures attached to the side elevation
of the cinema building. The work represents
variously coloured cinematic stars including
Marilyn Monroe, Charlie Chaplin, John Wayne
and Batman emerging from an exit door.
Nearby the two cut-out reliefs of Laurel and
Hardy and Fred Astaire stand by the seafront
railings.
History: the first of two sculptures in Redcar
built by Clinch for the centenary of the British
film industry (see p.304), *Showtime* decorates
the only cinema in the new unitary borough.[1]
Its installation in 1997, a year after the

Clinch, *Showtime*

centenary, was planned to coincide with a
season of art films shown at the Regent.[2]

[1] Cleveland Arts, 'Public Art in Redcar and
Cleveland' (unpub.), 1998, *passim.* [2] Information
provided by Regent Cinema, 1999.

Clinch, *Showtime* (*Laurel and Hardy*)

Family of Penguins

Sculptor: Tony Wiles
Fabrication: Great British Bollard
Company

Installed *c.*1994
Each work: steel, concrete and polyurethane
coating 1.05m high approx × 66cm wide approx
Status: not listed
Condition: good
Condition details: paint erosion in parts; large
cracks to largest work; dirty; scratched in some
areas
Commissioned by: Langbaurgh Borough
Council
Custodian: Redcar and Cleveland Borough
Council

Description: nine penguins stand on the
seafront esplanade. Seven birds seem lost and
surround a signpost which gives directions to
local places and to the South Pole. Another two
stand looking out to sea, apparently having
found their way.

Wiles, *Family of Penguins*

Clinch et al, *British Cinema Centenary
sculpture*

History: the penguins were commissioned by
the former council as a 'jolly' addition to a new
signpost erected on the seafront esplande.[1]
Fabricated to the artist's design by a company
that specialises in making customised litter bins,
bollards and street furniture, the Redcar
penguins are not classified as sculptures by
either party.[2]

[1] Information provided by Great British Bollard
Company, 1999. [2] Information provided by artist,
1999.

Lord Street

Junction with Granville Terrace and Coast Road

British Cinema Centenary sculpture

**Designer: John Clinch
Artists: Glenn Humphrey and
Tracey Potter
Blacksmith: James Godbold**

Installed 1997
Whole work: cut steel 2.5m high × 3.15m
diameter
Status: not listed
Condition: good
Condition details: water collected at base; some
paint erosion; dirty with sand accumulation
Commissioned and owned by: Redcar and
Cleveland Borough Council

Description: a sculpture comprising flat cut-
out figures, nautical and cinematic motifs
painted in bright colours. Arranged in a ring
around a curl of film and a seagull, the figures
represent a pirate; a mermaid; a lifeboatman;
Captain Cook and Gertrude Bell.

History: the sculpture is one of two works in
Redcar commissioned by the council in
celebration of 100 years of British Cinema (see
p.302). Although Clinch was invited to execute
the piece, a serious illness prevented him from
realising the project and his design was handed
over to two artists and a blacksmith to
complete.[1]

The various figurative elements refer to
Redcar's history; its links to the sea, the local
Regent cinema and two local heroes, Captain
Cook (see p.288–9) and Gertrude Bell.[2]

Born in Washington, County Durham in
1868, Bell spent her early childhood in Redcar.
After graduating from Oxford she travelled the
world, and explored uncharted deserts years
before T.E. Lawrence. Her knowledge of the
Bedouin tribes is said to have been crucial to
allied intelligence forces in World War One.
Also known as a capable archaeologist, linguist,
writer, mountaineer and photographer she died
in Iraq, the state she helped establish, in 1923.
She was buried in Baghdad with full military
honours.[3]

[1] Information provided by James Godbold.
[2] Cleveland Arts, 'Public Art in Redcar and
Cleveland' (unpub.), 1998, *passim.* [3] British Council,
'Gertrude Bell (1868–1926): An exhibition by the
British Council', University of Newcastle, 1999.

Glenside
Memorial Garden

Saltburn War Memorial
Sculptor: William Reynolds-Stephens

Unveiled 20 November 1920
Cross: granite 2.1m high × 1.83m wide × 26cm deep
Pedestal and base: granite 1.4m high × 1.53m wide × 1.03m deep
Signed on base of relief panel: W. Reynolds-Stephens 1919
Incised white letters on apex of cross: SACRIFICE
Incised white letters on north-west base of cross: TO THE MEMORY OF THOSE FROM / SALTBURN WHO GAVE THEIR LIVES / FOR ENGLAND IN THE GREAT WAR [names below]
Incised in white letters on dado of three other faces the names of the dead and the dates 1914 / 1918 / 1939–1945
Status: II*
Condition: fair
Condition details: relief panel weathered; dirty; green metallic staining on bronze and granite
Custodian: Redcar and Cleveland Borough Council

Description: a First World War memorial comprising an unusual broad-armed cross with a short shaft in polished grey granite atop a slightly tapering pedestal and base of the same stone. The cross bears a bronze relief which depicts two angels praying at the head and foot of the recumbent figure of Christ. Two bronze relief laurel wreaths decorate the pedestal on each side.

History: this highly individual war memorial, which has recently been awarded a Grade II* listing status, was presented to the town by an

anonymous donor shortly after the First World War. Although the relief was executed by a well-known proponent of the New Sculpture movement, no details of its commission have been found. It was unveiled by Major-General Sir Percy Wilkinson KCMG, CB, on the afternoon of 20 November 1920, in a ceremony which, according to the *Cleveland Gazette*, was performed with 'beautiful reverence and sublime simplicity'.[1]

[1] *Cleveland Gazette*, 20 November 1920.

Reynolds-Stephens, *Saltburn War Memorial*

A1085
Huntcliff, Cleveland Way

Trawl Door, Pillar and The Circle
Sculptor: Richard Farrington

Installed 1990
Circle: steel 2.2m diameter
Trawl Door: steel 1.12m high × 1.55m long × 42cm deep
Pillar: steel 1.9m high × 45cm wide × 80cm deep
Status: not listed
Condition: good
Condition details: some rust is evident in parts of the works
Commissioned and owned by: Skelton and Brotton Parish Council

Description: three steel sculptures sited a short distance from one another above a 100-metre-high cliff. *Trawl Door* is a representation of the doors of an open trawl net with its catch: a large fish and plankton. *Pillar* is a ridged marker post, supporting a chain of four metal sculptures which represent a star, the top of a plant growth, the shape air makes when striking a surface, and a jellyfish and its reflection in the water. In the largest work, *The Circle*, ten figurative sculptures hang on metal rods from a large steel hoop.

History: the clifftop sculptures were the result of a three-month 'New Milestones' residency commissioned by the local parish council. Constructed at the British Steel plant in nearby Skinningrove, each piece is made from locally produced metals and refers to the industrial, social and natural history of the district. Farrington lived in the area of Skelton, collaborating with the commissioners and a local support group on the subject of his work. *Trawl Door* takes its form from equipment used

Farrington, *The Circle*

(left) Farrington, *Trawl Door*

Bridge Road TOWN CENTRE
Castlegate Shopping Centre, entrance

John Walker

Sculptor: Jose Sarabia

Unveiled 29 May 1981; re-sited 1999
Bust: bronze 40cm high × 24cm wide
Pedestal: polished grey granite 1.7m high × 36cm wide
Incised in Roman letters painted black on steel plaque attached to pedestal: JOHN WALKER / (1781–1851) / STOCKTON BORN / INVENTOR / OF THE FRICTION / MATCH / IN 1826
Incised in Roman letters painted black on steel plaque attached to wall nearby: JOHN WALKER / 1781–1859 / NEAR THIS SITE AT 104 HIGH STREET / JOHN WALKER WAS BORN ON 29TH MAY, 1781. / DURING 1826 HE FINALLY DEVELOPED A PASTE CAPABLE, WHEN DRIED, / OF PRODUCING INSTANTANEOUS LIGHT, / WITH THE FIRST RECORDED SALE OF THE FRICTION MATCH / BEING DATED 7TH APRIL, 1827. / HE DIED AT 12 THE SQUARE, STOCKTON-ON-TEES / ON 1ST MAY, 1859, / AND WAS BURIED IN NORTON CHURCHYARD. / THIS PLAQUE WAS UNVEILED BY / THE WORSHIPFUL MAYOR OF STOCKTON-ON-TEES, / COUNCILLOR J.M.SCOTT, J.P., M.A. (OXON) / ON 29TH MAY 1981 / TO COMMEMORATE THE BICENTENARY OF / JOHN WALKER'S BIRTH.
Status: not listed
Condition: good
Custodian: Comgrove Properties Ltd

Description: bronze bust on a granite pedestal.
Subject: Dr John Walker (1781–1859), the inventor of the friction match, was apprenticed to a Stockton surgeon but later became a chemist and druggist, setting up his own

by fishermen in Whitby and the figurative elements in *Pillar* are intended to symbolise sky, earth, air and sea. *The Circle* includes the three-dimensional representations of the Cleveland Bay Horse and a cat – in the 1300s cats were hunted on the cliff.

Described by the sculptor as a 'giant charm bracelet', *The Circle* has become a notable local landmark. In 1996 vandals, having used specialised tools to saw through the work at its base, rolled the sculpture into the sea. Only the figure of a horse was recovered. Farrington's new circle, a replica of the first, has been the site of a Midsummer Day wedding, and the subject of stories by a Saltburn writers' group.[1]

The 'New Milestones' project was part of a Cleveland-wide arts initiative to link sculpture and the environment. Organised by Cleveland Arts in association with Common Ground, the scheme received additional funding from Northern Arts, British Steel and Langbaurgh Borough Council.[2]

[1] Information provided by the artist, 1999.
[2] Skelton and Brotton Parish Council, *Skelton and Brotton New Milestones*, 1990, *passim*.

Sarabia, *John Walker*

business in 1819. His friction matches, the result of several years of experiment, took the form of splints of wood coated in potassium chlorate, antimony sulphide and gum arabic which burst into flame when drawn through a folded piece of glass-paper. An entry in Walker's day-book for 7 April 1827 (Science Museum, London) records the first sale of 100 'Friction lights' in a tin case at one shilling and tuppence. By September 1829 he had sold 23,206.[1]

History: Walker's invention was first commemorated with a brass plaque which was put up on the site of his shop in 1893. Unfortunately two other plaques were also installed in 1893, one of which claimed,

mistakenly, that Walker had invented the 'Lucifer' match. In fact the 'Lucifer' was the name given by an unscrupulous London chemist called Samuel Jones (inventor of a slightly later and less satisfactory match, the 'Promethean') who had begun manufacturing direct copies of Walker's matches in 1829. By 1830 or 1831, when Jones's 'Lucifers' were becoming well-established on the market, Walker gave up making matches.[2]

Sarabia's bust of Walker shows him as he appears in a contemporary line engraving, 'a smart, trim little man'. It was originally erected at John Walker Square at the southern end of Stockton High Street but was moved several metres to its present position in Castlegate Shopping Centre in 1999.

The story goes that the artist initially depicted the wrong man. He was advised to base his work on a picture of John Walker in the National Portrait Gallery but unfortunately he was shown the picture of the wrong John Walker.[3]

[1] Woodhouse, R., *Stockton Past*, Chichester, 1994, p.62. [2] Thomas, D., 'The British genius who invented friction matches in 1826', *Durham County Local History Society Bulletin*, 46, May 1991, *passim*. [3] Information provided by J. Clift, Castlegate Shopping Centre, 1999.

Dovecot Street TOWN CENTRE

ARC, side elevation

Over Easy

Sculptor: Richard Wilson

Inaugurated 11 January 1999
Whole work: glass, rendering and steel 8m diameter
Status: not listed
Condition: good
Commissioned and owned by: Trustees of ARC

Description: a sculptural 'intervention' into a

Wilson, *Over Easy*

new piece of High Modernist-style architecture. A circular section of the street façade slowly and silently rocks backwards and forwards in the manner of a swing-boat at a fair. Although moving at the equivalent of less than two revolutions an hour, any point on the circumference travels a distance of almost 700 kilometres each year.

History: Over Easy is Wilson's first permanent architectural 'intervention' in Britain. Unlike some of his earlier works such as *Jamming Gears* at the Serpentine Gallery, London (1996), it is the product of a close collaboration between the artist and the host

building's architects, Renton Howard Wood Levine, and is intended to reveal how the host building is used (an art centre called ARC which specialises in the performing and digital arts) rather than how it is constructed.[1] As the artist has said, 'I did not want to distract the viewer away from the buildings' design and also recognised that the work could announce the Centre's intentions and functions.'

Fittingly, the work was inaugurated at the same time as the art centre itself. It cost £46,000 and was funded by the Henry Moore Foundation, the National Lottery, Northern Arts and Stockton City Challenge. The artist was assisted in its construction by Commercial Systems International, Hull (fabricators), Price and Myers, London (structural engineers) and W.S. Atkins Northern, Middlesbrough (mechanical engineers).

When *Over Easy* was first proposed, a leading Conservative councillor said, 'I think the people of Stockton will joke about this and call it the clockwork orange. We have a history of shipbuilding and industry. Why not honour that?' Once in place, however, it attracted relatively little comment of any kind.[2]

[1] Usherwood, P., 'Over Easy', *Art Monthly*, June 1999, pp.43–4. [2] Information provided by the artist and ARC, 1999.

Racing Ahead
Sculptor: Irene Brown

Installed 1995
Whole work: cast iron, enamel paint, stone
1.02m high × 13m long × 1.5m wide
Incised on east-facing metal plaque: RACING AHEAD / *Irene Brown 1995*.
Status: not listed
Condition: good
Condition details: chipped enamel; graffiti on tail of front greyhound
Commissioned by: Cleveland Arts

Custodian: Stockton-on-Tees Borough Council

Description: three cast-iron, painted greyhounds gambolling along amongst the shoppers in a pedestrianised street. They are naturalistically modelled and life-size.

History: explaining the intentions behind the sculpture, Reuben Kench, the chairman of the City Challenge Public Arts Panel, said that the relationship between the dogs is 'one of playing and collaborative progress. It's that spirit of moving ahead together that the artist wanted to portray in the sculpture.'

Racing Ahead was fabricated by Stockton Casting Co. at a cost of £30,000. At the time of its unveiling it was criticised for reinforcing Northern stereotypes. The Conservative councillor, Stephen Smailes declared, 'We've turned the clock back 30 years to an Andy Capp image'.[1] As a result it was decided not to site it on the High Street outside the Town Hall as initially planned. However, a survey undertaken at some later date by Cleveland Arts indicated that it gradually found favour with local residents: 17 per cent of respondents could name it and 54 per cent said they liked it.

[1] *Evening Gazette*, Middlesbrough, 7 March 1998.

Brown, *Racing Ahead*

High Street
John Dodshon Memorial Fountain
Designer: not known

Erected 1878; re-sited 1892; re-sited 1992
Whole work: marble, sandstone and brick tiles
8m high approx × 1.42m square
Incised on west-facing panel: JOHN DODSHON
Incised on south-facing panel: BORN / APRIL 21ST / 1811
Incised on east-facing panel: DIED / FEBRUARY 20TH / 1875
Incised on north-facing panel: ERECTED BY / VOLUNTARY SUBSCRIPTION / 1878
Status: not listed
Condition: good
Condition details: water spouts removed; spalling to steps and to sandstone elements;

Dodshon Fountain

weathering of decorative stonework; small cracks on steps; algal growth on pinnacle and steps; small amount of graffiti
Commissioned by: public subscription
Custodian: Stockton-on-Tees Borough Council

Description: stone drinking fountain with domed roof and tall staff at apex resting on a pedestal with recessed panel and basin on each side. The roof and entablature are decorated with relief swags and garlands.

Subject: John Dodshon (1816–75) was born in Sunderland and practised there as a chemist and druggist. He continued in the same line of business after moving to Stockton in 1842. The fountain commemorates his contribution as local Quaker, president of the Temperance Society and philanthropist. His obituary in 1875 said that 'By his death the poor have lost a friend unobtrusive, active and large-hearted.'[1]

History: the fountain was originally erected in the High Street and then moved to Ropner Park in 1892 after it was found that 'fishgutting fishwives' were using it to store fish.[2] In 1992 it was restored and two years later re-erected, without a water supply, in the High Street which had been newly pedestrianised.[3]

[1] *South Durham and Cleveland Mercury*, 27 February 1875. [2] *Evening Gazette*, Middlesbrough, 10 March 1995. [3] *Ibid.*, 27 August 1996.

THORNABY-ON-TEES
Stockton-on-Tees BC

Allensway

Wrightson House and Pavilion, outside

Thornaby (*The Spider*)

Sculptor: Brian Wall
Apprentices: Ben Postcliffe and John Simpson

Unveiled 26 March 1968
Whole work: steel, painted black 4m high approx × 8.72m wide × 1.98m deep
Raised letters on a metal plate inserted in the pavement beside the sculpture: Thornaby / Brian Wall 1968
Status: not listed
Condition: fair
Condition details: paint erosion in some areas, particularly on one beam; scratched and painted graffiti
Custodian: Stockton-on-Tees Borough Council

Description: a large abstract steel sculpture, painted black. Two sharp-angled geometric beams support a tilted central disc.

History: a local benefactor paid £9,000 for the sculpture in 1968.[1] Although it has come to be seen as a representation of a spider, the work takes its form from the two letter 'A's (Always

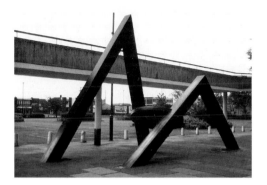

Wall, *Thornaby*

Advancing) on Thornaby's old coat of arms. One 'A' of the structure is said to symbolise the old village of Thornaby, the other, the new town.

Made to Wall's design at Head Wrightson's in Thornaby, the central disc was added at the suggestion of a local art student.[2] The sculpture, known locally as *The Spider*, is regularly used by children as a slide and this accounts for its shiny surface on one 'leg'.

[1] *Northern Echo*, 21 February 1991. [2] Information provided by Remembering Thornaby Group, 1999.

Thornaby Road (A1045)

Between Sinnington Road and Martinet Road

Thornaby Aerodrome Memorial

Sculptor: Tony Maw
Architect: David Shuttleworth
Stonemason: Bob Weatherill

Unveiled 8 May 1997
Figure: replica bronze 1.2m high approx
Pedestal: yellow stone 1.95m high × 1.27m wide × 85cm deep
Incised black letters on west face of pedestal: THIS MEMORIAL / STANDS ON THE SITE OF / THORNABY / AERODROME / AND IS TO THE MEMORY / OF THOSE WHO SERVED HERE / 1930–1958 / DEDICATED 8TH MAY 1997.
Incised black letters on north face of pedestal: HOME OF / 608 NORTH RIDING / (F) SQUADRON / ROYAL AUXILLARY / AIR FORCE / OMNIBUS UNGULIS / WITH ALL TALONS.
Incised in black letters on a metal plaque attached to the wall at the rear of the statue: THIS MEMORIAL WAS UNVEILED / BY / WING COMMANDER / H.D.'HANK' COSTAIN M.B.E., R.A.F. (RTD) 8TH MAY, 1997 / DESIGNER: D. SHUTTLEWORTH RIBA / COUNCILLLOR DERRICK BROWN / CHAIRMAN (MAYOR) / THORNABY TOWN COUNCIL.

Status: not listed
Condition: good
Commissioned and owned by: Thornaby Town
Council

Description: a smaller than life-size 'replica
bronze' statue of a wartime airman in RAF
battledress, standing at ease, with a flying jacket
thrown over his shoulder. He looks to the sky
as if watching a plane, his hand raised above his
brow partly to shade his eyes and partly in
salute. The statue surmounts a stone three-
sided, rock-faced pedestal atop a short flight of
steps.

History: the memorial was erected at the
suggestion of airmen who had served at the
nearby former RAF base. Commissioned by
Thornaby Town Council soon after its
establishment as a parish council in 1995, the
£12,000 memorial was part-funded by the
council with the aid of public subscription and
additional grants from the 'Remembering
Thornaby Group', the Ropner Trust and
Northern Arts.

It was unveiled on the anniversary of VE day
by an ex-Commanding Officer of RAF
Thornaby.[1] A similar memorial is sited near the
old aerodrome at Dalton-on-Tees, North
Yorkshire.

[1] Information provided by Thornaby Town
Council, 1999.

Maw, *Aerodrome Memorial*

Glossary

acanthus: long leaf usually curled over at the lip. It is the standard form of foliage in classical decoration, on a Corinthian *capital* for example.

accretion: the accumulation of extraneous materials on the surface of a sculpture, for example, salt, dirt, pollutants or guano.

acroterion (plural: acroteria): an ornamental block on the apex and at the lower angles of a *pediment*, bearing a statue or a carved *finial.*

aedicule: a *statue niche* framed by *columns* or *pilasters* and crowned with an *entablature* and *pediment*; also a window or door framed in the same manner.

alabaster: a sulphate of lime or gypsum. As a material for *sculpture* it can be polished smooth and take paint directly onto its surface.

allegory: a conventional depiction of a subject in the guise of another, usually using figures from mythology or history to personify abstract concepts.

aluminium: a modern, lightweight white metal obtained from bauxite.

angel: two types of angel appear on works in the region. The first is the winged female figure on war memorials, referred to variously as 'angel of victory', 'angel of peace' and 'renown'. This is a variant of *Nike*, the Greek winged goddess of victory. The second is the archangel Michael slaying a dragon, from the book of Revelation found on *pants* in Alnwick where St Michael is the patron saint of the parish church.

apotropaic: designed to ward off evil spirits.

arcade: a range of *arches* carried on piers or *columns*, either *free-standing* or attached to a wall (a blind arcade).

arch: a curved structure, which may be a *monument* itself or an architectural or decorative element within a monumental structure.

architrave: the main beam above a range of *columns*, the lowest member of an *entablature*; also the moulding around a door or window.

Art Nouveau: a decorative style that flourished in all fields of design in Europe and America *c.*1890–1910, characterised by asymmetry and sinuous lines. The willowy, elongated female figure with flowing locks and the fantastic curves of stylised flowers is a typical motif. In Britain it is much influenced by the *Arts and Crafts Movement*'s emphasis on truth to nature and materials and on the idea of the craftsman as artist.

Art on the Riverside: initiated by *Tyne and Wear Development Corporation* in the early 1990s, a public art programme concerned with projects along the Tyne and the Wear, run by a Joint Public Art Committee of councillors and officers from Sunderland, South Tyneside, North Tyneside and Newcastle.

artificial stone: a substance, usually cement or reconstituted stones, moulded and then fired rather than carved.

Artists' Agency: a charitable company based in Sunderland that manages artists' placements in communities that previously have had little experience of art. The Agency sees this as a two-way process, helping the development of both the artist and the communities within which they work. In the past sculptors, writers, musicians, dancers and craftspeople have worked in environments as diverse as hospitals, factories, prisons and housing developments throughout the North of England.

Arts and Crafts Movement: British social and artistic movement of the second half of the nineteenth century springing from a dissatisfaction with the quality of manufactured goods after the 1851 Great Exhibition. Under the leadership of Pugin, Ruskin and Morris it advocated a return to guild-like practices and an emphasis on craftsman skills. Looking to medieval art for its model, it advocated truth to materials in design and architecture.

attic course / attic storey: the course or storey immediately above the *entablature*, less high than the lower storeys.

attribute: a symbolic object by which an *allegorical* or sacred personage is conventionally identifiable.

avant-garde: a term derived from military terminology which has been used since the middle of the nineteenth century to describe art which rejects the conventional in favour of the novel and strange.

baroque: (i) a period of style in art history between the late sixteenth century and the early eighteenth century; (ii) florid or overwrought.

bas-relief: see *relief.*

base: the lowest part of a structure; that part on which the *shaft* rests in a *column* or on which the *dado* rests in a *pedestal*; the lowest

integral part of a *sculpture* (sometimes mounted on a *pedestal*).

boss: a block of wood or *keystone* which masks the junction of vaulting ribs in exposed roof spaces.

bronze: alloy of copper and tin, with traces of metals which affect the surface *patination* as the sculptural work weathers. A very responsive, strong and enduring substance, it is easily handled and has become one of the most common materials for *sculpture*.

bust: a representation of the head and upper portion of the body.

caduceus: attribute of Hermes and Mercury, messenger of the Gods. A staff, culminating in a pair of intertwined snakes, surmounted by two wings. As an emblem on its own, in post-Renaissance secular *iconography* it is a symbol of peace, justice, art or commerce.

canopy: a roof-like projection over a *monument, sculpture, cross*, etc.

capital: the transition between a *column* and the ceiling or *arch* above it. It can either be *free-standing* or attached to the wall.

cartouche: an ornamental panel with edges simulating a scroll of cut parchment, usually framing an *inscription* or shield.

caryatid: a support, taking the place of a *column*, in the form of a female figure.

cast: the reproduction of an object obtained when a material in a liquid state is poured into a mould and hardened. Recast: made from moulds taken from the original cast or from replicas.

cenotaph: (i) a *monument* which commemorates a person or persons whose bodies are elsewhere; (ii) a form of First World War memorial popularised by Sir Edwin Lutyens' precedent at Whitehall, London.

ciment fondu: a cement-like material which is easily moulded and can be coloured.

classical: governed by the rules of ancient Greek or Roman art, *sculpture* and architecture.

Cleveland Arts: an arts development agency with charitable status based in Middlesbrough. It promotes the arts in four local authorities: Hartlepool; Stockton; Middlesbrough and Redcar and Cleveland. Its Public Art Unit provides project management and funding advice to private, voluntary and public organisations.

Coade stone: *artificial stone* made in Lambeth from *c*.1769 to *c*.1820 and used in a wide variety of *sculpture* because of its resistance to frost. It is named after its inventor and first manufacturer, Mrs Coade.

colonnade: a range of *columns* supporting an *entablature*.

column: upright structural member with a *shaft*, topped by a *capital* and usually rising from a *base*. Whatever the shape of the *capital* or *base*, the *shaft* is usually round or octagonal in plan. In classical usage columns generally conform to five main types, or *Orders:* Corinthian, Doric, Ionic, Tuscan and Roman or Composite.

Common Ground: a British environmental lobby group and charity established in 1983. Its primary aims are to bring arts and nature conservation together and to encourage individuals and communities to take an active interest in their local environment. The charity promotes several community-led, art-in-the-landscape schemes which have been adopted by small organisations in various parts of Britain. Perhaps most popular amongst these has been the New Milestones Sculpture project, which invites local groups to collaborate with artists on the execution of public artworks in their localities.

concrete: a composition of stone chippings, sand, gravel, pebbles, etc., mixed with cement as a binding agent. Although concrete has great compressive strength it has no tensile strength and thus, when used for any *free-standing sculpture*, it is often reinforced with an armature of high tensile steel rods.

console: a decorative bracket with a compound curved outline, resembling a figure *S* and usually taller than its projection.

conversation piece: a class of composition, especially common to eighteenth-century English painting, in which portraits of individuals are grouped together in a life-like manner and usually engaged in discussion.

corbel: a brick or stone which projects from a wall and supports a feature on its horizontal surface.

Corinthian: see *order*.

cornice: (i) the overhanging *moulding* which crowns a *façade*; (ii) the uppermost division of an *entablature*; the uppermost division of a *pedestal*. The sloping *mouldings* of a *pediment* are called raking *cornices*.

corrosion: gradual deterioration of a material through chemical reaction with acids, salts or other agents. It is accelerated by the presence of moisture.

crazing: pattern of cracks on surface or coating.

crocket: an ornamental architectural feature, usually in the shape of a bud or curled leaf, projecting at regular intervals from the inclined side of pinnacles, *spires, canopies* or gables.

cross: there are three forms of cross commonly found in the public sculpture of the North East: (i) Latin cross – a cross with the three uppermost arms the same length, but the shaft longer; (ii) Cross fleury – a Latin cross each arm of which is tipped with a fleur-de-lis; (ii) Celtic cross – a Latin cross the centre of which is surrounded by a circle.

cusp: points formed at the meeting of *foils* in a *tracery*.

dado/die: on a *pedestal*, the middle division above the *plinth* (or *base*) and below the *cornice*.

delamination: see *spalling*.

Doric: see *order*.

drum: a vertical wall supporting a dome on a building, a *column* or the *base* of a *statue* on top of a column.

earthwork: a term which gained currency in the late 1960s to describe outdoor abstract sculptural works, often large in scale, which rather than representing the landscape are constructed out of it.

electroplating: the application of a metal coating to a surface by means of an electric current. Discovered in the early nineteenth century, it was first used for sculpture in 1839.

entablature: in *classical* architecture, the superstructure carried by the columns, divided horizontally into the *architrave*, *frieze* and *cornice*.

equestrian: see *sculpture*.

façade: front or face of a building or *monument*.

fasces: a bundle of rods bound up with an axe in the middle, the blade projecting. Fasces were a symbol of the authority of the higher magistrates in ancient Rome.

festoon: depiction of a garland suspended between two points.

finial: an ornament which finishes a vertical projection such as a *spire* or gable.

fluting: shallow concave grooves running vertically on the shaft of a *column* or other surface.

foil: leaf-shaped lobe created by *cusp*.

foliate: decorated with leaf designs or *foils*.

foundation stone: a stone situated near the base of a building or *monument*, bearing an *inscription* recording the dedicatory ceremony.

founder's mark: sign or stamp on a *sculpture* denoting the firm or individual responsible for casting.

free-standing: sculptural type. Free-standing *sculptures* are not attached to any kind of support, except for a *base* or *pedestal*.

frieze: in *classical* architecture such as Greek temples, the *frieze* was the middle division of the *entablature*, between *cornice* and *architrave,* which was often used for *relief sculpture*. Modern usage extends the concept of a frieze to any sculptural *relief* incorporated into an architectural work.

galvanize: to immerse a metal in molten zinc to give it a protective coating against rust.

gargoyle: a spout in the form of a carved *grotesque* human or animal head, projecting from the top of a wall to throw off rainwater.

genre: (i) a kind or type of visual art; (ii) a scene of everyday life.

gnomon: a pin or triangular plate on a sundial, the shadow of which indicates the time of day.

Gothic: a style of medieval art and architecture that predominated in Europe *c.*1200 – *c.*1450. In architecture it is characterised by the pointed *arch* and an overall structure based on a system of ribbed cross vaulting supported by clustered *columns* and flying buttresses, giving a general lightness to the building. In *sculpture* the figure is generally treated with naturalistic detail, but is often given an exaggerated elegance through elongation and the use of an *S* curve. During the Renaissance the Gothic went out of favour. In the eighteenth century, however, there was revival of interest in medieval forms, an interest which in the next century gradually grew more serious and scholarly.

graffiti: unauthorised lettering, drawing, or scribbling applied to or scratched or carved into the surface.

granite: an extremely hard crystalline igneous rock consisting of feldspar, mica and quartz. It has a characteristically speckled appearance and may be left either in its rough state or given a high polish. It occurs in a wide variety of colours including black, pink and grey-green.

Great North Forest: the first Community Forest to be developed in Britain. It was launched in 1990 as a partnership between the Forestry and Countryside Commissions and Chester-le-Street, Durham, Sunderland, Gateshead and South Tyneside district councils with the aim of revitalising scattered pockets of woodland on behalf of both the wildlife in them and nearby communities. Central to its work is an ongoing arts programme substantially funded by *Northern Arts* which has organised artists' residencies, festivals and workshops and commissioned temporary and permanent works of art throughout the area. The latter are seen both as markers within a 'massive open air art gallery' and as a way of 'rebuilding the essential link between people and the land'.

grotesque: a form of decoration composed of fanciful animal and human forms, fruit, flowers, etc.

guano: bird excrement.

iconography: the visual conventions by which traditional themes are depicted in art. The term is also used of a method of art history which concerns itself with the subject matter or meaning of works, as opposed to their form.

in situ (literally in 'place'): a term used to denote the original location of a work of art for which it was first intended.

inscription: written dedication or information.

Ionic: see *order*.

iron: a naturally occurring metal, silver-white in its pure state, but more likely to be mixed with carbon and thus appearing dark grey. Very prone to rust, it is usually coated with several layers of paint when used for outdoor sculptures and monuments. As a sculptural material it may be either (i) cast – run into a mould in a molten state and allowed to cool and harden; or (ii) wrought – heated, made malleable, and hammered or worked into shape before being welded to

other pieces.

keystone: the wedge-shaped stone at the summit of an *arch*, or a similar element crowning a window or doorway.

lettering: characters which comprise the *inscription*. Applied: metal letters stuck or nailed. Incised: letters carved into stone or etched in metal. Relief: low *relief* letters. Raised: high *relief* letters.

limestone: a sedimentary rock consisting wholly or chiefly of calcium carbonate formed by fossilised shell fragments and other skeletal remains. Most limestone is left with a matt finish, although some of the harder types can take a polish after cutting and are commonly referred to as marble. Limestone most commonly occurs in white, grey or tan.

lintel: horizontal beam or slab spanning a door or window, supporting the wall above.

Lisson Gallery: a London commercial gallery which launched the careers of some of the most highly regarded British sculptors of the 1980s including Tony Cragg, Richard Deacon, Richard Wentworth, Anish Kapoor and Bill Woodrow. Astutely managed by Nicholas Logsdail it has continued to represent these sculptors – often known as 'the Lisson Gallery sculptors' – whilst recruiting to its stable some of the star names of the 1990s such as Rachel Whiteread and Douglas Gordon.

lost wax: metal casting technique used in *sculpture*, in which a thin layer of wax carrying all the fine modelling and details is laid over a fire-proof clay core and then invested within a rigid-fixed, fire-proof outer casing. The wax is then melted and drained away (lost) through vents, and replaced with molten metal. The resulting cast is an extremely faithful replication of the wax original. (Also called *cire perdue*.)

maquette (Fr. 'model'): in *sculpture*, a small three-dimensional preliminary sketch, usually roughly finished.

marble: in the strictest sense, *limestone* that has been recrystallised under the influence of heat, pressure, and aqueous solutions; in the broadest sense, any stone (particularly limestone that has not undergone such a metamorphosis) that can take a polish. Although true marble occurs in a variety of colours, white has traditionally been most prized by sculptors, the most famous quarries being at Carrara in Italy, and at Paros (Parian marble) in the Aegean. Pentelic marble from Mound Pentelikos in Greece is characterised by its golden tone, caused by the presence of iron and mica.

medallion: a circular frame shaped like a large medal.

metope: the square space between two triglyphs (blocks with vertical grooves) in a Doric *frieze*.

modello (It. 'model'): a small-scale, usually highly finished, sculptor's (or painter's) model, generally made to show to the intended patron.

monument: a structure with architectural and/or sculptural elements, intended to commemorate a person, event, or action. The term is used interchangeably with memorial.

mosaic: design comprised of small, usually coloured, pieces of glass, tile or *marble*.

moulding: a projecting or recessed band used to ornament a wall or other surface.

mural: large-scale decoration on or attached to a wall.

neo-classical: artistic style and aesthetic movement which spread across Europe from the second half of the eighteenth century. It drew upon a renewed interest in antique art, *sculpture* and particularly architecture.

New Sculpture: a movement in British sculpture 1877–*c*.1920 away from the relative blandness of mid-nineteenth-century practice towards a type of work which was both more naturalistic and more imaginative.

Athlete Wrestling with Python (RA 1877) by the painter Frederick Leighton is customarily regarded as the starting point, although the term was first coined in 1894. The naturalistic side of the movement is best exemplified by the work of Hamo Thornycroft and John Tweed, the imaginative, symbolist side by the work of Alfred Gilbert. The two, however, were not necessarily mutually exclusive as is clear from, for instance, Gilbert's monument to Queen Victoria, Newcastle, with its sensitive modelling of the old queen and strange, fantastical treatment of the throne and pedestal. The deaths of Harry Bates and Onslow Ford and the virtual exile of Gilbert at the turn of the century are sometimes posited as the moment when the New Sculpture ran out of steam. However, the continued energy and invention of sculptors like William Reynolds-Stephens and William Goscombe John even after the First World War suggests that a later date for its demise may be more accurate.

Nexus: Tyne and Wear Passenger Transport Executive was formed in 1980 as a collaboration between the five district councils in Tyne and Wear. It changed its name to Nexus in 1997, and now spends over £44 million per year operating the Tyne and Wear Metro and Shields Ferries services and subsidising bus services and the Sunderland to Newcastle rail line. It has been responsible for 17 permanent works of art on its property since the early 1980s, mostly mosaics and murals, as well as many temporary poster installations.

niche: a recess in a wall used as a setting for a *statue*, *bust* or ornament.

Northern Arts: one of ten Regional Arts Boards in England, Northern Arts promotes access to art for new and existing audiences through educational programmes, funding artists and capital and revenue projects in

Cumbria and the North East.

Northern Freeform: see Biographies.

obelisk: tapering upright *pillar* with rectangular or square section, ending pyramidally, usually *free-standing*.

ogee arch: a type of archway consisting of two S shaped curves meeting at their apex. Introduced in the late thirteenth or early fourteenth century, this *arch* was commonly used in the late Middle Ages.

order: in *classical* architecture, an arrangement of *columns* and *entablature* conforming to a certain set of rules. The Greek orders are: (i) Doric – characterised by stout *columns* without *bases*, simple cushion-shaped *capitals*, an *entablature* with a plain *architrave*, and a *frieze* divided into triglyphs and *metopes*; (ii) Ionic – characterised by slender *columns* on *bases*, *capitals* decorated with *volutes*, and an *entablature* whose *architrave* is divided horizontally into fasciae and whose *frieze* is continuous; and (iii) Corinthian – characterised by even more slender *columns*, and a bell-shaped *capital* decorated with *acanthus* leaves. The Romans added Tuscan, similar to the Greek Doric, but with a plain *frieze*; and Composite, an enriched form of Corinthian with large *volutes* as well as *acanthus* leaves in the capital. They also had their own Roman Doric, in which the *columns* have *bases*.

panel: in architecture any surface sunk within a framework.

pant: a traditional Northern word for a fountain. The early nineteenth-century writer on Northern words, Trotter Brockett claims it may be derived from 'pond'.

patina: surface coloration of metal caused by chemical changes which may occur either naturally, due to exposure for example, or by processes employed at a foundry.

pavilion: a light, ornamental and often open building or temporary structure used for shelter, exhibits, concerts, etc.

pedestal: a support for a *sculpture* or *column*, consisting of a *base* (or *plinth*), a *dado* (or *die*) and a *cornice*.

pediment: in *classical* architecture, a low-pitched gable, framed by the uppermost member of the *entablature*, the *cornice*, and by two raking *cornices*. Originally triangular, pediments may also be segmental. In addition, a pediment may be open at the apex (i.e., an open-topped or broken-apex pediment) or open in the middle of the horizontal *cornice* (an open-bed or broken-bed pediment).

personification: the visual embodiment (often in the form of a classically-robed female figure) of an abstract idea.

pier: solid masonry support, distinct from a *column*.

pilaster: a shallow *pier* projecting only slightly from a wall.

pillar: a *free-standing* vertical support which, unlike a *column*, need not be circular in section.

pits/pitting: holes and other imperfections in a metal surface due to casting process or *corrosion*.

plaque: a plate, usually of metal, fixed to a wall or *pedestal*, including *relief* and / or an *inscription*.

plaster: material comprised of lime, sand, and water, with hair or muslin as a strengthener. Easily malleable when wet, it hardens when dry. It may be carved or poured into moulds to make casts.

plinth: (i) the lowest horizontal division of a *pedestal*; (ii) a low plain *base* (also called a socle); (iii) the projecting *base* of a wall.

podium: circular platform.

polychromy: the practice of finishing a sculpture, etc., in several colours.

putto (plural: putti): decorative child figure, derived from *classical* art, featuring either as angels in a religious context or as attendants of Cupid.

relief: *sculpture* in which the forms stand out or recess from a supportive surface (which need not necessarily be of the same material). The depth of the relief is often characterised as high or low, depending on how far the forms project forward from the surface.

roundel: circular or oval frame within which a *relief sculpture* may be situated.

Royal Academy of Arts: teaching and exhibiting society based in London. Founded in 1768 by Joshua Reynolds and other leading artists of the day, it was the pivotal institution of English art until the late nineteenth century. Since then the letters 'RA', denoting that an artist is an elected member of the Academy, have lost much of their prestige due to a widespread perception of the Academy as out of touch with significant tendencies in contemporary art.

rustication: masonry cut in blocks, often rough-hewn, separated from each other by deep joints. A rusticated *column* has alternate rough and smooth blocks comprising the *shaft*.

sandstone: a sedimentary rock composed principally of particles of quartz, sometimes with small quantities of mica and feldspar, bound together in a cementing bed of silica, calcite, dolomite, oxide of iron, or clay. The nature of the bed determines the hardness of the stone, silica being the hardest.

screen: a wall or other dividing element, often semi-circular, placed behind a *statue* or *monument*.

sculpture: three-dimensional work of art which may be either representational or abstract, *relief* or *free-standing*. Among the many different types are: (i) *bust* – strictly, a representation of the head and shoulders (i.e., not merely the head alone); (ii) *effigy* – representation of a person, usually a deceased person; (iii) *equestrian* – representation of a horse and rider; (iv) *kinetic* – a sculpture which incorporates

actual movement, whether mechanical or random; (v) *relief* – see separate entry; (vi) statue – representation of a person in the round, usually life-size or larger; (vii) statuette – a small-scale statue, very much less than life size; (viii) torso – representation of the human trunk without head or limbs.

shaft: main section of a *column*, between the *capital* and the *base*.

spalling: the splitting away of the surface layers of stone or brick parallel to the surface. Sometimes called delamination.

statuette: see *sculpture.*

steel: an alloy of *iron* and carbon, the chief advantages over iron being greater hardness and elasticity.

stele: an upright stone slab which may be carved, inscribed or support panels.

steps: often included in architectural elements of a *monument* or *sculpture*: for example, a stepped *base*.

string course: a continuous horizontal band projecting from or recessed into a *façade.*

Sustrans: a UK-based civil engineering charity founded in the 1970s which advocates the widespread use of SUStainable TRANSport. Since 1980 it has purchased several hundred disused rail lines, canal and towpaths and converted them into cycle tracks to create the National Cycle Network. Through its policy of commissioning decorative features and sculptures along its pathways it has become one of Britain's major commissioners of public art. Its C2C ('Sea To Sea') cyclepath running from Whitehaven to Sunderland is a key project in the Northern region.

swag: a representation of a drape of a curtain.

tablet: a stone *panel*, often inscribed.

terracotta: clay baked to an enduring hardness, which may come in a variety of colours dependent on the amount of iron oxide in the material. Can be modelled or *cast* in a number of ways and enamels or glazes applied.

tracery: an ornamental form characteristic of *Gothic* architecture, notably in windows.

trophy: a sculptured group of arms or armour commonly found on military *monuments* and war memorials.

turret: small tower, usually attached to a building.

Tuscan: see *order.*

tympanum: a section over a door or window which is often enclosed by a *pediment*. It has no structural function and so is usually filled with decoration or *relief sculpture.*

Tyne and Wear Development Corporation: an Urban Development Corporation set up in 1987, charged with regenerating 48 kilometres of riverside sites along the Wear and Tyne. It managed to attract over £750 million of investment to create business parks, landscaped leisure areas, new housing and access routes on previously derelict land. It allocated £2.5 million to commissioning new public art with a further £3.5 million from the Arts Lottery Fund for major landmark sculptures. TWDC was wound up in 1998 and its responsibilities have been taken over by individual councils. Many of the artworks resulting from TWDC funding continue to be promoted through the *Art on the Riverside* programme.

Tyne and Wear Passenger Transport Executive: see *Nexus.*

urn: a vase with lid originally made to receive ashes of the dead.

Visual Arts UK: as part of the Arts Council of England's millennium project, 1996 was designated year of the visual arts and the *Northern Arts* region selected as the venue for a year-long programme of exhibitions, performances, conferences and festivals. A number of permanent and temporary *sculptures* were installed as a result.

volute: a curvilinear ornament on *capitals.*

voussoir: wedge-shaped stones used in *arch* construction.

Biographies

Graciela Ainsworth (b.1960)
Printmaker, wood-carver and story-teller, based in Edinburgh. Studied at the University of Northumbria 1979–82, then specialised in Sculpture Conservation and Restoration at the City and Guilds of London Art School until 1985. She has exhibited widely, been artist-in-residence at several locations in the North East and in Salisbury, and her works are to be found in public and private collections.

[1] Gateshead, *Four Seasons*, p.25. [2] AXIS Artists Register, 1999.

Number of works in Catalogue: 2

Keith Alexander (b.1956)
Sculptor, trained and based in the North East. His carved figurative work, in wood and stone, usually serves a functional purpose. He has worked on a number of outdoor commissions often in collaboration with local communities.

[1] Northern Arts Index, 1998.

Number of works in Catalogue: 4

Raymond Arnatt (b.1934)
Sculptor, studied at Oxford School of Art and RCA, 1957–61. Arnatt has produced commissioned work for Lincoln College, Oxford; Weymouth Theatre; Minster Lovell Church; and the Church of the Holy Family, Pontefract. Won the Sainsbury Sculpture Award 1960.

[1] Spalding, p.56. [2] Buckman, p.80.

Number of works in Catalogue: 1

John Atkin (b.1959)
Trained as a painter at Teesside College of Art, Leicester Polytechnic and RA Schools 1977–85. Whilst at Leicester he exhibited his first sculpture *The Room* – a full-sized reconstruction in newspaper and plaster of his childhood home complete with figures of his parents. Much influenced by literary sources, especially the work of Albert Camus, his figurative sculptures incorporate recycled industrial detritus and clay. Exhibited in 'Recent British Sculpture' in 1985 and the National Garden Festival at Gateshead, 1990. Examples of his work can be found at the Yorkshire Sculpture Park and at Grizedale, Cumbria.

[1] Wheeler, P., *John Atkin: Embers*, n.d.

Number of works in Catalogue: 1

Pete Auty (1954–99)
Sculptor in bronze, wood and found objects. Trained at Hull (1978), gaining an MA from Newcastle University in 1981. Auty lectured at Wolverhampton, De Montfort and Northumbria universities 1990–5. Having worked mainly in the studio, Auty started to work outdoors for Gateshead's 'Marking the Ways' scheme in 1995.

[1] AXIS, Artists Register, 1999.

Number of works in Catalogue: 1

Alain Ayers (b.1952)
Midlands-based sculptor and stone-carver. Since completing a Fellowship in Sculpture at the South Glamorgan Institute of Higher Education at Cardiff in 1983, Ayers has shown work at a number of group exhibitions in England, Wales and Portugal. His installation pieces are usually conceptual and non-figurative, whilst his permanent outdoor sculptures make figurative references to the site. He currently lectures at Nottingham Trent University.

[1] AXIS, Artists Register, 1999.

Number of works in Catalogue: 2

Charles Bacon
Executed the equestrian statue of *Prince Albert* at Holborn Circus (1874) and exhibited at the RA 1842–84, mostly portrait busts.

[1] Graves, *Royal Academy Exhibitors*, vol.I, p.87.

Number of works in Catalogue: 1

Edward Hodges Baily (1788–1867)
Prolific and successful London sculptor. Baily began taking lessons in wax modelling at fourteen and later spent seven years in London as one of Flaxman's pupils. He entered the Academy Schools in 1808, winning the silver medal in 1811, the gold a year later, and in 1817 he began a twenty-five-year association with Rundell & Bridge (silver and goldsmiths). Examples of his work include the Doncaster Cup 1843 and the Ascot Gold Cup 1844. Baily's most celebrated work, *Eve at the Fountain* (1818–21), brought him European fame and was purchased for the Literary Institute, Bristol (now Bristol City Art Gallery).

Major examples of his public sculpture include the frieze for the portico of the Masonic Hall, Bristol (1825) and extensive work both for Marble Arch (1826) and for Buckingham Palace (mostly 1828), London. In 1839 his design for a statue of *Nelson* was selected for Nelson's

Column, Trafalgar Square. He exhibited at the Academy from 1810 to 1862 and became a Academician in 1825; in 1863 he was made 'Honorary Retired Academician' and given an annual pension.

Baily had a large practice as a monumental sculptor; examples of his work include a recumbent figure of *Lord Brome* (1837), Linton, Kent, and monuments to *Earl St. Vincent* (1823), St Paul's Cathedral, and *Bishop Grey* (1824), Bristol Cathedral. His statues include *John Flaxman*, (1849), University College, London, and *Robert Peel* (1852), Bury and busts of the *Rev. William Turner* (1829) and *Thomas Bewick* (1825), Newcastle Literary and Philosophical Society.

[1] Gunnis, pp.32–6. [2] Penny, N., *Church Monuments in Romantic England*, London, 1977, *passim*; 3] Read, *passim*. [4] *Art Journal*, vol.VI, 1 July 1867, pp.170–1. [5] Usherwood, P., *Art for Newcastle: Thomas Miles Richardson and the Newcastle Exhibitions 1822–1843*, Newcastle, 1984, p.85. [6] Turner (ed.), vol.3, pp.78–9.

Number of works in Catalogue: 2

Keith Barrett
Tyneside-based wood sculptor and printmaker who trained at Falmouth School of Art and the University of Northumbria in the early 1980s. His carved, usually abstract, outdoor sculptures, seats and stiles are sited in various countryside locations around the North East.

Number of works in Catalogue: 1

Julia Barton (b.1959)
Landscape sculptor. Barton turned to art after completing a geography degree at Portsmouth Polytechnic 1977–80. Living in Northumberland, her work includes *Seawall* at Barrow-in-Furness and others pieces in Yorkshire, Cumbria and the North East.

[1] Information supplied by the artist, 1999.

Number of works in Catalogue: 2

William Behnes (*c*.1795–1864)
The son of a Hanoverian piano manufacturer who settled in London, Behnes worked for his father for a while before, in 1813, starting at the RA Schools. He first practised professionally as a portrait painter but then changed to sculpture *c*.1819, producing mainly portrait busts over the next twenty years; it is said that no other sculptor produced more. These are mostly remarkable for their bold modelling and sensitivity to facial expression.

Behnes was appointed Sculptor in Ordinary to the Queen in 1837, but thereafter received no further royal patronage. He is best known for the statue of *Sir Henry Havelock* in Trafalgar Square, London (1861). Sadly, as his commissions multiplied, 'he fell into unsatisfactory habits' and eventually died penniless. Among his commemorative statues are *Dr Babbington* in St Paul's Cathedral and *Sir William Follett* in Westminster Abbey. His many notable pupils included Henry Weekes, Thomas Woolner, J.H. Foley and G.F. Watts.

[1] *DNB*, vol.II, pp.131–2. [2] Turner, (ed.), p.59. [3] *Art Journal*, 1864, pp.83–4.

Number of works in Catalogue: 1

Percy George Bentham (1883–1936)
Studied at the City and Guilds of London School of Art, the RA Schools and in Paris as well as under Alfred Drury and W.R. Colton. His works include portrait busts, statues and 'many war memorials'. He exhibited at the RA from 1915.

[1] *Who Was Who, 1929–1940*, London, 1941, p.98.

Number of works in Catalogue: 1

J.G. Binney
J.G. Binney is referred to as the sculptor for South Shields Town Hall. It is not clear whether he was related to, or the same person as, H.C. Binney who exhibited 1893–1922 with works in the Walker Art Gallery and at the Birmingham Royal Society of Artists.

[1] Gunnis, p.196. [2] Johnson, J. and Greutzner, A., *Dictionary of British Artists 1880–1940*, Woodbridge, 1976, p.57.

Number of works in Catalogue: 3

Victoria Brailsford (b.1966)
Trained at Humberside College of Higher Education in sculpture and at Bishop Burton Agriculture College in chainsaw maintenance and use. In 1991 she gained useful experience as an assistant to the 'woodman' sculptor, David Nash. She has been commissioned by a number of local authorities and has been artist-in-residence at sculpture parks in Britain and Canada.

[1] Information provided by Cleveland Arts, 1998.

Number of works in Catalogue: 1

Chaz Brenchley (b.1959)
Writer, particularly of horror fiction, based in Sunderland. Started writing romance stories in teenage magazines at the age of eighteen. His first published book was for a series of adult romances. He later switched to novels about serial killers: the first, *The Samaritan*, was published by Hodder and Stoughton.

Number of works in Catalogue: 4

Richard Broderick (b.1963)
Sculptor and designer living in North Tyneside, one of three lead artists at Northern Freeform. Trained at Newcastle Polytechnic 1982–5, Broderick exhibited at the first Fresh Art exhibition in London (1986) and was represented by the Nicholas Treadwell Gallery. From 1987, however, he became involved with collaborative arts projects which have included Fish Quay Festival, banner parades and large-scale sculptures. Works outside the North East include street furniture at Doulton-in-Furness.

[1] Information supplied by the artist, 1999.

Number of works in Catalogue: 2

W.G. Brooker
Brooker is listed as having exhibited a bust of
Sir C. Wheatstone at the RA in 1878.

[1] Gunnis, p.300.

Number of works in Catalogue: 1

Irene Brown (b.1960)
Trained at Cardiff College of Art and Design,
Nottingham Trent Polytechnic and Reading
University 1979–87, Brown has worked in a
variety of media: animation, theatre and interior
design, outdoor and installation sculpture.
Works include *Caesar's Sofa*, made of fibreglass
and modelled from a Newcastle bull terrier
(Gateshead Garden Festival, 1990); *Take a Seat*
for the King's Lynn Arts Centre, 1992; and
Light Fantastic at Walsall Museum and Art
Gallery, 1994.

[1] AXIS, Artists Register, 1998. [2] Northern Arts
Index, 1998.

Number of works in Catalogue: 1

George Burn
From c.1868 to 1880 Burn's skills as a sculptor
were in great demand on Tyneside.
Unfortunately, no records have been found of
his life or working practice beside the fact that
he lived in or near Neville Street, Newcastle,
from 1869 to 1878 and in Corporation Street,
Newcastle, in 1883. The stiff, rather awkward
manner of his sculpted figures suggest that he
did not receive an academic training, and it may
well be that he is the same George Burn whom
trade directories give as trading in Newcastle as
a 'grocer and beer retailer' in 1865.

[1] Information provided by John Pendlebury,
University of Newcastle, 1999.

Number of works in Catalogue: 6

Andrew Burton (b.1961)
Metal sculptor and lecturer at Newcastle
University, where he also studied fine art in the

1980s. Burton has works in many public
collections and has undertaken commissions
and residencies in Stevenage (1992) and
Edinburgh (1998). He has exhibited at the RA,
Laing and Hatton Galleries, Newcastle, as well
as in group shows abroad. Burton was awarded
the McGrigor Donald Sculpture Prize in 1990,
and the Northern Arts Award to Artists in
1994.

[1] *Who's Who in Art*, 27th ed., 1996, p.70. [2] AXIS,
Artists Register, 1999. [3] Buckman, p.218.

Number of works in Catalogue: 6

Cackett, Burns Dick (Architects)
Robert Burns Dick (1868–1959) was the
architect son of a Newcastle innkeeper and
brewer's agent. In 1893 he entered into
partnership with the Charles T. Marshall
(1866–1940) and five years later with James
Cackett (1860–1928). The firm was responsible
for a number of regional landmarks including
the Laing Art Gallery; Spanish City, Whitley
Bay; and the towers of the Tyne Road Bridge.

[1] Pearson, L., *Northern City: An Architectural
History of Newcastle upon Tyne*, Newcastle, 1996,
pp.69,72. [2] *DBArch*, pp.148 and 602.

Number of works in Catalogue: 2

Neil Canavan (b.1948)
Newcastle-based sculptor trained at Hull and
Newcastle University (1980–5). His work tends
to use found materials such as slate and
driftwood. He has had a number of
commissions in the North East.

[1] Information provided by the artist, 1999.

Number of works in Catalogue: 1

Alberto Carneiro (b.1937)
Portuguese sculptor. After a childhood
studying in religious sculptural workshops,
Carneiro studied sculptural practice in Oporto
and then at St Martin's School of Art in London

until 1958. He has exhibited frequently and has
been awarded a number of Portuguese prizes
for his work. Teaches sculpture at the Faculty
of Architecture, University of Oporto.

[1] Gateshead, *Four Seasons*, p.26.

Number of works in Catalogue: 1

Alexander Carrick (1882–1966)
Born in Musselburgh, Carrick trained as a
stone-carver with Birnie Rhind before going on
to become a student and then teacher at
Edinburgh College of Art. He received many
commissions for architectural sculpture and war
memorials, including those at Ayr, Dornoch,
Forres, Fraserburgh, Killin and Berwick.
Carrick was also one of the sculptors employed
by the architect Robert Lorimer on the Scottish
National War Memorial at Edinburgh Castle.
After his retirement from teaching in 1942 he
moved to the Borders.

[1] Information provided by Elizabeth Doley, 1998.

Number of works in Catalogue: 1

Geoffrey Clarke (b.1924)
Sculptor and graphic designer best known for
large-scale abstract works. Trained at Preston
and Manchester Schools of Art and then served
in the RAF, 1943–7. He studied at the Royal
College of Art 1948–52, and taught there in the
Light Transmission and Projection Department,
1968–73. He won the silver medal at the Milan
Triennale and represented Britain at the Venice
Biennale in 1952, 1954 and 1960. His
commissions for a range of new buildings made
him one of the leading public artists of the day
and included: *The Spirit of Electricity*, for
Thorn House in London (1958); the ceremonial
entrance portals for the Civic Centre at
Newcastle upon Tyne (1969); and *Cast
Aluminium Relief* for the Nottingham
Playhouse. Clarke has works in many
permanent collections including Coventry

Cathedral, Liverpool and Manchester Universities, the Tate Gallery and the British Council. Ipswich Museums and Galleries organised a touring retrospective of Clarke's work in 1994–5. He was elected ARA in 1970 and RA in 1976.

[1] Nairne and Serota, p.250. [2] Strachan, p.253. [3] *Who's Who in Art*, 23rd ed., 1988, p.87. [4] Black, P., *Symbols of Man*, 1995, *passim*. [5] Buckman, p.266.

Number of works in Catalogue: 1

John Clinch (b.1934)
Studied Fine Art at Kingston School of Art, 1951–5 and sculpture at the Royal College of Art, 1957–61. His usually figurative work is often based on popular imagery of the past. *Wish You Were Here* was one of the sculptures chosen to remain on permanent display at the close of Liverpool's International Garden Festival in 1994; other works include *The Great Blondinis*, Swindon, and *People Like Us* at Cardiff Bay. He has shown in group exhibitions since 1960 and had his first one-man exhibition in London in 1982.

[1] *PSoL*, pp.64, 325. [2] Buckman, p.271.

Number of works in Catalogue: 2

Richard Cole (b.1952)
Sculptor, specialising in forms derived from the English landscape. Studied at Newcastle University 1971–7 and subsequently worked as a lecturer at various universities, most recently at the University of Humberside. He has had many exhibitions in Britain and abroad. Commissions include: *Wave*, Wakefield train station, 1988; *Light Piece*, Gordon District Council, 1991; and *Le Parc de Merl*, Luxembourg, 1995.

[1] Buckman, p.278.

Number of works in Catalogue: 3

Henry Collins (1910–1994)
Painter and designer living and working in the Colchester area. Studied at Colchester School of Art and the Central School of Arts and Crafts. With his wife, Joyce Pallot (b.1912), he worked on designs and murals, including those at the Shell Centre, the General Post Office Tower and British Home Stores. For years he taught graphic design at St Martin's School of Art and Colchester School of Art.

[1] Buckman, pp.281 and 938.

Number of works in Catalogue: 1

Edward Bainbridge Copnall (1903–1973)
Sculptor in stone and wood, Copnall was born in Cape Town and moved to England as a child. He studied painting at Goldsmith's College of Art and at the RA schools, turning to sculpture in 1929. Head of the Sir John Cass College 1945–53, his most important commissions include: *Figure*, RIBA headquarters, London 1931–4; *Progression*, Marks and Spencer, Edgware Road, London 1959; *Swan Man*, ICI Building, Putney Bridge, London, and *Thomas à Becket*, St Paul's Cathedral churchyard 1973. He exhibited regularly at RA 1925–70 and was represented in 'British Sculpture of the Twentieth Century', Whitechapel Art Gallery, 1980–1. His *Sculptor's Manual* appeared in 1971.

[1] *PSoB*, p.188. [2] Buckman, p.294.

Number of works in Catalogue: 1

Tony Cragg (b.1949)
One of the 'New British Sculptors' represented by the Lisson Gallery, London, in the 1980s. Studied at Gloucester, Wimbledon, and the Royal College of Art 1969–77 and then moved to Germany in 1977 to teach at the Dusseldorf Academy where he began making the kind of work for which he is best known : floor- and wall-pieces made out of remnants of everday

found objects such as the shards of plastic household objects and toys which he would arrange in the shapes of larger three-dimensional structures. Such work has been seen as wittily questioning the emotional and imaginative relationships we have with the world about us and acclaimed as reinvesting the forms of Conceptual Art with narrative and social meaning.

He has had numerous exhibitions in Britain and abroad. From the mid-1980s he has often produced large-scale objects, using carved or machine-cut stone, cast iron and bronze.

[1] Celant, G., *Tony Cragg*, London, 1996, *passim*. [2] Turner (ed.), p.25. [3] Buckman, p.305.

Number of works in Catalogue: 1

Richard George Davies (c.1790–after 1857)
Sculptor of statues and monuments in stone. Possibly the son of R.Davies (*fl.*1777–1800), R.G. Davies was born and lived in Newcastle. His major monuments include *Grace Darling*, Farne Islands (1844); *Luke Clennell* in St Andrew's Church, Newcastle; *Margaret Clavering* (1821) and *Francis Johnston* (1822), both in Newcastle Cathedral. Exhibited *Actaeon Devoured by his Hounds* at Westminster Hall, 1844.

[1] Gunnis, p.122. [2] Hall, M., *A Dictionary of Northumberland and Durham Painters*, Newcastle, 1973, p.51.

Number of works in Catalogue: 1

Richard Deacon (b.1949)
One of the 'New British Sculptors' represented by the Lisson Gallery in the 1980s. Deacon's works tend to incorporate unlikely non-art materials such as linoleum, leather and laminated wood which he glues, rivets or bends in an elegant and craftsmanlike manner. Their forms seem to be derived from those of 1960s Modernist sculpture but at the same time, disconcertingly, to make metaphorical reference

to the body and its methods of gathering information.

Trained at Somerset College of Art, St Martin's and the Royal College of Art 1968–77, Deacon went on to teach at Chelsea and Winchester in the 1980s. His many one-man exhibitions include: Royal College of Art, 1975–6; Tate Gallery, 1985; Madrid and Antwerp, 1987–8; Whitechapel Gallery, 1989–90; Marian Goodman Gallery, New York, 1990 and 'New World Order' at the Tate Gallery, Liverpool, 1999. Deacon won the Turner Prize in 1997.

[1] Turner (ed.), vol.8, p.584. [2] Thompson, J., *Richard Deacon*, London, 1995. [3] Tate Gallery, *New World Order – Richard Deacon*, (exhib. cat.), Liverpool, 1999. [4] Buckman, p.340.

Number of works in Catalogue: 1

Roger Dickinson (b.1960)
Studied at Sunderland Polytechnic (1979–82) and Newcastle Polytechnic (1989–91). He was an assistant to Raf Fulcher and George Carter from 1983 to 1988. Subsequently he has worked on a number of exhibitions and public art projects in the Northern region both as an artist and as an administrator.

[1] Information provided by artist, 1998.

Number of works in Catalogue: 1

Michael Disley (b.1962)
Sculptor in stone. Studied at Sunderland Polytechnic and Trent Polytechnic 1981–6. He has worked in Britain and in Japan, but most of his major commissions and residencies have been in Northern England.

[1] Information provided by Cleveland Arts and by artist, 1999.

Number of works in Catalogue: 3

Mark Di Suvero (b.1933)
Born in Shanghai to Italian parents, Di Suvero's family emigrated to the USA when he was seven. He studied philosophy at the University of California and moved to New York in 1957 where he started to make sculptures out of raw blocks of wood at the same time as he became interested in the work of the Abstract Expressionist painters and the sculptor David Smith. After an accident in 1960 which left him wheelchair-bound for two years, he developed a more monumental scale of sculpture, using steel I-beams and cables, which he often painted in bright colours. He campaigned actively against the Vietnam War (his *Tower of Peace*, 1966, was removed from its site in Los Angeles) and left America in 1971 for self-imposed exile in Europe. He returned in 1975, establishing a gallery in Soho, New York and promoting the creation of the Socrates Sculpture Park; later he set up a studio for visiting artists in Chalon-sur-Saône in France. In 1975 he was the first living artist to have a solo exhibition in the Jardin des Tuileries in Paris, and his works can now be found in many major collections in both the USA and Europe.

[1] Turner (ed.), vol.9, pp.39–40. [2] Osterwold, T., *Mark Di Suvero* (exhib. cat.), Stuttgart, 1988.

John Dobson (1787–1865)
Prolific Newcastle architect, mainly in the classical style. He was a pupil of the architect David Stephenson in Newcastle and also studied drawing with John Varley in London. The region's prosperity in the early nineteenth century saw him establish an extensive North-East practice with many country houses, public buildings and churches to his name. In Newcastle he designed the original Eldon Square 1825–31, the Grainger Market 1835–6 and part of Grey Street 1836–9.

[1] Faulkner, T. and Greg, A., *John Dobson, Newcastle Architect 1787–1865*, Newcastle, 1987. [2] Colvin, pp.263–8. [3] *DBArch*, pp.253–4.

Number of works in Catalogue: 3

Abigail Downer
London-based sculptor and part-time lecturer in Southwark. She received a number of travel bursaries in the 1980s and went on to have solo shows in Sunderland Museum and Art Gallery, 1988; Newcastle Polytechnic, 1990; and in Huddersfield, 1995. Works by Downer can be found in Denby Dale, Derbyshire, 1995; and Kirklees, 1996.

[1] AXIS, Artists Register, 1999.

Number of works in Catalogue: 1

Chris Drury (b.1948)
Sculptor who uses natural materials to create baskets, cairns and shelter forms. Trained at the Camberwell School of Art 1966–70, Drury has exhibited in Europe, America and Japan since the early 1980s. His works include: *Cedar Log Sky Chamber*, Kochi, Japan (1996); *Copice Cloud Chamber*, Kings Wood, Kent (1997); *Hut of the Shadow*, Lochmaddy North Uist (1997); *Tree Vortex*, Odsherred Denmark (1998).

[1] Information supplied by the artist, 1998. [2] Buckman, p.371.

Number of works in Catalogue: 1

David Edwick (b.1954)
Edwick was a stonemason at St Paul's Cathedral and Chichester Cathedral from 1975 to 1979. For the next eight years he worked as a stone-carver and conservator at English Heritage Sculpture Studio, Vauxhall, London, and since then he has been a self-employed sculptor and architectural carver with a workshop in Hexham.

[1] *Newcastle Yearbook. A Local History, Guide and Annual Review*, Newcastle 1905.

Number of works in Catalogue: 3

Charles Errington (1869–1935)
Newcastle architect, practising independently from 1896 and Diocesan Surveyor from the late

nineteenth century until 1914. He was responsible for the design of a number of schools, memorial halls and housing developments in the city during that time, as well as Lloyds banks in Sunderland and Hartlepool. President Northern Architects' Association 1919–20.

[1] *DBArch*, p.293.

Number of works in Catalogue: 1

Richard Farrington (b.1956)
Metalworker and sculptor. Studied sculpture and printmaking at Bath Academy of Art, 1975–9. His major commissions have been for public sculptures and decorative way-markers and seats which are often figurative and sometimes based on childrens' drawings. He has been involved in a number of community artwork projects at sites across England.

[1] Information provided by the artist, 1998.

Number of works in Catalogue: 1

Karl Fisher
Sunderland-based sculptor in iron and stone. Fisher trained under Colin Wilbourn as an artist-in-residence at St Peter's Riverside, Sunderland, before moving on to create his own work.

Number of works in Catalogue: 8

John Henry Foley (1818–1874)
Studied at the Royal Dublin Society Schools from the age of thirteen. He then moved to London in 1834 and was admitted to the RA Schools in 1835. In 1844 his entry for the Westminster Hall competition brought him a commission to execute a statue of John Hampden, and thereafter he was one of the most sought-after sculptors in Britain and elected RA in 1858. His equestrian statue of *Viscount Hardinge* for Calcutta was regarded as his masterpiece. His most prestigious

commissions were *Prince Albert* and *Asia* for the *Albert Memorial*, Kensington Gardens. It was claimed that it was while working in the open on the cold wet clay of *Asia* that he contracted the pleurisy which eventually killed him. Many of his works were unfinished at his death, though several of them were completed by his leading assistant Thomas Brock, including the *O'Connell Monument* in Dublin, *Viscount Gough* and *Canning* in Calcutta and the Prince Consort for the *Albert Memorial*.

[1] *PSoL*, p.328. [2] Spielmann, p.26. [3] Sankey, J., 'Thomas Brock and the Albert Memorial', *Sculpture Journal*, vol.3, 1999, pp.87–92.

Number of works in Catalogue: 1

Edward Onslow Ford (1852–1901)
Studied at the academies in Antwerp and Munich (1870–2) and subsequently worked in Munich for five years. On his return to London he set up as a portrait sculptor and received his first public commission in 1881. In the mid-1880s his work became affected by what later came to be termed the New Sculpture, particularly the poetic symbolism of Alfred Gilbert. His later notable public commissions, for instance *General Gordon on a Camel* (1890) and the *Shelley Memorial*, Oxford, 1893, tend to be more conventional. He was elected ARA in 1888 and RA in 1895.

[1] Turner (ed.), vol.11, pp.302–4. [2] Spielmann, pp.51–63. [3] Dixon, M., 'Onslow Ford RA', *Art Journal*, 1898, pp.294–7.

Number of works in Catalogue: 1

George Frampton (1860–1928)
Sculptor and craftsman. First worked in an architect's office, then for a firm of architectural stone-carvers, before training at the Lambeth School of Art under W.S. Frith and at the RA Schools (1881–7). *An Act of Mercy*, exhibited at the RA in 1887, won the gold medal and travelling scholarship and Frampton

subsequently studied sculpture under Antonin Mercie in Paris (1888–90). His *Angel of Death* gained a gold medal at the Salon of 1889.

In the 1890s Frampton became interested in the Arts and Crafts Movement and wrote influential articles on enamelling, wood-carving, and polychromy, in addition to producing works in those media. His *Mysteriarch* of 1893, which shows the influence of French symbolism, was awarded the *medaille d'honneur* at the Paris International Exhibition 1900. Frampton was a member of the Art Workers' Guild from 1887 and a Master from 1902. Elected ARA in 1894 and RA in 1902, knighted in 1908. He was president of the RBS 1911–12, having been a founder member. Memorials by him to the Mitchell family in St George's Church, Jesmond, Newcastle (1903) incorporate elaborate and highly individual bronze reliefs.

[1] *PSoL*, p.328. [2] Beattie, pp.76–8. [3] Turner (ed.), vol.11, pp.499–500.

Number of works in Catalogue: 1

Linda France (b.1958)
Freelance writer and tutor in adult education. France returned to the North East in 1981 and is now based in Hexham. Her first collection *Red* was published by Bloodaxe Books in 1992 and she edited their anthology *Sixty Women Poets* the following year. France has taken part in various collaborations with artists, photographers and musicians, and her work has been featured on radio and television. In 1993 she was awarded the first Arts Foundation Poetry Fellowship. Her second collection *The Gentleness Of The Very Tall* was published by Bloodaxe in 1994.

[1] France, L. and Aris, B., *Acknowledged Land*, Newcastle upon Tyne, 1994, p.23.

Number of works in Catalogue: 3

Alan Franklin (b.1954)
Sculptor in a variety of materials. Graduated from Goldsmith's College with MA in 1983. He has exhibited since 1982 in Britain, Europe and Japan. Most of his major works have been for outdoor sites, for example the Chiltern Sculpture Trail, Grizedale Forest and the Gardens of Gaia in Kent. He was a founder of the Chiltern Sculpture Trust.

[1] Information supplied by the artist, 1998.
[2] Kielder Partnership Press Release, 1998.

Number of works in Catalogue: 1

Andy Frost (b.1957)
Sculptor using a variety of materials including wood, steel and fibreglass. Studied at Lanchester Polytechnic and Coventry and Reading universities. Frost visited the Netherlands and USA on scholarships 1979–82 and subsequently was Henry Moore Foundation Fellow in sculpture at Camberwell School of Arts and Crafts. He has exhibited at the ICA; Whitechapel Open (1983); and Welsh Sculpture Trust (1983).

[1] Buckman, p.451.

Number of works in Catalogue: 1

Raf Fulcher (b.1948)
Sculptor and landscape designer, Fulcher is known for works which combine architectural forms with landscaping. Studied at the University of Newcastle upon Tyne 1966–72. He has shown in several group exhibitions, including 'The Sculpture Show', Serpentine and South Bank 1983; Chelsea Flower Show (1985, 1987); and Garden Festivals in Liverpool (1984), Stoke (1986), Glasgow (1988) and Gateshead (1990). He has also designed landscaping for Easington District Council, 1996. In 1993 Fulcher was appointed Reader in Fine Art Practice at Sunderland University, where he continues to teach.

[1] Miles, M., *Art for Public Places*, Winchester, 1989, p.52. [2] France, L., *Looking Beyond: Easington District Council's Progamme for Visual Arts Year 1996*, 1997, *passim*. [3] Buckman, p.454.

Number of works in Catalogue: 2

Hideo Furuta (b.1949)
Trained in sculpture and quarry work in Hiroshima. Left Japan in 1983 and settled in Wales in 1985. Since then he has had many posts as artist in residence or as a lecturer at various universities in the United Kingdom, most recently in Grizedale Forest 1994 and at the University of Northumbria 1992–4. Works include: *Kido*, Edinburgh University, 1989; *East–West*, Margam Sculpture Park, Port Talbot, 1991; and *Quiescence*, Bottisham, Cambridgeshire, 1994–5.

[1] Press Release, Gateshead MBC, 1997.

Number of works in Catalogue: 1

Daniel Garrett (?–1753)
Architect trained as an assistant to Lord Burlington. In 1722 he was given a subordinate post in the Office of Works, first at Richmond and then at Windsor. From c.1735 he was practising on his own account in the North, remodelling Wallington Hall, Northumberland, and undertaking work at Castle Howard. This was probably why in 1737 he lost his Office of Works position for 'not attending his duty'. In the 1740s and 1750s he was working in London (Northumberland House) and in the North (Gibside, Fenham Hall, Nunwick, Kippax Par and Newcastle Infirmary).

Most of his buildings are in Burlington's Palladian style. He did, however, occasionally venture into the Gothic, e.g., for the Banqueting House at Gibside 1751.

[1] Colvin, pp.393–4.

Number of works in Catalogue: 1

John Gibson (1817–1892)
Architect-trained in Sir Charles Barry's office from 1835 to 1844. He later became a prolific bank architect, working mostly for the National Provincial. His works, for instance those in Middlesbrough and Newcastle, tend to be variants of Barry's Renaissance palazzo formula.

[1] Turner, J (ed.), *Dictionary of Art,* London, 1996, vol.12, p.599. [2] DBArch, pp.345–6.

Number of works in Catalogue: 1

Alfred Gilbert (1854–1934)
The foremost British sculptor at the turn of the century and a leading member of the New Sculpture movement. Trained at Heatherley's, the RA Schools and the École des Beaux Arts in Paris under various teachers including Joseph Edgar Boehm, Pierre-Jules Cavalier and Emmanuel Fremiet. A visit to Italy in 1878 spawned an interest in the sculpture of Donatello and Cellini which allowed him to escape the thrall of strict classicism and find his own, more personal way of treating the figure. It also encouraged him to experiment with unconventional materials and casting techniques. The works that followed such as the statuette of *Icarus* (1884, National Museum, Cardiff) and the monuments to the *Earl of Shaftesbury* (Eros, 1885–93, Piccadilly Circus) and *Queen Victoria* (1887–1912, Winchester Great Hall) are notable for their combination of realism and flights of fantasy. Although Gilbert was eventually knighted in 1932, the latter part of his career was marked by sadness. The expense of casting the ornate *Eros* plunged him into debt and he felt obliged, in 1901, to go into self-imposed exile in Belgium. During the twenty-five years he was there he produced relatively little.

[1] Turner (ed.), vol.12, pp.610–13. [2] Dorment, R., *Alfred Gilbert,* London 1995.

Number of works in Catalogue: 1

William Gofton (b.1945)
Featured regularly in the local press, Gofton originally worked as a shot-blaster, painting and sculpting in his spare time. He then became a marine engineer, able to work on contracts for half the year and on his art for the rest of the time. Gradually his work has become more widely known and he is now represented by a London-based agent. Gofton's house has become filled with many sculptures, usually made from scrap metal and cement. He has a keen sense of the grotesque, with most pieces being virtual caricatures: he is quoted as saying, 'I see only extremes of either beauty or ugliness'.

[1] *Local Biographies*, South Shields, vol..57, p.20.
[2] *South Tyneside Weekender*, 16 August 1980.
[3] *Evening Chronicle*, 22 August 1981. [4] *Journal*, Newcastle, 18 November 1983. [5] *Evening Chronicle*, 20 February 1992.

Number of works in Catalogue: 1

Andy Goldsworthy (b.1956)
Sculptor best known for works in the landscape using found materials such as icicles, maple leaves, pebbles and twigs. Studied at Bradford College of Art and Preston Polytechnic (1975–8), he now lives and works in Dumfriesshire. His sculptures are often very short-lived and have to be recorded as photographs (which are found in many public collections). Goldsworthy's approach stems from a desire not to make a 'mark' on the landscape but rather to contact the rhythms and more ephemeral aspects of the natural world. More recently, he has worked on large-scale, permanent pieces, most notably a series of sheepfolds across the Northern region in 1996.

[1] Kastner, J. and Wallis, B., *Land and Environmental Art*, London, 1999, p.69.
[2] Goldsworthy, A., *Stone*, London, 1994.
[3] Buckman, p.491.

Number of works in Catalogue: 3

Antony Gormley (b.1950)
One of the 'New British Sculptors' who emerged in the 1980s, Gormley studied at Cambridge (anthropology and art history) 1968–70 and then at Goldsmith's College and the Slade 1975–9. Unlike Cragg, Deacon or Wentworth, his work has been primarily concerned with the human body. Typically this comprises smooth-surfaced, impersonal casts in lead of his own body assuming enigmatic poses on the floors, walls or even ceilings of the gallery. Whilst at times the artist talks of these in almost Minimalist terms, as 'vessels that both contain and occupy space' he also sees them in a mystical light which owes something to the time he spent as a young man in India studying meditation. 'I am trying to make a sculpture from the inside, by using my body as the instrument and the material. I concentrate very hard on maintaining my position and the form comes from this concentration.'

Gormley has had one-man exhibitions throughout the world and won the Turner prize in 1994. His charismatic interview manner and the controversy surrounding various public works, notably the vandalised sculpture for the ramparts in Derry and the unrealised *Brick Man* for Leeds (1987), have long kept him in the public eye. However, it is undoubtedly the extraordinary publicity given to the *Angel of the North* – Gormley even appeared on *Desert Island Discs* – which has made him one of Britain's best known living artists.

[1] Hutchinson, J., Gombrich, E., and Njatin, L., *Antony Gormley,* London, 1995.[2] *Antony Gormley*, Tate Gallery Liverpool, 1994, *passim*. [3] Buckman, p.497.

Number of works in Catalogue: 1

William Goscombe John (1860–1952)
Worked in London for an architectural carver 1881–6, and for C.B. Birch 1886–7 whilst studying at the South London Technical Art School and the RA Schools. He won the RA gold medal and travelling studentship in 1889, visiting Sicily, North Africa and Spain, before setting up a studio in Paris for a year where he came under the influence of Rodin. Throughout the 1890s he exhibited ideal bronzes and in 1900 won a gold medal at the Paris International Exhibition for *The Elf, Study of a Head* and *Boy at Play*. He received many commissions for public statues and portrait busts and also designed the regalia for the investiture of the Prince of Wales in 1911, the year in which he was knighted. A member of the Art Workers' Guild from 1891, he was elected ARA in 1899 and RA in 1909. In 1942 he was awarded the gold medal of the RBS and continued to exhibit annually at the RA until 1948.

[1] *PSoL*, pp.331–2. [2] Spielmann, pp.129–32.

Number of works in Catalogue:1

Richard Goulden (1877–1932)
Sculptor living in London. Exhibited at the RA 1903–32, with works in the Walker Art Gallery.

[1] Johnson, J. and Greutzner, A., *Dictionary of British Artists 1880–1940*, Woodbridge, 1976, p.28.

Number of works in Catalogue: 1

Lee Grandjean (b.1949)
Stone-sculptor educated at Winchester School of Art 1968–71, and a Research Fellow there 1980–1. His work has been described as having 'essentially non-physical concerns, striving after a formal equivalent for a sensation, a belief or urgent desire'. Grandjean's works can be found in the collections of the Arts Council, Leicestershire Education Committee and the Department of the Environment, amongst others. Has exhibited widely in Britain in the 1980s and 1990s.

[1] *PSoB*, p.194. [2] Buckman, p.501.

Number of works in Catalogue: 1

Benjamin Green (1813–1858)
Architect son of the North-East architect and civil engineer, John Green. Trained with the elder Pugin; from the early 1830s he practised with his father. Whilst the latter is said to have been 'a plain practical, shrewd man of business' who looked after the engineering side of the business, Benjamin was 'an artistic and dashing sort of a fellow' whose style was 'ornamental, florid and costly'. Together father and son designed several rather pedestrian Gothic churches on Tyneside, some accomplished classical buildings such as the Theatre Royal, Newcastle (1836–7) and the Corn Market (1838, later destroyed), as well as stations and bridges for the North-East Railway.

[1] Welford, R., *Men of Mark twixt Tyne and Tweed*, London, 1895, vol.2, pp.326–30. [2] Colvin, pp.361–3.

Number of works in Catalogue: 3

John Green, Senior (1787–1852)
Started out in Northumberland as a carpenter and agricultural implement-maker and, later, builder with his father. In 1820 he moved to Newcastle and from the early 1830s practised there as an architect and civil engineer with his son Benjamin. His first notable buildings were the Newcastle Literary and Philosophical Society (1822–5) and Scotswood Bridge (1829–31). At the British Association meetings in Newcastle in 1838 his designs for the viaducts at Willington Dene and Ouseburn on the new North Shields railway were widely admired.

[1] Welford, R., *Men of Mark twixt Tyne and Tweed*, London, 1895, vol.2, pp.326–30. [2] Colvin, pp.361–3.

Number of works in Catalogue: 2

David Gross (b.1960)
Sunderland-based wood-sculptor, usually working in collaboration with community groups and schools. Trained at Bolton Metropolitan College and West Surrey College (1980–5) then University of Northumbria (1991–3). Gross has undertaken a number of residencies throughout Britain, and his work can be found in Leatherhead, Southampton, Scunthorpe and Anglesea. He has exhibited widely 1987–96, including group shows in France and Poland.

[1] Information provided by http://members.aol.com/dgross1998, 1999.

Number of works in Catalogue: 3

Richard Harris (b.1954)
Sculptor in wood, steel and stone, whose works have a close relationship to their sites in both form and materials. Harris studied at Gloucestershire College of Art and was resident sculptor at Grizedale Forest, 1977–8. He travelled and worked in Australia, where he was sculptor-in-residence at Birrigai school (1980–1) and exhibited at the First Australian Sculpture Triennial in Melbourne, 1981; returned to work at Grizedale Forest in 1982, 1988 and 1990–1. Harris has shown at several exhibitions including: 'Sculpture and Architecture – Restoring the Partnership' for the Welsh Sculpture Trust, 1985; '30 Years of British Sculpture' at Rouen, 1988; Bede Gallery, Jarrow, 1991; and Gate Foundation, Amsterdam, 1997. His works in public include *Passage Paving* made for 'The Sculpture Show', Royal Festival Hall, 1983–4 (still *in situ*); and pieces at Manchester Airport, 1993; West Dorset Hospital, 1996; Millennium Coastal Park, Llanelli, 1998; and Wrexham, 1999.

[1] Northern Arts Index, 1998. [2] Hooper, L., 'The Urban Grizedale', in Davies, P. and Knipe, T. (eds), *A Sense of Place*, pp.158–64. [3] Information provided by the artist, 1999. [4] Buckman, p.544.

Number of works in Catalogue: 2

Charles Leonard Hartwell (1873–1951)
Sculptor trained at the City and Guilds under Frith and at the RA Schools, also privately under Onslow Ford and Hamo Thornycroft. He exhibited at the Academy from 1900–50, mostly portrait busts and genre figures and was elected RA in 1924. He produced a number of war memorials, notably at Wimbledon, Clacton, Brighton, Bushmills, Cape Town, Denby and Lord's Cricket Ground in London.

[1] Christian, J. (ed.), *The Last Romantics. The Romantic Tradition. Burne-Jones to Stanley Spencer*, London, 1990, p.147.

Number of works in Catalogue: 1

Eddie Hawking (b.1926)
Studied at the West of England College of Art and taught at Middlesbrough College of Art, 1952–86, eventually becoming its Director of Studies. Most of his exhibitions and commissions have been local.

[1] Northern Arts Index, 1998.

Number of works in Catalogue: 1

Roger Hedley (1879–1972)
Roger Hedley and his brother Fred inherited their father Ralph's Newcastle carving firm in 1913, which continued to carry his name. (Ralph Hedley is best known today as a painter of genre scenes.) During the War, while Fred was away in the army, Roger used his woodworking skills in the manufacture of aeroplanes during the day, whilst keeping the business going in the evenings. After the War he undertook the figure-carving and masonry side of the business, his most renowned work being the replacement head for the statue of Earl Grey on the *Grey Monument* which was struck by lightning during the Second World War. In 1960 his premises in St Mary's Place, Newcastle, were given to one of his former employes, Bill Dixon, and the young Gilbert Ward.

[1] Millard, J., *Ralph Hedley. Tyneside Painter*, Newcastle upon Tyne, 1990, pp.87–8.

Number of works in Catalogue: 3

Christine Hill
Sculptor in bronze, wood, concrete and plaster, specialising in community-based projects, trained at Sunderland University to 1991. Her gallery work includes Indian Temple Elephant and Pegasus mosaic (both 1995). She undertook a residency at Gateshead's Bill Quay city farm in 1993.

[1] AXIS, Artists Register, 1999.

Number of works in Catalogue: 1

Charles Clement Hodges (1852–1932)
The son of a clergyman in Derbyshire, Hodges went to school in Oxford and Manchester. Through a family connection he secured a position on the drawing staff at Consett Ironworks in 1869 which he kept until 1876. He then, rather abruptly, turned to antiquarian studies, focusing particularly on the Roman and Anglo-Saxon remains in the Hexham area; the Roman standard bearer which now stands in Hexham Abbey is one of his finds. Among his many scholarly books are *The Abbey of St. Andrew Hexham* (1888), *An Historical Guide to Hexham and its Abbey* (1889), *All Works connected with Hexham Abbey* (1907) and *Hexham and its Abbey* (1919). Later in life he designed several memorial crosses (at Whitby, Durham, Roker, Hexham and Rothbury) all of which show the influence of his knowledge of Anglo-Saxon art.

[1] Oxberry, J., 'Memoir of Charles Clement Hodges', *Archaeologia Aeliana*, 4th series, vol.ix, pp.238–48.

Number of works in Catalogue: 2

Graeme Hopper (b.1961)
Blacksmith artist specialising in site-specific ironwork. His figurative sculptures, which usually take the form of over-life-size plants and animals, are sited at a number of outdoor locations across the North East.

[1] Information provided by the artist, 1998.

Number of works in Catalogue: 2

John Hoskin (1921–1990)
Self-taught sculptor in metal. At fourteen he left school to train as an architectural draughtsman, a job he continued after his service in the army in the Second World War. In his late twenties he began to paint and construct sculptures and within several years was exhibiting. Appointed principal lecturer in sculpture at Bath Academy of Art in 1968, he was later sculptor-in-residence at Lancaster, 1968–71, and Professor of Fine Art at Leicester Polytechnic 1978–86. The Arts Council, the Tate and the Yorkshire Sculpture Park hold examples of his figurative and abstract work.

[1] Abromson, p.172. [2] Buckman, p.610. [3] *Who's Who in Art*, Hants, 1988, p.231.

Number of works in Catalogue: 1

Maggie Howarth (b.1944)
Lancashire-based artist who ran Cobblestone Designs in the 1980s: 'reviving the ancient art of cobblestone mosaic'. One of her pieces was installed at Stoke Garden Festival, 1986.

[1] Northern Arts Index, 1999.

Number of works in Catalogue: 1

Graham Ibbeson (b.1951)
Studied at Barnsley School of Art, Trent Polytechnic and the Royal College of Art. Since 1975 he has been represented by the Nicholas Treadwell Gallery, London, and has exhibited widely in Britain and abroad. He specialises in life-size comic genre scenes depicting everyday domestic incidents and northern working-class life as he remembers it from his childhood, often using his own family as models. Ibbeson once estimated that his wife Carol has been the model for 100 of the 300 figures he has produced in his career. His statue of *Eric*

Morecambe attracted national attention when it was unveiled by the Queen at Morecombe Bay in July 1999.

[1] *Northern Echo*, 25 October 1990. [2] Buckman, p.635.

Number of works in Catalogue: 2

Walter Ingram
Sculptor in Brussels and London. His 38 exhibits at the RA 1862–94 were portrait busts or works with mythological, religious and literary subjects. He also exhibited at the Grosvenor Gallery, the New Gallery and Suffolk Street.

[1] Graves, *London Exhibitions*, p.149. [2] Bénézit, vol.5, p.717.

Number of works in Catalogue: 1

Matthew Jarratt (b.1966)
Sculptor and designer of seats, lighting and landscapes. Trained at Sunderland University and at the University of Northumbria. Has held residencies in Durham prison, Tyne Dock Ship Repair Yard and Easington Colliery, and lectured at Newcastle College and University of Northumbria. In 1996 he became Sunderland's Public Art Officer and two years later was seconded to Northern Arts as Visual Arts Officer. In 1999 he became Commissions Officer responsible for the new Commissions North agency, providing advocacy for the visual arts in the private and public sectors.

[1] Information provided by the artist, 1999.

Number of works in Catalogue: 6

James Johnson (1699–1777)
Johnson was a member of a family of stonemasons at Stamfordham, Northumberland, as a gravestone in the churchyard there indicates. His most important works are the replacement apotropaic figures on the battlements at Alnwick Castle for the 1st

Duke of Northumberland. These are said to have 'engaged him upward of twenty years'. On stylistic grounds it seems likely that the statue at Lady's Well and the summer house designed by Robert Adam for the Duke of Northumberland at Hulne Priory are also by him.

[1] Sykes, p.197.

Number of works in Catalogue: 1

Francis William Doyle Jones (1873–1938)
Francis (sometimes given as Franklin) Doyle Jones lived in London and trained with Édouard Lantèri. He specialised in war memorials and portrait busts. His South African War memorials include those for Middlesbrough (1904), West Hartlepool (1905) and Penrith (1906). His public works include monuments to *Captain Webb* at Dover (1910), *Burns* at Galashiels 1914, *T.P. O'Connor*, Fleet Street 1934 and *Edgar Wallace*, Ludgate Circus 1934. He exhibited at the RA 1903–36.

[1] *The Times*, 11 May 1938. [2] *PSoB*, p.190.

Number of works in Catalogue: 1

David Kemp (b.1945)
Sculptor, born in Walthamstow. Served in the Merchant Navy 1963–7 and then attended Farnham and Wimbledon art schools 1967–72. He had his first one-man exhibition in 1970 at the Newlyn Orion Gallery, Penzance, moving to west Cornwall in 1973. Resident sculptor at Grizedale Forest in 1981–2 and at Yorkshire Sculpture Park in 1983. His public sculptures, usually assembled from found objects, recycled scrap metal, etc., include *Lower Orders*, Yorkshire Sculpture Park (1983) and *The Navigators*, Hays Galleria, London Bridge. His studio was destroyed by vandals in 1995 but he has since gone on to show in 'A Quality of Light', Tate St Ives, 1997.

[1] *PSoL*, p.351. [2] Buckman, p.687.

Number of works in Catalogue: 3

William Day Keyworth (1843–1902)
The son of a sculptor of the same name, he trained at the Mechanics' Institute, Hull and at South Kensington before being elected RA in 1863. Based in his home town for much of his life (and always referred to as 'of Hull'), he executed a number of portrait statues in marble and bronze of Hull worthies including *Andrew Marvell* (1867), *William de la Pole* (1868) and *William Wilberforce* (1883). Several examples of his architectural statuary can be found in the city (*Britannia*, Exchange Buildings; *Minerva*, *Science* and *Art*, Royal Institution and others). He executed numerous privately commissioned portrait busts, ideal figures and monumental effigies, but perhaps his best-known work is in Westminster Abbey, the National Memorial bust of *Sir Rowland Hill*, originator of the Penny Post (1881).

[1] Tindall Wildridge, *Hull Sculptors: A Brief Note upon Loft, Earle, the Two Keyworths, and Mason with a Comprehensive Biography of William Day Keyworth*, Hull, 1889. [2] *Hull News*, 16 August 1902, p.9.

Number of works in Catalogue: 1

Roy Kitchin (1926–1997)
Apprenticed as a joiner in 1940, Kitchin saw wartime service in a coalmine and in REME workshops. He was an assistant to William Bloye whilst studying sculpture at Birmingham College of Art 1948–51 and then worked as an architectural sculptor 1954–62. For the next ten years he taught at Wolverhampton College of Art before moving in 1972 to the University of Newcastle. His early work was normally in bronze, but in the early 1960s he turned to materials such as steel and cast concrete to depict industrial themes.

[1] Buckman, p.75.

Number of works in Catalogue: 1

William Henry Knowles (1857–1943)
Newcastle architect. Knowles was articled to

W.L. Newcombe and then in practice from 1884 to 1922, for some time as Armstrong and Knowles, and later as Knowles, Oliver and Leeson. His principal buildings are part of what is now the University of Newcastle: the west front of Jubilee Tower (1904–6), the King Edward VII School of Art (1911), and the School of Bacteriology (1922). He was also an archaeologist and authority on Hadrian's Wall, directing and reporting on the excavations at Corstopitum, 1907–14.

[1] Pevsner, *Northumberland*, pp.451–2. [2] Grey, A., *Edwardian Architecture. A Biographical Dictionary*, Iowa, 1986, p.231. [3] *DBArch*, p.535.

Number of works in Catalogue: 5

Tania Kovats
Sculptor, installation artist and photographer. Trained at Newcastle Polytechnic 1985–8 and the Royal College of Art. Part-time lecturer from 1995 at Bath Royal College of Art and the City Literary Institute. Kovats won the Barclays Young Artist Award in 1991, the RSA Art and Architecture Award in 1995, and the Prix de Rome in 1997. Her residencies include the Institute of Education, London, 1995; and Public Art Development Trust Art in Hospitals, 1995.

[1] Kielder Partnership Press Release, July, 1998. [2] AXIS, Artists Register, 1999.

Number of works in Catalogue: 1

Édouard Lantèri (1848–1917)
Lantèri trained in Paris under Aimé Millet and François-Joseph Duret and at the École des Beaux-Arts under Pierre-Jules Cavalier and Eugène Guillaume. From 1872 to 1890 he was an assistant to the London sculptor, Joseph Edgar Boehm. From 1880 he taught modelling at the National Art Training School, South Kensington, and later was the first Professor of Modelling at the Royal College of Art (1900–10). His *Modelling: A Guide for Teachers*

and Students (1902–11) became a standard manual. Lantèri's special qualities lay in the vigour, animation and naturalistic romanticism of his work, which was characterised by dexterity in manipulation and rapidity of execution. The product of his training in France, Lantèri's style was influential on the exponents of the New Sculpture, particularly Alfred Gilbert.

[1] Turner (ed.), p.751. [2] Spielmann, p.128. [3] Staley, E., 'Édouard Lantèri, Artist and Teacher', *Art Journal*, 1903, p.244.

Number of works in Catalogue: 1

William Larson
Believed to be the second of a line of three artists of Dutch origin, all of the same name, working in the seventeenth century. He won a royal appointment under Charles II probably through the Duchess of Cleveland. There is a record in the archives of the Duke of Northumberland at Alnwick of William Larson being paid £12 for repairing statues at Northumberland House, Charing Cross, in 1655.

[1] Gunnis papers, Conway Library, Courtauld Institute. [2] Information provided by Kathleen Gibson, 1999.

Number of works in Catalogue: 1

George Anderson Lawson (1832–1904)
Trained in Edinburgh under A.H. Ritchie and R.S. Lauder before moving to Glasgow. He spent some time in Rome, where he admired Gibson's work, and returned to England, initially making his home in Liverpool. His winning entry in a competition to design the city's *Wellington* statue was inaugurated in 1863. Lawson lived in London from 1866, but was commissioned for many pieces in Scotland, chiefly architectural sculpture for Glasgow's Municipal Buildings (1883–8), as well as *Robert Burns* (bronze), Ayr, 1891 and *Motherless*

(plaster), Glasgow International Exhibition 1901 (purchased for Glasgow Art Gallery). He exhibited regularly at the RA and RSA 1860–93.

[1] *DNB*, 2nd supp, vol.2, pp.427–8. [2] Kelvingrove Museum Sculpture File, p.13. [3] Woodward, R.L., '19th Century Scottish Sculptors', thesis (unpub.), Edinburgh, 1977, pp.114–15. [4] Spielmann, pp.20–1.

Number of works in Catalogue: 2

Rosie Leventon
Sculptor in stone and other materials, often including found objects. Trained at Croydon College of Art 1976–9 and St Martin's School of Art, 1980, followed by spells as a part-time lecturer at various universities in the 1990s. Leventon has taken part in group shows in Barcelona, 1996, and the UK, 1992–7. Her work *A Long Way From the Bathroom* toured Holland and the UK in 1996–7.

[1] AXIS, Artists Register, 1999.

Number of works in Catalogue: 1

Nick Lloyd
Sculptor in stone and wood. Trained at Newcastle University 1970–5, he was awarded a Rome Scholarship 1975–6. From 1984–92 a part-time lecturer in Cumbria and Leicester. Since then he has been subject leader in sculpture at the University of Wolverhampton School of Art and Design. His solo shows include Lichfield International Arts Festival, 1997, and he has toured with the Newcastle Group in 1997–8. Works in public include two carvings for Wolverhampton 1997–8.

[1] AXIS, Artists Register, 1999. [2] Buckman, p.759.

Number of works in Catalogue: 1

John Graham Lough (1798–1876)
The son of a farmer at Greenhead, near Consett, Lough was first apprenticed to a local stonemason and then moved to Newcastle where he helped carve decorations on the new

premises of the Literary and Philosophical Society, 1822–5. About 1825 he went to London and there studied the Elgin Marbles which were to have a profound influence on his later, neo-classical work, as the figures at the base of the *Stephenson Monument* (1862) demonstrate.

In 1827 he suddenly shot to fame with his colossal, Michelangelesque figure of *Milo* (a later bronze version of which is at Blagdon Hall) which his friend and mentor, the painter B.R. Haydon, described as 'the most extraordinary effort since the Greeks – with no exception – not of Michel Angelo, Bernini, or Canova' and for a brief period the artist found himself fêted as a newly discovered, untutored genius.

Patronage by the Northumberland family which began with the third baronet in 1836 and continued with the fourth supported his studies in Rome from 1834 to 1838. On his return he settled into a prolific career, exhibiting ideal groups at the RA (until 1863) and the Great Exhibition in 1851, and executing numerous portrait busts and statues. The Blagdon home of Sir Matthew White Ridley, his most steadfast patron, still has many examples of his work.

Lough's models were offered to the City of Newcastle by the sculptor's widow in July 1876 and put on display permanently in Elswick Hall the following year. By 1928 there was pressure to close the Hall and get rid of the models (which had been supplemented in 1877 by those of the sculptor Matthew Noble). In 1932 the Council considered having the models transferred to the Industrial Museum in Exhibition Park, but before this could happen, probably at the time Elswick Hall became an ARP station in 1938, the y were either smashed or deposited elsewhere.

[1] Boase, T., 'John Graham Lough: A Transitional Sculptor', *Journal of the Warburg and Courtauld Institutes*, xxiii, 1960, pp.227–90. [2] *Literary Gazette*, 1827, p.229. [3] Lough, J. and Merson, E., *John*

Graham Lough 1798–1876 A Northumbrian Sculptor, Woodbridge, 1987.

Number of works in Catalogue: 2

David Mach (b.1956)
Studied at Duncan Jordanstone College of Art, Dundee, and at the Royal College of Art 1974–82; Mach has had numerous exhibitions and commissions around the world. Typically his works are temporary and entail the layering and structuring of non-art materials which are the opposite of what one would expect in the circumstances so that, for instance, a centurion tank is made out of telephone directories and a submarine out of car tyres. Many are vast in scale, for example *Parthenon*, Middleheim Museum, Antwerp (1985), a life-size Greek temple made out of car tyres.

[1] Turner (ed.), vol.19. p.892. [2] Livingstone, M., (ed.) *David Mach*, Kyoto, 1990. [3] Cassidy, D., *David Mach at the Zamek Ujazdowskie*, Tokyo, 1995. [4] Buckman, p.790.

Number of works in Catalogue: 1

Thomas Eyre Macklin (1863–1943)
Son of a Newcastle landscape artist, Lieutenant John Macklin, Macklin trained at the Newcastle School of Art from the age of ten. In 1884 he went to London where he drew from the antique at the British Museum and studied at Calderon's art school in St John's Wood and, from 1887, the RA Schools. On his return to the North East in 1893 he worked as an illustrator and landscape artist, exhibiting at the Bewick Club, the RA and elsewhere. Subsequently he enjoyed success primarily as a portrait painter and illustrator, with studios in London and Newcastle. His public work includes the war memorials for Auckland, New Zealand, and Bangor, Co. Down.

[1] *Monthly Chronicle*, p.373. [2] Hall, M., *Artists of Northumbria*, Newcastle, 1982, pp.112–13. [3] Graves, *Royal Academy Exhibitors*, vol.V, p.148.

Number of works in Catalogue: 1

John Maine (b.1942)
Sculptor of steel, wood and stone. Since the mid-1970s he has explored volumetric relationships and interlocking geometric forms in stone. Taught at Kingston Polytechnic and exhibited in a number of exhibitions in England, Australia and Japan. Work includes: *Six Markers on the Foreshore*, Portsmouth (1974); *Monolith II*, Sun Life Assurance building, Bristol (1980); *Pyramid*, Nene Park, Peterborough (1981); *Hagi Project*, Hagi city, Japan (1981); *Arch Stones*, British High Commission, Canberra, Australia (1982–4). His work, which is usually sited outdoors, has been shown at the Yorkshire Sculpture Park, 1978 and at the Welsh Sculpture Trust's outdoor exhibition at Margam, 1983.

[1] *PSoB*, p.198. [2] Buckman, p.808.

Number of works in Catalogue: 1

Sally Matthews (b.1964)
Trained at Loughborough 1983–6, Matthews started creating sculptures of animals in the outdoors with *Boars* at Grizedale Forest in 1987. Since then she has made two further pieces for Grizedale and has become well known for her prints and sculptures of animals which use scrap metal and discarded wood. Other works include *Six Dogs and a Peacock*, Prudential Insurance (1992–3); *Five Bison*, Aberdeen (1994–5); *Three Ponies*, Wolverhampton Borough Council (1996–7); and *Fallow Deer*, Diss, Norfolk (1998). Matthews's work has been shown at Gateshead Garden Festival, 1990; in a solo touring exhibition, 1994; Smiths Gallery, London, 1995; and in a touring exhibition from 1999 which will include the Laing Art Gallery, Newcastle. Awarded the Prudential Art Award Trophy in 1993.

[1] Information provided by the artist, 1999.

Number of works in Catalogue: 2

John Robert Murray McCheyne (1911–1982)
Studied at Edinburgh College of Art 1930–5 with Alexander Carrick, and later in Copenhagen. Whilst Master of Sculpture at King's College, University of Newcastle in the 1950s and 1960s he undertook various public commissions in Newcastle and the region, often working in collaboration with the local architect, Billy Williamson. His early work was in the mode of Aristide Maillol and the Danish sculptor Gerhard Henning. In the mid-1950s, however, he came under the influence of Henry Moore as is apparent from his *Family Group* in Shieldfield, Newcastle (1959, original now lost; small version in the Laing Art Gallery).

[1] Information provided by Derwent Wise, sometime assistant to McCheyne, 1999.
[2] Information provided by David Foster, sometime neighbour, 1999.

Number of works in Catalogue: 1

Phil Meadows (b.1961)
Sculptor in wood. Trained at Cleveland College and Sunderland University 1986–92. Involved with projects at Eston and Guisborough schools 1995–6. Artist in residence at Albert Park, Middlesbrough 1997–8 and at Stewart Park, Middlesbrough 1997.

[1] Information provided by Cleveland Arts.

Number of works in Catalogue: 2

John Mills (b.1933)
Prolific sculptor based in Brighton. Trained at Hammersmith College of Art 1947–54 and the Royal College of Art 1956–60, went on to become sculptor-in-residence at the University of Michigan. In 1986 he was elected President of the Royal Society of British Sculptors. His many commissions around Britain include *Jorrocks*, Croydon; a *Memorial to William Blake*, Blake House, London; and works in Oxford and Cambridge universities. Mills has published a number of books on sculpture

practice including *The Encyclopaedia of Sculpture Techniques* (1990).

[1] *Tunbridge Wells and Crowborough Leader*, 19 June 1998. [2] Buckman, p.853.

Number of works in Catalogue: 1

Raffaelle Monti (1818–1881)
Trained at the Academy in Milan and with his father Gaetano Monti (1766–1847). Worked for a time in Vienna and Budapest producing a series of allegorical figures for the Hungarian National Museum. In 1846 he visited England to execute *Veiled Vestal* for the 6th duke of Devonshire. After returning to Italy to take part in the ill-fated revolution of 1848, he emigrated to London, exhibiting *Eve after the Fall* at the Great Exhibition in 1851 and six works at the RA 1853–60. He also produced some decorative sculpture for the Crystal Palace in 1854. It seems that this may have been his financial undoing because it is recorded that he appeared before the Court of Bankruptcy in July 1855, where he undertook to do his best to complete contracts in hand to meet the claims of creditors. In the late 1850s he formed links with the Birmingham metalwork firm Elkingtons, and experimented with electro-plating copper. In later years he designed porcelain figures and busts for Coplands Statuary Porcelain and silverware for C.F. Hancock.

[1] Fodor, I. et al., *The Hungarian National Museum*, 1992, pp.10–12. [2] Turner (ed.), vol.22, pp.27–8. [3] Graves, *Royal Academy Exhibitors*, vol.V, p.276.

Number of works in Catalogue: 1

Nicola Moss (b.1960)
Trained at Canterbury College of Art & Design 1980–3 and at the International Medallic Workshop, Pennsylvannia State University, 1984. Since 1982 she has exhibited widely in Britain, USA, New Zealand and Europe, mostly as a medal maker.

[1] Information supplied by the artist, 1998.

Number of works in Catalogue: 1

Juan Muñoz (b.1953)
Spanish sculptor. Studied in London (1979–82) and New York (1982) before returning to live and work in his home country. Since his first solo exhibition at Madrid's Galeria Fernando Vijande in 1984, he has shown widely in Europe, Canada and the United States, describing himself as a story-teller or a builder 'of metaphors in the guise of sculptures'. His installations and outdoor sculptures often set a dramatic scene but deprive the viewer of a clear-cut narrative. In works such *The Wasteland* (1986), *Dwarf with Parallel Lines* (1989) and *Conversation Piece*, Dublin (1994), single or grouped figures are set in a room or upon an elaborately designed floorscape as though on stage. The figures may vary in form – ventriloquists' dummies, dwarves or 'sack-men' – but they have certain features in common: frozen gestures, vacant looks and seemingly mute mouths. Other installation work includes playful representations of miniaturised architectural objects: staircases which lead nowhere, balconies without entrances and unreachable handrails. Muñoz's writings have been published as *Segment* (1990) and his sculptures have been the subject of a collection of fictional tales (*Stories after the works of Juan Muñoz, Silence Please!*, 1996).

[1] Marlow, T., 'Juan Muñoz', *Burlington Magazine*, vol.CXXXII, no.1043, February 1990, p.144. [2] Tager, A., *Art Magazine*, 65, Summer, 1991, pp.36–9. [3] Melo, A., 'Conversation Piece', Berwick-upon-Tweed, 1996, in *Berwick Rampart: Project Guide*, pp.15–17.

Number of works in Catalogue: 1

Northern Freeform
A collaborative artists' group which promotes art in an urban context, with offices at Fish Quay, North Tyneside. Originally a northern branch of the London-based Freeform Arts Trust, the group was given separate funding by the Arts Council and has established itself as a successful instigator of community-based arts projects in the area. Work is undertaken by particular artists according to the skills required, but the responsibility for creation is taken by the entire organisation. Northern Freeform mostly works in co-operation with community groups, schools and redevelopment agencies. The group has been responsible for organising North Shield's Fish Quay Festival from 1987 and for a number of playground projects in the area. Members past and present include: Richard Broderick, Graham Robinson, Maggie Howarth, Maureen Black, Jyl Friggens and Angus Watt.

Number of works in Catalogue: 7

Maurice O'Connell (b.1966)
Sculptor trained at the National College of Art and Design in Dublin, 1986–92, with projects subsequently in Dublin. From 1994 he expanded his horizons, working in Britain, Poland and the USA as well as Ireland.

[1] Gateshead, *Four Seasons*, p.25.

Number of works in Catalogue: 1

Claes Oldenburg (b.1929)
One of America's most celebrated living artists, probably best known for his 'soft' sculptures and 'giant' objects from the 1960s. This work was influenced by Surrealism and the artist's own earlier practice as a performance artist, and is usually labelled Pop Art on account of its passionate, humorous engagement with modern urban life. In a much-quoted Whitmanesque statement for his exhibition, 'Store Days' in 1961, the artist outlined his credo: 'I am for an art that is political-erotical-mystical, that does something other than sit on its ass in a museum. I am for an art that grows up not knowing it is art at all, an art given the chance of having a

starting point of zero. I am for an art that embroils itself with the everyday crap and still comes out on top. I am for an art that imitates the human, that is comic, if necessary, or violent, or whatever is necessary. I am for an art that takes its form from the lines of life itself, that twists and extends and accumulates and spits and drips, and is heavy and coarse and blunt and sweet and stupid as life itself.'

Since 1965 he has increasingly devoted himself to projects for colossal monuments based on everyday objects set in specific sites, for example the replacement of the *Statue of Liberty* in New York Harbour by a giant electric fan and of *Nelson's Column* by a rear view mirror. The first of these to be realised was *Lipstick Ascending, on Caterpillar Tracks* (Yale University, 1969).

Although Oldenburg was born in Sweden he has lived in the United States almost continuously since 1930. He studied at Yale 1946–50 and at the Art Institute of Chicago 1952–4, and began making three-dimensional objects in 1957. Since 1976 he has frequently worked in partnership with his wife, the writer Coosje van Bruggen (born 1942).

[1] Russell, J. and Gablik, S., *Pop Art Redefined*, London, 1969, p.97. [2] Oldenburg, C. and van Bruggen, C., *Bottle of Notes*, Middlesbrough, 1997. [3] Oldenburg, C., *Bottle of Notes and Some Voyages* (exhib. cat.), Sunderland and Leeds, 1988.

Number of works in Catalogue: 1

Robert Olley (b.1941)
After leaving school at fifteen, Olley went straight into coal mining, but left when he was twenty-eight when he decided to become an artist. He then worked at Plessy Telecom in South Shields before dedicating himself to art full-time. He is well-known locally for an inimitable cartoon style, for example the character 'Westoe Netty'; his editions of small bronzes draw heavily on the artist's North-East roots, and include a series of Catherine Cookson characters. He owns and lives above the Gambling Man Gallery in South Shields. Olley's works include: *Mural*, Galleries shopping centre, Washington (1979); commemorative plaque, Plessy Telecom (1980); *Famous Faces* mural at Monument Metro entrance on Blackett Street, Newcastle (1985); glass fibre fountain shells and painted steel figures, South Shields sea-front (1985).

[1] *Evening Chronicle*, 'Echoes' section, 4 January 1991. [2] *Shields Daily News / Gazette*, 14 November 1979. [3] *Journal*, Newcastle, 19 July 1980. [4] *Northern Echo*, 21 March 1984.

Number of works in Catalogue: 5

James Paine (1717–1789)
One of the most individual and inventive exponents of the English Palladian style in the generation after Lord Burlington and William Kent. He was a leading pioneer of the Palladian villa as a country-house form and an early designer of Rococo interior decoration. In the 1750s he appears to have taken over the north-country practice of Daniel Garrett. The chapel and mausoleum at Gibside, Tyne and Wear, by him, date from 1760–6. His career epitomises the change in the role of the professional architect which took place during the mid-eighteenth century, from confinement largely to official circles and a narrow grouping of traditional patrons to the status of an independent figure in private practice. He was one of the first to take articled apprentices under the title of 'architects'.

[1] Turner (ed.), vol. 23, pp.280–2. [2] Colvin, pp.607–12.

Number of works in Catalogue: 1

Zora Palova
Sculptor in glass who has lived in the Czech Republic for most of her life. Educated at the Bratislava Academy of Fine Arts she became resident sculptor in glass at the Academy 1971–5. Since 1996 she has been a Research Professor at Sunderland University. She has had group and solo shows in the UK, Luxembourg, USA and Czech Republic, and her glass work is to be found in several hotels and hospitals throughout Europe.

[1] AXIS, Artists Register, 1999.

Number of works in Catalogue: 1

Kathleen Parbury (1901–1986)
Trained at the Slade from 1920 to 1924 under Henry Tonks and Harvard Thomas. Her major works include portrait busts of *Dame Sybil Thorndyke* and *Eisenhower*; *Madonna and Child*, St Anne's, London (1971); and *Risen Christ*, St Peter's, Druridge Drive, Newcastle (1972). She became interested in Anglo-Saxon sculpture as a student and visited Lindisfarne regularly before going to live there in 1966. In 1973 she gave up sculpture to concentrate on writing about the history of the North East and the lives of the saints.

[1] *Northumberland and Alnwick Gazette*, 5 Feb, 23 April 1971. [2] *Journal*, Newcastle, 27 November 1973. [3] Buckman, p.941.

Number of works in Catalogue: 1

Victor Pasmore (1908–1998)
Educated at Harrow, Pasmore worked as a clerk in local government for ten years in London before the patronage of Sir Kenneth Clark allowed him to engage in full-time art practice and teaching. In 1937–8 he formed the Euston Road School with William Coldstream and Claude Rogers. The influences of Sickert and the French Impressionists are evident in the style and subject matter of his work around this time. In 1948, having experimented with post-impressionist techniques in work such as *Quiet River: The Thames at Chiswick* (1943–4) and *The Park* (1947), Pasmore 'went abstract'. His conversion, independent of Parisian and American abstract movements, has been

claimed to be one of the most dramatic events in post-war British art.

Much influenced by the work of the American Constructivist Charles Biederman, Pasmore's 1950s and 60s work concentrated on the production of 'projective relief constructions' and murals. Examples of both can be viewed in Newcastle upon Tyne: two relief *Mural Constructions, White, Black and Indian Red*, in the entrance of the Stephenson Building at Newcastle University (1956), and two wall-size glass murals hanging in the Rates Hall of Newcastle Civic Centre (1961–3).

Pasmore's engagement with art education and practice in the North East began in 1954 with his appointment as head of Painting at the University of Durham at Newcastle. It was here, with Richard Hamilton, that he developed the 'basic design' course for first-year students which was subsequently to have a huge influence on art education nationally. A year later he became Consulting Director of Urban and Architectural Design for the South-West Area of Peterlee new town in County Durham. Exhibiting widely at galleries in Britain and abroad, the artist represented England in the 1960 Venice Biennale and a retrospective of his work was staged at the Tate Gallery, London in 1965. Pasmore moved to Malta in 1966 and continued to work into his eighties.

[1] Alley, R., *Victor Pasmore: Retrospective Exhibition 1925–65*, Tate Gallery, London, 1965, pp.3–5.
[2] Lynton, N., *Victor Pasmore: Paintings and Graphics 1980–92*, London, 1992, pp.103–15.
[3] *Guardian*, obit., 24 January 1998. [4] Buckman, p.947.

Number of works in Catalogue: 1

David Paton (b.1970)
Sculptor in stone, wood and metal, trained at Sunderland University 1989–93. Paton worked at Grizedale Forest and with schoolchildren in Sunderland and Hartlepool before co-founding Central East Studios in Sunderland. In 1997 he was appointed artist-in-residence at Herrington Stone Quarry. Has shown in Newcastle and London and undertaken commissions for various private clients.

[1] Information provided by City of Sunderland Library and Arts, 1999.

Number of works in Catalogue: 2

O.P. Pennacchini
Exhibited once at the RA in 1885. Otherwise nothing is known of him except that in 1908, at the time that he completed the *Jerningham* statue for Berwick, he was living in Ealing, West London. It is possible that, despite the slightly different spelling of the name, he is a relative of R. Pennachini who is listed as an exhibitor at the Academy in 1863.

[1] Graves, *Royal Academy Exhibitors*, vol.VI, p.101.
[2] *Journal*, Berwick, 5 November 1908.

Number of works in Catalogue: 1

Gary Power (b.1958)
Regionally-based sculptor specialising in abstract works. Trained at Reading University, Chelsea School of Art and Newcastle Polytechnic 1976–88. Since 1986 has taught at various art schools. His exhibitions and commissions have mostly been in London and the North East. He has also published a number of articles and organised conferences on aspects of public art.

[1] Information provided by the artist, 1998.

Number of works in Catalogue: 1

William Pym (b.1965)
Trained at Newcastle University as an undergraduate, Pym specialises in wrought iron and forged steel sculptures. He has been artist-in-residence at a number of schools and in the west end of Newcastle, and his work has been shown at the Gateshead Garden Festival and in touring exhibitions including 'Playing A Part' (1991). Member of the British Association of Blacksmith Artists and a director of Northern Freeform. Other works in the region include decorative gateways, railings and benches at Hebburn, Newton Aycliffe and Benwell; and an electric chandelier and two signs at Rothbury Northumberland National Park centre.

[1] Stephenson, p.60. [2] Information supplied by the artist, 1999.

Number of works in Catalogue: 7

Amanda Randall (b.1963)
Trained as a painter and woven textile designer at West Surrey College of Art and Design. Her paintings have been shown at various galleries in the North East.

[1] Northern Arts Index, 1999.

Number of works in Catalogue: 1

Richard Ray (1884–1968)
Painter, sculptor and designer. Studied at Brighton School of Art and the Royal College of Art. Appointed Principal of the College of Arts and Crafts at Sunderland, he remained deeply interested in painting, and also became involved in designing war and other memorials and badges of office. He rarely exhibited his work outside Sunderland, and continued to live at Sunderland following his retirement.

[1] Hall, M., *A Dictionary of Northumberland and Durham Painters*, Newcastle, 1973, p.141.

Number of works in Catalogue: 2

Vincent Rea (b.1936)
Born and educated on Tyneside, Rea was Director of the Bede Gallery, Springwell Park, Jarrow, for many years. He moved to the Viking Centre in Jarrow in 1996.

[1] *Journal,* Newcastle, 15 November 1996.

Number of works in Catalogue: 1

George Reavell (1865–1947)
Educated at Alnwick Grammar School, Reavell practised as an architect in Alnwick and Morpeth, designing and restoring public and private buildings in north Northumberland, including the United Free Church, Wooler, and Howick Hall (in collaboration with Sir Herbert Baker). He was president of the Northern Architectural Association 1925–6, commander of 2/7th and 35th Northumberland Fusiliers in the First World War and a leading figure in the Alnwick Boy Scouts and Free Masons.

[1] *Northumberland and Alnwick Gazette*, February 1947. [2] *Dictionary of Edwardian Biography – Northumberland*, Edinburgh, 1985, p.207. [3] *DBArch*, p.757.

Number of works in Catalogue: 1

Arnold Frédéric Rechberg (1879–after 1976?)
Taught by Seffner and Klinger at Leipzig and active in Paris 1904–12, where he came under the influence of Rodin. He designed the war memorial for his home town and has a number of portrait busts in museums in Leipzig and Dresden.

[1] Bénézit, vol.8, p.639.

Number of works in Catalogue: 1

Lynne Regan
Yorkshire-based sculptor in stone, brick and other materials. Trained in fine art at Sheffield City Polytechnic 1986–7 and Kent Institute of Art and Design 1989–92. Regan has taken part in group shows in London, Kent and Sheffield from the early 1990s.

[1] AXIS, Artists Register, 1999.

Number of works in Catalogue: 1

John Reid (born *c*.1890)
Reid (his name is sometimes given as Reed) studied at the Royal College of Art and then became Master of Sculpture at Armstrong College, Newcastle. After service in the First World War he returned to Armstrong College and remained there until the late 1920s, exhibiting both sculpture and landscapes at the Artists of the Northern Counties exhibitions at the Laing Art Gallery in the 1920s. In 1927 he became Master of Design at the School of Art in West Ham, London.

[1] Hall, M., *Artists of Northumbria*, Newcastle, 1982, pp.142–3. [2] *Durham University Journal*, vol.xxv, no.4.

Number of works in Catalogue: 3

Laurent Reynes (b.1961)
Studied architecture in France 1986–95 and teaches in Strasbourg. He has had several exhibitions from 1990 onwards, including solo shows in his home town of Montpellier. He has also contributed to residencies and symposia in a variety of countries.

[1] Gateshead, *Four Seasons*, p.26. [2] *Journal*, Newcastle, 2 September 1996.

Number of works in Catalogue: 2

William Reynolds-Stephens (1862–1943)
Sculptor, decorative artist and painter. Born in Detroit of British parents, he began training as an engineer before attending the RA Schools 1884–7. Much influenced by the ideals of the Arts and Crafts Movement and by the style and techniques of the New Sculpture, Reynolds-Stephens experimented with a variety of materials and with polychromatic sculpture. His *Lancelot and the Nestling* (1899) used bronze, steel, silver and ivory. He also executed a number of portrait memorials, such as *Archbishop Davidson*, Lambeth Palace; *William Quiller Orchardson*, St Paul's Cathedral; *The Scout in War*, equestrian statue for East London, South Africa, 1908. His chief work, *Royal Game*, 1906–11, depicts Queen Elizabeth I of England and King Philip II of Spain playing a game of chess with miniature ships in a symbolic fight to gain supremacy at sea (Tate Gallery, London).

President of the Royal Society of British Sculptors 1921–33 and knighted in 1931.

[1] *Who Was Who, 1941–1950*, London, 1952, p.968. [2] Turner (ed.), vol.26, p.283. [3] Beattie, p.249. [3] Spielmann, p.105.

Number of works in Catalogue: 1

William Birnie Rhind (1853–1933)
Edinburgh sculptor whose most notable works were a series of statues for the Scottish National Portrait Gallery (exhibited at the RA 1891–5) which he executed with his brother John (1830–92). Exhibited at the RA 1898–1904, Royal Scottish Academy 1897–1943 and the Glasgow Institute 1883–1928.

[1] Graves, *Royal Academy Exhibitors*, vol.3, p.279. [2] *Royal Scottish Academy Exhibitors 1826–1990*, Edinburgh, 1990, vol.iv, pp.43–6. [3] Read, p.359. [4] Spielmann, p.128.

Number of works in Catalogue: 1

Christopher Richardson (1709–1781)
A sculptor and chimney-piece carver, Richardson worked on decorative carving at Welbeck Abbey, Nottinghamshire for the 1st duke of Portland between 1747 and 1751. In 1756 he was working on the statue of *Liberty* for the top of the column at Gibside, and a year later had commissions at Alnwick and Berwick-upon-Tweed (the coat of arms on the Town Hall). From 1756 until 1762 he was working for the 2nd marquess of Rockingham at Wentworth Woodhouse in the West Riding, and two years later he was again at Welbeck, executing decorations for the cupola over the chapel clock.

[1] Gunnis, pp.319–20.

Number of works in Catalogue: 1

Michael Rizzello (b.1926)
Sculptor of heroic bronzes, portraits and medallions. After military service in the Second World War he studied at the Royal College, winning a travel scholarship which took him to France and Italy 1950–1. His major works include figures of *David Lloyd George*, Cardiff; *Sir Thomas Beecham*, Covent Garden, London; and a double-sided portrait medallion of the *Queen and Pope John Paul II*. Fellow of RBS in 1961 and its President from 1976–86.

[1] Buckman, p.1032.

Number of works in Catalogue: 1

Auguste Rodin (1840–1917)
Innovative and influential French sculptor with a preference for modelling. Studied under or assisted various masters in the 1850s and 1860s, but failed to gain entry to the École des Beaux-Arts, and his early work, *Man with a Broken Nose* (1864), was rejected by the Salon. Seeing the sculpture of Michelangelo on a visit to Italy in 1875 freed him, as he later said, from academicism and enabled him to produce his first major work, the daring, naturalistically modelled, *Age of Bronze* (1878). In 1880 he was commissioned to produce an elaborate doorway (*Gates of Hell*) for the Musée des Arts Décoratifs in Paris which, although still unfinished twenty years, later formed the basis for a number of his most famous independent sculptures such as *The Thinker* and *The Kiss*. The energy and novelty of his approach to public commissions, notably the *Burghers of Calais* (1884) and *Balzac*, ensured that even though by the turn of the century his reputation was firmly established both in France and elsewhere, he continued to be embroiled in controversy.

Rodin began to be noticed in England in the 1880s when W.E. Henley, editor of the *Magazine of Art*, championed his work, and *John the Baptist, Icarus* and the *Age of Bronze* were exhibited at the Grosvenor Gallery. Harry Bates, William Goscombe John, Édouard Lantèri and John Tweed were amongst the sculptors in England whom he influenced.

[1] Turner (ed.), vol.26, pp.508–14. [2] Butler, R., *The Shape of Genius*, New Haven, 1993. [3] Beattie, *passim*.

Number of works in Catalogue: 1

Gilly Rogers
Installation artist who uses found objects and mixed media. Trained at Sunderland University, she had artworks installed at the Buddle Arts Centre, Wallsend, and Tynemouth Metro station in 1995. From 1997–8 she was artist-in-residence at Royal Quays, North Tyneside.

[1] AXIS, Artists Register, 1999.

Number of works in Catalogue: 1

Colin Rose (b.1950)
Sculptor in steel, stone and wood. Studied at Newcastle Polytechnic and Newcastle University 1973–9. Rose has been an active member of the Newcastle Group since 1987, exhibiting in Russia, Finland and Latvia. He is a visiting lecturer at Sunderland and Newcastle Universities and has been artist-in-residence for various organisations in north-east England. Exhibitions include: Seaton Delaval Hall (1992); Yorkshire Sculpture Park (1992–3); 'Sculpture at Goodwood' (1996). Increasingly commissioned to make pieces abroad, Rose's work can be found in the collections of the British Council and Sculpture at Goodwood, amongst others.

[1] Stephenson, p.66. [2] AXIS Artists Register, 1999. [3] Buckman, p.1048.

Number of works in Catalogue: 5

Hans Schwarz (b.1922)
Sculptor and graphic designer, born in Austria. Expelled by the Nazis, Schwarz came to England in 1939, attending the Birmingham School of Art 1941–3. He taught at various art schools from the early 1940s to 1966 whilst also undertaking painting and sculpting commissions, and now lives in London. He has exhibited widely, with sculptures in Birmingham, Cardiff and Greenwich, and has work in the collections of the National Portrait Gallery, the National Maritime Museum and Glasgow Art Gallery. Since 1966 he has written several books on art for Studio Vista and Pitmans as well as articles for *The Artist*. Member of the New English Art Club and the Royal Watercolour Society.

[1] *PSoB*, p.24. [2] Buckman, p.1078.

Number of works in Catalogue: 1

George Gilbert Scott (1811–1878)
Highly successful and prolific Gothic Revival architect. His career as a church architect and restorer began to flourish in 1842 when he designed St Giles, Camberwell, in a historically-informed and liturgically-minded Gothic style which met with the approval of the Cambridge Camden Society. Thereafter he used the same mixed Anglo-French High Gothic style in his secular buildings, a practice which he defended in typically business-like manner in his book, *Remarks on Secular and Domestic Architecture, Present and Future* (1857).'I am no medievalist', he claimed. 'I do not advocate the styles of the middle ages as such. If we had a distinctive architecture of our own day worthy of the greatness of the age, I should be content to follow it; but we have not; and the middle ages having been the latest period which possessed a style of its own...I strongly hold that it has greater prima facie claims to be used than those of ancient Greece or Rome.' His most notable secular buildings are Kelham Hall, Nottinghamshire (1857), St Pancras Hotel (1865) and the *Albert Memorial* (1864).

[1] Turner (ed.), vol.28, pp.277–80. [2] Watkin, D., *English Architecture*, London, 1979, p.169.

Number of works in Catalogue: 1

Wendy Scott (b.1965)
Trained in Edinburgh, Loughborough and Sunderland University. Has worked since late 1980s on a number of different artistic projects on Tyneside including schools workshops and residencies at Sunderland Museum and Art Gallery, South Shields Museum and Gateshead MetroCentre.

[1] Information provided by the artist, 1998.

Number of works in Catalogue: 1

Masataka Sekiguchi (1921–1991)
Studied at the Tokyo Academy of Arts specialising in wood-sculpture. Major commissions include a bronze statue of the Japanese artist Hokusai at Seikyoji Temple, Tokyo.

[1] Information provided by Minh Chung, 1998.

Number of works in Catalogue: 1

Chris Sell (b.1950)
Printmaker and wood-carver who took up sculpture in 1982. Based in Sunderland he completed his MA in Fine Art at Newcastle Polytechnic in 1985. Since then he has been artist-in-residence in East Sunderland (1986–90) and rural Gateshead (1993–5), as well as a part-time lecturer at Sunderland University. Sell has exhibited at Cardiff University and the Northern Centre for Contemporary Art, amongst others.

[1] *Journal*, Newcastle, 13 September 1985.

Number of works in Catalogue: 5

George Skee (1884–?)
Born in Blyth, Skee studied art at Armstrong College, Newcastle before being sent to Barnstaple by Lord Ridley to learn the pottery trade. In 1910 he became manager of Newsham Art Pottery, Blyth. After serving in the army in the First World War he emigrated to California and there worked as a Hollywood model-maker, helping to produce monsters for *The Lost World* and gargoyles for *The Hunchback of Notre Dame*.

[1] Information provided by Blyth Public Library, 1998.

Number of works in Catalogue: 1

C. Raymond Smith (1798–1888)
Exhibited at the RA 1842–76 and produced statues for Eaton Hall 1852 and 1856. In 1865 he executed the *Principal Races of the Indian Empire* for the façade of the India Office. His funerary works include the monument to *Dr Britton*, Durham Cathedral (1829) and to *Alice Houghton*, St Luke's, Farnworth, Lancs (1852).

[1] Gunnis, p.353–6.

Number of works in Catalogue: 1

Ray Smith (b.1949)
Sculptor and graphic artist who studied at Cambridge University 1968–71. As well as producing free-standing steel sculptures, Smith has done a substantial amount of painted, mosaic and ceramic tile mural work for public and private commissions. He is also a book designer and illustrator, and has designed and edited practical painting and drawing books. Smith has lectured at various colleges and advised on public art policy at Liverpool and Newcastle. Exhibitions of his work include Ikon Gallery (1980); Gateshead Garden Festival (1990) (*Red Army*); Aspex Gallery, Portsmouth (1994); and Sidmouth Festival (1995). Winner of the 1993 RSA 'Art for Architecture' Award.

[1] *PSoB*, p.25. [2] Buckman, p.1122.

Number of works in Catalogue: 1

John Soane (1753–1837)
The son of a Berkshire builder, Soane trained with George Dance and Henry Holland and at the RA Schools. He completed his studies in Italy (1778–80) where he met Piranesi and came under the influence of French neo-classical ideas. His own idiosyncratic brand of simplified, romantic neo-classicism appears most fully in the austere and daring Bank of England (1788–1833), now largely destroyed, which he regarded as 'the pride and boast of his life'; Dulwich Picture Gallery (1811–14); and his own private house in Lincoln's Inn Fields (1812–13). From 1788 he had an established place amongst the leading English architects, and enjoyed a professional practice second only to that of Wyatt, with commissions throughout the country. He was made Professor of Architecture at the RA in 1806 and was knighted in 1831.

[1] Placzek, A. (ed.), *Macmillan Encyclopedia of Architects*, London, 1982, vol.4, pp.95–101. [2] Colvin, pp.765–72.

Number of works in Catalogue: 1

David Stephenson (1757–1819)
The son of a master carpenter in Newcastle, Stephenson was admitted to the RA Schools in January 1782. He returned to his home town to practice as an architect from 1783, and quickly obtained various civic commissions. These included the first Theatre Royal in Moseley Street (1787), the Circus (1789) and the north front of the Exchange (1796). His bold and original design for All Saints Church, Newcastle, is usually regarded as his masterpiece. In 1805 he was appointed Surveyor and Architect to the Duke of Northumberland and in that capacity designed several minor buildings and farmhouses as well as the *Percy Tenantry Column* (1816).

[1] Colvin, pp.779–80.

Number of works in Catalogue: 2

David W.S. Stevenson (1842–1904)
The son of a builder, Stevenson studied for eight years under William Brodie in Edinburgh (1860–8) whilst at the same time attending the School of Art and the Royal Scottish Academy. He practised on his own account from 1868 and was elected a member of the Royal Scottish Academy in 1886. In 1868 he undertook two of the groups on the base of Steell's Prince Consort memorial in Edinburgh. Later commissions included the Platt memorial, Oldham, the figure of Wallace for the national monument at Abbey Craig, and the statues of *Tannahill* at Paisley, *Highland Mary* at Dunoon, *Burns* at Leith, and *Queen Mary* and *James VI* on the Scott Monument in Edinburgh. His work shows the influence of contemporary French sculpture.

[1] *DNB*, 1912, vol. III, p.413.

Number of works in Catalogue: 2

W. Grant Stevenson
Sculptor based in Edinburgh and responsible for statues of *Wallace*, Aberdeen (the largest statue in Scotland) and of *Burns*, Kilmarnock. He was the younger brother of D.W.S. Stevenson.

[1] *Evening Chronicle*, 11 May 1903.

Number of works in Catalogue: 1

David Stewart (b.1961)
London-based sculptor of stone and other materials. Trained at Leicester Polytechnic and at the Royal College of Art. From 1991 he has been a lecturer in Watford and Wolverhampton. Stewart's solo and group shows in the UK include Midlands Art Centre, Birmingham (1992), Brighton Marina (1994), Morley Gallery, London (1995), Islington Arts Factory, London (1999). He has been artist-in-residence at Grizedale in 1996, Sunderland Enterprise Park, 1996–7, and Hinode Forest, Japan, 1997.

From the late 1990s he has increasingly worked in Japan.

[1] AXIS, Artists Register, 1999. [2] Information supplied by the artist, 1999.

Number of works in Catalogue: 2

Neil Talbot (b.1943)
Stone-carver, based in Northumberland. Trained at Newcastle University and resident artist at the British School at Rome in 1986. Talbot was Visiting Artist at the School of Art, Institute of Chicago (1980–1), TCU University, Texas (1989), and Head of Sculpture at Northumbria University, Newcastle (1992–3). He has exhibited regularly since the early 1980s: Serpentine Gallery, London, 1981; Chicago Art Institute, 1982; Fulham Gallery, 1982; Hatton Gallery, Newcastle, 1993. Talbot has works in a number of public and private collections in the UK, Europe and USA.

[1] Stephenson, p.76. [2] Information provided by the artist, 1998. [3] Buckman, p.1169.

Number of works in Catalogue: 2

Christopher Tate (1812–1841)
Sculptor apprenticed to R.G. Davies of Newcastle and assistant to David Dunbar the Younger. Early works include *Dying Christ Suitable for Catholic Chapels* and *Blind Willie*. His portrait busts include the *Duke of Northumberland*, *Sheridan Knowles*, *Lord Byron* and the singer *H. Philips*. Exhibited at the RA in 1828, 1829 and 1833.

[1] Gunnis, p.380. [2] *Newcastle Local Records 1832–1857*, p.138. [3] *DNB*, 1898, p.376. [4] Hall, M., *A Dictionary of Northumberland and Durham Painters*, Newcastle, 1973, pp.180–1.

Number of works in Catalogue: 2

Tom Taylor (b.1950)
Trained as a railway engineer before attending art school in the mid-seventies. Since graduating

from St Martins College of Art in 1980 he has combined post-graduate research with lecturing and art practice. Taylor's welded steel, predominantly mono-chromatic sculptures are usually figure-based, sometimes 'cartoonesque' and often influenced by the imagery of Zen Buddhism. He has exhibited in galleries in London and New York, and received commissions for sculptures in schools and hospitals in Britain and abroad. Taylor began using 'Tom' rather than 'Malcolm' as his first name in 1999.

[1] Information provided by, artist, 1998.

Number of works in Catalogue: 1

William Hamo Thornycroft (1850–1925)
Leading exponent of the New Sculpture. The son of sculptors Thomas and Mary Thornycroft, he studied first under his father and subsequently at the RA Schools, followed by a period of study in Italy. On his return he assisted his father with the *Poets Fountain* (1875, formerly Park Lane). In 1875 he won the RA Gold Medal for his group, *A Warrior Bearing a Wounded Youth from Battle*. His first major success was *Artemis* (shown as a plaster at the RA 1880). In 1881 his RA entry, *Teucer*, was purchased by the Chantrey Trust and in the same year he was elected ARA (RA in 1888). Thornycroft's *Mower* (1884, Walker Art Gallery) and *Sower* (1886, Kew Gardens) introduced a note of contemporaneity to figures that were nonetheless ideal. Success brought with it increased demand for public monuments and statues including: *General Gordon* (1888, Victoria Embankment Gardens); *Oliver Cromwell* (1899, outside Westminster Hall); the *Gladstone Memorial* (1905, Strand) and the *Lord Curzon Memorial* (1909–13, Calcutta). Thornycroft was also responsible for the figurative friezes on the Institute of Chartered Accountants at Moorgate in the City of London (1890–1). He was knighted in 1917.

[1] *PSoL*, p.340. [2] Manning, E., *Marble and Bronze. The Art and Life of Hamo Thornycroft*, London and New Jersey, 1982.

Number of works in Catalogue: 1

Albert Toft (1862–1949)

Exponent of the New Sculpture. Studied at Birmingham and then at Hanley and Newcastle under Lyme Schools of Art whilst at the same time serving an apprenticeship as a modeller at Wedgwood. In 1879 he won a scholarship to the National Art Training Schools and studied under Lantèri. His first great success was *Lilith* (1889, Birmingham Museums and Art Gallery). *Mother and Child* (1889, Preston), *Fate-led* (1862, Walker Art Gallery Liverpool), and *Spirit of Contemplation* (1901, Laing Art Gallery, Newcastle) followed. His public monuments include *Queen Victoria* (1905, Nottingham) and the *Welsh National Memorial* (1905, Cardiff).

[1] *PSoB*, p.26. [2] Spielmann, pp.118–25. [3] Reddie, A., 'Albert Toft Sculptor', *The Studio*, vol.66 1915, pp.18–27.

Number of works in Catalogue: 2

Philip Townsend

Studied three-dimensional design at Leicester Polytechnic in the early 1970s. Most of his commissions and exhibitions have been in the North. Since 1989 he has concentrated on producing carved reliefs on wood panels, mostly the human figure.

[1] Northern Arts, Slide Index and Library.

Number of works in Catalogue: 1

David Tremlett (b.1945)

Sculptor, installation artist and photographer. Studied at Birmingham College of Art and the Royal College, subsequently travelling widely, notably in Tanzania. From 1980 his work has tended to comprise abstract images drawn on the walls of museums, old churches and ruined buildings. Of these he once said that his intention was to 'give the building a certain new structure to support the window aperture or whatever part I was using. It's a gesture almost of "Don't fall down anymore, let me give you a little more life and hold you up."' Tremlett was short-listed for the Turner Prize in 1992.

[1] Turner (ed.), vol.31, p. 36. [2] Courtney, C., 'David Tremlett', *Art Monthly*, November, 1992, pp.13–16. [3] Buckman, p.1202.

Number of works in Catalogue: 1

Alfred Turner (1874–1940)

Son of the sculptor Charles Halsey Turner. Studied at South London Technical Art School, Lambeth and the RA Schools, 1895–8 and worked in the studio of Harry Bates, exhibiting at the RA 1898–1937. In 1902 he was commissioned to make two figures for the Fishmongers' Hall, London, and 1901–2 three monuments to Queen Victoria: for Delhi, Tynemouth and Sheffield. Turner made a figural group for the façade of the Old Bailey, 1905–6 and designed some metalwork there. Taught at the Central School of Art 1907–34. In 1912 he made a statue of *Owain Glyndwr* for the Welsh Heroes series at Cardiff City Hall. From 1919 onwards he was greatly occupied with war memorials. Elected ARA in 1922 and RA in 1931.

[1] Spalding, vol.6, p.439.

Number of works in Catalogue: 1

John Tweed (1869–1933)

Exponent of the New Sculpture. After studying at Glasgow School of Art, Tweed moved to London aged twenty-one. There he attended the RA Schools and worked as an assistant to Hamo Thornycroft. In 1893 his interest in the sculpture of Rodin took him to Paris where he worked under Alexandre Falguière. 'With Rodin, Tweed found the guidance he wanted; he absorbed and assimilated the work of the great realist and passionate student so far as he could, and returned to London to begin his life's work.' Following his return to England his first major commission was to execute a bronze relief for the Cape Town residence of Cecil Rhodes (1893). Later he was appointed the sculptor of the statue of *Cecil Rhodes* in Bulawayo (1902). Whilst some members of the art establishment were hostile to his Rodin-inspired modelling, his successful completion of Alfred Stevens's equestrian figure for the *Wellington Monument* at St Paul's Cathedral (1901) brought further large-scale commissions. Tweed's major works in London include *Lord Clive* (1917), *Lord Kitchener* (1926) and the war memorials at Grovenor Place (1924) and the House of Lords (1932).

[1] Turner (ed.), p.488. [2] Tweed, L. *John Tweed: Sculptor. A Memoir*, London, 1936.

Number of works in Catalogue: 3

John Vanbrugh (1664–1726)

Vanbrugh was the grandson of a Flemish refugee merchant. Little is known of his early life except that he was commissioned as an officer in 1686 and two years later imprisoned in France as a spy. On his release he gradually gave up soldiering and turned to writing plays. His two most famous comedies, *The Relapse* and *The Provok'd Wife*, were first produced in 1697.

In 1699 he abruptly changed career for the second time when he took up architecture, designing as his first commission, Castle Howard, the Earl of Carlisle's great house in Yorkshire. As Dean Swift remarked, 'Van's genius, without thought or lecture, / is hugely turn'd to architecture.' The Earl's influence subsequently secured him the post of Comptroller of Works in 1702, and this in turn brought him his most important commission, Blenheim Palace 1705–20. At Blenheim his highly personal version of the Baroque, 'massive and masculine', was given its fullest

and most appropriate expression. Vanbrugh's approach to landscape gardening was as original as his architecture (as is evident from his designs for Stowe and Castle Howard).

[1] Colvin, pp.1003–9.

Number of works in Catalogue: 1

Brian Wall (b.1931)
Wall worked as a glass-blower from 1945 to 1950 and then studied at Luton College of Art whilst serving in the RAF. In 1954 he moved to St Ives to be near Ben Nicholson and subsequently worked as an assistant to Barbara Hepworth. From 1962 to 1972 he taught sculpture at the Central School, London before moving to the University of California at Berkeley. His later work has tended to be welded steel constructions of an abstract nature.

[1] *Northern Echo*, 21 February 1991. [2] Buckman, p.1235.

Number of works in Catalogue: 1

André Wallace (b.1947)
Sculptor, trained at Liverpool College of Art, RA Schools (1970–1) and Royal College of Art (1971–3), where he has also worked as a Visiting Lecturer. Wallace has had many solo and joint shows over the years, including exhibits of his work at the RA, Arts Council Touring Exhibition and Stoke Garden Festival (1986). His work in public includes *The Whisper*, Milton Keynes (1984); and pieces in Telford (1986), London (1989 and 1996) and Manchester Exchange Quay, Salford (1990). Has work in many private and public collections both in the UK and abroad.

[1] Miles, M., *Art for Public Places*, Winchester, 1989, p.151. [2] Information supplied by the artist, 1997. [3] Buckman, p.1236.

Number of works in Catalogue: 3

Gilbert Ward (b.1935)
Sculptor trained at King's College, Durham University, subsequently living and working locally. Taught sculpture at Newcastle Polytechnic and has been involved in several residencies in north-east England. Ward is quoted as saying that 'I am most interested in making sculpture for places. It seems to me important that the work is considered for the place it is to occupy.' Mostly working in stone, his output ranges from abstraction to organic forms. His many exhibitions include: Laing Art Gallery, Newcastle (1986); York University, Toronto (1987); Olympia, London (1989); City Art Gallery, Bergen (1990); Gateshead Garden Festival (1992); Hall of Artists, Moscow (1992); Hatton Gallery and Atlanta USA (1996). Has had many commissions for works in the North East as well as at Grizedale Forest, International Sculpture Symposium, Yugoslavia, Aberdeen, and 'NORWEB', Carlisle.

[1] Information provided by the artist, 1997. [2] Stephenson, p.82.

Number of works in Catalogue: 15

Fred Watson (b.1937)
Sculptor of naturalistic and detailed still lifes in stone and wood. Born in Tyne and Wear, Watson trained at King's College, University of Durham and later taught at Newcastle Polytechnic where one of the students he particularly influenced was Colin Wilbourn. He has had a number of commissions and exhibitions in Britain and abroad including a piece at Milton Keynes and shows at the Welsh Sculpture Trust (1988) and Newcastle Group international tour (1990). Watson continues to live in Birtley, Northumberland.

[1] Information supplied by the artist, 1999. [2] Buckman, p.1249.

Number of works in Catalogue: 3

Felicity Watts
Stone-sculptor and graphic artist based in Gateshead. Having originally studied philosophy at Oxford University, and gained a PhD in the subject from a university in Pennsylvania in 1986, Watts trained for a diploma in sculpture in 1992. She has run art workshops in Tyne and Wear from 1996, taken part in group exhibitions in the region and was artist-in-residence at a school in 1998. She has stated that her inspiration is derived from her philosophical interests, particularly in ideas about subjectivity and an individual point of view.

[1] AXIS, Artists Register, 1999.

Number of works in Catalogue: 1

Richard Wentworth (b.1947)
Sculptor trained at Hornsey College of Art and the Royal College of Art 1965–70. In the late 1960s he was an assistant to Henry Moore and was awarded the Mark Rothko Memorial Award in 1974. Best known for works which give new and provocative identities to everyday objects, a much-reproduced example being *Pair of Paper Bags with Large & Small Buckets* (1982). His works are both unsettling and funny: he is quoted as saying that 'humour is trying to find breathable air in a stifling atmosphere'. As a teacher at Goldsmith's College 1981–8, he greatly influenced a number of British artists who came to prominence in the 1990s, such as Julian Opie, Simon Patterson and Grenville Davey. Represented by the Lisson Gallery, he has exhibited internationally and his works can be found in the Saatchi Collection, the Tate Gallery and other major collections.

[1] Warner, M., *Richard Wentworth*, London, 1993, *passim*. [2] Hicks, A. *New British Art in the Saatchi Collection*, London, 1989. [3] Buckman, p.1262.

Number of works in Catalogue: 1

J. Whitehead
Westminster-based sculptor whose portrait busts and statues in marble were exhibited at the RA 1889–95.

[1] Graves, *London Exhibitions*, p.258.

Number of works in Catalogue: 1

Nicholas Whitmore (b.1953)
Specialist lost wax bronze caster, trained at Winchester School of Art (1973–6) and subsequently lecturer at the University of Northumbria. In addition to making sculpture, Whitmore has been a freelance cartoonist for the *Spectator*, *Private Eye* and the *New Statesman*. Exhibitions include: Laing Art Gallery, Newcastle (1980 and 1985), Crafts Council London (1992), and the annual '*Spectator* Cartoon' exhibition, London (1995–8).

[1] Information supplied by the artist, 1999.

Number of works in Catalogue: 1

Jan Wijck (1652–1700)
Son of the artist Thomas Wijck. Especially noted for battle scenes and portraits of military officers. He travelled through British Isles and occasionally collaborated with others.

[1] Turner (ed.), vol.33, pp 176–7.

Number of works in Catalogue: 1

Colin Wilbourn (b.1956)
Sunderland-based sculptor in stone and steel. Trained at Newcastle Polytechnic and Newcastle University. He lectured at various university departments around the country from 1988 to 1993, before becoming a part-time lecturer at Sunderland University. From 1992 to 1999 he has been the lead artist-in-residence at Sunderland's St Peter's Riverside regeneration project. He has enthusiastically promoted this community-based arts programme and, along with colleagues, become a familiar sight there, making sculpture in all weathers. Wilbourn has shown work in London (1980), Liverpool (1985), Newcastle (1989) and the 'UNESCO Heritage Exhibition', Paris (1992).

[1] *Journal,* Newcastle, 24 August 1996. [2] AXIS, Artists Register, 1999.

Number of works in Catalogue: 10

Andrea Wilkinson
Educated at St Martin's School of Art and the Royal College of Art, London, graduating in 1994. She has had exhibitions in London, Australia and Italy from 1994 to 1998.

[1] Information supplied by the artist, 1998.

Number of works in Catalogue: 1

Eric Wilson
Sculptor in metal, trained at Sunderland University in the late 1970s, then again in the mid-1990s. Wilson was artist-in-residence at South Tyneside College 1993–4 and has also had residencies at St Andrews 1980–1 and Grizedale Forest 1985. He is currently associate tutor in sculpture at Durham University.

[1] AXIS, Artists Register, 1999.

Number of works in Catalogue: 1

Richard Wilson (b.1953)
Wilson studied at the London College of Printing, Hornsey College of Art and Reading University 1970–6. In 1983 he formed Bow Gamelan, an ensemble that staged sound and sculpture events. Their use of free-form percussion and spontaneous assemblage of found objects influenced his later sculptures, for instance one of his first large-scale works *One Piece at a Time* (1987), where 1,200 car parts were temporarily suspended on cords from rafters in the south tower of the Tyne Road Bridge, Gateshead. Best known for works which disrupt the spaces and structures which contain art, examples include: *Watertable,* Matt's Gallery, London (1994), which revealed the actual water-table beneath the building; and *20: 50* (1987, now permanently installed at the Saatchi Collection in London). The latter has been described as either 'latent Baroque illusionism, rejuvenated Dada or something completely new'. Wilson was DAAD artist-in-residence in Berlin, 1992 and has exhibited in many shows including at the Serpentine Gallery and Gimpel Fils, 1996.

[1] Turner (ed.), vol.33, p.223. [2] Matt's Gallery, Museum of Modern Art, Oxford and Arnolfini Gallery, *Richard Wilson* exhib. cat., 1989. [3] Hicks, A., *New British Art in the Saatchi Collection*, London, 1989, p.154. [4] Buckman, p.1293.

Number of works in Catalogue: 1

William Wilson (c.1820–1883)
Sculptor and stonemason. It is thought likely that William Wilson's family went to Berwick to work on the Royal Border Railway Bridge when that was started in 1847. By the mid-1850s he was certainly in business in the town; there are tombstones signed by him for the period mid-1850s to 1880s. His sons, John and William, carried on the family stonemason business until 1943.

[1] Information provided by Elizabeth Doley, 1998.

Number of works in Catalogue:4

Mike Winstone (b.1958)
Sculptor, draughtsman and teacher. Studied at Portsmouth College of Art and Design 1977–81 and the Royal College 1981–4. Winstone has lectured at a number of universities and was artist-in-residence at Grizedale Forest in 1984. His commissions include a sculpture for Buckmead School (1988). Northern Arts holds examples of his smaller works.

[1] Buckman, p.1296.

Number of works in Catalogue: 1

Austin Wright (1911–1997)

Sculptor in metal of abstract works based on natural forms; he once said that he looked to the sky for inspiration. Wright studied modern languages at Oxford University before pursuing his interest in modern art and becoming a teacher at York Art School 1949–54. In 1955 he decided to devote himself exclusively to art practice. A Gregory Fellowship in sculpture at Leeds University 1961–4 allowed him to move from wood and concrete to aluminium as his preferred material. He was collected both in Britain and abroad, and also had a number of public commissions including a large work at Roppa Bank (1977) and another on the North Yorkshire Moors at Helmsley. Wright's work was exhibited on Arts Council tours of Sweden and South America in the 1960s and at Newcastle (1974), Yorkshire Sculpture Park (1981) and York City Art Gallery (1994).

[1] *Guardian*, 25 February 1997. [2] Hamilton, J., *Austin Wright*, 1994. [3] Buckman, p.1312.

Number of works in Catalogue: 1

Margaret Wrightson (1877–1976)

Encouraged originally to take up art by her father, Sir Thomas Wrightson, MP for Stockton and later St Pancras, she studied sculpture at the Royal College under Sir William Blake Richmond and Édouard Lantèri. Exhibited at the RA and the Society of Women Artists from 1906. Her public sculpture includes the *Lamb Memorial* in the Inner Temple Gardens, London, and the small figure of *St. George* on the War Memorial at Cramlington 1922.

[1] Hall, M., *Artists of Northumbria*, Newcastle, 1982, p.21.

Number of works in Catalogue: 1

David Wynne (b.1926)

Sculptor best known for figurative and animal pieces. After serving in the Royal Navy 1944–7, Wynne studied at Cambridge under Georg Ehrlich, and later in Paris with Paul Landowski and Welles Bosworth. Since 1946 he has produced figures, portraits and animals, some carved, some modelled. Commissions include:

Boy with a Dolphin, Cheyne Walk (1974); *Five Swimmers Fountain*, Staines (1980); *Risen Christ and Seraphims*, Wells Cathedral (1984–5); *The Awakening Earth*, CBI, Geneva (1988); *Gaia and Tresco Children*, Isles of Scilly (1990); *Goddess of the Woods*, Highgrove, Gloucestershire (1991). Wynne designed the linked hands on the EEC 50 pence coin and the Jubilee Medal, 1977 as well as the gates onto Hyde Park made in honour of the Queen Mother's 90th birthday (1992). Awarded the OBE in 1994.

[1] Hughes, G., *Sculpture of David Wynne 1968–74*, London, 1975. [2] Stone, J. (ed.), *The Sculpture of David Wynne 1974–1992*, London, 1993. [3] Buckman, p.1316.

Number of works in Catalogue: 2

Bibliography

Books and Articles

Abbott, V. and Chapman, R., *The Great Metro Guide to Tyne and Wear*, Hawes, 1990.

Abromson, M.C., *Dictionary of Twentieth Century Art*, London, 1973.

Adam, D., *The Complete Works of Robert and James Adam*, London, 1991.

Airey, A. and Airey, A., *The Bainbridges of Newcastle: A Family History 1679–1976*, Newcastle upon Tyne, 1979.

Airey, J., *Newcastle upon Tyne in Old Picture Postcards*, Newcastle upon Tyne, 1987.

Allan's Illustrated Edition of Tyneside Songs, Newcastle upon Tyne, 1891.

Alley, R., *Victor Pasmore: Retrospective Exhibition 1925–65*, Tate Gallery, London, 1965.

Amery, L. (ed.), *The Times History of the War in South Africa 1899–1902*, vol.V, London, 1907.

Anon, *Guide to Blagdon*, Northumberland, 1984.

Anon, *Westmorland, Cumberland, Durham Illustrated*, vol.1, London, 1832.

Appleyard, R., *Charles Parsons*, London, 1933.

Armstrong, K., *The Wooden Dolly*, North Shields, 1994.

Arts Council of Great Britain, *The Sculpture Show* (exhib. cat.), Hayward and Serpentine Galleries, London, 1983.

Ayris, I., *A City of Palaces: Richard Grainger and the Making of Newcastle upon Tyne*, Newcastle upon Tyne, 1997.

Ayris, I., Jubb, P., Palmer, S. and Usherwood, P., *Tyne and Wear Guide to Public Sculpture and Monuments*, Newcastle upon Tyne, 1995.

Beattie, S., *The New Sculpture*, London, 1983.

Bellamy, J.M. and Saville, J., *Dictionary of Labour History*, London, 1972.

Bénézit, E., *Dictionnaire Critique et Documentaire des Peintres, Sculpteurs et Graveurs*, Paris, 1976.

Benson, Sir I., *The Man with the Donkey: J.S. Kirkpatrick the Good Samaritan of Gallipoli*, London, 1965.

Benwell Community Project, *The Making of a Ruling Class*, Newcastle, 1978.

Berwick Infirmary, *Maclagan Memorial report*, Berwick-upon-Tweed, 1922.

Bickers, P., 'Interview with Claes Oldenburg', *Art Monthly*, November 1993, pp.3–5.

Boase, T., 'John Graham Lough: A Transitional Sculptor', *Journal of the Warburg and Courtauld Institutes*, xxiii, 1960, pp.227–90.

Bourne, H., *History of Newcastle upon Tyne*, Newcastle upon Tyne, 1736.

Bowes, P., *Picturesque Weardale*, Bishop Auckland, County Durham, 1996.

Boyle, J.R., *Vestiges of Old Newcastle and Gateshead*, Newcastle upon Tyne and London, 1890.

Bradley, S. and Pevsner, N., *London 1: The City of London*, London, 1997.

Brand, J., *History and Antiquities of the Town and the County of the Town of Newcastle upon Tyne*, London, 1789.

Brennan, G., *A History of the House of Percy*, London, 1902.

Brett, P., 'The Newcastle Election of 1830', *Northern History*, vol.24, 1988, p.105.

Briggs, A., *Victorian Cities*, Harmondsworth, 1968.

Brockie, W., *Sunderland Notables: Natives, Residents and Visitors*, Sunderland, 1894.

Brooks, P.R.B., *Wylam and its Railway Pioneers*, Wylam, 1975.

Broumley, J.W., *The Lords of Raby and Staindrop*, Staindrop, 1957.

Buck, L., *Moving Targets. A User's Guide to British Art Now*, London, 1997.

Buckman, D., *Dictionary of Artists in Britain since 1945*, Bristol, 1990.

Burnett, W., *Old Cleveland: A Collection of Papers of Local Writers and Local Worthies*, Middlesbrough, 1886.

Butler, D., *Battle of Neville's Cross: An Illustrated History*, Durham, 1996.

Cassidy, D., *David Mach at the Zamek Ujazdowskie*, Tokyo, 1995.

Cavanagh, T., *Public Sculpture of Liverpool*, Liverpool, 1997.

Celant, G., *Tony Cragg*, London, 1996.

Charleton, R.J., *Streets of Newcastle*, Newcastle upon Tyne, c.1880.

Charlton, M., *Hexham: A Pictorial Record*, Hexham, 1987.

Christian, J. (ed.), *The Last Romantics. The Romantic Tradition. Burne-Jones to Stanley Spencer*, London, 1990.

Clank. P., *The Book of Durham City*, Buckingham, 1985.

Clasper, D., *Harry Clasper, Hero of the North*, Exeter, 1990.

Coia, A., *Spennymoor in Old Picture Postcards*, Zoltbomnel, Netherlands,

1983.

Collard, W. and Ross, M., *Architectural and Picturesque Views of Newcastle upon Tyne*, Newcastle upon Tyne, 1841.

Colvin, H., *A Biographical Dictionary of British Architects, 1600–1840*, New Haven and London, 1995.

Concise Dictionary of National Biography, 1901–1930, Oxford, 1930.

Cook, H., *Momento of Col. Sir Samuel A. Sadler VD, DL, JP*, Middlesbrough, 1913.

Corfe, T., *A History of Sunderland*, Newcastle upon Tyne, 1973.

Courtney, C., 'David Tremlett', *Art Monthly*, November, 1992, pp.13–16.

Craven, D., *The Mystery of the Wooden Dollies*, North Tyneside, 1990.

Crosby, J., *Durham in Old Photographs*, Stroud, 1990.

Cross, F. and Livingstone, E., *The Oxford Dictionary of the Christian Church*, London, 1974.

Culley, M. (ed.), *Letters of Cadwallader J.Bates*, Kendal, 1906.

Cunningham, C., *Victorian and Edwardian Town Halls*, London, 1981.

Darke, J., *The Monument Guide to England and Wales: A National Portrait in Bronze and Stone*, London, 1991.

Davies, P. and Knipe, T. (eds), *A Sense of Place*, Sunderland, 1994.

Davies, P., *Troughs and Drinking Fountains*, London, 1989.

Davis, H.W.C. and Weaver, J.R.H., *The Dictionary of National Biography 1912–1921*, Oxford, 1921.

Davison, W., *Descriptive and Historical View of Alnwick*, Alnwick, 1813 and 1822.

Derry, J., *Politics in the Age of Fox, Pitt and Liverpool. Continuity and Transformation*, London, 1990.

Dillon, W., *Life of Joseph Cowen*, New York, 1904.

Dixon, M., 'Onslow Ford RA', *Art Journal*, 1898, pp.294–7.

Dodd, M. (ed.), *A History of Northumberland*, London, 1935.

Dorment, R., *Alfred Gilbert*, London and New Haven, 1985.

Dougan, D., *The Great Gun-Maker*, Newcastle upon Tyne, 1970.

Downes, K., *Sir John Vanbrugh: A Biography*, London, 1987.

Dryden, M., *The New Town Hall and Municipal Buildings*, South Shields, 1981.

Duckham, H. and Duckham, B., *Great Pit Disasters: Great Britain 1700 to the Present Day*, Newton Abbot, 1973.

Dufferwiel, N., *Durham: A Thousand Years of History and Legend*, Edinburgh and London, 1996.

Durham County Environmental Education Curriculum Group in Co-operation with Northern Echo, *Coal Mining in County Durham*, 1993.

Emery, N., *The Coalminers of County Durham*, Stroud, 1992.

E.M.S.P., *The Two James's and the Two Stephensons: The Earliest History of Passenger Transit on Railways*, London, 1861.

English Heritage, *The Fortifications of Berwick-upon-Tweed*, 1995.

Farmer, D., *Oxford Dictionary of Saints*, Oxford, 1997.

Faulkner, T. and Greg, A., *John Dobson, Newcastle Architect 1787–1865*, Newcastle upon Tyne, 1987.

Faulkner, T. and Lowery, P., *Lost Houses of Newcastle and Northumberland*, York, 1996.

Felstead, A., Franklin, J. and Pinfield, L., *Directory of British Architects 1834–1900*, London, 1993.

Finlay, W., *Folk Tales from the North*, London, 1968.

First Tyne International, *A New Necessity* (exhib. cat.), Tyneside, 1990.

Flynn, G., *Darlington in Old Picture Postcards*, vol.II, Zoltbomnel, Netherlands, 1994.

Forbes, R. (ed.), *Polisses and Candymen: The Complete Works of Tommy Armstrong the Pitman Poet*, Consett, 1982.

Fordyce, T., *Local Records or Historical Register of Remarkable Events which have Occurred in Northumberland and Durham, Newcastle upon Tyne and Berwick upon Tweed*, Newcastle upon Tyne, 1867.

Forster, E., *The Death Pit: The Untold Story of Mass Death in a Mine*, Newcastle upon Tyne, 1970.

Foster, J., *Alumni Oxoniensi: the members of Oxford University, 1715–1816*, Oxford, 1888.

Foster, J., *Newcastle upon Tyne, A Pictorial History*, Newcastle upon Tyne, 1995.

France, L., *Looking Beyond: Easington District Council's Programme for Visual Arts Year 1996*, 1997.

Gard, R., *Northumberland Yesteryear*, Newcastle upon Tyne, 1978.

Goldsworthy, A., *Hand to Earth, Andy Goldsworthy Sculpture 1976–90*, Leeds, 1994.

Goldsworthy, A., *Stone*, London, 1994.

Gormley, A., *Making An Angel*, London, 1998.

Goulding, C., *Hidden Newcastle*, Newcastle upon Tyne, 1995.

Goulding, C., *Tinseltoon*, Newcastle upon Tyne, 1998.

Gradon, H.T., *Ye Ancient Citie of Durham in Ye Olden Tyme: Descriptive-Historical-Traditional*, Claypath, 1883.

Graham, F., *Northumberland's Lordly Strand. The Northumbrian Coast from Berwick to Tynemouth*, Newcastle upon Tyne, 1974.

Graves, A., *Dictionary of Artists who have Exhibited Works in the Principal London Exhibitions from 1760 to 1893*, London, 1901.

Graves, A., *Royal Academy of Arts. A Complete Dictionary of Contributors and their Work from its Foundations in 1769 to 1904*, London, 1906.

Green, F., *A Guide to the Historic Parks and Gardens of Tyne and Wear*, Newcastle upon Tyne, 1995.

Grey, A., *Edwardian Architecture. A Biographical Dictionary*, Iowa, 1986.

Gunnis, R., *Dictionary of British Sculptors 1660–1851*, London, 1961.

Hall, J., *A Dictionary of Subjects and Symbols in Art*, London, 1996.

Hall, M., *A Dictionary of Northumberland and Durham Painters*, Newcastle upon Tyne, 1973.

Hall, M., *Artists of Northumbria*, Newcastle upon Tyne, 1982.

Hamilton, J., *The Sculpture of Austin Wright*, London, 1994.

Hardy, C., *Gateshead in Focus*, Huddersfield, 1990.

Harle, W.L., *George Stephenson, or Memorials to Genius*, Newcastle upon Tyne, 1859.

Harrison, A., *A History of Ryton*, Gateshead, 1990.

Harrison, T., *Selected Poems*, London, 1984.

Haswell, G.H., *"The Maister": A Century of Tyneside Life*, London, 1895.

Henderson, P., *Whitley Bay, Past and Present*, 1989.

Herald and Daily Post, *The Victoria Hall Disaster*, Sunderland, 1883.

Hicks, A. *New British Art in the Saatchi Collection*, London, 1989.

Hind, A.L., *History and Folklore of Old Washington*, Coxhoe, 1976.

Hind, A.L., *Penshaw Monument*, 1978.

Hind, A.L., *The River Wear: History and Legend of Long Ago*, Washington, 1979.

Hodgson, J., *A History of Morpeth*, Newcastle upon Tyne, 1832.

Hodgson, J., *Northumberland County History*, vol.5, London, 1899.

Holt, R., *Football and Regional Identity in the North East of England: the Legend of Jackie Milburn*, Leicester, n.d.

Hooper, L., *Art in the Metro: Tyne and Wear*, Newcastle upon Tyne, 1985.

Howitt, W., *Visits to Remarkable Places*, London, 1856.

Hudson, M., 'Soane: Gratitude in Stone', *Country Life*, August 1978, pp.592–3.

Hudson, M., 'Landowner's Landmark. The Tenantry Column at Alnwick, Northumberland', *Country Life*, April 1981, pp.1211–12.

Hughes, G., *Sculpture of David Wynne 1968–74*, 1975.

Hutchinson, J., *Memoirs of the Public Life of Sir Walter Blackett of Wallington*, Newcastle upon Tyne, 1789.

Hutchinson, J., Gombrich, E. and Njatin, L., *Antony Gormley*, London, 1995.

Jeremy, D. and Shaw, C. (eds), *Dictionary of Business Biography*, London, 1986.

Johnson, J. and Greutzner, A., *Dictionary of British Artists 1880–1940*, Woodbridge, 1976.

Johnson, R.W., *The Making of the Tyne*, London, 1895.

Joint TCS: RIBA: MBC, *Historic Public Buildings: Middlesbrough Inner Area*, Middlesbrough, 1981.

Jones, E.R., *The Life and Speeches of Joseph Cowen M.P.*, London, 1885.

Kastner, J. and Wallis, B., *Land and Environmental Art*, London, 1999.

Kelly's Directory of Durham, Northumberland, Cumberland and Westmorland, Newcastle upon Tyne, 1894.

Kirkup, M., *Biggest Mining Village in the World*, Warkworth, 1993.

Knowles, W.H., *Vestiges of Old Newcastle*, Newcastle upon Tyne, 1890.

Knowles, W.H., 'The Gatehouse and Barbican at Alnwick Castle, with an account of the recent discoveries', *Archaeologia Aeliana*, series 3, vol.5, 1909.

Lampert C., *Rodin, Sculpture and Drawings* (exhib. cat.), Haywood Gallery, London, 1986.

Lasdun, S., *The English Park. Royal, Private and Public*, London, 1991.

Latimer, J., *Local Records or Historical Register of Remarkable Events which have Occurred in Northumberland, Durham, Newcastle upon Tyne and Berwick upon Tweed*, Newcastle upon Tyne, 1857.

Leach, P., *James Paine*, London, 1988.

Letch, H., *Gleanings from the History of Birtley*, Gateshead, n.d.

Livingstone, M., (ed.) *David Mach*, Kyoto, 1990.

Londonderry, E., *Frances Anne*, London, 1958.

Longstaffe, W., *The History and Antiquities of the Parish of Darlington*, Stockton, 1854, repr.1973.

Lough, J. and Merson, E., *John Graham Lough 1798–1876 A Northumbrian Sculptor*, Woodbridge, 1987.

Lovie, D., *The Buildings of Grainger Town*, Newcastle upon Tyne, 1997.

Lumley, D., *The Story of Gateshead Town*, Newcastle upon Tyne, 1932.

Lynton, N., *Victor Pasmore: Paintings and Graphics 1980–92*, London, 1992.

McCabe, J., *The Comedy World of Stan Laurel*, London, 1975.

McCucheon, J., *Troubled Seams: The Story of a Pit and its People*, Broughton Gifford, 1994.

McGill, J., *On the Death of Robert Chambers*, Newcastle upon Tyne, 7 June 1868.

Mackenzie, E., *An Historical, Topographical and Descriptive View of the County of Northumberland*, Newcastle upon Tyne, 1825.

Mackenzie, E., *Descriptive and Historical Account of Newcastle upon Tyne*, Newcastle upon Tyne, 1827.

McNee, T., *Seaham Harbour: The First 100 Years, 1828–1928*, 1985.

Manders, F.W.D., *A History of Gateshead*, Gateshead, 1973.

Manders, F.W.D., *A Selection of the Earliest Photographs*, Newcastle upon Tyne, 1995.

Manning, E., *Marble and Bronze. The Art and Life of Hamo Thornycroft*, London and New Jersey, 1982.

Martin, E., *Bedlingtonshire*, Chalford, 1997.

Mercer, D., *Chronicle of the Royal Family*, London, 1991.

Milburn, G.E. and Miller, S.T. (eds), *Sunderland: River, Town and People*, Sunderland, 1988.

Milburn, G.E., *The Travelling Preacher: John Wesley in the North East 1742–1790*, Newcastle upon Tyne, 1987.

Miles, M., *Art for Public Places*, Winchester, 1989.

Miles, M., *Art, Space and the City. Public Art and Urban Futures*, London, 1997.

Millard, J., *Ralph Hedley: Tyneside Painter*, Newcastle upon Tyne, 1990.

Mitchell, W.C., *History of Sunderland*, Manchester, 1919.

Moore, T., *Consett: A Town in the Making*, Durham, 1992.

Morley, A., *Parliamentary Report on the Tudhoe Colliery Explosion*, London, 1882.

Moses, E.W., 'The Williamsons of East Markham, Nottinghamshire, and Monkwearmouth, Co. Durham', *Antiquities of Sunderland*, vol. XXIII, 1964, pp.54–72.

Murray, G. (ed.), *Art in the Garden: Installations, Glasgow Garden Festival*, Edinburgh, 1988.

Nairne, S. and Serota, N., *British Sculpture in the Twentieth Century*, Whitechapel Art Gallery (exhib. cat.), London, 1981.

Neville, H., *Under a Border Tree: Sketches and Memories of Ford Castle, Northumberland*, Newcastle upon Tyne, 1896.

Newcastle Yearbook. A Local History, Guide and Annual Review, Newcastle upon Tyne, 1905.

Newman, M., *Richard Deacon: Sculpture, 1980–84* (exhib. cat.), Edinburgh, 1984.

Northumberland County Council National Park, *Battle of Otterburn*, Hexham, 1985.

Noszlopy, G.T. with Beach, J. (ed.), *Public Sculpture of Birmingham*, Liverpool, 1998.

Oldenburg, C. and van Bruggen, C., *Bottle of Notes*, Middlesbrough, 1997.

Oldenburg, C., *Bottle of Notes and Some Voyages* (exhib. cat.), Sunderland and Leeds, 1988.

Osler, A.G., *Mr Greathead's Lifeboats*, Newcastle upon Tyne, 1990.

Osterwold, T., *Mark di Suvero* (exhib. cat.), Stuttgart, 1988.

O'Sullivan, D. and Young, R., *English Heritage Book of Lindisfarne, Holy Island*, London, 1995.

Oxberry, J., 'Memoir of Charles Clement Hodges', *Archaeologia Aeliana*, 4th series, vol.IX, pp.238–48.

Parson, W. and White, W., *Directory and Gazateer of the Counties of Durham and Northumberland*, Newcastle upon Tyne, 1827.

Pearson, L.F., *Northern City: An Architectural History of Newcastle upon Tyne*, Newcastle upon Tyne, 1996.

Penny, N., *Church Monuments in Romantic England*, London, 1977.

Perry, P. and Dodds, D., *Curiosities of County Durham*, Seaford, 1996.

Pevsner, N. and Richmond, I., *The Buildings of England: Northumberland*, 2nd ed. revised by Grundy et al., London, 1992.

Pevsner, N., *The Buildings of England: County Durham*, Harmondsworth, 2nd ed., 1985.

Philipson, G., *Aycliffe and Peterlee New Towns 1946–1988*, Cambridge, 1988.

Pickard, T., *Jarrow March*, London and New York, 1982.

Pickersgill, A., *Discovering Sunderland*, Durham, 1977.

Pike, W. (ed.), *Contemporary Biographies – Durham*, Edinburgh, 1985.

Pike, W. (ed.), *A Dictionary of Edwardian Biography – Northumberland*, Edinburgh, 1985.

Placzek, A. (ed.), *Macmillan Encyclopedia of Architects*, London, 1982.

Pollard, A. (ed.), *Middlesbrough: Town and Communty 1830–1950*, Stroud, 1996.

Prince, G. and Cumings, S. (eds), *Festival Landmarks '90*, Gateshead, 1990.

Purdon, J., *Explosion at Easington, A Durham Mine Disaster Remembered*, Beamish, n.d.

Rea, V., *Palmer's Yard and the Town of Jarrow*, Jarrow, 1975.

Read, B., *Victorian Sculpture*, New Haven and London, 1982.

Reid, H. (ed.), *Middlesbrough and its Jubilee*, London, 1881.

Richardson, M.A., *Local Historian's Tablebook (Historical Division)*, Newcastle, 1841–4.

Roberts, M., *The Book of Durham*, London, 1994.

Robinson, R., *Thomas Bewick, His Life and Times*, Newcastle upon Tyne, 1837.

Rosenburg, E., *Architect's Choice: Art and Architecture in Great Britain since 1945*, London, 1992.

Royal Scottish Academy Exhibitors 1826–1990, Calne, 1991.

Russell, J. and Gablik, S., *Pop Art Redefined*, London, 1969.

Salter, M., *The Castles and Town Houses of Northumberland*, Malvern, 1997.

Sankey, J., 'Thomas Brock and the Albert Memorial', *Sculpture Journal*, vol.3, 1999, p.87–92.

Scott, W., *Border Antiquities of England and Scotland*, London, 1814.

Scott, W., *Marmion: A Tale of Flodden Field*, 1808.

Shaw, P. and Thompson, I., *St. Peter's Riverside Sculpture Project*, Sunderland, 1996.

Shaw, P., *The Public Art Report*, London, 1990.

Shildon Urban District Council, *Shildon Official Guide*, Cheltenham, 1959.

Smedley, C., *Grace Darling and Her Times*, London, 1932.

Smiles, S., *Life of George Stephenson, Railway Engineer*, London, 1857.

Smith, E., *Lord Grey, 1764–1845*, Oxford, 1990.

Smith, J. and Holden, T., *Where Ships are Born*, Sunderland, 1953.

South Tyneside Libraries, *The History of Hebburn 1894–1994*, South Shields, 1994.

Spalding, F. (ed.), *20th Century Painters and Sculptors*, Woodbridge, 1990.

Spielmann, M., *British Sculpture and Sculptors of To-day*, London, 1901.

Stapleton, R., 'The Life of Joseph Cowen Esq', *Newcastle Critic*, 24 January 1874.

Stephen, L. & Lee, S. (eds), *Dictionary of National Biography*, Oxford, 1960.

Stephenson, G. (ed.), *Directory of Professional Artists in Northumberland*, Ashington, 1994.

Stone, J. (ed.), *The Sculpture of David Wynne 1974–1992*, London, 1993.

Strachan, W.J., *Open Air Sculpture in Britain: A Comprehensive Guide*, London, 1984.

Stranks, C.J., *The Venerable Bede*, London, 1955.

Sturgess, R., *Aristocrat in Business: the Third Marquis as Coal Owner and Port Builder*, Durham, 1975.

Swan, K., *Speech on the occasion of the unveiling of the Memorial to Sir Joseph Swan*, Newcastle upon Tyne, 16 September 1969.

Swan, M. and Swan, K., *Sir Joseph Wilson Swan: Inventor and Scientist*, Newcastle upon Tyne, 1929, repr.1968.

Sykes, J., *Local Records or Historical Records of Northumberland and Durham, Newcastle upon Tyne and Berwick upon Tweed*, London, 1866.

Tate, G., *The History of the Borough, Castle and Barony of Alnwick*, Alnwick, 1866.

Tate Gallery, *New World Order-Richard Deacon* (exhib. cat.), Liverpool, 1999.

Thomas, D, 'The British genius who invented friction matches in 1826', *Durham County Local History Society Bulletin* no.46, May 1991.

Thompson, A.H. (ed.), *Bede, His Life, Times and Writings*, Oxford, 1935.

Thompson, J., *Richard Deacon*, London, 1995.

Thompson, J. and Bond, D., *Victorian and Edwardian Northumbria from Old Photographs*, London, 1976.

Thompson W., *The Hollon Drinking Fountain, Market Place Morpeth, Centenary 1885–1985*, Morpeth, 1995.

Tindall Wildridge, T., *Hull Sculptors: A Brief Note upon Loft, Earle, the Two Keyworths, and Mason with a Comprehensive Biography of William Day Keyworth, the Younger*, Hull, 1889.

Todd, N., *The Militant Democracy and Victorian Radicalism*, Whitley Bay, 1991.

Tomlin, D. and Williams, M., *Who Was Who in Nineteenth-Century Cleveland*, Redcar, 1987.

Tomlinson, W., *Comprehensive Guide to Northumberland*, Newton Abbot, 1968.

Tomlinson, W., *Northumberland*, Newcastle upon Tyne, 1880.

Toynbee, M., 'Fresh Light on William Larson's Statue of James II at Newcastle upon Tyne', *Archaeolgia Aeliana*, 4th series, vol.29, p.108–17.

Tremlett, D., *1,9,8,7 Front Side*, London, 1989.

Turner, J. (ed.), *Dictionary of Art*, London, 1996.

Tweddle, A.M., *Town Trail for Morpethians*, Morpeth, 1983.

Tweed, L. *John Tweed: Sculptor. A Memoir*, London, 1936.

Usherwood, P., *Art for Newcastle: Thomas Miles Richardson and the Newcastle Exhibitions 1822–1843*, Newcastle upon Tyne, 1984.

Usherwood, P., 'Deacon and Wodiczko on Tyneside', *Art Monthly*, February 1991, pp.8–9.

Usherwood, P., 'Monumental or Modernist? Categorising Gormley's Angel', *Sculpture Journal*, 1999, vol.III, pp.93–102.

Usherwood, P., 'Over Easy', *Art Monthly*, June 1999, p.44–5.

Usherwood, P., 'Park Life', *Art Monthly*, September 1998, p.44.

Vickers-Armstrong, *Elswick 1847–1947*, London, 1947.

Victoria and Albert Museum, *Gilbert Scott (1811–1878): Architect of the Gothic Revival* (exhib. cat.), London, 1978.

Wade, H., *The Captain Cook Birthplace Museum*, Middlesbrough, 1982.

Waggot, E., *Jackson's Town: The Story of the Creation of West Hartlepool and the success and Downfall of its Founder, Ralph Ward Jackson*, Hartlepool, 1980.

Wapperley, N., *Folklore of the County of Durham, Society of Antiquaries Proceedings*, vol.1, Gateshead, 1951–6.

Ward's Directory of Newcastle upon Tyne and Gateshead 1889–90, Newcastle upon Tyne.

Warner, M., *Richard Wentworth*, London, 1993.

Warren, K., *Armstrongs of Elswick*, Basingstoke and London, 1989.

Waterfield, G. (ed.), *Soane and Death*, London, 1996.

Wear Valley District Council, *Wesley's Weardale 1752–1790*, 1982.

Webster, L. and Backhouse, J., *The Making of England. Anglo-Saxon Art and Culture AD 600–900*, London, 1991.

Welford, R., *Men of Mark twixt Tyne and Tweed*, London, 1895.

Welford, R., *Monuments and Tombstones in the Church of St. Nicholas*, Newcastle upon Tyne, 1880.

Who Was Who, 1929–1940, London, 1941.

Who Was Who, 1941–1950, London, 1952.

Who's Who 1897–1916, London, 1920.

Who's Who in Art, 23rd edition, Havant, 1988.

Williams, M., *Inhabitants of Sir William Turner Hospital, Kirkleatham, 1841–1881*, Kirkleatham, 1984.

Willis, M., *Gibside and the Bowes Family*, Newcastle upon Tyne, 1995.

Wilson, M.E., *The Story of Eston: A Social History*, Redcar, 1972.

Wood, R., *West Hartlepool: The Rise and Development of a Victorian New Town*, West Hartlepool, 1967.

Woodhouse, R., *Darlington: A Pictorial History*, Chichester, West Sussex, 1998.

Woodhouse, R., *Stockton Past*, Chichester, 1994.

Yarrington, A., *Commemoration of the Hero 1800–1864: Monuments to the British Victors of the Napoleonic Wars*, New York and London, 1988.

Yarrington, A., 'Nelson the citizen hero: state and public patronage of monumental sculpture 1805–18', *Art History*, vol.6, no.3, September, 1983, pp.315–29.

Young, R., *Timothy Hackworth and the Locomotive*, London, 1923.

Brochures, Leaflets and Unpublished Material

Alnwick District Council, *District of Alnwick Official Guide*, 1966.

Alnwick District Council, *District of Alnwick Visitors' Guide*, 1986.

Anderson, A.E., *Victoria Hall Disaster*, Sunderland City Library Local Studies, n.d.

Anon, *Marking Parish Boundaries along the Teesdale Way*, n.d.

Anon, *Souvenir Programme: Opening Ceremony of the Gateshead War Memorial*, Gateshead, 1922.

Baldwin. A., *A Short History of the Turner Family and their Descendants*, Kirkleatham, n.d.

Berwickshire Naturalists Club, *Proceedings*, 1909–10.

Brett, R., 'The Grey Monument: The Making of a Regional Landmark', *Occasional Papers in North-East History*, (forthcoming).

British Council, *Gertrude Bell (1868–1926)* (exhibition), University of Newcastle, 1999.

Chester-le-Street District Council, *Chester-le-Street Riverside: Art in the Landscape* (leaflet), n.d.

City and County of Newcastle upon Tyne, *Competition for a Work of Sculpture to be Placed in the Redeveloped Cruddas Park*, Newcastle, 1960.

City of Durham Preservation Society Annual Report, Durham, 1962.

City of Sunderland, *publicart.sunderland.com*, Sunderland, 1998.

City of Sunderland, *The Stephenson Trail* (leaflets), Sunderland, n.d.

The Civic Project Committee of Darlington Lions Club, *Darlington Sculpture*, Darlington, 1967.

Cleveland Arts, *Hilton New Milestones: A Sculpture Commission by Alain Ayers* (leaflet), Middlesbrough, 1987.

Collingwood newspaper cuttings, 1838–40, Central Library, Newcastle upon Tyne.

Crosby, J., *Durham City Art Map*, Durham, 1998.

Darlington Borough Council, *Train* (information pack), 1997.

Durham County Council, *Walkabout Middleton-in-Teesdale* (leaflet), 1995.

Felton and Newton-on-the Moor and Swarland Parish Councils, *Davison's Obelisk*, 1995.

Gateshead Libraries and Arts, *Four Seasons: A Gateshead Sculpture Project*, Gateshead, 1997.

Gateshead Libraries and Arts, *Gateshead Art Map*, Gateshead, 1997.

Gateshead Libraries and Arts, *Introducing Art for Public Places, Gateshead*, Gateshead, nd.

Gateshead Libraries and Arts, *Marking the Ways in Gateshead* (leaflet), Gateshead, 1997.

Gateshead MBC, *War and Other Memorials: Report of a Survey*, Gateshead, 1977.

Gateshead South African War Memorial Official Souvenir, Gateshead, 1905.

Great North Forest, *Arts in the Forest*, Dunston, 1998.

Great North Forest, *Arts in the Forest: Map* (leaflet), Dunston, 1998.

Harris Research Centre for Northern Arts / The Arts Council of England, *Visual Arts UK: Public Attitudes Towards an Awareness of the Year of the Visual Arts in the North of England*, Newcastle upon Tyne, 1997.

Hewitt, L.W., 'South Shields Town Hall 1905–1910' BA dissertation (unpublished), University of Newcastle, 1990.

Institute of Mining Engineers, *Transactions*, vol. XXXIII, 1906–7.

Kielder Liason Committee, *Kielder Water's Outline Proposal for Recreation and Tourism*, Kielder, 1978.

Kielder Partnership, *Elements in Harmony*, 1997.

Kielder Partnership, *Kielder a Place for Public Art*, 1998.

Makepeace, J., 'The Spanish City, Whitley Bay', BA dissertation (unpublished), Newcastle University, 1992.

Newcastle upon Tyne Association of City Guides, *Parsons Polygon by David Hamilton*, Newcastle upon Tyne, n.d.

Newcastle upon Tyne City Council, *Proceedings*.

Nexus, *Public Art in Public Transport*, Newcastle upon Tyne, 1998.

Northumberland National Park, *Archaeological Sites and Buildings*, 1976.

Observer supplement, *Visual Arts in the North*, April, 1996.

The Record, *Shildon Town Centre Opening Celebrations: Programme of Events* (booklet), 1998.

Roberts, A.R., 'The Quadrangle, University of Newcastle upon Tyne: An Architectural History 1881–1958', B.Arch. thesis (unpublished), University of Newcastle, 1988.

Rochester, G.D. and Parton, G.M., 'The Durham Obelisk' (unpublished article), Durham, 1995.

Rohm and Haas (UK) Ltd, *Unveiling of the Rohm and Haas Time Line Sculpture*, Jarrow, 1998.

Royal Victoria Infirmary, *Newcastle upon Tyne: Official Souvenir on the Silver Jubilee of King George V*, Newcastle upon Tyne, 1935.

Skelton and Brotton Parish Council, *Skelton and Brotton New Milestones* (leaflet), n.d.

SUSTRANS, *Annual Review*, 1997.

Teesdale District Council, *Teesdale Lead Mining Trail in the North Pennines* (leaflet), Teesdale, 1991.

Teesdale District Council, *The Green Man: A Life Cycle* (leaflet), Teesdale, 1996.

Teikyo University of Japan in Durham, *Teikyo University of Japan in Durham*, Durham, n.d.

Tyne and Wear Development Corporation, *The Art of Regeneration*, Newcastle upon Tyne, n.d.

University of Durham, Kings College, *Official Opening of the New Physics Building*, Newcastle upon Tyne, March 1962.

Waitt, E., 'John Morley, Joseph Cowen and Robert Spence Watson: Liberal Divisons in Newcastle Politics', thesis (unpublished), University of Manchester, 1972.

Walton, C.R., *Old Gateshead* (collection of articles), Gateshead, n.d.

Newspapers and Periodicals

Alnwick and County Gazette.
Alnwick Guardian.
Cleveland Gazette, Middlesbrough.
Daily Chronicle, Newcastle upon Tyne.
Daily Mail, London.
Daily Telegraph, London.
Darlington and Stockton Times.
Durham Advertiser.
Durham County Advertiser.
Durham University Journal.
Evening Chronicle, Newcastle upon Tyne.
Evening Gazette, Middlesbrough.
Gateshead Observer.
Gateshead Post.
Guardian, London.
Hexham Courant.
Illustrated London News, London.
Independent / Independent on Sunday, London.
Irish Arts Review, Dublin.
Irish Times, Dublin.

Journal, Newcastle upon Tyne.
Journal, Berwick-upon-Tweed.
Literary Gazette, London.
Middlesbrough Daily Exchange.
Mirror, London.
Monthly Chronicle of North Country Lore and Legend, Newcastle upon Tyne.
Morpeth Herald.
Newcastle Daily Chronicle.
Newcastle Daily Express.
Newcastle Weekly Chronicle.
North-Eastern Daily Gazette, Middlesbrough.
Northern Echo, Darlingon.
Northern Liberator, Newcastle upon Tyne.
Northern Mail, Newcastle upon Tyne.
Northumberland and Alnwick Gazette.
Observer, London.
Port of Tyne Pilot.
Scotland on Sunday.
Shields Daily News, North Shields.
Shields Weekly News, North Shields.
South Durham and Cleveland Mercury.
South Tyneside Star, South Shields.
South Tyneside Weekender.
Sunday Sun, Newcastle upon Tyne.
Sunderland and Durham County Herald.
Sunderland Echo.
The Times, London.
Tyne Mercury, Newcastle upon Tyne.
Weekly Gazette, Middlesbrough.

Archives, Databases, Collections and Surveys

Association of Northumberland Local History Societies, War Memorials Survey 1988/93, Northumberland County Record Office, Gosforth, Newcastle upon Tyne.

AXIS, Visual Artists Register, Leeds Metropolitan University, Calverley Street, Leeds.

Conway Library, Courtauld Institute of Art, London.

Darlington Library, Local Studies Centre Picture Index.

Department of Environment, Lists of Buildings of Special Architectural and Historic Interest.

Durham City Council, Durham Record Image Database, Durham Library.

Gunnis Papers, Conway Library, Courtauld Institute of Art, London.

National Survey of War Memorials, Imperial War Museum, London.
Londonderry Papers, Durham County Record Office, Durham.
Newcastle City Libraries Local Studies, cuttings files and photographic
 collection.
Northern Arts, Slide Index and Library, Newcastle upon Tyne.
Palace Green Library, Gibby Negatives Collection, Durham.
University of Northumbria, Department of Historical & Critical Studies,
 slide library.
Wilson Collection, Central Library, Newcastle upon Tyne.

Index

Note: Titles of works are in italics. References to illustrations are in **bold**. Sculptures are indexed in three ways: by title, followed by location and maker's surname in brackets; by location; by maker/artist name. Location is the city, town or village shaded in the text. Personal names in a title are given as in the order of the text; reference should be made to the personal surname for the full entry. Additionally, where appropriate, buildings are included. General text references are to personal names; to initiatives (e.g. Marking the Ways); to type of sculpture (e.g. war memorials). For the broad outlines of the geographical arrangement readers are referred to the Contents list.

Abstracted Natural Forms, Sunderland (Ward) 201, **201**
Adam, John 3
Adam, Robert xix,3, 7, 9
Adam Robertson Fountain, Alnwick (Anon) 6–7, **7**
Adams, Charles John, architect 296
Adamson Memorial Drinking Fountain, Cullercoats (Anon) 55, **55**
Addison, Joseph 40
Admiral Lord Collingwood, Newcastle upon Tyne (Anon) 138–9, **139**
Admiral Lord Collingwood, Monument to, Tynemouth (Lough) 207–9, **207**
Aidan Walk, Newcastle upon Tyne 87–8
Ainsworth, Graciela 53, 59, 108, 205–6, 317
 Circling Partridges xxvii, 205–6, **206**
 Keelrow 108–9, **109**
Aion (Horsley) xv, 249
Aitchison, Sir Stephen 41
Aitchison, Sir Walter 40
Akam, Debby 105
Albert the Good, Durham (Gibson) 248, **248**
Albert, Prince 47–8, 121, **121**, 248, **248**
Alderman Hamond, Monument to, Newcastle upon Tyne (Anon) 220 (LOST)
Alexander, Keith 317
 Glaxo Gate 223, **223**
 Green Seat 228–9
 Moor or Less 261–2, **262**
 The Dive, The Surface, The Roll 222–3

Alexander and Margaret (brig) 159
Alexandra of Denmark 248
Allan, Eleanor (Dame Allan) 145
Allan, John 145
Allan, Professor J.S. 220
Allegorical Figures, Newcastle upon Tyne (Anon) 153–4, **154**
Allegories of the Four Seasons, South Shields (Binney) 180, **180**
Allegories of Learning and Art, Gateshead (Anon) 63, **63**
Allen, Councillor Bill 280
Allgood, Sir Richard 32
Allhusen, Christian 297
Allom, T. 44
Alnwick
 Adam Robertson Fountain 6–7, **7**
 Alnwick War Memorial 1, **1**
 Battlement Figures 7–8, **7**
 Lion Rampant 8, **8**
 Malcolm's Cross xix, 3–4, **4**
 Peace Column 5–6, **6**
 Percy Lion xiii, 3, **3**
 Percy Tenantry Column 1–3, **2**, 167
 St Michael's Pant xiii, 5, **5**
 Seven Ages of Man 4–5, **4**
 Will Dickson Fountain 8–9, **8**
 William the Lion Stone xix, 9, **9**
Alnwick Castle xix
 Battlement Figures 7–8, **7**
 Lion Rampant 8, **8**
Alnwick War Memorial, Alnwick (Hedley) 1, **1**
Always Open Gates, Sunderland (Wilbourn and Fisher) 193–4, **194**
AMARC 24, 84, 293, 300
Ambit, (Wilding) xvi, xxii, xxiii
Angel, Gordon 300
Angel of the North, Gateshead (Gormley) xiii, xvii, xx, xxiii, xxvi, 57–9, **58**
Anne, Princess 238
Annfield Plain, *Kyo Undercurrent* 222, **222**
Apollo Pavilion, Peterlee (Pasmore) xiii, **xiv**, 265–7, **266**
Archibold, Alderman George Greig 133
Aris, Birtley xxvii
Armstrong, Hilary MP 230

Armstrong, Tommy 277
Armstrong, Watson 93
Armstrong, William George (Lord Armstrong) xvii, 46, 92–3, **93**, 99, 122, 133, 135, 137, 141, 150
Armstrong College *see* Newcastle upon Tyne
'Armstrong Gun' 93
Armstrong World Industries 102–3
Arnatt, Raymond 134, 317
 Articulated Opposites 134, **134**
'Art into Landscape' competition 300
'Art in the Landscape' project 226
Art on the Metro 77, 83, 99, 114
Art in Public Places xxii, 67, 73–4
Art in Public Places Panel, Gateshead MBC 57, 58
Art on the Riverside 163, 172, 176, 193, 311
Art in Rural Areas 285
Articulated Opposites, Newcastle upon Tyne (Arnatt) 134, **134**
Artists' Agency xxii, xxiii, 193, 203, 311
Arts in the Forest xxiii
Arts Resource xxiii, 57
Arum Lily, Longbenton (Pym) 83–4, **84**
Ashington
 Ashington Colliery Disaster Memorial xviii, 9–10, 10
 Ashington War Memorial 10–11, 10
 Jackie Milburn xviii, 11–12, 11
Ashington Colliery Disaster Memorial, Ashington (Reid) xviii, 9–10, 10
Ashington War Memorial, Ashington (Rose) 10–11, 10
Ashleigh School 160
Astaire, Fred 302
Atkin, John, *The Watcher* 283–4, **283**, 317
Atkinson, J.B. 275
Auty, Pete 161, 317
 Water Sculpture 161, **161**
Axiom, Gateshead (Furuta) 70, **70**
Ayers, Alain 317
 Brewsdale Stepping Stones 284
 Hilton Wheel 284–5, **284**
 Oak Leaf 302

Bacchanalian Figures, Whitley Bay (Anon) 218, **218**
Bacchus, Elsdon (Anon) 25, **25**
Bacon, Charles 317

John Candlish, Monument to 181–2, **181**
Badger, Prudhoe (Power) xiii, 44–5
Bailey, Sir Stanley 102
Bailey, Walter, *The Natural Cycle* 157, **157**
Baily, Edward Hodges 97, 98, 139, 140, 149, 317
 Grey's Monument xiii, 96–8, **96, 97**, 208
 Thomas Bewick 139–40, **140**
Bainbridge, Emerson Muschamp 112, **112**, 132
Bainbridge, Eric, *Heaven and Earth Roundabout* xvi
Bainbridge, Thomas Hudson 131–2, **131**
Bamburgh 33
 Grace Darling Monument xiii, xvi, 12–13, **12**
Bandinelli, Giovanni 151
Barnard Castle
 Glaxo Gate 223, **223**
 The Dive, The Surface, The Roll 222–3
Barras Bridge 100
Barrett, Keith 318
 Carved Seats 227, **227**
Barribal, William, *Dainty Dinah* 226, **226**
Bartleman, Alexander 160
Barton, Julia 318
 Sea Spirals 262
 Shadow 37, **37**
Bartram, William 160
Basevi, George 41
Bates, Cadwallader J. 28
Bates, General Sir Loftus 29
Batman 302
Battle of Neville's Cross, Durham (Anon) 242, **242**
Battle of Otterbourne, The 44
Battlement Figures, Alnwick (Johnson) 7–8, **7**
Beacon of Europe, Ferryhill (Olley) 259, **259**
Beall, Robert, sculptural workshop 134
Beamish
 Beamish Shorthorns xxiii, 223–4, **223**
 Shepherd and Shepherdess 224, **224**
 Stone Cone 224–5, **224**
Beamish Path 81
Beamish Shorthorns, Beamish (Matthews) xxiii,
 223–4, **223**
Bede, Venerable 33, 190, 194
 Ecclesiastical History 190
 Life of St Cuthbert 190
Bede Memorial Cross, Sunderland (Hodges) 188–90,
 189, 190
Bedlington, *Trotter Memorial Fountain* 13, **13**
Beecham, Sir Jeremy 108
Beeches Walk 37
Behnes, William 318
 Major-General Sir Henry Havelock, Monument to
 183, **183**, 318
Bell, Mr, architect 5
Bell, Gertrude 304
Bell, Isaac Lowthian 52

Bellamy, David xxiii, 171, 260
Bellingham, *Bellingham South African War Memorial*
 13–14, **14**
Bellingham South African War Memorial, Bellingham
 (Milburn) 13–14, **14**
Bellway Homes 217
Benson, Colonel G.E. 30–1, **30**, 153
Benson, William 30
Bentham, Percy George 318
 Haydon Bridge War Memorial 28–9, **29**
Benwell 88, 89
Berwick-upon-Tweed 172
 Coat of Arms 17, **17**
 Duke of Wellington 16–17, **16**
 Eagle and Heads 17–18, **17**
 Jubilee Fountain 15–16, **15**
 Lady Jerningham, Monument to 14–15, **14**
 Philip Maclagan, Monument to 18–19, **18, 19**
 Three Busts 17
 Venetian Lions 18, **18**
 War Memorial 16, **16**
Berwickshire Historic Monuments Committee 15
Berwickshire Naturalists' Club 15, 22
Best, Norman, architect 295
Bewick, Thomas 127, **126, 127**, 128, 139–40, **140**
 General History of Quadrupeds, A 127
 History of British Birds, A 127
Beynes, William 183
B&F Fabrications Ltd, Derbyshire 86
Bill Quay Community Farm 68
Billingham, *Family Group* 280, **280**
Binney, J.G. 318
 Allegories of the Four Seasons 180, **180**
 Britannia, Neptune and Nymph 179, **179**
 Personifications of South Shields, Industry, Arts,
 Crafts and *Labour* 179–80, **179**
 Town Hall, South Shields, sculptures 178–80
Birmingham Guild Ltd 292
Birtley 82
 Colonel Edward Moseley Perkins, Monument to
 52, **52**
Birtley Hall 52
Biscop, Benedict 194
Black Hedley 47
Black, Maureen, *Herring Girls* 158
Black Rhinoceros, Newcastle upon Tyne (Hill) 102–3,
 102
Blackett family 50, 208
Blacksmiths' Needle, Newcastle upon Tyne
 (B.A.B.A.) xxvi, 111, **111**
Blagdon
 Cale Cross xiv, 19–20, **19**
 Ridley Bulls 20, **20**
Blagdon Hall 20
Blair, Tony 259, 267

Blaydon
 Head of Garibaldi 53–4, **54**
 Stones Garden 52–3, **53**
Blenkinsop, Thomas 277
Blyth
 Mastiffs 20–1, **20**
 Matthew White Ridley 21, **21**
Boer War *see* South African War
Bolckow, Henry xiv, xvii, 288, 289, 290, 297, **297**, 299
Boldon
 Dream Boat 54–5, **54**
 King George's School 55
Bookstack, Newcastle upon Tyne (Watson) 145–6,
 145
Borg, Alan 91
Borrowdale Brothers, *Wingate Grange Colliery*
 Disaster Memorial 278–9, **278**
Bottle Bank, Gateshead (Harris) 66–7, **67**
Bottle of Notes, Middlesbrough (Oldenburg and van
 Bruggen) xiii, xiv, xxiii, 292–4, **292**
Bottomley, Virginia 58
Boundary Markers, East Lendings (Wentworth and
 Fisher) 258–9, **258**
Bourne, Mary, *Untitled Boulders* 188
Bowes, George 214, 215, 245
Bowes Railway Path, sculptures 78–9, 80–1
Bowman, Renée 90
Boy with Wet Feet, Kibblesworth (Edwick) 81, **82**
Brady, Ann 276
 West Stanley Colliery Disaster, 1995, Memorial
 xviiii, 275–6, **275**
Brailsford, Victoria 318
 Tugboat xxiii, 301–2, **302**
Brancusi, *Endless Column*, Romania 201
Branxton
 Flodden Memorial 15, 21–2, **21**
 Robertson Memorial Fountain 22, **22**
Brenchley, Chaz xxvii, 190, 193, 196, 318
 The Red House 195, **195**
 Shadows in Another Light 191–3, **192, 193**
 Watching & Waiting xxvii, 195–6, **196**
 Windows and Walls 198
Brick Boat, Easington Colliery (Jarratt) 256
Brick Man (Gormley) 57
Bridge, Sunniside (Reynes) 81, 205, **205**
Bridgewood, Keith, *Tree* 238–9, **238**
Britannia, Neptune and Nymph, South Shields
 (Binney) 179, **179**
Britannia and Supporters, Middlesbrough (Mabey)
 298, 299
British Association of Blacksmith Artists,
 Blacksmiths' Needle xxvi, 111, **111**
British Cinema Centenary sculpture, Redcar (Clinch
 et al) 304, **304**
British Legion 100, **101**

British Liberty, Monument to, Whickham
 (Richardson, Garrett and Paine) xv, xix, 214–15,
 214
British Rail 249, 272, 305
British Steel 287, 301
Brock, Thomas 23, 78
 Field Marshall Viscount Gough 22–4, **23**
Brockett, John Trotter 110
Broderick, Richard 158, 318
 Groove 213–14, **213**
 Nater's Bank Seascape 165–6, **165**
 Play Area 164, **164**
 Wave 160, **160**
Bromly, Professor Tom 146
Brooker, W.G., *Victoria Hall Tragedy Memorial* 319
 183–5, **184**
Brown, Brian, *The Putter* xviii, 253, **253**
Brown, Irene, *Racing Ahead* 308, **308**, 319
Brownlee, *Ravensworth Fountain* 51, **51**
van Bruggen, Coosje, *Bottle of Notes* xiii, xiv, xxiii,
 292–4, **292**
Buchan, Norman MP 62, 67
Bug and Mushrooms, Newton Aycliffe (Hopper) 264,
 264
Bull, Darlington (Anon) 230–1, **230**
Bulmer, Willy 235
Bulmer's Stone, Darlington (Anon) 234–5, **235**
Burdon Moor, way-markers 81
Burke and Hare, grave-robbers 185
Burke, Edmund 39
Burma Campaign War Memorial, Newcastle upon
 Tyne (Whitmore) 139, **139**
Burn, George 53–4, 63–4, 103, 138, 216, 319
 Colonel Edward Moseley Perkins, Monument to
 52, **52**
 Harry Clasper, Monument to 215–16, **215**
 Head of Garibaldi 53–4, **54**
 James Renforth, Monument to xviii, 63–4, **64**
 Neptune and Fishwives 103, **103**
 Robert Chambers, Monument to 138, **138**
Burns, Robert (Rabbie) 220
Burt, Thomas 13, 144
Burton, Andrew 123, 319
 Column and Steps 109, **109**, 110
 Durham Cow 251, 254, **254**
 Elephant Under a Moroccan Edifice 123–4, **124**
 Lion 122–3, **122**
 Rudder 109, 110, **110**
 Tipping off the World 124, **124**
Byron, Lord 17, 48

C2C *see* Sustrans
Cackett & Burns Dick, architects (Cackett, Burns
 Dick and MacKellar) 100, 132, 319
 Cross House, Newcastle upon Tyne 153–4, **154**

North Shields First World War Memorial 158–9,
 159
 Spanish City, Whitley Bay 218, **218**
Cale Cross, Blagdon (Stephenson) xiv, 19–20, **19**
Calverley, Sir Walter 50
Cameron, Colonel 283
'Campaign for Local Distinctiveness' 302
Campbell, Beatrix xx
Camperdown, Earl of 183
Canavan, *Miner* xviii, 144, **144**
Canavan, Neil 75, 319
 Viewpoint Markers and Bench 75, **75**
Candlish, John 181–2, **181**
Captain Cook, Monument to, Marton (Anon) 288–9,
 289
Captain Cook Vase, Marton (Anon) 288, **288**
Carlisle, 10th Earl of 43
Carmichael, J.W. 97
Carneiro, Alberto 53, 59, 319
 Stones Garden 52–3, **53**
Carpenter, Andrew 245
Carr, Jo 131
Carr-Ellison, Colonel Sir Ralph 139
Carrick, Alexander 319
 War Memorial 16, **16**
Carrick Colliery 24
Carved Seats
 Chester-le-Street (Barrett) 227, **227**
 Kibblesworth (Sell) (Primetime Sculptors) 82–3,
 82
Case for an Angel, A (Gormley) 57
Castlereagh, Lord, 2nd Marquis of Londonderry 247
Cavendish, Lord Frederick 297
Cement Menagerie 22
Chadwick, Lyn 76
Chaine, Jean François 205
Chambers, Robert 64, 138, **138**, 216
Chaplin, Charlie 302
Chapman Taylor and Partners 111
Charles II, Newcastle upon Tyne (Anon) 137–8, **137**
Charles II, king of England 28, 137, 219
Charles, Prince of Wales 267, 268
Charles Stuart, Bonnie Prince Charlie 28
Charlton, Bobby 11
Charlton, George 71–2, **72**
Charlton, Jack 11, 12
Cheere, John 215, 286
Chester-le-Street xxiii
 'Art in the Landscape' project 226–7
 Carved Seats 227, **227**
 Dainty Dinah 226, **226**
 Lambton Earthwork xxiv, 225, **225**
 Mars Garden Chester-le-Street (Dickinson) 227–8,
 228
 The Milky Way xxvii, 228, **228**

Riverside Walk and Gardens xxii, 227–8
Way-markers and Seat 227, **227**
Chevy Chase 44
Chillingham, *Field Marshall Viscount Gough* 22–4, **23**
Chillingham Castle 23
Circling Partridges, Sunniside (Ainsworth) xxvii,
 205–6, **205**
City Challenge 89
City of Newcastle Coat of Arms and *Cornucopia*,
 Newcastle upon Tyne (Anon) 115–16, **115**
Clark, C.R.B. 153
Clark, Kenneth 266
Clark, T.T. 156
Clarke, C.W., *Farewell Squalor* 268
Clarke, Geoffrey 93, 319
 Spiral Nebula 142–3, **143**
Clarkson, Alderman 282
Clasper, Harry 138, 215–16, **215**
Classic Masonry 96
Clennell, Harriet Pennell 27
Clennell, Luke 29
Clennell Memorial Fountain, Harbottle (McMillan)
 27, **27**
Clerk, Jane and Eleanor 24
Cleveland, Duchess of (Lady Sophia Poulett) 273
Cleveland, Duke of 234
Cleveland, Henry Vane, 2nd Viscount and Duke of
 273, **273**
Cleveland Arts xxiii, 258, 281, 308, 312
Clinch, John 320
 British Cinema Centenary sculpture 304, **304**
 Showtime 302–3, **303**
Clock Tower, Morpeth, *Watchmen of the Clock
 Tower* 43
coalfields 88
Coat of Arms, Berwick-upon-Tweed (Anon) 17, **17**
Coats of Arms of Gateshead, Newcastle and *Port of
 Tyne Authority*, Newcastle upon Tyne (Anon)
 135, **135**
coats of arms
 Armstrong 144
 Berwick-upon-Tweed 17, **17**
 Gateshead, Newcastle and Port of Tyne Authority
 135, **135**
 Master Mariners 211, **211**
 Newcastle upon Tyne 115–16, **115**, 152, **152**
 Royal 118, **118**, 141–2, **141**
 Thornaby-on-Tees xv
 University of Newcastle 142, 143–4
Cockerel and Sun Stile, Kibblesworth (Sell) 79–80, **80**
Cockfield, *Green Seat* 228–9
Cole, Richard 74, 271, 320
 Reveal 251, **251**
 Spheres 124, **124**
 Windy Nook 74, **74**

colliery disasters xvi, xviii, 248, 252, 261
 Ashington Colliery Disaster Memorial xviii, 9–10, **10**
 Easington Colliery Disaster Memorial, 1952 256, **256**
 Easington Colliery Disaster Memorial, 1953 255–6, **255**
 Hartley Disaster Memorial xvi, 55–6, **56**
 Rocking Strike Memorial 276, **276**
 Seaham Colliery Disaster Memorial, 1871 269–70, **269**
 Seaham and Rainton Colliery Disaster Memorial, 1880 270–1, **270**
 Trimdon Colliery Disaster Memorial 277, **277**
 Tudhoe Colliery Disaster Memorial 277–8, **278**
 West Stanley Colliery Disaster Memorial, 1913 274–5, **275**
 West Stanley Colliery Disaster Memorial, 1995 xviii, 275–6, **275**
 Wingate Grange Colliery Disaster Memorial 278–9, **278**
Collingwood, Admiral Lord Cuthbert 128, 138–9, **139**, 140, 207–9, **207**
Collins, Henry and Joyce, *Newcastle Through the Ages* 125, **125**, 126, 320
Colonel Edward Moseley Perkins, Monument to, Birtley (Burn) 52, **52**
Colonel G.E. Benson, Monument to, Hexham (Tweed) 30–1, **30**
Column and Steps, Newcastle upon Tyne (Burton) 109, **109**, 110
columns
 British Liberty, Monument to 214–15, **214**
 Column and Steps 109, **109**, 110
 Endless Column 201, **201**
 Evelyn Column xiv, 39–41, **40**, **41**
 Grey's Monument 96–8, **96**, **97**
 John English, Monument to 216–17, **216**
 Peace Column 5–6, **6**
 Percy Tenantry Column 1–3, **2**, 167
 Seaton High Light Memorial 284
 Way-markers 227, **227**
 Wallsend First World War Memorial 155, **155**
Colvill, Miss 117
Colvill, Edwin Dodd 117, **117**
Colvill fountain, Newcastle upon Tyne 116
Common Ground xxiii, 285, 302, 312
Compagnie des Bronzes, Brussels 121
Cone, Gateshead (Goldsworthy) 67–8, **68**
Conservation Area Partnership Scheme 13
Consett
 Derwent Valley sculptures 230, **230**
 Terris Novalis xviii, xxiii, 229–30, **229**
Conversation Piece, South Shields (Muñoz) xxii, xxiii, 163, 172, **172**

Cook, Captain James 287, 288–9, **288**, **289**, 292, 293, 298, **298**, 304
Cooper, Henry 221
Copnall, Edward Bainbridge 280, 320
 Family Group 280, **280**
Cormorant marker post 302
Costain Property Developments Ltd 221
Coulson, Colonel William Lisle Blenkinsopp 118–19, **119**
 Musings on Moor and Fell 119
Couves, L.J., and Partners 133
Cowen, Joseph 53, 62, 95–6, 113, 152–3, **153**, 290
Cowen, Joseph, Jnr 54, 152
Cragg, Tony 320
 Terris Novalis xviii, xxiii, 229–30, **229**
Craggs, Joseph and Robert, *George Hawks, Monument to* 59–60
Cragside 46, 93
Cramlington, xviii, xxvi, *231* 24, **24**
Crawford, Douglas, architect, *Wingate Grange Colliery Disaster Memorial* 278–9, **278**
Crawford, Jack 182–3, **182**, 185, **185**
Crawford, William 252, 253
Cresswell, John 20
Cribbins, Bernard 73
Crichton, Fenella 114
Crimean War 78, 93
Cross, Lady's Well, Holystone (Anon) 33, **33**
Cross and Lion Rampant, Newcastle upon Tyne (Anon) 142, **142**
crosses xv
 Bede Memorial Cross 188–90, **189**, **190**
 Cross, Lady's Well 33, **33**
 Cross and Lion Rampant 142, **142**
 Duckett's Cross 279, **279**
 Earls of Derwentwater Memorial 28, **28**
 Malcolm's Cross xix, 3–4, **4**
 Percy Cross 43–4, **44**
 Percy's Cross 29, **29**
 Rothbury Cross 45–6, **45**
 Saltburn War Memorial 305, **305**
 Seaham Colliery Disaster Memorial, 1871 269–70, **269**
 Seaham and Rainton Colliery Disaster Memorial, 1880 270–1, **270**
Crozier, Margaret 24
Cullercoats, *Adamson Memorial Drinking Fountain* 55, **55**
Currie, Mr 151
Currie, William 90
Customs House Charitable Trust 176

Dainty Dinah, Chester-le-Street (Anon) 226, **226**
Dame Allan, Newcastle upon Tyne (Anon) 144–5, **145**

Darling, Grace xiii, xvi, 12–13, **12**, 210–11
Darling, William 210
Darlington
 Aldi supermarket 238
 Bull 230–1, **230**
 Bulmer's Stone 234–5, **235**
 Central House 234–5
 Figure Form; Pictogram; Zenga Dogs; Zen Column; Totem Group 239–40, **239**, **240**
 Fothergill Memorial Fountain xix, 235–6, **236**
 Joseph Pease, Monument to xvii, **xvii**, 232–4, **232**, **233**
 Morrison's supermarket 240, 241
 Personifications of Art and Science 234
 Resurgence xviii, xxiv, 237–8, **237**
 Retail Park 238
 South African War Memorial 236–7, **237**
 Town Hall 237, 238
 Train xiii, xxiii, 240–1, **241**
 Tree 238–9, **238**
 Untitled 238, **238**
 William Thomas Stead, Monument to 231, **231**
David II, king of Scotland 242
Davidson, Colin 76
 Vikings 76, **76**
Davies, Richard George 211, 320
 Duke of Northumberland, 3rd, Monument to the 210–11, **211**
Davison, Alexander 39, 49
Davison, John 39, 49
Davison, William 2
Davison, Sir William 39
Davy Safety Lamp 167
'Dawn, the Great Detective' 79
Dawson, Alan 111
Deacon, Richard 69, 320
 Once Upon a Time … xiii, xix, 66, 69–70, **70**
Deborah Hunter Associates 200
Decorative Frieze, Hexham (Oliver) 31, **31**
Delaval, Captain Francis Blake RN 46
Delaval, Admiral George 46
Denton, John 282
Denton, Gray & Co. 282
Derwent Valley sculptures, Consett (Ward) 230, **230**
Derwent Walk 53
Derwent Walk Country Park 217
Derwent Walk Express, Whickham (Frost) 217, **217**
Derwenthaugh Coke Works 53
Derwentside District Council DSO 276
Derwentwater, Charles, 5th Earl of 28, **28**
Derwentwater, James, 3rd Earl of 28
Dickinson, Roger 321
 Mars Garden 227–8, **228**
 Root House 228
 Sun Temple 228

Dickson, William 8–9, **8**
Dinosaurs and Mammoth, Middlesbrough (Anon)
300, **300**
Discovery Wood Sculpture, Marton (Meadows) 287,
287
Disley, Michael 321
Meeting Point xxvi, 272–3, **272**
The Sheaf Thrower 280–1, **281**
The Spirit of Haswell 261, **261**
Disraeli, Benjamin 247
Di Suvero, Mark 162, 163, 321
Tyne Anew xvii, xxiii, 162–3, **163**
The Dive, The Surface, The Roll, Barnard Castle
(Alexander) 222–3
Dobson, John, architect 6, 121, 208, 209, 321
Admiral Lord Collingwood, Monument to 207–9,
207
Central Station, Newcastle upon Tyne 121–2,
121
Docker, Sunderland (Stewart) 202, **202**
Dockwray, Thomas 157
Dodshon, John 308–9, **308**
Dolly Peel, South Shields (Gofton) 103, 175, **175**
Dolphin Mooring Post, North Shields (Northern
Freeform) 158, **158**
Donald, Simon 205
Donaldson, William, *W.D. Stephens, Monument to*
116, **116**
Douglas, Earl of 44
Douglas, Sir George 22, 33
Doulton tiles 137
Dower, Robin 25
Downer, Abigail 321
*Sleeping Dragon, Dragon's Footprints, Dragon's
Eggs* 203, **203**
Doxford Hall 42
Doxford International Business Park 86
Doyle, Aidan, *Steam* 155, **156**
Dream Boat, Boldon (Gross) 54–5, **54**
Drinking Fountain, Newcastle upon Tyne (Anon)
102, **102**, 113–14, **114**
Drury, Alfred 100
Drury, Chris 321
Wave Chamber 35, **35**
Dublin 23
Duckett, John 279
Duckett's Cross, Wolsingham (Ryder) 279, **279**
Duke and Duchess of Cleveland Memorial Fountain,
Staindrop (Anon) 273, **273**
Duke of Northumberland, 3rd, Monument to the,
Tynemouth (Davies and Tate) 210–11, **210**
Duke of Wellington, Berwick-upon-Tweed (Anon)
16–17, **16**
Dunn, Mr 270
Dunn, Archibald M., architect 148

Dunn, Matthias 148
Dunston 101
National Garden Festival *see* Gateshead Garden
Festival
Dunston Staithes 70
Durham
Albert the Good 248, **248**
Battle of Neville's Cross 242, **242**
Durham Cow 251, 254, **254**
Durham Miners 252, **252**
Durham Miners' Association Offices 252–3
Kasuga Lantern 243–4, **243**
Kathedra 250, **250**
Londonderry Monument 245, 246–8
Marquis of Londonderry, 3rd, Monument to
246–8, **247**
Miners' Leaders 252–3, **252**, **253**
Neptune xiii, 244–6, **245**, **246**
The Obelisk 249–50, **250**
Oriental Museum 243–4
Patrick Lafcadio Hearn 244, **244**
Prebends Bridge 250
The Putter xviii, 253, **253**
Redhills 242
Reveal 251, **251**
Untitled 243, **243**
The Upper Room 251, **251**
The Way xv, 248–9, **249**
Durham, Bishop of 181
Durham, Dean of 190
Durham Cathedral Artist-in-Residence Scheme 250,
251
Durham Cow, Durham (Burton) 251, 254, **254**
Durham Miners, Durham (Olley) 252, **252**
Durham Trust 246
Durham Wildlife Trust 75
Dyson, John
Burt Hall, Newcastle upon Tyne 144, **144**
Miner 144, **144**
Dyson, J.W. 120

Eagle and Heads, Berwick-upon-Tweed (Wilson)
17–18, **17**
Earls of Derwentwater Memorial, Haydon Bridge
(Anon) 28, **28**
Earsdon, *Hartley Disaster Memorial* xvi, 55–6, **56**
Easington
'Looking Beyond' xxii, 256, 257, 261, 264
Seaside Lane 256
Easington Colliery 170, 253, 255–6
Brick Boat 256
Easington Colliery Disaster, 1952, Memorial 256,
256
Easington Colliery Disaster, 1953, Memorial
255–6, **255**

Easington Colliery Disaster, 1952, Memorial,
Easington Colliery (Anon) 256, **256**
Easington Colliery Disaster, 1953, Memorial,
Easington Colliery (Anon) 255–6, **255**
Easington Lane, *Pigeon Race* 56–7, **57**
Easington Lane Environmental Improvement
Programme 57
Easington Village, *The Roundels* 257, **257**
East Castle, *The Old Transformers: Miner and
Ironmaster* 257–8, **257**, **258**
East End Community Sculpture, Sunderland (Jarratt)
188, **188**
East Lendings, *Boundary Markers* 258–9, **258**
Eaton, Wilma 170
Pit Wheel 169–70, **170**
Eden Colliery 263
Edinburgh, Duke of 280
Edward III, king of England 242
Edward IV, king of England 29
Edward VII, king of England 121, **121**, 136, 137, 142,
144, 269
as Prince of Wales 93, 137, 141, 248
Edward VII and Royal Coat of Arms, Newcastle
upon Tyne (Anon) 141–2, **141**
Edward, Prince of Wales (Edward VIII) 92
Edwick, David 81, 321
Boy with Wet Feet 81, **82**
Pigeon Race 56–7, **57**
Seven Ages of Man 4–5, **4**
Edwin Dodd Colvill Memorial Fountain, Newcastle
upon Tyne (Anon) 117, **117**
Eglington Tournament 26, 27
Elder, Lester and Partners 270
Eldon, Lord 100
Eldon Associates 113
Eleanor Crosses xvi
Elephant Under a Moroccan Edifice, Newcastle upon
Tyne (Burton) 123–4, **124**
Elizabeth II, queen of England 37, 194, 280
Ellison, Henry 44
Elsdon
Bacchus 25, **25**
Gibbet 24–5, **25**
Elswick 93, 99
Elswick Court Marble Works, *Richard and Rachel
Grainger Memorial Fountain* 147, **147**
Elswick Ordnance Company 122
Emley and Sons, *Newburn First World War Memorial*
87, **87**
E.M. Bainbridge, John Lewis and *John Spedan Lewis*,
Newcastle upon Tyne (Rizzello) 112, **112**
Emma Colliery War Memorial, Ryton (Anon) 170–1,
170
Emmerson, H.H. 93
Endless Column, Sunderland (Ward) 201, **201**

English Heritage 98
English, John 216–17, **216**
English, Simon, *Metroland* 88
Errington, Charles, *J.H. Rutherford Memorial
 Fountain* 95–6, **96**, 321
Erskine, Robert, *Quintisection* xxvi, 85–6, **86**
Eslington Hall 51
Etty, W. 185
European Ceramic Centre, Netherlands 254
Evelyn Column, Lemmington (Soane) xiv, 39–41, **40**,
 41
Evelyn, Edward and Julie 40
Evelyn, James 40

The Family, Gateshead (Young) 65–6, **65**, **66**
Family Group, Billingham (Copnall) 280, **280**
Family of Penguins, Redcar (Wiles) 303–4, **304**
Faraday, Michael 261
Farbridge, R., *W. Wouldhave and H. Greathead,
 Monument to* 176–7, **177**
Farewell Squalor (Clarke) 268
Farne Islands 12
Farrington, Richard, *Trawl Door, Pillar* and *The
 Circle* xxiii, 305–6, **306**, 322
Faulkner-Brown, Harry, architect 100, 101
Felbridge, Surrey 40, 41
Fenwick, John 208
Fenwick-Clennell family 27
Ferdinand I, monument to 151
Ferryhill
 Beacon of Europe 259, **259**
 William Walton, Monument to 259–60, **260**
Festival Landmarks '90 122
Fetch, Ernest Edward, architect 178
 Town Hall, South Shields 178–80, **178**, **179**, **180**
Field for the British Isles (Gormley) xxi, 58
Field Marshall Viscount Gough, Chillingham (Foley
 and Brock) 22–4, **23**
*Figure Form; Pictogram; Zenga Dogs; Zen Column;
 Totem Group*, Darlington (Taylor) 239–40, **239**,
 240
Figure, Griffins and *Lion Heads*, Newcastle upon
 Tyne (Anon) 148, **148**
figureheads 159–60
Figures, Animals and Keystone Heads, Spittal
 (Wilson) 48, **48**
Fish, Tynemouth (Northern Freeform) 209, **209**
Fisher, Karl 190, 193, 258, 322
 Always Open Gates 193–4, **194**
 Boundary Markers 258–9, **258**
 Passing Through 196–7, **196**, **197**
 Pathways of Knowledge 194, **194**
 The Red House 195, **195**
 Shadows in Another Light xxiii, 163, 191–3, **192**,
 193

Watching & Waiting 195–6, **196**
Windows and Walls 193, 198, **198**
Flat Fish, Newcastle upon Tyne (Turner) 146–7, **147**
Fletcher Joseph, architects 240
Flight, Sunderland (Knowles) xxvi, 198–9, **199**
The Flock, Kielder (Wilkinson) 36, **36**
Flock of Swans, Newcastle upon Tyne (Schofield)
 112–13, **113**
Flodden xix, 21–2, 26
Flodden Memorial, Branxton (Anon) 15, 21–2, **21**
Flower Bed (Tremlett) 69
Foley, John Henry 23, 322
 Field Marshall Viscount Gough 22–4, **23**
Ford 26, 27
 Sybil's Well xix, 25–6
 Untitled 220 (LOST)
 Waterford Memorial Fountain 26–7, **26**
Ford, Edward Onslow 322
 Ralph Ward Jackson, Monument to xvii, 282–3, **282**
Ford, Ken xxiii
Fordyce, Thomas xx
Foreman, John 252
Forestry Commission 35
Forfarshire xiii, 211
Forman, John 252
Forster, Thomas 114
Fossilised Insect, Kibblesworth (Ward) 82, **82**
Fothergill, Dr John 235
Fothergill Memorial Fountain, Darlington (Hind) xix,
 235–6, **236**
fountains xvi
 Adam Robertson Fountain 6–7, **7**
 Adamson Memorial Drinking Fountain 55, **55**
 Clennell Memorial Fountain 27, **27**
 Drinking Fountain 102, **102**, 113–14, **114**
 *Duke and Duchess of Cleveland Memorial
 Fountain* 273, **273**
 Edwin Dodd Colvill Memorial Fountain 117, **117**
 Fothergill Memorial Fountain xix, 235–6, **236**
 George Charlton Memorial Drinking Fountain
 71–2, **72**
 Hollon Fountain 42–3, **42**
 Holywell War Memorial Fountain 34–5, **34**
 J.H. Rutherford Memorial Fountain 95–6, **96**
 J.J. Roddam Memorial Fountain 274, **274**
 John Dodshon Memorial Fountain 308–9, **309**
 Jubilee Fountain 15–16, **15**
 Maccoy Memorial Drinking Fountain 55, **55**
 Memorial Fountain 41, **41**
 Philip Laing Memorial Drinking Fountain 203–4,
 204
 Ravensworth Fountain 51, **51**
 Richard and Rachel Grainger Memorial Fountain
 147, **147**
 Robertson Memorial Fountain 22, **22**
 St Michael's Pant 5, **5**

*Sir Hedworth Williamson Memorial Drinking
 Fountain* 187, **187**
Temperley Memorial Fountain 31–2, **32**
Trotter Memorial Fountain 13, **13**
Waterford Memorial Fountain 26–7, **26**
W.D. Stephens, Monument to 116, **116**
Wesley Memorial Fountain 106, **106**
Will Dickson Fountain 8–9, **8**
William C. Rippon Memorial Fountain 169, **169**
William Laing Memorial Fountain 117–18, **117**
'Four Seasons' project 53, 59, 80, 205, **206**
Fowler, A.M., architect, Old Fish Market, Newcastle
 upon Tyne 103, **103**
Frampton, George 136, 322
 Queen Victoria Monument, Calcutta 206
 Queen Victoria, Monument to 135–6, **136**
France, Alderman and Mrs A. 132
France, Linda xxvii, 57, 163, 322
 Kin 163, **163**
 The Tide is Turning 163–4, **164**
Franklin, Alan 323
 Skedaddle 38, **38**
Freeform Arts Trust xxiii, 166
 Nater's Bank Seascape 165–6, **165**
Freeman, Lucy xxvii
French, Lieutenant General Sir John 71
French Revolution 39
Frink, Elizabeth 213
Frost, Andy 323
 Derwent Walk Express 217, **217**
Fulcher, Raf 110, 114–15, 323
 Garden Front 114–15, **114**
 Swirle Pavilion 110–11, **110**
Furuta, Hideo 70, 323
 Axiom 70, **70**

Gaitskell, Hugh 220
Gandy, J.M. 41
Garden Festivals *see* Gateshead Garden Festival;
 Glasgow Garden Festival
Garden Front, Newcastle upon Tyne (Fulcher)
 114–15, **114**
The Gardener xiv, 294
Gardner, Ralph 155–6, **156**
Garibaldi, Giuseppe 53–4, **54**, 153
Garibaldi, Head of, Blaydon (Burn) 53–4, **54**
Garrett, Daniel, architect 50, 323
 British Liberty, Monument to xv, xix, 214–15, **214**
Gateshead xxi, xxii, 81
 Allegories of Learning and Art 63, **63**
 Angel of the North xiii, xvii, xxiii, xxvi, 57–9, **58**
 Axiom 70, **70**
 Baltic Centre for Contemporary Arts 66, 111
 Bottle Bank 66–7, **67**
 Cone 67–8, **68**

The Family 65–6, **65**, **66**
Gateshead Quays 66
Gateshead War Memorial 65, **65**
George Charlton Memorial Drinking Fountain 71–2, **72**
George Hawks, Monument to 59–60
'goat herd' 68
Goats 68, **68**
Gravel Artwork xiii, 69, **69**
Inside Outside 74–5, **74**
James Renforth, Monument to xviii, 63–4, **64**
John Lucas, Monument to 62–3, **62**
(Low Fell) South African War Memorial 62, **62**, 70–1, **71**
Maccoy Memorial Drinking Fountain 73
Old Town Hall 72–3, **72**
Once Upon a Time … xiii, xix, 66, 69–70, **70**
Queen Elizabeth Hospital, art programme 74
Queen Victoria and *Personifications of Arts and Industry* 72–3, **72**
Riverside Sculpture Park xix, xxii, 66, 69
Rolling Moon 68–9, **69**
Saltwell Park 63, 71, 72
Scotswood Bridge 74
Sculpture Trail 66
Sculpture Week 74
Sports Day 73–4, **73**
Town Hall 73
Tranwell Unit 75
Victorian Baker's Shop 61, **61**
Viewing Platform 59, **59**
Window 60–1, **60**
Windy Nook 74, **74**
see also Art in Public Places; Art in Public Places Panel; 'Four Seasons' project; 'Marking the Ways'
Gateshead Garden Festival xv, xxii, 57, 64, 66, 68, 69, 101, 122, 123, 124, 249, 293
Gateshead Ironworks 60
Gateshead War Memorial, Gateshead (Spink) (Goulden) 65, **65**
Gazzard, Roy 221
George I, king of England 17
George V, king of England 41
George, Prince KG 132
George Charlton Memorial Drinking Fountain, Gateshead (Anon) 71–2, **72**
George Hawks, Monument to, Gateshead (Craggs) 59–60
George Stephenson, Monument to, Newcastle upon Tyne (Lough) xvii, xviii, xix, xx, 149–52, **149**, **150**, **151**
Gibbet, Elsdon (Anon) 24–5, **25**
Gibbon, Captain F.A. Laing 155
Gibson, Ellen Elizabeth 245

Gibson, J., *Albert the Good* 248, **248**
Gibson, John, architect 299, 323
Gibson, John, sculptor 149
Gibson, John Pattison 32
Gibson, Alderman T. 144
Gibson, Wilfrid W. 32
Gilbert, Alfred 120–1, 206, 323
 Jubilee Monument, Winchester 120
 Queen Victoria, Monument to 119–21, **120**
Gladstone, W.E. 231
Glasgow Garden Festival 69
Glass, William 279
Glatt, Genevieve, *Teessaurus* 299–300, **299**
Glaxo Gate, Barnard Castle (Alexander) 223, **223**
Glaxo Wellcome 223
Glennie, Evelyn 111
'Glorious Revolution' 39, 137, 219
Glorious Revolution, Monument to the, Kirkley (Anon) xix, 38–9, **38**
Glover, Alfred, *Progress (Northern Goldsmiths Clock)* 132, **132**
Goats, Gateshead (Matthews) 68, **68**
Godbold, James, blacksmith, *British Cinema Centenary sculpture*, 304, **304**
Gofton, William (Billy) 324
 Dolly Peel 103, 175, **175**
Going Home (Hedley) 144
'Golden' Lion, South Shields (Anon) 173–4, **173**
Goldsworthy, Andy 68, 324
 Cone 67–8, **68**
 Jolly Drover's Maze 263, **263**
 Lambton Earthwork xxiv, 225, **225**
Gordon, General 133
Gormley, Antony 57–9, 157, 162, 324
 Angel of the North xiii, xvii, xx, xxiii, xxvi, 57–9, **58**
 Brick Man 57
 Case for an Angel, A 57
 Field for the British Isles xxi, 58
Goscombe John, William 91, 92, 100, 324
 The Response 1914 90–2, **91**, **92**
Gough, Field Marshall Viscount 22–4, **23**
Goulden, Richard 65, 324
 Gateshead War Memorial 65, **65**
Gowrie, Lord 58
Grace Darling Monument, Bamburgh (Smith) xiii, xvi, 12–13, **12**
Graham, Kenneth 134
Grahame, George 119
Grainger, Richard 97, 111, 118, 147, **147**, 208
Grandjean, Lee, *Head, Hand and Tool* 300–1, **300**, 324
Grasskamp, Walter xxvi
Gravel Artwork, Gateshead (Tremlett) xiii, 69, **69**
Gray, Thomas 113–14

Gray, Sir William xvii, 281–2, **281**
Great Aycliffe Way 264–5
Great British Bollard Company, *Family of Penguins* 303–4, **304**
Great North Forest xxi, xxiii, xxvi, 54, 78, 313
Great Reform Bill and Act xiii, 97, 98
Greatham, *The Sheaf Thrower* 280–1, **281**
Greathead, Henry 176–7, **177**
Green, Benjamin 97, 118, 325
 Grey's Monument xiii, 96–8, **96**, **97**
Green, Benjamin and John, Snr
 Penshaw Monument 166–7, **167**
 Theatre Royal, Newcastle upon Tyne 118, **118**
Green, John, Jnr 97
Green, John, Snr 1, 325
The Green Man, Hamsterley (Townsend) 260–1, **260**
Green Seat, Cockfield (Alexander) 228–9
Greenesfield locomotive shed, Gateshead 58
Greenspace Initiative (NatWest) 75
Grenfell, Julian xxvii, 206
Gresley, Sir Nigel 240
Grey, Earl 63, 153
Grey, Earl (Charles) (1764–1845) xiii, 96–8, **96**, **97**
Grey, Viscount 98
Grey, Sir Edward 15–16
Grey, Sybil 26
Grey Monument, Chillingham xvi
Grey's Monument, Newcastle upon Tyne (Baily) (Green) (Hedley) xiii, 96–8, **96**, **97**
Griffin, Councillor Neil 251
Griffins' Heads, Wallington (Anon) xiv, xv, 49–50, **50**
Grizedale Forest xxi,
Groove, Wallsend (Broderick) 213–14, **213**
Gross, David 55, 325
 Dream Boat 54–5, **54**
 Hand 175–6, **175**
 Mask 209–10, **210**
Grubb, Martyn and Jane, *Wooden Dolly* 159–60, **159**
Guinness, Robert 23

Hackworth, Timothy xviii, 271–2, **271**
Haig, Earl 100
Halcyon 208
Hall, John 137
 Peace Column 5–6, **6**
Hall, Sir John 141
Hamilton, David 99
 Parsons Polygon 98–9, **99**
Hamond, Sir Charles Frederick (Alderman Hamond) 220
Hamsterley, *The Green Man* 260–1, **260**
Hancock Museum, Newcastle upon Tyne 93, 102, 103
Hand, South Shields (Gross) 175–6, **175**
Harbottle 27
 Clennell Memorial Fountain 27, **27**

Hardinge, Viscount 23
Hardwicke, Thomas 2
Hardy, Oliver 157, 302
Harewood Forest Enterprise, *Gibbet* 24–5, **25**
Hargreaves, Halifax 171
Harington, General C.H. 212
Harlow Green Infants School 59
Harris, Richard 325
 Bottle Bank 66–7, **67**
 Kyo Undercurrent 222, **222**
 Passage Paving 67
Harrison, Tony, 'Newcastle is Peru' 98
Harry Clasper, Monument to, Whickham (Burn)
 215–16, **215**
'Harry Hotspur' *see* Percy, Sir Henry
*Harry Hotspur, Roger Thornton, Sir John Marley and
 Thomas Bewick*, Newcastle upon Tyne (Anon)
 126–7, **126**, **127**
Hartlepool 58, 59
 Ralph Ward Jackson, Monument to xvii, 282–3,
 282
 Seaton High Light Memorial 284
 Sir William Gray, Monument to xvii, 281–2, **281**
 The Watcher 283–4, **283**
Hartlepool Fabrications Ltd 58
Hartley Colliery disaster 55–6, 248
Hartley Disaster Memorial, Earsdon (Anon) xvi,
 55–6, **56**
Hart's of Stockton 300
Hartwell, Charles Leonard 325
 Newcastle First World War Memorial 99–101, **100**,
 101
Haswell, *The Spirit of Haswell* 261, **261**
Haswell, Thomas 154–5, **154**
Haswell Colliery disaster 261
Hauxwell, Hannah 260
Havelock, Lady 183
Havelock, Major-General Sir Henry 182, 183, **183**
Hawke, Bob, Prime Minister of Australia 174
Hawking, Eddie 325
 Untitled 295–6, **296**
Hawks, Crawshay and Sons 60
Hawks, George 59–60
Hawksmoor, Nicholas 17
Hawthorn Leslie Fabrication Ltd 293
Haydon Bridge
 Earls of Derwentwater Memorial 28, **28**
 Haydon Bridge War Memorial 28–9, **29**
Haydon Bridge War Memorial, Haydon Bridge
 (Bentham) 28–9, **29**
Head of Garibaldi, Blaydon (Burn) 53–4, **54**
Head, Hand and Tool, Middlesbrough (Grandjean)
 300–1, **300**
Head Wrightson, Thornaby 309
Healey, Gene *Ashington War Memorial* 11, **11**

Heaney, Seamus xxv
Hearn *see* Lafcadio Hearn, Patrick
Hebburn, *Viewpoint Markers and Bench* 75, **75**
Hebburn Riverside Park 75
Hedgehog Seat, Kielder (Anon) 37, **37**
Hedgeley Moor 29, 44
 Percy's Cross 29, **29**
Hedley, Ralph, *Going Home* 144
Hedley, Roger 98, 325
 Alnwick War Memorial 1, **1**
 Grey's Monument xiii, 96–8, **96**, **97**
 Swan Hunter War Memorial 212–13, **212**
Henderson, Sid 58
Hennebique and Co. 154, 218
Henry II, king of England 9
Henry IV, king of England 120, 127
Henry VII, king of England 21
Henry VIII, king of England 22
Henry Bolckow, Monument to, Middlesbrough
 (Stevenson)xiv, xvii, 296–7, **297**
Heraldic Dragon, Newcastle upon Tyne (Anon)
 147–8, **148**
Heraldic Head with Armaments, Newcastle upon
 Tyne (Anon) 125, **125**
Heralds, Newcastle upon Tyne (Smith) 129, **129**
Hercules 48
Herrington opencast mine 167, 168
Hester Pit 56
Hexham
 Colonel G.E. Benson, Monument to 30–1, **30**
 Decorative Frieze 31, **31**
 Temperley Memorial Fountain 31–2, **32**
Highway Percent for Art Programme 45
Hill, Christine 102, 326
 Black Rhinoceros 102–3, **102**
Hilton, *Hilton Wheel* 284–5, **284**
Hilton Wheel, Hilton (Ayers) 284–5, **284**
Hind, Septimus, *Fothergill Memorial Fountain* xiv,
 235–6, **236**
Hirst High School 11
HMS Resolution 78
HMS Staunch 93
Hobson, Councillor Gladys 174, **175**
Hodges, Charles Clement 326
 Bede Memorial Cross 188–90, **189**, **190**
 Rothbury Cross 45–6, **45**, **46**
Hodgkin, Thomas 114
Hodgkin, Dr Thomas 89
Hodgkin Park, Newcastle upon Tyne 88, 89
Hodgson, John 44
Hogarth, William, *Analysis of Beauty* 215
Holden, W.F.C. 292
Hollon, R.W. 43
Hollon Fountain, Morpeth (Hutchinson) 42–3, **42**
Holmes, John Gilbert 299

Holmes, Oliver Wendell 3
Holwick, *Moor or Less* 261–2, **262**
Holy Island, *St Aidan* 32–3, **33**
Holystone
 Lady's Well, Cross 33, **33**
 St Paulinus 34, **34**
Holywell, *Holywell War Memorial Fountain* 34–5, **34**
Holywell War Memorial Fountain, Holywell (Anon)
 34–5, **34**
Homing Pigeon Society 56
Hooper, Les 131
Hope, Mayor Mrs V.M. 76
Hopper family 47
Hopper, Graeme 57, 326
 Bug and Mushrooms 264, **264**
 Untitled 243, **243**
Horden, *Sea Spirals* 262
Horder, Morley 127
Horner, factory and memorabilia 226
Horner, George 226
Horns of Minos, Killingworth (Ryder, Yates and
 Partners) 221, **221** (LOST)
Horsley, Hamish, *The Way* xv, 248–9, **249**
Hoskin, John 326
 Resurgence xviii, xiv, 237–8, **237**
Hoskins, George Gordon, architect 295
 Town Hall, Middlesbrough 294–5, **294**, **295**
Hotspur, Henry 44, 126
Howard, Bob 10
Howarth, Maggie 66, 326
 Nater's Bank Seascape 165–6, **165**
Hudson, George, architect 121, 150
 Central Station, Newcastle upon Tyne 121–2, **121**
Hugh Lee Pattinson & Co. 116
Hughes, Walter 9
Humphrey, Glen, *British Cinema Centenary
 sculpture* 304, **304**
Hungerford, Lord 29
Hunter, Douglas, *Tempesta: Where the River Meets
 the Sea* 200–1, **200**
Hunter, Sir G.B. 212
Hunter, Kenny, *Inter Alia* 85
Hunter, Summers 212
Hutchinson, A., *Hollon Fountain* 42–3, **42**
Hutt, Right Hon. William MP 60
Hutter Jennings and Titchmarch 240–1
Hutton, John 93
Hygeia 18, 19, 154

Ibbeson, Graham 326
 The Gardener xiv, 294
 Scales of Justice 294, **294**
 Shopper and Child 294
 Timothy Hackworth, Monument to xviii, 271–2,
 271

Icarus (Speer) 58
Ignatieff, Michael 66
Imago, Longbenton (Pym) 84–5, **84**
Ingram, Walter, *Lady Jerningham, Monument to*
14–15, **14**, 326
Inside Outside, Gateshead (Watson) 74–5, **74**
Inter Alia, New Silksworth (Hunter) 85
Ireshopeburn, *John Wesley Pillar* 262–3, **262**
Iron Horse Reconstructed, Longbenton (Kemp) 83, **83**

J. Seymour Harris and Partners 213
J. Starkie Gardner Ltd 247
Jack Crawford, Monument to, Sunderland (Wood)
182–3, **182**
Jack Crawford, Monumental Grave Stone to,
Sunderland (Anon) 185, **185**
Jackie Milburn
Ashington (Mills) xviii, 11–12, **11**
Newcastle upon Tyne (Maley) xviii, 140–1, **141**,
(*Wor Jackie*) (Robinson) 105, **105**
Jackson, Ralph Ward xvii, 281, 282–3, **282**
James I, king of England 137
James II, Newcastle upon Tyne (Larson and Wijck)
219, **219** (LOST)
James II, king of England 39, 219
as James, Duke of York 137
James III, king of Scotland 29
James IV, king of Scotland 21–2, 26
James Renforth, Monument to, Gateshead (Burn)
xviii, 63–4, **64**
Jamming Gears (Wilson) 307
Jarratt, Matthew xxvi, 75, 176, 188, 238, 326
Brick Boat 256
East End Community Sculpture 188, **188**
Nautical Objects 176, **176**
Sign Post 81, **81**
Untitled 238, **238**
Viewpoint Markers and Bench 75, **75**
Jarrow
Jarrow March xxiv, 77, **77**
Palmer Memorial Hospital 78
Sir Charles Mark Palmer, Monument to xvii, 77–8,
77
Time Line 75–6, **76**
Vikings 76, **76**
Jarrow March 77
Jarrow March, Jarrow (Rea) xxiv, 77, **77**
Jefferson, Arthur Stanley 157
Jerningham, Lady Annie 14–15, **14**
Jerningham, Hubert (Sir), *Lady Jerningham,
Monument to* 14–15, **14**
J.H. Rutherford Memorial Fountain, Newcastle upon
Tyne (Errington) 95–6, **96**
J.J. Roddam Memorial Fountain, Stanhope (Anon)
274, **274**

John, William Goscombe *see* Goscombe John,
William
John Bowes 78
John Candlish, Monument to, Sunderland (Bacon)
181–2, **181**
John Dodshon Memorial Fountain, Stockton-on-Tees
(Anon) 308–9, **308**
John English, Monument to, Whickham (Norvell)
216–17, **216**
John Lucas, Monument to, Gateshead (Stevenson)
62–3, **62**
John Simpson Kirkpatrick, Monument to, South
Shields (Olley) 174, **174**
John Vaughan, Monument to, Middlesbrough
(Lawson) xiv, xvii, 289–90, **289**
John Walker, Stockton-on-Tees (Sarabia) 306–7, **307**
John Wesley Pillar, Ireshopeburn (Anon) 262–3, **262**
John's Rock, Penshaw (Paton) 168–9, **168**
Johnson, James 5, 7, 34, 326
Battlement Figures 7–8, **7**
St Michael's Pant 5, **5**
St Paulinus 34, **34**
Johnson, R.J., architect 144
College House, Newcastle upon Tyne 144–5, **145**
Johnston, Dr George 19
Johnstone, John, architect, Gateshead Old Town Hall
72
Joicey, Lord (James, Baron Joicy) 43
Joicey Memorial Plaque, Morpeth (Anon) 43, **43**
Joicey Museum *see* Newcastle upon Tyne
Jolly Drover's Maze, Leadgate (Goldsworthy) 263,
263
Jones, Francis William Doyle, *South African War
Memorial* 70–1, **71**, 327
Jones, Peter 241
Jones, Samuel 307
Joseph Cowen, Monument to, Newcastle upon Tyne
(Tweed) 152–3, **153**
Joseph Pease, Monument to, Darlington (Lawson)
xvii, **xvii**, 232–4, **232**, **233**
Jubilee Fountain, Berwick-upon-Tweed (Anon)
15–16, **15**
Jubilee Monument (Gilbert) 120
Justice, Kirkleatham (Anon) xiii, 286, **286**

Kapoor, Anish, *Taratantara* xxiii
Kasuga Lantern, Durham (Anon) 243–4, **243**
Kataky, Bill, *Beacon of Europe* 259, **259**
Kathedra, Durham (Wilburn) 250, **250**
Keegan, Kevin 276
Keelrow, Newcastle upon Tyne (Talbot) (Ainsworth)
108–9, **109**
Keelrow (folksong) 109
Keepsake, Kielder (Moss) 35, **35**
Kelley, Jeff xxv

Kelly, Henry (Harry) 64
Kemp, David 83, 327
Iron Horse Reconstructed 83, **83**
King Coal 265, **265**
The Old Transformers: Miner and Ironmaster
257–8, **257**, **258**
Kench, Reuben 308
Kenyon, George 93
Seahorse Heads 94–5, **95**
Keystone Heads, Middlesbrough (Anon) 296, **296**
Keystone Heads, Busts, Decorations and Dog, Spittal
(Wilson) 47–8, **48**
Keystone Heads and *Coat of Arms*, Newcastle upon
Tyne (Anon) 152, **152**
Keyworth, William Day 327
Sir William Gray, Monument to xvii, 281–2, **281**
Kibblesworth xxiii, xxvii
Boy with Wet Feet 81, **82**
Bowes Railway Path, sculptures 78–9, **80–1**
Carved Seats 82–3, **82**
Cockerel and Sun Stile 79–80, **80**
Fossilised Insect 82, **82**
Marker Post 78–9, **79**
Sign Post 80, **80**, 81, **81**
Untitled Way-marker 79, **79**
West Wind 80–1, **81**
see also 'Marking the Ways' scheme
Kielder
The Flock 36, **36**
Hedgehog Seat 37, **37**
Keepsake 35, **35**
Shadow 37, **37**
Skedaddle 38, **38**
Viewpoint 36, **36**
Waterstones 36–7, **36**
Wave Chamber 35, **35**
Whirling Beans 37–8, **37**
Kielder Dam 35, 36, 37
Kielder Forest 35, 36
Kielder Partnership 35
Kielder Water 35, 36, 37
Killingworth 221
Horns of Minos 221, **221** (LOST)
Locomotive xxiv, 220–1 (LOST)
Killingworth Wagonway 84
Kimme, Luise xxiv
Kin, North Shields (Peever) (France) 163, **163**
King Coal, Pelton Fell (Kemp) 265, **265**
Kinnock, Neil 77
Kirkleatham
Justice xiii, 286, **286**
Sir William Turner's Hospital 285–6
Turner's Hospital Inhabitants xiii, 285–6, **285**, **286**
Kirkley, *Glorious Revolution, Monument to* xix, 38–9,
38

Kirkpatrick, John Simpson 174, **174**
Kirkpatrick Bros, Messrs 177
Kitchener, Lord 100
Kitchin, Roy 327
 Mechanical Arch 301, **301**
Knowles, Craig 190, 193
 Flight xxvi, 198–9, **199**
 Paddle Gate and *Tree Guard Railings* 197–8, **198**
 Passing Through 196–7, **196**, **197**
 Shadows in Another Light xxiii, 163, 191–3, **192**, **193**
 Taking Flight 193, 199, **199**
 Watching & Waiting 195–6, **196**
Knowles, John, *Percy Lion* xiii, 3, **3**
Knowles, Oliver, Leeson, architects 142
Knowles, William Henry, architect 32, 142, 144, 327
 The Arches and Hatton Gallery, Newcastle upon Tyne 141–2, **141**
 Armstrong Building, Newcastle upon Tyne 143–4, **143**
 Ashington Colliery Disaster Memorial 9–10, **10**
 Lord Armstrong, Monument to 92–3, **93**
 Temperley Memorial Fountain 31–2, **32**
Kovats, Tania 327
 Viewpoint 36, **36**
Kvaerner Cleveland Bridge Ltd 240
Kyo Undercurrent, Annfield Plain (Harris) 222, **222**

Lady Jerningham, Monument to, Berwick-upon-Tweed (Pennacchini et al) 14–15, **14**
Lady's Well 33, 34
Lady's Well, Cross, Holystone (Anon) 33, **33**
Lafcadio Hearn, Patrick 244, **244**
Laing, Alexander 120
Laing, James 204
Laing, John 204
Laing, Philip 203–4, **204**
Laing, William 116, 117–18, **117**
Lambton, F.W. MP 279
Lambton, John George 167
Lambton Earthwork, Chester-le-Street (Goldsworthy) xxiv, 225, **225**
Lambton Worm 167, 225
Lancey, General de 49
Landseer, Sir Edwin 2
'Lang Jack' 216–17
Langbaurgh Council 302
Langley Castle 28
Lantèri, Edouard 291, 327
 Sir Samuel Sadler, Monument to xiv, xvii, 290–1, **291**
Lanton, *Obelisk* xix, 39, **39**
Larson, William 137, 138, 328
 James II 219, **219** (LOST)
Laurel, Stan xxvi, 157–8, **157**, **158**, 302

Lawrence, T.E. 304
Lawson, George Anderson 328
 John Vaughan, Monument to xiv, xvii, 289–90, **289**
 Joseph Pease, Monument to xiv, xvii, **xvii**, 232–4, **232**, **233**
Lawson, Thomas, *Memory Lingers Here* 101
Leadgate, *Jolly Drover's Maze* 263, **263**
Leaske, Brigadier 139
Lee, Peter 267–8
Leeds Slate and Granite Company, *South African War Memorial*, Darlington 236–7, **237**
Lemmington, *Evelyn Column* xiv, 39–41, **40**, **41**
Lemmington Hall xiv, 40, 41
Leonardo da Vinci 219
Leventon, Rosie 186, 328
 Standing Stones 185–6, **186**
Lewis, J. and J.S. 112, **112**
Light Transformer, Sunderland (Palova and Pala) 191, **191**
Lindisfarne 33
Lindisfarne Gospels 190
Link Column, Sunderland (Ward) 202, **202**
Lintzford, Newcastle upon Tyne (Lloyd) 122, **122**
Lion, Newcastle upon Tyne (Burton) 122–3, **122**
Lion Rampant
 Alnwick (Anon) 8, **8**
 Warkworth (Anon) 50
Lions House, Berwick-upon-Tweed, *Venetian Lions* 18, **18**
Lippard, Lucy xxv
Lippincott, Don 293
Lisson Gallery 314
Liverpool, Lord 39
Lloyd, Nick 122, 328
 Lintzford 122, **122**
Local Worthies, Mythical and *Allegorical Figures*, Newcastle upon Tyne (Anon) 127–8, **128**, **129**
Lockett, Isabella, *The Milky Way* xxvii, 228, **228**
Locomotion 272
Locomotive
 Killingworth (Sansbury) xxiv, 220–1 (LOST)
 Sunderland (Regan) 187–8, **188**
London
 Battersea Power Station 115
 British Museum 40
 Euston Station 149
 Lord's cricket ground 100
 Minster Court 123
 Nelson Monument 151, 208, 214
 Piccadilly Circus, *Shaftesbury Memorial* 120
 St Paul's Cathedral 215
 Serpentine Gallery 69
 Soane Museum 41
 Somerset House 94

 South Bank 67
 Trafalgar Square 151, 183, 208, 214
Londonderry, 2nd Marquis of (Lord Castlereagh) 247
Londonderry, Charles Stewart, 3rd Marquis of 246–8, **247**
Londonderry, Charles Stewart, 6th Marquis of 268–9, **268**, **269**
Londonderry, Marquis of 167
Long, Richard xvi
Longbenton
 Arum Lily 83–4, **84**
 Imago 84–5, **84**
 Iron Horse Reconstructed 83, **83**
 Rising Sun 85, **85**
 Sustrans National Cycle Network 84
Longframlington, *Memorial fountain* 41, **41**
Longstaffe, W.H.D. 230
Lonsdale, portrait of Collingwood 208
'Looking Beyond' *see* Easington
Lord, Sir Riley 135, 137
Lord Armstrong, Monument to, Newcastle upon Tyne (Thornycroft) xvii, 92–3, **93**
Losh, James 151
lost works
 Alderman Hamond 220
 Horns of Minos 221, **221**
 James II 219, **219**
 Locomotive xxiv, 220–1
 Rabbie Burns 220
 Untitled 220
Lot's Wives and *Relief Heads*, Sunderland (Anon) 186, **186**
Lough, John Graham 20, 47, 151, 328
 Admiral Lord Collingwood, Monument to 207–9, **207**
 George Stephenson, Monument to xvii, xviii, xix, xx, 149–52, **149**, **150**, **151**
Louis Pasteur, Newcastle upon Tyne (Anon) 142
Louis XIV, king of France 137
Lubetkin, Berthold 267
Lucas, John 62–3, **62**
Lunn, Alderman Sir George 91
Lunn & Sons, J.S. 23

Mabey, [? C.H.] 299
 Britannia and Supporters **298**, 299
McCheyne, John Robert Murray xxiii, 93, 329
 Seahorse Heads 94–5, **95**
Maccoy, John 73
Maccoy Memorial Drinking Fountain, Gateshead (Anon) 73
Macdonald, Alexander 252–3
MacDonald, Ramsay 98
Mach, David 329
 Running out of Steam 240

Train xiii, xxiii, 240–1, **241**
Macklin, Thomas Eyre 329
 South African War Memorial xix, 129–31, **130**,
 131
Maclagen, Dr Philip Whiteside 18–19, **18**, **19**
McMillan, D., *Clennell Memorial Fountain* 27, **27**
McMillan, David, *Untitled* 123, **123**
Main, Major-General Edmond 43
Main Dike Stone, Newcastle upon Tyne (Anon) 87–8
Maine, John 329
 Solid State 301, **301**
Major-General Sir Henry Havelock, Monument to,
 Sunderland (Behnes) 183, **183**
Malcolm, king of Scotland 4
Malcolm's Cross, Alnwick (Anon) xix, 3–4, **4**
Maley, Tom 105, 141
 Jackie Milburn xviii, 140–1, **141**
Mallard, locomotive 240
Man with Pigeons, Newcastle upon Tyne (Wallace)
 113, **113**
Manpower Services Commission 61, 67, 74, 203
Margetson, W., *St George and Personifications of
 Music, Painting, Literature* and *Commerce* 294–5,
 294, **295**
Marker Post, Kibblesworth (Sell) 78–9, **79**
Market Woman, Wallsend (Schwarz) xxiii, 213, **213**
'Marking the Ways' scheme xxiv, xxvi, 53, 59, 78, 79,
 80, 81, 82, 83, 206, 224
Marlborough, Duke of 23
Marley, John **127**, 290
Marmion 26
Marquis of Londonderry, 3rd, Monument to, Durham
 (Monti) 246–8, **247**
Marquis of Londonderry, 6th, Seaham (Tweed) 268–9,
 268, **269**
Mars Garden, Chester-le-Street (Dickinson) 227–8,
 228
Marshall, Wendy, *Rising Sun* 85, **85**
Marshalls Clay Products 223
Marshalls Mono Ltd, Halifax 241
Marton
 Captain Cook, Monument to 288–9, **289**
 Captain Cook Primary School 287
 Captain Cook Vase 288, **288**
 Discovery Wood Sculpture 287, **287**
 Easterside Primary School 287
 Totem Pole 287, **287**
Mary Clare, Revd Mother 279
Mask, Tynemouth (Gross) 209–10, **210**
Maslin, Joan 267
Master Mariners' Coat of Arms, Tynemouth (Anon)
 211, **211**
Mastiffs, Blyth (Anon) 20–1, **20**
Mather, Charles 14
Matthew White Ridley, Blyth (Skee) 21, **21**

Matthews, Sally 68, 329
 Beamish Shorthorns xxiii, 223–4, **223**
 Goats 68, **68**
Maw, Tony, *Thornaby Aerodrome Memorial* 309–10,
 310
Mazzini, Giuseppe 53, 54
Meadows, Phil 329
 Discovery Wood Sculpture 287, **287**
 The Voyages of Captain Cook 298, **298**
Mechanical Arch, Middlesbrough (Kitchin) 301, **301**
Meeting Point, Spennymoor (Disley) xxvi, 272–3, **272**
Melrose Abbey 44
Memorial fountain, Longframlington (Anon) 41, **41**
Memory Lingers Here (Lawson) 101
Merchant Navy Memorial, South Shields (Olley) 173,
 173
Methuen, General Lord 30
MetroCentre 88
Metroland, Newcastle upon Tyne (English) 88
Metrolands Arbour and *Nine Lives*, Newcastle upon
 Tyne (Pym) 88, **88**, **89**
Middlesbrough
 Bottle of Notes xiii, xiv, xxiii, 292–4, **292**
 Britannia and Supporters **298**, 299
 Cleveland Gallery, outdoor collection 300–2
 Dinosaurs and Mammoth 300, **300**
 Head, Hand and Tool 300–1, **300**
 Henry Bolckow, Monument to xiv, xvii, 296–7, **297**
 John Vaughan, Monument to xiv, xvii, 289–90, **289**
 Keystone Heads 296, **296**
 Mechanical Arch 301, **301**
 police station 295
 Relief Doors 291–2, **291**
 *St George and Personifications of Music, Painting,
 Literature* and *Commerce* 294–5, **294**, **295**
 Scales of Justice 294, **294**
 Sir Samuel Sadler, Monument to xiv, xvii, 290–1,
 291
 Solid State 301, **301**
 Teesdale Way 302
 Teessaurus 299–300, **299**
 Teessaurus Park 299–300
 Town Hall 294–5
 Tugboat xxiii, 301–2, **302**
 Untitled 295–6, **296**
 Urban Programme 294
 The Voyages of Captain Cook 298, **298**
Midland Bank, Hexham, *Decorative Frieze* 31, **31**
Milburn, G.W.
 Bede Memorial Cross 188–90, **189**, **190**
 Temperley Memorial Fountain 31–2, **32**
Milburn, J., *Bellingham South African War Memorial*
 13–14, **14**
Milburn, Jackie (John Edward Thompson Milburn)
 ('Wor Jackie') xviii, 11–12, **11**, 105, **105**, 140–1, **141**

Milburn, Laura 12
mile posts 204
The Milky Way, Chester-le-Street (Lockett) xxvii,
 228, **228**
Mill Hill Primary School 86
Millennium Mile Post, Sunderland (Mills) 204, **204**
Mills, John 105, 141, 329
 Jackie Milburn xviii, 11–12, **11**
Mills, Jon, *Millennium Mile Post* 204, **204**
Mills, Matthew 5
 St Michael's Pant 5, **5**
Miner, Newcastle upon Tyne (Canavan) xviii, 144,
 144
Miners' Leaders, Durham (Whitehead) 252–3, **252**,
 253
mining *see* coalfields; colliery disasters
Minstrelsy of the Scottish and English Borders 44
Mitchell, W.G. 231
Moncur, Jenny xxii
Monroe, Marilyn 302
Montagu, Lord 29
Monti, Raffaelle 247, 330
 Marquis of Londonderry, 3rd, Monument to
 246–8, **247**
Moody, Eric xxiv
Moor or Less, Holwick (Alexander) 261–2, **262**
Moore, Charles 150
Moore, Henry 220
Morpeth
 Hollon Fountain 42–3, **42**
 Joicey Memorial Plaque 43, **43**
 Viking Warrior 41–2, **42**
 Watchmen of the Clock Tower 43
Morris, Keith 59
Morris, William 89
Morrison, *South African War Memorial* 62, **62**
Moss, Nicola 330
 Keepsake 35, **35**
 Mother and Child (Ibbeson) xiv
Mott MacDonald 103
Mountbatten, Duchess of 173
Mousdell, Vivien, *Unity is Strength* 263–4, **264**
Muñoz, Juan 330
 Conversation Piece xxii, xxiii, 163, 172, **172**
Murton, *Unity is Strength* 263–4, **264**
Myers, Dan 256

Napoleon 48, 247
Napoleonic Wars 224
Nater's Bank Seascape, North Shields (Howarth et al)
 165–6, **165**
National Cycle Network *see* Sustrans
National Garden Festival *see* Gateshead Garden
 Festival; Glasgow Garden Festival
National Glass Centre, Sunderland 190, **191**

National Inventory of War Memorials Survey xvi
National Lottery xxi, xxiii, 258
National Museum of Science and Industry 103
The Natural Cycle, North Shields (Bailey) 157, **157**
Nature Trail (Hebburn) 75
Nautical Objects, South Shields (Jarratt) 176, **176**
Nelson, Lord (Horatio, Viscount Nelson) 6, 49, 208
Nelson Monument, Swarland (Anon) 48–9, **49**
Neptune, Durham (Anon) xiii, 244–6, **245**, **246**
Neptune and Fishwives, Newcastle upon Tyne (Burn) 103, **103**
Neville, Hastings 27
Neville, Ralph, 4th Lord of 242
Neville Monument, Staindrop xvi
Neville's Cross, Battle of 242, 243
'New Milestones' project xxi, xxiii, 305, 306
New Silksworth
 Inter Alia 85
 Quintisection xxvi, 85–6, **86**
New Works for Different Places (Foster et al) xxv
Newbiggin xxi
Newbottle, *Russell Wood Sculptures* xxvi, 86–7, **86**
Newbottle Primary School 87
Newburn, *Newburn First World War Memorial* 87, **87**
Newburn First World War Memorial, Newburn (Emley and Sons) 87, **87**
Newbury A. Trent of Chelsea, *Wallsend First World War Memorial* 211–12, **212**
Newcastle Business Park xxii, 122, 123, 125
Newcastle Daily Chronicle 54
Newcastle First World War Memorial, Newcastle upon Tyne (Hartwell) 99–101, **100**, **101**
Newcastle Polytechnic *see* University of Northumbria
Newcastle Teetotal Society 72
Newcastle Through the Ages, Newcastle upon Tyne (Collins) 125, **125**, 126
Newcastle University *see* University of Newcastle
Newcastle upon Tyne xiv
 Admiral Lord Collingwood 138–9, **139**
 Alderman Hamond, Monument to 220 (LOST)
 Allegorical Figures 153–4, **154**
 Armstrong College 122, 135–6, 141, 144
 Articulated Opposites 134, **134**
 Bath Lane Church 95
 Bigg Market 95, 96
 Black Rhinoceros 102–3, **102**
 Blackett Street 99
 Blacksmiths' Needle xxvi, 111, **111**
 Bookstack 145–6, **145**
 Burma Campaign War Memorial 139, **139**
 Burt Hall 144, **144**
 Business Park *see* Newcastle Business Park
 Carliol House 133
 Central Station 121, 150

Charles II 137–8, **137**
Chirton Dene 161, 163–4
City Challenge 89
City of Newcastle Coat of Arms and *Cornucopia* 115–16, **115**
City Sculpture Project xxiv
Civic Centre 91, 93, 94, 95, 139
Coats of Arms of Gateshead, Newcastle and *Port of Tyne Authority* 135, **135**
Column and Steps 109, **109**, 110
Cross House 153
Cross and Lion Rampant 142, **142**
Cruddas Park 220
Dame Allan 144–5, **145**
Discovery Museum 99
Dockwray Square 157, 158
Drinking Fountain 102, **102**, 113–14, **114**
E.M. Bainbridge, John Lewis and *John Spedan Lewis* 112, **112**
East Quayside xxii, 105, 107, 109, 111
Edward VII and *Royal Coat of Arms* 141–2, **141**
Edwin Dodd Colvill Memorial Fountain 117, **117**
Eldon Square 99, 100, 101, 111, 112, 113
Elephant Under a Moroccan Edifice 123–4, **124**
Elswick 113–14
Figure, Griffins and *Lion Heads* 148, **148**
Fish Market 103, **103**
Fish Quay 157, 158, 166
Flat Fish 146–7, **147**
Flock of Swans 112–13, **113**
Garden Front 114–15, **114**
George Stephenson, Monument to xvii, xviii, xix, xx, 149–52, **149**, **150**, **151**
Grainger Street 98
Grey Street 94, 96, 98
Grey's Monument xiii, 96–8, **96**, **97**
Hancock Museum 93, 102, 103
Harry Hotspur, Roger Thornton, Sir John Marley and *Thomas Bewick* 126–7, **126**, **127**
Heraldic Dragon 147–8, **148**
Heraldic Head with Armaments 125, **125**
Heralds 129, **129**
Hodgkin Park 88, 89
Jackie Milburn xviii, 140–1, **141**
James II 219, **219** (LOST)
Jesus Hospital 102
J.H. Rutherford Memorial Fountain 95–6, **96**
Joicey Museum 102
Joseph Cowen, Monument to 152–3, **153**
Keelrow 108–9, **109**
Keystone Heads and *Coat of Arms* 152, **152**
Laing Art Gallery 100, 148
Leazes Park 220
Lintzford 122, **122**
Lion 122–3, **122**

Local Worthies, Mythical and *Allegorical Figures* 127–8, **128**, 129
Lord Armstrong, Monument to xvii, 92–3, **93**
Louis Pasteur 142
Magnet House 115
Main Dike Stone 87–8
Man with Pigeons 113, **113**
Metro stations 98, 99, 114, 129, 131, 160
MetroCentre 88
Metroland 88
Metrolands Arbour and *Nine Lives* 88, **88**
Milburn House 139, 140
Miner xviii, 144, **144**
Miners' Institute 148
Museum of the Natural History Society 93
Neptune and Fishwives 103, **103**
Newcastle First World War Memorial 99–101, **100**, **101**
Newcastle Through the Ages 125, **125**, 126
Northern Goldsmiths Company 132
Northumberland Fusiliers, 6th, War Memorial 90, **90**
Northumberland Street 126, 127, 129, 131
Paradise, Oasis and *Lovers' Gates* 88–9, **89**
Parsons Polygon 98–9, **99**
Peace Sculpture 101–2, **101**
Personifications of Science and *Art*, and two *Coats of Arms* 143–4, **143**
Progress (Northern Goldsmiths Clock) 132, **132**
Queen Victoria, Monument to 119–21, **120**, 135–6, **136**
Queen Victoria, Prince Albert and *King Edward VII* 121–2, **121**
Rabbie Burns 220 (LOST)
Redburn Dene 161, 165
The Response 1914 90–2, **91**, 92
Richard and Rachel Grainger Memorial Fountain 147, **147**
River God xxii, 107–8, **108**
River God Tyne 94, **94**
River Tyne 106–7, **107**
Robert Chambers, Monument to 138, **138**
Royal Coat of Arms 118, **118**
Royal Quays 161–3
Royal Victoria Infirmary 122, 135, 136–7, **136**, 144
Rudder 109, 110, **110**
St James's Park football ground 92
St Mary Magdalene Hospital 91
St Nicholas's Cathedral 95, 140
St Thomas's Church 91, 92
Sandgate Steps 107, 108, 109
Sapling 89, **89**
Scenes Illustrating the Power of Electricity 115, **115**
School of Architecture 142
Seahorse Heads 94–5, **95**

Sir Joseph Swan, Monument to 133, **133**
Siren xxii, 108, **108**
South African War Memorial xix, 129–31, **130**, **131**
Spheres 124, **124**
Spiral Nebula 142–3, **143**
Sun, Emblems of Insurance and *Atlantes* 104, **104**
Sun Life House 104, **104**
Swan House 134
Swans In Flight 94, **94**
Swing Bridge 135
Swirle 110
Swirle Pavilion 110–11, **110**
Symbolic Figures; Cockerel and Snake; Urns
 136–7, **136**
T.H. Bainbridge, Memorial to 131–2, **131**
Thomas Bewick 139–40, **140**
Tipping off the World 124, **124**
Twenty-Two Heads 133–4, **134**
Untitled **123**, 123, **146**, 146, 220 (LOST)
Untitled (The Benwell Bird) 104–5, **104**
Vampire Rabbit 140, **140**
W.D. Stephens, Monument to 116, **116**
Wesley Memorial Fountain 106, **106**
White Cross (medieval) 116
William Armstrong Drive 125
William Coulson, Monument to 118–19, **119**
William Laing Memorial Fountain 117–18, **117**
Wor Jackie xviii, 105, **105**
Worswick House and Chambers 133
Newcombe and Adams, architects, Royal Victoria
 Infirmary, Newcastle upon Tyne 136–7, **136**
Newnham, G.L., *Memoirs of Vice-Admiral Lord
 Collingwood* 208
Newton Aycliffe
 3M UK 264
 Bug and Mushrooms 264, **264**
 Sleeping Deer and *Newt* 265, **265**
 see also Great Aycliffe Way
Nexus (formerly Tyne and Wear Passenger Transport
 Executive) 83, 314
Nietzsche, Friedrich, *The use and abuse of history* xix,
 xx
Nine Lives (Pym) 88, **89**
Noble, Sir Andrew 93
Norfolk, Duke of 22
Norgas House, Killingworth 221
Norman, Francis Martin RN 15, 19, 22
North Shields 97
 Dolphin Mooring Post 158, **158**
 Kin 163, **163**
 Nater's Bank Seascape 165–6, **165**
 The Natural Cycle 157, **157**
 North Shields First World War Memorial 158–9,
 159
 Play Area 164, **164**

Prophecy Monolith 165, **165**
Ralph Gardner, Monument to 155–6, **156**
Sea Dreamer's Rest 161–2, **162**
Stan Laurel xxvi, 157–8, **157**, **158**
Steam 155, **156**
Thomas Haswell, Monument to 154–5, **154**
The Tide is Turning 163–4, **164**
Tyne Anew xvii, xxiii, 162–3, **163**
Walter Sculpture 161, **161**
Wave 160, **160**
West Allotment First World War Memorial 155,
 155
Wooden Dolly 159–60, **159**, 160–1, **160**, 166, **166**
North Shields First World War Memorial, North
 Shields (Reid and Proudfoot) 158–9, **159**
North Tyneside Arts 162
Northern Arts xxi, xxiii, 114, 166, 293, 314
Northern Freeform xxiii, 158, 330
 Dolphin Mooring Post xxiii, 158, **158**
 Fish 209, **209**
 Play Area 164, **164**
 Sundial 171, **171**
 Wave 160, **160**
Northern Reform League 62, 152
Northumberland, Duchess of xix, 146
Northumberland, Elizabeth, Duchess of 4
Northumberland, 1st Duke of xix, 4, 215
Northumberland, 3rd Duke of 210–11, **210**
Northumberland, Dukes of 2, 3, 4, 6, 7, 8, 87, 93, 159
Northumberland, 2nd Earl of 29
Northumberland Fusiliers, 6th, War Memorial,
 Newcastle upon Tyne (Reid) 90, **90**
Northumberland National Park Fell Rescue Team 98
Northumberland War Memorial (later *South African
 War Memorial*) 31
Northumbrian Water 265
Norvell, John, *John English, Monument to* 216–17,
 216

Oak Leaf (Ayers) 302
Obelisk
 Durham (Anon) 249–50, **250**
 Lanton (Anon) xix, 39, **39**
 Monument to the Glorious Revolution 38–9, **38**
 Nelson Monument 48–9, **49**
 (Newcastle) South African War Memorial xix,
 129–31, **130**, 130
 Ralph Gardner, Monument to 155–6, **156**
 Seaton Delaval (Vanbrugh) 46–7, **46**
 Thomas Haswell, Monument to 154–5, **154**
 Wesley Memorial Fountain 106, **106**
 Wingate Grange Colliery Disaster Memorial
 278–9, **278**
 William Walton, Monument to 259–60, **260**
obelisks *see also* columns

O'Connell, Maurice 53, 59, 330
 Viewing Platform 59, **59**
Ogle, Newton 39
Olav V, king of Norway 93, 94
The Old Transformers: Miner and Ironmaster, East
 Castle (Kemp) 257–8, **257**, **258**
Oldenburgh, Claes 292, 293, 330
 Bottle of Notes xiii, xiv, xxiii, 292–4, **292**
Oliphant, Lieut.-General Sir Laurence 131
Oliver, George Dale, *Decorative Frieze* 31, **31**
Oliver, Thomas, architect 151
Oliver, Leeson and Wood, architects 138, 139
 Admiral Lord Collingwood 138–9, **139**
 Sun Life House, Newcastle upon Tyne 104, **104**
 Thomas Bewick 139–40, **140**
 27 Dean Street, Newcastle upon Tyne 104, **104**
Olley, Robert 331
 Beacon of Europe 259, **259**
 Durham Miners 252, **252**
 John Simpson Kirkpatrick, Monument to 174, **174**
 Merchant Navy Memorial 173, **173**
 Stan Laurel xxvi, 157–8, **157**, **158**
Once Upon a Time ... Gateshead (Deacon) xiii, xix,
 66, 69–70, **70**
Original (lifeboat) 176
Otterburn
 Battle of 44, 126
 Percy Cross 43–4, **44**
Ove Arup & Partners 57
Over Easy, Stockton-on-Tees (Wilson) 307–8, **307**
Oxberry, John 65

Paddle Gate and *Tree Guard Railings*, Sunderland
 (Knowles) 197–8, **197**
Paine, James, architect 7, 214, 215, 331
 British Liberty, Monument to xv, xix, 214–15, **214**
Pala, Stepan, *Light Transformer* 191, **191**
Palmer, Lady 78
Palmer, Sir Alfred 119
Palmer, Sir Charles Mark xvii, 77–8, **77**
Palmer, George 78
Palmer Memorial Hospital (Jarrow) 78
Palmer's shipyard 75, 78
Palova, Zora 331
 Light Transformer 191, **191**
Palumbo, Lord 241, 293
Paolozzi, Eduardo 146
Paradise, Oasis and *Lovers' Gates*, Newcastle upon
 Tyne (Pym) 88–9, **89**
Parbury, Kathleen 331
 St Aidan 32–3, **33**
Park, Gilbert
 contractor 159
 Ralph Gardner, Monument to 155–6, **156**
Parker, Henry Perlee xvii

Parsons, Charles Algernon 99
Parsons Polygon, Newcastle upon Tyne (Hamilton) 98–9, **99**
Pasmore, Victor 93, 266, 267, 331
 Apollo Pavilion xiii, **xiv**, 265–7, **266**
'Pasmore's Folly' 267
Passage Paving (Harris) 67
Passing Through, Sunderland (Wilbourn, Fisher and Knowles) 196–7, **196**, **197**
Pasteur, Louis 142
Pathways of Knowledge, Sunderland (Wilbourn) (Fisher) 194, **194**
Paton, David 167, 168, 169, 332
 John's Rock 168–9, **168**
 Spires 167–8, **168**
Patrick Lafcadio Hearn, Durham (Sekiguchi) 244, **244**
Patterson, William Hammond 252
Pattison, Keith 168
Peace Column, Alnwick (Hall) 5–6, **6**
Peace Sculpture, Newcastle upon Tyne (Whitworth) 101–2, **101**
Pease, Edward 233
Pease, Joseph xvii, **xvii**, 232–4, **232**, **233**, 289, 290, 297
Pease, W.E. 237
Pedalling Art 131
Pederson, Hans Hartvig Seedorff, 'The Swans from the North' 94
Peel, Dorothy (Dolly) 175
Peel, Reg 175
Peel, Sir Robert 261
Peever, Alec
 Kin 163, **163**
 Prophecy Monolith 165, **165**
 The Tide is Turning 163–4, **164**
Pelton Fell, *King Coal* 265, **265**
Pennacchini, O.P. 332
 Lady Jerningham, Monument to 14–15, **14**
Penshaw
 John's Rock 168–9, **168**
 Penshaw Monument 166–7, **167**
 Spires 167–8, **168**
Penshaw Hill 167, 192
Penshaw Monument, Penshaw (Green) 166–7, **167**
Peppered Moth 84–5
Percy, Earl 7
Percy, Sir Henry ('Harry Hotspur') 44, 126–7, **126**, **127**
Percy, Sir Ralph 29
Percy, Ralph 44
Percy Cross, Otterburn (Anon) 43–4, **44**
Percy lion 2, 50
Percy Lion, Alnwick (Knowles) xiii, 3, **3**
Percy Tenantry Column, Alnwick (Stephenson) xiii, 1–3, **2**, 167
Percy's Cross, Hedgeley Moor (Anon) 29, **29**

Perkins, Colonel Edward Mosely 52, **52**
Personifications of Art and Science, Darlington (Anon) 234
Personifications of Science and Art, and two Coats of Arms, Newcastle upon Tyne (Rhind) 143–4, **143**
Personifications of South Shields, Industry, Arts, Crafts and Labour, South Shields (Binney) 179–80, **179**
Peter Johnson Ltd 24
Peter Lee, Peterlee (Anon) 267–8, **267**
Peterlee
 Apollo Pavilion xiii, **xiv**, 265–7, **266**
 Peter Lee 267–8, **267**
Petheridge, Deanna xxii
Pevsner, Nikolaus xx, 8, 25, 50, 52, 88, 115, 267
Philip VI, king of France 242
Philip, Birnie, *Waterford Memorial Fountain* 26–7, **26**
Philip Laing Memorial Drinking Fountain, Sunderland (Anon) 203–4, **204**
Philip Maclagan, Monument to, Berwick-upon-Tweed (Stevenson) 18–19, **18**, **19**
Phillips, Patricia xxvii
Phoenix Cobbles 66
Picture Postcard Railings, Redcar (Topp) 302, **302**
Pigeon Race, Easington Lane (Edwick) 56–7, **57**
Piper, John 93
Pipewellgate, Gateshead 68
 Cone 67–8, **68**
 Goats 68, **68**
 Gravel Artwork 69, **69**
 Rolling Moon 68–9, **69**
Pit Wheel, Ryhope (Eaton) 169–70, **170**
Pitt, William 6
Play Area, North Shields (Broderick and Robinson) 164, **164**
Poe, Edgar Allan, 'Ms in a Bottle' 293
Pontoon, Sunderland (Stewart) 201–2, **202**
Potter, Tracey, *British Cinema Centenary sculpture* 304, **304**
Poulett, Lady Augusta Mary 273
Poulett, Lady Sophia 273
Pound, Ezra, 'Fish and the Shadow' 201
Power, Gary 332
 Badger xiii, 44–5
Primetime Sculptors xxiii, 83
 Carved Seats 82–3, **82**
Pringle, Miss 2
Prism 102
Progress (Northern Goldsmiths Clock), Newcastle upon Tyne (Glover) 132, **132**
Prophecy Monolith, North Shields (Peever) 165, **165**
Proudfoot, Alex, *North Shields First World War Memorial* 158–9, **159**
Prudhoe, Badger xiii, 44–5
The Putter, Durham (Brown) xviii, 253, **253**

Pym, William 83–4, 85, 88, 157, 332
 Arum Lily 83–4, **84**
 Imago 84–5, **84**
 Metrolands Arbour and *Nine Lives* 88, **88**, **89**
 Paradise, Oasis and *Lovers' Gates* 88–9, **89**
 Sapling 89, **89**
 Untitled (The Benwell Bird) 104–5, **104**

Quaking Houses, Stanley xxiii
Queen Victoria *see* Victoria, queen of England
Queen Victoria Monument, Calcutta (Frampton) 206
Queen Victoria Monument, Nottingham (Toft) 78
Queen Victoria, Monument to
 Newcastle upon Tyne (Frampton) 135–6, **136**
 Newcastle upon Tyne (Gilbert) 119–21, **120**
 South Shields (Toft) 177–8, **177**
 Tynemouth (Turner) 206–7, **206**
Queen Victoria and *Personifications of Arts and Industry*, Gateshead (Anon) 72–3, **72**
Queen Victoria, Prince Albert and *King Edward VII*, Newcastle upon Tyne (Anon) 121–2, **121**
Queen's Head, Rothbury (Anon) 45, **45**
Quintisection, New Silksworth (Erskine) xxvi, 85–6, **86**

Rabbie Burns, Newcastle upon Tyne (Anon) 220 (LOST)
Racing Ahead, Stockton-on-Tees (Brown) 308, **308**
Raine, Kathleen, 'The Healing Spring' 84, 85
Raine, Walter MP 181
Ralph Gardner, Monument to, North Shields (Park) 155–6, **156**
Ralph Ward Jackson, Monument to, Hartlepool (Ford) xvii, 282–3, **282**
Randall, Amanda 332
 The Roundels 257, **257**
Ravensworth, Athole, 3rd Earl of 51
Ravensworth, Lord 150
Ravensworth Fountain, Whittingham, (Brownlee)(Reavell) 51, **51**
Ray, Richard 181, 332
 Sir Joseph Swan, Monument to 133, **133**
 Sunderland First and Second World War Memorial 180–1, **181**
Rea, Vincent 77, 332
 Jarrow March xxiv, 77, **77**
Reavell, George 333
 Ravensworth Fountain 51, **51**
 Robertson Memorial Fountain 22, **22**
Rechberg, Arnold Frédéric 333
 William Coulson, Monument to 118–19, **119**
The Red House, Sunderland (Wilbourn and Fisher) 195, **195**
Redcar xxii
 British Cinema Centenary sculpture 304, **304**

Family of Penguins 303–4, **304**
Picture Postcard Railings 302, **302**
Showtime 302–3, **303**
Redheugh Toll Bridge xix, 70
Regan, Lynne 188, 333
 Locomotive 187–8, **188**
Reginald, Lord 269
Reid, John 333
 Ashington Colliery Disaster Memorial xviii, 9–10,
 10
 North Shields First World War Memorial 158–9,
 159
 Northumberland Fusiliers, 6th, War Memorial 90,
 90
Reid Printers 94
Relief Doors, Middlesbrough (Anon) 291–2, **291**
Renforth, James xviii, 63–4, **64**, 138, 216
Renton Howard Wood Levine, architects 308
Renwick, Lady 91, 92
Renwick, Sir George 91, 92
The Response 1914, Newcastle upon Tyne (Goscombe
 John) 90–2, **91**, **92**
Resurgence, Darlington (Hoskin) xviii, xxiv, 237–8, **237**
Reveal, Durham (Cole) 251, **251**
Reynes, Laurent 53, 59, 80–1, 205, 333
 Bridge 81, 205, **205**
 West Wind 80–1, **81**
Reynolds-Stephens, William 333
 Saltburn War Memorial 305, **305**
Rhind, William Birnie 333
 Personifications of Science and *Art*, and two *Coats
 of Arms* 143–4, **143**
Richard and Rachel Grainger Memorial Fountain,
 Newcastle upon Tyne (Elswick Court Marble
 Works) 147, **147**
Richardson, Alderman 63
Richardson, Christopher 215, 333
 British Liberty, Monument to xv, xix, 214–15, **214**
Richardson, Moses Aaron xx, 94
Richardson, T.M. Snr xx, 97
Richmond, Sir William 291
Ridley, Sir Matthew White (1st Viscount) xiv, 21, **21**
Ridley, (2nd Viscount) 21
Ridley, (4th Viscount) 20
Ridley, Richard 21
Ridley Bulls, Blagdon (Anon) 20, **20**
Ridley Park 21
Rippon, Mary A. 169
Rippon, William C. 169, **169**
Rising Sun, Longbenton (Marshall) 85, **85**
Rising Sun Country Park 85, 157
Rites of Durham 242
Ritson, Utrick 106
River God, Newcastle upon Tyne (Wallace) xxii,
 107–8, **108**

River God Tyne, Newcastle upon Tyne (Wynne) 94,
 94
River Tyne, Newcastle upon Tyne (Talbot) 106–7,
 107
Riverside art projects, Sunderland 200, 202
Riverside Sculpture Park *see* Gateshead
Rizzello, Michael 334
 E.M. Bainbridge, John Lewis and *John Spedan
 Lewis* 112, **112**
Robert Chambers, Monument to, Newcastle upon
 Tyne (Burn) 138, **138**
Robert Thompson Ltd, *Wooden Dolly* 160–1, **160**
Roberts, Lord 237
Robertson, Alderman Adam 6–7, **7**
Robertson, Watson Askew 22
Robertson Memorial Fountain, Branxton (Reavell) 22,
 22
Robinson, Graham
 Nater's Bank Seascape 165–6, **165**
 Play Area 164, **164**
 Sundial 171, **171**
Robinson, Susanna, *Wor Jackie* xviii, 105, **105**
Robson, Cllr Chris 287
Robson, E.R. 245
Robson, W., *Seaham Colliery Disaster, 1871,
 Memorial* 269–70, **269**
The Rocket 272
Rocking Strike Memorial, Sunnybrow (Anon) 276,
 276
Roddam, John Joseph 274, **274**
Rodin, Auguste 30, 119, 153, 334
Rogers, Gilly 162, 334
 Sea Dreamer's Rest 161–2, **162**
Rogers, J. 133, **134**
 Twenty-Two Heads 133–4, **134**
Rohm and Haas company 75, 76
Rolling Moon, Gateshead (Rose) 68–9, **69**
Roman Ford Picnic Site, sculptures 223
Roos, Lord 29
Root House (Dickinson) 228
Rose, Colin 11, 38, 61, 67, 69, 146, 224, 334
 Ashington War Memorial 10–11, **10**
 Rolling Moon 68–9, **69**
 Stone Cone 224–5, **224**
 Whirling Beans 37–8, **37**
 Window 60–1, **60**
Ross, Mr 236
Rossi, monument to Collingwood 208
Rothbury
 Queen's Head 45, **45**
 Rothbury Cross 45–6, **45**, **46**
Rothbury Cross, Rothbury (Hodges) 45–6, **45**, **46**
Rothesay, Lord Stuart de 26
Rothley Castle 50
The Roundels, Easington Village (Randall) 257, **257**

Rovini and Partanti, foundry, *Sir William Gray,
 Monument to* 281–2, **281**
rowers, monuments to 63–4, 138, 215–16
Rowlands Gill, *William C. Rippon Memorial
 Fountain* 169, **169**
Royal Coat of Arms, Newcastle upon Tyne (Tate) 118,
 118
Royal George 272
Royal Society of British Sculptors 86
Royal Sovereign 208
Rudder, Newcastle upon Tyne (Burton) 109, 110, **110**
Runciman, Walter 42
Running out of Steam (Mach) 240
Russell Wood, Newbottle 87
Russell Wood Sculptures, Newbottle (Watts) xxvi,
 86–7, **86**
Rutherford, J.H. 95–6, **96**
Rutherford Fountain 120, **121**
Ryder, G.
 Duckett's Cross 279, **279**
 *Seaham and Rainton Colliery Disaster, 1880,
 Memorial* 270–1, **270**
 Trimdon Colliery Disaster Memorial 277, **277**
 Tudhoe Colliery Disaster Memorial 277–8, **278**
Ryder, Yates and Partners, architects, *Horns of Minos*
 221, **221** (LOST)
Ryhope, *Pit Wheel* 169–70, **170**
Ryhope Colliery 170
Ryton, *Emma Colliery War Memorial* 170–1, **170**

Sadler, Sir Samuel MP 290–1, **291**
St Aidan 33
St Aidan, Holy Island (Parbury) 32–3, **33**
St Cuthbert xv, 190, 249, 254
St George 90, 91, 99
*St George and Personifications of Music, Painting,
 Literature* and *Commerce*, Middlesbrough
 (Margetson) 294–5, **294**, **295**
St Michael's Pant, Alnwick (Johnson) (Mills) 5, **5**
St Ninian 33
St Paulinus 34
St Paulinus, Holystone (Johnson) 34, **34**
St Peter's Riverside *see* Sunderland
Salisbury, Lord 269
Saltburn War Memorial, Saltburn-by-the-Sea
 (Reynolds-Stephens) 305, **305**
Saltburn-by-the-Sea, *Saltburn War Memorial* 305, **305**
Samuel Smiths, brewery 160
Sans Pareil 272
Sansbury, Charles 93
 Locomotive xxiv, 220–1 (LOST)
Sapling, Newcastle upon Tyne (Pym) 89, **89**
Sarabia, Jose, *John Walker* 306–7, **307**
Scales of Justice, Middlesbrough (Ibbeson) 294, **294**
Scandinavia 94

Scenes Illustrating the Power of Electricity, Newcastle upon Tyne (Anon) 115, **115**
Scheemakers, Peter 286
Schier, Herman 277
Schofield, Mrs 32
Schofield, David, *Flock of Swans* 112–13, **113**
Schwarz, Hans 334
 Market Woman xxiv, 213, **213**
Scicluna, Tom 53
Scien Raen Women's Group 87
Scotswood Bridge (Gateshead) 74
Scott, Gawain 6
Scott, George Gilbert 334
 Waterford Memorial Fountain 26–7, **26**
Scott, Robert Sadler 94
Scott, Councillor Wally 168
Scott, Sir Walter xiii, xix, 17, 26, 44, 48
Scott, Wendy 75, 335
 Time Line 75–6, **76**
Scott and Reed, architects
 56 Westgate Road, Newcastle upon Tyne 152, **152**
Scoular, Andrew, *West Allotment First World War Memorial* 155, **155**
sculptural seat 55
Sculpture North 230
Sea Dreamer's Rest, North Shields (Rogers) 161–2, **162**
Sea Spirals, Horden (Barton) 262
Seaham
 Marquis of Londonderry, 6th 268–9, **268**, **269**
 Seaham Colliery Disaster, 1871, Memorial 269–70, **269**
 Seaham and Rainton Colliery Disaster, 1880, Memorial 270–1, **270**
Seaham Colliery disaster **xviii**, 252, 269–71
Seaham Colliery Disaster, 1871, Memorial, Seaham (Robson) 269–70, **269**
'Seaham Letter' 247
Seaham and Rainton Colliery Disaster, 1880, Memorial, Seaham (Ryder) 270–1, **270**
Seahorse Heads, Newcastle upon Tyne (McCheyne) 94–5, **95**
Seaton Delaval, *Obelisk* 46–7, **46**
Seaton High Light Memorial, Hartlepool (Anon) 284
Section Building Company of Sheffield 86
Sekiguchi, Masataka 335
 Patrick Lafcadio Hearn 244, **244**
Selby, Henry Collingwood 6
Sell, Chris 79, 83, 335
 Carved Seats 82–3, **82**
 Cockerel and Sun Stile 79–80, **80**
 Marker Post 78–9, **79**
 Sign Post 80, **80**
Sellers, J. Henry 31
Seven Ages of Man, Alnwick (Edwick) 4–5, **4**

SGS Environment 163, 165
Shadow, Kielder (Barton) 37, **37**
Shadows in Another Light, Sunderland (Wilbourn, Fisher and Knowles) xxiii, 163, 191–3, **192**, **193**
Shakespeare, William 17, 48
Shaw, Norman 46, 145
Shaw, Phyllida xxii
The Sheaf Thrower, Greatham (Disley) 280–1, **281**
Shearer, Alan 58
Shepherd and Shepherdess, Beamish (Anon) 224, **224**
Shepherds Construction 241
Shildon, *Timothy Hackworth, Monument to* xviii, 271–2, **271**
Shipley, J.A.D. 63
Shipley Art Gallery 216
 Allegories of Learning and Art 63, **63**
 Monument to James Renforth 63–4, **64**
Shiremoor, *Sundial* 171, **171**
Shopper and Child (Ibbeson) 294
Shotton Brothers 156
Showtime, Redcar (Clinch) 302–3, **303**
Shuttleworth, David, architect, *Thornaby Aerodrome Memorial* 309–10, **310**
Sign Post
 Kibblesworth (Jarratt) 81, **81**
 Kibblesworth (Sell) 80, **80**
Silksworth, *Silksworth War Memorial* 171–2, **172**
Silksworth War Memorial, Silksworth (Anon) 171–2, **172**
Silverlink Country Park, Shiremoor 171
Simm, Mayor Henry 134
Simpson, John Bell 142
Singer & Co., Frome 153
Sir Charles Mark Palmer, Monument to, Jarrow (Toft) xvii, 77–8, **78**
Sir Hedworth Williamson Memorial Drinking Fountain, Sunderland (Anon) 187, **187**
Sir Joseph Swan, Monument to, Newcastle upon Tyne (Ray) 133, **133**
Sir Samuel Sadler, Monument to, Middlesbrough (Lantèri) xiv, xvii, 290–1, **291**
Sir William Gray, Monument to, Hartlepool (Keyworth) xvii, 281–2, **281**
Sir William Turner's Hospital, Kirkleatham 285–6
 Turner's Hospital Inhabitants xiii, 285–6, **285**, **286**
Siren, Newcastle upon Tyne (Wallace) xxii, 108, **108**
Skedaddle, Kielder (Franklin) 38, **38**
Skee, George 335
 Matthew White Ridley 21, **21**
Skelton
 'New Milestones' residency 305, 306
 Trawl Door, Pillar and *The Circle* xxiii, 305–6, **306**
Slater, Jim 172
Sleeping Deer and *Newt*, Newton Aycliffe (Ward) 265, **265**

Sleeping Dragon, Dragon's Footprints, Dragon's Eggs, Sunderland (Downer) 203, **203**
Smailes, Stephen 308
Smiles, Samuel, *Life of George Stephenson, Railway Engineer* 150
Smirke, Robert 2
Smith, Councillor 114
Smith, C. Raymond 12, 335
 Grace Darling Monument xiii, xvi, 12–13, **12**
Smith, Sir David W. 2
Smith, James 275
Smith, Michael 271
Smith, Ray 131, 335
 Heralds 129, **129**
Smith, Revd Sydney 98
Smith, T. Dan 101, 134, 220
Smithson, Sir Hugh (1st Duke of Northumberland) 4, 215
Snod's Edge, Soldier, Fox and Dog 47, **47**
Soane, John 2, 40, 41, 335
 Evelyn Column xiv, 39–41, **40**, **41**
Soldier, Fox and Dog, Snod's Edge (Anon) 47, **47**
Solid State, Middlesbrough (Maine) 301, **301**
South African War 30, 35, 62, 70–1, 129–31, 206, 236
South African War Memorial
 Bellingham (Milburn) 13–14, **14**
 Darlington (Anon) 236–7, **237**
 Gateshead (Jones) 70–1, **71**
 Gateshead (Morrison) 62, **62**
 Newcastle upon Tyne (Macklin) xix, 129–31, **130**, **131**
South Shields
 Allegories of the Four Seasons 180, **180**
 Britannia, Neptune and Nymph 179, **179**
 Conversation Piece xxii, xxiii, 163, 172, **172**
 Customs House Arts Centre 173, 176
 Dolly Peel 103, 175, **175**
 'Golden' Lion 173–4, **173**
 Hand 175–6, **175**
 John Simpson Kirkpatrick, Monument to 174, **174**
 Marine Parks 176
 Merchant Navy Memorial 173, **173**
 Museum and Art Gallery 173
 Nautical Objects 176, **176**
 Personifications of South Shields, Industry, Arts, Crafts and *Labour* 179–80, **179**
 Queen Victoria 177–8, **177**
 St Joseph's School 176
 SS Peter and Paul's RC Primary School 175–6
 Town Hall 177–80, **178**, **179**, **180**
 W. Wouldhave and H. Greathead, Monument to 176–7, **177**
South Tyneside Groundwork Trust 75
Speer, Albert, *Icarus* 58
Spence, Sir Basil 143

Spennymoor, *Meeting Point* xxvi, 272–3, **272**
Spheres, Newcastle upon Tyne (Cole) 124, **124**
The Spider see Thornaby (The Spider)
Spielmann, M.H. 78
Spink, J.W., *Gateshead War Memorial* 65, **65**
Spiral Nebula, Newcastle upon Tyne (Clarke) 142–3, **143**
Spires, Penshaw (Paton) 167–8, **168**
The Spirit of Haswell, Haswell (Disley) 261, **261**
Spittal
 Figures, Animals and Keystone Heads 48, **48**
 Keystone Heads, Busts, Decorations and Dog 47–8, **48**
Spittal Tongues 101, 220
Spooner, Peter 220
Sports Day, Gateshead (Winstone) 73–4, **73**
Stabler, Arthur 220
Staindrop, *Duke and Duchess of Cleveland Memorial Fountain* 273, **273**
Stan Laurel, North Shields (Olley) xxvi, 157–8, **157**, **158**
Standing Stones, Sunderland (Leventon) 185–6, **186**
Stanhope, *J.J. Roddam Memorial Fountain* 274, **274**
Stanley
 West Stanley Colliery Disaster, 1913, Memorial 274–5, **275**
 West Stanley Colliery Disaster, 1995, Memorial xviii, 275–6, **275**
Stead, William Thomas 231, **231**
Steam, North Shields (Doyle) 155, **156**
Steedman, R.D. 98
Steele, W.J. 127
Steetley Quarries 273
Stella Hall 54, 153
Steng Cross 24
Stephens, William Davies 116, **116**, 118
Stephenson, David 2, 20, 335
 Cale Cross xiv, 19–20, **19**
 Percy Tenantry Column xiii, 1–3, **2**, 167
Stephenson, George xvii, xviii, xix, xx, xxiv, 83, 84, 128, 149–52, **149**, **150**, **151**, 187, 221, 235, 240, 272
Stephenson, Robert 150, 151
Stephenson, William Haswell 114, 120, 121
Stephenson monument 97, 147, 149–52, 209
Stephenson Trail xxii, 85, 186, 188
Stevenson, David W.S. 19, 336
 Henry Bolckow, Monument to 296–7, **297**
 Philip Maclagan, Monument to 18–19, **18**, **19**
Stevenson, W. Grant 336
 John Lucas, Monument to 62–3, **62**
Stewart, David 336
 Docker 202, **202**
 Pontoon 201–2, **202**
Stewart, T.D. 288
Stewart Park Discovery Wood 287

Stockton 77
Stockton Casting Co. 258, 308
Stockton-on-Tees
 ARC 307–8
 John Dodshon Memorial Fountain 308–9, **308**
 John Walker 306–7, **307**
 Over Easy 307–8, **307**
 Racing Ahead 308, **308**
Stockwell, Arthur, architect, Shipley Art Gallery 63
Stone Cone, Beamish (Rose) 224–5, **224**
Stone Stair Carpet, Sunderland (Wilbourn) 199–200, **200**
Stones Garden, Blaydon (Carneiro) 52–3, **53**
Stringfellow, Rita 162
Sun, Emblems of Insurance and *Atlantes*, Newcastle upon Tyne (Oliver, Leeson and Wood) 104, **104**
Sun Temple (Dickinson) 228
Sunderland xxiii
 Abstracted Natural Forms 201, **201**
 Always Open Gates 193–4, **194**
 Bede Memorial Cross 188–90, **189**, 190
 Bishopwearmouth Cemetery 183, 185
 boundary of 56
 Dame Dorothy Primary School 198
 Docker 202, **202**
 East End Community Garden 188
 East End Community Sculpture 188, **188**
 Endless Column 201, **201**
 Flight xxvi, 198–9, **199**
 Fulwell Junior School 198
 Gibbons's Butcher Shop 186
 Hylton Dene 203
 Jack Crawford, Monument to 182–3, **182**
 Jack Crawford, Monumental Grave Stone to 185, 185
 John Candlish, Monument to 181–2, **181**
 Light Transformer 191, **191**
 Link Column 202, **202**
 Locomotive 187–8, **188**
 Lot's Wives and *Relief Heads* 186, **186**
 Major-General Sir Henry Havelock, Monument to 183, **183**
 Millennium Mile Post 204, **204**
 Monkwearmouth Local History Group 198
 Mowbray Park 180–3
 Paddle Gate and *Tree Guard Railings* 197–8, **197**
 Passing Through 196–7, **196**, **197**
 Pathways of Knowledge 194, **194**
 Philip Laing Memorial Drinking Fountain 203–4, **204**
 Pontoon 201–2, **202**
 The Red House 195, **195**
 Roker 188–90
 Roker Park 187
 St Benet's RC school 198

St Peter's Riverside xv, xxii, xxiii, xxvi, xxvii, 190–1
 National Glass Centre 190, 191
 North Sands Business Centre 194
 Sculpture Project 190–200
 University 194
Shadows in Another Light xxiii, 191–3, **192**, **193**
Sir Hedworth Williamson Memorial Drinking Fountain 187, **187**
Sleeping Dragon, Dragon's Footprints, Dragon's Eggs 203, **203**
Standing Stones 185–6, **186**
Stone Stair Carpet 199–200, 200
Sunderland First and Second World War Memorial 180–1, **181**
Taking Flight 193, 199, **199**
Tempesta: Where the River Meets the Sea 200–1, 200
Trinity Churchyard 185
Untitled Boulders 188
Victoria Hall Tragedy Memorial 183–5, **184**
Watching & Waiting xxvii, 195–6, **196**
Windows and Walls 198, **198**
Sunderland, Mayor of 190
Sunderland Art Gallery 133
Sunderland College of Art 102
Sunderland Enterprise Park xix, 200–2
 'Riverside Exposed' Art Programme 200
 'Riverside Revealed' scheme 202
Sunderland First and Second World War Memorial, Sunderland (Ray) 180–1, **181**
Sundial, Shiremoor (Robinson) (Northern Freeform) 171, **171**
Sunniside
 Bridge 81, 205, **205**
 Circling Partridges xxvii, 205–6, **206**
Sunnybrow, *Rocking Strike Memorial* 276, **276**
Surrey, Earl of 22
Sustrans xxi, 157, 230, 316
 C2C xxiii, 84, 165, 222, 223, 224, 225, 229, 258, 265
 National Cycle Network 84, 225, 229, 258, 263
Swan, Sir Joseph 133, **133**, 134
Swan, Sir Kenneth 134
Swan, Robert 261
Swan Hunter War Memorial, Wallsend (Hedley) 212–13, **212**
Swans In Flight, Newcastle upon Tyne (Wynne) 94, **94**
Swarland, *Nelson Monument* 48–9, **49**
Swift, Jonathan 293
Swinburn, R., *William Walton, Monument to* 259–60, **260**
Swirle Pavilion, Newcastle upon Tyne (Fulcher) 110–11, **110**
Sybil's Well, Ford (Anon) xix, 25–6

Symbolic Figures; Cockerel and Snake; Urns, Newcastle upon Tyne (Anon) 136–7, **136**

Taborska, Halina xxiv
Tacca, Pietro 151, 219
Tait, Burnet and Lorne 133
Taking Flight, Sunderland (Knowles) 193, 199, **199**
Talbot, Anna 107
Talbot, Jay 107
Talbot, Neil 107, 336
 Keelrow 108–9, **109**
 River Tyne 106–7, **107**
 Victorian Baker's Shop 61, **61**
Tarmac Roadstone 70
Tate, Albert, Mayor of South Shields 174
Tate, Christopher 211, 336
 Duke of Northumberland, 3rd, Monument to the 210–11, **211**
 Royal Coat of Arms 118, **118**
Tatlin, *Monument to the Third International* 24
Taylor, John 106
Taylor, Tom 336
 Figure Form; Pictogram; Zenga Dogs; Zen Column; Totem Group 239–40, **239**, **240**
Teams Colliery 59
Tebbit, Norman MP 284
Teesdale District Council Artist-in-Residence Scheme 223, 229, 260, 262
Teessaurus, Middlesbrough (Glatt) 299–300, **299**
Temperley family 32
Temperley, William A. 32
Temperley Memorial Fountain, Hexham (Knowles) (Milburn) 31–2, **32**
Tempesta: Where the River Meets the Sea, Sunderland (Hunter) 200–1, **200**
Tennyson, Alfred, Lord, *Idylls of the King* 248
Terris Novalis, Consett (Cragg) xviii, xxiii, 229–30, **229**
Terry Farrell Associates 105
T.H. Bainbridge, Memorial to, Newcastle upon Tyne (Anon) 131–2, **131**
Thomas Bewick, Newcastle upon Tyne (Baily) 139–40, **140**
Thomas Haswell, Monument to, North Shields (Anon) 154–5, **154**
Thomas, Jack 54
Thompson, William 236
Thomson, James, 'Liberty' 214
Thornaby Aerodrome Memorial, Thornaby-on-Tees (Maw) 309–10, **310**
Thornaby (The Spider), Thornaby-on-Tees (Wall) xv, 309, **309**
Thornaby Town Council 310
Thornaby-on-Tees
 Thornaby Aerodrome Memorial 309–10, **310**

Thornaby (The Spider) 309, **309**
Thornley Woodlands Centre 53
Thornton, Roger 126, **127**
Thornycroft, William Hamo 93, 291, 336
 Lord Armstrong, Monument to xvii, 92–3, **93**
Three Busts, Berwick-upon-Tweed (Wilson) 17
Throckley Coal Co. 120
The Tide is Turning, North Shields (Peever) (France) 163–4, **164**
Tilesheds 54
'Time Garden' 249
Time Line, Jarrow (Scott) 75–6, **76**
Timothy Hackworth, Monument to, Shildon (Ibbeson) xviii, 271–2, **271**
Tipping off the World, Newcastle upon Tyne (Burton) 124, **124**
Titanic 231
Toft, Albert 78, 177, 178, 337
 Queen Victoria 177–8, **177**
 Sir Charles Mark Palmer, Monument to xvii, 77–8, **78**
Topp, Chris, *Picture Postcard Railings* 302, **302**
Totem Pole, Marton (Anon) 287, **287**
Town Hall, South Shields (Binney) (Fetch) 178–80, **178**, **179**, **180**
Townsend, Philip 337
 The Green Man 260–1, **260**
Train, Darlington (Mach) xiii, xxiii, 240–1, **241**
Trawl Door, Pillar and *The Circle*, Skelton (Farrington) xxiii, 305–6, **306**
Tree, Darlington (Bridgewood) 238–9, **238**
Treleaven, M.V., architect, 45 Northumberland Street, Newcastle upon Tyne 127
Tremlett, David 69, 337
 Flower Bed 69
 Gravel Artwork xiii, 69, **69**
Trevelyan, Sir Charles 98
Trevelyan, G.M. 98
Trimdon, *Trimdon Colliery Disaster Memorial* 277, **277**
Trimdon Colliery disaster 277, 278
Trimdon Colliery Disaster Memorial, Trimdon (Ryder) 277, **277**
'Tripod of the North' 162
Trotter, Dr James 13
Trotter, Dr William 43
Trotter Memorial Fountain, Bedlington (Anon) 13, **13**
Tucker, William, *Beulah IV* xxiv, xxvi
Tudhoe, *Tudhoe Colliery Disaster Memorial* 277–8, **278**
Tudhoe Colliery disaster 277–8
Tudhoe Colliery Disaster Memorial, Tudhoe (Ryder) 277–8, **278**
Tudor Art Metal Co. 132
Tugboat, Middlesbrough (Brailsford) xxiii, 301–2, **302**

Turbinia 99
Turner, Alfred 337
 Queen Victoria, Monument to 206–7, **206**
Turner, Chomley 286
Turner, Marwood 286
Turner, Piper James 139, 147
 Flat Fish 146–7, **147**
Turner, Sir William 285–6
 Hospital 285–6
Turner's Hospital Inhabitants, Kirkleatham (Anon) xiii, 285–6, **285**, **286**
Tweed, John 30, 153, 337
 Colonel G.E. Benson, Monument to 30–1, **30**
 Joseph Cowen, Monument to 152–3, **153**
 Londonderry family portraits 269
 Marquis of Londonderry, 6th 268–9, **268**, **269**
Twenty-Two Heads, Newcastle upon Tyne (Rogers) 133–4, **134**
231, Cramlington (Wilson) xviii, xxvi, 24, **24**
TWPTE (Tyne and Wear Passenger Transport Executive) xxii
 see also Art on the Metro; Nexus
Tyne Anew, North Shields (Di Suvero) xvii, xxiii, 162–3, **162**
Tyne Dock Engineering Ship Repair Yard 176
Tyne International exhibition 69, 101
Tyne Steam Shipping Co. 116
Tyne and Wear Development Corporation xxi, xxii, 75, 105, 106, 109, 111, 157, 158, 161, 163, 172, 174, 190, 193, 316
Tyne and Wear Passenger Transport Executive *see* Art on the Metro; Nexus
Tynemouth
 Admiral Lord Collingwood, Monument to 207–9, **207**
 Duke of Northumberland, 3rd, Monument to the 210–11, **211**
 Fish 209, **209**
 Fish Quay Festival 209–10
 Mask 209–10, **210**
 Master Mariners' Coat of Arms 211, **211**
 Master Mariners' Homes 210–11, **211**
 Metro station 209
 Norham Community High School 210
 Queen Victoria, Monument to 206–7, **206**
Tyneside 59

Unity is Strength, Murton (Mousdell) 263–4, **264**
University of Newcastle xv
 The Arches 141
 Armstrong Building 143–4
 debating chamber 142
 Hatton Gallery 141–2
 Herschel Physics Building 142–3
 School of Architecture 142

University of Northumbria 144
 Burt Hall 144
 College House 144–5
 Ellison Building 145–6
 Fashion Building 146–7
Untitled
 Darlington (Jarratt) 238, **238**
 Durham (Hopper) 243, **243**
 Middlesbrough (Hawking) 295–6, **296**
 Newcastle upon Tyne (Ford) 220 (LOST)
 Newcastle upon Tyne (McMillan) 123, **123**
 Newcastle upon Tyne (Wright) 146, **146**
Untitled Boulders, Sunderland (Bourne) 188
Untitled (The Benwell Bird), Newcastle upon Tyne
 (Pym) 104–5, **104**
Untitled Way-marker, Kibblesworth (Ward) 79, **79**
The Upper Room, Durham (Wilbourn) 251, **251**
Urwin, Alan 25

Vampire Rabbit, Newcastle upon Tyne (Anon) 140,
 140
van Bruggen, Coosje
 Bottle of Notes 292–4, **292**
 'Memos of a Gadfly' 293
Van Nost 245
Vanbrugh, Sir John 46, 47, 337
 Obelisk 46–7, **46**
Vane-Tempest, Frances Anne 247
Vaughan, John (Jacky) xiv, 289–90, **289**, 297, 299
Vaughan, Thomas 290
Vaux, Colonel Ernest CMG, DSO 181
Venetian Lions, Berwick-upon-Tweed (Anon) 18, **18**
Victoria, queen of England 12, 45, 48, 73, 120, 121,
 135, 137, 152, 177, 184, 206–7, 248
 monuments to 72–3, **72**, 78, 119–21, **120**, 121–2,
 121, 135–6, **136**, 177–8, **177**, 206–7, **206**
Victoria Hall Tragedy Memorial, Sunderland
 (Brooker) 183–5, **184**
Victorian Baker's Shop, Gateshead (Talbot) 61, **61**
Viewing Platform, Gateshead (O'Connell) 59, **59**
Viewpoint, Kielder (Kovats) 36, **36**
Viewpoint Markers and Bench, Hebburn (Jarratt and
 Canavan) 75, **75**
Viking Warrior, Morpeth (Wrightson) 41–2, **42**
Vikings, Jarrow (Davidson) 76, **76**
Viola, Bill, *The Messenger* xxi
Visual Arts UK xxi, 53, 59, 80, 172, 205, 206, 209, 226,
 227, 240, 243, 254, 256, 260, 316
The Voyages of Captain Cook, Middlesbrough
 (Meadows) 298, **298**

Walker, Dr John 306–7, **307**
Wall, Brian, *Thornaby (The Spider)* xv, 309, **309**, 338
Wallace, Aidan, restorer, *John English, Monument to*
 216–17, **216**

Wallace, André 107, 338
 Man with Pigeons 113, **113**
 River God xxii, 107–8, **108**
 Siren xxii, 108, **108**
Wallington, *Griffins' Heads* xiv, xv, 49–50, **50**
Wallington Hall xiv, 49, 50
Wallsend
 Buddle Arts Centre 213, 214
 Forum shopping centre 213
 Groove 213–14, **213**
 Market Woman xxiv, 213, **213**
 Memorial Hall 212
 Swan Hunter War Memorial 212–13, **212**
 Wallsend First World War Memorial 211–12, **212**
 Winter Garden 212
Wallsend First World War Memorial, Wallsend (Anon)
 211–12, **212**
Walton, William 259–60, **260**
War Memorial, Berwick-upon-Tweed (Carrick) 16,
 16
war memorials xvi, 119
 Alnwick War Memorial 1, **1**
 Ashington War Memorial 10–11, **11**
 Bellingham South African War Memorial 13–14,
 14
 (Berwick upon-Tweed) War Memorial 16, **16**
 Burma Campaign War Memorial 139, **139**
 (Darlington) South African War Memorial 236–7,
 237
 Emma Colliery War Memorial 170–1, **170**
 (Gateshead) South African War Memorial 62,
 62,70–1, **71**
 Gateshead War Memorial 65, **65**
 Haydon Bridge War Memorial 28–9, **29**
 Holywell War Memorial Fountain 34–5, **34**
 Merchant Navy Memorial 173, **173**
 Newburn First World War Memorial 87, **87**
 Newcastle First World War Memorial 99–101, **100**,
 101
 (Newcastle) South African War Memorial 129–31,
 130, **131**
 North Shields First World War Memorial 158–9,
 159
 Percy Cross 43–4, **44**
 The Response 1914 90–2, **91**, **92**
 Saltburn War Memorial 305, **305**
 Silksworth War Memorial 171–2, **172**
 6th Northumberland Fusiliers War Memorial 90,
 90
 Sunderland First and Second World War Memorial
 180–1, **181**
 Swan Hunter War Memorial 212–13, **212**
 Thornaby Aerodrome Memorial 309–10, **310**
 Untitled (Neville's Cross) 243, **243**
 Wallsend First World War Memorial 211–12, **212**

West Allotment First World War Memorial 155,
 155
Ward, Gilbert 79, 82, 131, 338
 Abstracted Natural Forms 201, **201**
 Derwent Valley sculptures 230, **230**
 Endless Column 201, **201**
 Fossilised Insect 82, **82**
 Link Column 202, **202**
 Sleeping Deer and *Newt* 265, **265**
 Untitled Way-marker 79, **79**
Warkworth, *Lion Rampant* 50
Wars of the Roses 29
Warwick, Earl of 29
The Watcher, Hartlepool (Atkin) 283–4, **283**
Watching & Waiting, Sunderland (Wilbourn, Fisher
 and Knowles) 195–6, **196**
Watchmen of the Clock Tower, Morpeth (Anon) 43
Water Sculpture, North Shields (Auty) 161, **161**
Waterford, Henry de la Poer, 3rd Marquess of 26, 27
Waterford, Louisa, Marchioness of 26, 27
Waterford Memorial Fountain, Ford (Philip) (Scott)
 26–7, **26**
Waterhouse, Alfred 295
Waterstones, Kielder (Anon) 36–7, **36**
Watkin, David 41
Watson, Fred 74, 338
 Bookstack 145–6, **145**
 Inside Outside 74–5, **74**
 Way-markers and Seat 227, **227**
Watson, John Edward, architect, 19–25 Grainger
 Street, Newcastle upon Tyne 115–16, **115**
Watt, Angus xxi
Watt, George 99
Watteau, Jean-Antoine 172
Watts, Felicity xxvi, 87, 338
 Russell Wood Sculptures 86–7, **86**
Wave, North Shields (Broderick) (Northern
 Freeform) 160, **160**
Wave Chamber, Kielder (Drury) 35, **35**
The Way, Durham (Horsley) xv, 248–9, **249**
way-markers 79, 81
Way-markers and Seat, Chester-le-Street (Watson)
 227, **227**
Wayne, John 302
W.D. Stephens, Monument to, Newcastle upon Tyne
 (Donaldson) 116, **116**
Weatherill, Bob, *Thornaby Aerodrome Memorial*
 309–10, **310**
Wellington, Duke of 6, 16–17, **16**, 23
Wentworth, Richard xxiii, 258, 338
 Boundary Markers 258–9, **258**
Wesley, Charles 106
Wesley, John 106, **106**, 262–3, **262**
Wesley Memorial Fountain, Newcastle upon Tyne
 (Anon) 106, **106**

West Allotment First World War Memorial, North
 Shields (Scoular) 155, **155**
West Hartlepool Business Group 284
West Stanley Colliery disaster 274–6
West Stanley Colliery Disaster, 1913, Memorial,
 Stanley (Anon) 274–5, **275**
West Stanley Colliery Disaster, 1995, Memorial,
 Stanley (Brady) xviii, 275–6, **275**
West Wind, Kibblesworth (Reynes) 80–1, **81**, 205
Whale and a Snail 55
Wharton, John 250
Wharton, W.L. 248, 250
Whickham
 British Liberty, Monument to xv, xix, 214–15, **214**
 Derwent Walk Express 217, **217**
 Gibside 214–15
 Harry Clasper, Monument to 215–16, **215**
 John English, Monument to 216–217, **216**
Whirling Beans, Kielder (Rose) 37–8, **37**
White, Matthew 21
White, Robert 44
White, William 278
Whitehead, J. 339
 Miners' Leaders 252–3, **252**, **253**
Whitfield, William, Student debating chamber,
 Newcastle upon Tyne 142, **142**
Whitley Bay, *Bacchanalian Figures* 218, **218**
Whitmore, Nicholas 339
 Burma Campaign War Memorial 139, **139**
Whittingham, *Ravensworth Fountain* 51, **51**
Whitworth, Dawn 101, 102
 Peace Sculpture 101–2, **101**
Whitworth, Joseph 122
Whylock, Dr 117
Wijck, Jan 219, 339
 James II 219, **219** (LOST)
Wilbourn, Colin xxvi, 190, 191, 339
 Always Open Gates 193–4, **194**
 Kathedra 250, **250**
 Passing Through 191, 196–7, **196**, **197**
 Pathways of Knowledge 193, 194, **194**
 The Red House 195, **195**
 Shadows in Another Light xxiii, 163, 191, 191–3,
 192, 193, **193**

Stone Stair Carpet 199–200, **200**
 The Upper Room 251, **251**
 Watching & Waiting 195–6, **196**
 Windows and Walls 193, 198, **198**
Wilding, Alison, *Ambit* xvi, xxii, xxiii
Wiles, Tony, *Family of Penguins* 303–4, **304**
Wilkinson, Andrea 339
 The Flock 36, **36**
Wilkinson, Ellen MP 77
Wilkinson, Major-General Sir Percy KCMG, CB 305
Will Dickson Fountain, Alnwick (Anon) 8–9, **8**
William of Orange 39, 219
William C. Rippon Memorial Fountain, Rowlands
 Gill (Anon) 169, **169**
William Coulson, Monument to, Newcastle upon
 Tyne (Rechberg) 118–19, **119**
William Laing Memorial Fountain, Newcastle upon
 Tyne (Anon) 117–18, **117**
William the Lion 9
William the Lion Stone, Alnwick (Anon) xix, 9, **9**
William Thomas Stead, Monument to, Darlington
 (Anon) 231, **231**
William Walton, Monument to, Ferryhill (Swinburn)
 259–60, **260**
Williams, A.V. 267
Williamson, Sir Hedworth 177, 187, **187**
Wilson, Eric 339
 231 xviii, xxvi, 24, **24**
Wilson, F.R. 5, 13
Wilson, Major-General Sir Percival S. 90
Wilson, Richard 339
 Jamming Gears 307
 Over Easy 307–8, **307**
Wilson, Councillor Walter 100
Wilson, William 17–18, 48, 339
 Eagle and Heads 17–18, **17**
 Figures, Animals and Keystone Heads 48, **48**
 Keystone Heads, Busts, Decorations and Dog 47–8,
 48
 Three Busts 17
Window, Gateshead (Rose) 60–1, **60**
Window on the World 61
Windows and Walls, Sunderland (Wilbourn and
 Fisher) 193, 198, **198**

Windy Nook, Gateshead (Cole) 74, **74**
Wingate, *Wingate Grange Colliery Disaster Memorial*
 278–9, **278**
Wingate Grange Colliery disaster 278–9
Wingate Grange Colliery Disaster Memorial, Wingate
 (Borrowdale Brothers) 278–9, **278**
Winning, Ross 74
Winstone, Mike 73, 339
 Sports Day 73–4, **73**
Winter, William 24
Wise, Elizabeth 93
Wolsingham, *Duckett's Cross* 279, **279**
Wood, Nicholas 235
Wood, Percy, *Jack Crawford, Monument to* 182–3,
 182
Wooden Dollies 103, 159–60
Wooden Dolly
 North Shields (Anon) 166, **166**
 North Shields (Grubb) 159–60, **159**
 North Shields (Robert Thompson Ltd) 160–1, **160**
Woodhorn Colliery 9
'Wor Jackie' *see* Milburn, Jackie
Wor Jackie, Newcastle upon Tyne (Robinson) 105,
 105
Wouldhave, William 176–7, **177**
Wren, Sir Christopher 219
Wright, Austin 146, 340
 Untitled 146, **146**
Wright, R.S. 271
Wright, Thomas 227, 228
Wrightson, Margaret 340
 Viking Warrior 41–2, **42**
W. Wouldhave and H. Greathead, Monument to,
 South Shields (Farbridge) 176–7, **177**
Wyatt, James 20
Wynne, David 93, 340
 River God Tyne 94, **94**
 Swans In Flight 94, **94**

Yates, Peter, architect 221
Yeavering Stone xvi
York, Archbishop of 190
Young, Gordon, *The Family* 65–6, **65**, **66**

Zetland, Thomas, Earl of 167